RAPHAEL
FROM URBINO TO ROME

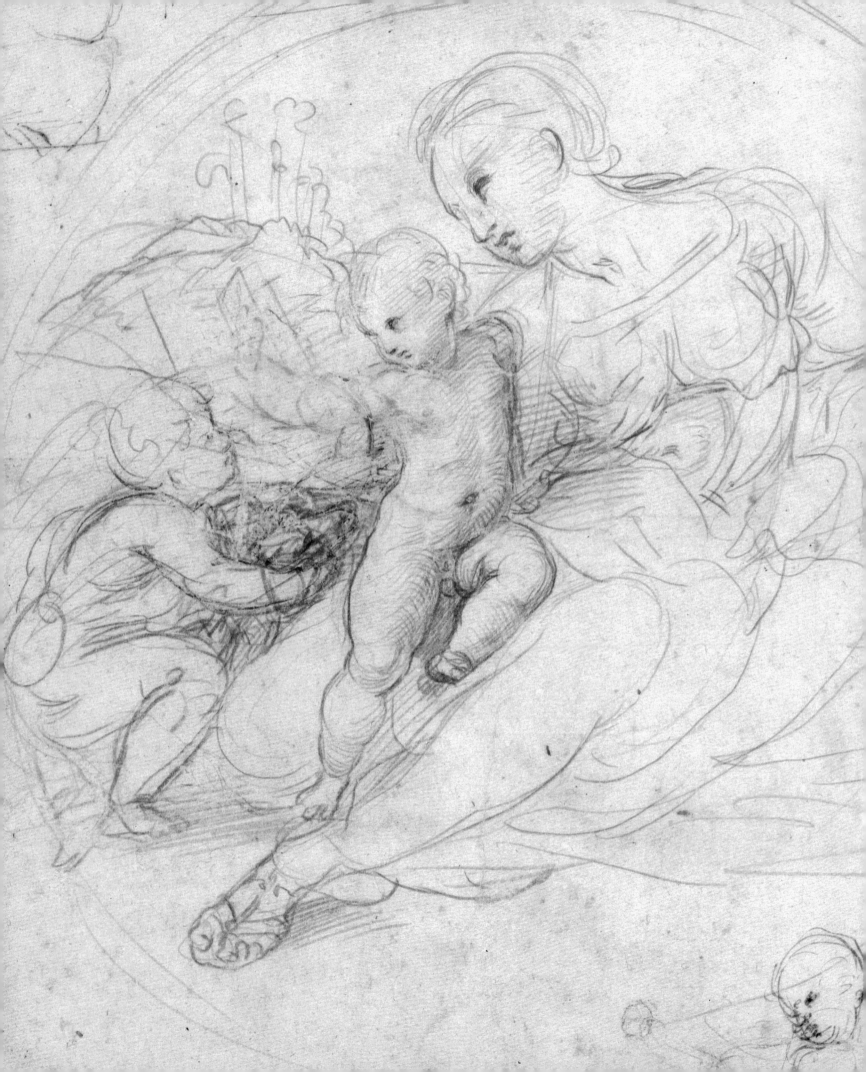

Hugo Chapman, Tom Henry
and Carol Plazzotta

WITH CONTRIBUTIONS FROM

Arnold Nesselrath and Nicholas Penny

RAPHAEL
FROM URBINO TO ROME

NATIONAL GALLERY COMPANY, LONDON
DISTRIBUTED BY YALE UNIVERSITY PRESS

Published to accompany the exhibition
RAPHAEL: FROM URBINO TO ROME
at the National Gallery, London
from 20 October 2004 to 16 January 2005

Exhibition supported by

Catalogue research supported by

A·H·R·B
arts and humanities research board

First published in Great Britain in 2004 by
National Gallery Company Limited
St Vincent House
30 Orange Street
London WC2H 7HH
www.nationalgallery.co.uk

ISBN 1 85709 999 0 paperback 525096
ISBN 1 85709 994 X hardback 525094

British Library Cataloguing-in-Publication Data
A catalogue record is available from the British Library

Library of Congress Catalog Card Number 2004107913

PROJECT EDITOR Jane Ace
PUBLISHER Kate Bell
CONSULTANT EDITOR Caroline Elam
COPY-EDITOR Diana Davies
EDITORIAL ASSISTANCE Rebeka Cohen and Tom Windross
DESIGNER Philip Lewis
PICTURE RESEARCHER Xenia Corcoran
PRODUCTION Jane Hyne and Penny Le Tissier

Printed and bound in Italy by Conti Tipocolor

All measurements give height before width

FRONT COVER/JACKET *The Virgin and Child with Saint John*
(*The Alba Madonna*) (detail), about 1509–11 (cat. 93)
FRONTISPIECE *Study for the Alba Madonna* (detail), about 1509–11 (cat. 94)
PAGE 6 *The Madonna and Child with the Infant Baptist*
(*The Garvagh Madonna*) (detail), about 1509–10 (cat. 91)
PAGE 8 *The Madonna and Child with Saint John the Baptist
and Saint Nicholas of Bari* (*The Ansidei Madonna*) (detail), 1505 (cat. 45)
PAGES 12–13 *The Crucified Christ with the Virgin Mary, Saints
and Angels* (*The Mond Crucifixion*) (detail), about 1502–3 (cat. 27)
PAGES 66–7 *Study for the Massacre of the Innocents* (detail), about 1510 (cat. 89)

CONTENTS

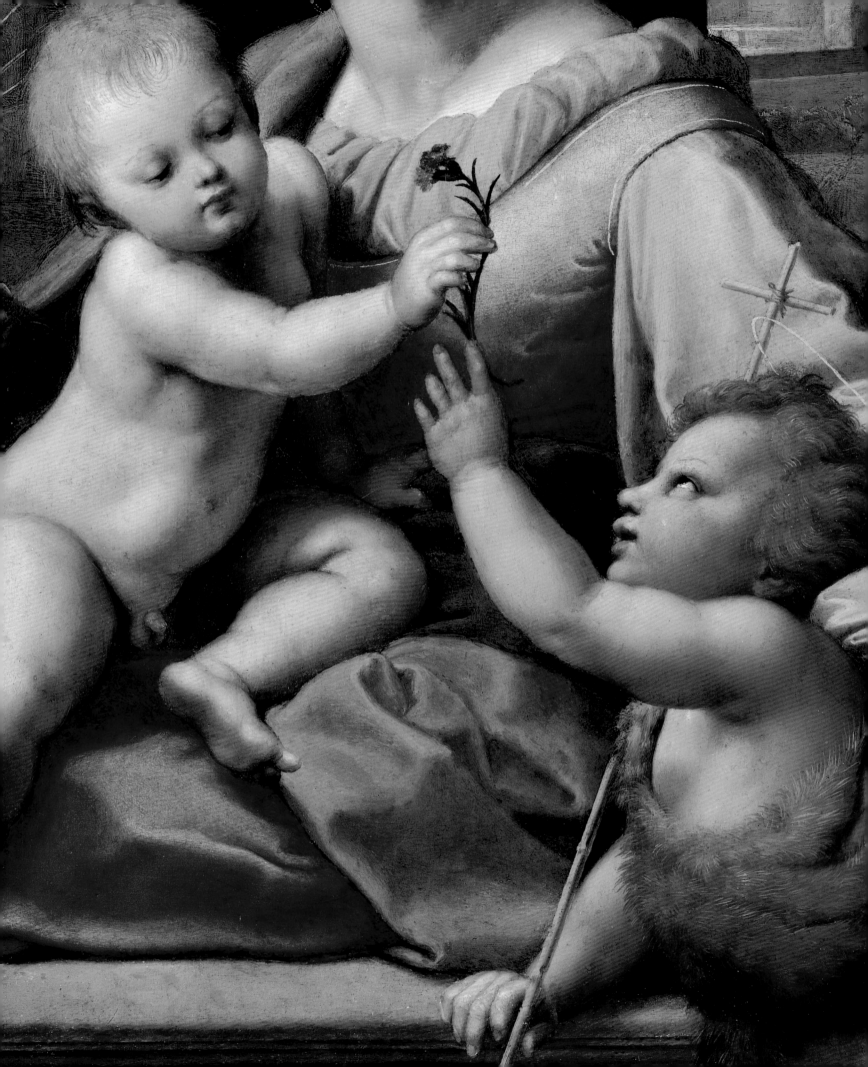

Credit Suisse First Boston has a long tradition of supporting the arts and is delighted to be sponsoring *Raphael: From Urbino to Rome* at the National Gallery. This is the first major exhibition of paintings and drawings by Raphael to be held in Britain and we are proud to be involved in bringing the wonder of the Renaissance period to a new audience.

Raphael's paintings form the cornerstone of Western art. The young Raphael developed into one of the world's most celebrated and renowned Renaissance artists. Throughout his short career, he pushed the boundaries of artistic influence and evolution.

This unique exhibition, which brings together the National Gallery's own paintings with key loans from the National Gallery of Art, Washington, the Louvre, the Hermitage and the Uffizi, also reflects the collaborative spirit of our organisation. At Credit Suisse First Boston, we strive to bring the Firm's strengths to bear for the benefit of our clients.

Congratulations to the National Gallery for successfully bringing such an extraordinary event to the United Kingdom. We hope that you enjoy your visit to this magnificent exhibition.

CHRISTOPHER CARTER
Chairman
Credit Suisse First Boston (Europe)

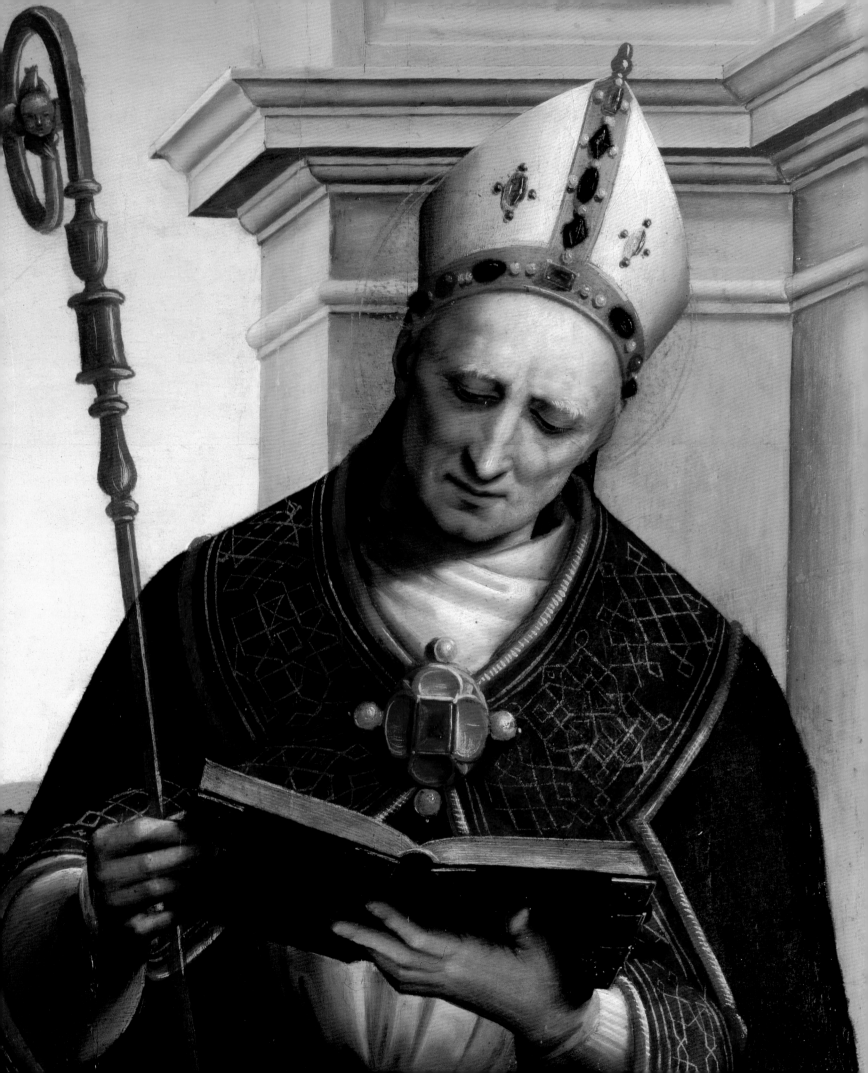

DIRECTOR'S FOREWORD

An exhibition of paintings and drawings by Raphael is a rare event. His iconic works, invariably the stars of any collection, are fragile, and can seldom travel. The National Gallery, with its rich holding of nine early paintings by Raphael, is therefore one of the few venues in the world that can stage a comprehensive monographic exhibition. Its collection of two major altarpieces, two predellas, an allegory, two small Madonnas and a papal portrait represents the full range and variety of Raphael's output and illustrates, almost year by year, the formative part of his career. This exhibition concentrates on the young artist's development up to the death of Pope Julius II in 1513, and his emerging style is studied in a chronological sequence of over 80 autograph works, interspersed with paintings and drawings by his early teachers and prime influences.

The wealth of paintings and drawings by Raphael in Britain reflects a long-standing admiration for the artist in this country. He has been represented in the National Gallery since its foundation in 1824, when his *Portrait of Pope Julius II* (cat. 99) was acquired with John Julius Angerstein's collection. The mistaken demotion of this work to the status of a copy within two decades (only rectified in 1970) made it imperative to acquire other Raphaels, and the story of subsequent purchases (*Saint Catherine* in 1839, the *Vision of a Knight* in 1847 and the *Garvagh Madonna* in 1865) is told in Nicholas Penny's admirable essay at the end of this catalogue. However, the high sums demanded for Raphael's paintings, fanned by interest from Europe, Russia and America, made it difficult for the Gallery to secure them. The attempt by Sir Charles Eastlake, before he became the first Director of the Gallery, to purchase Raphael's great altarpiece of the *Crucifixion* (cat. 27) at the sale of Cardinal Fesch's collection in 1845 failed due to budgetary restrictions set by the government and Trustees.

Another opportunity to acquire a Raphael altarpiece arose when the 8th Duke of Marlborough decided to sell key paintings from the family collection at Blenheim Palace, foremost among which was the *Ansidei Madonna*. However the prices were so high that only the two most important, the Raphael and Van Dyck's *Equestrian Portrait of Charles I*, could be considered by the Gallery. Following an appeal of Royal Academicians and interventions from every level of society, the government offered a special grant of £87,500 in 1885, more than eight times the Gallery's annual purchase grant (suspended for the following four years), of which £70,000 went towards the Raphael. The *Ansidei Madonna's* predella depicting *Saint John the Baptist Preaching* (cat. 46) happily rejoined the altarpiece in 1983 when it was acquired from the heirs of Lord Lansdowne.

In 1895, the Gallery contemplated purchasing Raphael's *Colonna Altarpiece* (fig. 68) from the collection of the King of Naples, which had been displayed in Trafalgar Square between 1871 and 1872, and in the South Kensington Museum between 1886 and 1896. Its reception was controversial and the Gallery declined to buy it on grounds of condition. The five elements of the predella, first dispersed at the Orléans sale in London in 1798, remained in British collections throughout the nineteenth century. Two little saints (cats 43 and 44) found their way into the Dulwich Picture Gallery as early as 1811, but the others were highly marketable in the face of growing demand for Renaissance works from wealthy American collectors. In 1900, the dealer Joseph Duveen brokered the sale of the *Pietà*, then in London, to Mrs Gardner of Boston. In 1913, the Gallery succeeded in securing the *Procession to Calvary* (cat. 41) from Lord Windsor, 1st Earl of Plymouth, a longstanding Trustee, but could never have competed with the price Duveen paid for the *Agony in the Garden* in 1924 (he sold it on to an American industrialist for the reputed sum of half a million dollars). Thanks to the generosity of the Gardner and Metropolitan Museums, and Dulwich Picture Gallery the *Colonna Altarpiece* predella is here reunited for the first time in over 200 years.

Despite the appointment of Lord Ward, 1st Earl of Dudley, as Trustee in 1877, neither the *Three Graces* (fig. 65), which he inherited from his father, nor Raphael's *Crucifixion*, which he bought from the Fesch heirs in 1847, was offered to the National Gallery (the latter was bought at Lord Ward's posthumous sale in 1892 by Ludwig Mond). It was only through the generosity of the Mond family that this great altarpiece joined the Ansidei in the National Gallery in 1924. Another gift to the Gallery was the ruined Madonna named after Eva Mackintosh, who presented it in 1906. The *Mackintosh Madonna* is the Gallery's phantom tenth Raphael, rarely cited because of its lamentable condition which also excludes it from the exhibition (the composition is, however, represented by cat. 98, the splendid cartoon from the British Museum).

Enthusiasm for Raphael has not waned in the twenty-first century. The threatened sale in 2002 of the Duke of Northumberland's *Madonna of the Pinks* to the Getty Museum in California provoked furious debate reminiscent of public reaction to the Blenheim sale. The urgency of the campaign was heightened by the fact that the *Madonna* was one of the last paintings by Raphael remaining in British private collections (there are only three others, all owned by the Duke of Sutherland, who has generously lent cat. 62). The painting was eventually acquired in March 2004, following a widely

supported public appeal and the allocation by the Heritage Lottery Fund of the largest grant ever given for a single work of art.

Many of the international loans to this exhibition have not been seen in this country before, including the processional banner from Città di Castello (cats 18 and 19), which until now has never left the city for which it was painted. Several other paintings return for the first time since being sold from British private collections in the nineteenth and twentieth centuries. The little-known *Resurrection of Christ* (fig. 21), which has been lent by São Paulo, was sold from Lord Kinnaird's collection in 1946 as a minor follower of Perugino. This is the first time the painting has been seen in the context of other works by Raphael, including two well-known preparatory drawings from the Ashmolean Museum (cats 23 and 24) and a newly discovered study from Pesaro (cat. 22). The National Gallery's rumoured interest in acquiring the *Resurrection* cannot be proved, but other paintings in this exhibition were certainly offered to the Gallery and turned down, including the Hermitage Museum's *Conestabile Madonna* (cat. 32) and the Louvre's *Apollo and Daphnis* (cat. 7) now acknowledged as a work by Perugino, which the Gallery could not accept as by Raphael (correctly as it turned out) when it was offered to them in the 1850s.

Raphael's drawings first began to filter into this country in the seventeenth and eighteenth centuries, but their number increased dramatically following the revolutionary upheavals in continental Europe. The English connoisseur William Young Ottley was in Italy at the time of the French invasion of Italy in 1796 and, as well as buying paintings (including cat. 35), he amassed a substantial collection of Raphael's drawings. Several of the nine Raphael drawings bequeathed to the British Museum by Richard Payne Knight in 1824 came from Ottley (including cats 58 and 96), and even more

ended up in the collection of the fashionable portraitist Sir Thomas Lawrence (for example fig. 45 and cat. 37). Lawrence's discerning eye and reckless disregard for expense led him to amass perhaps the greatest ever collection of Italian drawings. One of its outstanding strengths was a group of around 180 studies by Raphael, mostly of indisputable authenticity and supreme quality. On his death in 1830, his entire collection was offered to various buyers, including both the National Gallery and the British Museum, but tragically negotiations fell through and parts were sold off by Lawrence's major creditor, the dealer Samuel Woodburn. This missed opportunity was partly repaired in 1845 by the University of Oxford's purchase for its galleries (now the Ashmolean Museum) of a group of 150 ex-Lawrence Raphael drawings (just under half of which are now considered authentic). The British Museum also acquired more than seventeen Raphael drawings from Lawrence's collection, after Woodburn's collection was dispersed following his death in 1860.

The study of Raphael, pioneered with impressive thoroughness by scholars in the nineteenth century, was immeasurably enriched by the surge of new research that emerged from quincentennial exhibitions held worldwide in 1983–4 and by John Shearman's recent publication of all known Raphael documents to 1602. The catalogue pays homage to and builds on what has gone before, but also contributes new information arising from recent archival finds and technical investigation. The exhibition's success is a testament to generations of collectors, scholars, directors and curators, and not least to the dedication and enthusiasm of its curators, Carol Plazzotta of the National Gallery, Tom Henry and Hugo Chapman.

CHARLES SAUMAREZ SMITH
Director, The National Gallery, London

ACKNOWLEDGEMENTS

For Caroline Elam and Nicholas Penny

'aiutandoli et insegnandoli con quello amore che non ad artifici, ma figliuoli proprii, si conveniva'

GIORGIO VASARI, *'Life' of Raphael*, 1568 (translated below)

The National Gallery would like to thank the many lenders to this exhibition for helping us to realise this ambitious endeavour (see p. 316). The British Museum and the Ashmolean Museum have been spectacularly generous, enabling us to chart the development of Raphael's compositions as well as his presence in British collections with remarkable thoroughness, and we are especially grateful to them. The Gallery is also most grateful to Credit Suisse First Boston who have generously sponsored the exhibition, and in addition would like to thank the Arts and Humanities Research Board for funding Tom Henry in the course of his research for this project. Special thanks are also due to Oxford Brookes University and to the Department of Prints and Drawings of the British Museum for kindly allowing Tom Henry and Hugo Chapman time to research and write the catalogue.

The authors would like particularly to thank Jill Dunkerton, Rachel Billinge, Ashok Roy and Marika Spring with whom we conducted technical examinations of all the Raphaels in the National Gallery. David Jaffé, Luke Syson, Caroline Campbell and Minna Moore Ede also made valuable contributions, while Arnold Nessselrath was a great help in allowing access to the Vatican collections. Caroline Elam generously agreed to be our Consultant Editor, and the catalogue has been greatly honed and improved by her unrivalled editorial skills. Nicholas Penny also kindly read the catalogue, and his account of the collecting and reception of Raphael in the nineteenth century (see pp. 295–303) is a fitting testament to his curatorship of the Italian Renaissance paintings in the National Gallery from 1990 to 2002, and his scholarly work on Raphael over many years. Vasari described how Raphael would 'help and teach his fellow artists with a love due rather to his own children, than to colleagues', and the dedication of the book to Caroline and Nick, who have been friends and mentors to each of us in our own formative periods, reflects our admiration of the standards they set, and our gratitude for the inspiration they have provided. Finally we would like to thank the many members of staff at the National Gallery and the National Gallery Company who have contributed their expertise, as well as the following friends and colleagues for their incalculable help along the way:

Christopher Baker, Carmen Bambach, Karen Barbosa, Herbert Beck, Giordana Benazzi, George Bisacca, Caterina Bon Valsassina, Hugo Bongers, Antonio Brancati, Arnauld Brejon de Lavergnée, Barbara Brejon de Lavergnée, Julian Brooks, Christopher Brown, Michelle Brown, William P. Brown, David Alan Brown, David Bull, Francesco Buranelli, Michael Bury, Kim Butler, Lorne Campbell, Frances Carey, Dawson Carr, Stefano Casciù, Alessandro Cecchi, Fernanda Cecchini, Isabella Chapman, Marco Chiarini, Alan Chong, Keith Christiansen, Michael Clarke, Martin Clayton, Sir Timothy Clifford, Roberto Contini, Donal Cooper, Dominique Cordellier, Principessa Corsini, Alba Costamagna, João da Cruz Vicente de Azevedo, Jean-Pierre Cuzin, Paolo Dal Poggetto, Diana Davies, Jonathan Davies, Peter Day, Ian Dejardin, Christiane Denker Nesselrath, Rodolfo Donzelli, Barbara Dosso, Alexander Dückers, Rembrandt Duits, David Ekserdjian, Albert Elen, Miguel Falomir, Sylvia Ferino Pagden, Gabriele Finaldi, Maria Teresa Fiorio, Sarah Fisher, Jennifer Fletcher, Donald Forbes, Cecilia Frosinini, Vittoria Garibaldi, Achim Gnann, Catherine Goguel, Antony Griffiths, Eugenia Gorini Esmeraldo, Silvana Grosso, Roberto Guerrini, Maja Häderli, Colin Harrison, Anne Hawley, Kristina Hermann Fiore, Michel Hilaire, Michael Hirst, Charles Hope, Philippa Jackson, Paul Joannides, Laurence Kanter, Larry Keith, Jan Kelch, Bram Kempers, Phillip King, Monique Kornell, Giulio Lepschy, Laura Lepschy, Philip Lewis, Franca Lilli, Richard Lingner, Christopher Lloyd, Andrea di Lorenzo, Henri Loyrette, Neil MacGregor, Dorothy Mann, Eckart Marchand, Luciano Marchetti, Patrick Matthiesen, Nick Mayhew, Liz McGrath, Paola Mercurelli Salari, Lorenza Mochi Onori, Philippe de Montebello, Bruno Mottin, Antonio Natali, Fausta Navarro, Jonathon Nelson, Arnold Nesselrath, Julio Neves, Fabrizio Nevola, Laura Nuvoloni, Cardinal Cormac Murphy-O'Connor, Noelle Ocon, Serena Padovani, Antonio Paolucci, Marilia Pereira, Annamaria Petrioli Tofani, Teresa Pinto, Mikhail Piotrovsky, Vincent Pomarède, Lisa Pon, José Luis Porfirio, Pamela Porter, Earl A. Powell III, François Quiviger, Janice Reading, Patrizia Riitano, Sir Hugh Roberts, The Hon. Lady Roberts, Patricia Robertson, Duncan Robinson, Cristiana Romalli, Gianfranco Romani, Pierre Rosenberg, Francesco Rossi, Patricia Rubin, Axel Rüger, Francis Russell, Rosario Salvato, Mirko Santanicchia, Cécile Scailliérez, Klaus Albrecht Schröder, Hein-Th. Schulze Altcappenberg, David Scrase, Alberto Seabra, Desmond Shawe-Taylor, †John Shearman, Jutta Schütt, Mark Slattery, Martin Sonnabend, Nicola Spinosa, R.W. Stedman, David Steel, MaryAnne Stevens, Leslie Stevenson, Claudio Strinati, Margret Stuffmann, Valentine Talland, Bette Talvacchia, Barbara Tavolari, Anna Maria Traversini, Mariella Utili, Claire Van Cleave, Françoise Viatte, Aidan Weston-Lewis, Lawrence J. Wheeler, Catherine Whistler, Lucy Whitaker, Jon Whiteley, Timothy Wilson, Linda Wolk Simon, Martin Wyld, Annalisa Zanni, Olivier Zeder, Miguel Zugaza Miranda.

HUGO CHAPMAN, TOM HENRY AND CAROL PLAZZOTTA

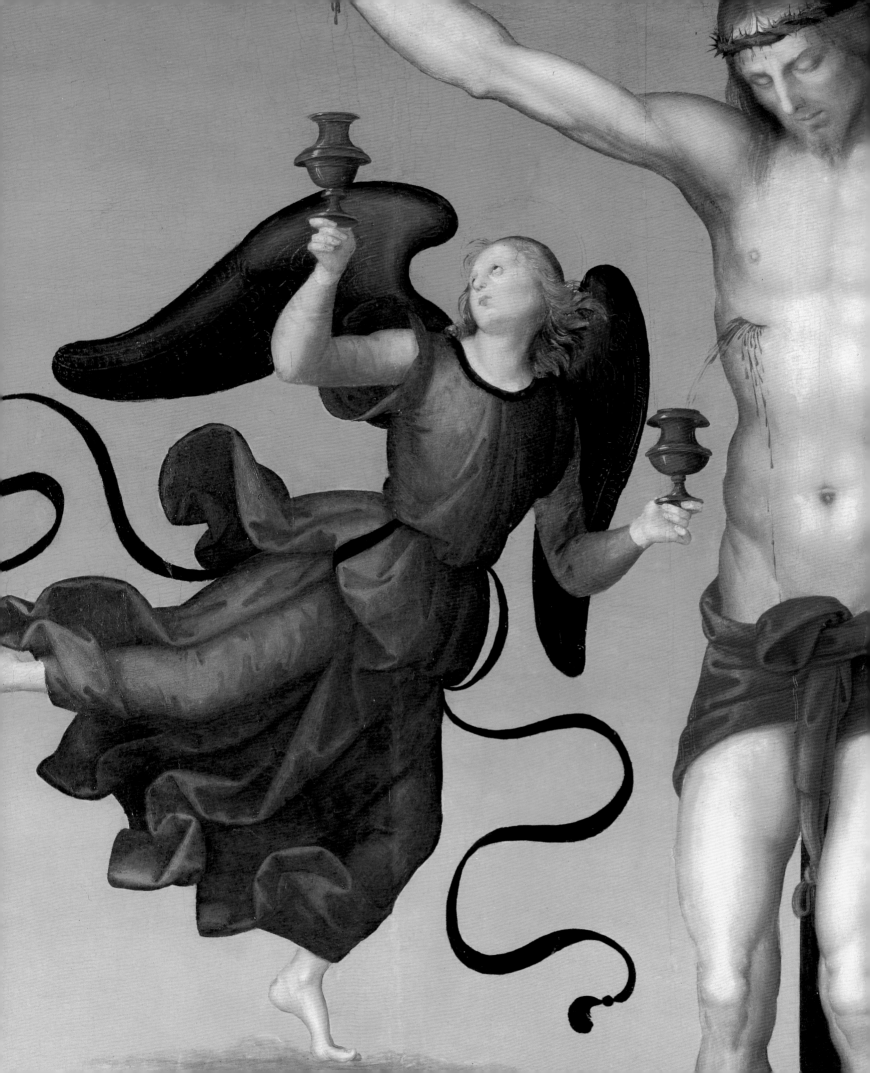

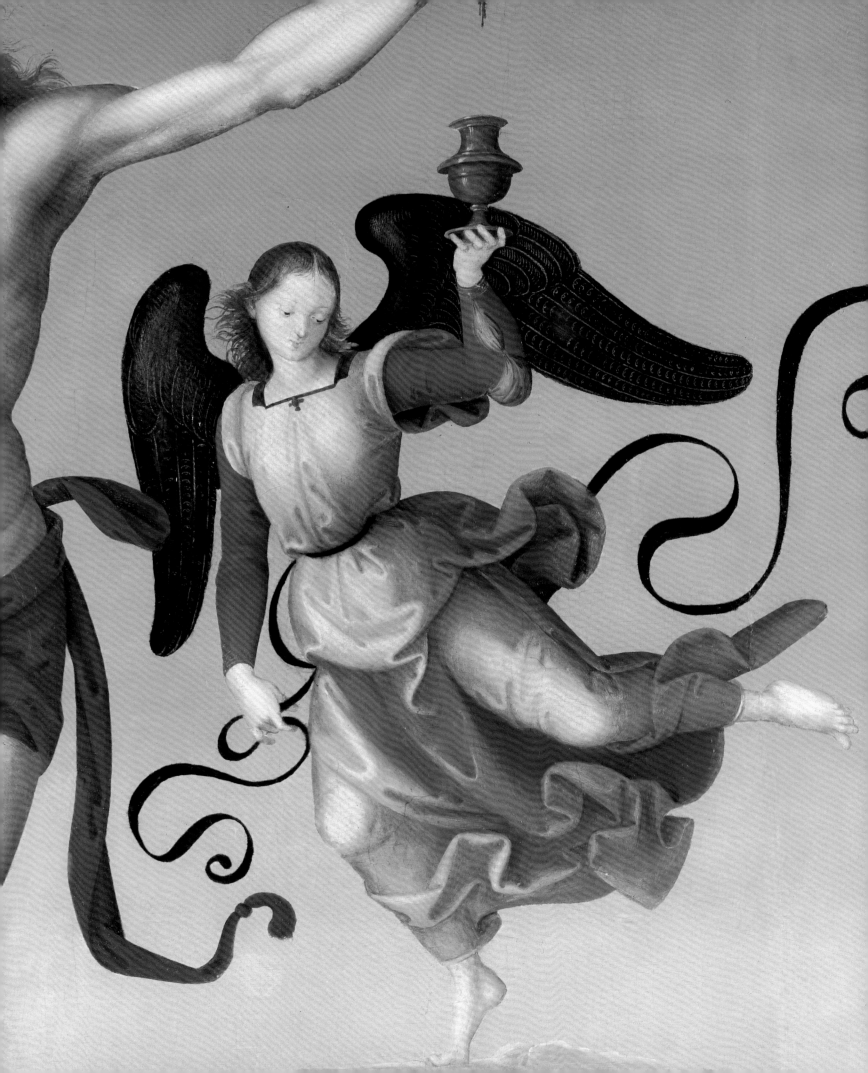

BOLOGNA Budrio C. Bolognef C.S. Pietro Imola Faenza Firenzuola

P. Primaro

RAVENNA Claffe Ceruia Rimini La Cattolica Pefaro Fano Sinigaglia ANCONA

Forlimpopoli Cefena Forli Cittadel Sole Bertinoro

ROMAG Humana S.M. di Cit

Scarperia Camaldoli Sarfina S. Marino S. Leo Macerata Carpegni Iefi Osmo ADRI

Fiefole Vallombrofa Borgo S. Sepolero Caftel Durante Foffembrone URBINO

FIORENZA Focognano S. Giouanni Cagli Rocchacotrada Recanati

S. Caffiano Arezzo M. Chiari Citra di Caftello Cantiano Saffo Ferrato Matelica Macerata

Barberino SIENA M.S. Maria Fratta Agubbio Fabriano Tolentino Fallerone

Cortona Sigello Noceri Camerino Mont

Maciareto Buon Conuento Valiano LAGO DI PERVGIA Perugia Ciuitella d'Amo Affifi Foligno M. Fortino

Pienza Marfciano Diruta Beuagna Treui Viffe Arquata

S. Quirico Chiufi Todi VMBRIA Spoleto Norcia Leonella Ciu Amatrice

M. Alcino Radicofani Cigliano Aqualparta Terni Cafcia Reali

Triuignano Oruieto Amelia Narni Interdoco Amiterno

Montieri A Campagnatico Acquapendente Bolfena Orta Otricoli Vefcouo C. Ducale Aquila

S. Fiora Giriano LAGO DI BOLSENA M. Fiafcone Magliano Vallnof Cicoli Albi Celano

Grofletto Sonana C. Caftellana Farfa LVDI FELANO

Ombrone Saturnia Viterbo Nepi M. Ritondo Vicouaro Veneri

Talamone Magliano M. Auto Caftro S. Marta Tofcanella Sutri Tiuoli Tagliacozzo Tivoli

S. Stefano Orbetello Anfedonia M. Alto Bieda Treuignana Baccano Frafcati Caua Ciui d'Antina

ARGENTARO Corneto Bracciano Galera ROMA Valmontone Anagni Alatri Sora

Il d'Hercole Cerueteri Ceri Porto Offia Albano Velletri Segni Ferentino Ifola

C. Vecchia Palo Ardea Sermoneta Veroli Arce

Giannura Nettuna Sezze Piperno Faluaterra Fondi Ieri

S. PIAGGIA ROMAN P. d'Anzo C. d'Anzo Aftura M. Circello Molo

GOIFO DI GAITA

Raphael: From Urbino to Rome

TOM HENRY AND CAROL PLAZZOTTA

This exhibition tells the story of Raphael's artistic journey from the Duchy of Urbino, where he was born in 1483, to the papal court in Rome, via the Central Italian cities of Città di Castello, Perugia, Siena and Florence (fig. 1). It is a story of extraordinary precocity and of equally extraordinary determination. Raphael's first securely dated work, an altarpiece painted for a church in the Umbrian town of Città di Castello, was delivered in September 1501 when he was only eighteen (see cats 15–17).[1] Within ten years, the young artist had moved from a relatively provincial practice in The Marches and Umbria to assume a near monopoly of papal patronage in the field of painting at the court of Pope Julius II, where his art attracted international demand and commanded extraordinary prices. During this period, Raphael's style underwent one of the most dramatic transformations in the history of art: one that prompted the first art-historical comment recorded from a Renaissance pope, and fits of jealous rage from his rivals.[2] In the course of a decade of great artistic activity and ceaseless assimilation of the styles of others, Raphael developed a personal style that is radically different from his earliest work.[3]

Raphael died in Rome in 1520 at the age of 37. In the last seven years of his life he maintained and extended his dominance of the Roman artistic scene under Leo X (1513–21), diversifying into architecture and archaeology, and increasingly delegating the execution of his paintings to his expanding workshop. The exhibition concentrates on the period of the painter's artistic formation up to the death of his first papal patron, Julius II, in 1513, examining his origins, experiences and training, and exploring how his art developed in response to a series of forceful influences.[4]

Raphael's earliest biographers and acquaintances held differing views on the degree to which his success could be attributed to natural talent as opposed to diligent study, but both these strands of his creative personality are crucial to any assessment of his art. His career can be charted through his response to cutting edge developments in the art that surrounded him, and this thrust emerges very strongly in the sequence of exhibits that follows. He was quick to appreciate quality and absorb innovation, adapting and improving the inventions of other masters with incredible ease.

But even in his earliest works, it is evident that Raphael far outstripped his father Giovanni Santi, and the other mature artists with whom he associated, in his own innate ability as a designer. The grace and fluency of his sketches and designs reveal his natural facility for drawing and their variety and inventiveness bear witness to his remarkably fertile imagination. Raphael's genius for design was complemented by an instinctive feeling for harmonious combinations of colour, and his paintings typically cohere as beautifully balanced unities. He was indeed a great perfectionist and the execution of his finished pictures depended upon a meticulous process of serial refinement through preparatory drawings, leading up to the production of near perfect cartoons. His graceful inventions were informed by his unusual capacity to empathise with his subjects, and his natural propensity for characterisation and narrative came to serve the interests of the wealthiest and most powerful patrons in Italy.

Raffaello di Giovanni Santi was born in Urbino at Easter 1483.[5] His mother, Magia di Battista Ciarla, died in October 1491 when Raphael was only eight, while his father, the painter Giovanni Santi, died three years later in August 1494.[6] Santi left half of his estate to Raphael and entrusted his eleven-year-old son to the care of his uncle, Bartolomeo, a priest, who also lived in Urbino.[7] Raphael's early childhood experiences were in this hilltop city-state ruled by members of the Montefeltro family, famous both as mercenary generals and as discerning patrons of the arts. Federigo da Montefeltro (d. 1482) had built a great Renaissance palace, which still dominates the city, filled its library with humanist manuscripts, and employed painters of repute such as Piero della Francesca and Justus of Ghent to work for him.

In the almost complete absence of contemporary documentation for Raphael's whereabouts and training before his first documented work of 1500–1 (cats 15–17),[8] Giorgio Vasari's account of his origins in the *Lives of the Artists,* published in two editions of 1550 and 1568, has assumed a central position in defining this formative period of the artist's life.[9] Vasari's analysis of how Raphael perfected his

successive *maniere* (styles) has not been surpassed, and the structure of his *Life* of Raphael, which has been extremely influential on perceptions of Raphael's early formation, remains fundamental.[10] Although Vasari's biography is demonstrably well informed (especially about the artist's activity in Florence and Rome),[11] it was also written to serve a rhetorical purpose, doubling as an exemplary essay on the benefits of education, application and study as the key to artistic success.[12] If his division of Raphael's career largely by the location of his works might at first reading seem simplistic, underestimating the extent to which Raphael moved around between a number of cities in Central Italy in these early years, on closer inspection the description of Raphael's movements appears in the main to be remarkably accurate.

Vasari emphasises Raphael's auspicious start in life, describing an ideal progression from nurturing mother and attentive father to the recognition of his talents by a solicitous teacher. He opens the *Life* with a paean of praise for Raphael's character, going on to describe his birth on Good Friday,[13] and his naming after an archangel for good fortune. Giovanni Santi's concern for his infant son was exemplified by his wish that his wife should nurse the child herself so that he should not be exposed to the rough manners of peasants – in contrast with Michelangelo, who was sent to a wetnurse in Settignano. As Raphael grew up, Santi began to train him in painting, 'seeing that he was much inclined to that art and of great intelligence', and while still a child the boy assisted his father in many works made for the state of Urbino.[14] But, according to Vasari, Santi soon realised that Raphael had learned all he could from him, and decided to apprentice his son to Pietro Perugino, the leading painter of Central Italy, whom he sought out in Perugia. Perugino was particularly struck by Raphael's ability in drawing (as well as his beautiful manners and behaviour), and Vasari tells how the boy soon learned to imitate Perugino's style so exactly that it was impossible to distinguish his copies from the master's originals.

Although scholars in the past used to reject the idea that Raphael could have learnt anything from his father before the latter's death in August 1494,[15] a different view is now emerging which suggests that he may well have been taught by Santi to draw and paint from a very young age. Taken at face value, Vasari's *Life* implies that Raphael was apprenticed to Perugino before Santi's death, and even before his mother died in 1491 (when Raphael was just eight years old). This position has been adopted by numerous writers, and it is certainly true that in the Renaissance apprenticeships could start very young.[16] Others have modified Vasari's account to suggest that Raphael joined Perugino's workshop soon after his father's death, perhaps benefiting from the connections between Santi and Perugino which can probably be traced to the years 1488–94 when both painters were working for the church of S. Maria Nuova at Fano.[17] Links between Santi and Perugino are also suggested by the figural motifs shared by the two artists (indeed Raphael would

have been able to absorb aspects of Perugino's repertoire before any direct contact with him).[18] Santi's expressed admiration for Perugino as 'a divine painter' has also lent credence to Vasari's account.[19]

However, although Raphael clearly had a very close association with Perugino later on (as will be discussed below), the grounds for believing that he was formally apprenticed to Perugino's shop before his father's death, or that he spent a lengthy time with Perugino in the 1490s, now look flimsy. His most Peruginesque works are not his first independent paintings, and attempts to attribute to Raphael paintings produced by the Perugino workshop in the 1490s make very little sense in the light of his subsequent development (as seen in cats 15–17).[20] Moreover, while many of Perugino's pupils are mentioned by name in documents, Raphael is never among them.[21]

By contrast, a consistent body of evidence supports the idea that Raphael's earliest training took place with Santi or in his workshop, which may have continued to operate after the master's death and certainly seems to have been accessible to Raphael in 1500. Michelangelo later observed that Raphael's style had evolved from the combined early influences of 'his father who was a painter, and his master Perugino',[22] and Raphael was still described as a *scolaro* (student) of his father in a document drawn up at the Vatican in 1511.[23]

This evidence is backed up by examination of Raphael's first documented work: the Saint Nicholas of Tolentino altarpiece (cats 15–17) for the church of S. Agostino in Città di Castello, a small city in the upper Tiber valley (about 35 miles south-west of Urbino). The painting was commissioned in December 1500 by Andrea Baronci from Raphael and Evangelista di Pian di Meleto (d. 1549), Santi's closest assistant and a documented member of his household from 1483. It was delivered in September 1501.[24] Evangelista is known to have returned to Urbino during the course of the picture's execution,[25] and the clause in the altarpiece's contract stating that its terms were to be enforced in Città di Castello or in Urbino would seem to confirm that both artists were based in the latter city at this time. The absence of any reference to Perugia also suggests that the Baronci altarpiece was executed before Raphael had any sustained contact with either that city or with Perugino.[26] The involvement of two artists necessarily complicates discussion of this picture, but even the most Raphaelesque parts (the *Angel* in Brescia, fig. 2) are deeply indebted to Santi in the way that they are painted and in the range and balance of colours.

Differences between the painting techniques of this picture and Peruginesque works, such as, for example, the *Mond Crucifixion* (cat. 27), present the most compelling evidence that Raphael trained in his father's workshop. The most obvious difference is in the treatment of areas of flesh. In Santi's panel paintings and in the surviving fragments of his son's first altarpiece, the flesh painting is solid and opaque, the result of using relatively large amounts of lead white,

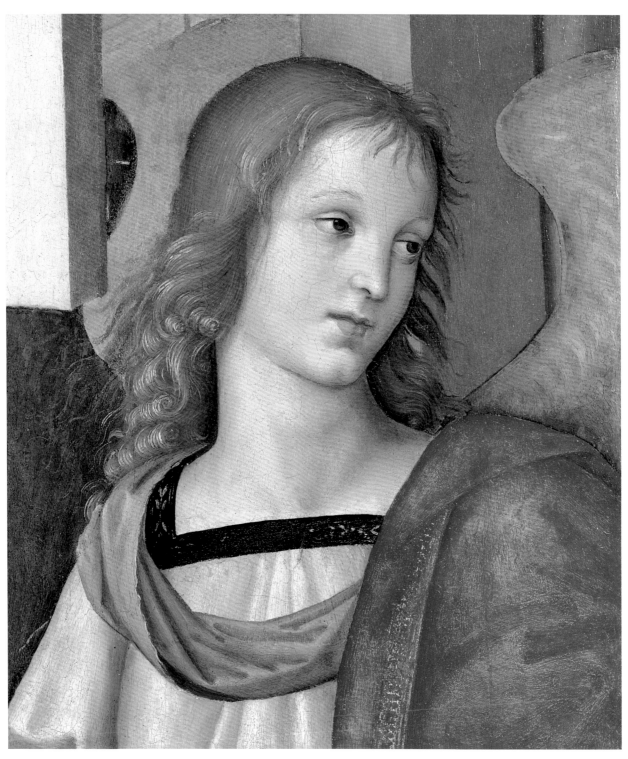

fig. 2 **Bust of an Angel**, about 1500–1
Oil on wood, transferred to canvas, 31.5 × 27 cm
Pinacoteca Tosio Martinengo, Brescia, inv. 149

not just for the highlights, but also in the mid-tones and shadows.[27] When X-rayed, the flesh tints produce relatively flat light images, without much contrast between highlight and shadow. The shading is achieved mainly by the admixture of red, brown and black pigments to the lead white, resulting in cool sometimes slightly grey undertones, and the complexions are heightened by touches of red on chins, noses and cheeks, with a distinctive pink flush spreading down almost to the jawline. In addition Raphael used one of his father's workshop drawings or props – the crown which appears for example in Santi's frescoes in the Tiranni chapel (fig. 3).[28] This crown is also found in other pictures by Raphael (see cat. 15 and fig. 13).

More generally, one can see Raphael referring back to prototypes in his father's work on numerous other occasions,[29] so that the weight of evidence favours a training in the Santi workshop. This could have continued in the later 1490s (after Santi's death), quite possibly in tandem with a formal education. Raphael had apparently assumed control of his father's workshop by December 1500. He was still extremely young, just seventeen years old, but was already described in the contract for the Baronci altarpiece as a *magister* – a matriculated master of a painter's guild – and was in a favourable position to achieve early independence as the son of a painter who had probably inherited his father's workshop.[30] However, it must be admitted that the evidence that Santi's workshop was indeed still active after his death in 1494 remains ambiguous. Works by a follower of Santi, Bartolomeo di Maestro Gentile (1465–c.1534), can be dated to these years (for example a signed and dated altarpiece of 1496) but they are not particularly close to Santi's own productions.[31] The oeuvre of Evangelista di Pian di Meleto, Raphael's collaborator in the Baronci altarpiece, has not been properly identified.[32] Another painter who has been connected with the workshop is Timoteo Viti (c.1470–1523), who seems to have taken on the position of court painter in Urbino in the first decade of the sixteenth century, and was once proposed as Raphael's first teacher.[33] Viti returned to Urbino from Bologna around 1495, and it has been hypothesised that he may have helped Evangelista maintain Santi's workshop until Raphael was old enough to take it over himself, although there is no evidence for this or of his immediate impact in Urbino.[34] It is nevertheless interesting that these artists all seem to have been present in Urbino in the second half of the 1490s, and to their number can be added the name of Girolamo Genga (1476–1551), who became a friend of Raphael's.[35] It is also striking that these individuals collaborated with one another later on.[36]

In order to understand how a training in the Santi workshop could have influenced Raphael and his aspirations, one needs to appreciate Giovanni Santi's standing as a Central Italian painter of the late fifteenth century. Born at Colbordolo (near Urbino) in the early 1440s, he is poorly documented as a painter until the 1480s and early 1490s, when he produced a number of works for the churches and court of Urbino, as well as for the neighbouring towns of Cagli, Fano and Montefiorentino. His fame as a portrait painter led to his being invited to the Gonzaga court in Mantua in 1493 (where he remained until just before his death in August 1494).[37] Although Vasari characterised Santi as a 'painter of no great excellence', he added that he was 'a man of good intelligence, well able to direct his children on that good path';[38] and Santi plainly enjoyed more than local success. Recent renewed interest in his activity as a painter has highlighted his sensitivity not just to the work of Perugino but to a range of developments in Florence and Northern Italy, as well as in Netherlandish art (aspects which are clearly seen in Santi's work in this exhibition, cats 3–5, and were transmitted to Raphael).[39] His most appealing pictorial qualities, and his ambition and technical skill, are clearly seen in his frescoes for the Tiranni chapel at S. Domenico, Cagli, a work which brings out his responses to the art of both Perugino (in the Virgin and Child) and Melozzo da Forlì (in the Resurrection).[40]

In addition to his skills as a fresco painter, Santi was experienced at working with oil paint, by then widely used in Northern Italy, although many painters active in The Marches, notably Carlo Crivelli, and also some Florentine workshops, retained panel painting techniques based on the traditions of egg tempera. The presence of Justus of Ghent as court artist in Urbino must have been important for Santi, although curiously he does not mention Justus in his rhymed chronicle (see below). A partial copy of Justus's *Communion of the Apostles* (Casa di Raffaello, Urbino) is sometimes attributed to Santi or his workshop, but Santi's borrowings from Perugino and other Flemish-influenced Italian painters mean that the direct influence of Northern painting on his art is not necessarily immediately apparent. His Virgins, angels and female figures are based on Italian ideals, but older male figures are distinctively characterised, hinting that his fame as a portraitist was based on his ability to imitate Justus's example. Details such as bejewelled clasps and borders obviously replicate Northern examples, although not with any degree of refinement. However, it is worth observing that the surviving paintings (mostly badly damaged and often fragmentary) generally attributed to Justus of Ghent's stay in Urbino are not notable for the minute illusionistic detail so often prized at the time in Netherlandish painting; rather they are boldly painted large-scale compositions with figures placed in convincing architectural interiors, often with glimpses of rooms beyond, and dramatically lit by strongly raking light. Buildings with rooms opening into one another appear in Santi's compostions, and his clear and sometimes harsh light probably owes more to Justus than to the diffuse enveloping light of Piero della Francesca, whose portraits and religious works for Federigo da Montelfeltro were among the most significant works of art in Urbino at the time. Most significantly, Santi had learnt how to exploit the translucency of certain pigments when mixed with oil to achieve the rich deep tones of Netherlandish painting, glazing draperies to achieve the dark reds, purples and greens to be seen in

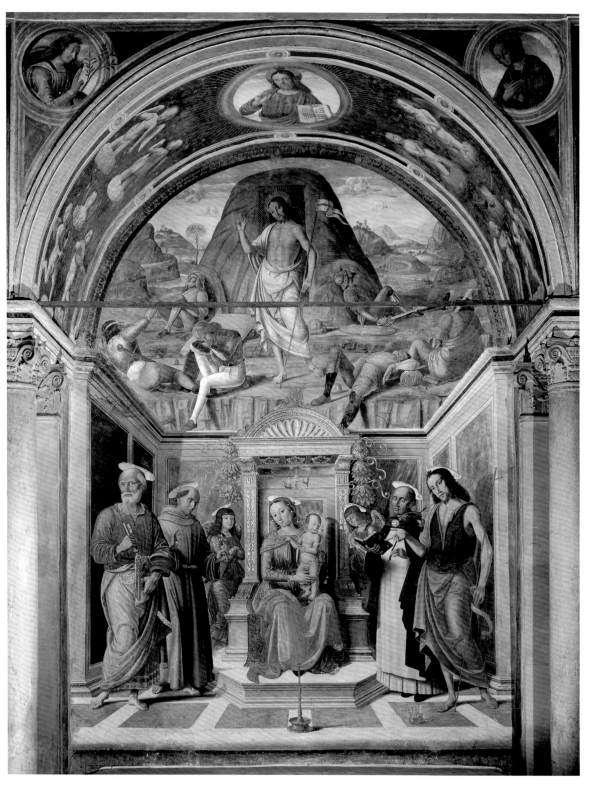

fig. 3 Giovanni Santi
Sacra Conversazione with the Resurrection of Christ, 1481
Fresco, 420 × 295 cm
Tiranni Chapel, Church of S. Domenico, Cagli

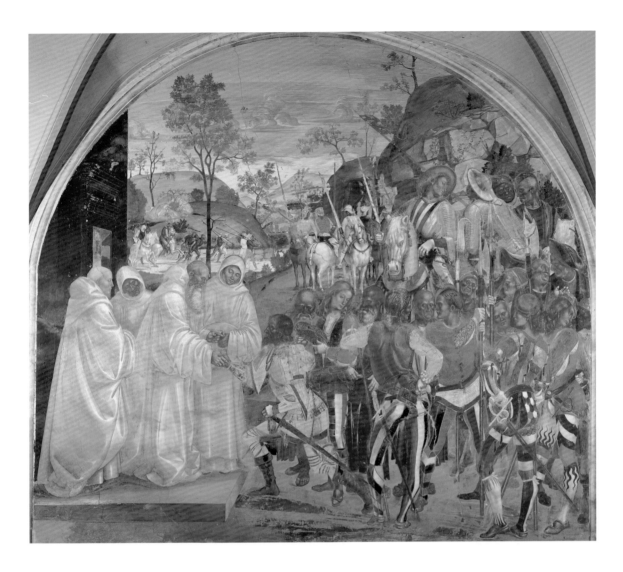

fig. 4 Luca Signorelli
**How Saint Benedict
recognised and received
the True Totila**, 1498–9
Fresco, width at base 300 cm
Abbazia di Monteoliveto
Maggiore, Siena

works such as the Fano *Visitation*, the Corsini *Muses* (e.g. fig. 48) and the *Apostles* in Urbino (Galleria Nazionale delle Marche).

As a child Raphael must have watched his father at work and instructing his assistants in the preparation of materials for the various painting techniques, whether on walls, canvas or panel. As the precociously talented son of an unusually well-educated painter, he might have been excused the labour of grinding pigments, and allowed to concentrate on drawing as a preliminary to learning how to paint. Assuming that Raphael was heir to his father's workshop premises and contents as part of the property left jointly to him and his uncle, then he could have learnt the craft aspects of painting from the assistants who remained, regardless of their particular merits as painters.

Perhaps Santi's greatest legacy to Raphael was as a role model. In addition to his profession as a painter, Santi was an accomplished poet and courtier. He was responsible for the text and design of court masques in 1474 and 1488,[41] but his most significant literary achievement was *La Vita e Le Gesta di Federico di Montefeltro* (1482–7),

an epic poem written in *terza rima* extolling the life of Federigo, father of his patron Guidobaldo da Montefeltro, Duke of Urbino (Santi is the only fifteenth-century artist to leave this kind of literary output).[42] Although there is no evidence regarding Raphael's schooling, Santi's own cultivated background suggests that he would have wished to bestow some form of education upon his only surviving son, as Vasari implies.[43] Raphael's handwriting (as seen on cats 84 and 85) is elegant and self-consciously 'Italic', even if his letters and poetry lack the sophistication of his father's style. A few draft sonnets by Raphael exist, in which he experimented in a somewhat mechanical way with familiar Petrarchan models, but these are all on sheets of drawings (for example cats 84–5), which always remained his primary medium for invention. What is every-where apparent in his work as a visual artist is his acute intelligence, expressed in his highly original approach to narrative as well as in his ability to assimilate the essential elements of works by other artists into his own style.[44] The *'Vision of a Knight'* (cat. 35) offers a fascinating instance of Raphael depicting a type of subject his

father could only express in words. His ability to bring theological truths to life in a direct and believable way emerges in his early devotional paintings and was one of the qualities that later attracted the attention of the most powerful ecclesiastics of the day.

Santi's position gave Raphael an entrée into both courtly and artistic circles. As an adult, Raphael demonstrated a taste for learned company and intellectual endeavours unusual among contemporary artists. He befriended intellectuals associated with the court at Urbino, such as the poet and literary theorist Pietro Bembo and the diplomat and writer Baldassare Castiglione, who alluded to Raphael's wit as well as his painterly skill in his *Book of the Courtier*.[45] Raphael painted portraits of both men, and his friendship with them became even closer after they were all reunited at the papal court in Rome.[46] It is clear that throughout his career Raphael was extremely well connected and knew how to comport himself in aristocratic circles, and he is frequently described as an accomplished and gracious courtier. It was one thing to thrive in the mercantile cities of Umbria and Tuscany, quite another to succeed at court, and Raphael demonstrates a rare versatility in being able to adapt to the different environments in which he worked.[47]

The most frequently cited passage of Santi's erudite rhymed chronicle deals with the greatest artists of the fifteenth century, and confirms the impression conveyed by his paintings that the author was an attentive student of the most innovative artists of his day.[48] In his turn, Raphael carefully studied the work of the living artists mentioned in his father's poem – particularly Perugino, Leonardo and Signorelli – and continued to apply this habit of study to other leading artists of the early sixteenth century.[49] Vasari likened Raphael to the classical painter Zeuxis, who synthesised the best qualities of the most beautiful women in order to concoct a creation more beautiful than any real individual, eloquently praising Raphael's ability to improve his art: 'through studying the efforts of the old and modern masters, he took the best from each of them, and by gathering all this together, enriched the art of painting.'[50]

In addition to the Baronci altarpiece, Raphael painted two more altarpieces for Città di Castello and a processional banner. The artistic flowering the city enjoyed in the 1490s, under the ruling Vitelli family and their allies, had been dominated by Luca Signorelli (*c*.1450–1523), whose five altarpieces for Città di Castello included *The Martyrdom of Saint Sebastian* (fig. 55) and the *Nativity*, now in the National Gallery (NG 1133). His departure in 1498 created an opportunity for Raphael to work in the city, and Signorelli may even have introduced Raphael to his first patrons there,[51] including perhaps Baronci, who can be linked to the commissioning of Signorelli's high altarpiece for the church of S. Agostino. Raphael also painted altarpieces for Domenico Gavari's chapel in S. Domenico (cat. 27) and Filippo Albizzini's chapel in S. Francesco, and cats 18 and 19 were painted for the Confraternity of the Holy Trinity. The

three private patrons were all wool merchants, active in local politics, and seem to have formed a close-knit coterie around Andrea Baronci.[52] It is clear that Signorelli's art made a deep impression on Raphael when he first arrived in Città di Castello, and it became an important stimulus to his development from 1500 to 1505.[53]

In his pioneering study of Raphael written in Urbino in 1829, Padre Pungileoni suggested that Signorelli might have been one of Raphael's first teachers.[54] While a direct master-pupil relationship can be excluded, the two artists clearly knew each other; they may have first met when Signorelli's confraternity banner was delivered to Urbino in about 1494.[55] Signorelli's vigorous figures offered a sculptural dynamism otherwise absent in models known to Raphael, who carefully studied the older artist's altarpieces in Città di Castello when embarking on commissions of his own there. On a sheet of studies for the processional banner (cat. 20), he made an interpretative copy after one of the crossbowmen in Signorelli's *Martyrdom of Saint Sebastian* of 1498, and he surely had a Signorellesque model in mind when drawing the dramatically foreshortened figure of Satan beneath the figure of Saint Nicholas of Tolentino in a design for the Baronci altarpiece (cat. 17).[56] At some time in this early period, Raphael also visited Orvieto and studied the extraordinary frescoes of the *End of the World* and the *Last Judgement* that Signorelli had painted in the Cappella Nuova of the cathedral.[57] A little later on, he drew on the reverse of a drawing originating from Signorelli's workshop at Orvieto (cat. 47), demonstrating direct contact between the two artists.[58]

A small group of related drawings appears to confirm that in around 1502–4 Raphael visited the Olivetan abbey at Monteoliveto Maggiore where Signorelli had painted scenes from the Life of Saint Benedict in the great cloister (fig. 4). At this time, Raphael was assisting Pintoricchio in designing frescoes for the Piccolomini Library in nearby Siena, and it is entirely plausible that he rode out down the Via Cassia to Monteoliveto (and indeed on to Orvieto) to study Signorelli's frescoes. Indeed at least one of his designs for the library, a metalpoint study for a group of soldiers,[59] is clearly informed by his study of Signorelli's frescoes at Monteoliveto.[60] Raphael may even have offered proposals for the completion of the cloister which Signorelli had abandoned in order to decorate the cathedral at Orvieto; a task eventually undertaken by Sodoma in 1505–8.[61] Raphael's drawings after Signorelli typically show him seeking to recreate the swagger and movement of the male (nude) in action – qualities absent in the works of Pintoricchio and Perugino. He adopted some of Signorelli's bold foreshortenings and energetic outlines in his predella panels of this period (e.g. cats 29–30), and he continued to seek out prototypes by the master after he arrived in Perugia, turning for inspiration to the dynamically posed figures in Signorelli's revolutionary *Vagnucci Altarpiece* in Perugia Cathedral (fig. 71) when tackling the *sacra conversazione* for the first time in his Colonna and Ansidei altarpieces (fig. 68 and cat. 45).[62]

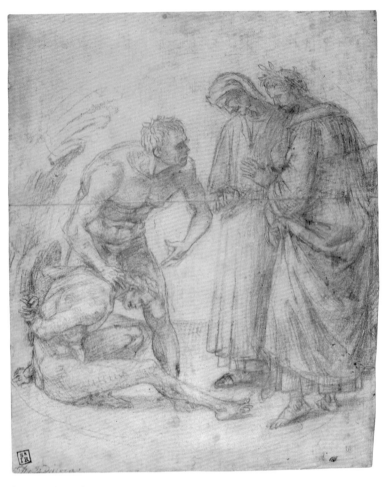

fig. 5 Luca Signorelli
Dante and Virgil with Count Ugolino, about 1500
Black chalk, 31.2 × 25.6 cm
The British Museum, London, 1885-5-9-41

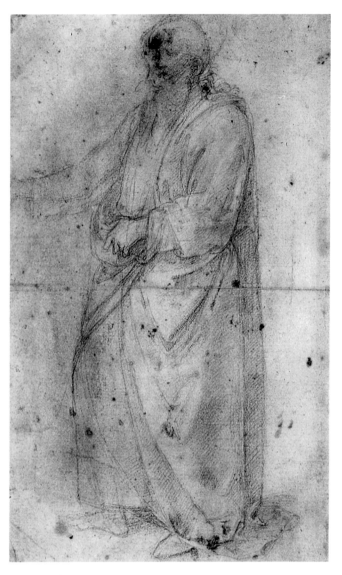

fig. 6 **Study for God the Father**, about 1500–2
Black chalk and touches of white chalk, 37.7 × 22.4 cm
The British Museum, London, 1895–9–15–618

Raphael's early drawings in black chalk are so like Signorelli's as to suggest direct study from the older artist's designs (see, for example, cats 17, 22 and figs 5, 6).[63] Their breadth and the way in which Raphael used the black chalk to establish poses and investigate lighting derive from Signorelli's work in the same medium, and the two artists' handling of the chalk is astonishingly close at this date.

Raphael's subsequent altarpieces for Città di Castello (cat. 27 and fig. 12) are markedly more advanced than his earlier work and – together with the *Oddi Coronation* painted for Perugia (fig. 13) – show evidence of close contact with Perugino. The depth of Raphael's immersion in Perugino's style (which he had already encountered at one remove in his father's work) suggests that he moved his centre of operations to Perugia (seen in the background of fig. 17) in the course of 1502. The first works that demonstrate this contact are his small devotional pictures such as cats 9, 21, 25 and fig. 10. Raphael was still engaged on altarpiece commissions for Città di Castello when he transferred to Perugia, where his first works seem to have been predominantly private (for example cat. 27) – a similar pattern of activity was to emerge a few years later in Florence.

Although Raphael's most important artistic experience in Perugia was plainly his contact with Perugino, it is striking that these very early works in Perugia are also indebted to Pintoricchio,[64] one of the few Central Italian painters whose reputation rivalled that of Perugino.[65] A native of Perugia, Bernardino di Betto, called Pintoricchio (*c*.1454–1513), received commissions throughout Umbria and was active as a painter of altarpieces as well as frescoes. He probably collaborated with Perugino in the Sistine Chapel in the Vatican and subsequently enjoyed great independent success in the papal city, working for four successive popes (Innocent VIII, Alexander VI, Pius III and Julius II). He was one of the first Renaissance artists to take a serious interest in the decorative painting of antiquity, and to simulate the fanciful caprices of ancient painting known as *grottesche* (so called after the paintings discovered in Nero's Domus Aurea in Rome, which was by then underground as if in a grotto, hence the English word 'grotesque'). Using such motifs, Pintoricchio developed a highly influential approach to fictive architectural decoration (which frequently imitates antique mosaics), and he was greatly concerned with recreating historical verisimilitude through details of dress and setting.

Despite being Pintoricchio's junior by almost thirty years, Raphael took the inventive lead in their collaboration by supplying the older artist with designs for at least two commissions.[66] The most important of these was the fresco decoration in the Piccolomini Library attached to the cathedral in Siena, commissioned by Cardinal Francesco Piccolomini, Archbishop of Siena and for a very brief period Pope Pius III (he died ten days after his coronation in October 1503). The decoration of this library was commissioned

from Pintoricchio in June 1502.[67] The contract stipulated that the ceiling should be painted with *grottesche*, and the ten bays on the walls below were to depict scenes from the life of Enea Silvio Piccolomini (Pope Pius II, 1458–64).[68] Pintoricchio was legally bound to execute all the preparatory drawings and the cartoons.[69] Work may have started by the time Cardinal Francesco made his will in April 1503, with provision for the library's completion after his death, and the decoration seems to have been well advanced by February 1504 when a scaffold was removed from the large fresco above the entrance depicting Pius III's coronation. The whole of the east wall of the library may have been completed by this date, and Raphael's involvement probably occurred during the winter of 1502–3 (or at least by the end of 1503).

It is an indication of Raphael's manifest talents as a designer that, despite his youth (he was not yet twenty), and in contravention of the explicit terms of the contract, he provided the much more experienced Pintoricchio with numerous compositional drawings for this prestigious project. In his *Life* of Raphael Vasari states that Pintoricchio 'being a friend of Raphael and knowing him to be an excellent draughtsman brought him to Siena where Raphael made for him some drawings and some cartoons', reiterating in his *Life* of Pintoricchio that Raphael was responsible for 'the sketches and cartoons of all the frescoes' of the Piccolomini Library.[70] While the uneven compositional quality of the ten scenes makes it unlikely that Raphael was involved in designing all the frescoes as Vasari asserts, at least five drawings by him can be related to this project: a sketch and a worked-up *modello* for the *Journey of Enea Silvio Piccolomini to Basle* (both Uffizi, Florence, the latter is fig. 7); a *modello* for the *Betrothal of Frederick III and Eleanora of Toledo* (Pierpont Morgan Library, New York); a sketch for *Enea Silvio Crowned Poet Laureate by Frederick III* (fig. 9); and recently identified studies for the shield-bearing putti standing in front of the fictive architecture separating each bay (Louvre, Paris; Ashmolean Museum, Oxford).[71] On the basis of these drawings, and of particular elements in some of the other frescoes (for example the complex architecture in *Enea Silvio Crowned Poet Laureate*[72]), it is now widely accepted that Raphael was responsible for at least three *modelli,* and possibly as many as five,[73] but did not (as Vasari claimed) play any part in the preparation of the final cartoons, or in the translation of these cartoons into paint. Raphael's spatially sophisticated designs, with figures moving backwards and forwards through space, are rendered 'flat' in the frescoes, having been assimilated into Pintoricchio's own decorative style (for which see further under cat. 6). Raphael's designs penetrate space at an angle, with the figures arranged along diagonals, a sophistication which Pintoricchio rejects by showing the figures in silhouette parallel to the picture plane.[74]

These observations are borne out by comparing one of Raphael's *modelli* with the fresco as painted (figs 7 and 8). The *modello* – an exceptionally large drawing on two pieces of paper – is technically

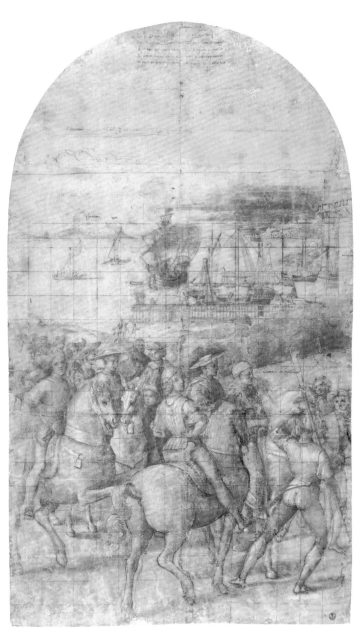

fig. 7 **Modello for the Journey of Enea Silvio Piccolomini to Basle**, about 1502–3
Pen and brown ink, brush and brown wash
white heightening over traces of black chalk
and stylus underdrawing, 70.5 × 41.5 cm
Gabinetto dei disegni e delle stampe degli Uffizi,
Florence inv. 520E

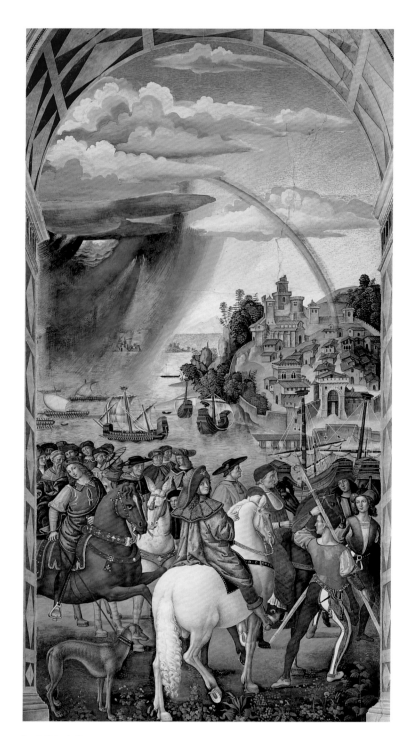

fig. 8 Pintoricchio
The Journey of Enea Silvio Piccolomini to Basle, 1502–8
Fresco, 700 × 260 cm
Piccolomini Library, Duomo, Siena

complex and underpinned by ruled perspective lines and a series of arcs drawn with a pair of compasses. Raphael placed Piccolomini in the centre – a tall feather rising from his hat along the central axis of the composition. The lower two-thirds of the drawing is squared for transfer (usually indicative of intent to translate the design accurately to a larger scale), but Pintoricchio changed Piccolomini's pose and costume, and made the tail of his horse fall more decorously. He also substituted Raphael's backdrop of beautifully observed boats, and added still-life elements to the foreground: flowers and a dog, which are positioned exactly parallel to the picture plane with a facile simplicity that only emphasises the spatial sophistication of Raphael's original solution.

Looking at a drawing like this (fig. 7), one can easily understand how Raphael achieved precocious fame as a draughtsman and designer. Throughout his career he continued to provide designs for other artists, such as Domenico Alfani in Perugia,[75] and on his arrival in Rome he supplied drawings to the goldsmith Cesarino Rossetti, and was increasingly able to delegate the execution of his pictures by supplying his assistants (Lorenzo Lotto, Baldassare Peruzzi, Giulio Romano, Gianfrancesco Penni, as well as the print-maker Marcantonio Raimondi) with designs from which to work.[76]

The energy of Raphael's designs can also be appreciated in his lively metalpoint study (fig. 9) for a group of soldiers in the background of *Enea Silvio Crowned Poet Laureate by Frederick III*. Raphael was interested in the dynamic between the figures as a group and thus explored different solutions for their heads and arms in quick succession, as is evident from the many pentiments in these areas. When he arrived at a satisfactory solution, he would reinforce his chosen contours repeatedly, the springy outlines and deft parallel hatching imbuing the figures with a rounded quality particular to Raphael. The intelligent design of this group, drawn with such natural fluency, is greatly diluted in the equivalent passage in

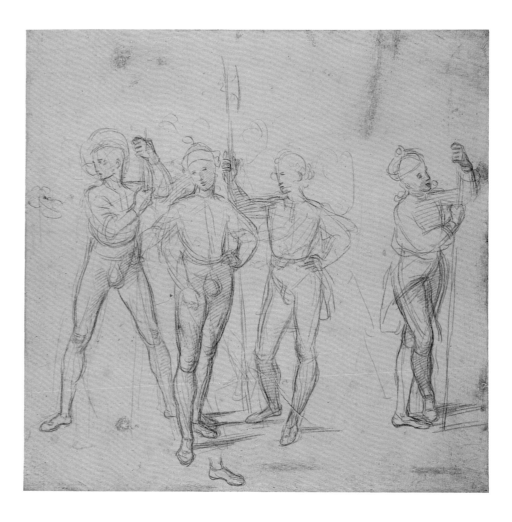

fig. 9 **Four soldiers**, about 1502–3
Metalpoint on blue prepared paper, 21.3 × 22.1 cm
The Ashmolean Museum, Oxford, 154 P II 510

Pintoricchio's fresco as a result of the mechanical reversal and rearrangement of several of the individual figures.[77]

The experience of designing narrative histories (*istorie*) for the unified space of the Piccolomini Library was an important precedent for Raphael's later work in the Vatican Stanze (the Stanza della Segnatura was also a library). It also came in useful when he came to design, on a much smaller scale, the animated predella scenes of the *Mond Crucifixion* (cats 29–30) and the *Oddi Coronation*. Debts to Pintoricchio can also be seen in works such as the *Colonna Altarpiece* (fig. 68 and cats 25 and 26) which show the impact of Pintoricchio's private devotional works upon Raphael's development.

The Piccolomini Library commission also brought Raphael to the attention of various Sienese patrons. He seems to have maintained his links with the powerful Piccolomini, later painting a tondo now lost (the *Madonna del Silenzio*) for another member of the family, probably Pierfrancesco.[78] While working on the library, he had the opportunity to study an antique sculpture representing the Three Graces which Cardinal Piccolomini had brought from Rome to Siena, and he responded to this statue in his painting of the same subject now in the Musée Condé at Chantilly (fig. 65).[79] This picture and its pendant depicting a scene from the life of Scipio Africanus, usually associated with the court of Urbino, could equally have been painted for a Sienese patron (a member of the Borghese family has been suggested).[80] Raphael's connections with Sienese artists (Sodoma in 1508–9 and Peruzzi in 1511) and patrons (including Agostino Chigi) during his first years in Rome may also point to earlier connections with the city.[81]

In the same period (1502–3) in which Raphael was providing Pintoricchio with drawings, he was also adopting in an extremely thorough fashion the manner of Perugino (to which Vasari attributed much of his early success).[82] Vasari stated at four points in his *Lives of the Artists* that Raphael was Perugino's pupil,[83] and although this now seems unlikely he was clearly right to identify a Peruginesque style in Raphael's Umbrian work. Indeed, this was already noted in Raphael's own lifetime. Pope Leo X commented on how Raphael's experience of Michelangelo's art prompted him to move beyond the '*maniera del Perosino*',[84] and later Michelangelo made a very similar observation to Condivi.[85] Mastering the older artist's style so comprehensively was a fundamental step in Raphael's career.

Born Pietro di Cristoforo Vannucci around 1450 in Castel della Pieve (near Perugia), Perugino trained in Perugia and Florence before assuming a leading role in the decoration of the Sistine Chapel (1481–2) and receiving other Roman commissions (for Sixtus IV, various cardinals, and later for Julius II). He married a Florentine, maintained a workshop in Florence from 1487 (having joined the local guild of painters by 1472),[86] and painted numerous

public and private works for Florentine patrons (these works included cat. 8 and possibly cat. 7). He simultaneously kept a workshop in Perugia (at least from 1501), and worked for most of the city's churches and for many of the surrounding towns. In the early years of the new century, he was also working for the Duke of Milan (cat. 10), the Marchioness of Mantua,[87] and for discerning patrons in Siena,[88] Bologna (see cat. 9) and elsewhere. The period of his greatest success was brief and judgements of his merits soon became less favourable, but Vasari's claim that around the turn of the century, people thought 'it would never be possible to improve upon [his style]'[89] finds widespread corroboration, for example in Agostino Chigi's description of him as 'the best master in Italy'. While never as sculptural as his Florentine contemporaries, Perugino learnt from their lessons and responded profoundly to Netherlandish art, especially in regard to landscape painting, at which he excelled, transmitting his skills in this sphere to the young Raphael. His style was praised in his lifetime as exhibiting an 'angelic and very sweet air', and this is likely to have referrred both to the delicate countenances of his figures and to the subtlety of his rendering of atmospheric perspective.[90] Moreover, his creation of a modern devotional style revolutionised the visual language of religious painting in Central Italy and had a huge impact on Raphael's subsequent creation of the modern style or *maniera moderna*.

While Raphael's motive for gravitating towards the orbit of the leading painter in Central Italy is not difficult to fathom, exactly in what capacity he did so is shrouded in mystery. The reasons to doubt a formal apprenticeship have been set out above, and nothing within Raphael's response to Perugino necessitates a traditional period of training within his workshop. On the other hand, he assimilated Perugino's style so successfully around 1502–3 that he is likely to have been closely associated with the artist at this time – Vasari claimed that Raphael learnt from Perugino 'in just a few months'.[91] This seems entirely consistent with the period of his activity that seems most Peruginesque, and those commentators who have observed that at this date Raphael, having already executed independent commissions, 'must have been more of a colleague than a pupil' (as he was to Pintoricchio) are likely to be correct.[92]

The most compelling evidence for a connection between the two artists lies in a comparison of their techniques. Perugino's techniques for painting flesh were rather different from those employed by Santi and initially taken over by Raphael (see above). By the 1490s Perugino had adopted a more Netherlandish method – perhaps inspired by the paintings of Hugo van der Goes and Hans Memling that had created such a stir in Florence – in which opaque paints containing a high proportion of lead white were reserved only for the strongest highlights, on brows, noses and chins when painting a head, for instance. The rest of the face was modelled with translucent greenish-brown mixtures, thinly applied so as not to eliminate the

reflective properties of the white or cream-coloured preparation. In X-radiographs only the highlights register strongly. In Perugino's paintings female and youthful complexions tend to be pale olive in colour, usually with no more than a hint of pink on the apple of the cheeks.

In the *Mond Crucifixion* for S. Domenico in Città di Castello (cat. 27) the flesh painting is strikingly close to that of Perugino and very different from that of his earlier altarpiece for the city. Furthermore, for some of the drapery painting he appears to have adopted Perugino's method of shading folds by hatching and cross-hatching the shadows with thick dark oil paint, instead of building up layers of translucent deep-toned glazes. This technical short cut – effective when the painting is viewed from a distance – is a feature of several of Perugino's panels and frescoes; it can also be seen, on a much smaller scale, in draperies by Memling. In other areas of the *Crucifixion* the glazes are applied more conventionally and it is possible that Raphael learnt from his father the unusual technique of applying red lake glazes over dark green to achieve a deep rich colour, neither red nor green but without the opacity of black, as in the wings and fluttering ribbons of the flying angels. The depth of glazing in the draperies and green cushion in the Norton Simon *Virgin and Child* (fig. 10), surely very close in date to the *Crucifixion*, is also reminiscent of Santi, as are the flesh tints which have the same rosy flush as Raphael's angels from the Saint Nicholas of Tolentino altarpiece. Unlike Santi, however, with his preference for imitation of gold with paint in the Netherlandish manner, Raphael developed a taste, partly perhaps to fulfil the expectations of his new patrons, for lavish decoration of drapery borders with patterns in gold and sometimes silver, applied either as powdered metal (shell gold) or by laying gold leaf onto painted lines of mordant.

The second strand of evidence for Raphael's closeness to Perugino at this date lies in his response to the models that Perugino's art provided. There are countless examples,[93] but two of these suffice to show how Raphael would use a Perugino composition as a starting point for his own developments. In the case of the *Mond Crucifixion*, Vasari commented that had it not been signed by Raphael one would have thought it to be the work of Perugino.[94] It is closely related to Perugino's altarpiece for S. Francesco al Monte (fig. 60), which was probably painted at very much the same time.[95] Raphael borrowed the foreground setting, the basic compositional solution, the poses of the Virgin Mary, Saint John and (in reverse) the Magdalen, as well as details such as the golden sun and silver moon, and the fluttering banderoles of the two angels.[96] In addition, the mannered angles of the figures' heads, the cast of their faces and the expressive hands come straight out of Perugino's repertoire. The greater spatial, pattern-making and figural sophistication of the *Mond Crucifixion* represents Raphael's translation of Perugino's composition into his own idiom.[97]

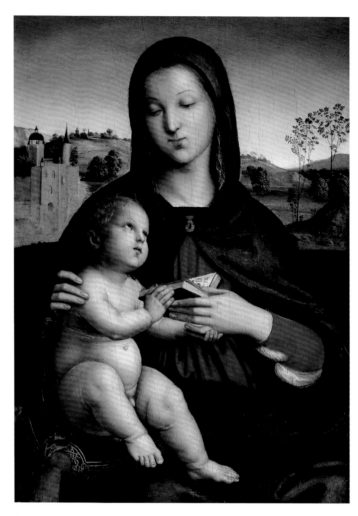

fig. 10 **The Virgin and Child**, about 1503
Oil on wood, 52.7 × 40 cm
The Norton Simon Museum of Art, Pasadena
M.1972.2.P

The textbook comparison of the two artists' interests has always been their two versions of the *Betrothal of the Virgin* (figs 11 and 12). Raphael's picture was his fourth commission for Città di Castello and the discovery of new documents has proved that his patron was Filippo Albizzini, whose chapel in the church of S. Francesco was dedicated to Saint Joseph (thereby explaining why the subject of the Betrothal of the Virgin was chosen) and the Holy Name of Jesus.[98] Perugino's altarpiece, now in Caen, was painted for an altar (dedicated to the Blessed Virgin Mary and Saint Joseph) in Perugia Cathedral.[99] It was commissioned in April 1499 but Perugino had still not completed the painting by December 1503, although he probably delivered it in the course of 1504. Vasari chose Raphael's picture to show how the younger artist had surpassed his master – and Raphael clearly added a more nuanced narrative and a greater sense of space to Perugino's original idea.[100]

In both cases it seems that Raphael had knowledge of Perugino's compositions before they were unveiled, just as he was later apparently granted previews of works by Leonardo and Michelangelo.[101] This suggests that he had access to Perugino's workshop in the Ospedale della Misericordia in Perugia,[102] and it also suggests two hypotheses regarding Perugino's workshop practice, both of which are supported by other evidence. The first is that Perugino apparently designed pictures (even those which had a very protracted execution and delivery) soon after he received the commissions.[103] The second is that even though Raphael's direct experience of Perugino's work was probably much less long lasting and formalised than is usually admitted, he was nonetheless able to study works in progress as well as a great stock of designs of the previous decade.[104] Perugino's maintenance of workshops in Florence and Perugia, and sometimes in Fano and Rome too, must have involved careful management and a rigorous control of the design process (as is also suggested by the fact that he left able and well-trained pupils schooled in his style on his death).[105]

In between the *Mond Crucifixion* and the *Betrothal of the Virgin* (both of which could easily have been executed in Perugia), Raphael received his first Perugian altarpiece commission, following which he rapidly assumed Perugino's mantle as the leading painter in the city (in part because Perugino was increasingly occupied in Florence). The *Coronation of the Virgin* (fig. 13), which was painted for the Oddi family chapel in the church of S. Francesco al Prato, is intensely Peruginesque.[106] The altar was dedicated to the feast of the Assumption and the picture combines this iconography with that of the Coronation of the Virgin, which is venerated on the same feast day and was particularly popular as a subject with Franciscan foundations in Umbria.[107] The picture's Peruginesque qualities, and the fact that it was the first work to be mentioned by Vasari (who initially called this picture a collaborative work, but revised this to describe it as a painting that one would attribute to Perugino if one didn't know better), have influenced the wide range of dates

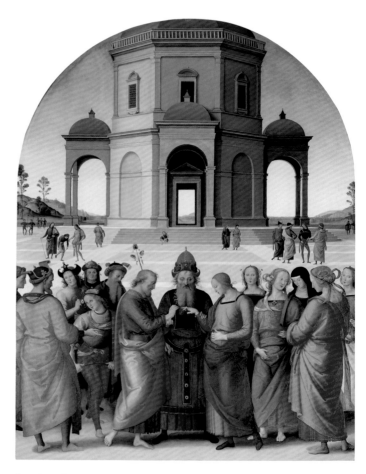

fig. 11 Pietro Perugino
The Betrothal of the Virgin, 1499–1504
Oil on wood, 236 × 186 cm
Musée des Beaux Arts, Caen, 171

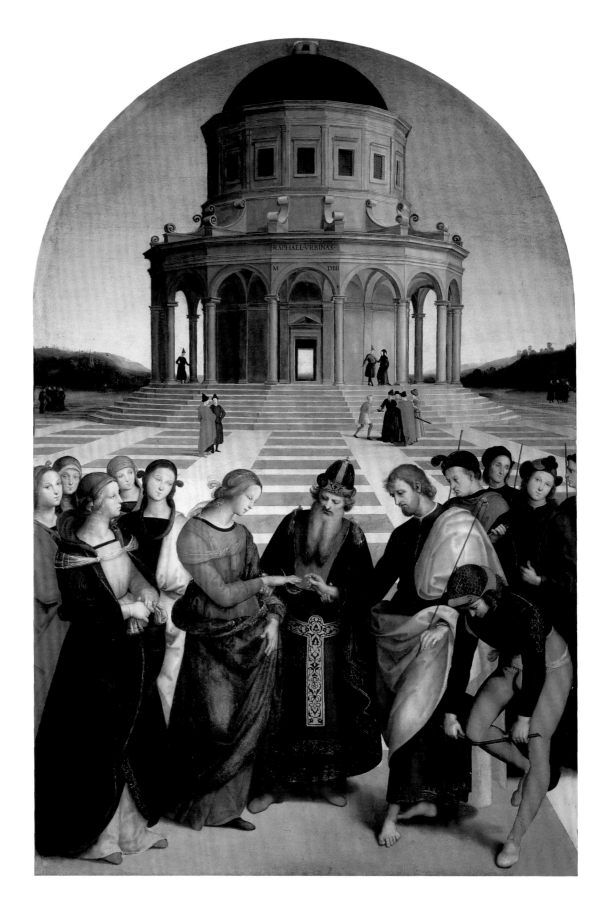

fig. 12 **The Betrothal of
the Virgin ('Sposalizio')**, 1504
Oil on wood, 170 × 118 cm
Pinacoteca di Brera, Milan, 472

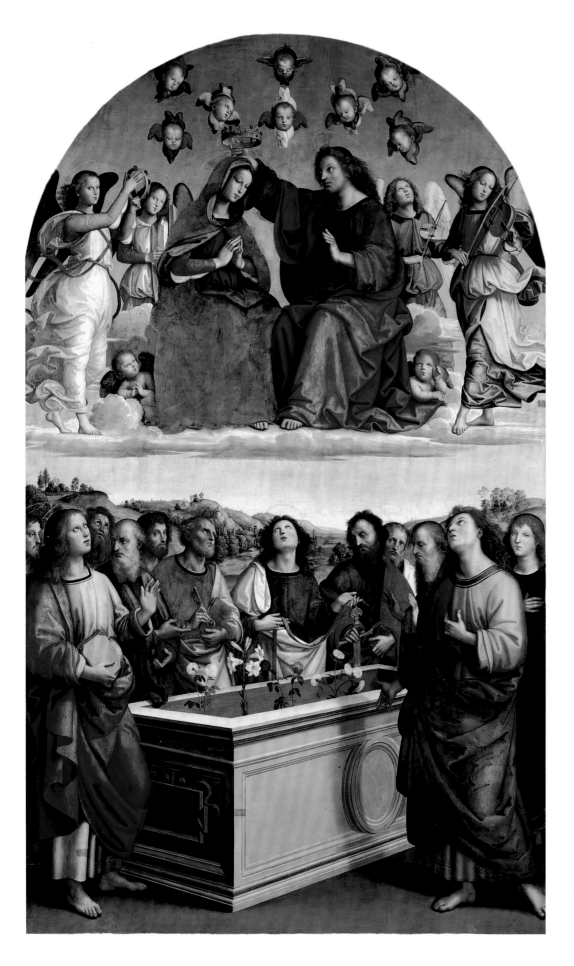

fig. 13 **The Coronation of the Virgin (The Oddi Altarpiece)**, 1503–4
Oil on canvas, transferred from panel
267 × 163 cm
Vatican Museums, Vatican City, inv. 334

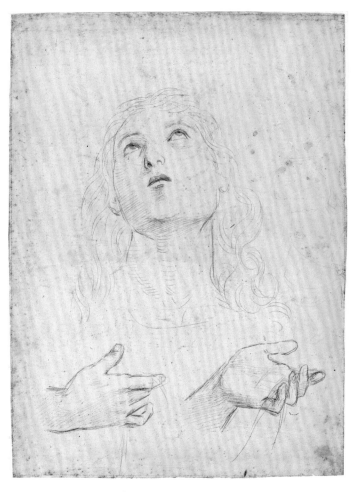

fig. 14 **Study for the head of Saint Thomas**, 1503–4
Metalpoint on white prepared paper, 26.8 × 19.6 cm
Musée des Beaux-Arts, Lille, inv. PL 441

ascribed to it (from 1498 to 1504).[108] Although the circumstantial reasons given in the past for dating the picture to about 1503 look less convincing than they did,[109] a date of around 1503–4 is nevertheless probable. The stylistic similarities with the *Mond Crucifixion* are significant, and in both altarpieces Raphael carefully divided the celestial and earthly realms, and further differentiated them by their tonalities.[110] The *Oddi Coronation* is probably the more advanced painting of the two: its predella is particularly sophisticated and can be linked to Raphael's role in the Piccolomini Library in Siena (although its starting point was Perugino's Fano predella).[111] Apart from his evident mastery of the dominant styles in Perugia, it is not known what brought Raphael to the attention of the Oddi patron. He could have been recommended by Perugino, who had recently worked for the Franciscans in the city, or by Pintoricchio, who had links with the Oddi family and was putting his affairs in order in Perugia in late 1502 prior to moving to Siena. Another possibility is that he was recommended by a branch of the degli Oddi family in Urbino, with whom the Santi family had dealings over many years.[112] In any event, the sequence of Raphael's work in Perugia is comparable to his subsequent Florentine experience: he seems to have moved to a city, developed close relationships with the leading artists and patrons there, producing small works to prove his mettle, and subsequently obtained more prominent commissions.

In preparing the prestigious commission for the *Coronation*, Raphael went to special lengths by making numerous drawings, including detailed cartoons for the heads and full cartoons for the predella. A metalpoint drawing for the head of Saint Thomas (fig. 14) shows how, at this moment, he was working in a manner technically, stylistically and methodologically very close to that of Perugino. His use of a single sheet to make detail studies of the saint's foreshortened head and graceful hands (the little finger elegantly crooked), holding wisps of what was to become the Virgin's belt, can be compared to drawings by Perugino such as cat. 73. His conception of the bodily forms in terms of simple planes is typical of Perugino, but Raphael drew with much greater freedom than his mentor and the quality of the dancing lines with which he described Thomas's tumbling curls is unique to him.

The *Oddi Coronation* was a breakthrough for Raphael, and the particular effort that he put into the picture compared with the *Mond Crucifixion*, both in terms of the design process and in the much higher degree of finish in the main panel and predella, underlines its importance in his eyes. The picture also offers clear demonstration that Raphael had mastered Perugino's style for the local market, and his timing proved perfect (just as it had when he supplanted Signorelli in Città di Castello). Perugino, who had spent much of the years 1500–2 in Perugia, transferred the centre of his activities back to Florence in October 1502, and after that was only intermittently in Perugia until 1507. During this period Raphael was to receive four more altarpiece commissions in the city (discussed below), for the

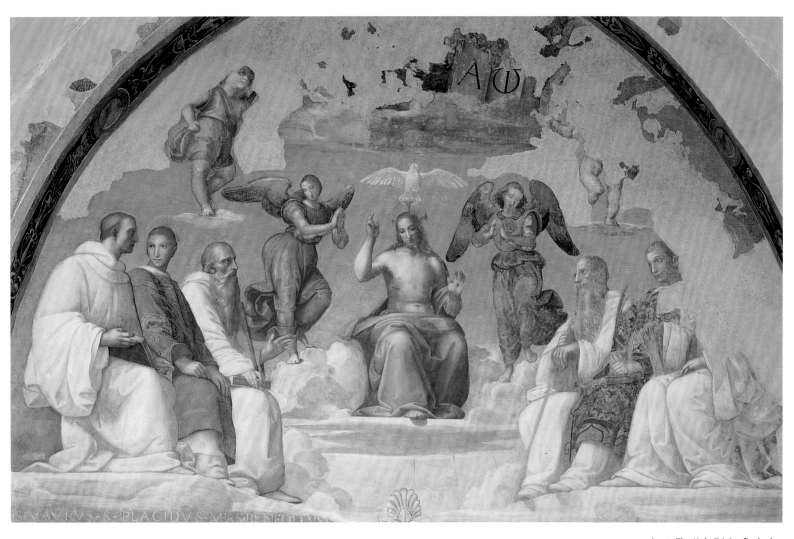

fig. 15 **The Holy Trinity flanked by Saints**, 1505
Fresco, width at base 390 cm
S. Severo, Perugia

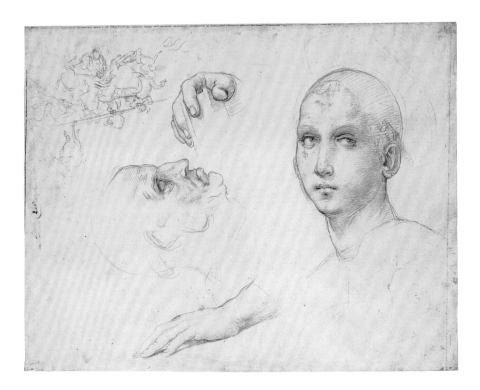

fig. 16 **Studies for the Holy Trinity at S. Severo**, 1505
Metalpoint heightened with lead white on
white prepared paper, 21.2 × 27.4 cm
The Ashmolean Museum, Oxford, 176 P II 535

penultimate of which he was promised 177 ducats, five times as much as for his first commission in Città di Castello.[113] Perugino did not receive any new commissions for altarpieces in Perugia between 1502 and June 1507, although his workshop was still engaged in other projects and in the delivery of pictures commissioned before he left.[114]

Raphael is documented in Perugia in January and March 1503, and was described as living in the city in January 1504.[115] There is no reason why he should not have based himself there for much of the period from 1502 until late 1505, when the volume of works for Florentine patrons suggests a more prolonged stay in Florence. By December 1505, following the quest of the nuns of Monteluce for a suitable candidate to execute a new altarpiece for the high altar of their convent church in Perugia, Raphael's name had emerged clearly as 'the best master who had been recommended by the most citizens and also our reverend fathers, who had seen his works'.[116] In addition to the five altarpieces that Raphael was commissioned to paint for Perugia, he also painted a fresco of the *Holy Trinity flanked by Saints* for the Camaldolese monastery of S. Severo (fig. 15 and study, fig. 16), and several small-scale works, presumably for the city's patricians, including the *Conestabile Madonna* (cat. 12), which was probably painted for the nobleman Alfano Alfani, and the *Madonna of the Pinks* (cat. 59), which may have been painted for Maddalena degli Oddi, whom Vasari named as the patron of the *Coronation of the Virgin* (fig. 13).[117] Seventeenth- and eighteenth-century guide books to Perugia record countless other paintings attributed to Raphael, and although many of these attributions may have been fanciful, it is nevertheless probable that he produced more works for Perugian patrons, now lost (or lacking in secure provenance from the city).[118] One of these seems to have been a composition of Saint Jerome shown against a backdrop of the city, studied in a drawing of about 1504 (fig. 17), which also includes studies for the landscape of the *Colonna Altarpiece* (on the verso).[119]

Raphael probably worked on the *Colonna Altarpiece* for the convent of S. Antonio (fig. 68 and cats 40–42), and on the *Ansidei Madonna* for S. Fiorenzo (cat. 45), over an extended period between 1504 and 1505, most likely finishing them following his first long stay in Florence.[120] Both altarpieces were principally inspired by prototypes by Perugino and Signorelli then in prestigious locations in Perugia, the former's *Decemviri Altarpiece* in the Palace of the Priors and the latter's *Vagnucci Altarpiece* in the cathedral (figs 61 and 71). In the *Colonna Altarpiece* Raphael may have been adhering to strict requirements set down by the conservative nuns, for he produced a somewhat awkward ensemble which scholars have never been able to fit comfortably into his otherwise clear stylistic trajectory. Vasari explained the clothed Christ Child, without parallel in Raphael's oeuvre (but a frequent feature of Pintoricchio's paintings), as a concession to the coy reverence of the nuns, and their taste may have governed the extensive gilt decoration, including the Virgin's dark gold-stippled mantle, characteristic of traditional Umbrian altarpiece

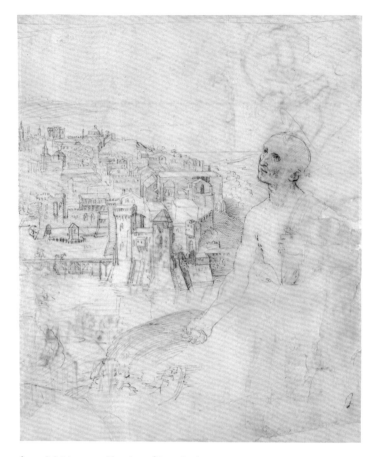

fig. 17 **Saint Jerome with a view of Perugia**, about 1504
Pen and brown ink over traces of black chalk, 24.4 × 20.3 cm
The Ashmolean Museum, Oxford, 10 P II 34

design. Raphael's altarpiece for the chapel in S. Fiorenzo that belonged to the Ansidei family is a more refined variation on the same theme, one in which his mastery of geometry and his capacity for representing space and light emerge with startling lucidity.

The fame of these works won Raphael the commission to paint the altarpiece for the Franciscan nuns of S. Maria di Monteluce, just outside the walls of Perugia. The contract, which was signed in December 1505, was entered into jointly with Berto di Giovanni, and the picture (a *Coronation of the Virgin*) was required to match or surpass in quality Ghirlandaio's altarpiece of the same subject in the church of S. Girolamo at Narni in order to earn the fee of 177 ducats.[121] Although Raphael drew the first payment of 30 ducats on 22 December, ten days after he had signed the contract, and agreed to supply the picture within two years, no further work appears to have been carried out on the altarpiece until the agreement was renegotiated in 1516, and the picture (which was eventually painted by Gianfrancesco Penni and Giulio Romano) was not delivered until 1525.[122] The Monteluce contract provided for carriage and import duty upon the picture's delivery to its patrons, which implies that work at least on the main panel of the altarpiece was to be carried out elsewhere and that the artist had either already moved or decided to move his centre of operations away from Perugia. It also catered for the resolution of any disputes between the parties in any one of eight cities (Perugia, Assisi, Gubbio, Rome, Siena, Florence, Urbino and Venice), suggesting the artist's ever-widening horizons.[123] At the same time, Raphael seemingly left another major work in Perugia unfinished, namely the fresco at S. Severo (later dated 1505), of which he completed only the upper register of saints seated around the Holy Trinity,[124] further confirming that he had competing demands on his time by the end of this year. Even after he had left the city for good, however, Raphael maintained the friendships he had forged with the Perugian painters Berto di Giovanni[125] and Domenico Alfani, who continued to look after his interests there.[126]

Raphael's departure was prompted by rumours of great developments in the artistic scene in Florence.[127] He had surely visited the city earlier in his career, but in October 1504 he sought an introduction into the heart of the action by asking Giovanna Feltria, widow of Giovanni della Rovere and sister of Guidobaldo da Montefeltro, Duke of Urbino, to write a letter recommending him to Piero Soderini, head of government of the Florentine Republic.

> The bearer of this will be Raffaelle, painter of Urbino, who, being gifted in his profession, has determined to spend some time in Florence in order to learn [*per imparare*]. And because his father, of whom I [was] very fond, [was] most worthy, and the son is a sensible and well-mannered young man, on both accounts I bear him great love and desire him to attain perfection.[128]

Although the authenticity of this document has been doubted, it corresponds so convincingly with other genuine documentary material, as well as with the visual evidence of Raphael's experience of Florentine art in late 1504 or early 1505, that it cannot be easily dismissed.[129] The only other contemporary written record of Raphael's presence in Florence is his letter of April 1508 to his uncle, Simone Ciarla, which is signed '*El vostro Raphaello dipintore in Fioreza*',[130] and it is one of the peculiarities of the time he spent in the city that he left no documentary trace there.[131]

Giovanna Feltria's emphasis on Raphael's desire to study in Florence is consistent with Vasari's account of the young artist being drawn to the city by the wish to see for himself the cartoons that Michelangelo and Leonardo were producing for the Sala del Consiglio, the newly constructed council hall in the Palazzo Vecchio, the seat of the Florentine government.[132] The hall had been constructed following the expulsion of the Medici in 1494, and was intended as a showpiece of the Florentine Republic. Soderini had commissioned, as its principal adornment, two murals representing important Florentine military victories. Leonardo had been appointed to paint the Battle of Anghiari in October 1503 and as a pendant the Battle of Cascina was allocated to Michelangelo in the summer of 1504.

The two artists worked on full-scale cartoons for the central sections of their respective frescoes in different sites. Leonardo was given the keys of the Sala del Papa in S. Maria Novella in 1503 where he developed his cartoon until painting commenced on 6 June 1505. He only ever completed the central portion of the fresco, the so-called *Battle for the Standard,* before leaving Florence for Milan in the summer of 1506. (The completed section was widely copied before its deterioration and substitution after 1563 by frescoes painted by Vasari.) It showed a group of horsemen clashing with extraordinary violence for possession of a standard, the horses attacking each other with their hooves and teeth with as much savagery as the men (see figs 18 and 19). Leonardo succeeded in conjuring up the aggressive fury of battle as no artist had before him, and Raphael must have marvelled at the composition's muscular energy, which he had never hitherto had cause to depict in his graceful devotional and chivalric paintings. Distant reflections of Leonardo's rearing horses and twisting warriors can be perceived in two small pictures he painted of *Saint George and the Dragon* (see cat. 34),[133] and even more faintly in the horsemen leading the procession in the predella of the *Colonna Altarpiece* (cat. 41), but Raphael's horses show no evidence of direct study from life (his principal models were other artists' representations). With their pretty faces and calligraphic manes and tails, they remain elegant components in his beautifully designed compositions, and a far cry from Leonardo's snorting, champing beasts. Only later, in his own monumental frescoes in the Stanza di Eliodoro, would he unleash some of the power recollected from his early study of Leonardo's epic work.

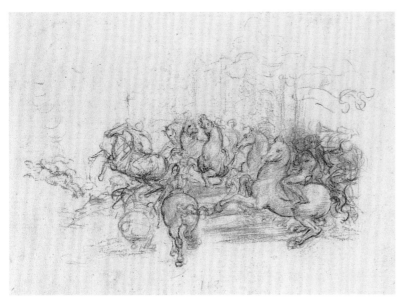

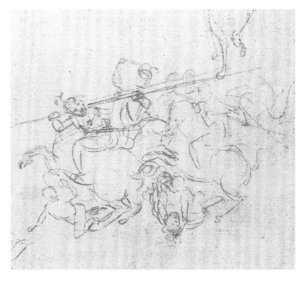

fig. 20 **Study after Leonardo's sketches for the Battle of Anghiari** (detail of fig. 16)

fig. 18 Leonardo da Vinci, 1452–1519
Study for the Battle of Anghiari, 1503–5
Charcoal and black chalk (?), 16 × 19.7 cm
The Royal Collection, RL 12339

fig. 19 Peter Paul Rubens
(perhaps over a drawing by
an unknown sixteenth-
century artist)
**The Battle of Anghiari
(after Leonardo)**, about 1603
Black chalk, pen and brown ink
and watercolour, heightened
with lead white, 45.2 × 63.7 cm
Département des Arts
Graphiques, Musée du Louvre,
Paris, inv. 20271

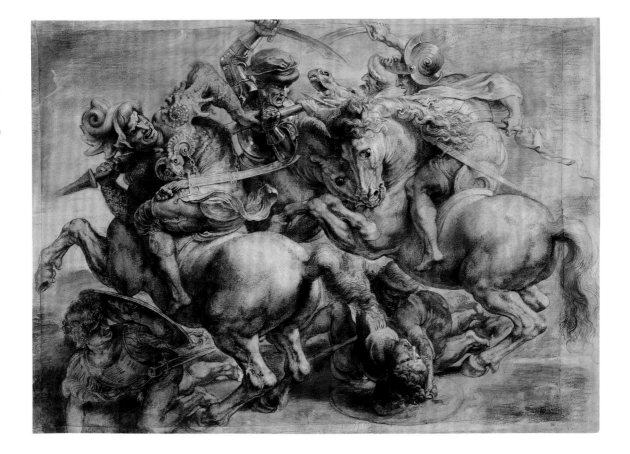

Raphael made a tiny metalpoint sketch after the *Battle for the Standard* in the corner of a sheet of studies for his fresco of the *Holy Trinity flanked by Saints* at S. Severo in Perugia which is dated 1505 (fig. 20).[134] The *mise-en-page* suggests that he made the studies for the fresco (see fig. 16) before he saw Leonardo's designs, and tucked his copies after them into the spaces around the head and the hands of a youthful saint. However, the technique of all the sketches is so similar as to suggest that they were made in close succession, implying that Raphael may have designed the S. Severo fresco while he was in Florence (as was later the case with the Baglioni *Entombment*). The minute scale of Raphael's sketch of the *Battle of the Standard* and slight variations from the finished composition (for example in the position of the standard-bearer's left arm) suggest that he was probably copying a similarly tiny preparatory sketch by Leonardo, a type of jotting in which the older artist specialised. The sheet contains other small sketches of a cavalcade of horsemen and two horses biting each other, also after Leonardo. Raphael's copies are faithful but quite distinctive, when compared with Leonardo's rapid improvisatory manner, in their clarity of outline and lightness of touch, enlivened by instinctive flourishes. Between the two studies of hands, Raphael drew a grim-faced man in profile, a leitmotif among Leonardo's drawings, and undoubtedly copied from one by him.[135] All the sketches are executed in the traditional technique of metalpoint, but the much more minute scale of hatching and cross-hatching in his drawings of this period shows Raphael adapting his habitual linear approach to imitate the subtle gradations of tone Leonardo was pioneering in the softer medium of chalk.

Equally fundamental for Raphael was another famous cartoon by Leonardo of the Madonna and Child with Saint Anne made in connection with a commission for the high altar of SS. Annunziata in Florence (see also cat. 49). Vasari, who describes the wonder this revolutionary composition elicited from artists and public alike when it was displayed in 1501, praised Leonardo's ingenuity in evoking not just the beauty and grace of the Madonna, but also her inner qualities – including simplicity, modesty, humility, joy, tenderness and honesty – appropriate to her unique role as virgin and mother of Christ.[136] It was Leonardo's ability to convey the intangible motions of the mind, emanating as if naturally from within his graceful figures, that 'left Raphael amazed and entranced', and persuaded him to add to what he had learned from Perugino.[137]

During his years in Florence (1500–6), Leonardo also worked on private commissions of different types: a small Madonna for private devotion (the *Madonna of the Yarnwinder*), a portrait (the *Mona Lisa*), and a mythology (*Leda and the Swan*).[138] Together with the Saint Anne cartoon, these works explored the female form in all its guises: young, old, religious, secular, draped and nude. All of these approaches were of interest to Raphael and he rapidly introduced the tender expressions and intricate coiffures of Leonardo's female figures into his own repertoire. Many of Leonardo's Florentine works

remained unfinished, or were completed by assistants,[139] but Raphael was evidently able to study Leonardo's compositions in the form of preparatory drawings, cartoons or underdrawings, and he emerged from his Florentine sojourn having digested every one of Leonardo's most recent designs for paintings (see for example cats 52 and 54), and having learnt new styles and techniques of draughtsmanship as well as compositional solutions. The overwhelming impression is that Raphael had direct access to Leonardo's workshop, perhaps facilitated by Soderini (Leonardo's patron in the Sala del Consiglio), or by Perugino, who had worked with Leonardo in Verrocchio's shop.

During this period, Raphael also had the opportunity to study earlier works by Leonardo such as his great altarpiece of the *Adoration of the Magi* for S. Donato a Scopeto (again left unfinished at the time of Leonardo's departure for Milan in 1482–3, see fig. 105). He also knew Leonardo's *Benois Madonna* of the late 1470s (fig. 81), a small devotional painting which may then have been in the possession of one of the Florentine patrician families into whose circle the young Raphael had recently been introduced. One of his most exquisite small-scale Madonnas, the *Madonna of the Pinks* (cat. 59), closely follows the overall composition of the *Benois Madonna* recast in Raphael's own idiom, so that the work is simultaneously a homage to the older artist's painting, and an assertion of his own creative independence (remarkable in one so young). In composition, theme and palette, as well as in the fall of the drapery, details of the costume, and the complex braiding of the Virgin's hair (even more evident in the underdrawing), Raphael was extremely faithful to Leonardo's example. The darker tones in the painting, and the sophisticated lighting, by which the figures are illuminated not from the daylight coming through the window but artificially from a light source outside the picture space, are also inspired by Leonardo's painting, as well as by Netherlandish models. The provision of additional anecdotal detail and context in support of the narrative such as the landscape view through the window is highly typical of Raphael (and is in contrast to Leonardo's concentration on the physical and emotional interaction of the figures). Leonardo's figure group also draws inspiration from Quattrocento sculpture, particularly Florentine exponents of the 'sweet style' such as Desiderio da Settignano, who specialised in representations of women and children with parted lips and faces suffused with joy. Raphael in turn appears to have had sculpture in mind as he set about reorganising Leonardo's figure group, 'correcting' the proportions of Leonardo's oversize baby, clarifying the position of the figures in space (the Virgin's lap forms the base of a monumental pyramid from which the child is no longer in danger of slipping), and clearly defining the contours of each limb and member right down to the individual fingers and toes.

In the *Madonna of the Pinks* (fig. 21 and cat. 59), Raphael experimented with new and unexpected colour combinations that continue to feature in other paintings from this period, including the *Saint Catherine* (cat. 74) and especially the Baglioni *Entombment* (fig. 34).

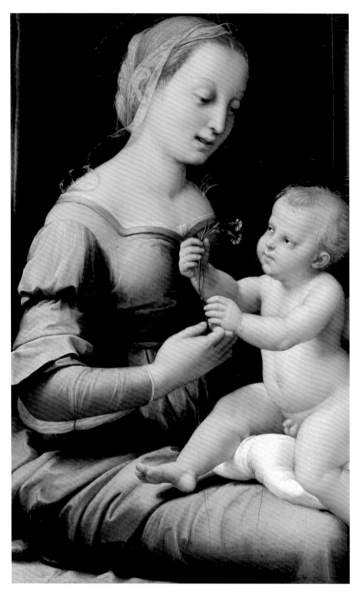

fig. 21 Detail of cat. 59

the *Small Cowper Madonna* (fig. 86) of around 1505, the *Madonna del Granduca* of 1505–6 and the *Madonna Tempi* (fig. 87) of about 1507 are characterised by an unusual tenderness and intimacy, as the Virgin holds, caresses or actively cuddles her naked baby, who in turn responds by reaching out to her or nestling into her embrace. In others, such as the Orléans and Colonna Madonnas, she prepares to feed him. Raphael infused these devotional pictures with an unprecedented naturalism and grace and his extremely rapid turnover of variations on this theme in this period is indicative of the demand for works of this type from his hand.

As a monumental tour de force of the male nude in action, Michelangelo's cartoon of the *Battle of Cascina* (see cat. 56) was a worthy rival to Leonardo's *Battle of Anghiari*. With the exception of Signorelli's frescoes at Orvieto (which Michelangelo greatly admired[141]), no attempt had ever been made to depict the naked human form on such a grand scale. Vasari described Michelangelo's cartoon as 'a school for artists', and mentioned Raphael among the legions who studied this exceptional drawing.[142] Vasari himself was struck by the violence of the subject, the musculature of the individual figures, the complexity of the foreshortenings and the variety of the attitudes (as well as by the different levels of finish in the drawing).[143] To judge from motifs in drawings datable to around 1505–6 (see for example cat. 57),[144] Raphael may have gained access to the cartoon when Michelangelo was working on it in the Dyer's Hospital at S. Onofrio before his departure for Rome.[145]

Under the influence of Michelangelo, Raphael could move beyond Perugino's formative influence. Vasari commented that such a stylistic transformation would have taken a lesser artist several years.[146] By studying works such as Michelangelo's two marble tondi of the Virgin and Child with the infant Saint John which brilliantly exploit the circular format, Raphael learned to conceive a composition in the round (in all senses) as he did with the *Holy Family with the Palm*, and later with the *Alba Madonna* (cat. 93) and – perhaps closest to the spirit of Michelangelo and most successfully – the *Madonna della Sedia* (fig. 44).[147] Study of these sculptures taught Raphael how to make his figures interact dynamically with each other, and, by imitating the fall of light and shade on the surfaces of the sculptures, he also learned to create a more convincing illusion of relief in the two-dimensional plane to which he was necessarily confined. He even made a tentative attempt at mimicking sculpture in the grisaille predella panels of the Baglioni *Entombment* where the roundel of *Charity* (cat. 67), showing the allegorical figure beset by suckling infants, combines elements of both of Michelangelo's carved tondi.

Raphael also carefully studied all the free-standing marble sculptures that Michelangelo had recently produced in Florence, including the colossal figure of *David* (fig. 79), which had been set up outside the entrance to the Palazzo Vecchio in May 1504, the

The pure, bright colours of the Virgin's blue mantle (painted with ultramarine over an underpaint of azurite) and its golden-yellow lining are contrasted with the more subdued mixed colours of her greyish-purple dress and slightly acid greenish-yellow sleeves (although the colours may have faded in these areas the presence of black pigment in the mixture and the choice of azurite instead of ultramarine confirm that the colour was always to be muted).

Raphael produced a number of small and mid-sized Madonnas during these years. Such was the fertility of his imagination that he generated ideas for several compositions in a single campaign of sketching (see for example cat. 63, which includes sketches related to the *Madonna of the Pinks* and six other Madonnas).[140] Works such as

Madonna and Child for Alexander Mouscron, made between 1504 and August 1506, when it was sent to the church of Notre Dame in Bruges,[148] and the *Saint Matthew* for the interior of Florence Cathedral which was carved in the course of 1506 (fig. 92).[149] Raphael adapted Michelangelo's figures to his own purposes, in the case of the *David* adjusting the statue's giant head and hands to more human proportions and in another drawing bringing the statue to life by making it step forward (cat. 58 and fig. 80). His drawings for the Baglioni *Entombment* of 1507 show him beginning to make nude studies of dynamically interacting figures in order to imbue a composition with monumentality and vigour (see cat. 72). Only after he arrived in Rome did Raphael begin to design multi-figure compositions of comparable complexity to Michelangelo's cartoon, as demonstrated by his nude composition studies for the *Disputa* and the *Massacre of the Innocents* (see cats 82 and 88). Michelangelo came to resent Raphael's ability to borrow his ideas and animate them as flesh and blood, transforming them into noble actors in his majestic histories, but his complaint that 'what he had of art, he had from me' does not do justice to the creativity with which Raphael assimilated material from so many different sources.[150]

Although Michelangelo never executed the fresco of the *Battle of Cascina*, he left behind him in Florence an example of his brilliance as a painter in the form of a Holy Family (fig. 22) executed for Agnolo Doni (probably 1504–6), whose portrait, with that of his wife, Raphael painted soon after.[151] Michelangelo ingeniously adapted his figure group to the tondo format, making his composition work as a two-dimensional design (Mary and Joseph's spiralling limbs echo the circular shape of the panel) while at the same time creating the illusion of a three-dimensional group (the foreshortening of the Virgin's left arm and right knee as she reaches back to receive her infant son over her shoulder makes her figure appear to emerge from the panel). Raphael used the Virgin's dynamic twisting pose to animate the group of the three Maries who support the swooning Virgin in the Baglioni *Entombment* (fig. 34), contrasting dramatically with the much simpler group in his predella scene of the *Procession to Calvary* (cat. 41), of only a couple of years earlier.

An idiosyncrasy of Michelangelo's painting style was a very pronounced contrast between light and shade, the exaggerated highlights in the *Doni Tondo* providing the key to its powerful illusion of relief. This also had the effect of making his colours appear unnaturally vivid (as the cleaning of the Sistine Chapel ceiling has so dramatically revealed[152]). Raphael never pursued to the same degree the sculptor's fascination with contrasts in chiaroscuro (which sometimes threaten to disrupt the picture surface), preferring to maintain a sense of pictorial unity through subtle harmonies of colour and tone.[153] He was praised by Vasari for having the good sense to recognise his own limitations as well as his talents, realising 'that painting does not consist of representing nude figures alone',

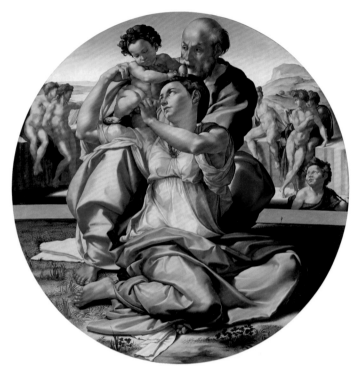

fig. 22 Michelangelo Buonarroti
**The Holy Family with the Infant Saint John the Baptist
(The Doni Tondo)**, probably 1504–6
Oil on wood, diameter 120 cm
Galleria degli Uffizi, Florence, inv. 1456

and never populated his compositions with figures for their own sake in the manner of Michelangelo's enigmatic nudes in the middle-ground of the *Doni Tondo*.[154] He had a strong sense of a picture as a whole and was always careful to create a sense of continuity between the figures and their setting (although there is mounting evidence to suggest that he frequently conceived these elements independently[155]). Moreover, as a gifted architect, he often used space to articulate or emphasise narrative elements within his paintings (see fig. 12), while Michelangelo – who also came to excel in the design of buildings – paid almost no regard to the role of architecture in his paintings.

In addition to showing his thorough knowledge of Michelangelo's Florentine work, Raphael's drawings demonstrate that he also studied Michelangelo's draughtsmanship during this period (as reflected for example in cats 56–57). The overall impression is that, despite their subsequent rivalry and Michelangelo's stated contempt for Raphael after his death (with its implied accusation of plagiarism), the two artists may nevertheless have been on cordial terms at this stage in their careers.[156]

Raphael befriended a wide circle of other artists in Florence. One of these was Fra Bartolommeo (1472–1517), a talented painter and an outstanding draughtsman who had abandoned his profession in 1500

to become a Dominican friar, only resuming artistic activity at around the time Raphael first arrived in the city.[157] As a painter, he represented a middle way between the innovations of Leonardo and Michelangelo, a position Raphael himself came to occupy, and there was much in the friar's more traditional approach to picture painting, including the collaborative nature of the workshop he ran with Mariotto Albertinelli, with which the younger artist could identify. According to Vasari, Raphael 'associated constantly with him, wishing to paint in the manner of the friar because he liked his management and blending of colours'.[158] The suggestion that Raphael learnt from Fra Bartolommeo as a colourist has often been overlooked, perhaps because Raphael's approach to colour changed again in Rome under the influence of Venetian and North Italian painters.

Fra Bartolommeo prepared the monumental figures in his paintings by making exquisite drapery studies in black chalk, heightened with white chalk, the transitions between the lights and the darks softly smudged to create an almost ethereal effect (see fig. 107), a technique that Raphael adopted more consistently after he moved to Rome and began designing figure compositions on a grand scale. Indeed the entire composition of the first fresco he painted in the Stanza della Segnatura, the *Disputa* (cat. 78), is based on Fra Bartolommeo's harmoniously designed fresco of the *Last Judgement* for the Hospital of S. Maria Nuova, begun in 1499–1500 (and completed by Albertinelli after the friar took orders). Raphael's admiration for this work is reflected in his arrangement of the saints around the Trinity in his S. Severo fresco and in their voluminous draperies (fig. 15). Fra Bartolommeo's own deeply felt spirituality is reflected in his many devotional paintings, for both church and domestic settings, and his drawings in particular movingly evoke the rapture of the witnesses and participants in the divine mysteries. This quality of visionary ecstasy which Raphael learnt from Fra Bartolommeo again emerges most clearly in his later Roman works, tellingly expressed for example in the figure of Saint Francis in the *Madonna di Foligno* (fig. 131).

Both Fra Bartolommeo and Raphael were sensitive to the depiction of landscape, Raphael's interest having been first awakened by Perugino.[159] Inspired by the friar's novel and evocative *plein-air* studies of buildings and landscapes in the Tuscan countryside, Raphael developed more naturalistic backgrounds for his paintings from this period onwards (see for example cat. 74). He may have taken some of Fra Bartolommeo's drawings (or his own copies after them) with him to Rome since he used one as the basis for the landscape background of the *Disputa*.[160] Even before his contact with the friar, Raphael had introduced vignettes of recognisable local scenery into the backgrounds of his paintings (the Tiber valley in the *Mond Crucifixion* and the view from Perugia in the *Ansidei Madonna*), and he continued to do so in subsequent works (see for example the view of S. Bernardino from Urbino in the *Small Cowper Madonna* in Washington).

Artists closer to his own age with whom Raphael made friends included Ridolfo Ghirlandaio (1483–1561) and Bastiano (known as 'Aristotile') da Sangallo (1481–1551), both descended, like Raphael, from established artistic families. (Ridolfo was the son of the successful painter Domenico Ghirlandaio, and Bastiano, a nephew of Giuliano da Sangallo, was a pupil of Perugino in whose Florentine workshop Raphael may first have encountered him.)[161] All three are listed by Vasari among the many painters who studied Michelangelo's cartoon, and Bastiano made a faithful copy of it (see cat. 55).[162] Ridolfo was a successful painter of altarpieces and portraits and Raphael relied on him to attend to his unfinished business at the time of his departure from Florence (as Domenico Alfani and Berto di Giovanni did after he left Perugia) – Ridolfo apparently finished off the blue drapery in a Madonna which Raphael had begun for some Sienese patrons.[163] Raphael also met other young artists in the workshop of the woodworker and architect Baccio d'Agnolo, and his new awareness of Alberti's ideas on painting and his growing familiarity with Northern prints, especially those of Dürer, may have been stimulated by the 'remarkable discussions and important disputes' that took place there on cold winter evenings.[164]

Nor did Raphael neglect to study the works of fifteenth-century artists as well as the modern masters. Vasari mentions that he looked at Masaccio, above all the frescoes in the Brancacci Chapel (that other great school for artists), and from his drawings it is apparent that he paid close attention to Donatello's sculptures on the exterior of Orsanmichele (cat. 47).[165] Indeed, in Florence he found himself surrounded by extraordinary sculptural models from which to study, including the Madonna reliefs by Quattrocento sculptors such as Desiderio da Settignano and Luca della Robbia in which his father had shown a lively interest.[166] Painters and draughtsmen such as Pollaiuolo, Verrocchio and Ghirlandaio were also of interest, along-side Perugino and Signorelli. Filippino Lippi may have been alive when Raphael first visited Florence, and there are two drawings in the Louvre that show Raphael's studies after his Patriarchs on the vault of the Strozzi chapel in S. Maria Novella, while cat. 41 shows he had knowledge of Lippi's designs for the high altarpiece of SS. Annunziata before Perugino took over the project. Curiously, Raphael took little if anything from Botticelli (d. 1510), whose star had waned in the first years of the sixteenth century.

Raphael did not confine himself to studying the work of others and soon succeeded in attracting the patronage of important Florentine citizens.[167] Vasari's account of his painting activity in Florence is more accurate and well informed than his descriptions of the artist's commissions for other cities because he knew the paintings first hand, the majority of them having remained in the possession of the descendants of Raphael's original patrons. Raphael attracted private commissions from a number of wealthy families of the ruling elite, all interlinked by marriage.[168] Although Vasari mentions only five families (Raphael's commissions for all

five survive), the large number of unassigned Madonnas datable in this period suggests that he may have worked for many others, especially since several of these have provenances from Florentine collections.[169]

Perhaps Raphael's most significant contact in Florence was the prominent merchant Taddeo Taddei, described by Vasari as 'one who loved the society of men of ability', whose palace on the Via de' Ginori was designed by Baccio d'Agnolo.[170] In 1508 when Taddei visited Urbino (where he had connections at court via his and Raphael's friend Pietro Bembo), Raphael wrote ahead to his uncle, instructing him to welcome his beloved Taddei with open arms, and stating that he was 'as much obliged to him as to any man alive'.[171] Taddei was closely connected to a number of Raphael's Florentine patrons, including the Nasi, patrons of the *Madonna del Cardellino* (fig. 26), and may have opened other doors for Raphael in Florence.

According to Vasari, Raphael returned Taddei's hospitality by making him two pictures, which combined both 'the early manner of Pietro and the other which he learned afterwards through studying, and which was much better'.[172] This duality certainly applies to the first painting associable with Taddei, the *Terranuova Madonna* (fig. 23), datable around 1504–5, which has much in common with Raphael's

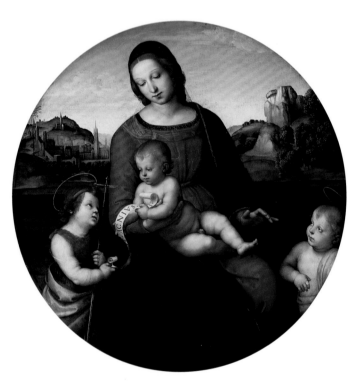

fig. 23 **The Madonna and Child with Saints (The Terranuova Madonna)**, about 1504–5
Oil on wood, diameter 88 cm
Gemäldegalerie, Staatliche Museen zu Berlin-Preußischer Kulturbesitz, Berlin, 247A

contemporary Perugian works such as the *Conestabile* and *Ansidei Madonnas*.[173] The inclined head, pear-shaped face, downturned eyes and sweet expression of the frontally posed Virgin all recall Peruginesque models (as does the upturned open-mouthed gaze of the infant Baptist), while the monumentality of the Virgin's bust, the foreshortening of her hand hovering to silence any interruption of the significant interchange between Christ and his cousin,[174] the more complex twisting pose of the Christ Child, and the delicate rendering of his hair and flesh, reveal Raphael's new awareness of the designs of Leonardo. Raphael's inexperience is nevertheless evident in that his painting as yet makes little concession to the Florentine tondo format, a valuable lesson that he was soon to absorb from Michelangelo's marble tondi, including that for Taddeo Taddei himself.[175]

One of Raphael's studies after Michelangelo's tondo for Taddei is on a sheet of preparatory sketches for the other painting that Raphael produced for this patron, the *Madonna of the Meadow* (fig. 24; see also cat. 50), datable from the gold lettering in the Virgin's neckline to 1505 or 1506.[176] With little more than a year separating it from the *Terranuova Madonna*, the transformation in Raphael's style is astounding. In this beautiful picture, the young artist remained faithful to certain key aspects of Perugino's manner, for example in the rich saturated colours of the Virgin's costume, the landscape, with its verdant meadow strewn with symbolically laden daisies, strawberries and poppies, and the blue haze enshrouding the distant lakeside town and hills (compare cat. 10). Yet in the figures' informal poses and natural expressions, the soft tactile flesh of the children, that of the Christ Child yielding under the tender caress of the Virgin, the satisfying pyramidal design of the group and the convincing monumentality of the figures, Raphael's study of Leonardo is manifest. The Virgin's outstretched leg reveals a specific debt to Leonardo's *Virgin and Child with Saint Anne* (fig. 83), which Raphael would have known at least from drawings. It is worth pointing out that Raphael was never interested in reproducing, or even experimenting with, the harshness of Leonardo's rocky landscapes, but for the graceful forms and expressions of his figures he knew no better master.

In the same circle as Taddei, and linked to his family by marriage, was Lorenzo Nasi (1485–1547), a merchant, with whom Raphael also enjoyed a close friendship (*amicizia grandissima*).[177] At the time of Nasi's marriage to Sandra Canigiani, Raphael painted another picture of the Madonna and Child with Saint John for his *camera* or bedchamber.[178] The *Madonna del Cardellino* is extremely close in date to the *Madonna of the Meadow*, as is confirmed by the stylistically similar preparatory drawings for the two compositions.[179] These share motifs for the striding infant Saint John (fig. 25), a pose that was eventually adopted for the Christ Child in the *Madonna of the Meadow* (whom the Virgin supports as he takes his first steps), but in the painted version of the *Madonna del Cardellino*, Christ leans back into the refuge of his mother's lap, seeking the comforting

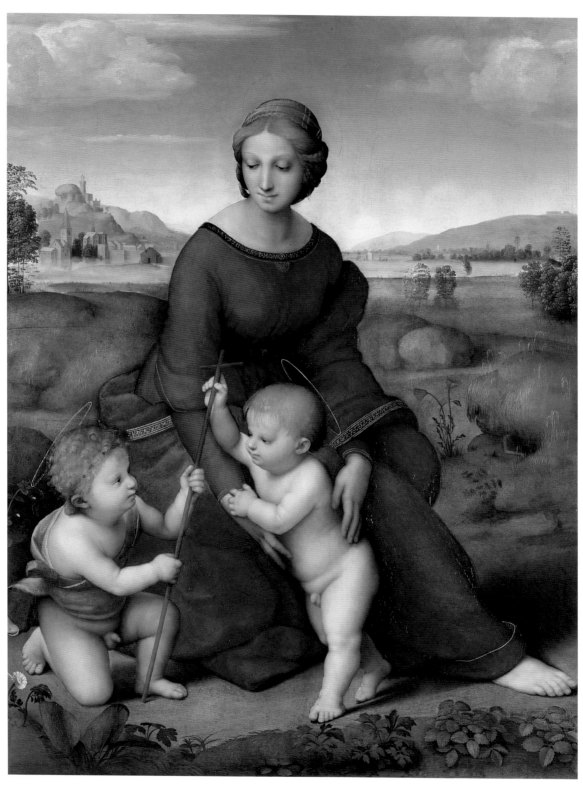

fig. 24 **The Madonna of the Meadow**
(Madonna Belvedere), 1505–6
Oil on wood, 113 × 88 cm
Kunsthistorisches Museum, Vienna, GG175

presence of her foot with his.[180] He is nevertheless fascinated by his cousin's offering of the goldfinch (a symbol of his future Passion) and reaches out to stroke the bird's head as if it were a domestic pet. A curiosity in this painting is that, other than their superimposed feet, there is little interaction between the Virgin and Child (in all Raphael's other Madonnas, the Virgin is protective toward her child, holding or touching him tenderly with one or both hands), and, although in her monumentality the Virgin is undoubtedly Leonardesque, Raphael had yet fully to master the affective interplay between the protagonists that the older artist pioneered. This absence of tenderness expressed through touch, together with a residual hieratic formality still reminiscent of his Perugian altarpieces, suggests that the *Cardellino* might have been painted before the *Madonna of the Meadow*, in which this deficiency is so successfully addressed (as it also is in subsequent works such as the *Belle Jardinière*, fig. 27). Indeed, Raphael's principal influence in the *Cardellino* seems to be Michelangelo: he may have derived the rather contrived pose of the Christ Child glancing back over his shoulder from the Virgin in the *Doni Tondo*, and the way the child nestles between his mother's knees is undoubtedly inspired by Michelangelo's Bruges Madonna.

The *Madonna del Cardellino* and the *Madonna of the Meadow* are examples of a larger and more ambitious type of Madonna painting produced for a wealthy clientele with sophisticated tastes in which Raphael came to specialise. Also in this category are the *Holy Family* painted for Domenico Canigiani (1487–1548), the brother-in-law of Lorenzo Nasi, perhaps in the year of his marriage to Lucrezia Frescobaldi in 1507, and the *Belle Jardinière*, possibly painted for Siena and dated 1508.[181] These large-format rectangular or arch-topped compositions of the Madonna and Child with Saint John at full length combined the intimacy of small-scale devotional works with the majesty of altarpieces, and were destined for domestic use in living rooms or private chapels. They were luxury items, comparable in value to the painted tondi in elaborately carved frames that had become popular among the Florentine élite in the previous century.[182] Indeed the three tondi Raphael produced in the period 1504–8, that for Taddei, the *Holy Family with a Palm* of about 1506–7 for an unknown patron, and a lost work known as the *Madonna del Silenzio* (apparently destined for Siena), should be classified in the same category.[183] Raphael was by no means the first to depict the Madonna full-length on this scale, but his innovation was to bring the subject to life by making the figures interrelate not only compositionally (in pyramidal arrangements inspired by the monumental figure groups of Leonardo and Michelangelo), but also physically and emotionally through touch and nuances of expression. He went to great lengths to integrate his figures into beautiful pastoral landscapes often adorned with symbolic flowers.

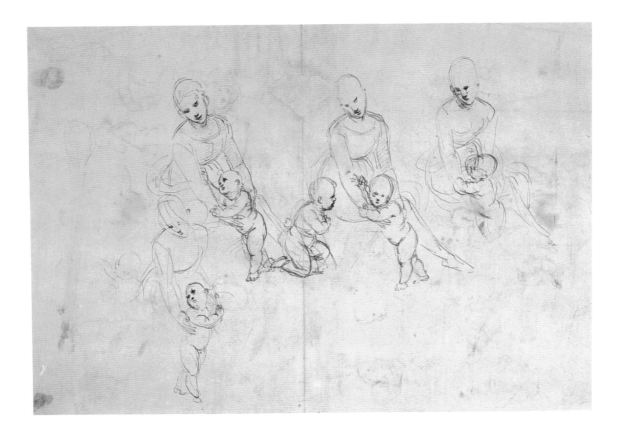

fig. 25 **Studies for the Madonna of the Meadow**, about 1505
Pen and brown ink over stylus underdrawing, 24.5 × 36.2 cm
Albertina, Vienna, Bd. IV, 207

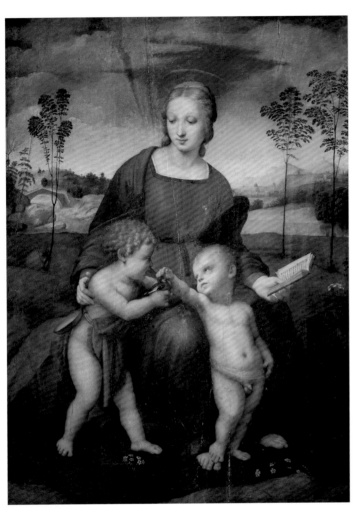

fig. 26 **The Madonna del Cardellino**, about 1505
Oil on wood, 111 × 77.5 cm
Galleria degli Uffizi, Florence, inv. 1890, no. 1447

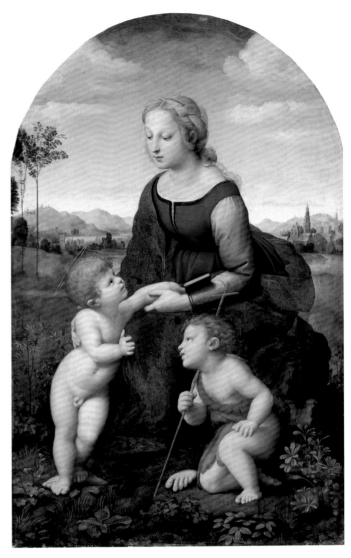

fig. 27 **La Belle Jardinière**, 1508
Oil on wood, 122 × 80 cm
Musée du Louvre, Paris, inv. 602

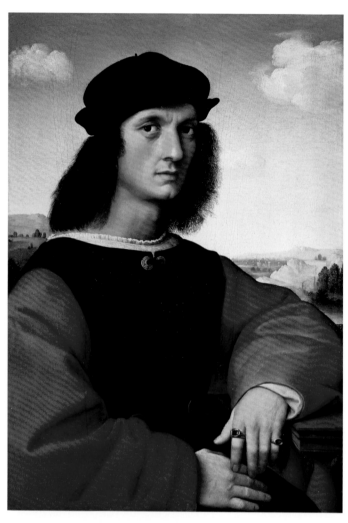

fig. 28 **Portrait of Agnolo Doni**, about 1506–7
Oil on wood, 65 × 45.7 cm
Galleria Palatina, Palazzo Pitti, Florence, inv. 1912, no. 61

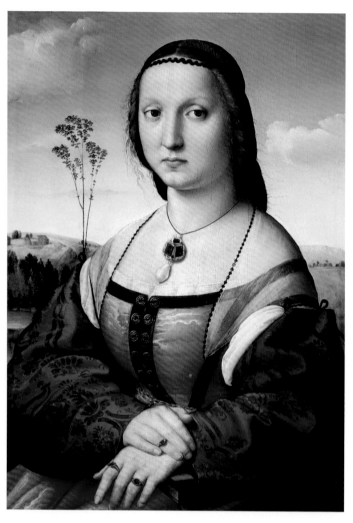

fig. 29 **Portrait of Maddalena Doni**, about 1506–7
Oil on wood, 65 × 45.8 cm
Galleria Palatina, Palazzo Pitti, Florence, inv. 1912, no. 59

In the field of portraiture too Raphael learned to compose and characterise through studying the works of others, and he rapidly became a master of this art. Among the finest of several portraits he produced while in Florence were the pair painted as pendants for Agnolo Doni (b. 1474) and his young wife Maddalena Strozzi (b. 1489) (figs 28 and 29).[184] The couple were married in January 1504, when the bride was only fifteen, and the portraits are datable on stylistic grounds to two or three years later, around 1506–7. Vasari described Doni as parsimonious (he haggled unsuccessfully with Michelangelo over the price of his painted tondo), but an enthusiast for paintings and sculpture, in which he was prepared to invest.[185] The portraits are decorated on the reverse with monochrome scenes of subjects from Ovid associated with fecundity, expressive of the couple's hope of offspring, which indeed soon materialised with the birth of their daughter in September 1507 and their son in November 1508.[186]

The two portraits were conceived as a pair from the start and are on panels of limewood from the same tree. Both in his observation of nature and in the way the sitters are juxtaposed against a landscape background, Raphael was drawing on a tradition of portraiture that had its roots in Netherlandish models, notably in the portraits of Memling, perpetuated in Florence by Perugino, Leonardo and Domenico Ghirlandaio. Raphael's portrait of Agnolo is markedly Peruginesque, particularly in the way his shock of dark hair is silhouetted against the sky (compare cat. 8), though the sophistication and balance of his pose, with his left arm resting on the parapet of a balustrade and his right anchoring the lower corner of the composition, are derived from Leonardo. As was conventional for a male portrait, Agnolo's likeness is more particularised than that of his wife, his large nose, cleft chin (covered with a hint of stubble) and frown of concentration are all described in impressive detail, as are the veins and wrinkles in his hands. The impact of Leonardo's portrait of Lisa del Giocondo, known as Mona Lisa (fig. 75), embarked upon around 1503, is much more evident in the portrait of Maddalena (as it also is in his *Portrait of a Lady with a Unicorn*, for which see cat. 51). Raphael retains much of Leonardo's revolutionary design, but brings the composition robustly down to earth. Instead of Mona Lisa's ethereal expression we meet Maddalena's far more worldly gaze, while her hands are carefully arranged not as assets in themselves, but to display the gold rings set with precious gems that adorn her plump fingers (Agnolo was a keen collector of jewels and gems[187]). The young woman is presented as fair in complexion and idealised in her bodily form (the orb of her head rests on a columnar neck and arched shoulders), yet her features are too large for her face, her torso strains against the fastenings of her bodice, her rings are too tight. Even the jewel suspended from a delicate cord around her neck, with its unicorn setting symbolising chastity and the huge drop pearl standing for purity, seems – like its owner – larger than life. Leonardo's panoramic view over a mysterious rocky

landscape is replaced in Raphael's portraits by a more recognisably Tuscan countryside beneath a sunny sky, the two haystacks nestling beside a farmhouse behind Maddalena again reminiscent of Fra Bartolommeo's studies of local landscapes.

Raphael was obliged to interrupt his Florentine sojourn in order to attend to his neglected affairs in Urbino, and he is recorded there in October 1507 in documents relating to his purchase of a house.[188] The artist had clearly maintained his links with his hometown, where his relatives continued to live, and he may have returned there much more frequently than we know. Although never officially attached to the court as Giovanni Santi or Timoteo Viti were, he seems, nevertheless, to have provided his courtly patrons – namely Duke Guidobaldo, his Duchess Elisabetta Gonzaga (fig. 30), and the Duke's sister, Giovanna della Rovere, and later her son Francesco Maria – with a steady flow of portraits and exquisite small paintings, which

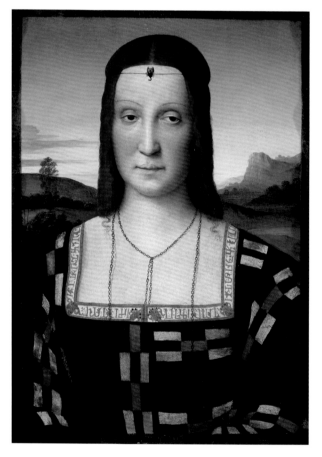

fig. 30 **Portrait of Elisabetta Gonzaga**, 1504–6
Oil on wood, 52.5 × 37.3 cm
Galleria degli Uffizi, Florence, inv. 1890, no. 1441

had the advantage of being easily portable.[189] To judge from an aside in a letter written to his uncle in Urbino in 1508, Raphael may have worked on many of these small courtly commissions in Perugia or Florence and sent them back to Urbino.[190] After the death of Duke Guidobaldo and the succession of Francesco Maria della Rovere, Raphael was particularly keen to fulfil Giovanna della Rovere's requests swiftly, since she was now in an even stronger position to promote his ambitions not just at the court at Urbino, but more importantly, through her family connection with Pope Julius II, at the papal court in Rome.[191]

Raphael's works for the court at Urbino would have been prized as rare and skilfully wrought objects. The outstanding quality of the *Vision of a Knight* (fig. 31), combined with its literary and courtly subject, has led scholars to suppose that it and its pendant or cover representing the *Three Graces* were painted for a patron at Urbino, around 1504, although a Sienese connection has also been posited (see cat. 35). While there is no firm evidence for this either way, another pair of pictures similar in scale and quality but datable

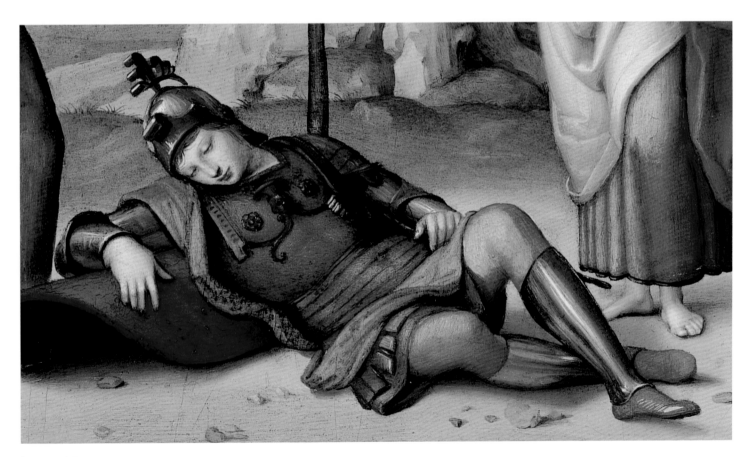

fig. 31 Detail of cat. 35

a year or two later, representing *Saint George* and *Saint Michael* (fig. 32 and cats 33–4), are unquestionably connected with the Urbino court, the saints being the patrons respectively of the English Order of the Garter and the French Ordre de Saint Michel. Since Giovanna Feltria's father and brother had been honoured with the first and her husband and son with the second, the pictures may have been commissioned by her or by her relatives. Another small picture of *Saint George* in Washington with H O N I inscribed on the garter, datable around 1506, must be connected with Duke Guidobaldo's investiture as a knight of the garter in 1504.[192] A little later, around 1506–7, the Duchess commissioned Raphael to paint an *Agony in the Garden* as a gift for the hermit monks of Camaldoli (between Urbino and Florence). Pietro Bembo's description of it, and that of Vasari a few decades later, implies that the painting was of the highest quality and minutely worked in the manner of a miniature.[193] Two 'small but very beautiful Madonnas in his second manner' which Vasari stated that Raphael painted for Guidobaldo da Montefeltro during his stay in Urbino in 1507 remain to be identified.[194]

At around this time Raphael began an important altarpiece for Atalanta Baglioni's chapel in S. Francesco al Prato, Perugia.[195] He must have embarked on his designs around 1506 and delivered the altarpiece (fig. 34) in 1507.[196] The seriousness with which he approached this prestigious assignment from the matriarch of the Baglioni clan is attested to by the large number of surviving preparatory studies, the complex genesis of both design and subject (the composition evolved from a Lamentation to the Transportation of Christ to the Tomb), and the extraordinary quality of the finished altarpiece. Although the painting was for Perugia, Raphael would have been keen to establish himself as a painter of altarpieces in the competitive environment of Florence, and the painting is Florentine both in conception and style. It follows Alberti's precepts for narrative painting and draws inspiration from a specific classical source – a Meleager sarcophagus – recommended by him, and it combines Michelangelo's vigorous figural repertoire with Perugino's talent for landscape painting. Vasari's extended commentary on the painting reveals his wholehearted admiration. Although he does not mention the history behind Atalanta's commission, which was to commemorate and expiate the violent death of her son, he seems to have intuited the closeness of the subject to the patron's immediate experience, and he praised Raphael's ability to convey the emotional impact of the subject: 'In composing this work, Raphael imagined the grief of loving relations in carrying to burial the body of their dearest, the one on whom all the welfare, honour and advantage of the entire family depended.'[197] Raphael's approach to the *Entombment* was groundbreaking in the way he transferred the narrative action, usually confined to the predella of an altarpiece, into the main field, replacing the predella narratives in turn with fictive stone reliefs representing the theological virtues.[198]

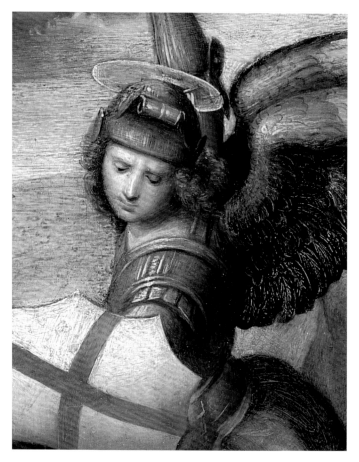

fig. 32 Detail of cat. 33

Raphael's first studies for the composition reflect Perugino's *Lamentation* (fig. 33) for the church of S. Chiara in Florence, showing Christ's body surrounded by an entourage of onlookers engaged in a graceful theatre of ritualised gesture, but he quickly abandoned this static approach in favour of a more dramatic solution in which the bearers strain to support the weight of Christ's dead body (drained of colour), the Magdalen, her hair undone and tears streaming down her face, rushes in to assist in holding up the hand and head of her Lord, and the Virgin swoons into the embrace of the three Maries, her limp arm mirroring that of her dead son. As well as owing debts to antiquity and to prints by Mantegna, the altarpiece is a virtual manifesto of Raphael's admiration for Michelangelo. After exploring a wide range of poses for the dead Christ, Raphael selected a pose very close to that in Michelangelo's *Pietà* in St Peter's (the iconography of the mourning mother was of course pertinent to his theme).[199] The pose of Joseph of Arimathaea, based on Michelangelo's unfinished *Saint Matthew* (fig. 92), was also woven into the composition at a late stage. The kneeling woman who twists round to catch the Virgin is inspired by Michelangelo's *Doni Tondo*, and the bearers may be an echo of those in Michelangelo's altarpiece of the same subject painted for S. Agostino in Rome.[200] There is some evidence to suggest that Raphael went to Rome in around 1506 (indeed this may not have his first visit), which would explain his familiarity with Michelangelo's Roman works.[201]

In around 1507–8, Raphael at last received a major Florentine altarpiece commission, the *Madonna del Baldacchino*, the only large-scale work he was to embark upon in Florence – and one he was not destined to finish.[202] The altarpiece was for the Dei family chapel in the church of S. Spirito for which Rinieri di Bernardo Dei left provision in his will of July 1506. Raphael's increasingly canny head for business emerges in his letter to his uncle, Simone Ciarla, in which he relates that he had not agreed a price for the altarpiece in advance because it would be more advantageous for him to have it valued independently after completion (indicating considerable confidence in his own abilities and the esteem of his peers).[203] The patron had, however, given him reason to expect at least 300 ducats, a 'major league' price for an altarpiece commission, and almost ten times greater than the sum he received for the Baronci altarpiece.[204] By the date of the letter, 21 April 1508, Raphael had finished the cartoon and must have worked very rapidly to get the painting to the degree of finish in which we see it today before he left for Rome that summer. The design of the altarpiece, a *sacra conversazione* with the Virgin and Child on a dais flanked by Saints Peter, Bernard, Anthony Abbot and Augustine,[205] harks back to the raised dais seen in his earlier Perugian altarpieces, and the angels are descended from those in the small *Resurrection* Raphael had painted in about 1501–2 (cat. 21), but the work is given a monumental modern cast by the majestic figures and the grand classical architecture, designed to blend with Brunelleschi's *pietra serena* articulation of the real space of the church.

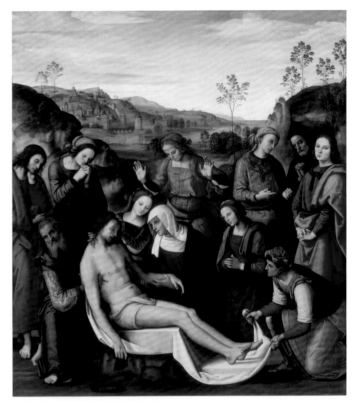

fig. 33 Pietro Perugino
The Lamentation over the Dead Christ, 1495
Oil on wood, 214 × 195 cm
Galleria Palatina, Palazzo Pitti, Florence, inv. 1912, no.164

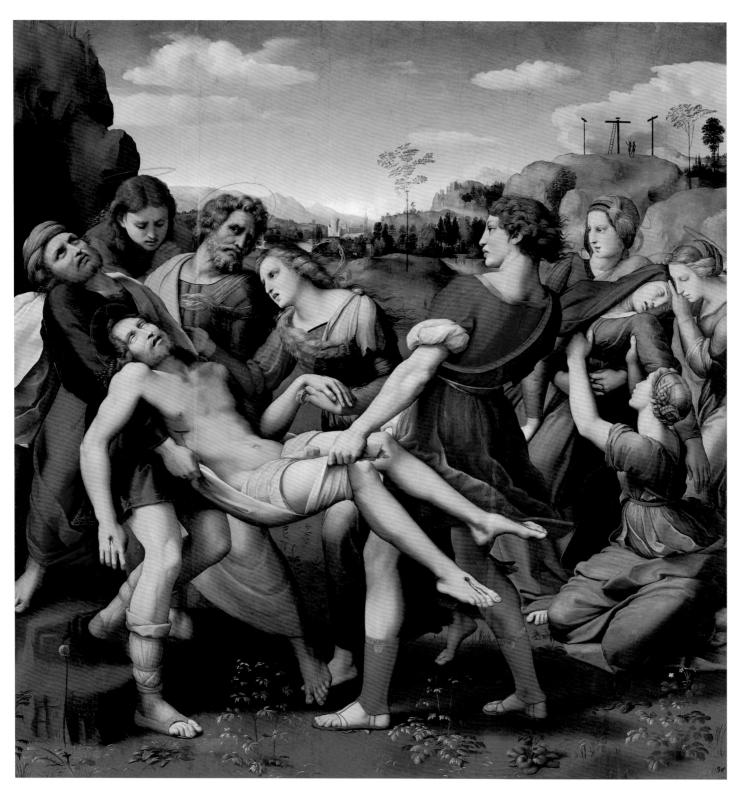

fig. 34 **The Entombment**, 1507
Oil on wood, 184 × 176 cm
Museo e Galleria di Villa Borghese, Rome, inv. 170

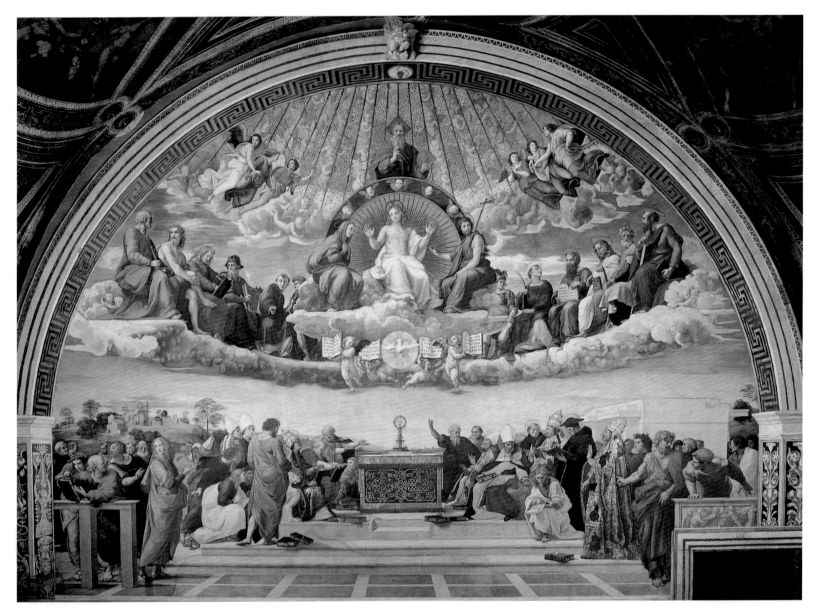

fig. 35 **The Disputation of the Holy Sacrament**
(La Disputa), 1509
Fresco, width at base 770 cm
Stanza della Segnatura
Vatican Museums, Vatican City

Raphael's letter of April 1508 reveals that he was already manoeuvring for a position in the most powerful and prestigious centre of artistic patronage in the land, the papal court in Rome. Not content with just having received his first Florentine altarpiece commission, he wished his uncle to obtain on his behalf another letter of recommendation to Piero Soderini, this time from Francesco Maria della Rovere – significantly Pope Julius's nephew – who was about to be invested as the new Duke of Urbino. Raphael's interest lay in 'a certain room [certa stanza] to be worked on', the commission for which still remained to be allocated.[206] It has sometimes been suggested that this was the Sala del Consiglio in Florence and that Raphael was lining himself up to take over where Leonardo and Michelangelo had left off (it was already clear that Leonardo, at least, was not going to return to Florence to complete his battle-scene).[207] However, the room alluded to in the letter was probably not the Sala Grande (which would never have been referred to as a 'stanza'), but one of a suite of rooms in the apartments that Pope Julius II was converting for his own use in the Vatican Palace (still known today as the Stanze).[208]

Giuliano della Rovere (1443–1513), whose uncle Pope Sixtus IV had made him a cardinal in 1471, was elected to the Papal See in October 1503 and took the title of Pope Julius II. Early on in his pontificate, around the end of 1505, Julius had moved out of the apartment formerly occupied by Pope Alexander VI (1492–1503). Adapting the third-floor summer apartment of Pope Nicholas V (1447–55) constructed fifty years before, he initiated a campaign of restoration and redecoration that came to bear the unmistakable stamp of his beliefs, policies and personality.

Whether by the intervention of Soderini, through recommendations from friends and fellow artists or through links between the Della Rovere at Urbino and the Pope (who would have encountered works by Raphael during his peregrinations through the Papal States), by January 1509 Raphael was firmly ensconced in the Vatican and had already received the substantial sum of 100 ducats for work in the Stanze.[209] These semi-public rooms in the Pope's new apartment were adjacent to an inner sanctum consisting of his bedroom, antichamber and private chapel.[210] The room in which Raphael began work is today known as the Stanza della Segnatura because by the time Vasari wrote his life of Raphael it had become the meeting room of a division of the supreme tribunal of the Curia, the Signatura gratiae. Flanked by other rooms used for papal audiences and meetings, it was almost certainly a library, although the Pope could also conduct official business and entertain visitors there, and its aim was therefore to impress, both in form and content.

Julius II had entrusted the decoration of the Stanze to a group of artists who were apparently working simultaneously in the three principal rooms in about 1508–9.[211] Vasari suggests that Julius's original idea was to assign all three rooms to Perugino,[212] but when the relatively elderly artist refused to accept such a huge commission, others were brought in to help. Perugino started work in the room

to the west, later called the Stanza dell'Incendio, Raphael and Sodoma worked side by side on the vault of the Stanza della Segnatura,[213] and several artists (including Lotto, Bramantino and Signorelli) embarked upon the room which came to be known as the Stanza di Eliodoro, on the other side of the Stanza della Segnatura. Raphael evidently thrived in this competitive yet convivial atmosphere, but although he must have been entrusted with the completion of the Stanza della Segnatura early on (in the course of 1509?), Vasari's claim that Julius, on seeing the School of Athens (fig. 37), had the work of the other painters destroyed and gave the decoration of the entire suite of rooms to Raphael is no longer plausible.[214] Raphael's appointment to a papal sinecure in October 1511 (see p. 58) probably marks the point at which he assumed overall control of Julius's projects. As in Perugia and Florence, therefore, Raphael's rise to pre-eminence may have taken longer than is sometimes assumed as he proved his mettle in a new environment.[215]

The Stanza della Segnatura's original function as a library – the Bibliotheca Iulia, reserved for the Pope's private use[216] – is reflected in its decorative scheme, which is divided up into the four branches of learning or 'faculties', according to how the books would have been classified. The key to the overall scheme is contained in the four roundels in the vault, each of which contains a beautiful female figure personifying one of these faculties: Theology, Poetry, Philosophy and Jurisprudence (see fig. 124). On the four walls below are scenes in which each abstract discipline is brought to life by an impressive cast of characters from ancient and more recent history, debating or enacting their allotted learned subject, and armed with numerous books and manuscripts, as befit scholars in a library. On the west wall, beneath Theology is the Disputa (figs 35 and 36), in which theologians debate the mystery of the Holy Sacrament.

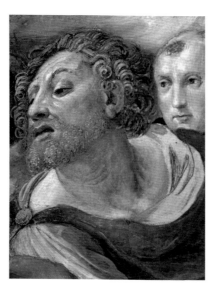

fig. 36 Detail of two figures on the left of fig. 35

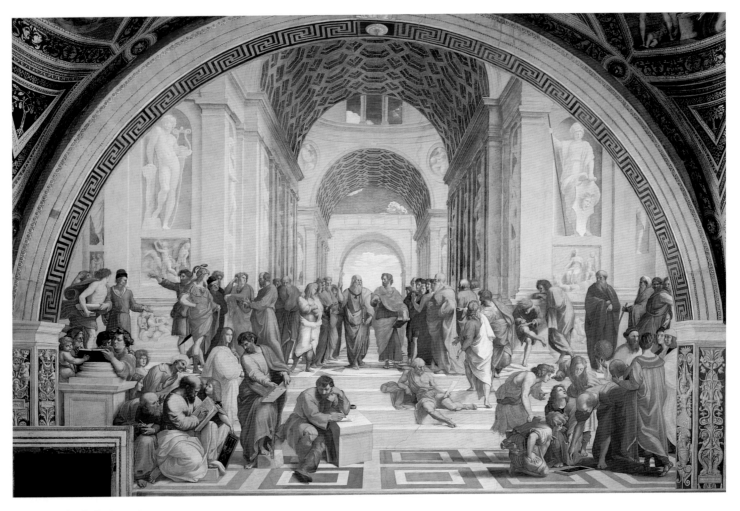

fig. 37 **The School of Athens**, about 1509–10
Fresco, width at base 770 cm
Stanza della Segnatura
Vatican Museums, Vatican City

On the north wall, beneath Poetry, poets gather around Apollo and the Muses on Mount Parnassus (fig. 38). To the east, beneath Philosophy, Greek philosophers and sages discuss their theories surrounded by their pupils (the *School of Athens*, fig. 37). To the south, beneath Jurisprudence (who appears in the guise of Justice), are the three other cardinal virtues also essential to the exercise of this discipline: Fortitude, Prudence and Temperance (fig. 39). Below these are two historical episodes illustrating the establishment of codes of law: *Tribonian presenting the Pandects to the Emperor Justinian* and *Gregory IX approving the Decretals*. While the distribution of subjects and choice of protagonists were surely devised by someone at the papal court, it is clear that Raphael developed their visual expression in a highly personal fashion.

The two main frescoes, the *Disputa* and the *School of Athens*, mark an extraordinary watershed in Raphael's artistic development. Working on a scale he had never previously attempted and in a medium of which he had only limited experience, he succeeded in bringing to life abstract subjects of a complexity and scope far beyond his previous range. The selection of his drawings for the

Disputa included in this exhibition (cats 78–86) show the inventiveness and ingenuity with which he developed the overall composition and the individual figures and groups, combining the threads of all he had learned in Florence. In this dazzling fresco, the risen Christ displays his wounds, blessed by the figure of God the Father above. The dove of the Holy Spirit soars downwards, linking Christ's gleaming white body with its miraculous manifestation on earth in the form of the host, the subject of the theologians' wonder and discussion. This central axis, animated by a series of descending spheres, is balanced by the bold horizontal organisation of the heavenly and earthly companies. The saints and prophets seated in a semi-circle around the Trinity recall in their arrangement Fra Bartolommeo's *Last Judgement* in S. Maria Nuova and Raphael's own fresco at S. Severo, but here the figures are enlivened by a remarkable variety of pose, characterisation and costume, as exemplified by the semi-naked Adam's startlingly informal posture as he turns to listen to Saint Peter (see fig. 125). The platform-like floor harks back to methods of organisation learned from Perugino (and seen for example in his *Consignment of the Keys to Saint Peter* in the Sistine Chapel),

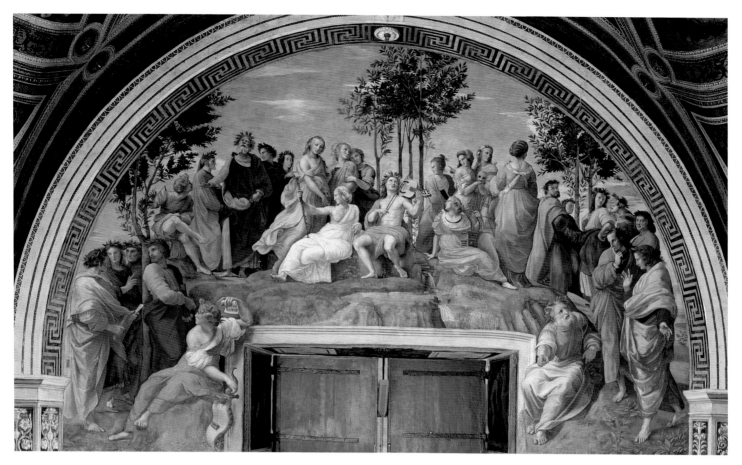

fig. 38 **Parnassus**, about 1510–11
Fresco, width at base 670 cm
Stanza della Segnatura
Vatican Museums, Vatican City

but Raphael's solutions are here far more spatially sophisticated and daring. Lifelike figures in the foreground apparently lean into the real space of the room over balustrades introduced as cunning devices to conceal the intrusion of the door-frame into the picture space. The monumental figures and their splendidly rendered draperies owe much to Leonardo as well as Fra Bartolommeo, the former also inspiring the variety and animation of the characters while the latter's drawings provided inspiration for the distant landscape with its buildings supported by scaffolding and signature haystack. The influence of both artists is also particularly evident in the soft stumped chiaroscuro of some of Raphael's drawings for figures in the upper register for this fresco (cats 78–9, 86), which can be compared, for example, with Fra Bartolommeo's drawings for the *Last Judgement* (fig. 107). Raphael combined all these influences to achieve a new grand style that was demonstrably his own, and particularly fitted to Julius's propagandistic purposes. The beautiful, idealised figure of the young man in yellow and blue on the left of the *Disputa* gesturing gracefully towards the host, and the more humorous characterisation of the figures peering over the shoulders of the sage

behind him, are examples of his broad dramatic range and humanising touch (see fig. 35).

On the opposite wall of the Stanza is a scene of even more breathtaking audacity and assuredness, the so-called *School of Athens*, the rational equivalent of the theological debate represented in the *Disputa*, with Plato and Aristotle surrounded by other ancient sages seeking truth by philosophical enquiry.[217] The architecture in this fresco has a new and impressive grandeur. The perspectival foreshortenings of the coffered barrel-vaulted ceilings, the colossal white marble statues peeping out of disappearing niches, and the patterned floor receding behind the central figures, spring from the Florentine tradition of single-point perspective dating back to Masaccio, but its heroic classical vocabulary was no doubt inspired by Bramante and by surviving examples of ancient Roman architecture such as the Pantheon. Just as impressive as the architecture is the extraordinary cast of characters debating different philosophical propositions in beautifully arranged groups, or meditating alone. Leonardo's observation of nature and Perugino's grace are subsumed in the fresco into a powerful new rhetoric of gesture and expression

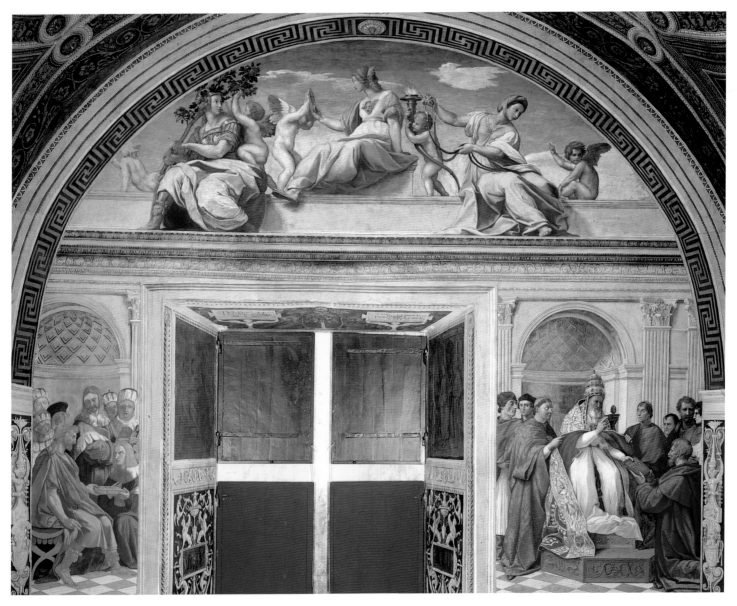

fig. 39 **The Jurisprudence Wall**, 1511
Fresco, width at base 660 cm
Stanza della Segnatura
Vatican Museums, Vatican City

that was so effective in terms of conveying a believable narrative that it was to become the academic standard for centuries to come. It may well have been the unprecedented ambition of the *School of Athens*, in which Raphael revealed his 'determination to hold the field, without rival, against all who wielded the brush', which caused Julius to give Raphael sole control of his decorative project.[218]

Vasari believed that the *School of Athens* was the first wall to be painted in the Stanza della Segnatura, and he attributed Raphael's success in Rome to this masterpiece. Nesselrath has now marshalled technical evidence in support of Vasari's chronology (pp. 284–8),[219] but ever since Giovan Pietro Bellori reversed Vasari's sequence in 1695, most modern studies have concluded that the *Disputa* preceded the *School of Athens*, a conclusion shared by the authors of this essay.

The clear stylistic continuities between the *Disputa* and Raphael's numerous designs for it (e.g. cats 78–86), as well as the artist's recent works in Umbria and Florence, make it extremely problematic to argue for the chronological precedence of the *School of Athens*, even if, as is demonstrably the case, both compositions were worked on in very close succession. The ethereal quality of the figures in the *Disputa* harks back to characterisation learned from Perugino. In addition, the flesh tones in the faces in this fresco are thin and greenish (as they are in the roundels of the ceiling), while in the *School of Athens* these areas are blended with heavily laden brushstrokes in a much more sophisticated way, which compares much more closely with the last wall to be painted in the room (the Jurisprudence wall, and especially the three Virtues in the upper part).

On the two short walls Raphael had to contend with the added challenge of large windows piercing the picture fields. This he overcame on the *Parnassus* wall by using the bay of the window to support the crest of Mount Parnassus (the window overlooks the Vatican hill which had been sacred to Apollo in antiquity, and was chosen as the site of Julius's outstanding collection of antique sculpture), again employing the device of figures leaning forward beyond the fictive moulding of the window frame to give a sense of depth and also connection between the real and painted worlds.[220] Despite the absence of architecture, the composition is beautifully organised around the central group of Apollo and the nine graceful Muses. Raphael integrated telling likenesses of his contemporaries, such as the bold portrait of Lodovico Ariosto with his finger pressed to his lips, with imaginary portraits of the ancient poets and conventional effigies of the great medieval triumvirate Dante, Petrarch and Boccaccio. The Muses with their voluptuous forms and softly undulating drapery contrast with the three magnificent female Virtues in the lunette above the window on the opposite wall. The lunette and the frescoes with the historical scenes below constitute a last-minute change to the original programme, which was to have included the beardless Pope kneeling before an apocalyptic vision of the Opening of the Seventh Seal being witnessed and recorded by Saint John on Patmos.[221] The change may have been made after the Pope's return from his campaigns in the Romagna in June 1511, by which time he had grown a beard as a symbol of mortification (and with which he appears in the guise of an earlier pope in *Gregory IX approving the Decretals*).[222] The magnificent Virtues are on a monumental scale beyond anything else in the Segnatura (and a far cry from the female personifications of the library's faculties on the ceiling). The winged putti cavorting about the parapet and assisting the Virtues are virtual hallmarks of Raphael – similar playful touches lend light relief to even his most solemn Roman altarpieces.

The revolution Raphael effected in the Stanza della Segnatura frescoes is astounding. The challenges and resources offered by this supremely important project commissioned by the wealthiest and most powerful of patrons, the erudite environment of the papal court, and the competitive rivalry that naturally existed among so many talents working alongside each other evidently stimulated in Raphael a desire to surpass all others.[223] Vasari described the artist's development in his early years in Rome as his most extreme transformation to date, and he attributed his grander and more majestic style to the study of antiquity and the Roman works of Michelangelo.[224] While Raphael had shown an occasional interest in ancient Roman art in his earlier work (e.g cats 34, 68–73), he devoted himself with increasing assiduity to the study of the antique after settling in Rome. His enthusiasm for classical sculpture emerges in the moving depiction of the blind Homer in the *Parnassus*, which was inspired by the *Laocoön* group discovered in Rome in 1506 and subsequently placed in Julius's sculpture garden in the Vatican, as well as in numerous drawings.[225] His mature classicism is especially evident in his later career under the papacy of Leo X, when he reported on the state of the antiquities of Rome in a letter to the Pope, and famously began to map the ancient city.[226]

Raphael's evolving style, as Vasari noted, was also in part the result of renewed exposure to Michelangelo who had preceded Raphael to Rome, and in May 1508 had embarked upon painting the ceiling of the Sistine Chapel.[227] The first half of the ceiling was unveiled in August 1511, the whole being completed by October of the following year. With the exception of the monumental figure of Heraclitus, known as 'the Thinker', cut into the plaster of the *School of Athens* after the fresco's completion, there is little reflection in Raphael's work on the first three walls of the Stanza della Segnatura of the strikingly monumental sculptural forms and brilliant colours of Michelangelo's ceiling, which might suggest that he was not able to see Michelangelo's work until the unveiling of the first half. According to Vasari, however, Bramante let Raphael into the Sistine Chapel during one of Michelangelo's absences from the city 'and showed him Michelangelo's methods (*modi*) so that he might understand them'.[228] Whatever the truth of this anecdote, the impact of the latter's powerful new figure style was immediately evident in Raphael's projects from around 1511–12, including the *Isaiah* in S. Agostino (fig. 40), and the frescoes in S. Maria della Pace (fig. 42) and the Stanza di Eliodoro.[229] Whether Raphael went so far as to repaint the *Isaiah*, commissioned by the apostolic protonotary Johann Goritz, from scratch after he had seen the Sistine figures, as Vasari suggests, can be doubted. Raphael would have seen the Sistine frescoes well before July 1512 when the *Isaiah* was apparently completed. In the muscularity and monumentality of the figure, Raphael pushed his figure style as far as was possible towards the promethean grandeur of Michelangelo (only the garlanded putti retain something of his innate sweetness and charm). The impact of Michelangelo's work in Rome was as vital to Raphael's stylistic evolution as it had been in Florence, but there was a danger of going too far in a direction that did not come naturally to him, and Raphael's most successful Roman works are those in which his own flair for graceful design, easily legible narrative, exquisitely judged colouring, and animated characterisation are not overly dominated by any one style or influence.

Important for Raphael in this context was the presence in Rome of several Venetian painters who brought with them a more painterly approach to the depiction of both landscape and the human form (including portraiture). His easel *Portrait of Pope Julius II* (cat. 99) is among the first works to reflect his appreciation of paint as a substance in itself rather than as a means of description. The freedom of his brushwork in this portrait, and the way in which paint is manipulated to suggest textures, is unlike anything that had gone before. The heavy red velvet of the Pope's cap and *mozzetta* is worked with broad strokes, while the white fur linings are depicted with

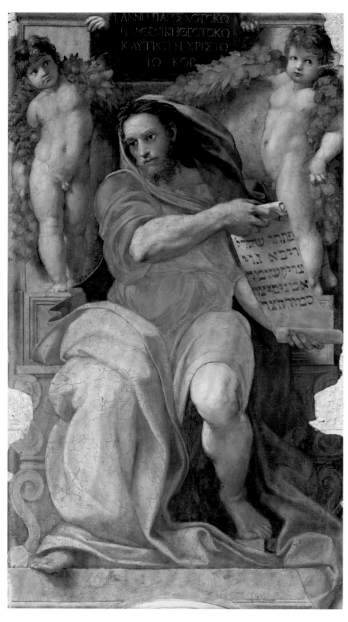

fig. 40 **The Prophet Isaiah**, about 1511–12
Fresco, 250 × 155 cm
S. Agostino, Rome

short flicks of paint made across the long strokes of stiff lead white that sweep round their edges. Similarly, the hairs of Julius's beard and the tufts of fur trapped by the buttons are no longer painted as fine individual hairs. In the gold threads of the tassels of the throne, Raphael particularly relished the raised, slightly clotted quality of lead tin yellow in oil. At a later date textures such as this and the rippling pleats of soft white fabric impressed even Titian, who not only made a copy of Raphael's painting, but introduced a similar waterfall of folds into his *Portrait of Pope Sixtus IV* (Uffizi, Florence)

– though in turn one wonders whether Raphael had not had the opportunity to see works by the young Titian, which may have reached Rome at around this time. The extraordinary rendering of texture in the layers of fabric in the sitter's sleeve in Raphael's portrait known as *La Velata* (cat . 101), as well as softer, more palpable flesh, are also due to Raphael's new awareness of Venetian innovations in portraiture.

The most likely inspiration for this new style was Sebastiano Luciani (later known as del Piombo, *c.*1485–1547), arguably the most daring of all the young Venetian painters in Giorgione's circle in terms of the handling of oil paint, who was brought from Venice to Rome by Agostino Chigi in August 1511 (exactly the moment at which Raphael must have begun his portrait of Julius). Sebastiano may well have brought some completed paintings with him, and Raphael probably sought him out and studied his work as soon as he arrived. Certainly by the following year, the two artists were working side by side in Chigi's urban villa (now known as the Farnesina). The possibility that their initial contact was friendly has frequently been overlooked because of the intensity of their later rivalry (just as we have seen that the contact between Raphael and Michelangelo in Florence does not seem to have been as fraught as the later correspondence of Michelangelo would suggest it became).[230] Even the technique of the *Portrait of Julius* suggests familiarity with the innovations of Sebastiano. Raphael did not prepare the surface with his usual creamy-white priming, but applied instead a light brownish-grey priming which is very similar in composition to those found on some of Sebastiano's Roman panels. These more tinted primings seem still to have been relatively novel even in Northern Italy, and Sebastiano, always an experimental painter, is likely to have been among the first to use them.[231]

Raphael's success in Rome was in part due to his ability to continue to satisfy the Pope, while still managing to work for other important patrons, 'whom it was not in his interest to decline'.[232] His early Roman activity included the painting of altarpieces (discussed below, pp. 280–93), frescoes (including figs 40–2), as well as portraits and Madonnas. He was able to cope with the volume of work by increasingly taking on assistants to help him meet deadlines, and the nature of his method (learned above all from Perugino) whereby, from initial sketches and preparatory studies, he produced finished cartoons that could be transferred mechanically to the wall or panel, was eminently suitable for delegation. Raphael had always thrived in the company of other artists and befriended many whom he subsequently persuaded to work with or for him, and this was more than ever the case in Rome.[233] As the pressure of work mounted, particularly following the increase in his reputation as a result of his work in the Segnatura, Raphael ceased to work alongside others, but began to employ them in the execution of his own designs. Lorenzo Lotto, who had already been working in the Stanze at the time of Raphael's arrival, completed

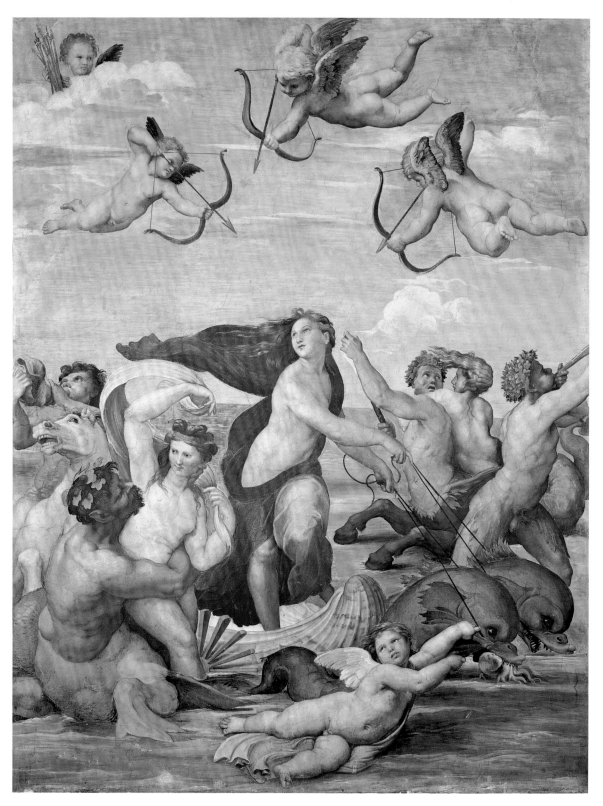

fig. 41 **Galatea**, about 1512–14
Fresco, 295 × 225 cm
Palazzo della Farnesina, Rome

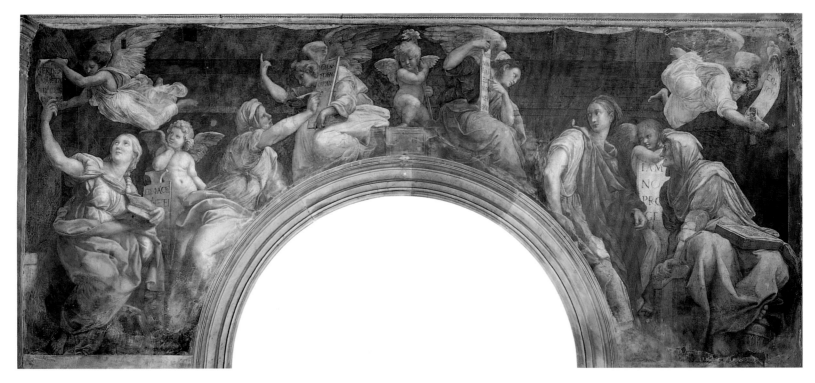

fig. 42 **Sibyls**, 1511–13
Fresco, width at base 615 cm
Chigi Chapel, S. Maria della Pace, Rome

a discrete scene on the south wall of the Segnatura, namely *Tribonian presenting the Pandects to the Emperor Justinian*,[234] and was subsequently put to work in the Stanza di Eliodoro. Numerous other artists were employed on later decorations in the Vatican, as Raphael established a highly organised and productive workshop.[235] This emergence of Raphael as the undisputed master painter at the Vatican coincides with his appointment to the office of *Scriptor Brevium*, an official sinecure bestowed by Pope Julius on 'our dear son Raphael' in October 1511, 'in order that he may be maintained more fitly'.[236]

Chief among the patrons Raphael could not refuse was the Sienese banker Agostino Chigi (1465–1520). His estimated income in 1509 was in excess of 70,000 ducats, and he was confirmed as the Treasurer of the Papal States in 1510.[237] In 1506 he had commissioned Peruzzi to build him a classically inspired villa on the banks of the Tiber in Rome, which became the location for lavish entertaining (parrots' tongues featured on his menus) and *all'antica* theatrical extravaganzas. Once construction of the villa was completed, Chigi turned to its decoration, employing Peruzzi (and later Sodoma) from his native Siena, as well as Raphael and Sebastiano. Raphael's *Galatea* (fig. 41) was probably painted in 1512 and represents a story in part derived from Poliziano's *Giostra* (Lodovico Dolce went so far as to claim that it 'competed with the beautiful poetry of Poliziano').[238] This was Raphael's first opportunity to paint a mythological subject and to conjure up the world of antiquity in paint. Like other works of this period (including the *Massacre of the Innocents*, cat. 89), the fresco is almost a manifesto of his new style, combining the strong treatment of the male and female

nude that he had added to his repertoire with the painterly skills and *dolcezza* (sweetness) that seemed to be innate features of his art.

The fresco in the Farnesina was not Raphael's first work for the papal banker.[239] He had also decorated Chigi's chapel in S. Maria della Pace with a fresco depicting four Sibyls accompanied by angels (fig. 42). The fresco is usually dated 1512–14, but new evidence suggests that the design of the chapel was well advanced by the end of 1510,[240] leading to the conclusion that the frescoes may well have been executed in 1511. This dating is borne out by parallels between the Sibyls and the cardinal virtues on the Jurisprudence wall of the Stanza della Segnatura and clear links between the drawings for the Pace commission and the Segnatura frescoes. Other circumstances support this conclusion, for the Pope was absent from Rome during much of the period 1510–11 and could not keep an eye on his painters, while Timoteo Viti, whom Vasari credits with the execution of the Prophets above Raphael's Sibyls, was apparently absent from Urbino from November 1510 to July 1511.[241] If this revised dating could be proved, it might finally demonstrate that Raphael had seen the Sistine ceiling before it was unveiled, for in their monumentality and colouring, the Sibyls clearly betray the impact of those painted by Michelangelo.

Raphael's drawings for an unexecuted altarpiece showing the Resurrection of Christ, which was designed to stand on an altar beneath these frescoes in S. Maria della Pace, also show Michelangelo's influence. The *Three guards* in the Devonshire Collection, Chatsworth (fig. 43), and other drawings for this commission show how Raphael, inspired by Michelangelo, had begun to make drawings from the

male nude in dramatic poses and, like him, had turned to soft black chalk as a means to study the play of light and shadow across the musculature (although both artists also used red chalk for similar purposes).

While these drawings (and monumental works such as the *Isaiah* and the S. Maria della Pace frescoes) reveal Raphael's response to Michelangelo's grandeur, the younger artist was also able to channel some of Michelangelo's strong sense of design into his more intimate compositions such as the *Alba Madonna* and the *Madonna della Sedia* (fig. 44). The newly restored *Alba Madonna* of around 1509–10 is in the same category of large-scale luxury pictures for private devotion as the Florentine Madonnas discussed on pp. 40–3.[242] Here, the Madonna is shown seated on the ground and with much greater informality than hitherto. She leans against a curious petrified tree stump, which may have some symbolic significance now lost to us. Her pose, with one leg outstretched, and the drapery spiralling down her shoulder, are reminiscent of Leonardo, while the vigour with which Raphael studied the pose from a *garzone* model in a red-chalk sketch (cat. 94) bears the hallmark of Michelangelo's influence (the finished figure has a much greater sense of corporeality than his early, more ethereal Virgins). The Christ Child's pose, propping himself up with his left arm on his mother's belly and with one leg raised, is akin to the Child's pose in the *Garvagh Madonna* of the same period (cat. 91) and may conceivably reflect an idea borrowed from classical sculpture as well as study from life. Raphael subtly interweaves all these different

sources of inspiration into an image of great tenderness, in which both the Virgin and her Child simultaneously embrace and recoil from the reed cross proffered by the sweet figure of Saint John the Baptist. The subtlety of Raphael's colouring is all the more evident following the recent cleaning and, like the palette of the *Garvagh Madonna*, is quite distinct from the richer more saturated hues of his Umbrian and Florentine works. The soft blue of the Virgin's robe, her rose-coloured dress and white undershirt are echoed in the background and in the wild flowers that surround the figures, tying the figures into the beautiful verdant landscape. The *Madonna della Sedia* (fig. 44) is surely Raphael's most resolved answer to the problem of designing circular compositions.[243] It demonstrates his intuitive sympathy for the relationship between mother and child, his instinctive engagement with feminine subjects (the model for his Madonna may have been someone he knew well), and his pleasure in rendering the softness of flesh and the rich textures of material things. His sensibility to colour was never subservient to the demands of design, and this picture, with its links to the *Garvagh Madonna* (in the figure of Saint John), to the Julius portrait (in the seated pose), and to *La Velata* (in its sensuous response to a female model), sums up Raphael's individuality and is the clearest statement of his fundamental independence.

Raphael's meteoric rise to fame in the course of the dozen or so years covered by this exhibition was the result of a unique combination of natural genius and a rare capacity for growth and development through the study of nature and the works of other

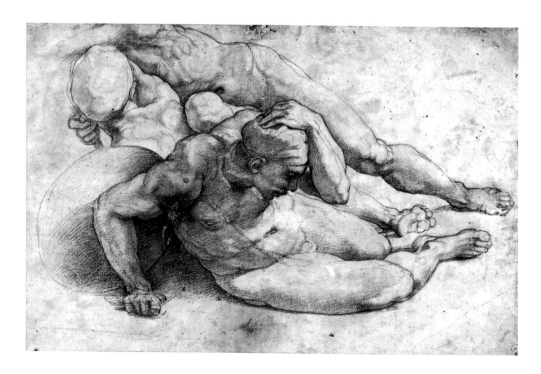

fig. 43 **Three guards**, about 1511–12
Black chalk, 23.4 × 36.5 cm
Devonshire Collection, Chatsworth, 20

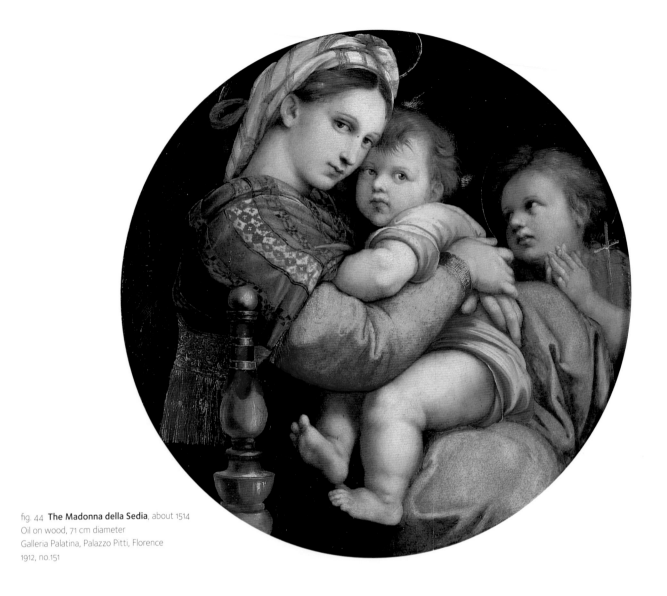

fig. 44 **The Madonna della Sedia**, about 1514
Oil on wood, 71 cm diameter
Galleria Palatina, Palazzo Pitti, Florence
1912, no.151

artists. He was exceptionally receptive to new ideas, assimilating forms and techniques with great versatility into his own personal style, which was characterised by a remarkable clarity and grace. His career was driven at every stage by a powerful determination not only to succeed but also to surpass even the most celebrated of his role models. Accustomed from youth to the court culture of Urbino, he flourished at the papal court under the enlightened patronage of two successive popes. His transformation of the revolutionary innovations of Perugino, Leonardo and Michelangelo into a less idiosyncratic and more intelligible classical style explains how it was he and not they to whom academic tradition subsequently bowed as the epitome of stylistic perfection (a factor which has also counted against modern appreciation of his art), and his influence was paramount for generations of artists, from Correggio to Rubens, Velázquez to Delacroix, and from Renoir to Picasso. Raphael also

pioneered a new more human approach to devotional subjects and the unprecedented tenderness and sensitivity of his Madonna and Child groups have guaranteed their enduring popularity. Even when conveying the most complex theological themes, he was always concerned to delight the viewer by the inclusion of diverting or sensuous elements, alongside the more serious task of serving the didactic and pious requirements of his patrons. His many insightful portraits of these patrons and friends demonstrate his psychological acuity and are frequently laced with affectionate humour. Above all, however, Raphael's reputation rests on his outstanding natural talent as a designer, draughtsman and painter, which was immediately recognised wherever he went and mourned as a loss to the world at the time of his premature death. The catalogue of drawings and paintings that follows demonstrates better than any words the story of this remarkable journey.

We are particularly grateful to Jill Dunkerton for her extensive contributions to this essay on Raphael's technique.

For ease of reference we have consistently referred to John Shearman's recently published compendium of documents and sources: *Raphael in Early Modern Sources (1483–1602)*, London and New Haven 2003 (Shearman 2003), and to Paul Joannides, *The Drawings of Raphael with a Complete Catalogue*, Los Angeles and Oxford 1983 (Joannides 1983).

1 Shearman 2003, pp. 73–5.
2 Shearman 2003, pp. 619–20 (15 October 1520 Sebastiano to Michelangelo): '*Sua Santità me disse più: "Guarda l'opere de Rafaelo, che come vide le hopere de Michelagniolo, subito lassò la maniera del Perosino et quanto più poteva si acostava a quella de Michelagnolo. . ."*'. ibid., pp. 928–9 (24 October 1542, Michelangelo to an unidentified Monsignore): '*Tutte le discordie che nacquono tra papa Julio e me fu la invidia di Bramante e di Raffaello da Urbino; e questa fu causa che non e' seguitò la sua sepultura in vita sua, per rovinarmi. Et avevane bene cagione Raffaello, ché ciò che haveva dell'arte, l'aveva da me.*' Condivi also reported Michelangelo's opinion (ibid., pp. 1029–30): '*[Michelangelo] ha sempre lodato universalmente tutti, etiam Raffaello da Urbino, infra il quale e lui già fu qualche contesa nella pittura, come ho scritto. Solamente gli ho sentito dire che Raffaello non ebe quest'arte da natura, ma per lungo studio.*' See also Sellaio's letter to Michelangelo (1 January 1519), ibid., pp. 365–6.
3 Vasari/BB, IV, p. 204.
4 Berenson 1897, p. 113, characterised this process as follows: 'Ever ready to learn, Raphael passed from influence to influence. At whose feet did he not sit? Timoteo Viti's, Perugino's, and Pintoricchio's, Michelangelo's, Leonardo's and Fra Bartolommeo's, and finally Sebastiano del Piombo's.' A similar observation is found in Crowe and Cavalcaselle 1882–5, I, pp. 4–5: 'Between Urbino and Rome, the poles of his existence, [Raphael] wandered with but one apparent purpose in life, the purpose – diligently pursued and never abandoned – of studying everything that had been done by others before him, of assimilating the good and eliminating the bad amongst the numerous examples which had come within his ken. . . . he studied one after another, nature, the antique, and the Tuscan, and when he finally broke the fetters of Umbrian tradition, not a single one of the craftsmen then living would have said that he copied any of them.'
5 The exact date has not been determined and is variously given as 28–29 March or 6–7 April. Vasari states that he was born on Good Friday, which was 28 March 1483; see Shearman 2003, pp. 45–50.
6 Ibid., pp. 52, 60.
7 Henry 1999, pp. 223–6; Shearman 2003, pp. 53–61.
8 For the few references to Raphael in documents made in Urbino in the late 1490s, see Shearman 2003, pp. 53–71.
9 Vasari's *Lives* were published in two editions in 1550 and 1568. We have referred to Paola Barocchi and Rosanna Bettarini's comparative edition (cited here as Vasari/BB; the Raphael *Life* is found in vol. IV, pp. 155–214). Unless otherwise stated we have quoted from the

1568 edition, and translations are usually from the de Vere/Everyman edition (ed. D. Ekserdjian, London, 1996; the Raphael *Life* is vol. I, pp. 710–48).
10 For Vasari's reference to Raphael's styles see Vasari/BB, IV, pp. 204–7. The use of the plural is unique in the *Lives*.
11 Rubin 1995, pp. 357–401; Butler 2002, pp. 22–38.
12 Vasari/BB, IV, p. 207 (1568 only): '*Ho voluto . . . fare questo discorso, per mostrare con quanta fatica, studio e diligenza si governasse sempre mai questo onorato artefice, e particolarmente per utile degli altri pittori, acciò si sappiano difendere da quelli impedimenti dai quali seppe la prudenza e virtù di Raffaello defendersi.*'
13 Good Friday is *venerdì santo* in Italian and Vasari makes much play on the sanctity of Raphael's surname, Santi. This is the first of a number of Christological parallels that recur throughout the *Life*.
14 '*ancor fanciullo*'/*fanciulletto*', Vasari/BB, IV, p. 157. In the *Life* of Perugino Vasari stated that Raphael worked for '*molti anni . . . con Pietro in compagnia di Giovanni de' Santi, suo padre*' (Vasari/BB, III, pp. 611–12). The emphasis on working with Perugino has been reasonably related to the older artists' activity at Fano, discussed below, and it is perfectly plausible that Raphael and Perugino met at this time.
15 This scepticism began as a result of Pungileoni's discovery that Giovanni Santi died in 1494 (Pungileoni 1822, pp. 133–7).
16 Mantegna had completed his training and was established as an independent master by the age of sixteen, see Christiansen in ed. Martineau 1992, p. 99.
17 Rubin 1995, p. 382.
18 For example the standing child in fig. 3 which probably derives from Perugino's Fano altarpiece. For Perugino's altarpiece (commissioned in 1488 and dated 1497) see Scarpellini 1984, cats 71–3. There has been some debate over the direction of influence, but we share the view that this motif originated with Perugino and was subsequently adopted by Santi.
19 '*un divin pittore*', see ed. Michelini Tocci 1985, vol. II, p. 674 (discussed below).
20 The attribution to Raphael of cats 10 (an altarpiece which is signed by Perugino) and 7 is typical of the way that Raphael's hand has been sought in Perugino's best works of the period about 1495–1504. In recent years the cornerstone of these arguments has been the attribution to Raphael of the Fano predella and related drawings in the Uffizi (366E and 368E, Ferino Pagden 1982, nos 47–8). The drawings have been attributed to Perugino by Ferino Pagden and Scarpellini, while Russell, Joannides and Turner favour an attribution to Raphael (see Ferino Pagden 1983, pp. 87–8, Scarpellini 1984, p. 92, Joannides 1983, nos 1 and 2, Turner 1983, pp. 118–20, and idem. 2000, p. 18). The curators of this exhibition studied the drawings together in June 2003, and could see no reason why they should not be by Perugino. For the attribution of the painted predella to Raphael, see Longhi 1955, p. 14, Gregori 1987 and Perugia 2004, pp. 314–15, 362–4.
21 For the many references to pupils such as Lo Spagna, Rocco Zoppo and Giovanni Ciambella 'Fantasia', see Coonin 1999, pp. 100–5, and the copious documentation in Canuti 1931.
22 Condivi 1553 (Shearman 2003, p. 1029): '*Raffael da Urbino, quantunque volesse concorrer con Michelagnolo, più volte hebbe a dire che*

ringraziava Iddio d'esser nato al suo tempo, havendo ritratta da lui altra maniera di quella che dal padre, che dipintor fu, e dal Perugino suo maestro, havea imparata.'
23 Shearman 2003, pp. 150–2: '*Raphaeli, Johannis de Urbino scolari*'.
24 Shearman 2003, pp. 71–3.
25 Evangelista was in Urbino on 29 and 30 March 1501 see Henry 2002, p. 278, with reference to Alippi 1891, pp. 51–3. Interestingly, both the Baronci altarpiece and the *Sposalizio*, also for Città di Castello, had a layer of canvas glued to the panel before application of the gesso, by this date a relatively rare practice and one that might suggest that the panels were prepared for painting by the same craftsman (not necessarily a member of the painter's workshop). If the panels were constructed and prepared for painting in their place of destination, then they were probably also painted there (a conclusion which also follows from their size).
26 Shearman 2003, pp. 71–3. In other cases it has been observed that the list of places where a contract could be enforced followed local practice, but this is not the case here and Perugia would surely have been mentioned if either of the contracting parties expected this clause to be called upon in that city. This acts as a corrective to Vasari's claim (Vasari/BB, IV, p. 158) that Raphael came to Città di Castello from Perugia.
27 Similar traits are evident in the banner for Città di Castello where the solid opaque flesh painting is to some extent the result of the relatively straightforward and direct – almost *alla prima* – technique usually employed when painting canvas banners (in this instance almost certainly in oil, a medium that had been used in Italy for canvases for the past half century). A similar opacity is apparent on Santi's canvases of *Tobias and the Angel* and *Saint Roch* (Urbino, Galleria Nazionale), perhaps also once a banner.
28 Butler 2004.
29 See cats 18, 19 and 25 and the further discussion of Joannides 1987 and Butler 2004.
30 Giovanni Santi's will of July 1494 makes no reference to his workshop (probably considered part of his '*bonis, mobilibus et immobilibus*' which passed jointly to Raphael and Don Bartolomeo, and presumed to have been in the house where he lived, now the Casa di Raffaello) or any provision for its continuation or disposal, but as his legal heir and as a painter, it is likely to have passed to Raphael, see Henry 1999 and Shearman 2003, pp. 53–60. The fact that Raphael asked Simone Ciarla to ensure that Bartolomeo send a panel to Florence on Raphael's behalf might indicate that this uncle managed the shop in Raphael's absence; see Shearman 2003, pp. 112–18.
31 Varese 1994, pp. 172–3, and Fontana 1981, pp. 79–82. Benazzi (forthcoming) publishes another Santesque work in Gubbio as an early work by Raphael.
32 For the inconclusive bibliography regarding Evangelista, see Bombe 1915, pp. 96–7.
33 Morelli 1882, pp. 147–78.
34 See Pungileoni 1835, and Ferino Pagden 1979, pp. 127–43. The extremely Signorellesque character of Viti's drawings is striking, and he is known to have owned drawings by the Cortonese master (see Van Cleave 1995, and Forlani Tempesti and Calegari 2001, pp. 2–4).

This is usually explained with reference to Viti's later collaboration with Genga, but might have resulted from direct contact.
35 Genga's friendship with Raphael was traced to Perugino's workshop by Vasari (Vasari/BB, V, p. 347: '*e fu nel medesimo tempo che con il detto Pietro stava il divino Raffaello da Urbino*'), who knew Genga and his family personally. For a discussion of Genga's origins and his training with Signorelli and Perugino, see Fontana 1981, pp. 164–8, and Kanter 2004.
36 For Viti's collaborations with Genga, with Raphael at S. Maria della Pace, and later with Evangelista, see Ferino Pagden 1979, pp. 127–43, Vasari/BB, IV, p. 267, and Pungileoni 1835, p. 107.
37 Calzini 1912, pp. 11–17. This raises the interesting possibility that Raphael might have accompanied his father to Mantua and could perhaps have met Mantegna.
38 '*pittore non molto eccellente, ma sì bene uomo di buono ingegno et atto a indirizzare i figliuoli per quella buona via*', Vasari/BB, IV, p. 156.
39 Varese 1994; ed. Varese 1999.
40 For the Tiranni Chapel see Varese 1994, pp. 235–7, and Butler 2002, pp. 45–6.
41 Varese 1994, pp. 16–18 and 22: *Love at the Trial of Modesty* was a masque held in honour of the arrival in Urbino of Federico of Aragon in 1474, and the *Contest between Juno and Diana* was part of the wedding festivities to mark the marriage of Guidobaldo della Rovere and Elisabetta Gonzaga in 1488.
42 Vatican Library, Codice Vat. Ottob. Lat 1305 (published by Michelini Tocci 1985). This poem is frequently discussed, e.g. by Varese 1994, pp. 16, 29–57.
43 Vasari/BB, IV, p. 157: '*volle . . . che piuttosto ne' teneri anni apparasse in casa i costumi paterni.*'
44 Raphael's visual intelligence is discussed by Ferino Pagden 1986a. We cannot agree with Becherucci 1968, p. 12, that Raphael had no school education. See also the observations of Vasari/BB, IV, pp. 179–80, and Dolce 1557 (Shearman 2003, p. 1064).
45 Castiglione 2002, pp. 45, 58, 126–7.
46 For the portrait of Castiglione in the Louvre, Paris, about 1514–5, see Dussler 1971, pp. 33–4.
47 Luigi Ciocca's letter to Isabella d'Este (24 April 1505) draws out the contrast of Perugino working for these different environments: '*non haveva a fare con spoletini o marchi[gi]ani, ma con una Marchesana di Mantua*' (Canuti 1931, II, p. 233).
48 Santi (see ed. Michelini Tocci 1985, II, pp. 672–4) discusses 12 Florentine, 2 Tuscan, 4 Venetian, 1 Marchigian, 1 Umbrian, 5 North Italian and 2 Netherlandish artists.
49 This is further discussed by Joannides 1987, Dalli Regoli 1999 and Butler 2002.
50 Vasari/BB, IV, pp. 8–9 (1550 and 1568): '*studiando le fatiche de' maestri vecchi e quelle de' moderni prese da tutti il meglio, e fattone raccolta, arrichì l'arte della pittura di quella intera perfezzione che ebbero anticamente le figure d'Apelle e di Zeusi.*' For an even earlier application of this comparison to Raphael, see the famous '*Signore Conte*' letter, discussed by Shearman 2003, pp. 734–41. As seen above (note 2) this quality has also been turned against Raphael by his critics.
51 See Henry 2002, pp. 268, 270, with reference to the connections between Baronci, Raphael and Signorelli (as well as between Raphael's other patrons in Città di Castello).

52 Ibid. pp. 270–5. Albizzini was a notary as well as a merchant.

53 The origins of the contact between the two artists can probably be traced to Urbino and hence to Giovanni Santi (see Henry 1999, pp. 223–6), although the new evidence that Genga was part of Signorelli's shop by the summer of 1499 opens up an alternative means of contact between Signorelli and Raphael (see Henry 2004, foreshadowed in Kanter 2004, and the earlier comments of Gilbert 1986, pp. 109–10).

54 Pungileoni 1829, pp. 13–15.

55 'Luca de ingegno e spirito pellegrino.' For an analysis of this phrase – so suggestive of an intelligence that Raphael shared – see Henry 2002a, pp. 175–83. For connections between the double-sided banner that Signorelli painted for the confraternity of the Holy Spirit in Urbino in 1494 and the Mond Crucifixion, see Crowe and Cavalcaselle 1882–5, I, p. 133. This connection was investigated further by Gilbert 1986, pp. 109–10.

56 Raphael's interest in the Signorellesque motif of a muscular figure seen from the rear is also evident in several other early drawings (Joannides 1983, nos 3v, 6v, 7r). Crowe and Cavalcaselle (1882–5, I, p. 68) characterise Raphael's drawings after Signorelli as 'impressed with the general features of Signorelli's style [but] tempered in their ruggedness and strength by something mild that modifies the asperity of the master'.

57 Raphael sketched two figures from Signorelli's Destruction of the World at Orvieto on the verso of a drawing in Florence (Joannides 1983, no. 57v). The Siege of Perugia, Paris (Joannides 1983, no. 93r), and related drawings (Joannides 1983, nos 108v and 185) include variations on the figure who is seen from behind on the right of Signorelli's fresco of the Torments of the Damned, also at Orvieto. These connections were noticed by Vischer 1879, pp. 334–5, and discussed by Gronau 1902, pp. 46–8. Signorelli's Carrying of Christ in the Chapel of Saints Faustino and Pietro Parenzo at Orvieto also played a part in Raphael's solution for the Baglioni Entombment (fig. 34) – see p. 215, Gilbert 1986, pp. 109–24, and Rosenberg, 1986, pp. 175–87. Raphael still seemed to have Signorelli's frescoes at Orvieto in mind when working in the Vatican Stanze.

58 Henry 1993, pp. 612–19. Bambach 1992, pp. 9–30 (repeated in Bambach 1999, p. 475, n. 33), connects the pricked head on this drawing with a design by Raphael. The visual evidence that it was preparatory to Signorelli's fresco at Orvieto (Henry loc. cit.) is, however, very difficult to ignore.

59 Joannides 1983, no. 58r, pl. 9.

60 See Henry and Kanter 2002, pp. 39–45, 124–32.

61 Derivations from Signorelli's frescoes at Monteoliveto can be found in the Venice Libretto (fols 4v and 9v) which has been attributed to Domenico Alfani and is widely held to derive from copy drawings made by Raphael before 1509; see Ferino Pagden 1984. The Libretto contains other evidence of Raphael's interest in Signorelli, including copies after a Massacre of the Innocents (further discussed in Henry 1998–9, p. 25) which may be significant for the genesis of cat. 90. For the possibility that a drawing attributed to Raphael of Saint Benedict welcoming Maurus and Placidus into the Benedictine Order (about 1502–3, New York, private collection, illustrated when sold at

Christie's, London, 19 April 1988 (27), pp. 24–5) was the artist's proposal for this scene at Monteoliveto, see Henry 2004 (with further bibliography).

62 See further under cats 27 and 45 below.

63 See also Gilbert 1986, pp. 114–15.

64 Oberhuber 1986, p. 156, has argued that Pintoricchio should be considered 'a secondary teacher or mentor to the young Raphael'.

65 On 8 November 1500 Agostino Chigi recommended first Perugino and then Pintoricchio to his father, Mariano: 'Sopra la capella vostra . . . Se quel perigino che dite avere parlato è messer pietro perugino, vi dico che volendo fare di sua mano, lui è il meglio maestro di Italia, e questo che si chiama il pintorichio è stato suo discepolio, il quale, a presente non è qui', see Rowland ed. 2001, pp. 11–13.

66 The second collaboration between the artists involved Raphael's design assistance for the altarpiece that Pintoricchio painted for Fratta Perugina (modern day Umbertide). Pintoricchio was paid for this altarpiece, which is now in the Musei Vaticani (Oberhuber 1986, fig. 12), in June 1503 (with final payments in 1505, see Archivio storico dell'arte, 1890, pp. 465–6), and drawings in the Louvre demonstrate that Raphael designed the two foreground saints (Joannides 1983, nos 60–1). Raphael probably developed designs for both projects in the winter of 1502–3 (see now the interesting arguments of Scarpellini and Silvestrelli 2004, pp. 227–30, with their implications for the dating of the Oddi Coronation). He was also said to have collaborated with Pintoricchio on an altarpiece for Filippo Sergardi's chapel in the church of S. Francesco, Siena, see Henry 2004 and Shearman 2003, pp. 77–9.

67 See Oberhuber 1986, pp. 155–72.

68 For the contract see Milanesi 1856, III, pp. 9–16.

69 Ibid.: 'Item sia tenuto fare tutti li disegni delle istorie di sua mano in cartoni et in muro.'

70 Vasari refers to Raphael's assistance in this project at two points. In Raphael's Life he states that: 'avendo egli [Raphael] acquistato fama grandissima nel séguito di quella maniera [Perugino], era stato allogato da Pio Secondo pontefice la libreria del duomo di Siena al Pinturicchio, il quale, essendo amico di Raffaello e conoscendolo ottimo disegnatore, lo condusse a Siena, dove Raffaello gli fece alcuni disegni e cartoni di quell'opera' (Vasari/BB, IV, p. 159). In the Life of Pintoricchio Vasari states: 'Ma è ben vero che gli schizzi e i cartoni di tutte le storie che egli vi fece, furono di mano di Raffaello' (Vasari/BB, III, pp. 571–2). Vasari lends authority to his account by going on to say that he had seen one surviving cartoon for the project in Siena and owned several related sketches by Raphael himself.

71 Joannides 1983, nos 56–61. These drawings have sometimes been attributed to Pintoricchio, but Raphael's authorship is attested to by the presence of his handwriting on two of them (see Shearman 2003, pp. 75–7) as well as by stylistic analysis.

72 Shearman 1986a, p. 206; the architecture is of a complexity and sophistication far beyond Pintoricchio's capabilities.

73 Oberhuber 1977 argues that a drawing at Chatsworth is a copy after another lost modello by Raphael for the scene of Enea Silvio as Envoy at the Court of Eugenius IV. This was accepted by Shearman 1986a, p. 206.

74 Oberhuber 1986

75 For the documents suggesting Raphael's friendship with Alfani see Shearman 2003, pp. 111–12, 157, and the discussion of Ferino Pagden 1986, pp. 93–107.

76 For Raphael's generosity with his drawings, see Vasari/BB, IV, p. 212.

77 For this fresco see Oberhuber 1986, p. 164.

78 This may be the picture that Vasari said was painted for 'alcuni gentiluomini sanesi', see Vasari/BB, IV, p. 165 (1568, see also 1550), and V, p. 438 (1568). For these arguments see Henry 2004.

79 See the copy drawing in the Venice Libretto, fol. 28r (Ferino Pagden 1982, no. 82, fig. 156).

80 See Panofsky 1930, pp. 76ff, Wind 1967, pp. 81–5.

81 For these see Shearman 2003, pp. 143–6, 154–5.

82 'avendo egli [Raphael] acquistato fama grandissima nel séguito di quella maniera [of Perugino]', Vasari/BB, IV, p. 159.

83 In the Lives of Raphael, Perugino, Pintoricchio and Niccolò Soggi (see Rubin 1995, p. 382).

84 Shearman 2003, pp. 619–20, see note 2 above.

85 Condivi 1553 (Shearman 2003, p. 1029), see note 2 above.

86 See Coonin 1999, pp. 100–5, and Henry 2004a, p. 75.

87 Scarpellini 1984, pp. 109–10.

88 On 8 November 1500 Agostino Chigi recommended Perugino to his father, Mariano: 'Sopra la capella vostra . . . Se quel perigino che dite avere parlato è messer pietro perugino, vi dico che volendo fare di sua mano, lui è il meglio maestro di Italia', see Rowland ed. 2001, pp. 11–13.

89 Vasari/BB, IV, p. 8.

90 'El Perusino Maestro singulare: et maxime in muro: le sue cose hano aria angelica, et molto dolce'; for the text and translation see Baxandall 1972, p. 26.

91 Vasari/BB, IV, p. 158: 'in pochi mesi' (1550 only). See also Butler 2004.

92 Ferino Pagden 1979a, pp. 9–15.

93 Other examples include the predella of the Coronation of the Virgin and its response to the Fano predella; the São Paulo Resurrection and its connections with Perugino's Vatican Resurrection (for which see Nesselrath 2004); and Raphael's first idea for the Baglioni Entombment and its relation to Perugino's S. Chiara Lamentation (figs 33 and 34).

94 'se non vi fusse il suo nome scritto, nessuno la crederebbe opera di Raffaello, ma sì bene di Pietro' (Vasari/BB, IV, p. 158). See further under cat. 27.

95 The S. Francesco al Monte altarpiece was commissioned from Perugino in September 1502 (for delivery by Easter 1503), but completion is usually dated about 1504–6 (see Canuti 1931, I, pp. 179–80, II, p. 237, and Scarpellini 1984, pp. 106–7). There is, however, no reason why Perugino should not have designed the picture when it was commissioned (see below), and it could have been painted in the course of 1503 (with Perugino overseeing completion on the various occasions on which he returned to the city in that year).

96 Raphael's altarpiece has also been compared with the Crucifixion that Perugino painted for the Chigi chapel in S. Agostino, Siena (commissioned August 1502; delivered 1506), but this is a much less successful composition and the connections with Raphael are generic. See Scarpellini 1984, cat. 141.

97 Hiller 1999, pp. 52–3, demonstrates how the precedents for the Monteripido altarpiece can all be found in Perugino's work of the 1490s, so Perugino need not have known Raphael's composition before designing his own work. For an analysis of the way in which Raphael's painting offers a critique of Perugino's models, see Brown 1992, pp. 29–53. See also the comments of Vasari/BB, IV, pp. 204–5.

98 Henry 2002, pp. 274–7, with a further analysis of how the two commissions were interrelated. See also De Vecchi 1996.

99 For the documents relating to this commission, see Canuti 1931, II, pp. 199–203 (and I, pp. 167–72).

100 See Vasari/BB, IV, pp. 158–9, and – for Vasari's knowledge of Perugino's picture – III, p. 607. Rubin 1990, p. 174, observes that: 'Raphael's pre-Roman altars are marked by an adherence to the demanded and respected prototypes, but they also display a critical and competitive attitude inspired by and aiming at achieving that migliore perfectione [for the phrase see Shearman 2003, p. 87]. . . . [Raphael] studied and sought the emotions and motivations of the poses and the gestures, turning stock, if dignified action into dramatic reaction, seeking the story (storia) in the image (imago), a process of transformation which constituted an assertion of the painter's inventive powers.' See also De Vecchi 1996.

101 It follows that the Mond Crucifixion was probably not designed until late 1502 at the earliest.

102 Canuti 1931, II, pp. 302–3.

103 This is supported by early derivations from Perugino's Fano altarpiece (such as fig. 3) and is argued by Ferino Pagden 1984b, p. 87.

104 This is, in fact, comparable to Raphael's later surprisingly comprehensive knowledge of Leonardo's work, see pp. 34–6. For a full discussion of this subject see Hiller 1999.

105 One only needs to study the work of Berto di Giovanni, Lo Spagna, Eusebio da San Giorgio and others to see how Perugino – like Raphael – had a pervasive impact on his followers.

106 See Cooper 2001, pp. 554–61.

107 See Cooper 2001, Ferino Pagden 1986a and the Coronations painted in these years – e.g. Pintoricchio's for Umbertide, Perugino's for S. Francesco al Monte, Perugia – sometimes (as in Raphael's slightly later Monteluce contract, Shearman 2003, pp. 86–92) with direct reference to Ghirlandaio's earlier prototype at Narni.

108 Vasari/BB, IV, p. 158. Wittkower 1963, pp. 150–68, and Becherucci 1968, pp. 25–6, favoured an early date. De Vecchi 1986, pp. 73–84, favours a protracted execution between 1502 and 1504. (For the technical arguments in favour of an execution in two distinct phases see Mancinelli 1986, pp. 127–38.)

109 A date in 1503 had been favoured on the grounds that there was a period when the Oddi family were able to reassert their position in the city, and on the grounds that the picture must have been completed before the nuns of Monteluce selected Raphael as the best master in Perugia. The former argument has been undermined by the researches of Donal Cooper, and the latter by Shearman's correct redating of the Monteluce document to December 1505 (instead of December 1503).

110 The evidence for a two-phase execution (as proposed by De Vecchi 1986, pp. 73–84, and Mancinelli 1986, pp. 127–38) is not convincing.

111 For the possibility that the picture's unusual iconography (which was compellingly analysed by Ferino Pagden 1986a) had Sienese origins see Krems 1996. Crowe and Cavalcaselle's emphasis (1882–5, I, p. 150) on the picture being more indebted to Pintoricchio than to Perugino was in part prompted by these aspects of the predella.

112 For Raphael's connections with the Urbino notary Matteo degli Oddi, see Shearman 2003, pp. 57, 59, 60 and passim.

113 His penultimate altarpiece commission in Perugia was for the nuns of Monteluce, for whom see below and Shearman 2003, pp. 86–96.

114 These included the double-sided altarpiece for S. Francesco al Monte (for which he would receive 120 ducats), the enormous altarpiece for S. Agostino (500 ducats), as well as the Sposalizio for the Cathedral (price unknown).

115 Mancini 1987, pp. 33–7, published the first two documents. The third was discovered by Donal Cooper, discussed in his lecture of November 2002, and will shortly be published by him. In the meantime the discovery has been referred to by Shearman 2003, p. 1642.

116 'el maestro el migliore li fusse consigliato da più citadini et ancho da li nostri venerandi patri, li quali havevano vedute le opere suoi, lo quale se chiamava maestro Raphaello da Urbino' (Shearman 2003, p. 93). The conclusion that Raphael was based in Perugia for much of the period 1502–5 was at least partially shared by Crowe and Cavalcaselle (1882–5, I, p. 124).

117 For Maddalena's status, see Cooper 2004; for the Leandra/Maddalena problem, see Luchs 1983 and Cooper 2001.

118 See, for example, Orsini 1784.

119 See Ferino Pagden 1981, pp. 231–52. The Siege of Perugia in the Louvre (Joannides 1983, no. 73) is also likely to have been preparatory to a commission in the city: see Henry 2004.

120 For Florentine influences in the predellas see cats 40–2. Waagen recorded the date 1505 on the Colonna Altarpiece in 1859, though the inscription no longer survives (Shearman 2003, p. 97). The Ansidei altarpiece is inscribed with a date most frequently interpreted as MDV (Shearman 2003, pp. 97–8). The dating is generally agreed by scholars on stylistic grounds though Oberhuber (1977) made a case for dating the Colonna Altarpiece earlier, to 1501–2. For the protracted genesis of the two altarpieces, see Crowe and Cavalcaselle 1882–5, I, pp. 217–27 and 235–42.

121 See Shearman 2003, pp. 86–96. If their work was judged better than the Narni altarpiece the artists could expect to earn more.

122 Shearman 2003, pp. 86–92.

123 Jones and Penny 1983, p. 21; Shearman 2003, pp. 88 and 90.

124 The lower part of the fresco was completed by Perugino in 1521 (see Shearman 2003, pp. 712–14).

125 For Raphael's relationship with Berto di Giovanni, see Henry 1996, pp. 325–8, and further bibliography.

126 For the documents suggesting Raphael's friendship with Alfani see Shearman 2003, pp. 111–12, 157, and the discussion in Ferino Pagden 1986, pp. 93–107. (Alfani has been described as 'manager . . . of his Perugian painting-room', Crowe and Cavalcaselle 1882–5, I, p. 298.)

127 Vasari/BB, IV, p. 159. The most thorough and exemplary account of Raphael's activity in Florence remains ed. Gregori 1984. See also Meyer zur Capellen 1996.

128 'Sarà lo esibitore diquesta Raffaelle pittore da Urbino, il quale avendo buono ingegno nel suo esercizio, ha deliberato stare qualche tempo in Fiorenza per imparare. E perchè il padre so, che è molto virtuoso, & è mio affezionato, e così il figliolo discreto, e gentile giovane; per ogni rispetto io lo amo sommamente, e desidero che egli venga a buona perfezione' (Shearman 2003, pp. 1457–62).

129 This document was first published by Bottari in 1754 who claimed to have copied it from a manuscript in the Casa Gaddi which was subsequently lost. Doubts as to the letter's authenticity arose as a result of Pungileoni's discovery that Giovanni Santi died in 1494 but is mentioned in the present tense in the letter. Shearman is among several scholars who have viewed the document as a forgery because of this discrepancy. Many ingenious alternative transcriptions have been devised to explain this puzzling present tense (here rendered in the past by square brackets). An important argument in favour of the letter's authenticity is Raphael's letter to his uncle Simone Ciarla, which was first published in 1779, more than twenty years after Bottari published Giovanna Feltria's letter. In this, Raphael himself asserted his reliance on her favour and sought another letter of recommendation from her son Francesco Maria. It seems unreasonable to argue that a fake could have so brilliantly anticipated and dovetailed with evidence supplied in genuine documentary material published only subsequently, although it remains prudent to retain some doubt. For a contemporary letter of recommendation with similar wording see Michelangelo writing on behalf of Alonso Berruguete (2 July 1508), in Barocchi-Ristori 1965–83, I, p. 70: 'L'aportatore di questa sarà uno giovine spagnuolo, il quale viene chostà per imparare a dipignere.' We are grateful to Caroline Elam for drawing this comparison to our attention.

130 Shearman 2003, pp. 112–13.

131 Caglioti 2000, I, pp. 336–8, has discovered new documents that demonstrate that a 'Raffaello di Giovanni dipintore' gilded the 'grillanda' of Michelangelo's marble David and painted a Madonna for the Udienza dei Nove in the Palazzo Vecchio in 1508. However, Caglioti's identification of this 'Raffaello' as Raphael is not convincing. Raphael is usually referred to as from Urbino, and this would be all the more likely if he were appearing as a newcomer in communal documents; this artist is far more likely to be the Florentine Raffaello di Giovanni d'Antonio [Riccomani] (1471–1545?) whose career was discussed by Milanesi in a note to the Life of Raffaellino del Garbo (Vasari 1906–, IV, p. 244). See also the rejection of these documents in Shearman 2003, pp. 118–20.

132 For the Sala del Consiglio and the competition between Michelangelo and Leonardo, see Rubinstein 1995 and Meyer zur Capellen 1996, pp. 86–97.

133 The writhing dragons in Raphael's paintings of Saint George may also reflect knowledge of Leonardo's much earlier sketches for this subject.

134 Joannides 1983, no. 99 and pl. 10; Gere and Turner 1983, no. 69.

135 This profile recurs frequently in Leonardo's notebooks, on occasion superimposed with a grid as part of Leonardo's enquiries into systems of proportion (see, for example, Clayton 2002–3, cat. 4).

136 Vasari/BB, IV, pp. 29–30.

137 Vasari/BB, IV, pp. 204–5.

138 Franklin 2001, ch. 2.

139 For Pietro da Novellara's observations to Isabella d'Este on Leonardo's slow rate of progress during this period see Beltrami 1919, p. 72, doc. 107 (3 April 1501): 'Altro non ha facto, se non dui suoi garzoni fano retrati, et lui a le volte in alcuno mette mano: dà opra forte ad la geometria, impacientissimo al pennello', p. 73, doc. 108 (4 April 1501): 'li suoi esperimenti matematici l'hanno distracto tanto dal dipingere, che non può patire il pennello'.

140 Shearman 2003, p. 1064: 'quando il pittore va tentando ne' primi schizzi le fantasie, che genera nella sua mente la historia, non si dee contentar d'una sola ma trovar più inventioni e poi fare iscelta di quella che meglio riesce, considerando tutte le cose insieme e ciascuna separatamente, come soleva il medesimo Rafaello, il quale fu tanto ricco d'inventione che faceva sempre a quattro e sei modi, differenti l'uno dall'altro, una historia, e tutti havevano gratia e stavano bene.'

141 Vasari/BB, III, p. 637.

142 Vasari/BB, VI, p. 25.

143 Vasari/BB, VI, p. 23–4.

144 Raphael made sketchy copies after the Bathers on the reverse of studies for the Holy Family with the Palm, datable about 1506 (see fig. 78).

145 See further under cat. 55.

146 Vasari/BB, IV, p. 205.

147 For two studies by Raphael after the Taddei Tondo see fig. 85 and Joannides 1983, no. 111v.

148 Despite Michelangelo's documented paranoia about anyone seeing the statue (Barocchi and Ristori, 1965–83, I, p. 12: 'non lasciassi vedere a persona'), Raphael must have had a chance to study it before its dispatch.

149 Amy 2000, pp. 493–6.

150 Shearman 2003, pp. 928–9.

151 Of the three easel pictures known by Michelangelo, the Doni Tondo is the only finished work (two unfinished paintings, the Manchester Madonna and the Entombment, are both in the National Gallery, NG 809 and NG 790). See Forlani Tempesti 1985 and Hirst and Dunkerton 1994–5.

152 See ed. De Vecchi 1994.

153 Vasari singled out Raphael's 'grazia de' colori' for special praise (Vasari/BB, IV p. 205).

154 Vasari/BB, IV, p. 206.

155 Alterations to the architectural or landscape backgrounds in Raphael's paintings are present in cats 45, 62 and 91 and in other paintings not in the exhibition such as fig. 29 and the Madonna del Granduca.

156 For the rivalry between the two artists, see note 2 above.

157 Fischer 1990.

158 Vasari/BB, IV, p. 94. For the suggestion that Raphael's Holy Family with a Palm of 1506–7 is closely based on a tondo of a similar subject by Fra Bartolommeo, see Weston-Lewis 1994, pp. 36–9, under no. 5.

159 Fischer 1990, p. 107. For Fra Bartolommeo as a landscape draughtsman see ibid., ch. 6.

160 Ibid., p. 393.

161 For these two artists see Franklin 2001, ch. 6, and Ghisetti Giavarina 1990.

162 Vasari/BB, IV, p. 25.

163 Vasari/BB, IV, p. 165; V, p. 438.

164 Vasari/BB, IV, p. 610. For Raphael's knowledge of Northern prints see Quednau 1983, pp. 129–5; and Passavant 1983, pp. 193–222.

165 Vasari/BB, IV, p. 163; Crowe and Cavalcaselle 1882–5, I, p. 245, evoke the naturalness with which this would have occurred: 'and when his labours were over in the painting-room, he doubtless wandered into the Brancacci chapel to study Masaccio; past Orsanmichele to look at the statues of Donatello, into Santa Maria Nuova to admire the "Last Judgement" of Baccio della Porta, or into Santa Maria Novella to wonder at the grand creations of Domenico Ghirlandaio.'

166 For this subject, see Butler 2002.

167 The researches of Alessandro Cecchi (especially in ed. Gregori 1984) are fundamental to our knowledge of Raphael's patrons in Florence. The subject is also considered in Meyer zur Capellen 1996.

168 For these patronage networks see Cecchi, in ed. Gregori 1984, pp. 37–46.

169 In addition to the pictures discussed in the text the following have a provenance from Florentine collections: the Madonna del Granduca, the Colonna Madonna, the Tempi Madonna and the Large Cowper Madonna.

170 Vasari/BB, IV, pp. 160, 611. For Taddei see Cecchi, in ed. Gregori 1984, pp. 40–1.

171 Vasari/BB, IV, p. 160; Shearman 2003, pp. 112–18.

172 Vasari/BB, IV, p. 160.

173 Cecchi, in ed. Gregori 1984, p. 41, more plausibly suggested that the second infant saint in the Terranuova Madonna might be Taddeo's name-saint, Saint Thaddeus, another of Christ's cousins, whom Perugino had included in his Family of the Virgin now in Marseilles (for which, see Scarpellini 1984, cat. 125).

174 Raphael changed the position of the Virgin's hand at the last minute (see Meyer zur Capellen 2001, p. 190, for detail of the X-ray), and it has sometimes been associated with his knowledge of the Madonna of the Yarnwinder or designs for the Virgin of the Rocks.

175 The figure group is in fact borrowed from an earlier design he had made for an arch-topped composition (see Joannides 1983, no. 69).

176 Vasari recorded Raphael's two pictures in the possession of Taddei's heirs (Vasari/BB, IV, p. 160), and more than a century later, in 1681, Baldinucci recorded the Madonna of the Meadow still in their ownership (See Cecchi, in ed. Gregori 1984, p. 41); Baldinucci's record offers convincing proof that the picture in Vienna was one of the two painted for Taddei.

177 For Nasi, see Cecchi, in ed. Gregori 1984, p. 41. Nasi's sister Ippolita had married Taddei's brother Gherardo in 1500 (ibid., p. 39).

178 Vasari/BB, IV, p. 160 (Vasari only mentions the location for which the picture was destined in the 1550 edition). The painting is currently being restored at the Opificio delle Pietre Dure, to spectacular effect (see Riitano 2003). Vasari/BB, IV, pp. 160–1: Lorenzo was the son of Bartolomeo di Lutozzo Nasi, for whom Perugino had painted an altarpiece depicting the Vision of Saint Bernard in the 1480s (now Munich; Scarpellini 1984, cat. 47).

179 Joannides 1983, nos 110–13 and 115–16.
180 This motif is also found in the *Belle Jardinière* and the *Canigiani Holy Family*.
181 See Sonnenburg 1983 and Béguin 1983–4.
182 Olson 2000.
183 For the *Holy Family with a Palm* see Weston-Lewis 1994, no. 5; for the *Madonna del Silenzio*, see Golzio 1971, and Henry 2004.
184 For the portraits, see ed. Gregori 1984, nos 8–9. Doni was born in 1474, and lived in the Corso de' Tintori not far from the Badia (where following his death in 1539 he was buried in the family burial chapel, on the altar of which was Francesco Botticini's *Archangel Raphael and Tobias*, now in the Duomo on deposit from the Accademia). Doni owned several workshops associated with the wool trade, and various other properties; on Doni, see Cecchi, in ed. Gregori 1984, p. 41–2, and Cecchi 1987.
185 Vasari/BB, IV, pp. 162–3; and VI, pp. 22–3.
186 The scenes on the reverse represent scenes from Ovid's *Metamorphosis*, the Flood sent by Zeus to punish mankind on the reverse of Agnolo's portrait, and Deucalion and Pyrra recreating humankind by throwing stones over their shoulders on the reverse of Maddalena's. On these scenes, attributed to the Maestro di Serumido, see Gregori ed. 1984, pp. 108, 117; Dülberg 1990, p. 240; Padovani, in Chiarini and Padovani eds 2003, II, p. 316, and Padovani 2004.
187 Cecchi, in Gregori ed. 1984, p. 42.
188 Shearman 2003, pp. 104–6; *pace* Jones and Penny 1983, p. 5, this is the only document for Raphael in Urbino between 1500 and 1510.
189 For Raphael's portraits of the Duke and Duchess and their heir Francesco Maria della Rovere see ed. Gregori 1984, cats 2–4. During this period he also painted a small portrait of Pietro Bembo (recorded by Marcantonio Michiel *about* 1532: *'Il ritratto piccolo di esso Messer Pietro Bembo, alhora che giovine stava in corte dil Duca d'Urbino, fu di mano di Rafael d'Urbino'* (Shearman 2003, p. 875). Garas (1983, pp. 53 ff.) identifies this as the *Portrait of a Youth* in Budapest (see Meyer zur Capellen in Paris 2001, no. 4), but the identification of the sitter as Bembo (whose likeness is known from portrait medals and who would, at 37, have been far older in 1507 than the sitter in the portrait) is not convincing, and the attribution of the portrait to Raphael doubtful.
190 Shearman 2003, p. 112: *'Io scrissi l'altro dì al zio prete che me mandasse una tavoleta che era la coperta de la Nostra Donna dela profetessa. Non me l'a mandata. Ve prego voi li faciate sapere quando c'é persona che venga, ché io possa satisfare a Madona, ché sapete adesso averà biognio di loro.'* The small size of the *tavoleta* surely eliminates the possibility advanced by Clifford (in Weston-Lewis 1994, pp. 15–17) that this *Madonna for Giovanna della Rovere* is the *Holy Family with a Palm*. For the same reason, it is also difficult to accept Shearman's suggestion (*loc. cit.*) that this panel could be the *Small Cowper Madonna* in Washington.
191 See the passage quoted in note 190.
192 A stylistic connection with a diptych by Memling in the collection of the Bembo family reinforces the Urbinate origin of this work: see Brown 1983, pp. 153–7.
193 Bembo refers to *'la qualità del lavorio, che è sottile e minuto molto'* (Shearman 2003,

p. 102). He wrote to the fathers of the monastery to apologise for the fact that the production of the work by a *'gran maestro della pittura'* had been delayed (giving the excuse of the weather being inclement for the production of such fine work). Vasari added that the brothers reserved it for their chapter and venerated as if it were a relic (Vasari/BB, IV, p. 161), but were forced to relinquish their treasure to Guidobaldo II da Montefeltro, Duke of Urbino, in 1570 (Shearman 2003, pp. 1214–15).
194 Vasari/BB, IV, p. 161. It is not known what these works are, though the *Small Cowper Madonna*, which has in the background the Montefeltro church of S. Bernardino, has been suggested (see note 190). For the identification of the church see H. Burns, in Fiore and Tafuri 1993, pp. 230 ff. Weston-Lewis (1994, p. 54) associated the *Madonna of the Pinks* with the type of high quality work that Raphael produced for Urbino.
195 see Cooper 2001.
196 The altarpiece is dated 1507. In a *ricordo* on the back of a design for an altarpiece sent to Domenico Alfani in about 1507–8, Raphael asked Alfani to chase Atalanta for payment for the *Entombment* (Shearman 2003, p. 111).
197 Vasari/BB, IV, p. 164.
198 For a discussion of Raphael's dramatic departure from traditional devotional models, see Nagel 2000, pp. 113–36.
199 Ibid., p. 130.
200 See Hirst and Dunkerton 1994–5, ch. V. For its influence on Raphael's composition see Nagel 2000, pp. 132–4.
201 Shearman 1977.
202 For the *Madonna del Baldacchino* see ed. Gregori 1984, cat. 10, and ed. Chiarini, Ciatti and Padovani 1991.
203 Shearman 2003, pp. 112–13. On the association of the *tavola* mentioned by Raphael with the Dei altarpiece see Gregori ed. 1984, p. 119.
204 Compare Shearman 2003, pp. 71–5 and 112–18.
205 The saints were correctly identified by Franklin 1994, p. 88.
206 Shearman 2003, pp. 112–18 (and further bibliography): *'una certa stanza da lavorare, la quale t[oc]ha a sua S. de alocare.'*
207 Caglioti 2000, p. 337.
208 Vasari/BB, IV, p. 165, also referred to *'certe stanze'* when describing Raphael's call to Rome (*'Bramante da Urbino, essendo a' servigi di Giulio II, per un poco di parentela ch'aveva con Raffaello . . . gli scrisse che aveva operato col papa, il quale aveva fatto fare certe stanze, ch'egli potrebbe in quelle mostrare il valor suo'*). Raphael's allusion to the patron of the project as *'sua S.'* has sometimes been taken to refer to Soderini himself (standing for *sua Signoria*, or his Lordship), but it is far more likely to be shorthand for *sua Santità* (i.e. His Holiness), the Pope. Soderini was easily the most powerful person in Florence for Raphael to turn to when seeking a recommendation for employment at the papal court, and he had involved himself in Julius's relations with other artists at the Vatican (indeed Soderini's relationship with the Pope was very important to his foreign policy in these years, see Hirst 2000, pp. 487–92).
209 Shearman 2003, pp. 122–3.
210 For the functions and decorations of the Vatican Stanze see Shearman 1971 and Jones and Penny 1983, pp. 49–57.

211 *'pictoribus concertantibus'*, see Albertini 1510, fol. Yv. For the individual artists (including, in addition, Johannes Ruysch, Michele del Becca, Baldino Baldini and Andrea da Venezia), see Vasari, *passim*, and Hoogewerff 1945–6, pp. 253–68, De Zahn 1867, p. 187 and Henry 2000, pp. 29–35. Convincing attributions have been made to some of these artists, as well as to Signorelli and Peruzzi (see Nesselrath 1992, pp. 31–60, *idem.*, 1998b, p. 245). A number of later accounts suggest the international character and conviviality of this team (e.g. Caporali 1536, fol. 102r, and Vasari/BB, VI, p. 179).
212 Vasari/BB, V, p. 383: *'E perché Pietro Perugino, che dipingeva la volta d'una camera che è allato a torre Borgia, lavorava, come vecchio egli era, adagio e non poteva, come era stato ordinato da prima, mettere mano ad altro, fu data a dipingere a Giovan'Antonio [Sodoma] un'altra camera che è a canto.'*
213 It is increasingly clear that he collaborated with Sodoma on the vault of the Stanza della Segnatura (see p. 284 below; Bartalini 2001, pp. 544–53).
214 Vasari stated that the work of the other artists was thrown down when Julius saw how clearly Raphael's work surpassed theirs (*'e dal Papa conosciuto quanto gli altri avanzasse, comandò Sua Santità che nelle dette camere non lavorasse più né il Perugino né Giovan Antonio [Sodoma], anzi che si buttasse in terra ogni cosa'*, Vasari/BB, V, p. 384). Giovio also noted that Raphael painted in two rooms before his authority was established (see Shearman 2003, p. 807, *'Pinxit in Vaticano nec adhuc stabili authoritate cubicula duo ad praescriptum Julii pontificis'*), and he may not have replaced the artists at work in the Stanza di Eliodoro and Stanza dell'Incendio until late in 1511.
215 An interesting solution to the discrepancies presented by Vasari's text might follow from these arguments. If the *School of Athens* was not complete before Julius II left Rome in the autumn of 1510, then the Pope would have seen it for the first time on his return to the papal city in June 1511. At this point Raphael received the commission to replace recent work in the Stanza di Eliodoro, and shortly afterwards the sinecure of the *Scriptor Brevium*.
216 Shearman 1971, pp. 10–17.
217 For an account of the restoration of this fresco, see Nesselrath 1996.
218 Vasari/BB, IV, p. 167.
219 As ever, technical evidence requires interpretation. The cracking of the plaster present only in the upper half of the *School of Athens* (which Nesselrath views as an initial technological problem subsequently overcome, pp. 285 below) could have another explanation, and it is also possible to interpret the evidence of how the frescoes were transferred onto the wall to reach different conclusions. As noted in Henry 1997, the technique by which the *School* was transferred is at odds with Raphael's only pre-Roman fresco: *The Trinity with Saints* in S. Severo, Perugia. The restorer of this fresco, Carlo Giantomassi, confirms that Raphael used a traditional *spolvero* technique without any incision in this fresco (see also Santi 1979, pp. 57–64), and this is also the technique of the *Disputa* (but not the *School*).
220 Jones and Penny 1983, pp. 68–74; Nesselrath 2004b.

221 Shearman 1965, pp. 158–80.
222 For Lotto's execution of *Tribonian presenting the Pandects to the Emperor Justinian*, see Nesselrath 2000. For the date of the *Gregory IX approving the Decretals*, see cat 99.
223 These opportunities might never have arisen in Urbino, Perugia or Florence.
224 Vasari/BB, IV, pp. 175–6.
225 For Julius's sculpture garden, see Nesselrath 1998. For drawings in which Raphael displays a debt to antique sculpture, see Joannides 1983, nos 202, 240, 241, 268.
226 For these examples and other evidence of Raphael's study of the antique, see Shearman 2003, pp. 238–9, 500–45, 546–51. See also Nesselrath 1986, pp. 357–69.
227 *'per le cose vedute di Michel Angelo, migliorò et ingrandì fuor di modo la maniera e diede più maestà'*, Vasari/BB, IV, p. 176.
228 Vasari/BB, IV, pp. 175–6. Condivi also described the impact of this monumental new style of painting on Raphael 'as one who excelled in imitating', but he also attributed the breakdown in relations between the two artists to this moment by relating how Raphael 'tried with the help of Bramante to get the order to paint the rest'. Condivi 1553 in Shearman 2003, p. 1029. See also the discussion of Robertson 1986.
229 Vasari/BB, IV, pp. 175–6: *'avendo Bramante la chiave della capella, a Rafaello, come amico, la fece vedere, acciò che i modi di Michele Agnolo comprender potesse. Onde tal vista fu cagione che in Santo Agostino . . . Rafaello sùbito rifacesse di nuovo lo Esaia profeta che ci si vede . . . nella quale opera, per le cose vedute di Michel Agnolo, migliorò et ingrandì fuor di modo la maniera e diede più maestà.'* Michelangelo's own bitterness towards Bramante and Raphael emerges in his letter of 24 October 1542 to an unidentified Monsignore: *'Tutte le discordie che naqquono tra papa Iulio e me fu la invidia di Bramante et di Raffaello da Urbino; et questa fu causa che non e' seguitò la sua sepultura in vita sua, per rovinarmi. Et avevane bene cagione Raffaello, ché ciò che haveva dell'arte, l'aveva da me.'* (Shearman 2003, p. 928). It is worth noting that Vasari's phrasing might allow for Raphael having seen Michelangelo's studies for the ceiling as well as the frescoes themselves, and this might account for some of the parallels between Raphael's black chalk figure-studies of these years (e.g. fig. 43) and Michelangelo's drawings for the Sistine ceiling.
230 See, *inter alia*, Hirst 1981, pp. 66–75.
231 Dunkerton and Spring 1998, p. 122.
232 Vasari/BB, IV, pp. 192–3.
233 A good example of Raphael's friendships with artists in Rome is the one he enjoyed with Cesare da Sesto (1477–1523), who was already present in the Vatican when Raphael arrived, see Lomazzo 1584 in Shearman 2003, p. 1313, Carminati 1994, pp. 58–65, and Henry 2000, pp. 29–35.
234 Raphael's Venetianism could partly derive from his early contact with Lorenzo Lotto, who worked alongside him in the Stanze from as early as 1509, as Nesselrath suggests, although there is little in Lotto's panel paintings of the first decade of the century, or indeed ever, to suggest that he could have influenced Raphael to paint with such unprecedented boldness. See pp. 288–92 of Nesselrath below, and *idem* 2000 and in a forthcoming issue of

the *Burlington Magazine*. Baldassare Peruzzi's hand has also been identified in one of the monochromes of the window embrasures on this wall.

235 On the cordial atmosphere in Raphael's work-shop, see Vasari/BB, IV, p. 212: '*Dicesi che ogni pittore che conosciuto l'avesse, ed anche chi non lo avesse conosciuto, se lo avessi richiesto di qualche disegno che gli bisognasse, egli lasciava l'opera sua per sovvenirlo: e sempre tenne infiniti in opera, aiutandoli ed insegnadoli con quello amore che non ad artefici, ma a figliuoli propri si conveniva. Per la qual cagione si vedeva che non andava mai a corte, che partendo di casa non avesse seco cinquanta pittori, tutti valenti e buoni, che gli facevano compagnia per onorarlo.*'

236 Shearman 2003, pp. 150–2. The document has usually been misdated 4 October 1509, but see *loc. cit.*, and Henry 2001, p. 25. The implications are further discussed by Henry 2004.

237 See Cugnoni 1878, Gilbert 1980, Rowland 1986.

238 For the iconography, see Thoenes 1986, pp. 59–72, and Jones and Penny 1983, pp. 93–100. For Dolce 1557, see Shearman 2003, pp. 1065–6: '*sua Galathea, che contende con la bella poesia del Policiano.*'

239 Vasari suggested that the *Galatea* preceded the Pace frescoes (Vasari/BB, IV, p. 176). Raphael later also designed and decorated Chigi's chapel in S. Maria della del Popolo and returned to the Farnesina to decorate the loggia of Cupid and Psyche.

240 In November 1510 (when Julius was absent from Rome) the Perugian goldsmith Cesarino Rossetti (d.1527) received Chigi's commission to produce two bronze tondi 'following the order and form given to him by master Raphael' (Shearman 2003, pp. 143–6). Raphael's close contact with Cesarino can be traced to Perugia (where he was mentioned in a note to Domenico Alfani, ibid., pp. 111–12) and the goldsmith also witnessed the first document for Raphael's activity in Rome in 1509 (ibid., pp. 122–3). It has usually been suggested that these '*tondorum de brongiorum*' were domestic plates or salvers, and they have been connected with the verso of cat. Windsor (fig.), which was almost certainly a design for this type of object. But a new interpretation of the document (Bartalini 1996, pp. 58–60, with an important proposal to explain a discrepancy between the document and the tondi) suggests that these tondi are actually those usually attributed to Lorenzetto, today in the Abbazia di Chiaravalle, Milan, which were originally destined to decorate the sides of the arch above the altar of the Chigi chapel. If the connection is accepted, Raphael's drawings for the tondi (Joannides 1983, nos 312–15) should be redated to 1510. We are grateful to Mirko Santanicchia for his comments on this question.

241 See Pungileoni 1835, p. 105 and Vasari/BB, IV, p. 267.

242 For the *Alba Madonna* and its association with Julius see Zezza 1999 and cat. 99 below.

243 For the *Madonna della Sedia*, see ed. Gregori 1984, cat. 13.

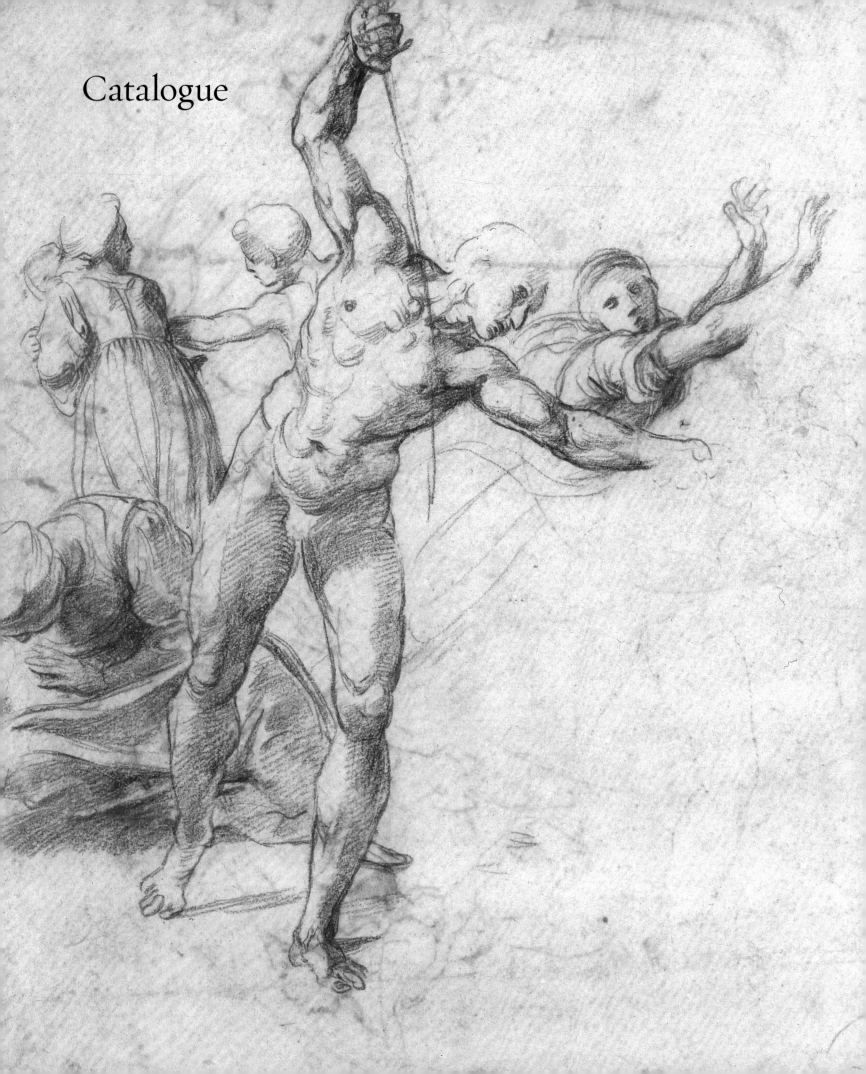

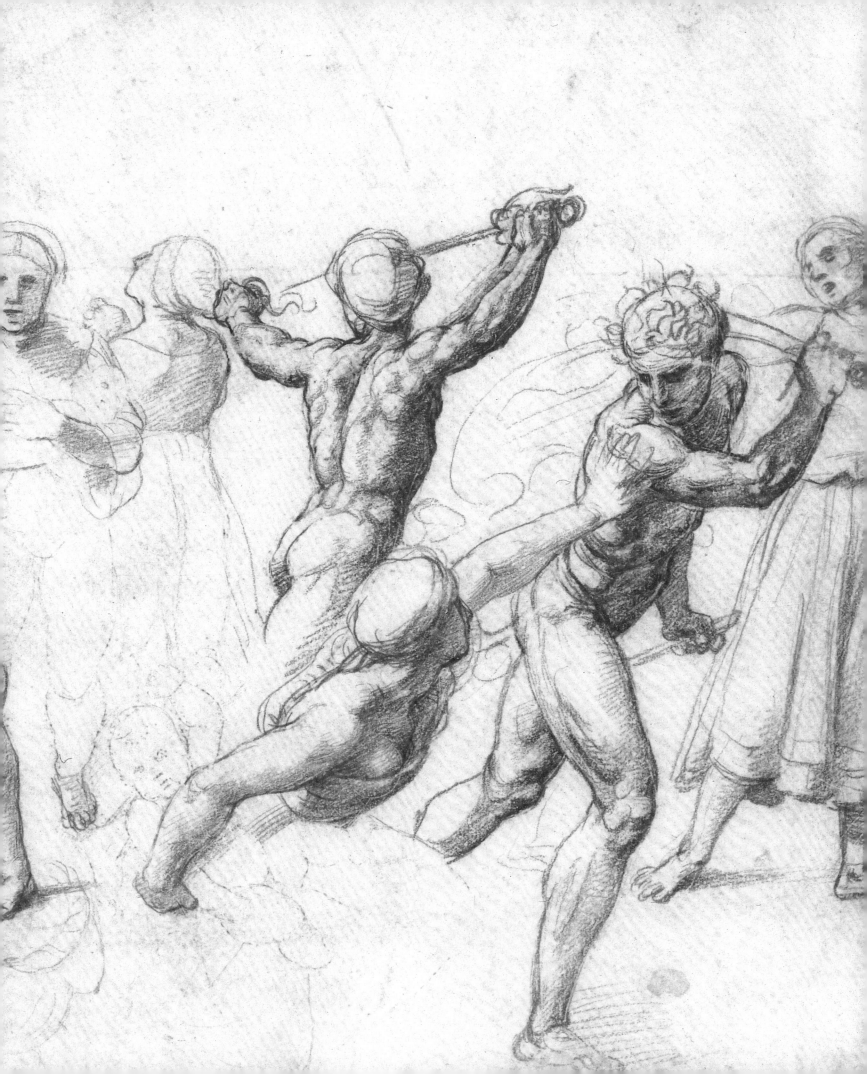

1 Self Portrait (?)

about 1500–2

Black chalk, 38.1 × 26.1 cm
Inscribed in ink at the bottom of the sheet:
Ritratto di se medessimo quando Giovane
('Portrait of himself when young')
The Ashmolean Museum, Oxford. Presented by a Body of Subscribers, 1846. 158 P II 515

This extraordinary drawing – a classic example of economy of style – is described in an eighteenth-century Italian inscription as a self portrait.[1] Although this inscription is too late to be reliable evidence, the facial type can be persuasively compared with the widely accepted self portrait in the Uffizi (cat. 2), in which the figure is studied facing to the right.

The boy's face dominates the sheet and his chest and shoulders are only vaguely indicated. His hat, and the locks of hair falling onto his neck and shoulders, have been more fully drawn, but nevertheless serve principally to frame his face and to enhance the three-dimensionality of the pose. The eyebrows and nose have been very

fig. 45 **Self portrait**, about 1498
Black chalk over stylus underdrawing, 31.4 × 19 cm
The British Museum, London, 1860-6-16-94

faintly delineated, largely by soft stumping (or smudging) that suggests subtle shading. The brim of the hat and the contours of the face – the brow, cheek, chin and neck – are made up of more than one line and have been drawn repeatedly and with greater pressure than else-where in order to establish the form. The eyelids and mouth have been reinforced in the same way so that the paper serves as both mid-tone and highlight. The right-hand side of the face (as we look at it) has been established with delicate parallel shading that follows the underlying form and becomes more hesitant (and complicated) around the jawline. This area is especially close in handling to the hatching seen in the under-drawing of the Uffizi *Self Portrait* where the mouth and the overall sense of the face are closely comparable (see fig. 47). The pose is also very similar, the turn of the head orientated around a central line running from the crown of the head, past the left eye and through the middle of the neckline – a line that in this drawing is also the central axis. These affinities reinforce the idea that both examples are self portraits, albeit executed at different moments of Raphael's career.

The identification of the sitter is not univer-sally accepted, however. It has been claimed that his eyes have pale irises while Raphael's painted self portraits show dark brown eyes. In fact, no conclusion can be drawn about the colour of the eyes from this generally light-toned study and in any case the eyes in the Uffizi *Self Portrait* are not dark, although they are chestnut brown. It has also been proposed that the sophistication of the drawing style, which a number of scholars have suggested points to a date around 1504 (when Raphael was 21), cannot be reconciled with the apparent age of the sitter, argued to be about 14 or 15 years old (and these authorities have there-fore rejected the idea that this drawing is a self portrait).[2] Although the drawing does presage Raphael's best portraits of the years after 1504, it does not necessarily follow that the drawing must be as late as this; nor indeed need the sitter be as young as 15. The physiognomy and

characterisation seem so close to the *Self Portrait* in the Uffizi that, although the painting is surely later, there could be as little as four years between the two images, and this favours the identification of this drawing as a self portrait. TH

NOTES

1 An identical inscription by the same later hand also identifies a faint drawing in the British Museum (fig. 45) as a self portrait.
2 Robinson, Crowe and Cavalcaselle, Parker, and Gere and Turner as cited below.

SELECT BIBLIOGRAPHY

Passavant 1860, II, p. 498, no. 459; Robinson 1870, pp. 140–1, no. 26; Crowe and Cavalcaselle 1882–5, I, p. 282; Fischel 1898, p. 225, no. 619; Fischel 1913–41, I, p. 35, no. 1; Popham 1931, p. 33, no. 113; Parker 1956, II, pp. 264–5, no. 515; Gere and Turner 1983, pp. 56–7, no. 34; Joannides 1983, p. 136, no. 9; Knab, Mitsch and Oberhuber 1984, p. 589, no. 76; White, Whistler and Harrison 1992, no. 11.

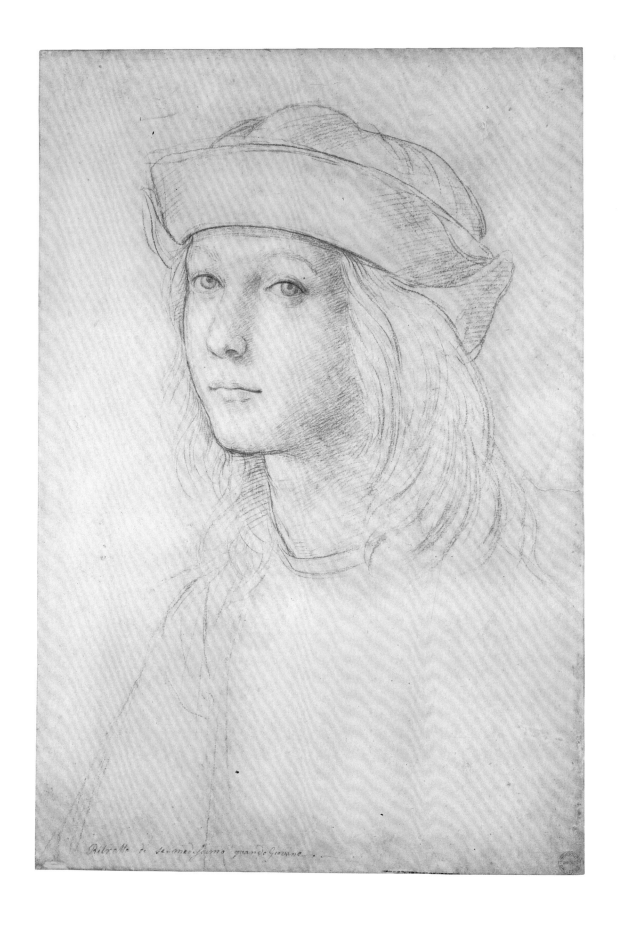

Ritratto di se medesimo quando giovane...

2 Self Portrait

about 1506

Oil on poplar, 47.3 × 34.8 cm
Much abraded, with numerous scattered losses.
Restored on several occasions, most recently in 1983–4.
Galleria degli Uffizi, Florence, inv. 1890, no. 1706

This haunting portrait has a provenance from the Palazzo Ducale in Urbino. When it was sent to Florence in 1631 it was described as '*un ritratto di Raffaello di sua mano*' ('a portrait of Raphael by his own hand'), and the physiognomy can be compellingly compared with the coarser self portrait in the *School of Athens* (fig. 47) and with cat. 1. On the basis of this evidence, the portrait would appear to represent Raphael in his early twenties. It shows the head and shoulders of the artist, with his shadow projected against a wall on the right. There is no reference to his profession as an artist. The huge fame of the portrait is attested to by the number of drawn, painted and engraved copies after it, but these demonstrate only that the picture was more famous for its subject than for its intrinsic quality. Edward Gibbon, for instance, described the picture as 'without expression, without drawing and without colour'![1] In the nineteenth century, however, this picture (and related self portraits) was used to establish a pervasively influential idea of the artist. Quatremère de Quincy described Raphael in 1824 as having 'a symmetrical, pleasing and refined face, the features well proportioned, the hair brown, as are the eyes, which are full of sweetness and simplicity. . . . All in all an expression of grace and tenderness. His complexion and build were entirely in harmony with his looks. He had a long neck, a small head, and a slender frame: nothing about him gave the impression that he had a strong constitution. His manners were pleasant, his bearing attentive, his style elegant.'[2]

Raphael was evidently concerned with his self-image. He frequently signed his work in very prominent places, and broadcast his skill as a designer through closely supervised engravings after his compositions (works destined to reach a much broader audience than was possible for the majority of his commissioned works, see cat. 90). There is thus some evidence that he tried to control his own 'press', and the 'image' that he projected to the outside world. Several putative drawn and painted self portraits exist, and he also inserted

his portrait into paintings of other subjects, such as the *School of Athens*.

However, there is no consensus regarding Raphael's self portraits, and although this picture probably has the best claim to be Raphael's painting of himself, the picture also has its doubters (usually arguing that it is an old copy after a lost? original). This is partly a matter of condition. The picture has undergone several restorations over the centuries, is badly abraded, and may be unfinished. The thin collar of the sitter's shirt is bare, unpainted, gesso (some underdrawing in this area can be detected with the naked eye), and the sitter's hair also appears to be unfinished (Raphael routinely paints strands of hair over the middleground behind a figure, but here the hair does not overlap the beige background at all). The loss of surface modelling contributes to the unsatisfactory way in which the face and the neck relate to one another (although this characteristic is also found in other works by the artist). Nevertheless, one of the most convincing proofs that the picture is Raphael's self portrait is the remarkable nervous quality of the liquid underdrawing that has emerged in infrared photographs (fig. 46), since it has the exploratory nature found in the artist's independent drawings.

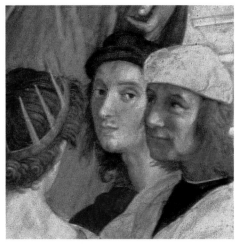

fig. 47 Detail of fig. 37

The picture is usually dated to 1505–9, and it has even been suggested that it might have been started towards the beginning of this period and returned to at a later date (although this seems unlikely). Given its condition it is difficult to be more precise, but a date about 1506 seems possible. TH

fig. 46 Detail from an infrared reflectogram mosaic of cat. 2

NOTES

1 '*sans expression, sans dessein et sans coloris*', Gibbon 1764 (1961 edn), p. 131.
2 '*une figure régulière, agréable et délicate, les traits bien proportionnés, les cheveux bruns, les yeux de même, pleins de douceur et de modestie . . . en tout, l'expression de la grâce et de la sensibilité. Sa complexion et le reste de sa conformation paraissent avoir été tout-à-fait en harmonie avec sa physionomie. Il avoit le col long, la tête petite, la taille grêle: rien en lui ne présageoit une constitution de longue durée. Ses manières étoient pleines d'agrément, son extérieur étoit prévenant, sa mise annonçoit de l'élégance.*' Quatremère de Quincy 1824, p. 397.

SELECT BIBLIOGRAPHY

Passavant 1860, II, pp. 48–50; Crowe and Cavalcaselle 1882–5, I, pp. 281–2; Wagner 1969, p. 62; Dussler 1971, p. 58; Gregori (ed.) 1984, pp. 47–57, 241–3; Woods-Marsden 1998, pp. 112–14, 121–4; Meyer zur Capellen 2001, pp. 286–90, no. 43.

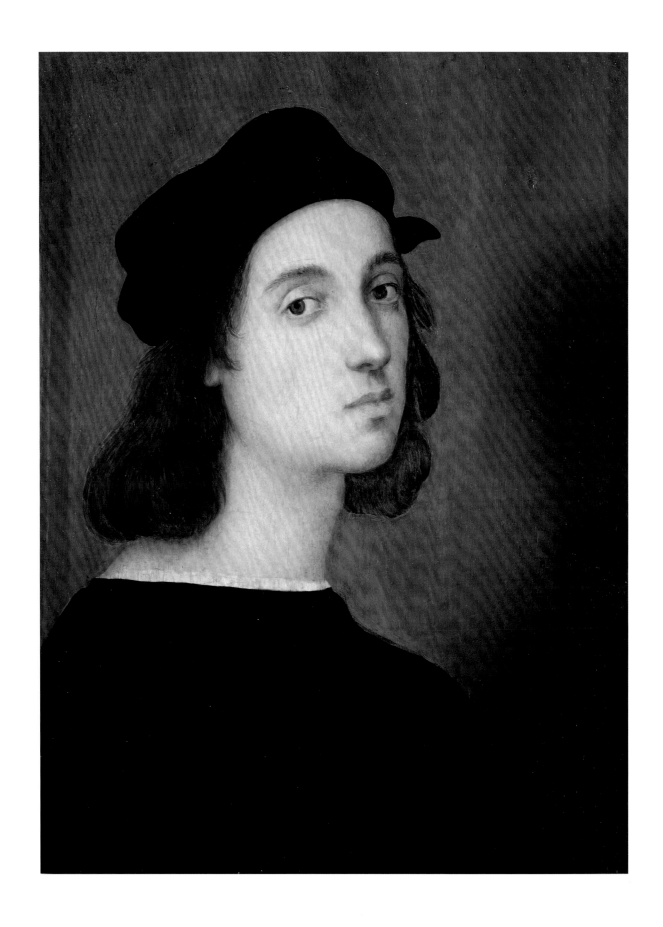

GIOVANNI SANTI (about 1440/5–1494)

3 A woman standing before rocks (The Muse Clio) 1480s

Pen and brown ink, brown wash, heightened with lead white, over stylus underdrawing
on green prepared paper, 24.6 × 18 cm
Rubbed along a fold in the middle of the sheet and some discolouration of the highlights, top left.
The Royal Collection, RL 12798

Raphael's father Giovanni Santi was a successful painter, poet and courtier (see pp. 18–21), but his reputation has suffered over time. Nevertheless this drawing, and the two paintings by Santi in the exhibition, demonstrate his importance to Raphael's formation and artistic culture.

The drawing shows a woman standing in front of an outcrop of rocks, and studies drapery, lighting and pose in a highly finished fashion. When it was acquired by the Royal Collection, the drawing was attributed to Mantegna, and the names of Botticelli and Perugino have also been

suggested in the past, indicating the esteem in which the drawing was held. While Giovanni Santi's graphic oeuvre is insufficiently defined to permit conclusive statements, this drawing is usually attributed to him because of its connection with the paintings of the Muses in the Tempietto delle Muse in the Palazzo Ducale at Urbino, which Santi was involved in around 1480–90. These Muses are now in the Galleria Corsini, Florence, and although some of them were not completed until the early sixteenth century, Santi was responsible for most, including the figure of *Clio*, the Muse of History (fig. 48).

Apart from similarities of pose and setting, the comparable lighting and the way that the highlights continue behind the figure in order to isolate her silhouette against the sky make a case for this drawing having been preparatory to the Tempietto *Clio*. Joannides rejected a specific connection, suggesting that the drawing was rather a generic model, but the factors outlined above suggest that it was made for the *Clio*, and was only subsequently reused in Santi's repertoire.[1] (The two figures are not, however, identical: the painting omits the fluttering ribbon and the winged headdress and adds classicising footwear.) If one accepts that the drawing was preparatory, then it should probably be attributed to Santi himself, and this is the present writer's opinion (based on a rather higher regard for Santi's talents than is commonly admitted). It is nevertheless possible that Santi's painting was based on a model supplied by someone else, since the drawing is of a much higher quality than the finished picture. The only other serious contender for the author of this sheet would be Perugino, a conclusion which would further support the idea of Santi's close involvement with him, help to explain Raphael's gravitation to the Umbrian artist's orbit, and establish an interesting precedent for Raphael's own provision of drawings to other artists (but the case is not proven). The difference in quality between this drawing and Santi's painting does not in any case rule out that he made it. Santi, in common with many other

artists, may have been more talented as a draughtsman than as a painter, which supports the view that from his earliest years Raphael learnt from a technically accomplished master. The Peruginesque qualities of the figure are, in either case, indicative of how Raphael could absorb Perugino's influence before any direct contact with him. TH

fig. 48 Giovanni Santi
The Muse Clio, 1485–90
Oil on wood, 82 × 39 cm
Galleria Corsini, Florence

NOTE

1 Joannides 1987. For the figure's reappearance in Santi's Fano *Visitation*, see Varese 1994, pp. 242–3.

SELECT BIBLIOGRAPHY

Popham and Wilde 1949, pp. 176–7, no. 28; Dubos 1971, p. 131; Ferriani 1983, pp. 150–5; Joannides 1987, p. 59; Varese 1994, p. 256; Clayton 1999, pp. 26–7, no. 1; Dalli Regoli 1999, pp. 46–7; Varese 2004, pp. 184–5.

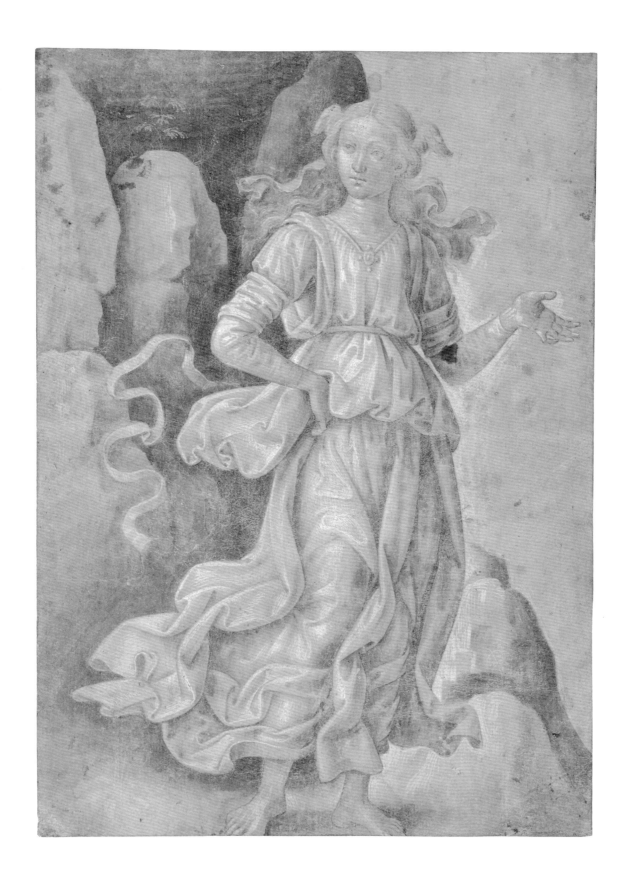

4 The Virgin and Child 1480s

Egg tempera and oil on wood, 67.8 × 48.8 cm
The National Gallery, London, NG 751

The finest among the surviving small-scale Madonnas by Raphael's father Giovanni Santi, this painting exemplifies several aspects of Santi's work that Raphael absorbed into his own stylistic vocabulary. Architectural structure in some form frequently underlies Santi's compositions. In this case, the picture is divided up by the curtains, the cloth of honour and the two parapets in front of and behind the Virgin, providing a framework within which the diagonally inclined figures are contained. Raphael adopted similar methods but developed them in a much more systematic way, often preparing his drawings and paintings by dividing them into quadrants. He was much more precise than Santi, who, for example, was not concerned to make the silver brocade cloth of honour exactly perpendicular or to match in size the squares formed by its folds.

Although Santi's grasp of anatomy was on the whole weak, certain graceful features of his figures find echoes in his son's early works. Several elements in cat. 4 recur in Raphael's paintings up to 1508, for example the ovoid, three-dimensional head of the Virgin, her carefully arranged left hand, prominent hemispherical eyelids, downcast crescent-shaped eyes, and lips parted to reveal her teeth (she is perhaps singing her child to sleep). Santi, who praised Jan van Eyck and Rogier van der Weyden as masters of oil painting in his rhymed chronicle, borrowed many of these features from Netherlandish painting, both studied directly and filtered through Piero della Francesca and Venetian painters such as Giovanni Bellini. The parapet, the cloth of honour and the rich textiles in cat. 4, as well as the landscape, with its clumps of spherical trees and distant blue mountains, are all typical of Northern European models (see for example fig. 49). Raphael's acute powers of observation and meticulous attention to detail made him even better equipped to emulate the subtleties of Netherlandish landscape painting, and his backgrounds are frequently enlivened by tiny figures, buildings, stretches of water and misty mountains.

Christ's sleep presages his death, and his coral necklace symbolises the blood he will shed during his Passion. Fischel noted that his recumbent pose, lying on a cushion on a parapet, with his head resting in the palm of his mother's hand and his arm hanging down limply, was an invention of Giovanni Bellini, whose *Virgin and Child* of about 1465 in the Isabella Stewart Gardner Museum, Boston, is very similar in design, but in reverse. Raphael also knew Bellini's composition, because he made a sketch of the sleeping child (even closer to the Bellini model), on a sheet of studies datable around 1508–9 in the Ashmolean Museum, Oxford.[1] It would appear that Raphael's tendency to assimilate styles and motifs from other artists may have been in part learned from his father. CP

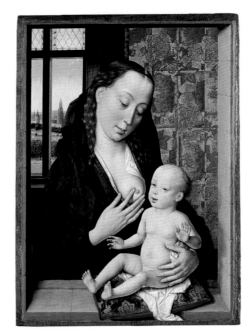

fig. 49 Dirk Bouts
The Virgin and Child, about 1465
Oil with egg tempera on oak, 37.1 × 27.6 cm
The National Gallery, London, NG 2595

NOTE

1 Joannides 1983, no. 132v.

SELECT BIBLIOGRAPHY

Crowe and Cavalcaselle 1864–6, II, pp. 588–9; Fischel 1939a; Davies 1961, pp. 463–4; Dubos 1971, p. 118; Martelli 1984, pp. 38–9; Varese 1994, p. 229; Dunkerton 1999.

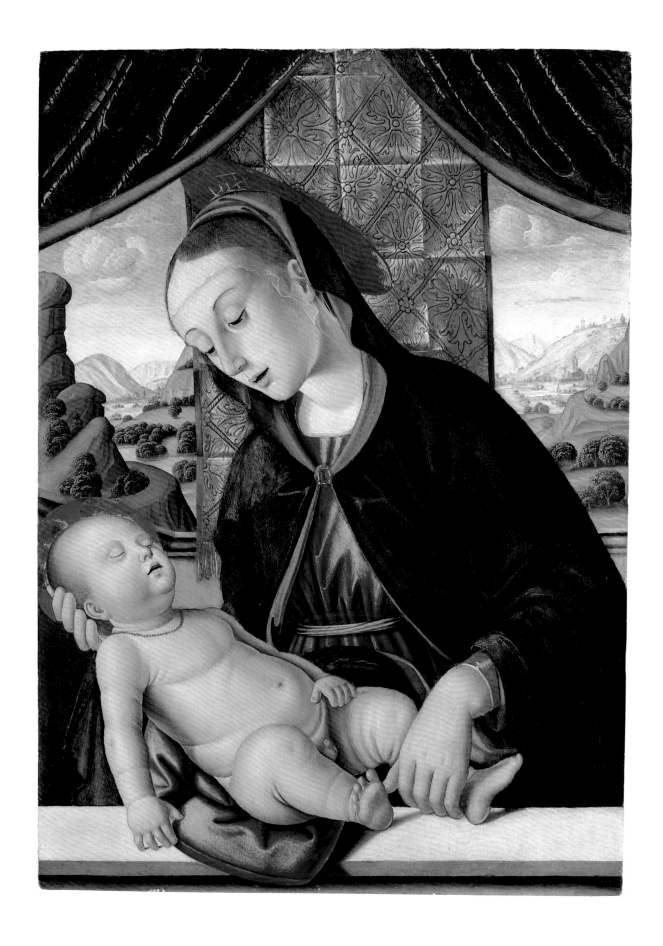

GIOVANNI SANTI (about 1440/5–1494)

5 The Dead Christ supported by Two Angels
about 1485–94

Oil on wood, 35 × 23.5 cm
Galleria Nazionale delle Marche, Urbino

The image of the dead Christ supported by two angels was common in Venice, The Marches and along the East coast of the Italian peninsula. It was intended to stimulate meditation on Christ's suffering, and was promoted by the mendicant orders, especially the Franciscans. The subject frequently appears in the crowning elements of altarpieces, and the iconography subsequently filtered down to independent devotional works, on a small or medium scale, and examples can be found in the work of Antonello da Messina and Giovanni Bellini (e.g. NG 3912), who seem to have been particularly influential on Giovanni Santi. He mentioned both artists in his rhymed chronicle, and would have known their work in Venice and elsewhere (Bellini's influence also lies behind cat. 4). This picture also reveals a knowledge of Netherlandish technique. Santi knew Justus of Ghent (Joos van Wassenhove) who worked in his hometown of Urbino in the 1470s, and his own work frequently demonstrates a response to Netherlandish models.

Although this picture has sometimes been attributed to followers of Santi, such as Evangelista di Pian di Meleto and Bartolomeo di maestro Gentile, it is much more likely to be by Santi himself.[1] There are no certain works by Evangelista, and the picture does not resemble the signed works of Bartolomeo,[2] while it can be convincingly compared with signed works by Santi. Such comparisons suggest a date in the last decade of Santi's career, during Raphael's early childhood.

Aspects of the colour and handling of Raphael's *Coronation of Saint Nicholas of Tolentino* altarpiece (see fig. 2) are closely comparable with this picture; and the Dead Christ here can also be compared with the figure of Adam in the Città di Castello banner (cats 18–19). The thick handling of paint, both in the flesh and in the draperies, is also reminiscent of Raphael's early works and the cumulative evidence points to Raphael having spent some of his earliest formative years as an apprentice in his father's shop.

The picture is said to have come from the church of San Donato in Urbino and to have been subsequently placed on the pulpit of the church of San Bernardino, just outside the city.
TH

NOTES

1 Ciartoso 1911, pp. 258–62, Van Marle 1933, pp. 493–503.
2 Martelli 1984, pp. 55–8.

SELECT BIBLIOGRAPHY

Dubos 1971, pp. 120–1; Varese 1994, pp. 244–5; Tempestini 1999, p. 173.

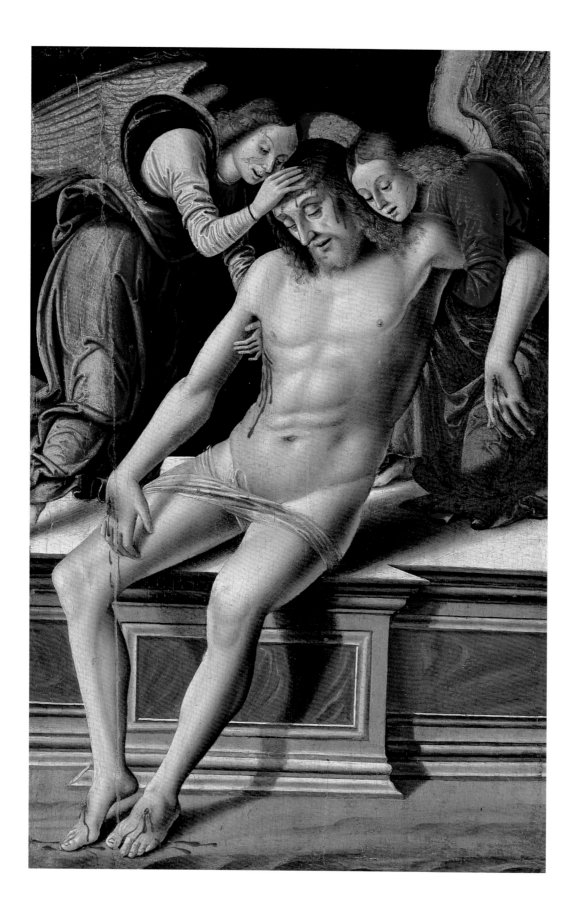

PINTORICCHIO (BERNARDINO DI BETTO) (about 1454–1513)

6 The Virgin and Child with Saint John the Baptist

about 1490–5

Egg tempera and oil on wood, 56.7 × 40.7 cm
Inscribed, on the scroll attached to Saint John the Baptist's cross:
ECCE / AGN / VS / DEI
The Fitzwilliam Museum, Cambridge, 119

This arch-topped panel of the Virgin and Child with Saint John the Baptist was probably painted as a private devotional work in the 1490s, either just before or just after the altarpiece for S.M. dei Fossi (or degli Angeli) in Perugia which was commissioned in 1495 (and where the main group is closely related but more sophisticated). The background here includes two groups of small-scale figures, which may or may not have a special significance. On the left there are soldiers with dogs, and on the right what appears to be an encounter outside a city gate (possibly the Visitation or the meeting of Anna and Joachim).

The picture's ornate style is typical of Pintoricchio (whom Berenson described as 'all tinsel and costume-painting').[1] Palm trees with exotic gilded fronds, verdant landscapes packed with narrative incident, and rich draperies with intricate stitched or gilded patterns, as found in this picture, are all characteristic features of Pintoricchio's art. These aspects of his style had an enormous success in papal Rome in the 1480s and 1490s, and were subsequently exported to other cities in Central Italy and beyond. Raphael became familiar with Pintoricchio's work (and his success) from their collaboration on at least two projects: the decoration of the Piccolomini Library in Siena, and an altarpiece of the *Coronation of the Virgin* painted for the church of S. Francesco in Fratta Perugina, modern-day Umbertide, both datable around 1502–3.[2] In both cases Raphael seems to have provided the much older artist with compositional and/or figural drawings, and Vasari specifically related this

provision of drawings to Raphael's early fame as a designer.[3] As a result it has become commonplace to comment on what Pintoricchio gained from this relationship, but Raphael also learned from the experience, as can be seen in his early Madonnas, such as the *Virgin and Child with Saints Francis and Jerome* in Berlin (cat. 25) in which he plainly responded to the style of Pintoricchio's religious paintings. The facial features can be compared, and Raphael also looked at the way Pintoricchio used motifs such as small crosses and books to add narrative interest to his compositions. In the Berlin painting, and in the Bergamo *Saint Sebastian* (cat. 26), Raphael also adopted some of the methods for decorating drapery (e.g. with gold stippling) which Pintoricchio had popularised in Umbria, and the idea of the fully clothed Christ Child was adopted by Raphael in the main panel of the *Colonna Altarpiece* (fig. 68).

Raphael must, however, have been aware of the limitations of Pintoricchio's art. The flatness caused by the gilding and the defective three-dimensionality of the figures would have been contrary to Raphael's sensibilities (as demonstrated by contrasting Raphael's drawings for the Piccolomini Library and the frescoes themselves, figs 7 and 8 and pp. 23–6). Pintoricchio's figures resemble cardboard cut-outs, whereas Raphael's always appear set in space. Pintoricchio would also fall back on formulaic solutions, while Raphael was always looking for novel ways to introduce greater emotional depth into his paintings. TH

NOTES

1 Berenson 1897, p. 93.
2 See pp. 21–6.
3 Vasari/BB, IV, p. 159: 'era stato allogato da Pio Secondo pontefice la libreria del duomo di Siena al Pinturicchio, il quale, essendo amico di Raffaello e conoscendolo ottimo disegnatore, lo condusse a Siena, dove Raffaello gli fece alcuni disegni e cartoni di quell'opera.'

SELECT BIBLIOGRAPHY

Ricci 1902, pp. 147–8; Earp 1902, pp. 156–7; Carli 1960, pp. 56–7, pl. 99; Goodison and Robertson 1967, pp. 133–4; Oberhuber 1977, pp. 69–72; Scarpellini and Silvestrelli 2004, pp. 227, 229.

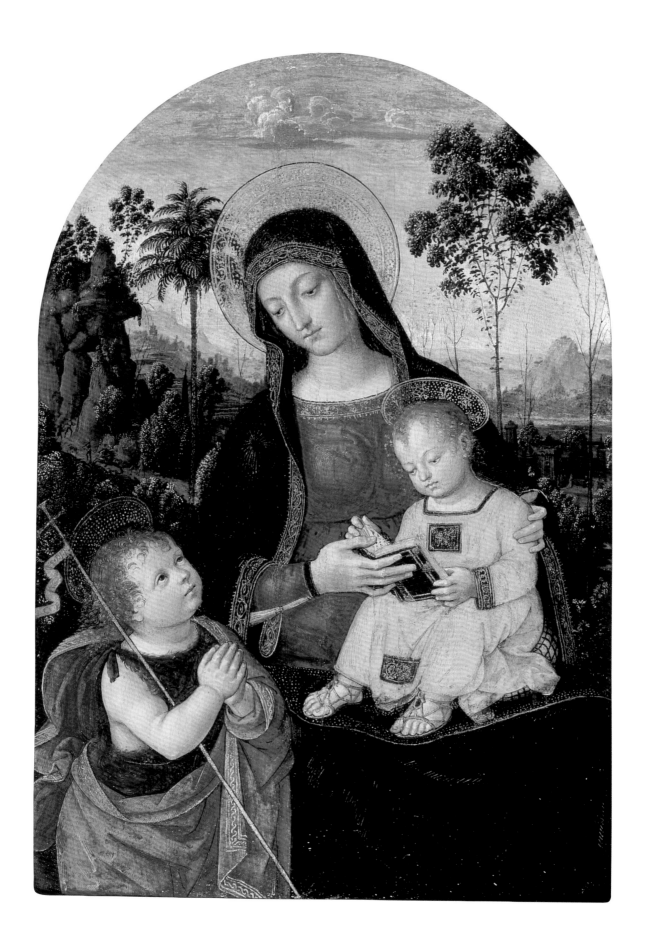

PIETRO PERUGINO (about 1450–1523)

7 Apollo and Daphnis 1490s

Oil on poplar, 39 × 29 cm
One or two small losses and some discoloured retouchings in the sky.
Musée du Louvre, Paris, RF 370

This small secular picture was probably painted to decorate the home of an educated patron, and its rich attention to detail, designed to appeal to such collectors, is found in other works of a similar type by Raphael, such as cat. 35. It is usually said to represent Apollo's musical contest with Marsyas, but it differs from the classical story in several respects. Del Bravo's suggestion that it might represent Apollo teaching Daphnis to play a reed pipe is a convincing alternative. Del Bravo (and Scarpellini) also suggests that the picture was painted for Lorenzo de' Medici (d. 1492), not least because Lorenzo was compared to Daphnis by Naldo Naldi, but there is no trace of this picture in any of the Medici inventories, and its early provenance is unknown (although a derivation in a picture by the Florentine artist Bacchiacca (1494–1557), in the John G. Johnson collection, Philadelphia Museum of Art, might imply that the picture was at one time in Florence).

In the second half of the nineteenth century this picture was perhaps the most controversial Old Master painting in existence. Its English owner Morris (known as 'Taste') Moore, an implacably fierce critic of the National Gallery, believed passionately that he owned a great early Raphael and did everything he could to try and prove it. Although he was supported by some influential authors, the National Gallery and others did not accept the attribution and in 1883 Moore sold his picture to the Louvre. The curators at the Louvre also had their doubts, but were rightly convinced that it was a masterpiece whoever had painted it. In recent years the picture has been unanimously attributed to Perugino (although as Haskell observed, this has been 'due more to quiescence than to absolute conviction'), and it appears to represent the artist at his very best. Almost more than his signed manuscript illumination (cat. 9) it shows that Perugino had an extraordinary miniaturist skill, in which he was emulated by Raphael. The tiny figures of the middleground, the strings of the lyre picked out in gold, and the carpet of tiny flowers, all find parallels in Raphael's work (e.g. cat. 35); and Perugino's graceful response to antique sculptural models as well as to Netherlandish landscape painting also influenced Raphael's early development.

A badly damaged preparatory drawing for the composition is in the Gallerie dell'Accademia, Venice (fig. 50). This drawing is on the same scale as the picture, but has some minor differences, such as the foliage crown that Apollo wears in the drawing, and the tree that divides the two figures. The seated figure is also partly dressed in the drawing, but nude in the painting (although infrared photographs show that he was drawn onto the panel with these minimal draperies – they are also visible to the naked eye at the top of his right leg). In addition, this figure has pointed ears, the attributes of a faun or satyr, which would identify him as Marsyas, not Daphnis. In the finished painting his ears are rounded (but this area of the picture has been damaged) and the identification as Daphnis is probably correct,

although it may have been a very late change to the picture's iconography.

The question of the painting's date has been bound up with the various views on its authorship and patronage. If it is by Perugino (and there have been no other serious contenders in recent times), the most likely period (based on the picture's quality and stylistic links with other works) would have to be the 1490s. This would not exclude a Medici provenance, but would recognise that the *Apollo* could also have been painted after Lorenzo's death.

In terms of its classical subject matter and tone, the picture is exceptional in Perugino's surviving oeuvre. There is evidence, however, that he painted other mythological subjects and a drawing of a classicising nude figure in the Uffizi, the so-called *Idolino*, shows a similar sensibility.[1] Perugino is also known to have been in contact with humanists and artisans with antiquarian interests (see further under cat. 8).

TH

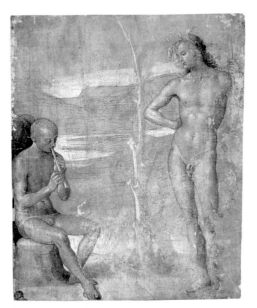

fig. 50 Pietro Perugino
Apollo and Daphnis, 1490s
Metalpoint, heightened with lead white, grey wash on pale pink prepared paper, 32 × 27 cm
Gallerie dell'Accademia, Venice, 198

NOTE

1 Ferino Pagden 1982, no. 54. The attribution of this drawing has been debated over time, but Ferino Pagden's reasons for preferring Perugino are convincing despite the arguments of Venturini 2004, pp. 354–5.

SELECT BIBLIOGRAPHY

Crowe and Cavalcaselle 1882–5, I, pp. 209–12; Del Bravo 1983, pp. 201–16, esp. pp. 211–12; Béguin 1983–4, pp. 133–6, no. 34; Ferino Pagden 1984, pp. 142–3, no. 54; Scarpellini 1984, p. 85, no. 49; Haskell 1987, pp. 155–74.

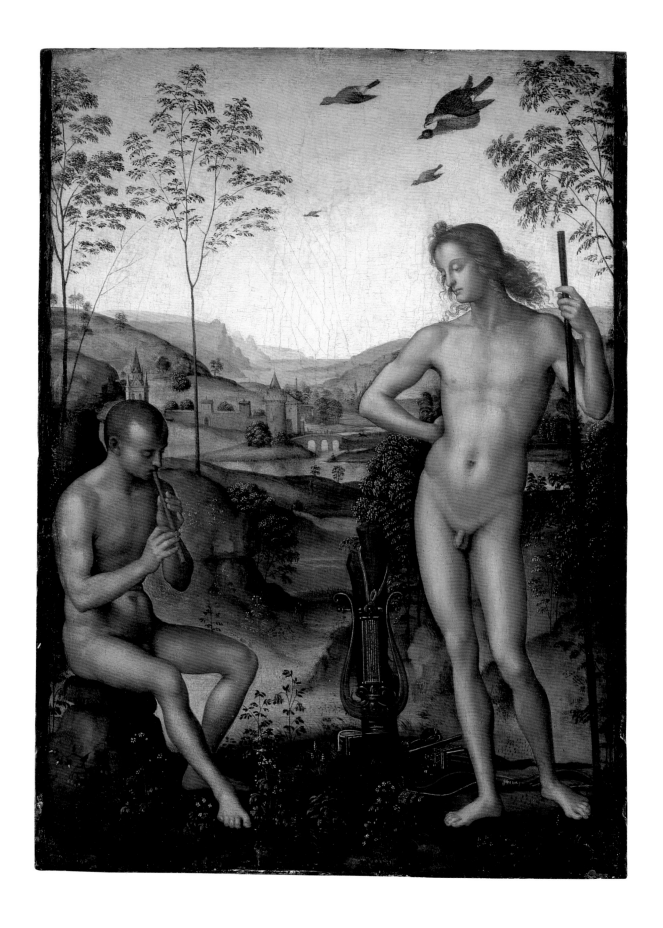

PIETRO PERUGINO (about 1450–1523)

8 Portrait of Francesco delle Opere 1494

Oil on close-grained (fruit?) wood, 53 × 44 cm
Restored in 1837, and again between 1965 and 1978. The panel has been cradled, but has not
been thinned (the reverse of the panel was, however, neatly planed at the time of painting).
Inscribed on the scroll held by the sitter: TIMETE DEVM ('Fear God')
Galleria degli Uffizi, Florence, inv. 1890, no. 1700

When in the collection of Cardinal Leopoldo de' Medici (1617–1675) this superbly well-preserved portrait was attributed to Raphael, but in the early nineteenth century it was recognised as the work of Perugino, and thought to be his self portrait. A fifteenth-century inscription discovered on the back of the panel in the 1830s confirmed the attribution to Perugino, but only when it was more fully transcribed in the 1870s did it become clear that the sitter was not Perugino, but a Florentine called Francesco delle Opere (the inscription, which is incised onto the panel, reads: *1494 di luglo | Pietro perugino pinse franc° de lopere [–lyno-go]*).[1]

Francesco di Lorenzo di Piero delle Opere was born in 1458, and died in Venice in 1496, so he would have been 36 years old at the time the portrait was painted. He came from a family famous for working silk, especially *'ad opera'*, that is, with intricate embroidery, from which their name 'delle Opere' was derived. However, Francesco was described in the 1480 tax return (*catasto*) as a leather worker (*choiaio*). His connection with Perugino may have been through his brother, Giovanni, who was called *'delle corniole'* because of his high reputation as a carver of cornelians and other gems. Perugino and Giovanni were to collaborate in June 1505.[2] If, like Giovanni (and indeed Perugino), Francesco was a successful artisan, both his dress and the sophisticated manner of his presentation here seem above his station in society.

The scroll in Francesco's right hand can be linked to the impact in Florence of the reforming Dominican friar Fra Girolamo Savonarola (1452–1498) in the months preceding the flight from the city of Piero de' Medici (November 1494). The words TIMETE DEVM announce the Last Judgement in the New Testament Book of Revelation, 14.7, and were used by Savonarola in his fiery sermons exhorting the Florentines to reform their ways. Francesco delle Opere's brother later carved Savonarola's posthumous portrait onto a gem,[3] and there seems every reason to believe that Francesco was actively demonstrating his penitential sympathies in this portrait. In fact the unfurled part of the scroll with its inscription may even have been added to make this explicit, since it was painted over the sitter's dark plum jacket.

The picture was probably painted in Venice where Francesco can be found from 1488, and where Perugino is otherwise recorded in August 1494.[4] Perugino was at the height of his powers in the 1490s. The handling of the oil medium – especially in Francesco's wonderfully asymmetrical face – and the controlled atmospheric perspective of the landscape background testify to Perugino's great technical virtuosity, and to his study of Netherlandish art (particularly the portraits of Hans Memling).[5] These qualities were clearly of great importance to Raphael, whose manner of painting portraits – especially in the years 1504–8 – owes much to Perugino's influence, as well as to the more often cited example of Leonardo. The way the sitter is posed against a receding landscape background, with a fireball of hair exploding from under his hat, can be compared, for example, with Raphael's portrait of *Agnolo Doni* in the Galleria Palatina, Florence (fig. 28). The positioning of the hands on a ledge that abuts the frame of the picture is another device borrowed from Netherlandish portrait painting, which was subsequently developed by Raphael (e.g. in *La Muta*, Palazzo Ducale, Urbino). Raphael also employs the mediating devices of the small trees on the left, and the reflective expanse of water in the middle-ground in other pictures (e.g. cat. 32). But it is above all the quality of the observation, the subtle dynamism of the angle at which the head is studied, the sophistication of the lighting of the face and the subtle description of highlights that mark out this portrait as one of Perugino's greatest works. TH

NOTES

1 'July 1494 Pietro Perugino painted Francesco delle Opere [*unintelligible*].' The last part of the inscription has never been properly deciphered.
2 Canuti 1931, II, p. 296.
3 Now in the Museo degli Argenti in Florence, inv. 321.
4 See Canuti 1931, II, pp. 165–6 and the discussion of Baldini 2004, pp. 250–1.
5 e.g. Memling's *Portrait of a Man* also in the Uffizi.

SELECT BIBLIOGRAPHY

Vermiglioli 1837, pp. 263–6; Vasari/BB, III, p. 604; Canuti 1931, I, pp. 89–91; Scarpellini 1984, p. 88; Gregori (ed.) 1984, pp. 208, 217; Campbell 1990, p. 233; Borchert 2002, p. 262, no. 104; Baldini 2004, pp. 250–1, no. I.40.

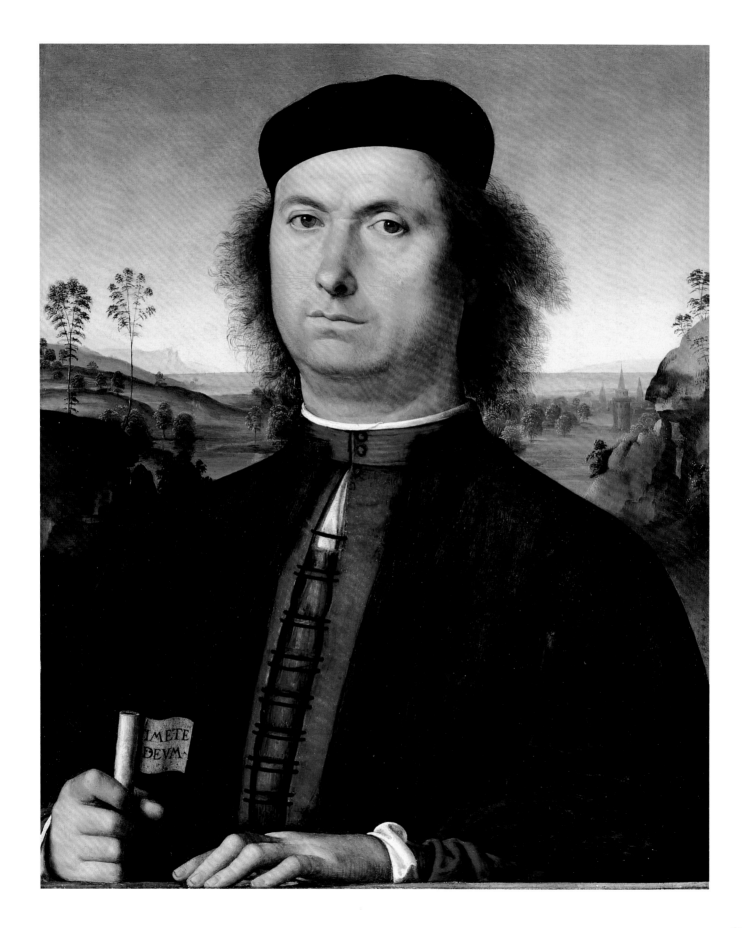

PIETRO PERUGINO (about 1450–1523)

9 The Martyrdom of Saint Sebastian
about 1500

Tempera, with gold highlights, on parchment, folio size 19.7 × 14.2 cm (painted area 18.7 × 13.3 cm)
Signed in gold, bottom centre: PETRVS · P[E]RVSINVS · PINXIT
The British Library, London, Yates Thompson MS 29, folio 132 verso

Saint Sebastian, a Roman officer who converted to Christianity and was martyred for refusing to renounce his faith, is shown tied to the trunk of a tree while two archers (in contemporary dress) aim their arrows at his body. Two angels appear in the sky above, with martyrs' palms and fluttering belts.

This manuscript illumination is, as far as we know, a unique example of Perugino working as a miniaturist, but it clearly demonstrates his skill on this scale. The tiny gold highlights on the arrows, quivers and sashes of the archers, as well as in the trees, the angels' draperies and in the hair of the saint and both angels, are also seen in the panel painting of *Apollo and Daphnis* (cat. 7), and are comparable with some of Raphael's early work. Both this illumination and the *Apollo* panel provide invaluable points of comparison for Raphael's paintings on the smallest of scales (e.g. cat. 35), and help to explain how the younger artist developed his extraordinary talent as a miniature painter.

Perugino successfully brought some of the most remarkable aspects of his paintings on a larger scale into this tiny image – the '*aria dolce*' of atmospheric perspective, the rich palette and *cangiante* effects in the draperies. The saint's body has been painted with a soft feathery touch that is unusual in Perugino's work of this date, but this can probably be explained by the demands of painting in the quick-drying technique of tempera. Despite the difference in scale, this illumination also provides interesting points of comparison in the composition and figures with Raphael's *Trinity with Saints* and the *Mond Crucifixion* (cats 18 and 27).

This illumination was originally bound into the Hours of Bonaparte Ghislieri as fol. 132 verso (it has now been detached from the rest of the book, which is also in the British Library), where it would have faced the beginning of the Office of the Holy Spirit. This Book of Hours was apparently written and illuminated in Bologna in the early years of the sixteenth century, and in addition to Perugino's single, signed illumination, there are miniatures by Amico Aspertini of Bologna, Matteo da Milano and others. There is some evidence that the book was completed before the death of Pope Alexander VI in August 1503, and it is certain that the patron was a member of the Bolognese Ghislieri family, probably Bonaparte (d. 1541), whose initials appear on fol. 16 recto.

The border of Perugino's illumination is unlike those in the rest of the Ghislieri Hours, and the miniature is also unusual in being so prominently signed. It has been suggested that the patron was 'trophy-hunting' signed works by the leading artists of the time, an unusual practice comparable to the collecting habits of Isabella or Alfonso d'Este. The fact that Perugino did not make any allowance for the other illuminations (which are, for the most part, stylistically homogenous), and that his miniature was not integrated with the text of the volume (its recto is one of the few blank pages in the book), support the idea that it was executed separately from the rest. Ghislieri is likely to have taken advantage of Perugino's connections with Bologna (the artist painted an altarpiece for the church of San Giovanni al Monte, around 1497–1501) when commissioning this miniature for his exquisite Book of Hours. TH

SELECT BIBLIOGRAPHY

Scarpellini 1984, pp. 103–4, cat. 116; Alexander 1994–5, pp. 222–3, cat. 117; Ciardi Dupré Dal Poggetto 2004, pp. 326–7, no. I. 64.

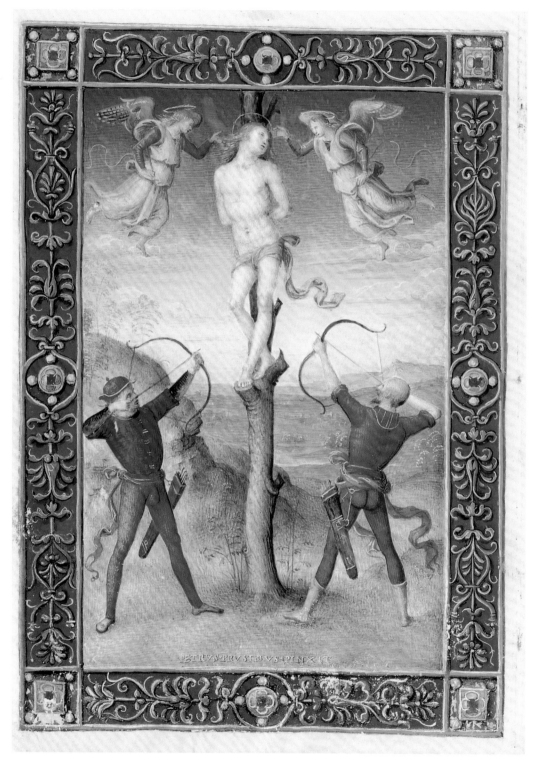

10 The Virgin adoring the Christ Child, the Archangel Michael, and the Archangel Raphael with Tobias about 1499–1500

Oil with some egg tempera on poplar, central panel 127 × 64 cm (cut down);
side panels 126.5 × 58 cm each (cut down)
Inscribed below the bottom pan of Saint Michael's scales in gold: PETRVS PERVSINV[S]/ PINXIT
The National Gallery, London, NG 288.1–3

Between 1490 and 1496 Duke Ludovico il Moro, the ruler of Milan, was looking for painters to decorate his castle in Pavia and the Carthusian monastery (the Certosa or Charterhouse) outside the city. Highly recommended by the Duke's agent as one of the best painters in Florence, 'an exceptional master [whose] works have an angelic and very sweet air', [1] Perugino was commissioned to paint an altarpiece for a side chapel in the Certosa dedicated to the Archangel Michael.

The altarpiece was a two-tier polyptych of which the three National Gallery panels formed the lower tier. All three have been cut, especially at the bottom, but their original appearance is recorded in copies that remain in the chapel. The Virgin adoring the Christ Child is flanked in the left-hand panel by the chapel's dedicatee Saint Michael standing triumphantly over Satan (largely cut away but for his horns, his pointed ear and left wing). A pair of scales for weighing the souls of the dead is slung over a small tree stump. The right-hand panel depicts another Archangel, Raphael, protector of travellers and venerated for his healing powers, with the youthful Tobias. The Archangel told Tobias to catch a fish, and extract its heart, liver and gall as a cure for his father's blindness. The gutted fish hangs from Tobias's wrist and the dainty box held by the angel contains these remedies.

It is likely that Perugino completed the National Gallery panels and the *God in Glory* of the upper tier (still *in situ* in the Certosa) soon after May 1499, when Duke Ludovico wrote to his representative in Florence demanding the imposition of a deadline. However, following the Duke's arrest by the invading French army three months later, work on the commission was interrupted. The remaining two panels depicting a third Archangel, *Gabriel*, and the *Annunciate Virgin* (now in the Musée d'Art et Histoire, Geneva) were eventually assigned to the Florentine painters Fra Bartolommeo and Mariotto Albertinelli in 1511.

The consistently high quality of these panels (indicative, at least in the principal figures, of

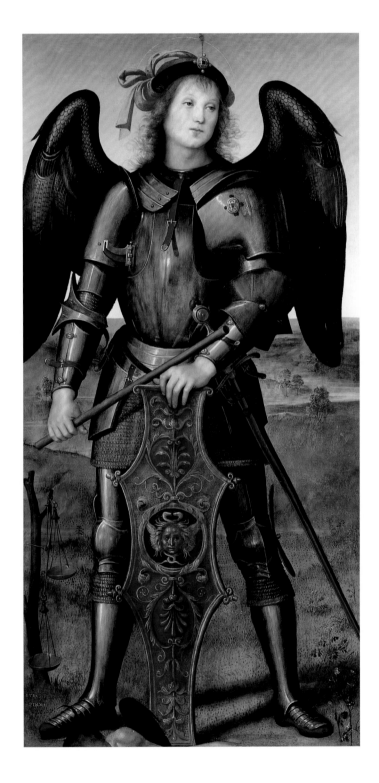

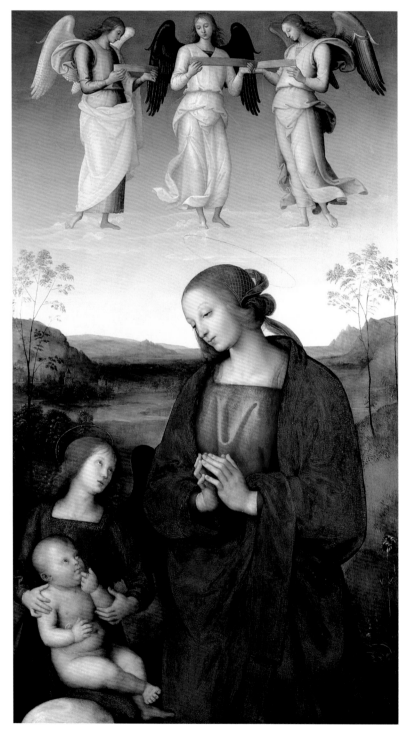

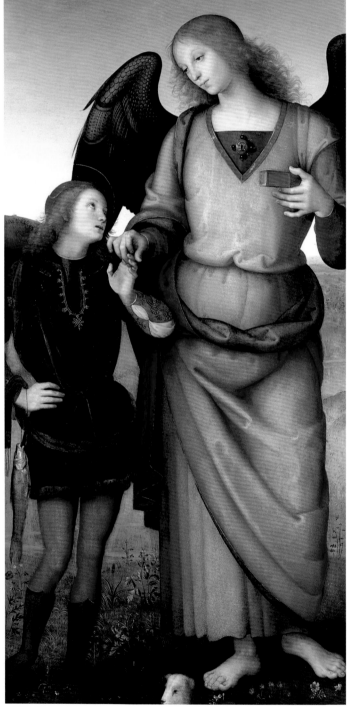

Perugino's own hand), the fact that specific new designs were made for them (see cat. 12), and the richness of the pigments used, demonstrate how much attention Perugino paid to this prestigious commission. The designs then entered his stock repertoire and recur in later projects such as the Vallombrosa altarpiece and the Collegio del Cambio.

Perugino's figure types as typified by the Certosa altarpiece, with their sweetly raised or inclined heads, gracefully classicising postures and simple volumetrically conceived forms, remained Raphael's principal models throughout his early years as an independent artist in Umbria (see cat. 27 and pp. 26–33). He even assimilated several of Perugino's quirks into his own stylistic vocabulary, such as the manner of painting a single eyelash emerging from the middle of the eyelid (see the figure of Tobias), the small pursed Cupid's bow lips (the Virgin) and the delicately arched little fingers (the Archangel Raphael). He also absorbed aspects of his master's (Netherlandish) technique, for example the method of painting flesh in very transparent layers, using only very small amounts of lead white, to achieve a soft luminous effect by allowing the white ground to glow through.

Perugino's methods of landscape painting were also imitated by Raphael throughout his pre-Roman period. The dreamy blues and greens of the landscape behind the Virgin in the Certosa panel, with a stretch of water and buildings emerging from behind trees, are re-evoked, for example, in the landscape of the *Mond Crucifixion* (cat. 27). Raphael also adopted Perugino's alternative, more schematic, method of landscape painting seen here in the flanking panels with the two Archangels. A hazy middle-ground with grass summarily indicated with dots and dashes is brought to life with carefully observed studies of wild flowers. The two types of landscape would become staples of Raphael's repertoire, perhaps most eloquently combined in his Florentine Madonnas and the Baglioni *Entombment* (fig. 34).

In the nineteenth century, critics identified Raphael's hand in parts of the polyptych, and proposed him as the author of cat. 12. However, the Certosa panels, in which (following Netherlandish models) oil paint is expertly manipulated to achieve subtle effects of light, texture and atmosphere, are of a technical and stylistic sophistication far beyond the young Raphael at this point in his career. Effects such as the reflections in the polished steel of Saint Michael's armour were mastered – and surpassed – by Raphael only at a later date, as for example in the dazzling steel greaves of the sleeping knight in cat. 35. Perugino's skill in depicting the softer textures of flesh, hair and fabric took still longer for Raphael to absorb – arguably not until after he came into direct contact with the Florentine milieu, above all with the works of Leonardo. The fish, hanging from Tobias's wrist (added at a late stage over the boy's tunic), is a *tour de force* of naturalistic painting of a kind rarely attempted by Raphael, with superbly observed highlights over its cheeks and gills and soft stippling with the brush to denote scales ranging from silver to brown. Perugino also introduced luxurious touches, such as the spotted fur trim around Tobias's rich green velvet tunic. Only after his arrival in Rome, where he came into direct contact with Venetian painters, did Raphael become more interested in conveying tactile qualities of this kind (see cats 99 and 101). CP

NOTE

1 'El Perusino Maestro singulare . . . le sue cose hano aria angelica, et molto dolce', Baxandall 1972, p. 26.

SELECT BIBLIOGRAPHY

Vasari/BB, III, p. 605; Passavant 1839–58, I, pp. 58–9, II, pp. 6–7; Canuti 1931, I, pp. 128–30; Davies 1961, pp. 403–7; Bomford, Brough and Roy 1980; Scarpellini 1984, nos 103–5; Fabjan (ed.) 1986; Dunkerton et al. 1991, no. 59; Hiller 1999, pp. 179–81; Butler 2002, pp. 54–5.

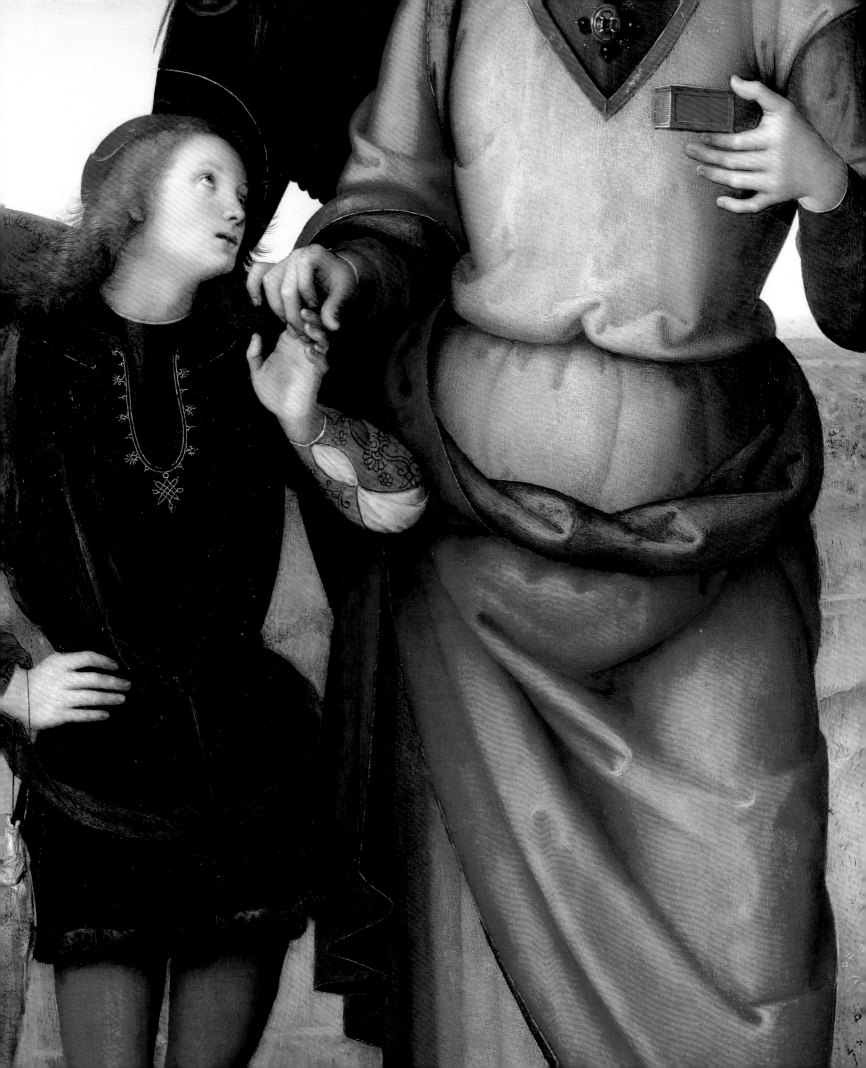

PIETRO PERUGINO (about 1450–1523)

11 A man in armour

about 1490–3

Pen and brush and brown ink over metalpoint, heightened with lead white on
blue prepared paper, 25 × 18.9 cm
Inscribed lower right, in pencil: *Masaccio*
The Royal Collection, RL 12801

The drawing corresponds in pose and virtually every detail of the armour with the figure of Saint Michael in the Certosa altarpiece (cat. 10), and must have been the model for it. However, it is unlikely to have been made specifically for that commission. Two drawings certainly preparatory for the project (cat. 12 and fig. 51) are lit, as is the altarpiece, from the left, whereas the delicate cast shadows and deftly applied white heightening in this study indicate a light source to the right. Furthermore, the head in the drawing is that of a mature man, with a fierce determined expression, whereas the painted Saint Michael is younger and more ethereal. The shield in the drawing (which Perugino seems to have invented as he drew, as suggested by the exploratory lines and arcs in metalpoint in this area) bears a screaming Medusa head, a generic motif worn by warriors to frighten their enemies (it appears on the shield of Horatius Cocles in the Collegio del Cambio, Perugia, and recurs in Raphael's work, see for example the statue of Minerva in the *School of Athens*, fig. 37). Saint Michael's shield in the painting has a winged head with snakes, the attributes of Mercury with whom Michael was sometimes associated because he was believed to have weighed the souls of ancient heroes in the underworld.

Since this splendid and very expensive suit of armour, probably of North Italian origin, would not have been a standard workshop prop, Perugino most likely made a record of it when the opportunity arose, posing his model in a stock pose based on Florentine representations of famous warriors. Such studies were carefully preserved in the workshop as valuable reference tools. Perugino himself reused the present design,

which may date from the early 1490s, at least three times over that decade. Apart from the Certosa altarpiece, commissioned around 1497, it also served for the figure of Lucius Sicinius among the antique heroes in the Cambio in Perugia, painted around 1498, and for another Saint Michael in the *Assumption of the Virgin*, for S. Maria at Vallombrosa, dated 1500, although both these figures wear more fanciful classical armour. The figure was known to Perugino's pupils, for example Lo Spagna, who used it for one of his soldiers in the background of the *Agony in the Garden* in the National Gallery (NG 1032). Raphael adapted the pose, but not the details, for one of a group of soldiers in a drawing for the Piccolomini Library of around 1502 (fig. 9).

The man's warlike attitude, characterised by the alert turn of the head and wide-legged stance, reflects Andrea del Castagno's fresco of the famous Florentine *condottiere* Pippo Spano, from the series of famous men and women that formerly adorned the loggia of the Villa Carducci at Legnaia, outside Florence.[1] The position of the shield and the hand resting upon it recall Donatello's marble statue of *Saint George*, made for the niche of the Armourers' Guild on Orsanmichele, Florence, a sculpture that also greatly interested Raphael (see cat. 47).

The technique of making preparatory studies in metalpoint on prepared paper was probably transmitted to Raphael in Perugino's workshop. Only occasionally in his early drawings did he make use of lead-white heightening, as Perugino does here, to create an impression of three-dimensionality (see cats 23–4), though he adopted this more frequently after his move to Rome. CP

NOTE

1 Horster 1980, p. 31, pl. VI.

SELECT BIBLIOGRAPHY

Fischel 1917, no. 54; Popham and Wilde 1949, no. 21; Ferino Pagden 1986b; Meyer zur Capellen 1996, pp. 128–9; Clayton 1999, no. 5 (biblio) and under no. 6; Perugia 2004, pp. 360–1.

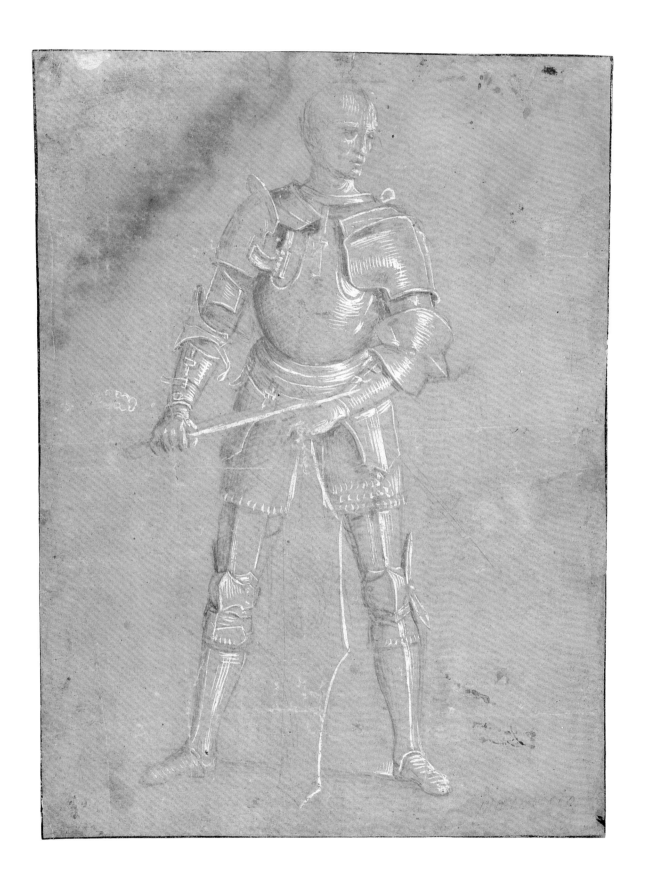

12 Studies for the Archangel Raphael with Tobias

about 1499–1500

Metalpoint heightened with lead white (partly discoloured)
on pale cream prepared paper, 23.8 × 18.3 cm
Some staining; the top left corner made up.
The Ashmolean Museum, Oxford. Presented by a Body of Subscribers, 1846. 3 P II 27

This sheet shows how Perugino studied live models to work out the interrelated poses of the Archangel Raphael and the young Tobias in the Certosa altarpiece (cat. 10). The models were almost certainly *garzoni* – apprentices or assistants – wearing everyday clothes, which Perugino adapted imaginatively in the painting. The adult posing as the Archangel Raphael wears a knee-length tunic, with a leather belt slung low over his left hip, marking the line of the drapery in the finished work, while a boy apprentice in a fitted jacket, codpiece and hose models for Tobias. The pair are lit from the left, in anticipation of the eventual illumination of the altarpiece, the chiaroscuro built up in subtle gradations of multi-directional metalpoint hatching, and lead-white highlights applied with a fine brush.

In the blank spaces surrounding the principal study are a number of subsidiary sketches in which the hands of the angel and the head of Tobias are studied in greater detail. In the largest blank field above the boy's head is a beautiful study of the figures' joined hands. Perugino worked hard at perfecting this key passage, which epitomises the angel's gentle and graceful guardianship of his tender charge. Compared to the main study, the position of the boy's hand is raised so that more of the palm is visible and the angel's little finger is delicately crooked, refinements that feature in the painting. In the top right corner is a more detailed study for the angel's left hand holding the box with the fish's heart, liver and gall.

Down the left-hand side of the sheet are two further studies for Tobias's head. Beside the equivalent passage in the main study is a rapid sketch in which Perugino adjusted the angle of the head, tilting it further back and placing it in three-quarters view. This was presumably to correct the unhappy coincidence of the boy's chin with the hand of the angel in the principal study. In the painting, the interval between the child's head and the two hands is judged to perfection. Studies, on a sheet in the National-museum, Stockholm (fig. 51), for the angel holding Christ in the central panel of the altarpiece, are based on the same *garzone*, his head held in a very similar pose.

In the space below the boy's elbow, bottom left, Perugino made a more detailed study for Tobias's head in the new pose. This vivid life study was the direct inspiration for Tobias's dreamy expression of trust and wonder in the painting. The upward tilted head in three-quarters view was to become a stock pose for Raphael too, and indeed the head of the angel in his first altarpiece commission, the *Coronation of Saint Nicholas of Tolentino* (cat. 17), may be modelled on that of Tobias.

Life study was to become fundamental to Raphael's method of preparation. He adopted the practice of making drawings from *garzoni* as early as 1500–1, in studies for the Saint Nicholas of Tolentino altarpiece, and life models in tight jackets, codpiece and hose recur in drawings throughout his career. Moreover, he never abandoned the habit first learned in Perugino's workshop of making detail studies of heads, hands and feet in the margins of figure studies (see fig. 14 and cat. 84). CP

fig. 51 Pietro Perugino
Studies for an angel holding Christ, about 1499–1500
Metalpoint, heightened with lead white, 18 × 14.7 cm
Nationalmuseum, Stockholm, NM H 286/1863

SELECT BIBLIOGRAPHY

Robinson 1870, p. 129, no. 16 (as Raphael); Parker 1956, II, no. 27; Ferino Pagden 1986b; White, Whistler and Harrison 1992, no. 2.

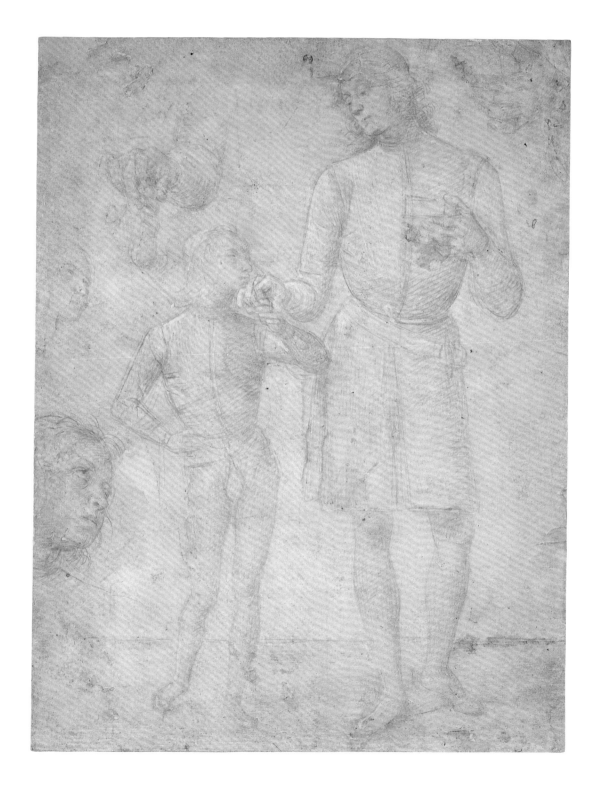

13 Roundels of the Virgin Mary and Saint Peter
about 1500–2

Pen and brown ink over stylus underdrawing, the figures pricked for transfer, 10.3 × 17.2 cm
Kupferstichkabinett, Staatliche Museen zu Berlin-Preußischer Kulturbesitz, Berlin, KDZ 494

This carefully finished drawing was evidently made in preparation for painting the roundels of a processional cross (the figures have been pricked for transfer), and it may even have been preparatory to cat. 14. The two figures have been drawn half-length in circular frames (these frames have been indented into the paper using a compass which has left a pricked hole in the centre of each roundel). Like the Poldi Pezzoli processional cross they are lit from the left. Saint Peter's downcast gaze strongly suggests that he was going to be shown in a roundel above the crucified Christ, just as he appears in cat. 14. The roundels are approximately 8 cm in diameter: bigger than the painted equivalents in cat. 14

which are 6 cm in diameter but not so much bigger that a connection between the two must be ruled out (the drawing could have been made without having the wooden cross to hand).

The female figure was designed for a position on the left and is probably intended for the Virgin Mary, who occupies this position on the Poldi Pezzoli cross. The quality of the drawing of this figure is weaker than that of Saint Peter, but it has been suggested that her forms have been simplified to concentrate on her gestures of grief (towards her crucified son, who would have been shown to the right). The attribution of this drawing to Raphael is supported by comparison with a number of other early pen and ink drawings

by him (e.g. cat. 36). It can also be compared with Raphael's drawings in the Ashmolean Museum, Oxford, for the Norton Simon *Virgin and Child* (fig. 10) which would indicate a date of about 1500–2. The coincidence of lighting, scale and date, and the prominence given to Saint Peter, suggest a connection with cat. 14, whether or not the cross was actually painted by Raphael.

Although a specific connection with the Poldi Pezzoli cross cannot be proved, the drawing clearly demonstrates that Raphael was involved in the production of this type of object at this early point in his career, which might bolster the attribution of the cross to the young artist. T H

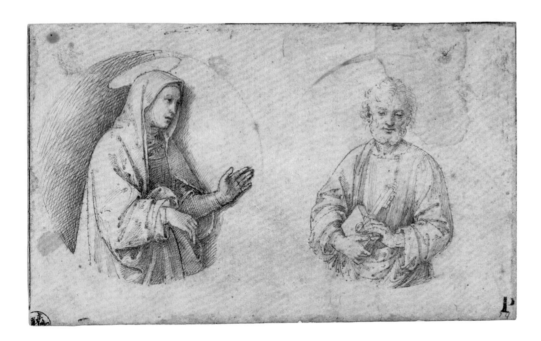

SELECT BIBLIOGRAPHY

Fischel 1913–41, I, p. 61, no. 39; Joannides 1983, p. 140, no. 30; Knab, Mitsch and Oberhuber 1984, p. 590, no. 94.

ATTRIBUTED TO RAPHAEL

14 Processional Cross

about 1498–1502

Tempera and gold on wood, maximum dimensions 46.8 × 33.5 cm
Painted on both sides. Small losses and repaints are evident,
especially in the blue backgrounds.
Inscribed below Saint Peter on the front face: S.P.; and above the cross on the reverse: INRI
Museo Poldi Pezzoli, Milan, 4129 (d.t. 733)

This double-sided cross was designed to be carried around a church during religious ceremonies. Both sides depict Christ crucified. The front face also represents in the trilobate ends of the arms of the cross (clockwise, from the top) Saints Peter, John the Evangelist, Mary Magdalene and the Virgin Mary. The reverse represents Saints Louis of Toulouse, Claire, Anthony of Padua and Francis, all of whom are Franciscan saints, establishing that the cross came from a Franciscan foundation. The prominence given to Saint Peter might suggest that it was painted for a church dedicated to that saint, but its early provenance is not known. It entered the collection of Emilio Visconti Venosta before 1897, and was left by his heirs to the Museo Poldi Pezzoli in 1982.

The painted areas of the cross have been variously given to Pintoricchio and to Perugino, as well as to Raphael, and to anonymous assistants of all three. It has justly been observed that two artists may have worked on the cross, and that the reverse is of a lower quality than the front face. The figure of Christ on the front, with the graceful contour of his torso, the careful shading under his arms and the delicate depiction of the blood emerging from his wounds, is of high quality (and can be contrasted to the pedestrian nature of the same figure on the reverse). The four figures on the ends of the cross on the front face are also more delicately painted than on the reverse, and are much more successfully related to the crucified Christ. Although the best of the figure painting on the front is of a notable quality, an attribution to Raphael is difficult to accept on the basis of this work alone. The picture may well represent a very early work by the artist – dating from the late 1490s – but the case partly depends on the attribution of a small group of panels, including the predella of a Perugino altarpiece in the church of S. Maria Nuova in Fano (which is probably not by Raphael) and a *Resurrection* in São Paulo, Brazil (cat. 21). The style of the figures on the cross appears to be particularly closely related to those in the *Resurrection*, here attributed to Raphael partly on account of the three autograph drawings for the picture (see cats 22–4). The Poldi Pezzoli cross can also be related to a drawing by Raphael in the Kupferstichkabinett, Berlin (cat. 13). Although there is no precise figural connection with the Berlin drawing, its existence proves, at the very least, that Raphael was involved in the design of an object of this type. Infrared photography of the cross has also revealed an underdrawing that bears some comparison with other works by Raphael (although this evidence has not been very clearly published).

The cross and the *Resurrection* have never until now been seen together, nor have they ever been exhibited alongside so many certain Raphaels, and it is hoped that the opportunity to study the pictures in this context might help to resolve the debate over their attribution. The crucified Christ can also be compared with the *Mond Crucifixion* (cat. 27) and with Raphael's work on a small scale (cats 25, 32, 35), as well as with miniature works by Perugino (cats 7 and 9). Whether or not Raphael played any part in the execution of this processional cross, there is plenty of evidence that he was famed as a designer from early in his career, which opens up a number of possible avenues for explaining how the cross might have originated, and casts fascinating light on Raphael's development and youthful fame. The date of the cross is not at all clear, and that proposed here is based entirely on the possibility that it is a very early work by Raphael.
TH

SELECT BIBLIOGRAPHY

Volpe 1956, pp. 3–18; Dussler 1971, pp. 64–5 (biblio); Scarpellini 1984, p. 49; Gregori 1987, pp. 649–55; Mottola Molfino 1985, pp. 11–20; Natale 1987, pp. 310–11; Meyer zur Capellen 2001, p. 305, no. X-5.

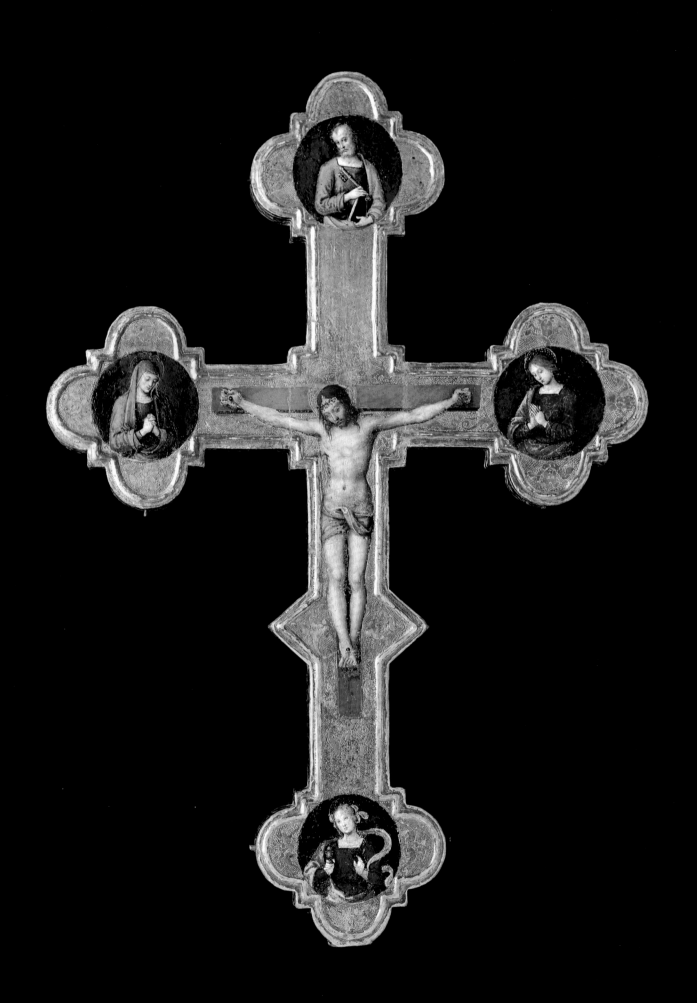

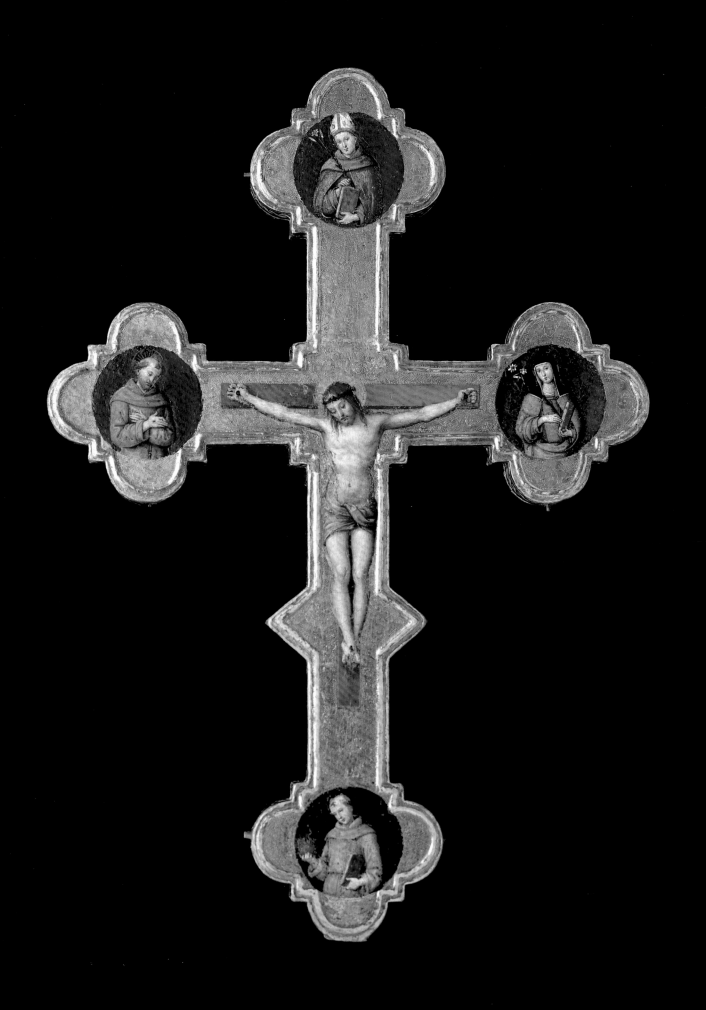

15, 16 God the Father; The Virgin Mary 1500–1

Oil on wood, 112 × 75 cm (*God the Father*), 51 × 41 cm (*The Virgin Mary*)
Museo Nazionale di Capodimonte, Naples, 50Q

In 1912/13 Oskar Fischel identified these hitherto anonymous fragments as surviving parts of the lost altarpiece of the *Coronation of Saint Nicholas of Tolentino* (see further under cat. 17). The altarpiece was commissioned by Andrea Baronci, a wool merchant, for his chapel in the church of Sant'Agostino in Città di Castello in December 1500. Two artists, Raphael and the older Evangelista di Pian di Meleto, were paid a total of 33 ducats for the finished picture in September 1501.[1] The church of Sant'Agostino was largely destroyed by an earthquake in 1789. Although other altarpieces in the church survived, Raphael's suffered so much damage that it was subsequently cut into several fragments, four of which survive: these two panels, and the busts of two angels in the Pinacoteca Tosio Martinengo, Brescia, and the Louvre, Paris (figs 2 and 54).[2] Our knowledge of the appearance of the altarpiece is supplemented by a free copy made by Ermenegildo Costantini in Rome in 1791 (fig. 52), which omitted all the figures in the top half of the composition, a sensitive description of the picture by the art historian Luigi Lanzi, and a number of preparatory drawings (including cat. 17). The various reconstructions that have been proposed demonstrate that the altarpiece was very large – 3.9 × 2.3 metres (almost double the height of the Ansidei altarpiece, cat. 45).

There has been considerable debate regarding the authorship of the surviving fragments, and the contract for the altarpiece gives very few clues about the division of labour between Raphael and Evangelista (except that Raphael is named first and as a master). The figure of God the Father was described as '*maestosissimo*' by Lanzi, and Fischel among others largely accepted the two Naples panels as the work of the young Raphael. Other scholars have been reluctant to accept his authorship, suggesting Evangelista instead,[3] but have taken as Raphael's work the Brescia *Angel* with its beautiful flowing curls, subtle *cangiante* colours and more typically Raphaelesque features. Attempts to identify Evangelista's role are handicapped by the absence of any certain works by him, but he may have

had a hand in some of the less important passages (especially in the top half of the picture). The preparatory drawings (see cat. 17 where the drawings are discussed) are, however, by Raphael and his overall responsibility for the altarpiece is not in doubt. Moreover, the somewhat laboured painting of the present fragments (not over-looking the presence and expression of the two figures) is not inconsistent with Raphael's earliest work when he was still in the mould of his father's workshop and as yet untouched by Perugino's subtlety. This is especially clear in the use of bright greens and reds that are typical of Santi, and rare in Perugino. It is also clear that Raphael had access to his father's studio props – in particular a bejewelled crown which makes

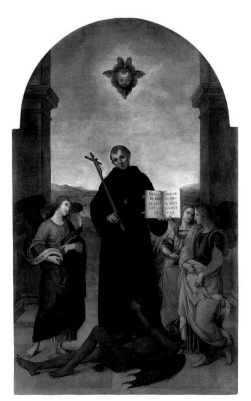

fig. 52 Ermenegildo Costantini
**The Coronation of Saint Nicholas of Tolentino
(after Raphael)**, about 1791
Oil on canvas, 310 × 176 cm
Pinacoteca Comunale, Città di Castello

three appearances in these two panels (slightly varied each time) as well as in works by Santi, including the Buffi altarpiece in the Galleria Nazionale, Urbino, and the Tiranni frescoes in S. Domenico, Cagli (fig. 3).[4] There are also points of connection between the thickly painted and characterful figure of God the Father and Signorelli's work of this period, for example his *Lamentation* in the Museo Diocesano, Cortona.[5]

Both of Raphael's figures have double haloes, a common feature of his work at this time (see cats 18 and 27), and they also appear in the other surviving fragments of this altarpiece (figs 2 and 54). Another feature of the picture, and one that is very important for Raphael's subsequent development, are the grotesques painted on the arch behind the figures (which Lanzi described as '*alla mantegnesca*'). This style of decoration, which had been pioneered by the generation of Pintoricchio, Perugino and Signorelli – inspired by antique frescoes and sculpture in Rome – also appears in the *Conestabile Madonna* (cat. 32) and was subsequently taken to unimagined heights of sophistication in the Vatican under Raphael's direction.[6] T H

NOTES

1 Shearman 2003, pp. 71–4.
2 Highly plausible proposals for the early nineteenth-century where-abouts of another fragment (the profile bust of Saint Augustine, whose right hand can be seen in the bottom right-hand corner of the *God the Father*) have also been made by Leone De Castris 1999, p. 206.
3 Longhi 1955, p. 17, Ferino Pagden and Zancan 1989, p. 15, De Vecchi 2003, p. 36.
4 Butler 2004.
5 Henry and Kanter 2002, Pl. XIV, pp. 142–3.
6 e.g. in the Stufetta and Loggetta of Cardinal Bibbiena: Jones and Penny 1983, p. 194.

SELECT BIBLIOGRAPHY

Lanzi 1795–6, I, pp. 378–9; Fischel 1912, pp. 105–21, esp. pp. 108–10; Dussler 1971, pp. 1–2; Jones and Penny 1983, pp. 12–13; Béguin 1986, pp. 15–28; Mercati 1994, pp. 13–15; Spinosa 1999, pp. 205–7; Hiller 1999, pp. 42–6; Meyer zur Capellen 2001, pp. 98–105, nos 1A and B; Henry 2002, pp. 268–78.

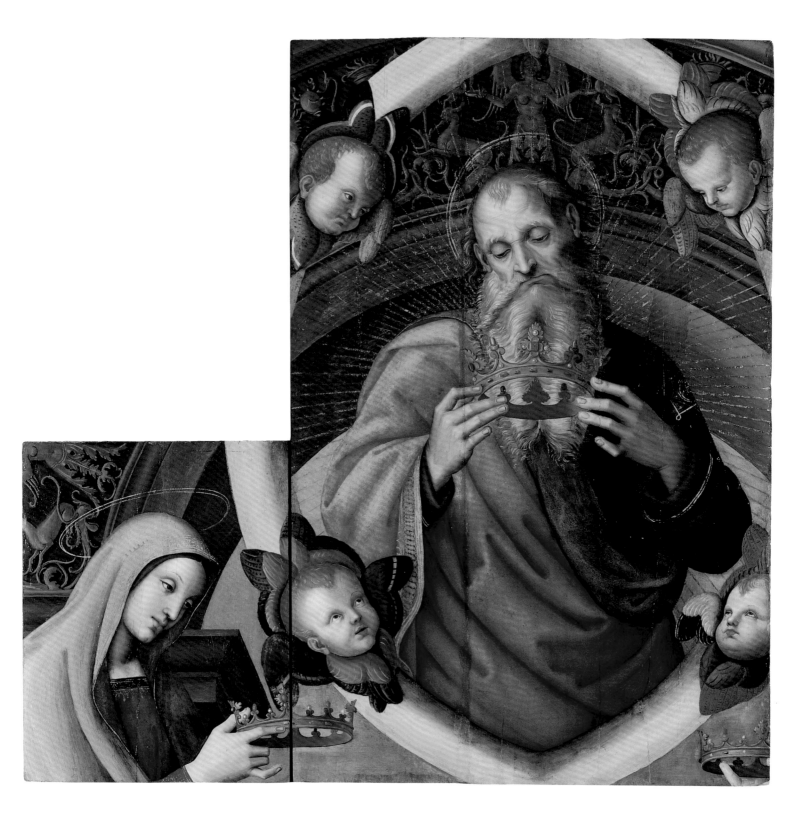

17 Studies for the Coronation of Saint Nicholas of Tolentino
about 1500–1

Recto: black chalk over stylus indications, with some pricking along a vertical centre-line,
and squared in black chalk.
Verso: black chalk, pen and light brown ink, 39.4 × 26.3 cm
Musée des Beaux-Arts, Lille, inv. PL 474 (recto) and 475 (verso)

The studies on this double-sided sheet are for an altarpiece of the *Coronation of Saint Nicholas of Tolentino*, Raphael's first documented work (now largely destroyed). The altarpiece showed Saint Nicholas holding the Bible and a crucifix and trampling on the devil, flanked by four angels. God the Father was represented above, with the Virgin Mary and Saint Augustine to either side. These three figures held crowns above Saint Nicholas's head, his reward for upholding God's word. Nicholas of Tolentino (1245–1305) was an Augustinian friar and frequently featured in Augustinian altarpieces (he also occurs in Raphael's later study for an altarpiece in Frankfurt, cat. 31), but the subject of his coronation is quite rare at this date, especially combined with his victory over Satan. This innovative approach to altarpiece design recurs throughout Raphael's work (e.g. in the Oddi *Coronation of the Virgin*, fig. 13, which combines an Assumption and a Coronation).

This drawing is of great sophistication and technical interest. Raphael began by mapping out the architectural background with a straight edge and a compass, using a sharp stylus to leave an almost invisible structure on the sheet before any elements were actually drawn (a favourite and unobtrusive method for establishing designs). The precision of this initial stage can be seen in the almond-shaped mandorla around the figure of God the Father, but Raphael also used his stylus to sketch the figures in the upper part of the drawing, freehand, before they were drawn. This is most clearly seen in the figure of Saint Augustine, who was incised without a mitre, which was subsequently added in chalk (the incisions appear as thin white lines under the chalk). All the figures were drawn in black chalk, but they demonstrate varying degrees of finish and a striking variety of touch. This ranges from light hesitant investigation at the bottom (where Saint Nicholas's legs are tried in three different positions), to confident detailed description at the top of the sheet (where the figures are worked up more fully than elsewhere). There is also some broad reworking – very much

like that found in Luca Signorelli's drawings – in the figure of Satan, itself closely related to Signorelli's painted oeuvre. The way in which Raphael has used black chalk to fix poses and investigate lighting also recalls Signorelli's studies in the same medium, indicating, perhaps, that Raphael owned drawings by the older artist.

The last addition to the recto was a grid, ruled at 30 mm intervals, 13 squares high by 8 squares wide. This process of 'squaring up' was usually preparatory to transferring the design onto another drawing or enlarging it onto a finished cartoon or painting support (see also fig. 95). In this case there must have been an intermediate stage before any full-scale enlargement, since the composition is still incomplete. Raphael may have originally envisaged a much more sparse composition, or this sheet might point to his economy of design where one cherub could stand for many cherubim, and one angel for several. Eventually four or five cherubim and four angels were shown, and Satan's orientation was changed. Other changes involved the transformation of the workshop assistants who served as models into the figures seen in the altarpiece. God the Father, for instance, is a clean-shaven young man in a contemporary costume with a codpiece in this drawing, but he was always going to be painted as old, bearded and generously draped; and the Virgin Mary also appears to have been based on a young man. It was common practice in Renaissance workshops to use male models for all the figures, and it is not until later that Raphael started to use female models. Saint Augustine is the only figure to have been given any identifying attributes (he is shown in full ecclesiastical vestments), perhaps because of his significance as the titular saint of the church for which the picture was destined. His head was also studied a second time, higher up the sheet.

The principal drawing on the verso is a study for the head of Saint Nicholas (or perhaps God the Father, and apparently based on the same model used for this latter figure on the recto), but there are also chalk studies of drapery solutions for the legs of one of the angels on the left, and

fig. 53 Reconstruction of the lost altarpiece for the church of Sant'Agostino, Città di Castello, with surviving fragments shown in blue (drawing by David Ace)

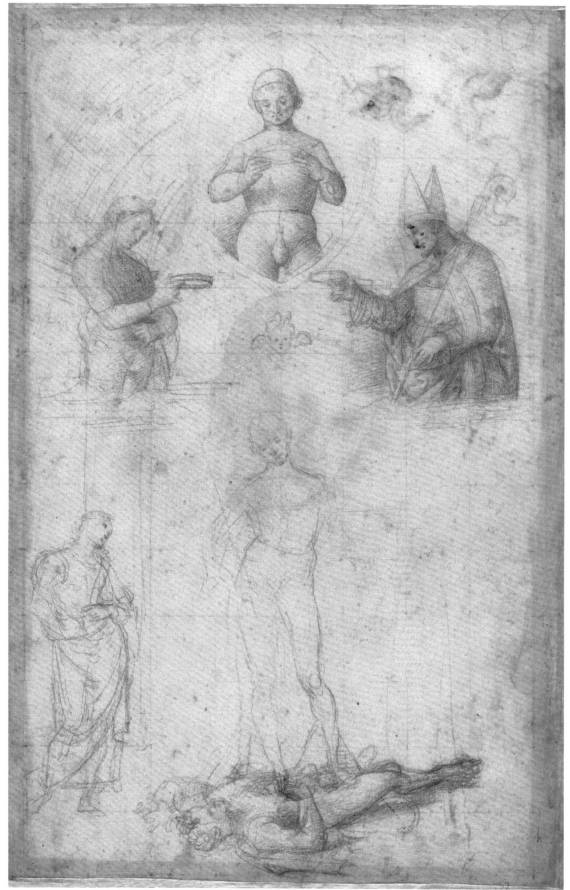

Recto

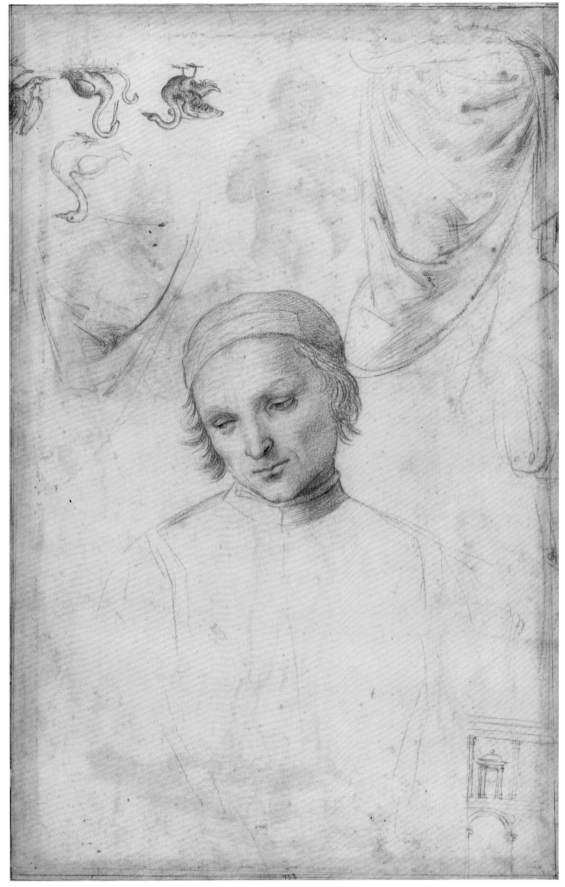

Verso

ink sketches of a swan, a duck, an eagle (?) and
a stork, apparently attacking a snake (top left),
and of a façade (bottom right), but seemingly
drawn at a different moment.[1]

The study of a male face demonstrates
Raphael's precocious ability as a draughtsman
and as a portraitist. As he is studied here the saint
may have made eye contact with his vanquished
adversary squirming beneath his feet, but this
was not the case in the finished picture. One
can see in this sheet how Raphael was already
developing a style that gave his figures a sense
of calm and a characteristic sweetness which can
also be seen in the surviving painted fragments
(e.g. fig. 2).

A number of other preparatory drawings
survive for this important altarpiece, and they
demonstrate how Raphael would make particular
types of drawings for different aspects of his
commission. These include a double-sided sheet
in the Ashmolean Museum, Oxford (P II 504),
showing two full-length figures and careful
studies of the hands of Saint Nicholas and Saint
Augustine (again using black chalk). Another
drawing survives in the Louvre, Paris (inv. 3870),
and shows a forceful head, perhaps intended for
that of Satan.[2] TH

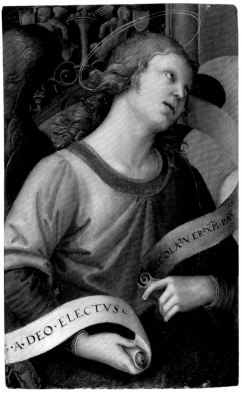

fig. 54 **Angel with Scroll**, 1500–1
Oil on wood, 58 × 36 cm
Musée du Louvre, Paris, inv. RF 1981–55

NOTES

1 The birds have been related to cat. 21, which includes a stork and
a snake, separately, and to studies from embroidery, or copies
from Perugino's frescoes in the Collegio del Cambio, Perugia. The
architectural sketch demonstrates Raphael's interest in architecture
from a very early date, and has been linked to creative copies
after the courtyard of the Palazzo Ducale at Urbino, to a painted
Annunciation by Perugino in the Ranieri collection, Perugia, and
to the façade of Spoleto Cathedral.

2 For these two drawings see Joannides 1983, nos 17 and 18.

SELECT BIBLIOGRAPHY

Crowe and Cavalcaselle 1882–5, I, pp. 139–40; Magherini Graziani 1897,
pp. 266–8, 371–3; Fischel 1913–41, I, nos 5–6; Joannides 1983, pp. 38–41,
137, no. 14; Frommel (ed.) 1984, p. 112, cat. 2.1.1; Béguin 1986, pp. 15–28;
Gilbert 1986, pp. 113–14; Brejon de Lavergnée 1997, pp. 177–8; Henry
2002, pp. 268–78.

18,19 The Trinity with Saints Sebastian and Roch; The Creation of Eve about 1500–2

Oil on canvas, 167 × 94 cm (each)
The two sides of the banner were separated in 1632, and have been relined and restored on several occasions.[1]
Inscribed at the top of the cross in the *Trinity*: INRI
Fragmentary letters – including a prominent 'R' – on the hem of God the Father's cloak in the *Creation*.[2]
Pinacoteca Comunale, Città di Castello

These two canvases were painted as a double-sided processional banner or *gonfalone* for the confraternity of the Holy Trinity in Città di Castello. Both retain their original framing borders (a gilded variant of a Greek Key motif). One side shows the Trinity with Saints Sebastian and Roch, two saints whose protection was commonly invoked at times of plague. The other depicts the Creation of Eve, with God the Father plucking a rib from the sleeping Adam's flank to create his female companion. Two cherubim flank the Trinity, and two angels appear above the Creation. Both scenes are lit from the left and are set in a verdant landscape.

The *gonfalone* was first recorded and attributed to Raphael in 1627 in the confraternity church of S. Trinità, and was subsequently described in most early manuscript and published guides to Città di Castello. The red capes worn by the company may have influenced how God the Father and Saint Roch are depicted. It is not clear why the Creation of Eve appears on the other side of the banner, but one might speculate that the subject related iconographically to scenes from the Creation and Fall painted on the walls of the church (these paintings were destroyed in 1695).

There are very few documentary references to the confraternity of the Holy Trinity in Città di Castello in the period of Raphael's activity. It had been in existence since 1266, had about 35 members and administered a hospital in Città di Castello, as well as the confraternity church (acquired in 1454). The confraternity's principal feast-day was the Feast of the Holy Trinity (10 June) and the company regularly participated in processions on the feast of Corpus Domini and on Good Friday. Raphael's banner would have been carried aloft during these civic processions, which helps to explain the poor condition of the paintings.

The painted surface was further damaged when the two sides of the banner were separated in 1632 and has suffered subsequent wear and tear, relining and restoration. There are huge losses where the bare canvas is visible, revealing some liquid underdrawing. Despite this damage, the surviving passages of original paint are of high quality. The flesh painting is very delicate, for example in the faces of the figures in the *Creation*, and the hands of Saint Roch, and the sense of depth is impressive. The clouds on which God the Father sits and rests his feet in the *Trinity* are very striking, as is the dawn light that breaks over the landscape. Both backgrounds include a lake or river, but claims that shepherds or animals can be made out are fanciful; as is the suggestion that the distant town in the *Trinity* can be identified as Città di Castello.

There are strong points of comparison with the *Mond Crucifixion* of 1502–3 (cat. 27; e.g. in the crucified Christ, and the angels in the *Creation*) and the figure of *God the Father* in Naples and the *Angel* in Brescia, both of 1500–1 (cat. 15 and fig. 2; these can be compared to the figures in the *Trinity*). The banner is usually dated between 1499 and 1504, with most writers preferring a date about 1499–1500/1 (which would make the picture the artist's first known work). Attempts to date the pictures more precisely by reference to the incidence of plague in Città di Castello in these years overlook the fact that plague struck the city several times in this period, and the iconography of the two plague saints (Sebastian and Roch) was appropriate to the administrators of a hospital at any time. In recent years the picture has sometimes been dated between the *Coronation of Saint Nicholas of Tolentino* of 1501 (cat. 17) and the *Mond Crucifixion* of 1502–3. Individual motifs can be related to both pictures, but it is likely both on stylistic and historical grounds that the banner was painted around 1500–2, in other words closer to the *Nicholas of Tolentino* than the *Crucifixion*, and during the period when we know that Raphael was working for Città di Castello.

The two angels in the *Creation* have been compared with Perugino's angels in Lyon (Musée des Beaux-Arts; formerly Perugia, S. Pietro, commissioned 1495), and in the Collegio del Cambio, Perugia (1498–1500), but Raphael's angels are both more varied and more clearly defined than Perugino's at this date. Their drapery is more closely related to Giovanni Santi's *Muses* in the Palazzo Corsini, Florence (see fig. 48) than to Perugino, and other aspects of the picture's style also recall Santi (compare, especially, the head of Adam with the *Dead Christ supported by Two Angels*, cat. 5) – aspects which all favour a relatively early date for the banner.

Two preparatory drawings survive, one in the Ashmolean Museum, Oxford (cat. 20), and the other in the British Museum (fig. 6). Both demonstrate Raphael's early interest in Signorelli's art. T H

NOTES

1 The first recorded restoration was in 1767; the last in 1983.
2 These have been interpreted as a signature but it is impossible to extract a version of Raphael's name from these letters.

SELECT BIBLIOGRAPHY

Conti 1627, p. 179; Certini 1726–8, fols 315r–322v; Mancini 1832, I, pp. 71–4; Crowe and Cavalcaselle 1882–5, I, pp. 135–8; Magherini Graziani 1897, pp. 219–34, 349–50; Oberhuber 1977, pp. 65–7; Marabottini 1989, pp. 170–2; Meyer zur Capellen 2001, pp. 105–8, nos 2A and B.

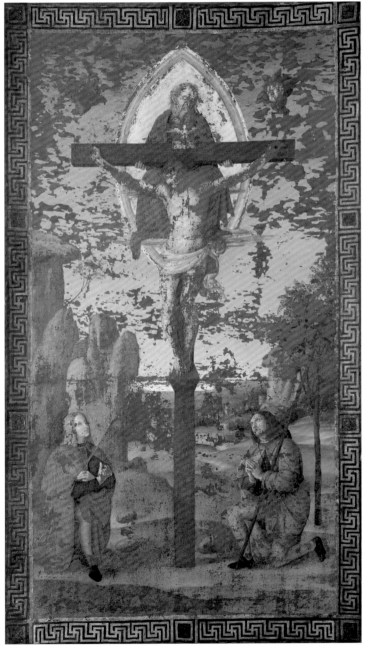

18

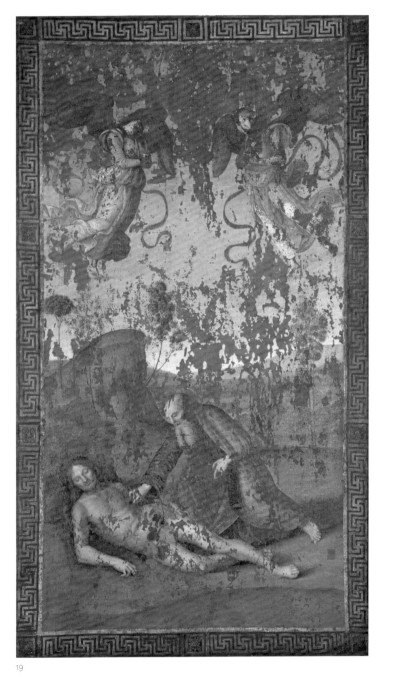

19

20 Back view of a standing man; the drapery of a kneeling figure

about 1500–2

Pen and ink and black chalk, 25.4 × 21.6 cm
The Ashmolean Museum, Oxford. Presented by a Body of Subscribers, 1846. 145 P II 501

The left-hand drawing on this sheet is a copy after a figure in a painting by Luca Signorelli and the right-hand figure is a study for God the Father in the *Creation of Eve* (cat. 19). The two drawings are different in type and are drawn with quite distinct techniques. Raphael used a pen when making a careful copy of an existing model (concentrating especially on the outline and flowing rhythm of the figure), and powdery black chalk when planning the lighting and drapery of a figure in one of his own compositions.

Raphael's investigations of light and drapery in the chalk study found expression in the finished work. In a drawing for the *Creation* in the British Museum (fig. 6) Raphael had experimented with representing God the Father standing, probably bearing in mind the more traditional solution of Eve rising fully formed out of Adam's side.

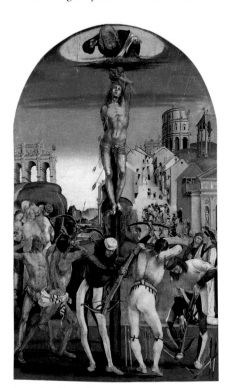

fig. 55 Luca Signorelli
The Martyrdom of Saint Sebastian, about 1498
Oil on wood, 288 × 175 cm
Pinacoteca Comunale, Città di Castello

Raphael drew this study for God the Father's cloak after deciding to show him bending over the sleeping Adam and removing one of his ribs to form Eve. The underlying figure is only sketched in very lightly as this was not the artist's principal concern here – instead he concentrates on the definition of drapery folds through tonal modelling. The pose of the figure had already been established and there are only very small variations between this drawing and the finished painting, designed to give a slightly increased sense of movement.

The left-hand sketch is an interpretative copy after one of the crossbowmen in Signorelli's *Martyrdom of Saint Sebastian* of 1498 (fig. 55), painted as an altarpiece for the church of S. Domenico in Città di Castello (now in the Pinacoteca Comunale). Raphael's study shows that he visited Città di Castello when painting pictures for the city, and that he made sketch copies after the most up-to-date models available. Indeed Signorelli's picture can be seen to have influenced the composition of the *Mond Crucifixion* which eventually faced it across the nave of S. Domenico. Raphael seems to have been attracted by the exaggerated *déhanchement* of Signorelli's figure. He paid particular attention to the definition of the left leg – the upper torso and right leg are (like the body of God the Father in the other sketch) scarcely indicated at all. It has justly been observed that 'the contour in fact is much livelier than in Signorelli's original',[1] and Raphael has drawn the figure naked, indicating the tendons and hatching around the volumetric forms of the leg with parallel strokes – in effect correcting the anatomical anomalies of the painted figure. A further study after this figure is recorded on the verso of a drawing by Raphael at the Musée des Beaux-Arts, Lille.[2] Raphael incorporated lessons he had learnt from Signorelli's altarpiece into other early works, for example in the *Sposalizio* (fig. 12) and in the predella of the *Oddi Coronation*, now in the Vatican.

The verso of this sheet has various pen and ink studies of a Virgin and Child with the infant Saint John the Baptist, and of fortified city walls,

fig. 56 **Studies of the Virgin, Child and Saint John; sketch of a building**, about 1500–2
Pen and brown ink (verso of cat. 20)

a church and a campanile (fig. 56). The figure sketches have been imprecisely related to works by Perugino and Pintoricchio, while the buildings are sometimes said to derive from prints by Schongauer. They are also related to the Duomo of Città di Castello which was being built when Raphael visited the city. Raphael also tried out the opening words of a letter ('*Carissimo*', '*Carissimo quanto fratelo*'),[3] perhaps to test a new pen, or to rehearse a gracious greeting to a close friend. TH

NOTES

1 Joannides 1983, p. 34.
2 Inv. PL 442/3 (Joannides 1983, no. 34v). The motif also recurs on a drawing in the Ashmolean Museum, Oxford, P II 503v (Joannides 1983, no. 3v).
3 'Dearest', 'Dearest as a brother'.

SELECT BIBLIOGRAPHY

Passavant 1860, II, p. 502, no. 491; Robinson 1870, pp. 114–15, no. 5; Crowe and Cavalcaselle 1882–5, I, pp. 116–19; Fischel 1913–41, I, pp. 35–6, nos 2–3; Parker 1956, II, pp. 252–3, no. 501; Gere and Turner 1983, p. 29, no. 9; Joannides 1983, pp. 34, 36, no. 11; Knab, Mitsch and Oberhuber 1984, p. 581, nos 5–6; Gilbert 1986, pp. 110–11; Camesasca 1993, pp. 61–2.

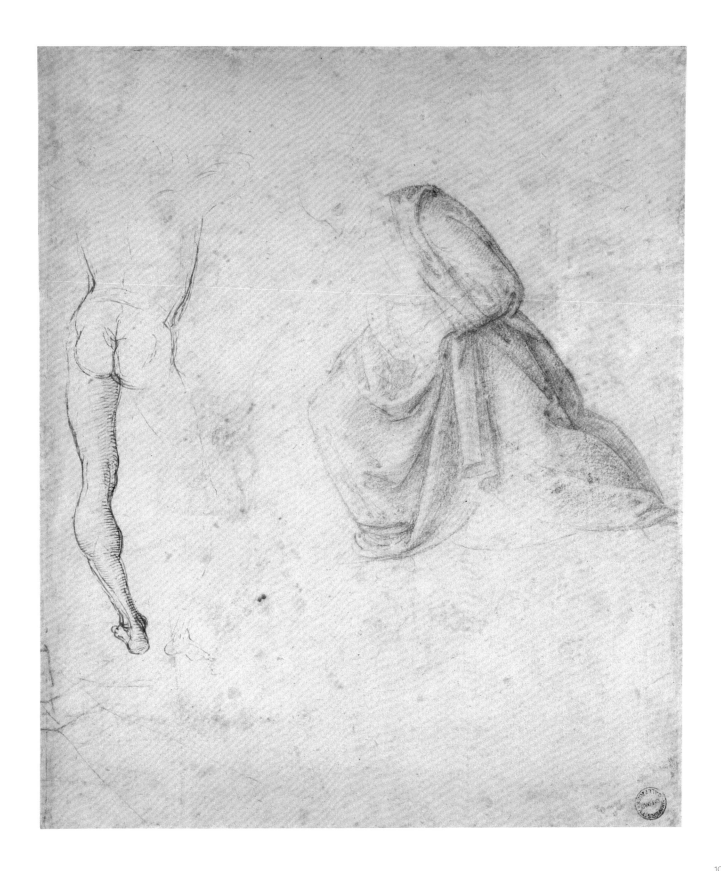

21 The Resurrection of Christ

about 1501–2

Oil on wood, 52 × 44 cm
Painted on a single board, cut at all four edges outside a double ruled and incised border.
No significant losses except under Christ's chin and above the tip of the right-hand angel's wing.
Inscribed on the reverse: *Museo, B.R. Museo, Restato al Sig. Conte*, and, in black ink, a much older, possibly sixteenth-century inscription of a name starting with the initials J[. . .] M[. .]¹
Museu de Arte de São Paulo Assis Chateaubriand, São Paulo, 17.1958

This beautiful painting, here acknowledged as an autograph work by Raphael, has yet to gain universal acceptance in the scholarly literature, principally because it has rarely been seen, having remained in remote locations for most of its recorded history. Indeed, this is the first time the painting has been displayed in the context of other works by Raphael, and of several drawings which are preparatory for it (cats 22–4).

Nothing is known of the painting's first owner (though it was surely intended for private devotion), nor indeed of its whereabouts before Wilhelm von Bode saw it in the collection of Lord Kinnaird at Rossie Priory, in Perthshire, Scotland, in 1880. He pointed it out to Crowe and Cavalcaselle, who consigned it to a footnote in their monograph of 1882.² The picture was not mentioned in print again until 1954, despite J. van Regteren Altena's astute observation in 1927 that it was related to two sheets of studies by Raphael in the Ashmolean (cats 23–4).³ It was sold with a large part of the Kinnaird collection at Christie's, London, in 1946 under an implausible attribution to Mariano di Ser Austerio, a minor follower of Perugino.⁴ The painting subsequently passed through the dealer Tomàs Harris and was acquired through Knoedler's in New York (as Raphael) by the Museo de Arte de São Paulo in 1954. Touring exhibitions of masterpieces from São Paulo in 1954 (Europe), 1957 (America) and 1987 (Italy) led to more widespread acceptance of the painting as an autograph work by Raphael.⁵ However, the picture also had its detractors and attributions to Perugino (or an anonymous follower of his), Evangelista di Pian di Meleto and Timoteo Viti have also been proposed. The painting's very high quality, and the many technical, stylistic and compositional features consistent with other early works by Raphael, together with the recent discovery of a third sheet of related autograph studies (cat. 22), and a free underdrawing full of intelligent revisions, present conclusive evidence for the young artist's authorship.

As told in the gospels, the scene takes place 'at the rising of the sun' in a garden near Golgotha on the third morning after Christ's death. Pilate's guards scatter in amazement and fright at the sight of the risen Christ hovering above the tomb in which he was buried, flanked by two angels who point heavenwards. In the distance, Mary Magdalene and the other Holy Women approach, bearing 'spices and ointments' to anoint the body, little suspecting that they will find the tomb empty. This narrative emphasis explains why the picture has mistakenly been classified as a predella scene in the past.⁶

Although probably painted before his twentieth year (for the dating of this picture to around 1501–2 see cat. 22), the composition already reveals Raphael's precocious inclination for balanced composition and harmonious design. The four guards, three Holy Women and two angels are arranged about the risen Christ with a sensitive symmetry, enlivened by the variety of their poses. There is nevertheless a certain naïvety in the way the figures are dispersed, with little attempt to integrate them within the whole or make them relate to each other, attesting to Raphael's relative inexperience. His youthful enthusiasm is also evident in the way he filled the picture with enlivening details, inserting animals and flowers in any available spaces late in the painting process, an instinct he curbed in the more distilled creations of his maturity.

The foreground is dominated by Christ's spectacular white marble tomb, inlaid with panels of red, green and yellow veined marble, its displaced lid made of a fourth orange and pink marble. The architecture of the tomb, with its Doric pilasters, unusual foot and *all'antica* lid, reveals Raphael's innate flair for architectural design. The landscape, with its rhyming zigzags of river and path, is reminiscent of many of Raphael's backgrounds (see cat. 27).

The interweaving of elements taken from the gospel narratives with symbolic embellishments of his own invention is characteristic of Raphael. The stork in the background is a traditional emblem of piety and self-sacrifice, while the snake in the foreground is a clear reference to the Fall, which Christ here redeems.⁷ The snail

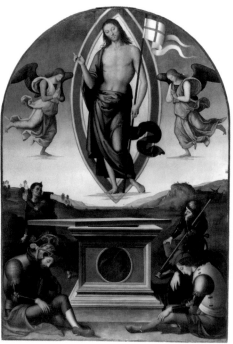

fig. 57 Pietro Perugino
The Resurrection, 1499
Oil on wood, 233 × 165 cm
Vatican Museums, Vatican City, inv. 318

in the right foreground probably stands for one born without sin since snails were thought not to mate. A lily standing for purity grows by a gushing spring – traditionally a source of spiritual life and therefore salvation. In the bottom left corner is a dandelion, a symbol of Christian grief, which appears in many later paintings by Raphael (see further, cat. 74). Even the *all'antica* gilt dolphins on the lid and the anthropomorphic fish supporting the body of the tomb with their tails may contribute to the picture's meaning, since the sign of a fish traditionally symbolised faith in Christ, and was also associated with the Resurrection.

Close examination of the surface reveals further elements characteristic of Raphael. In terms of technique, one notes the familiar double haloes, the fine gilded ornament on the hems of Christ's and the angels' robes, the

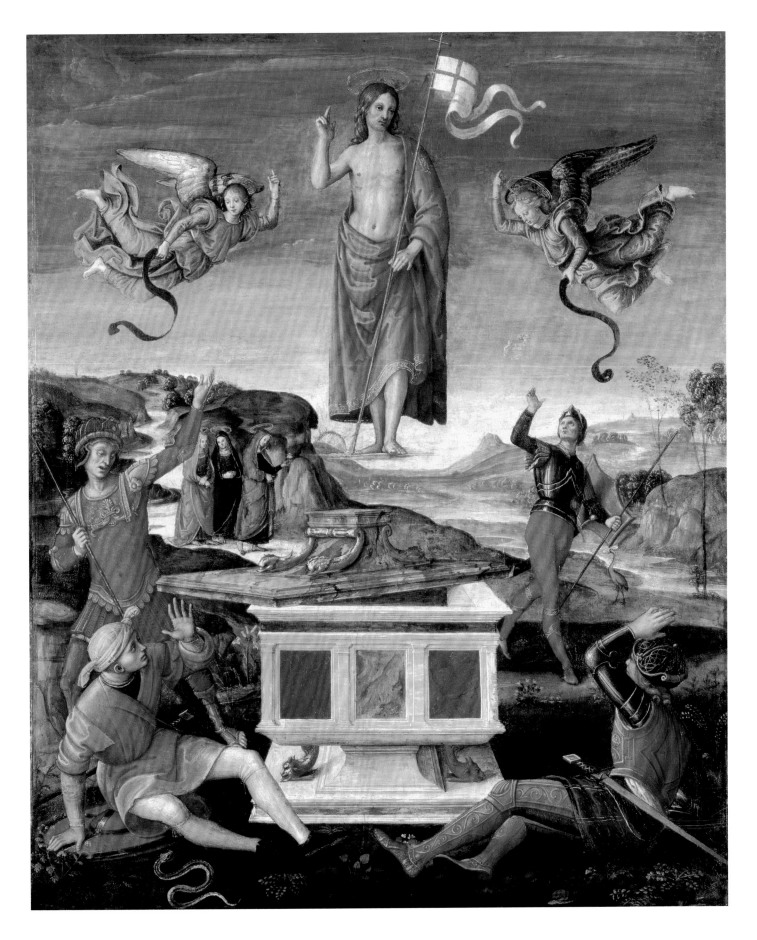

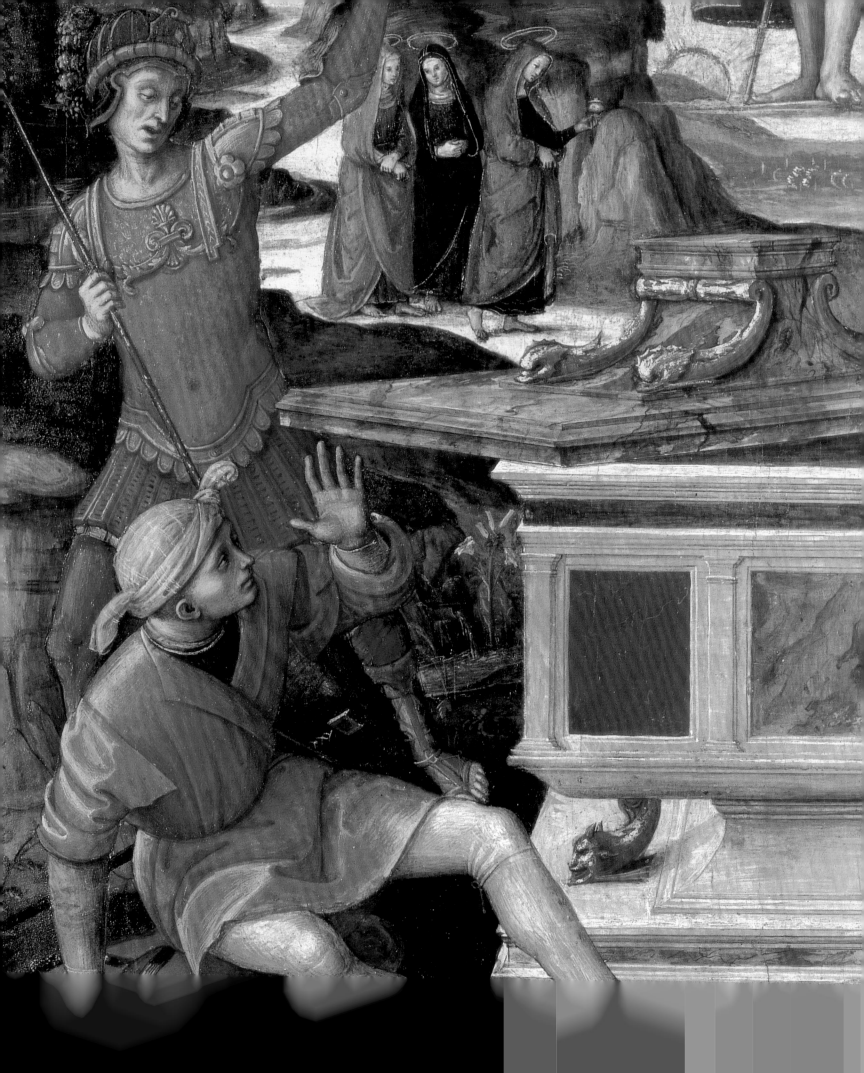

beautiful reflective orb of the rising sun (outlined with a compass and water gilt on red bole, like the sun in the *Mond Crucifixion*), the delicately incised shafts of Christ's banner and the soldiers' staffs, as well as the extensively incised contours of the tomb architecture. The sustained attention to detail – for example in the delicate garters holding up the leggings of the soldier bottom left – is also typical of Raphael, who frequently worked on a scale far smaller than this (see cats 25–6, 32–5). Every scale, rivet, stud and hinge of the guards' armour (although invented) is logically described in such a way as to inform us of how the elements are assembled.

Infrared reflectography (as yet unpublished) has recently revealed underdrawing in a liquid material beneath all the main elements of the painting. Many revisions characteristic of Raphael are visible, for example in the hands and feet of angels and in the contours of their drapery, as well as in the raised hands and costume of guards. A more major revision was found in the underdrawing beneath the soldier in the bottom left-hand corner whose pose and costume were significantly changed. Originally his head was drawn further to the right, and his right hand was raised. He was wearing armour and epaulettes, so the more oriental-looking figure in the finished painting, wearing a turban and tunic, may constitute a change in iconography as well as pose. These many revisions contradict the idea that Raphael provided designs for another artist to execute in paint, and suggest instead that he continued to develop ideas previously studied on paper on the prepared panel. Many features of the drawings recur in the underdrawing, for

example the long hair of the soldier in the right background and the pothook folds in the drapery of Christ's robe. Small arcs to denote the knuckle bones in the guard's hand can be compared to those in several drawings and underdrawings by Raphael.

The painting contains a combination of Umbrian and Tuscan influences that is also consistent with Raphael's authorship. The principal prototype for Raphael's painting was Perugino's altarpiece for S. Francesco al Prato, commissioned in 1499 (fig. 57), and the preparatory drawings reveal the debt clearly, in the figure of Christ and in the guards. However, the São Paulo picture is not markedly Peruginesque and many scholars attribute its delicate decorative qualities to the influence of Pintoricchio. The two angels are close to Santi prototypes, particularly in the calligraphic circling draperies around their shoulders, and the choice of pale mauves and greens, but Verrocchiesque echoes are undoubtedly present, both in the angels and in the tomb architecture, particularly the gilt ornamentation. In fact the tomb – arguably more sophisticated in its details than Perugino's simpler equivalent – is perhaps most dependent on models deriving from Piero della Francesca who frequently imitated marble and porphyry in his painted architecture. Raphael would have known his works both directly and filtered through Giovanni Santi. Piero's influence is also evident in the solidity and equipoise of Christ, who more human than divine, is a far cry from Perugino's formulaic Christ in a mandorla, which had been Raphael's point of departure in conceiving the figure (see cat. 22). C P

NOTES

1 Suida tentatively deciphered this as *Giachino Mignatelli*, but this could not positively be confirmed during a recent examination. Camesasca's (1987, p. 78) creative association of this name with the Mignanelli, a leading family of Siena from the thirteenth to the seventeenth century, has incorrectly found its way as fact into subsequent accounts of the painting's provenance (see Barone and Marques, in Marques *et al.* 1998, p. 67; Meyer zur Capellen 2001, p. 307).

2 Crowe and Cavalcaselle 1882–5, I, p. 92, note, as 'ascribed to Raphael'.

3 Oral communication to Oskar Fischel who had excluded the Ashmolean drawings from his corpus and who died in 1939 before having a chance to see the painting.

4 Christie's, London, 21 June 1946, lot 48 (bt. Drown, 600 guineas). The painting's evident quality is reflected in the high price paid.

5 Suida's 1955 article was the first in-depth study of the painting, though Longhi's discussion of it in his seminal article in *Paragone* of the same year (see bibliography) is also useful. Other scholars who were convinced by the attribution in the 1950s included Ragghianti, Volpe, Gamba and Camesasca.

6 Dussler 1971, p. 3; Camesasca 1987, p. 74; Barone and Marques, in Marques *et al.* 1998, p. 64.

7 A stork attacking a snake was frequently used in Renaissance painting to represent the defeat of sin, and Raphael's awareness of this subject is proved by its occurrence on the verso of the exactly contemporary cat. 17 (see Gregori 1987, p. 652).

SELECT BIBLIOGRAPHY

Crowe and Cavalcaselle, 1882–5, I, p. 92, note; Suida 1955, pp. 3–10; Longhi 1955, pp. 9–10, 18–20; Dussler 1971, pp. 3–4; Cuzin 1983, pp. 18–20; Gregori 1987, pp. 652–3; Camesasca 1987, pp. 74–81 (biblio); Carvalho Magalhães 1993; De Vecchi 1995, p. 202, no. 5; Barone and Marques, in Marques *et al.* 1998, pp. 64–7; Meyer zur Capellen 2001, no. X-8; Nesselrath 2004, p. 31.

22 Study for the resurrected Christ
about 1501–2

Black chalk, 21.6 × 10.4 cm
Ente Olivieri, Biblioteca Oliveriana, Pesaro, inv. 185

This recently rediscovered drawing is the sole example remaining in Pesaro of an important group of youthful drawings by Raphael formerly owned by the Urbinate painter Timoteo Viti (1469–1523), who worked with Raphael on the Chigi Chapel in S. Maria della Pace in Rome in 1512–13.[1] It is not known how the drawings passed to Viti but they may have been a gift from Raphael, who was known to have been generous with his designs.[2] These passed down to Viti's heirs in Urbino and thence by inheritance to the Antaldi family, who moved to Pesaro. The highlights of the Viti-Antaldi collection were sold to collectors in the eighteenth century, and much of what was left was bought *en bloc* by the English dealer Samuel Woodburn in 1824, forming the basis of the important holdings of Raphael (and other Umbrian) drawings in the Ashmolean and British Museums (see pp. 9–10 and cats 23–4, 50, 70, 72–3). On the death of the last surviving Antaldi heir in 1907, eleven portfolios of drawings that had remained in the family passed to the Biblioteca Oliveriana, where their existence was overlooked until 1992. Anna Forlani Tempesti then attributed the present drawing to Raphael and connected these studies with the figure of the resurrected Christ in the São Paulo *Resurrection* (cat. 21).

The Pesaro sheet, together with two other related drawings (cats 23–4, also with a Viti-Antaldi provenance), include no less than five studies for four of the figures in the São Paulo painting. The existence of so many drawings, and the very free underdrawing in the panel, full of revisions and refinements, make it increasingly difficult to argue that Raphael was providing designs for another (highly skilled yet unidentifiable) painter to execute. Instead, the surviving drawings suggest that Raphael was preparing a composition of his own design by making figure studies for the different protagonists, as was his usual practice.

Of the two studies for the figure of Christ, the freer, more dynamic nude study on the verso was probably executed first. Signorelli's influence is clearly apparent, particularly in the

exaggerated contours and pronounced musculature of the legs, though Perugino's elegant mannerisms are also reflected in the simple oval head, the delicately foreshortened hands and above all the *contrapposto* pose, which was one of his stock favourites. Perugino had used this pose for the figure of the risen Christ (with the swing of the hips and the arrangement of the drapery reversed) in a number of paintings embarked upon around 1499 for Perugia.[3] Giovanni Santi (probably influenced by Perugino) had also used it for the risen Christ in his *Resurrection* in the Tiranni Chapel frescoes (fig. 3).[4] It seems therefore that when thinking about the subject of the Resurrection, Raphael began working from traditional prototypes in his immediate orbit, before arriving at his own more monumental solution for the figure. His principal concern in this drawing was to establish the pose, reworking the contours around the head, torso and legs. Lighter notations over the left arm, abdomen and legs indicate the approximate arrangement of the drapery.

The figure on the recto (fig. 58) is sturdier and adopts a more stable pose, closer to that in the painting. The focus of the artist's attention is reversed compared to the verso study, with the head and torso of the figure barely indicated, but the drapery much more fully explored. The arrangement of the folds and the fall of the fabric anticipate almost line for line the equivalent passages in Christ's crimson shroud in the painting. The hook-ended notations for the drapery, a standard Umbrian mannerism most likely learned from Perugino, also feature in the underdrawing of the painting. The tentative quality of the drawing reveals Raphael's lack of experience in study from life.

The two studies compare remarkably closely with the nude and draped preparatory studies in cat. 20, and must be extremely close in date to the Città di Castello banner. Other telling comparisons can be made with the surviving drawings for the Saint Nicholas of Tolentino altarpiece (see cat. 17), corroborating an approximate date for the *Resurrection* of 1501–2. CP

fig. 58 **Study for the resurrected Christ**,
about 1501–2
Black chalk heightened with white chalk
(recto of cat. 22)

NOTES

1 Vasari/BB, IV, p. 267.
2 Vasari/BB, IV, p. 212.
3 The *Ascension* for S. Pietro, now in Lyon, the *Transfiguration* in the Collegio del Cambio, Perugia, and above all the *Resurrection* for S. Francesco al Prato, now in the Vatican Museums (see fig. 57).
4 Santi also used it for the Baptist in the *Sacra Conversazione* in the same chapel, and Raphael adapted the pose in his depiction of Saint John the Baptist preaching in the Ansidei predella (cat. 46), and in the half-length figure of Christ Blessing in Brescia.

SELECT BIBLIOGRAPHY

Forlani Tempesti 2000, pp. 34–41; Forlani Tempesti and Calegari 2001, no. 16.

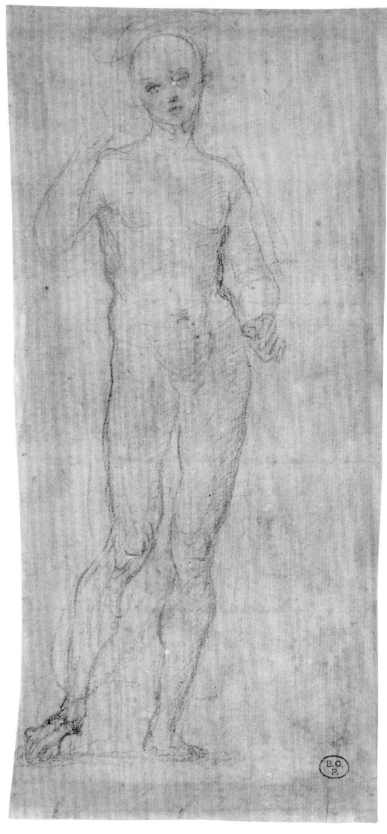

ACTUAL SIZE

23 Two guards for the Resurrection
about 1501–2

Metalpoint, heightened in lead white on grey prepared paper, 32 × 22 cm
Inscribed in ink, bottom left: R.V.[1]
The Ashmolean Museum, Oxford. Presented by a Body of Subscribers, 1846.
149 P II 505

24 An angel and a guard for the Resurrection
about 1501–2

Metalpoint, heightened in lead white on grey prepared paper, 32.7 × 23.6 cm
Inscribed in ink, bottom left: R.V.[1]
The Ashmolean Museum, Oxford. Presented by a Body of Subscribers, 1846.
150 P II 506

These two metalpoint drawings are preparatory for the *Resurrection of Christ* (cat. 21) and study the poses of the guards and an angel, the latter presumably unrelated to the Resurrection. In cat. 23 one guard sleeps, sitting on his shield, while another reacts balletically to the Resurrection on his right. In cat. 24 the guard in the foreground looks up dazzled from his rest, while another figure (identified as an angel by the mere outline of a wing at his back) kneels as he offers an object (variously interpreted as the nails with which Christ was crucified, or as a chalice) to an imagined figure on his left.

Raphael started by sketching his figures very faintly, suggesting some forms – such as the sword of the reclining guard – with the lightest touch. At this point Raphael had a pose in mind and was trying out some small refinements which are now visible as faint alterations (e.g. the right foot of the angel, the buttocks of the guard in the foreground and the longer shoe of the figure in motion). He also made a separate study in a characteristic shorthand of the head of the angel between the two figures on cat. 24. As his ideas took shape Raphael reinforced the outlines of the figures, and added some shading. He paid particular attention to the contour of the standing figure (where the outline of the leading leg can be related to his awareness of Signorelli's art, see cat. 20) and to his firm grip on his shield, as well as to the solution for the legs of the reclining guard (aspects that are less successful in the finished painting, although these are arguably the two most complex poses since they involved trying to show a figure in the round). The last additions were touches of lead white applied with a brush to add highlights to the two foreground figures.

As in other early studies by Raphael, the figures are studied from life, probably from workshop assistants. That the drawings were executed at the same time for the same project is suggested by their close similarities of style and technique, and by the harmonised lighting. The seated figure in cat. 23 is also particularly Peruginesque (and can be compared with his

Resurrection in the Vatican, fig. 57), and Raphael has paid great attention to the way in which the highlights model the figure.

The drawings are related to the *Resurrection* in São Paulo (cat. 21), here attributed to Raphael. One figure from each sheet is repeated in the painting (the standing guard from cat. 23 and the reclining figure in the foreground of cat. 24), but the other figures were not used. It has been noted, however, that the sleeping guard may have been planned for the left-hand corner of the painting, where the figure is in a similar relationship with the edge of the finished picture as is suggested in this drawing by the vertical line that cuts across the figure's shield. It is striking that their legs are in very similar positions, and that the underdrawing of cat. 21 differs from both this drawing and the figure as painted, suggesting continued revisions in this area, which might imply Raphael's dissatisfaction with the Peruginesque idea of showing any of the guards asleep.

Although the attribution of these drawings to Raphael is widely accepted, doubts have frequently been expressed about their connection to the São Paulo *Resurrection* and whether that painting is by Raphael. Passavant accepted these two drawings, but suggested that they were for Perugino's *Resurrection*, arguing that Raphael played a major part in the execution of that picture.[2] It seems more likely, however, that Raphael merely used Perugino's picture as a starting point from which to develop his own repertoire (as he did on other occasions, e.g. the *Mond Crucifixion*, cat. 27). Robinson described how 'the present drawings are full of the ineffable grace which only Raffaello's works display' (an indication of the ultimately intuitive way in which attributional conclusions are reached).[3] Morelli attributed them to Perugino, however; while Fischel could not decide between Raphael and Perugino, and Joannides accepted the drawings but doubted the connection with the painting in São Paulo (which he rejected as a Raphael). T H

NOTES

1 R[aphael] V[rbinas] as inscribed on Viti-Antaldi collection drawings.
2 Passavant 1860, I, p. 51.
3 Robinson 1870, p. 124.

SELECT BIBLIOGRAPHY

(23) Passavant 1860, II, p. 501, no. 479; Robinson 1870, pp. 123–5, no. 12; Crowe and Cavalcaselle 1882–5, I, p. 90; Fischel 1917, pp. 135–6, no. 74; Popham 1931, p. 34, no. 118; Parker 1956, II, pp. 255–6, no. 505; Gere and Turner 1983, pp. 32–3, no. 13; Joannides 1983, p. 140, no. 27; Knab, Mitsch and Oberhuber 1984, p. 588, no. 70; White, Whistler and Harrison 1992, no. 12.

(24) Robinson 1870, p. 125, no. 13; Crowe and Cavalcaselle 1882–5, I, p. 90; Fischel 1917, pp. 137, 140, no. 75; Parker 1956, II, pp. 255–6, no. 506; Gere and Turner 1983, p. 33, no. 14; Joannides 1983, p. 140, no. 28; Knab, Mitsch and Oberhuber 1984, pp. 588–9, no. 71.

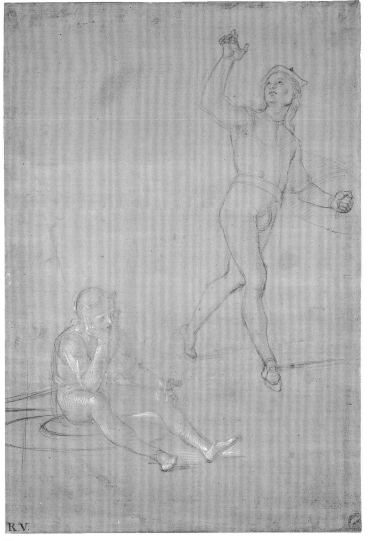

23

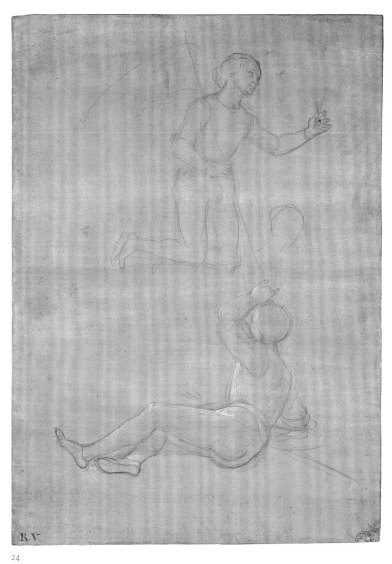

24

25 The Virgin and Child with Saints Jerome and Francis
about 1502

Oil on poplar, 34 × 29 cm
The surface is quite abraded, especially in the flesh tones, and the gilding in the sky may be retouched.
Inscribed in gold in the double halo of Saint Francis: S·FRANCISCVS·
Gemäldegalerie, Staatliche Museen zu Berlin-Preußischer Kulturbesitz, Berlin, 145

This extremely refined picture was almost certainly produced as a private devotional work in Perugia about 1502. The earliest of the series of seven independent painted Madonnas by Raphael in this exhibition (possibly even the artist's very first surviving example),[1] it differs substantially from his later paintings of the theme (e.g. the *Bridgewater* and *Alba Madonnas*, cats 62 and 93). Painted within an eight- or nine-year period, the Madonnas displayed here show an astonishing stylistic evolution, but from the outset Raphael exhibited great sensitivity to the tender relationship of the mother and her child. It is seen here, for example, in the very delicate arrangement of their hands, and in the sweetness of their expressions. Raphael's typical attention to incidental detail is also evident in the little clasp that secures the Virgin's open sleeve.

The arrangement of the two main figures is simple and static, with the Christ Child seated on a cushion on the Virgin's lap, his hand raised in a benediction directed towards the viewer. The seated Virgin is veiled and gazes down intently at her son. Saint Jerome is shown at prayer on the left and Saint Francis appears on the right, displaying his stigmata in a way that echoes the blessing hand of the Christ Child. The choice of these two saints was common in Central Italian painting at the end of the fifteenth century, and the picture resembles various Umbrian models (although it is not, as has often been claimed, related to any Peruginesque model). Raphael's relative inexperience is evident from the way in which the harmony of this picture is undermined by the slightly awkward placement of Saints Jerome and Francis. Jerome appears uncomfortably close to the Virgin with the rim of his hat almost touching her head, while Francis's view of the Christ Child is obscured. Although creating intimacy, the compression of the figures into the foreground drastically curtails Raphael's opportunity for depicting the atmospheric landscape at which he excelled, and allows only two tantalising glimpses of towered buildings against a range of hills. The flat gilded haloes are also rather awkwardly crammed into the limited space above the figures' heads.

The picture relates to the work of Raphael's early contemporaries in a fascinating way, the combination of stylistic influences being so precise as to suggest a specific time and place. The pose of the Virgin and Child is related to a prototype used by his father Giovanni Santi (e.g. in the Buffi altarpiece),[2] while the extensive gilding (a star on the Virgin's shoulder, little dots on her draperies, and intricate patterning on the cuffs and borders, as well as on the child's cushion) and the richness of the colours are comparable with the decorative style of Pintoricchio (e.g. cat. 6). Saint Francis (while again dependent on the Buffi altarpiece) is the most Peruginesque of the figures, but is still not quite as indebted to Perugino as those in the *Mond Crucifixion* (which was probably painted slightly later and offers numerous points of comparison, especially in the predella panels, cats 29–30). Nevertheless, Raphael's interest in Perugino's art was clearly intensifying and this is also evident in a black chalk study for the figure of Saint Jerome which survives in Lille.[3] These influences all point to a date around 1502, soon after Raphael's probable arrival in Perugia and his certain contact with the two leading artists of the city: Pintoricchio and Perugino. That Raphael's composition was well known in Perugia is confirmed by the existence of a drawn variant of it in the Albertina attributed to Berto di Giovanni, another Perugian artist with whom Raphael later collaborated, and by the existence of other painted copies.[4] TH

NOTES

1 Oberhuber 1982, p. 28.
2 See Varese 1994, p. 162.
3 Joannides 1983, no. 25. Although Raphael's early black chalk drawings are frequently comparable to those of Signorelli, in this case the soft handling of the chalk resembles studies by Perugino.
4 For the drawing see Costantini in Paris 2001–2, p. 86; for Raphael and Berto di Giovanni see Henry 1996, pp. 325–8; and for the painted copies see Meyer zur Capellen 2001, p. 117.

SELECT BIBLIOGRAPHY

Crowe and Cavalcaselle 1882–5, I, pp. 109–10; Dussler 1971, p. 4; Ferino Pagden and Zancan 1989, no. 6, p. 20; Meyer zur Capellen 2001, no. 5, pp. 115–17; Costantini in Paris 2001–2, pp. 86–90, no. 2; Butler 2002, pp. 63–6.

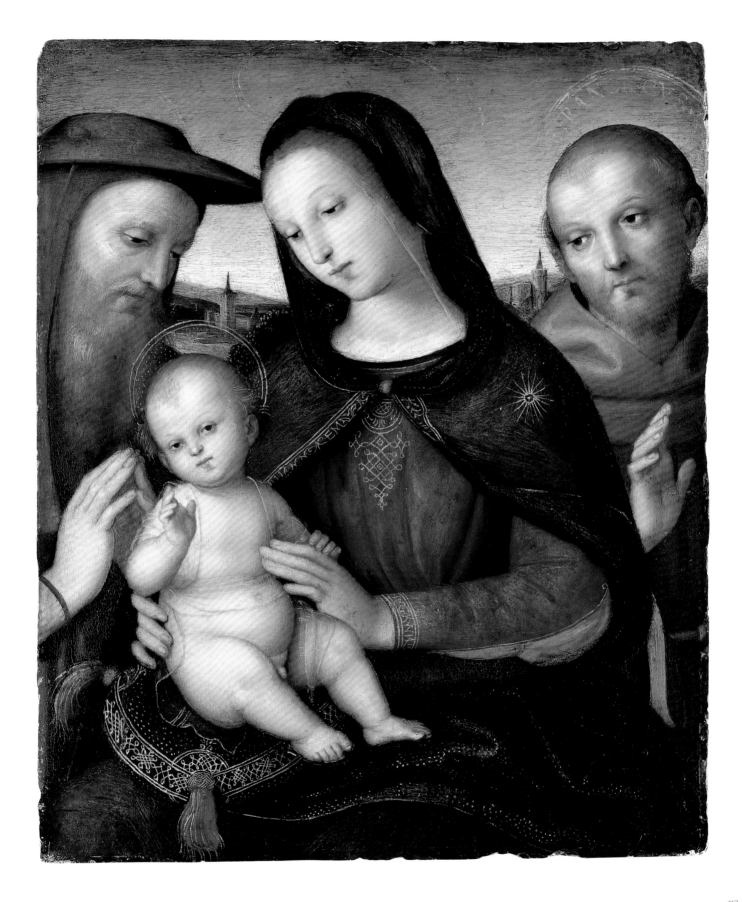

26 Saint Sebastian
about 1502–3

Oil on wood, 45.1 × 36.5 cm (painted area 43.9 × 34.3 cm)
Pinacoteca dell'Accademia Carrara, Bergamo, inv. 314 // 647-1866

Saint Sebastian is shown bust length and holds an arrow, the emblem of his martyrdom (see cat. 9). A pentiment can be seen in his hair, which was originally shorter.

With its double halo and 'sweet air', this picture is Raphael's most Peruginesque work, and should probably be dated to a period of intimate acquaintance with the older artist. This points to a date around 1502–3, although slightly earlier or later dates have also been proposed. The treatment of the figure of Saint Sebastian can be contrasted with the same figure in the Città di Castello banner (cats 18–19); and the very rapid progress that Raphael made in these years supports Vasari's claim that Raphael learnt a great deal from Perugino in the course of just a few months.[1] In this case, however, a specific Perugino model has not been discovered and may not have existed: Perugino specialised in painting Saint Sebastian, but always in the alternate iconography of the bare-chested saint wounded by arrows. Nevertheless, the delicacy of this image, typical of Raphael at this date, highlights some of the most important lessons that he was absorbing from Perugino. The refined treatment of the hand, for instance, is typical of Perugino, and Raphael was similarly mindful of creating elegant poses for hands as can be seen in a drawing for the Oddi *Coronation* (fig. 14).[2]

The picture is also reminiscent of Pintoricchio, especially in the very fine mordant gilding on the hems and neckline, and the decorative 'stitching' on the figure's shirt. The fine looping pattern of the gold thread on Saint Sebastian's tunic recalls Pintoricchio's interest in knot-patterns. This was the period during which Raphael was providing drawings for Pintoricchio's frescoes in the Piccolomini Library in Siena (see pp. 23–6 and figs 7 and 9) and for an altarpiece for Fratta Perugina, modern-day Umbertide.

The picture was probably painted as a small devotional work for a private patron, or possibly for a confraternity. The existence of an old Umbrian copy (by Lo Spagna or Eusebio da San Giorgio) suggests that the picture may have been made in Perugia and remained accessible there.[3] At the very least the culture surrounding this picture – Perugino, Pintoricchio, Lo Spagna – firmly locates it in an Umbrian orbit, and suggests Raphael's adaptability to local tastes. TH

NOTES

1 Vasari/BB, IV, p. 158 (1550 only): '... *in pochi mesi ... studiando Rafaello la maniera di Pietro ... lo imitava ... che i suoi ritratti non si conoscevano dagli originali.*'
2 Joannides 1983, no. 47r.
3 Berenson 1896, pp. 211–14.

SELECT BIBLIOGRAPHY

Passavant 1860, II, p. 20; Berenson 1896, pp. 211–14; Longhi 1955, p. 20; Dussler 1971, p. 5; Rossi 1979, pp. 114–15; Meyer zur Capellen 2001, pp. 117–19, no. 6; Baldriga in Paris 2001–2, pp. 82–5.

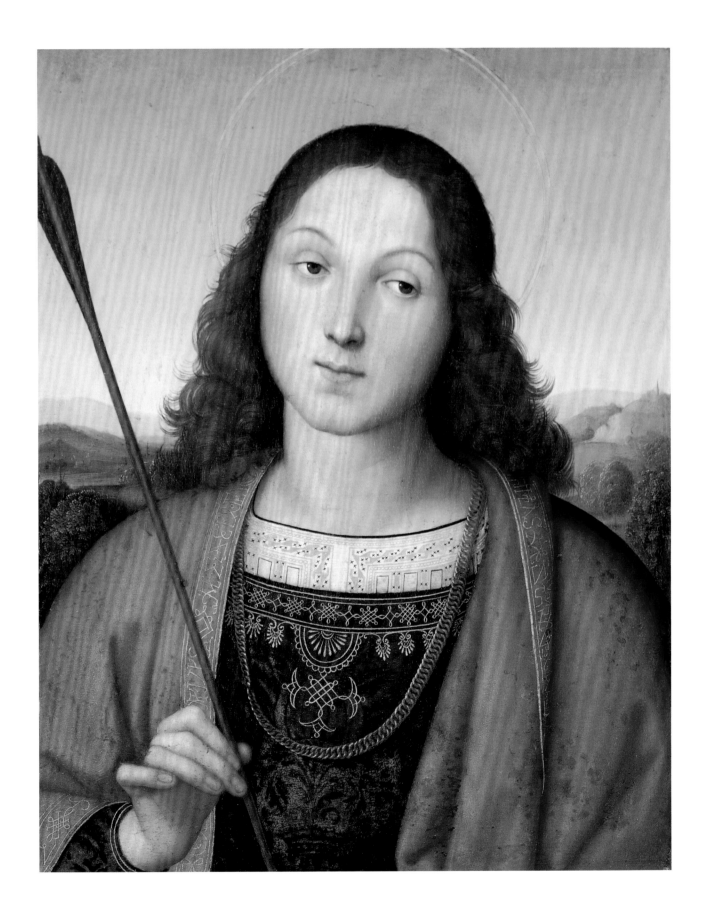

27 The Crucified Christ with the Virgin Mary, Saints and Angels (The Mond Crucifixion) about 1502–3

Oil on poplar, 283.3 × 167.3 cm (painted area within incised border 281 × 164.5 cm)
Signed in silver leaf on the foot of the cross RAPHAEL/VRBIN/AS/·P[INXIT]·
Inscribed in gold leaf on a placard above the cross ·I·N·R·I·
The National Gallery, London, NG 3943

This is the second of three altarpieces that Raphael painted for churches in Città di Castello in the years 1500–4 (see also cats 15–17 and fig. 12). It was commissioned by the wool merchant and banker Domenico Gavari for his burial chapel dedicated to Saint Jerome in his local church of S. Domenico. Gavari was a close friend of Andrea Baronci, for whom Raphael had painted the Saint Nicholas of Tolentino altarpiece (cats 15–17), and it was probably through that connection that the young artist received this commission. When Baronci's widow made Gavari her universal heir in 1512, her will was witnessed 'at the altar of the Crucifix'[1] and the close relationship between the two families was sealed in front of Raphael's painting.

Raphael's altarpiece was set into the monumental *pietra serena* architecture of Gavari's side-chapel, in the south aisle to the right of the

fig. 59 The surviving frame of cat. 27 in the church of S. Domenico, Città di Castello

high altar. The frame (see fig. 59) bears an incised Latin inscription: *HOC·OPVS·FIERI· FECIT·DNICVS | THOME·DEGAVARIS·MDIII* ('Domenico di Tommaso Gavari had this work made 1503'). It is likely that this date refers to the completion of the chapel by the installation of Raphael's painting.

Suspended above the other figures is the beautiful long-limbed body of Christ. Blood drips down from his hands, and spurts from the wound in his side. Two angels balancing on delicate slivers of cloud hover about him, collecting his blood in vessels reminiscent of the chalices in which wine would have been distributed during the mass. The eucharistic emphasis is fitting in a funerary chapel where masses would have been said for the soul of Gavari, who in his early wills left legacies to furnish every chapel he endowed with new chalices.[2]

The subject of the Crucifixion may also be associable with the Gavari arms of a hand holding a cross (prominently displayed on the frame). In the painting, the cross stands on a brown foreground stage that contrasts with the illuminated Umbrian landscape – possibly the Val Tiberina with Città di Castello in the distance – into which Golgotha has been transported.[3] The halcyon midday sky is disturbed only by the simultaneous appearance of the sun and the moon, symbolising the eclipse that coincided with Christ's death. Other narrative and anecdotal details relating to the Crucifixion are, however, suppressed in favour of a timeless image more adapted to contemplation and prayer. On their knees at the foot of the cross are two penitent saints, Jerome and Mary Magdalene, who gaze up at the dead Christ with a mixture of reverence and pity, providing worshippers at the altar with models of devotion. The Virgin, robed in purplish black to mark her mourning, and Saint John the Evangelist look on, engaging the viewer with their gaze, their grief expressed only by the delicate wringing of their hands.

The sixth-century Saint Jerome, one of the Doctors of the Church, and the translator of the

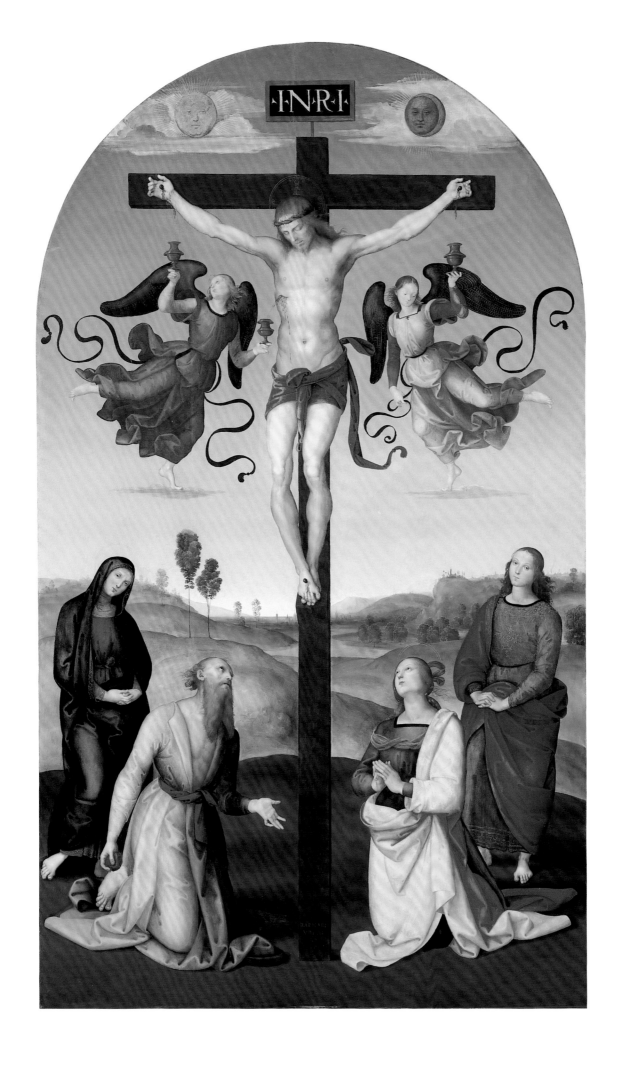

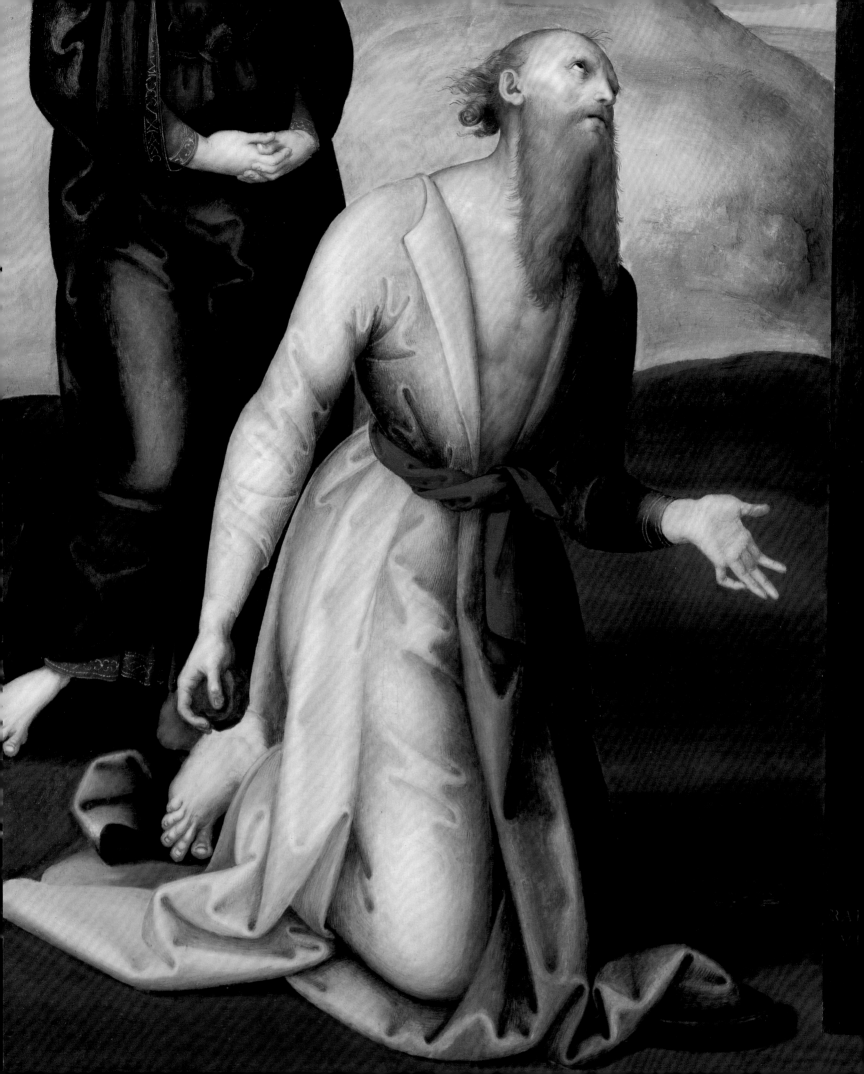

Bible into Latin, is the only figure of the painted group who was not present at the Crucifixion. He gestures to the cross and holds the stone with which he beat his breast in the wilderness (his chest, while not bloody, is pink from his exertions). His inclusion among the figures at the foot of the cross and the depiction of his posthumous miracles in the predella (see cats 29–30) can be explained by the chapel's dedication to him. Gavari may have personally chosen to dedicate his chapel to the saint, since he made donations to the local Hieronymites and named his first-born son Girolamo.[4]

Gavari's chapel was modelled on a very similar one in the opposite aisle, erected in the previous decade by Tommaso Brozzi and dedicated to Saint Sebastian. This contained an almost identically proportioned altarpiece depicting the *Martyrdom of Saint Sebastian* by Signorelli (fig. 55), with a comparable male nude at the centre of the composition. Raphael must have carefully studied this work and indeed made a copy after one of the crossbowmen (see cat. 20). He was not, however, deflected from the principles of symmetry, clarity and harmony in part learned from Perugino, and his painting is a virtual manifesto of those aspects of his mentor's manner, in notable contrast to the busy asymmetry and foreshortenings of Signorelli's altarpiece. Raphael prominently signed his work by scratching through the brown paint at the foot of the cross to a layer of silver leaf beneath. Vasari famously commented that were it not for this signature, no one would have believed it had been painted by Raphael and not Perugino.[5]

In terms of composition, figure type, detail, and technique, the *Mond Crucifixion* is indeed Raphael's most Peruginesque altarpiece, even more so than the slightly earlier *Coronation of the Virgin* (fig. 13) and the *Sposalizio* (fig. 12) of the following year. Raphael's overall design relates to several versions of the Crucified Christ in a landscape painted by Perugino in the late 1480s and 1490s (though these lack the sacramental references of the angels gathering blood). The saints in Raphael's painting are dependent

on more closely contemporary works. His Saint Jerome is lifted straight out of Perugino's *Pala Tezi* for S. Agostino in Perugia, dated 1500, and the Saint Sebastian in that work is not dissimilar to the Magdalen here. The figures of the Virgin, Saint John and the Magdalen in Perugino's double-sided altarpiece for the convent of S. Francesco al Monte in Perugia (fig. 60), commissioned in 1502 but not finished until 1506, are extremely close in form and pose to their equivalents in the *Mond Crucifixion*. (In this case one wonders in which direction the influence passed, as Perugino's saints do not seem properly integrated in that work.) The foreshortening of the saints' egg-shaped heads in Raphael's work, their small facial features, the eyelashes protruding from the centre of their eyelids, the stylised gestures of their hands, and the forms of the feet with the elongated second toe, are also plucked from Perugino's repertoire.

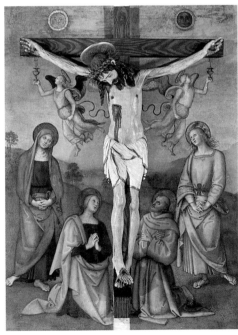

fig. 60 Pietro Perugino
The Crucifixion, about 1502–6
Tempera on wood, 240 × 180 cm
Galleria Nazionale dell'Umbria, Perugia, inv. 263

Perugino's influence is less obvious in the upper half of the picture. The play of light over Christ's muscular limbs suggests at least some reference to a live model, while the anatomy and silhouette may, as Crowe and Cavalcaselle suggested, show the influence of Signorelli's confraternity banner for S. Spirito in Urbino which Raphael would have known as a boy. The drapery and pose of the balletic angels, as well as their heart-shaped faces and colouring, are reminiscent of angels or Muses in Giovanni Santi's paintings (see cat. 3). The unusual motif of the angel bearing two chalices may derive from a Northern source (it features, for example, in the *Crucifixion* from Dürer's woodcut series *The Large Passion*).[6] If so, Raphael's love of compositional symmetry meant dispensing with the conventional third angel collecting blood from the wound in Christ's feet.

Although the figures are not here arranged within a constructed architectural space as they are in the *Sposalizio* and the *Ansidei Madonna*, the design is rooted in the same careful geometrical planning. It has frequently been pointed out that the composition is made up of a series of arcs, echoing the arched top of the composition, detectable for example in the placement of the angels' feet, and the heads of the figures below the cross, and that the horizon line falls at the level of the capitals in the frame.[7] All of this implies that Raphael mapped out the design of the altarpiece in advance, probably in a composition drawing similar to cat. 31. As with other altarpieces (see cat. 45), he may have transferred the design to the panel by means of squaring (there is no sign of pouncing). Underdrawing in a liquid material is present under most of the main features, and Raphael painted up to the drawn boundaries, making no revisions or pentiments, a further indication that the whole project was scrupulously designed in advance. CP

NOTES

1 Henry 2002, p. 278.
2 Henry 2002, p. 274.
3 Magherini Graziani 1897, p. 237.
4 Henry 2002, p. 273.
5 Vasari/BB, IV, p. 158.
6 Crowe and Cavalcaselle (1882–5, I, p. 132) note Alunno's use of the motif in a predella of 1492 in the Louvre. Lorne Campbell kindly pointed out its Northern European derivation.
7 Shearman 1986a, pp. 203–10.

SELECT BIBLIOGRAPHY

Vasari/BB, IV, p. 158; Passavant 1839, II, no. 7; Crowe and Cavalcaselle 1882–5, I, pp. 128–35; Magherini Graziani 1897, pp. 235–46; Dussler 1971, pp. 8–9; Jones and Penny 1983, p. 13; Marabottini 1983, pp. 64–5, 194–5; Dunkerton *et al.* 1991, pp. 204, 366–7; Hiller 1999, pp. 46–54; Meyer zur Capellen 2001, no. 7A (biblio); Henry 2002, pp. 270–4; Shearman 2003, pp. 82–3; Roy, Spring and Plazzotta 2004, pp. 12–15.

28 A kneeling youth

about 1502–3

Metalpoint on cream prepared paper, later scribbles in black chalk
26.5 × 18.4 cm
The Ashmolean Museum, Oxford
Presented by a Body of Subscribers, 1846. 153 P II 509

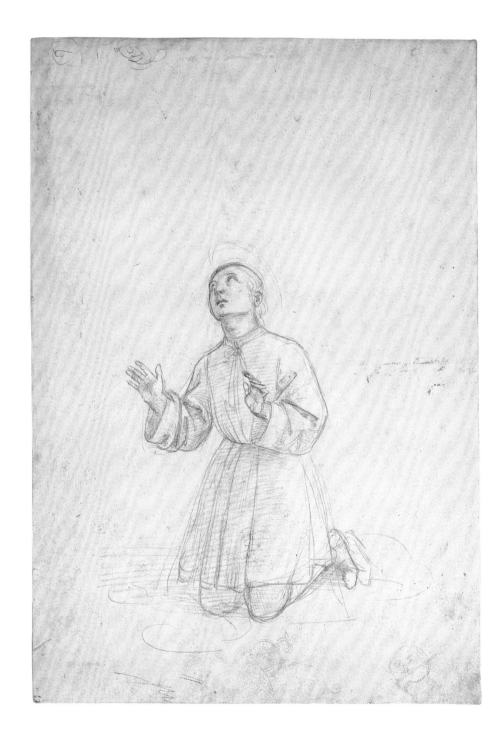

The tunic and hose of the youth in this drawing suggest that he was a studio assistant, or *garzone*. Raphael studied him kneeling and gazing upwards, as if contemplating a vision, and transformed him into a saint by the addition of a faint double halo. The metalpoint technique, including the subtle gradations of hatched modelling and the hook-ended drapery folds, is close to Perugino's, and the kneeling pose, the foreshortening of the round head and the small, delicate hands are also reminiscent of the older artist's work. The study shows Raphael drawing with exquisite lightness of touch and freedom (see the pentiment made to the left foot and the light indications of drapery folds on the ground).

Parker was the first to suggest that the drawing may be a study for the Magdalen in the *Mond Crucifixion* (cat. 27), but the figure's gesture, with both hands raised, is expressive of surprise or wonder, and would not be appropriate for a saint worshipping at the foot of the cross. Moreover, Raphael's studies tend to anticipate the fall of light in the painting for which they are preparatory, but, as Gere and Turner pointed out, the drawing is lit from the right, in the opposite direction to the painting. Although the drawing does not therefore appear to be directly related to the altarpiece, it represents the type of study Raphael undoubtedly made or referred back to when preparing it. Kneeling figures marvelling at the miracles being performed in the two surviving predella panels (cats 29–30) adopt very similar poses. No other drawings for the *Crucifixion* or its predella are known. C P

SELECT BIBLIOGRAPHY

Robinson 1870, no. 28; Crowe and Cavalcaselle 1882–5, I, p. 138; Fischel 1913–41, I, no. 41; Parker 1956, II, no. 509; Gere and Turner 1983, no. 30; Joannides 1983, no. 36; Knab, Mitsch and Oberhuber 1984, no. 72.

29 Eusebius of Cremona raising Three Men from the Dead with Saint Jerome's Cloak

about 1502–3

Oil on poplar, 25.6 × 43.9 cm
Cut on all four sides and some scattered losses
The reverse has the crown of the Portuguese Royal Academy and the number 568
Museu Nacional de Arte Antiga, Lisbon, 568

This is one of two surviving panels from the predella of the altarpiece of the *Mond Crucifixion* (cat. 27) formerly in S. Domenico, Città di Castello. The chapel for which the altarpiece was painted was dedicated to Saint Jerome, who features prominently in the main panel, and to whom the patron Domenico Gavari was particularly devoted. The predella (from which one or more other elements have been lost) was devoted to scenes relating to Saint Jerome's cult. The surviving scenes represent miracles performed by the saint's followers after his death. Cat. 29 depicts Eusebius of Cremona (stooping in the centre) resuscitating three dead men by momentarily laying Saint Jerome's cloak over them.[1] Soon after Jerome's death a heretical sect publicly doubted the existence of purgatory, and Eusebius prayed for divine assistance. Saint Jerome appeared to Eusebius and told him to gather both believers and non-believers around three young men who had died that night. By holding the saint's cloak over each corpse he raised them from the dead 'and they knelt, raising their hands up to Heaven' and recounted their experience of purgatory. In this way the heretics were defeated (they are seen here to either side, marvelling at the miracle), and Jerome's cult was bolstered.

The two narrative episodes in cats 29 and 30 originated in Saint Cyril's apocryphal letter to Saint Augustine and were popularised by the *Hieronymianum*. This was a short text written by Giovanni d'Andrea di Bologna (d. 1348) which was frequently published and translated in Italy in the fifteenth century – usually as *Il Devoto Transito del Glorioso Sancto Hieronymo* – and appears to have been the principal source for the predellas of several altarpieces dedicated to Saint Jerome (e.g. those by Perugino and Signorelli –

the latter is in the National Gallery, NG 3946).

Raphael's predella was broken up at an unknown date (see further under cat. 30) and reuniting these two panels allows one to appreciate the continuous landscape background linked by a winding river. It is nevertheless possible that there was some distance and perhaps a dividing element between the two scenes. There would certainly have been one more scene, and it is just possible that there were two, which probably depicted earlier incidents from the *Hieronymianum*. The scene of resurrection in this panel would have been directly below, or below and just to the right, of the crucified Christ in the main panel of the altarpiece – perhaps to reinforce the central Christian message of the triumph over death.

Raphael's visual repertoire in this predella is drawn from both Perugino and Signorelli. The standing figures can be compared with those in Perugino's predellas, while the foreshortened resurrected corpses are reminiscent of Signorelli's work at Orvieto and elsewhere, and of Raphael's earlier studies for a Resurrection (cat. 23). The way in which Raphael shows the three youths at different stages of resuscitation – the right-hand figure is still pale and lifeless and a shadow lies across his face while the youth at the left is already alert and praying – is a powerful narrative device, comparable to time-lapse photography. This sophistication might represent the unexpected benefit of Raphael being asked to paint a relatively rare subject, and therefore being forced to develop a novel iconography – something which he was increasingly adept at doing.[2]

Infrared photographs show an underdrawing that appears to be freehand – it can be seen with the naked eye in the legs of the youths – and is very close to the painted version. TH

NOTES

1 See *Il Devoto Transito*, XXIX.
2 For Raphael as an iconographer, see Ferino Pagden 1986a, pp. 13–27.

SELECT BIBLIOGRAPHY

Passavant 1860, II, p. 315; Gronau 1908, pp. 1071–9; Pillion 1908, pp. 303–18; Roberts 1959, pp. 283–97; Dussler 1971, pp. 9–10; Seabra Carvalho 1999, p. 99; Meyer zur Capellen 2001, pp. 123–5, no. 7B; Henry 2002, p. 273.

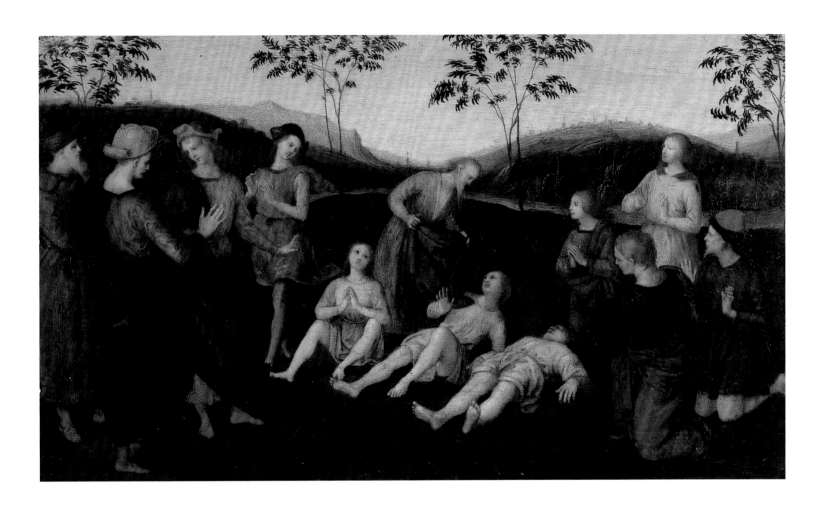

30 Saint Jerome saving Silvanus and punishing the Heretic Sabinianus

about 1502–3

Oil on poplar, 24.8 × 42 cm
Cut on all four sides. Inscribed bottom right with an inventory number (213).[1] Red wax seal on reverse.
North Carolina Museum of Art, Raleigh, Purchased with the funds from Mrs. Nancy Susan Reynolds,
the Sarah Graham Kenan Foundation, Julius H. Weitzner and the State of North Carolina, G.65.21.1

This predella panel, which (like cat. 29) stood beneath the *Mond Crucifixion* (cat. 27) in S. Domenico, Città di Castello, depicts Saint Jerome (top, centre) saving Silvanus and punishing the heretic Sabinianus.[2] Silvanus, the Archbishop of Nazareth (shown at prayer in the centre), had disputed the dual nature of Christ with Sabinianus (who lies decapitated to the right) and had accused him of faking a text in the name of Saint Jerome to support his heretical position. Unable to resolve the dispute Silvanus and Sabinianus agreed that if divine intervention did not prove the book to be a forgery by morning Silvanus would be executed, and if it did Sabinianus would suffer the same fate. In the absence of a sign Silvanus was duly taken to a place of execution but then Saint Jerome suddenly appeared and took the sword which was about to decapitate Silvanus, and instantaneously 'the head of the heretic fell to the ground, separated from his body as if the executioner had struck him with the sword'. Following the miracle, Sabinianus's followers were converted to Christianity.

Saint Jerome can be compared with the same figure in the painting in Berlin (cat. 25) and the youth who has fallen to his knees in amazement is very closely related to a drawing in the Ashmolean (cat. 28), which may have been preparatory to the main panel. The stance of the executioner anticipates that of *Saint Michael* in the Louvre (cat. 33). As with the Lisbon panel (cat. 29), the influence of Perugino and Signorelli is strongly marked. The Peruginesque figure who flees the scene and looks up and back at Saint Jerome recalls one of the soldiers in Raphael's drawings for the *Resurrection* (cat. 24), while the figure in front of him with the spotted shield brings to mind the crossbowmen in Signorelli's *Martyrdom of Saint Sebastian* (fig. 55), one of whom was copied by Raphael (cat. 20). The foreshortened figure of the dead Sabinianus is also related to Raphael's study of Signorelli.

Some underdrawing is visible with the naked eye, especially in the kneeling boy, and examination under infrared suggests that this drawing was done freehand, with a brush, and involved several small revisions. It is also clear that some of the straight edges have been incised into the gesso, and there are some slightly unusual free-hand incisions in the yellow leggings of one of the soldiers on the left. These appear to have been a rejected idea for adding armour to the lower half of this figure. As in the panel at Lisbon, the trees were added very late, and one figure's head has also been painted over the sky (compare the *Procession to Calvary*, cat. 41).

The predella of the *Mond Crucifixion* seems to have been separated from the main panel in the seventeenth century. Francesco Vitelli recorded that it was given to Cardinal Bevilacqua (1571–1627) in the first quarter of the seventeenth century, while Francesco Andreocci made a note in his diary that '*un gradino*' (a common word for a predella, or part of a predella) was given to Cardinal Rasponi on 27 October 1668. Unfortunately nothing about the provenance of the Lisbon or Raleigh panels confirms either of these accounts. T H

NOTES

1 This is almost certainly a Borghese inventory number.
2 See *Il Devoto Transito*, XXXI, discussed under cat. 29.

SELECT BIBLIOGRAPHY

Buchanan 1824, II, p. 22, no. 10; Passavant 1860, II, p. 327; Crowe and Cavalcaselle 1882–5, I, pp. 125–7; Gronau 1908, pp. 1071–9; Pillion 1908, pp. 303–18; Roberts 1959, pp. 283–97; Gilbert 1965, pp. 3–35; Dussler 1971, pp. 9–10; Brown 1983, pp. 113–14; Meyer zur Capellen 2001, pp. 123–5, no. 7C; Henry 2002, p. 273.

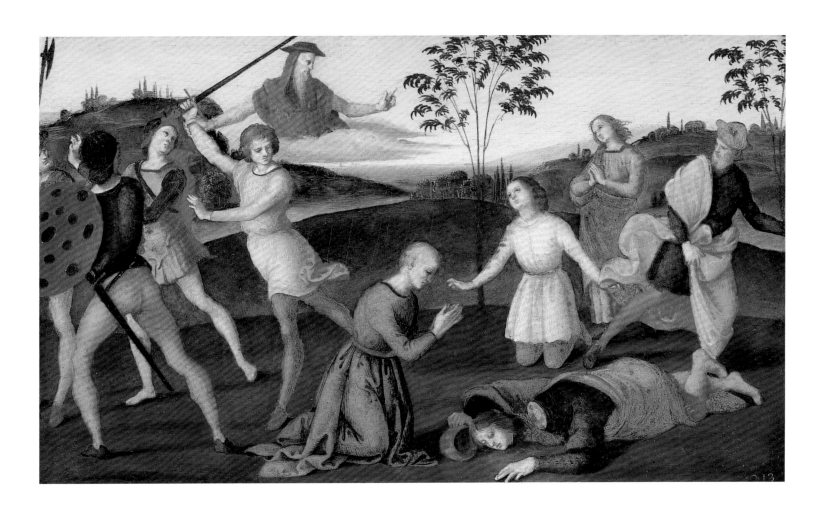

31 Study for a Virgin and Child enthroned with Saint Nicholas of Tolentino

1503–4

Pen and brown ink over traces of black chalk in Saint Nicholas and some freehand incision in Saint Nicholas, the Virgin and the top of the throne, a vertical and a horizontal registration line and the horizontals of the steps ruled and incised with a stylus, 23 × 15.5 cm
Städelsches Kunstinstitut, Frankfurt, inv. 376

This beautiful drawing is closely based on Perugino's *Decemviri Altarpiece* for the chapel of the Palazzo de' Priori in Perugia (now Vatican Museums) of around 1496 (fig. 61). Raphael transformed the heavy marble throne into a narrower, more graceful structure, and strengthened the architecture of the loggia. He compressed the overall design, bringing the saint closer to the throne and taking the heaviness out of his drapery. He also changed the composition from a rectangular to an arch-topped format, and consequently made the canopy of the throne flat, but enlivened it with flowing acanthus volutes and calligraphic sweeps of a suspended rosary. In Raphael's drawing the architecture forms a virtual grid of verticals and horizontals, providing a measure and a structure within which the figures come to life.

Only the left half of the composition is fully developed, implying that this may have been a demonstration drawing made for approval by a prospective patron. The suspended rosary beads, for example, are deftly sketched in on the left, but on the right-hand side a simple line suffices. Some of the architectural features, while cursory, are brilliantly descriptive, for example the scrolling top of the volute in the throne to the left of Christ's head.

Cat. 31 has many features in common with the *Ansidei Madonna* (cat. 45), from the overall structure of the throne, to details such as the arrangement of the rosary beads and the way the Christ Child clutches a bunch of drapery. The lighting is also from the top right as in the painting. It has not been considered a specific preparatory study for it because of the identity of the saint, who, from the sunburst on his breast and crucifix is clearly the Augustinian saint, Nicholas of Tolentino, and not Nicholas of

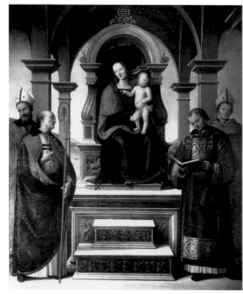

fig. 61 Pietro Perugino
The Virgin and Child Enthroned with Saints (The Decemviri Altarpiece), about 1496
Oil on wood, 193 × 165 cm
Vatican Museums, Vatican City, inv. 40317

Bari. Since no commission of this date including the former is known, it is worth considering the possibility that Raphael began designing the Ansidei altarpiece with the 'wrong' Saint Nicholas in mind, perhaps thinking back to the subject of his earlier altarpiece for S. Agostino in Città di Castello (see fig. 52). It may be no coincidence that the saint's pose recalls that of the left-hand angel in that work (see cat. 17). Alternatively this could be a design for a slightly earlier project, never completed, to which Raphael referred when designing the *Ansidei Madonna*. CP

SELECT BIBLIOGRAPHY

Fischel 1913–41, I, no. 52; Joannides 1983, p. 142, no. 37; Malke 1980, no. 73; Ekserdjian 1984; Knab, Mitsch and Oberhuber 1984, no. 26; Schütt 1994–5, no. 16.

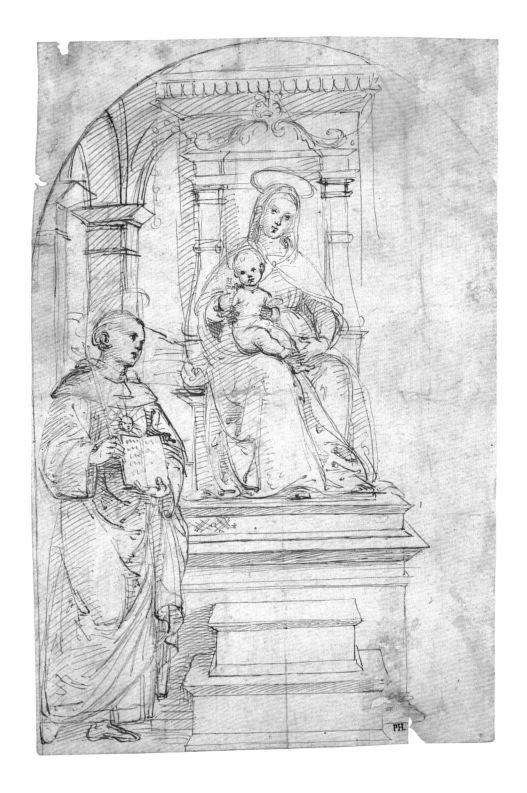

32 The Conestabile Madonna
about 1503–4

Oil on wood, transferred to canvas in 1871, 17.5 × 18 cm
Some damages, suffered pre-transfer, are visible in the figure of the Virgin
(they run vertically through her neck). The blue pigment of the Virgin's mantle
has blanched and as a result the folds have lost definition in the modelling.
The State Hermitage Museum, St Petersburg, GS 252

In this tiny painting the Virgin is shown half-length but standing, holding her child in one hand and a small book (in all probability a Bible or breviary) in the other. The Christ Child also holds the book, and is peering intently at the open page. The child's precocious interest in holy books, suggesting prescience of his future Passion, is repeated in a number of Raphael's representations of the Madonna and Child (e.g. the *Ansidei Madonna*, cat. 45, and the Norton Simon *Virgin and Child*, fig. 10). The figures appear in front of an extensive wintry landscape, with a river or lake, four minuscule figures and, in the far distance, snow-capped mountains.

The picture is usually dated about 1500–4, with recent writers tending towards a later date on the basis of comparisons with works such as the *Vision of a Knight* (cat. 35). The idea of the Virgin standing and effortlessly holding the child in front of her is revisited in the *Madonna del Granduca* (originally planned as a tondo), and in the *Tempi Madonna*; there are also points of comparison with the *Terranuova Madonna* in Berlin (fig. 23) and a related drawing in Lille (inv. 431). All three of these paintings are usually dated to around 1504–6. On the other hand, the weightlessness and pose of the child are in stark contrast to Raphael's later types (e.g. in the *Bridgewater Madonna* of about 1507, cat. 62).

The *Conestabile Madonna* is documented as belonging to the Alfani family in Perugia by 1600, subsequently passing to the Conestabile della Staffa collection in the same city. The National Gallery expressed an interest in acquiring the picture in 1868, but it was bought by Tsar Alexander II in 1871, and passed to the Hermitage in 1880. The picture may have come by descent from Domenico Alfani (about 1480 – after 1533), a Perugian painter who is known to have represented and collaborated with Raphael in Perugia, and to have received drawings from him, or it may have been commissioned by Alfano di Diamante (about 1465–1550), a merchant banker, who was the leading member of the family in the early sixteenth century and certainly knew Raphael at a later date – he was

fig. 62 Cat. 32 in its frame

a witness to a document of 1516 in which Raphael renewed his agreement to paint an altarpiece for the church of Monteluce in Perugia – and Alfano's aunt (Antonia di Alfano degli Alfani) had been the moving force behind the original contract for this altarpiece in December 1505.[1] Alfano Alfani also witnessed Pintoricchio's contract for the S.M. dei Fossi altarpiece in Perugia in 1495.[2]

Pintoricchio's altarpiece for S.M. dei Fossi was one of the first freestanding Renaissance works of art to incorporate *all'antica* grotesques into its decoration, testimony to the artist's study of Nero's Golden House in Rome. This style of painting spread rapidly in Siena and Perugia (Perugino employed it in his frescoes in the Collegio del Cambio), and Raphael was later famed for the way that he developed this decorative style in Roman works of the 1510s. Raphael transformed the square picture field of the *Conestabile Madonna* into a roundel by painting four spandrels in the corners, decorated with fine grotesques on a black ground.[3] The physical evidence suggests that these areas were gessoed

(and painted) at the same time as the rest of the painted surface. This transformation of a square into a roundel is unusual but not unique, and clearly relates to how the picture was framed. The picture now has a magnificent and very old frame (fig. 62), although it appears to have been modified to fit Raphael's picture and may not be original.

The transfer to canvas revealed an underdrawing, of which a tracing and subsequently a print were made. The print, which is in the opposite sense from the finished picture because it records the underdrawing from behind, shows that the Virgin was originally holding an apple or pomegranate instead of a book. Raphael's original design was plainly known to his circle of Perugian followers (it was precisely copied by Berto di Giovanni in a drawing now in Berlin),[4] and Raphael returned to this invention in a slightly later drawing in Vienna (cat. 39) where both a pomegranate and a book are shown. TH

NOTES

1 Shearman 2003, pp. 86–92.
2 See also (for Alfani's involvement with Perugino) Canuti 1931, II, pp. 180–1, 187, 201.
3 Another early instance of grotesque decoration can be found in the predella of the *Coronation of the Virgin*, and in the slightly different contexts of the architectural decoration of the Saint Nicholas of Tolentino altarpiece, e.g. cats 15–16, and the framing of the Baglioni *Entombment* (fig. 89).
4 See Mitsch 1983, p. 20.

SELECT BIBLIOGRAPHY

Passavant 1860, II, pp. 15–16; Rossi 1877, pp. 321–36; Crowe and Cavalcaselle 1882–5, I, pp. 170–4; Ferino Pagden 1986, pp. 100–1; Kustodieva 1994, pp. 368–9; Shearman 1996, pp. 201–2; Nucciarelli and Severini 1999; Meyer zur Capellen 2001, pp. 141–4, no. 10.

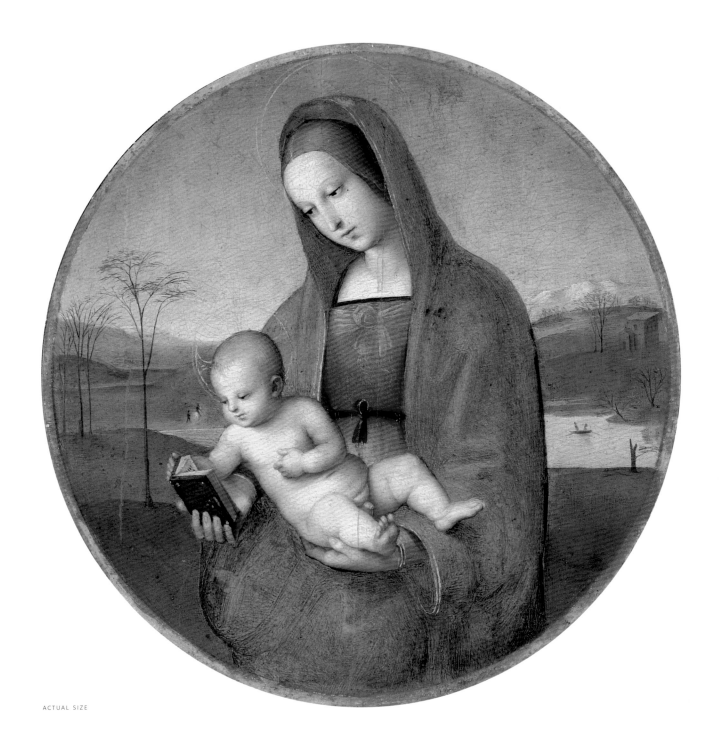

ACTUAL SIZE

133

33 Saint Michael
about 1503–4

Oil on poplar, 30.9 × 26.5 cm
Musée du Louvre, Paris, inv. 608

According to the New Testament Book of Revelation, the Archangel Michael triumphed over the devil in aerial combat. He is traditionally represented standing over the fallen Satan (who was commonly depicted as a fantastical animal, or part-man, part-beast). Here Satan, still resisting Michael's victory, is shown wrapping his tail around the saint's knee and grasping Michael's ankle with the talons of his hind legs (in an attempt to remove Michael's foot from his neck).

In 1584 this picture was recorded in Milan by Lomazzo (it may have been there as early as 1520/3, when it was apparently copied by Cesare da Sesto),[1] and seems to have already formed a diptych (leather-bound in 1661) with the *Saint George*, also in the Louvre (cat. 34).[2] The two pictures were subsequently in the collection of Ascanio Sforza at Piacenza, and of Cardinal Mazarin (1602–1661), on whose death they were acquired by King Louis XIV (and thence to the Louvre). Until recently they had always been thought to be a pair, and were frequently associated with the investiture in 1503–4 of Duke Guidobaldo da Montefeltro of Urbino and his adopted heir Francesco Maria della Rovere into the chivalric royal orders of France (l'Ordre de Saint-Michel) and England (the Order of the Garter, whose patron saint was Saint George).[3] Although they are not a perfect pair, and differ in terms of handling, style and probable date, the fact that they have been together for so much of their histories may support the thesis that they were both painted for a single Montefeltro/Della Rovere patron, whether Guidobaldo, Francesco Maria, or Giovanna Feltria della Rovere. They are typical of the kind of picture that Raphael painted for some of the most elevated patrons of central Italy.

The picture is executed in an almost miniaturist style and can be compared with Perugino's work of this type, such as the *Apollo and Daphnis* (cat. 7), in which the use of tiny gold highlights is analogous to the gilded definition in the archangel's wings.[4] Within Raphael's oeuvre the picture is most closely comparable to the *Vision of a Knight* (cat. 35), which emphasises similar

chivalric qualities in a different way. The pose of the figure can also be compared with that of the executioner in cat. 30, although it is more resolved in this slightly later work.

Raphael sets the encounter with Satan in hell itself, with figures from the sixth and seventh chasms of the eighth circle of Dante's *Inferno* in the background and strange hybrid beasts in the foreground. On the left are the hypocrites whom Dante describes as wearing cowls pulled down over their eyes and cloaks which appeared gilded on the outside but underneath were made of lead.[5] This leaden procession loops from the flaming tomb on the left round to the figures of two demons who will chastise them. Beyond them a flaming city may represent the city of Dis.[6] On the right Raphael has shown four naked men attacked by serpents. These are the

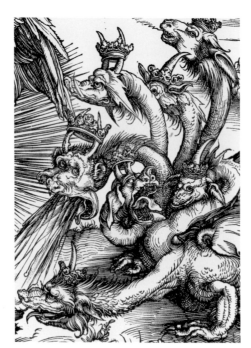

fig. 63 Albrecht Dürer
Detail from **The Apocalyptic Woman (The Apocalypse)**, 1498
Woodcut, 39.5 × 28.3 cm
The British Museum, London, 1895-1-22-568

thieves of canto 24, probably including Vanni Fucci, the so-called 'beast' of Pistoia (the figure closest to Saint Michael with his arm raised in an obscene gesture towards heaven, as in the poem) who was a murderer as well as a thief, and had stolen relics from the church.[7] If an Urbino provenance is accepted then the idea that this scene might refer to the Montefeltro victory over Cesare Borgia (who occupied Urbino in 1502 and who could well have been described as a hypocrite, murderer and despoiler of the city) is entirely plausible. There are no precise textual sources for the generic monsters of the foreground and middleground, but it has frequently been noted that their visual inspiration seems to lie in Northern European art. While the paintings of Hieronymus Bosch have sometimes been adduced in this context, the inspiration is more likely to lie in the engravings of Schongauer or Dürer. A specific connection can be made between the head of Satan and one of the beasts in Dürer's woodcut of an *Apocalyptic Woman* from the 1498 *Apocalypse* (fig. 63). TH

NOTES

1 See Lomazzo in Shearman 2003, pp. 1312–13, Béguin 1987, pp. 462–3, and Carminati 1994, pp. 244–5 (D18).
2 'n. 1177 – Raphael – un autre qui se ferme en deux en forme de couverture de cuir, d'un costé est représenté Sainct Georges à cheval qui combat avec le dragon, et dans l'autre Sainct Michel qui combat aussi un monstre, le tout faict par Raphaël' (de Cosnac 1885, p. 330).
3 Ettlinger 1983, pp. 25–7.
4 Vasari/BB, IV, p. 161, described one of Raphael's works for the court of Urbino as 'tanto finita, che un minio non può essere nè migliore nè altrimenti'.
5 *Inferno*, canto 23, lines 58–66.
6 *Inferno*, canto 8, lines 70–8.
7 *Inferno*, cantos 24, lines 91–9, 121–38, and 25, lines 1–6.

SELECT BIBLIOGRAPHY

Crowe and Cavalcaselle 1882–5, I, pp. 204–6; Jones and Penny 1983, pp. 6–7; Ettlinger 1983, pp. 25–7; Passavant 1983, pp. 200–4; Béguin 1983–4, pp. 78–80, 414–16; Mulazzani 1986, pp. 149–53; Béguin 1987, pp. 455–64; Jungic 2001, pp. 61–72; Shearman 2003, pp. 1312–13, 1321–2, 1354, 1428.

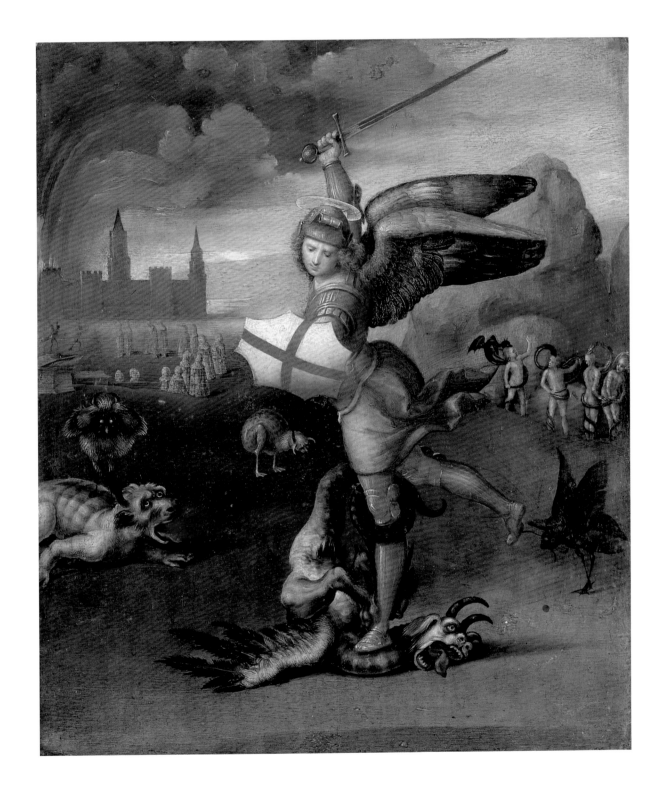

34 Saint George
about 1504–5

Oil on poplar, 30.7 × 26.8 cm
Musée du Louvre, Paris, inv. 609

This small panel depicts Saint George's combat with the dragon, a narrative subject popularised by its inclusion in the *Golden Legend*. According to this story, George, a fourth-century Christian soldier from Cappadocia, by killing the dragon saved the Princess of Silene (seen to the right) and spared her native city from further human sacrifices (thereby prompting mass conversion to Christianity). Condensing the narrative as was customary, Raphael shows the saint, who has broken his lance in subduing the dragon, poised to dispatch the beast with his sword. The dragon is not yet defeated (despite being impaled by the lance) and is springing up to attack Saint George, much to his horse's alarm. Raphael emphasises the saint's bravery by showing him with his mouth impassively shut – calm in his resolve to slay the dragon (and in contrast to his appearance in a preparatory drawing in the Uffizi, fig. 64).

Raphael painted another version of this subject, now in the National Gallery of Art in Washington, a year or two later, around 1506. The existence of two versions has sometimes confused the discussion of their provenance, although Lomazzo's reference to the fleeing Princess firmly establishes that the Louvre picture was in Milan by 1584.[1] As discussed under cat. 33, the Louvre *Saint George* was then paired with another small picture by Raphael depicting *Saint Michael*, also now in the Louvre, and the two panels seem to have been painted for the court of Urbino, probably to commemorate Montefeltro/Della Rovere investitures into the chivalric royal orders of France and England.[2] The panel bears evidence of having had a clasp or hinge attached to the left-hand edge, suggesting that it was one half of a diptych. It is nevertheless increasingly clear that the two pictures were not painted at the same time, nor conceived or designed as a pair. The treatment of the land-scapes, and of the haloes, is noticeably different in both pictures. The *Saint George* is less thickly painted on a more carefully prepared panel, and it was probably made as a pendant to the *Saint Michael* a year or two after that picture had been

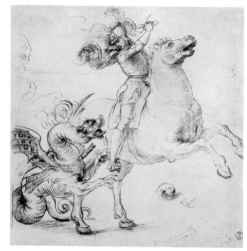

fig. 64 **Cartoon for Saint George**, about 1504–5
Pen and brown ink over traces of black chalk, 26.5 × 26.7 cm
Galleria degli Uffizi, Florence, inv. 530 E

painted. The *Saint George* is stylistically closest to the predella of the *Colonna Altarpiece* (cats 40–1) and probably dates from about 1504–5. In common with those predella panels, it shows signs of Raphael's first direct contact with Florentine art, in particular that of Leonardo. The fabulous dragon and the feathered helmet are reminiscent of Leonardo's interests, and Raphael has also learnt compositional complexity and a new dramatic pathos from him, as well as ways in which to animate horses and their riders. The horse's monumentality in this painting is also related to a new interest on Raphael's part in the art of antiquity, which he began to develop in Florence (as a result of contact with Leonardo and Michelangelo), and may also have been stimulated by an undocumented trip to Rome in these years (the horse is close to the famous horses of the *Dioscuri* on the Quirinal, which were often copied in the period, but the closeness might reflect direct study in this instance).[3]

Comparison with the pricked pen and ink drawing in the Uffizi shows how some of the Leonardesque and classical aspects of the picture were added at a late stage in the planning of this picture (although the drawing is also indebted

to Leonardo). The drawing is on exactly the same scale as the painting, and may have functioned as its cartoon, but the differences between the two are telling. Raphael suppressed the horse's spiralling tail, and added the Princess and extended the sword behind Saint George's head when he came to paint. He also made changes to the foreground, replacing scattered bones and a skull (which are not pricked, and had therefore been rejected before Raphael transferred the design) with the broken lance. Other conspicuous (and arguably less successful) changes are the additions of bit, bridle and other elements of the harness. An X-radiograph shows that he continued to invent as he painted (eliminating a bridge from the left-hand side of the landscape), and slightly modified the position of the head of the horse.[4] TH

NOTES

1 See Shearman 2003, p. 1354.
2 Lomazzo 1584 in Shearman 2003, pp. 1312–13, refers to '*quel S. Giorgio che già fece el Duca d'Urbino*'. In 1587 the same writer described the fleeing princess and stated how both pictures had been given to Conte Ascanio Sforza of Piacenza (Shearman 2003, p. 1354).
3 See Grimm 1882, pp. 267–72, and Shearman 1977, p. 132. For Raphael's later copy after the *Dioscuri* see Joannides 1983, no. 398.
4 See Béguin 1987, pl. 229a.

SELECT BIBLIOGRAPHY

Crowe and Cavalcaselle 1882–5, I, pp. 206–7; Lynch 1962, pp. 203–12; Joannides 1983, p. 148; Jones and Penny 1983, pp. 6–7; Béguin 1983–4, pp. 75–8, 414–16; Gregori (ed.) 1984, pp. 296–7; Béguin 1987, pp. 455–64; Clough 1987, pp. 275–90; Bambach 1999, p. 298; Meyer zur Capellen 2001, pp. 154–8, no. 13; Shearman 2003, pp. 1312–13, 1321–2, 1354, 1357–8, 1428.

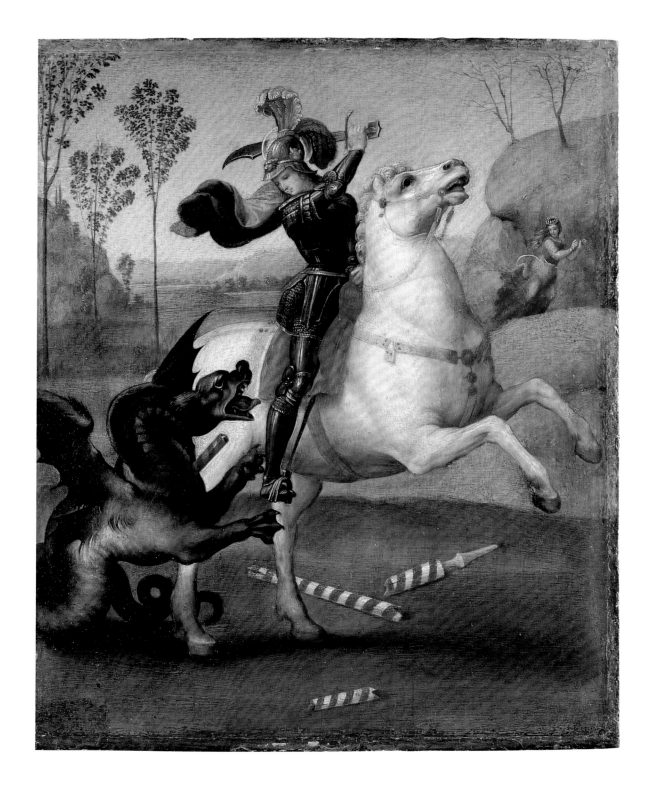

35 An Allegory ('Vision of a Knight')

about 1504

Oil on poplar, 17.5 × 17.5 cm (painted area 17.1 × 17.3 cm)
Inscribed in the bottom left corner, in dark paint: 69 (Borghese inventory number).
The National Gallery, London, NG 213

The subject of this exquisite *'quadruccio'*[1] was inspired by a passage in the *Punica*, an epic poem recounting the story of the Second Punic War by the Latin poet Silius Italicus (AD 25–101). Resting in the shade of a bay tree, the young soldier Scipio is visited by a vision of two ladies, Virtue and her adversary Pleasure (*Voluptas*). Virtue, described in the poem as a mannish figure, with her hair set low over her brow, promises Scipio honour, fame and glory through victory in war, but warns that the path leading to her chaste mountain abode is steep and rocky. Pleasure, with fragrant, flowing locks and languorous eyes, advocates instead a life of easeful serenity. Raphael subtly contrasts the characters in his painting through their appearance and attire. Virtue, on the left, is soberly dressed and her dark hair is covered, while Pleasure's dress is hitched up becomingly at the hip and her blonde tresses, adorned with coral beads and a flower, escape from beneath a billowing veil. The arduous path advocated by Virtue is represented by the craggy eminence in the background, linked by a drawbridge to her palace; behind Pleasure gently undulating hills lead down to a sunlit lake. Raphael represented the appeals of the ladies in the poem emblematically, through the objects they offer: a sword standing for valour is balanced in Virtue's other hand by a book signifying learning (an embellishment of Raphael's own, not anticipated in the poem), while Pleasure holds out a sprig of flowers (possibly myrtle, sacred to Venus) standing for love.

Silius's passage was based on the story of Hercules at the Crossroads, in which the hero had to choose between the alternative paths of virtue and pleasure.[2] Scipio, like Hercules before him chose Virtue, with her accompanying trials, victories and fame. Although Raphael followed Silius's text closely, he interpreted the theme in a different way, representing the double visitation not in terms of a moral dilemma, but rather as a convergence of all the qualities to which an ideal soldier or knight should aspire (although his slumbering form inclines towards virtue). The ladies, who both smile upon the young hero, mirror each other, and this symmetry revolves significantly around the slender laurel at the very heart of the composition. The evergreen leaves of the bay (*laurus nobilis*) symbolise the enduring honour a good knight could hope to win through appropriate endeavour in military, scholarly and amorous spheres. Raphael originally conceived Pleasure as a more seductive figure (see cat. 36) but in the finished painting she is modestly attired, further emphasising her role here as the knightly prize, Love.

Raphael must have been familiar with the story of the choice of Hercules from childhood, since the legend inspired the prologue of his father Giovanni Santi's epic poem about the life and deeds of Federigo da Montefeltro, Duke of Urbino.[3] In Santi's version, the poet falls asleep in the shade of a leafy beech tree (not a laurel) and hears a voice exhorting him not to waste time. He realises he must abandon the easy path, strewn with grass and flowers, which he has hitherto followed, in order to pursue a new, harsh and rocky road, leading up bare cliffs to the temple of Apollo and the Muses. There he prays for inspiration and the submission of passion to reason (Virtue versus Pleasure), so that he may give free rein to the '*alto concepto*' of his poem. Remembering this allegory of creative endeavour, Raphael may have had a subjective interest in painting the unusual story from the life of Scipio – who at the time, Silius repeatedly emphasises, was very young, like Raphael himself. Santi referred to his prologue as '*una visione in somno*', and it may be significant for Raphael's painting that his father's is the only version of the tale in which the protagonist is asleep.

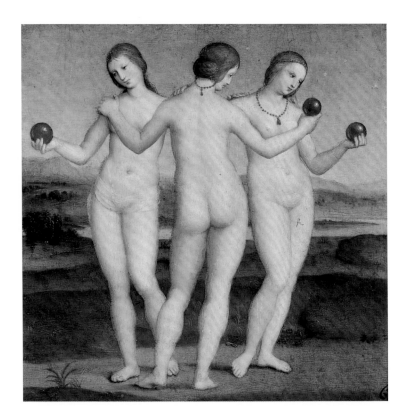

fig. 65 **The Three Graces**,
about 1504
Oil on wood, 17 × 17 cm
Musée Condé, Chantilly
inv. 38

138

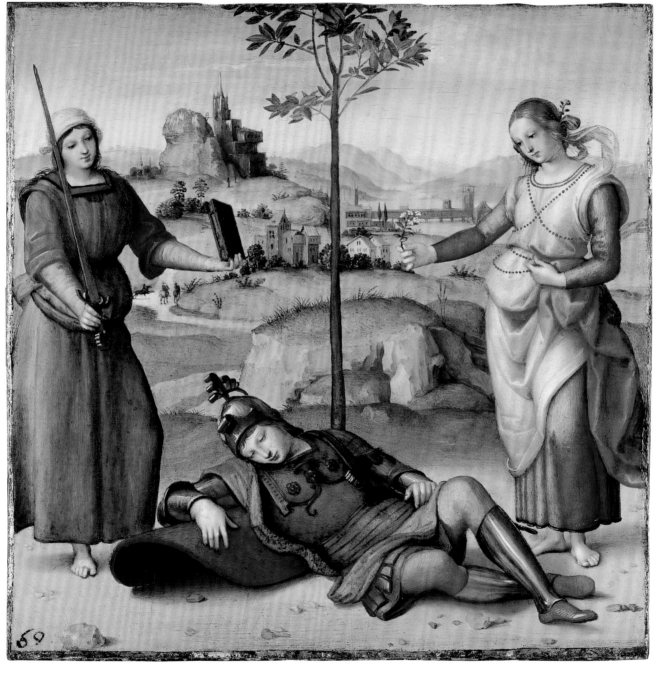

ACTUAL SIZE

The *Allegory* is first recorded in the Borghese collection in the seventeenth century together with a painting of identical size and style now in the Musée Condé, Chantilly (fig. 65). This shows the *Three Graces* (Chastity, Beauty and Love) each holding a perfect golden ball.[4] Although – surprisingly – the paintings were not framed together or even at times exhibited in the same room during the 150 years they were in the Borghese collection, their identical size, tripartite subject matter, the similarity in the faces and poses of the female figures, and the strings of coral beads worn both by the Graces and Pleasure in the *Allegory*, suggest that they were conceived as a pair. Different hypotheses have been put forward as to how the two images were originally combined. The difference in figure scale makes it unlikely that they formed the wings of a diptych. The subjects are appropriate for painted portrait covers, but portraits were never square in format, and it is far more likely that one was the cover for the other, or that they were framed back to back, or even kept as independent treasures in a cloth bag or a drawer. Only by holding the *Allegory* up close, like a manuscript illumination (to which the picture is comparable also in the way it illustrates a written text), could the original owner have appreciated its minute attention to detail and jewel-like finish. (The landscape, the pointed roofs and spires of the buildings and the tiny figures in the distance, including three on horse-back meeting at a crossroads, are reminiscent of Netherlandish manuscripts of extraordinarily high quality that were circulating at this date.) Regardless of how they were originally related, these delightful paintings form an ideal pair: indeed their conjunction of the masculine virtues of courage, learning and love with the feminine virtues of chastity, beauty and love might suggest they were made to mark the occasion of a marriage.[5]

The *Allegory* and the *Three Graces* are the only secular pictures – other than portraits – that Raphael is known to have painted before he moved to Rome. The *Allegory*'s presumed

subject – the Elder Scipio Africanus – was revered in the Renaissance for his victory over the African Hannibal and for his defence of republican Rome, and he was frequently included in traditional series of *uomini famosi* (famous men). However, unlike the choice of Hercules which inspired it, this particular scene from Scipio's legend was unprecedented as a subject for painting. Since no vernacular version of the *Punica* had yet been published, Raphael may have been directed to this rare theme by his patron or a learned friend.[6] Silius's text was certainly well known in the humanist circles in which Raphael moved (his friend Baldassare Castiglione for example mentions the poet in his *Book of the Courtier*),[7] and the paintings are undoubtedly of a scale, quality and subject appropriate to the courtly environment of Urbino.[8] The combination of sword and book had been a distinctive feature in the iconography of Giovanni Santi's patron, the soldier and scholar Duke Federigo da Montefeltro, whose portrait from the work-shop of Justus of Ghent (about 1475) shows him studying a manuscript while in armour, and who indeed had been likened to Scipio by his biographer Vespasiano da Bisticci.

However, it is also possible that the pictures were painted for a Sienese patron. The figure group of the *Three Graces* is based on a Roman sculpture owned by the Piccolomini family who moved it from their Roman palace to Siena in 1502. At around this time Raphael was himself in the city, assisting Pintoricchio with designs for the Piccolomini Library where the sculpture was displayed. Although datable a couple of years later, it has been suggested that the *Allegory* could have been painted for a youthful member of the Sienese Borghese family named Scipione, since it was subsequently recorded in the Borghese collection in Rome.[9] Whatever its original destination, no more evocative exemplum could be imagined for a virtuous young nobleman, particularly if – as the *Allegory*'s counterpart in Chantilly implies – he stood on the threshold of marriage with one in whom all the feminine graces were reunited.
CP

NOTES

1 This diminuitive of *quadro* (picture) was used to describe the painting and its pair in the Borghese inventory, Della Pergola 1959 (II), p. 458, nos 315 and 318.
2 The story of the Choice of Hercules (from Prodicus) is told in Xenophon's *Memorabilia* (II, I, 20–34).
3 Michelini Tocci (ed.) 1985, I, pp. 5–10.
4 Symbols of perfection, these are sometimes interpreted as the golden apples which, as his eleventh Labour, Hercules had to gather from the tree guarded by the Hesperides.
5 A suggestive comparison is afforded by the reverse of Niccolò Fiorentino's portrait medal of Giovanna Tornabuoni made to mark the occasion of her marriage to Lorenzo Tornabuoni on which the Three Graces are represented (see Béguin 1987, p.464; Brown 2001–2, cat. 11).
6 Silius's text, discovered in manuscript by the Florentine humanist Poggio Bracciolini in 1417 and first published in 1471, was an important source for the life of Scipio since Plutarch's *Life* of him is lost.
7 Castiglione's *Book of the Courtier* was first printed in 1528, but was composed from 1507, and claimed to be based on soirées at Urbino of around that time.
8 See Béguin 1987, p. 464.
9 Panofsky's suggestion that they were painted for the first communion of a Scipione Borghese (b. 1493), which took place in 1501, should, however, be discounted: this date is too early for the painting and the subjects are inappropriate for such an occasion.

SELECT BIBLIOGRAPHY

Passavant 1833, pp. 104–5; Passavant 1836, I, pp. 231–4, 248; Passavant 1839–58, II, no. 19; Crowe and Cavalcaselle 1882–5, I, pp. 199–202; Panofsky 1930, pp. 37 ff., 76 ff., 142 ff.; Wind 1967, pp. 81–5; Dussler 1971, p. 6; Gould 1975, pp. 212–25; Lohuizen-Mulder 1977; Bon Valsassina 1984, pp. 17–18, 64; Dülberg 1990, pp. 137–43 and no. 327; Jones and Penny 1983, p. 8; Dunkerton *et al.* 1991, no. 63; Meyer zur Capellen 2001, no. 14; Roy, Spring and Plazzotta 2004, pp. 15–17.

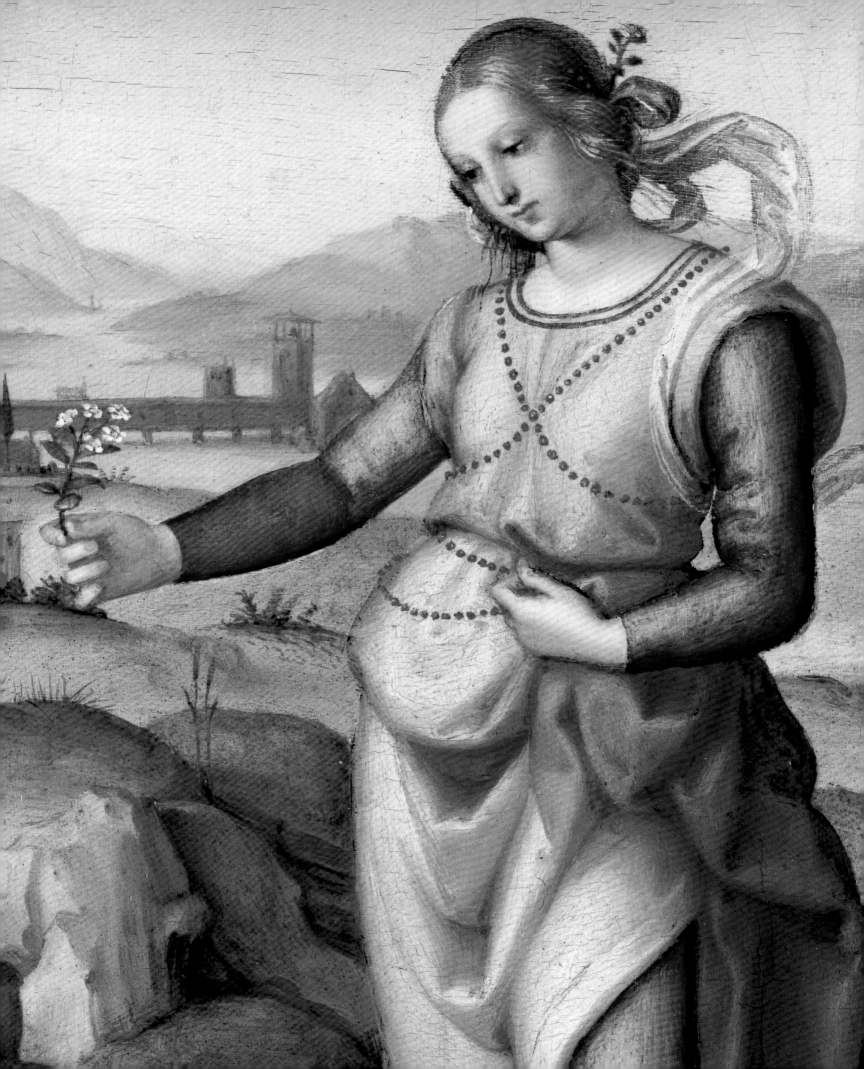

36 Cartoon for An Allegory ('Vision of a Knight')
about 1504

Pen and brown ink over traces of stylus underdrawing, pricked for transfer,
the reverse blackened with pouncing dust, 18.3 × 21.5 cm
Inscribed in brown ink in the bottom right corner: S3.
The British Museum, London, 1994-5-14-57 (formerly National Gallery NG 213a)

This detailed drawing is the cartoon which Raphael used to transfer his design for the *Vision of the Knight* (cat. 35) to panel. In addition to laying out the overall composition, he paid close attention to nuances of light and shade in the figures, confidently building up the shadows with rapid diagonal strokes of hatching and cross-hatching. The figure of Scipio and the upper body of Virtue are elaborated in more detail than other parts. For the areas of deepest shade on and beneath the shield he intensified this linear hatching into a diamond pattern reminiscent of engraving, a technique with which he was familiar through study of Northern prints. The cartoon – with its indications of light and shadow – would have been kept for reference during the execution of the painting, since only the outlines could be transferred by pouncing. The main outlines were pricked through with a pin and black chalk dust was pounced through onto the gessoed panel in preparation for painting. These dots have mostly been brushed off the gesso and are therefore difficult to detect in the underdrawing. However, some of the under-drawn lines have a blotchy quality where the ink has stuck to remnants of chalk, confirming that pouncing was indeed used, and their hesitant character is indicative of the mechanical procedure of joining up the dots, and is quite unlike freehand drawing.[1]

The cartoon was first recorded in 1833 when Passavant saw it, together with the painting, in the London collection of Lady Sykes. No other drawings for this composition are known, although it is probable that Raphael made some, since the outlines of the cartoon are unerring, as if he had already worked out the design else-where. Characteristically, he made a number of minor changes when he began painting. He adapted the neckline of Virtue to a rectangular design and modified the *décolletage* of Pleasure from a tight bodice with cleavage visible through a transparent chemise, to a looser, more modest tunic, with strings of coral beads criss-crossing over her breast. A stream traversed by a flat bridge was replaced by a crossroads with three horsemen. Otherwise the drawing is identical to the painting.

Raphael's habit of using cartoons was almost certainly learned in Perugino's workshop, which specialised in the production of replicas by this method. However, the younger artist's use of them differed somewhat from his master's. His interest lay less in recycling his compositions and more in perfecting his designs in advance so that they could be reproduced in paint with little adjustment. This explains why his cartoons often have the appearance of works of art in their own right rather than everyday workshop patterns, and also why so many of them survive. The present cartoon's high quality was charac-terised by Crowe and Cavalcaselle as 'the faultless treatment of a hand trained to every finesse of drawing'.[2] Most of the exquisite miniature paintings Raphael made for private patrons in his early years depend upon similarly detailed cartoons (see cat. 34). This method of painstaking preparation is reflected in the clear construction and confident execution of the finished work.

Similar landscape features, including the buildings with steep roofs and spires and the flat bridge, appear in preparatory drawings for other compositions of approximately the same date and are most likely inspired by Northern prototypes. CP

NOTES

1 This disproves the opinion expressed by Plesters, in Shearman and Hall 1990, pp. 17–18.
2 Crowe and Cavalcaselle 1882–5, I, p. 201.

SELECT BIBLIOGRAPHY

Passavant 1833, p. 105; Passavant 1836, I, p. 33; Gould 1975, pp. 212–15; Gere and Turner 1983, no. 15; Joannides 1983, no. 31; Knab, Mitsch and Oberhuber 1984, no. 93; Dunkerton *et al.* 1991, pp. 169–70; Bambach 1999, pp. 26, 97, 105; Hiller 1999, pp. 223–4; Dunkerton and Plazzotta in Bomford (ed.) 2002, p. 66.

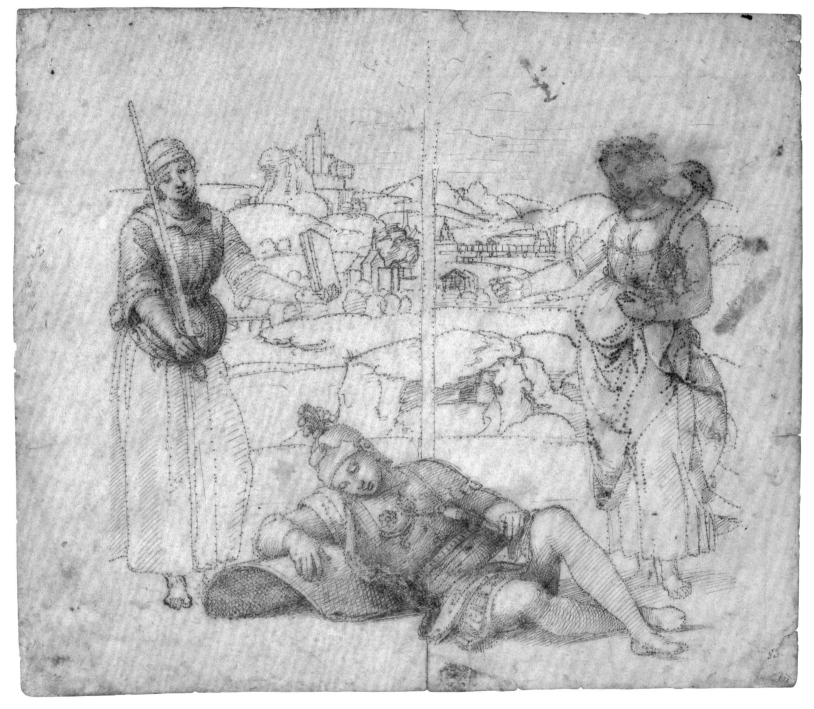

37 A young woman, half-length
about 1503–4

Black chalk, 25. 9 × 18.3 cm
The British Museum, London, 1895-9-15-613

This drawing appears to be a careful study for a lost or unexecuted painted portrait. In the early nineteenth century it was believed to be a portrait of the artist's sister until Passavant pointed out in his 1839 monograph that she was not born until 1494, and died when still a child. The details of the sitter's costume, such as the transparent veil partly covering her shoulders and the slashed opening at her elbow revealing a knot of fabric, are similar to those in Raphael's female painted portraits from about 1505 to 1508, for example the *Lady with a Unicorn* (cat. 51), and *Maddalena Doni* (fig. 29) and *La Gravida* in the Palazzo Pitti, Florence. The drawing also shares with these paintings the placement of the sitter at a slight angle with the head turned to the front, a pose derived from Leonardo's *Mona Lisa* (fig. 75). Raphael's adaptation of Leonardo's composition in the drawing is much less assured than in the paintings, the stiffness of the pose compounded by the rather stilted handling of the chalk, and the drawing is almost certainly slightly earlier. If it does indeed mark Raphael's first reaction to the *Mona Lisa* it may explain why he does not take up, as he would do in the later portraits, Leonardo's innovative positioning of the sitter's furthest arm across the body to enhance the sense of depth. It is not entirely clear what pose Raphael did intend for the arms as he abandoned the one on the left unfinished. As a measure of Raphael's rapid artistic development it is instructive to compare this portrait with his confident reworking of Leonardo's model just a few years later in the pen portrait study in the Louvre (cat. 52).

The sitter in this drawing is remarkably similar in her cast of features to Raphael's paintings of female figures in the period around 1504–5 such as the Virgin in the National Gallery's *Ansidei Madonna* (cat. 45). The same sitter is apparently depicted in a more informal style in a metalpoint drawing at Lille (fig. 66).[1] The two drawings differ in minor details of costume and in the direction of lighting, but the woman's pose in both is much the same. For all the formal similarities between the two, the Lille drawing is the more

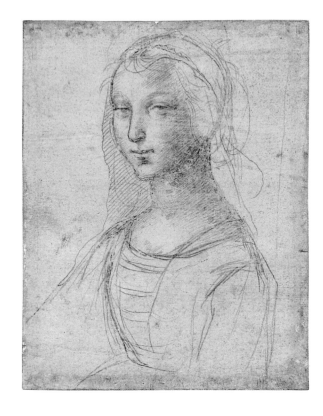

fig. 66 **A young woman, half-length**
about 1503–4
Metalpoint on green prepared paper
12.6 × 10.1 cm
Musée des Beaux-Arts, Lille
inv. PL 469

sophisticated: its *sfumato* modelling and the self-contained, somewhat feline, quality of the sitter's expression are markedly more Leonardesque. Perhaps the most likely explanation for this difference lies in the fact that although Raphael was capable of incorporating elements of Leonardo's style into his drawing, he could not yet manage to do the same in the technically more demanding medium of paint. For this reason the more sophisticated Leonardesque elements are missing from the London drawing because it was created with the practicalities of a painted portrait very much in mind. Even though it is a much more formal and composed rendering of the sitter, it still has the look of having been drawn from life, with the artist making slight adjustments to the contour of the left side of her face and adding telling realistic touches such as the stray hairs escaping from beneath her scarf (a feature repeated in a

number of his painted female portraits from *Maddalena Doni* to the *Donna Velata*, cat. 101). The exaggerated slope of the woman's shoulders in the drawing to create a smooth unbroken upward contour from her left shoulder to the neck is another feature found both in Raphael's painted female portraits and in his Madonnas of the period such as the slightly earlier Norton Simon *Virgin and Child* (fig. 10). HC

NOTE

1 Joannides 1983, no. 78.

SELECT BIBLIOGRAPHY

Fischel 1913–41, I, no. 33; Pouncey and Gere 1963, no. 13; Gere and Turner 1983, no. 68; Joannides 1983, no. 79; Knab, Mitsch and Oberhuber 1984, no. 73; Turner 1986, no. 20; Meyer zur Capellen 1996, pp. 116–18, fig. 62; Meyer zur Capellen 2001, pp. 55–6, fig. 26.

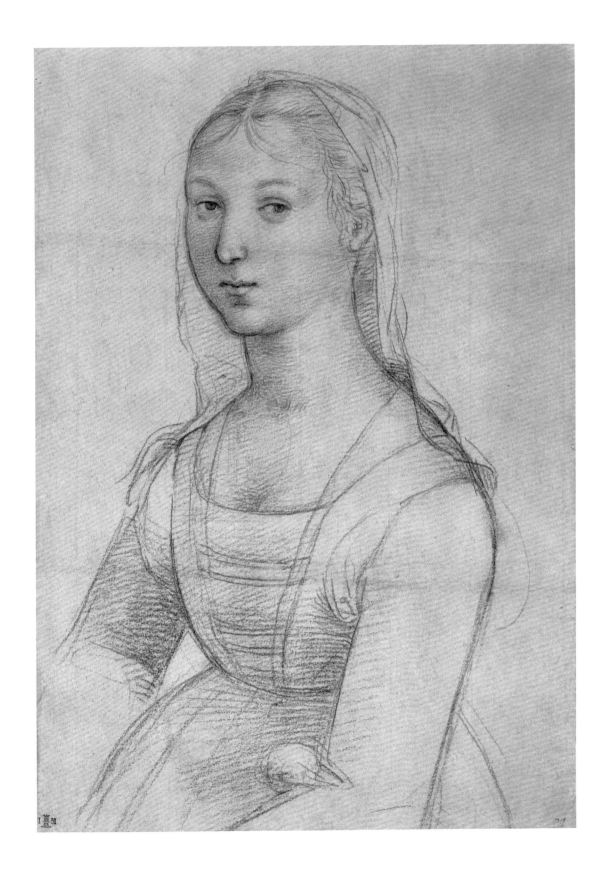

38 Head of a middle-aged man
about 1504

Black chalk, over stylus underdrawing on light brown paper
25. 4 × 18.9 cm
The British Museum, London, 1895-9-15-619

Raphael began this drawing by making an initial sketch with a stylus. Such underdrawing is usually quite difficult to detect unless the surface of the drawing is seen in raking light, but in this case it is easily visible as the indented contours are deep and the black chalk has skipped over the resulting furrow of paper so that the scored indentations appear as white lines. The advantage of making a preliminary underdrawing in stylus was that it allowed the draughtsman to experiment freely without marring the sheet with corrections. The technique was one that Raphael continued to utilise throughout his career, as is shown, for example, by the presence of stylus underdrawing in the Windsor study for the *Massacre of the Innocents* of about 1510 (cat. 89).

It is difficult to determine the function of the drawing. It is sufficiently particular in the description of the features, especially in the detail of the slightly puffy flesh and wrinkles beneath the eyes, to suggest that it is a drawing from a model. The suggestion of movement in the turn of his head and the direction of his gaze to the left rule it out as a preliminary study for a painted portrait, and it is more likely a preparatory study from life for a figure in a painting, although none corresponding to it is known. The strongly contrasting lighting might, as Joannides observed, suggest a nocturnal subject such as an *Adoration*.

There are intriguing parallels between Raphael's drawing and a study in black chalk over vigorous stylus underdrawing of a man's head by Perugino in the British Museum, a rare example of a life drawing by the artist (fig. 67). Perugino's drawing reveals a degree of naturalistic observation – visible in the detailing of the sitter's sinewy neck and rather pinched features – that is somewhat unexpected for an artist whose painted figures are so homogenous and idealised. Rather than the usual emphasis on elegant linear rhythms Perugino concentrates instead on establishing sculptural volume, the form

described by modelling in sharply delineated areas of light and shade. The similarities between the two studies are sufficiently telling to indicate that the inspiration for the searching naturalism and the chiaroscuro lighting of Raphael's work might stem from Perugino and not, as had sometimes been suggested, the influence of Florentine art. Perugino's drawing is generally believed to date from around the same period as his frescoes of 1496–1500 in the Collegio del Cambio, Perugia, whereas Raphael's is usually placed around 1504. HC

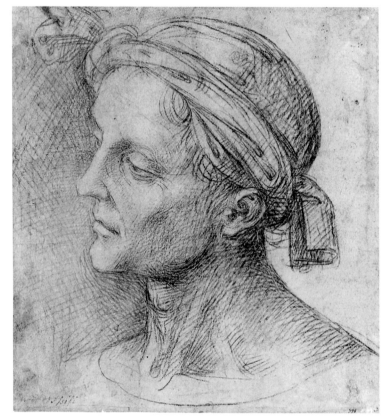

fig. 67 Pietro Perugino
Head of a man in profile
about 1496
Black chalk over stylus under-drawing, 20.1 × 18.8 cm
The British Museum, London
1895-9-15-600

SELECT BIBLIOGRAPHY

Fischel 1913–41, I, no. 32; Pouncey and Gere 1963, no. 8; Gere and Turner 1983, no. 32; Joannides 1983, no. 66; Knab, Mitsch and Oberhuber 1984, no. 88.

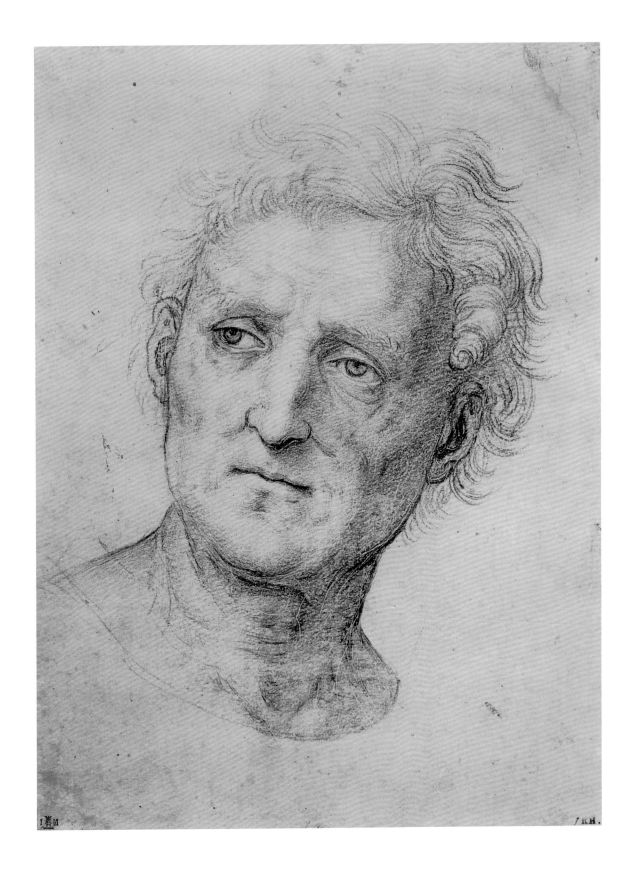

39 The Virgin and Child with a pomegranate

about 1504

Black chalk, 41.2 × 29.4 cm
Graphische Sammlung Albertina, Vienna, 4879

This composition is exceptional among Raphael's early Madonnas in showing the Virgin standing behind a parapet, upon which the Christ Child is seated on a plump cushion. It harks back to a type of design for small-scale Madonnas favoured by Giovanni Santi (see cat. 4), which ultimately has its roots in Northern European models.[1] Christ sits comfortably on the cushion, crossing his chubby feet and curling his toes back in a thoroughly lifelike fashion (a similar cross-legged pose was used for the Christ Child in the *Ansidei Madonna* (cat. 45) which must be very close in date). He and his mother are connected both by gaze and touch through the pomegranate delicately offered by the Virgin, a symbol of the Resurrection (on account of its classical association with Persephone who returned every spring to regenerate the earth). Christ fingers the seeds in contemplation of his future Passion, no doubt also alluded to in the open prayer book in which the Virgin calmly marks her place.

The scale of this impressive drawing, and the clarity and confidence of its execution, has led to the suggestion that it may have been designed as a cartoon for a small Madonna, but since it is neither pricked nor indented, and no corresponding painting by Raphael is known, it is more likely to be an unusually large composition study, on a similar scale to contemporary portrait drawings such as cat. 37.[2] Lines at the left edge and along the top (interrupting the halo) indicate the intended confines of the composition.

Raphael's approach in this drawing is exclusively linear, and he used black chalk sharpened to a point in the manner of a metalpoint or pen (compare cat. 36). He continued to adopt conventional pot-hooked marks for delineating drapery folds, but his growing confidence in building form is evident in his masterful control of multi-directional parallel hatching, ranging from the most delicate strokes in the Virgin's head to dense cross-hatching in the darkest shadows.

The drawing is the culmination of all that Raphael had absorbed in Umbria, and it must have been made just before his departure for Florence. The Virgin's heavy-lidded eyes, the graceful turn of her neck and head, and her frontal pose still contain echoes of his very earliest renderings of this subject such as the *Diotalevi Madonna* in Berlin and the Norton Simon *Virgin and Child* (fig. 10), while the bulky form of her bust and the delicate gestures of her hands remain rooted in the Peruginesque idiom (compare cat. 26). But in comparison with even the almost contemporary *Conestabile Madonna* (cat. 32), there is a new awareness of *contrapposto*, a more naturalistic subtlety of characterisation, and an increased mastery of sculptural monumentality and foreshortening, all of which demonstrate Raphael's growing maturity. Many features of cat. 39 recur in one of the first Madonnas the young artist executed after his arrival in Florence, the large-scale *Terranuova Madonna* (fig. 23) of around 1504–5, probably painted for Taddeo Taddei. The child's pose in the present drawing was originally closer to that in the painting, as a pentiment for his left arm folded across his belly reveals, and Raphael surely had recently worked-up designs such as this in mind as he embarked on that significant commission. C P

NOTES

1 Mitsch 1983, pp. 18–19, cites for example Schongauer's engraving of the *Madonna of the Parrot*.
2 A pedestrian painting based on this composition formerly in the Borletti collection in Milan (Mitsch 1983, pp. 19–20) was most likely copied from the drawing.

SELECT BIBLIOGRAPHY

Fischel 1913–41, I, no. 53; Joannides 1983, no. 68; Mitsch 1983, no. 1; Knab, Mitsch and Oberhuber 1984, pp. 68–9 and no. 95; Birke and Kertesz 1992–7, III, pp. 1688–9.

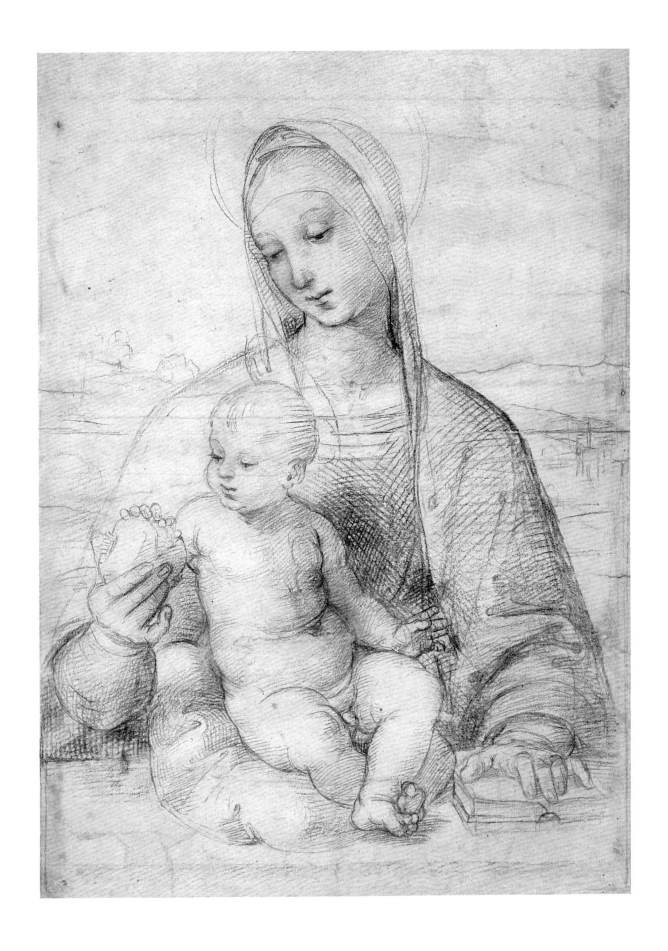

40 The Agony in the Garden

about 1504–5

Oil on wood, 24 × 29 cm
The Metropolitan Museum of Art, New York
Funds from various donors, 1932, 32.130.1

41 The Procession to Calvary

about 1504–5

Oil on wood, 24.4 × 85.5 cm
The National Gallery, London, NG 2919

42 Pietà

about 1504–5

Oil on wood, 23.5 × 28.8 cm
Isabella Stewart Gardner Museum, Boston, P16e3

fig. 68 **The Madonna and Child Enthroned with Saints (The Colonna Altarpiece)**, about 1504–5
Tempera and gold on wood, main panel 169.5 × 168.9 cm (painted surface); lunette, 64.8 × 171.5 cm (painted surface)
The Metropolitan Museum of Art, New York
Gift of J. Pierpont Morgan, 1916, 16.30ab

These three scenes from Christ's Passion formed the predella of an altarpiece painted by Raphael for the convent of Sant'Antonio da Padua in Perugia, a religious house (now largely destroyed) for female tertiaries of the Franciscan Order. The altarpiece, known as the *Colonna Altarpiece*, consisted of a unified central panel depicting the Virgin and Child enthroned with saints (Saints Peter, Paul, Catherine and another female martyr) surmounted by a lunette representing God the Father blessing with two angels (now in the Metropolitan Museum of Art, New York, fig. 68). In the predella, the long central *Procession to Calvary* (cat. 41) was flanked on the left by the *Agony in the Garden* (cat. 40), and on the right by the *Pietà* (cat. 42). Two smaller panels of Franciscan saints (cats 43–4) completed the ensemble. On stylistic grounds, most scholars date the altarpiece to around 1504–5, which accords with the date of 1505 recorded on the work in the nineteenth century.[1] The altarpiece remained intact and *in situ* until 1663 when the impecunious nuns of Sant'Antonio sold the predella to an agent of Queen Christina of Sweden. A few years later (1677–8), they sold the main panel and lunette to Antonio Bigazzini of Perugia, who in turn sold them to the Colonna family in Rome (after whom the altarpiece is now named).

Raphael made detailed preparatory cartoons for the individual predella scenes.[2] The scenes were painted on a single plank that was cut into three at the time of their sale from the convent. Vasari, who hailed the altarpiece as 'a marvellous and devout work of art held in great honour by those nuns and highly admired by all painters', did not neglect to mention the predella scenes as well, describing each one individually.[3] His attention may have been caught by the sensitive range and diversity of colours, echoing the vivid hues of the main altar panel above, which Raphael here deployed to organise and define his narratives, no doubt wishing to ensure maximum legibility in the enclosed inner sanctum of the nuns' church. Some of the brightly coloured draperies are further enlivened by highlights in a contrasting colour, such as the lemon accents on the Magdalen's rose-coloured robe in cat. 42, and Raphael used touches of gold to define the borders of several of the figures' draperies and their double haloes. Although less overtly dependent on Peruginesque models than the predella of the Oddi *Coronation* of a year or two earlier, the two smaller scenes at either end of the predella nevertheless recall the older master's formulae, as seen for example in his *Agony in the Garden* and *Pietà* for the convent of S. Giusto degli Ingesuati in Florence (both now in the Uffizi). These, and other, connections to works in Florence by other artists may imply that the predella scenes were completed after the main altarpiece, following Raphael's first extended stay in the city.

The *Agony in the Garden* shows Christ on the Mount of Olives when he prayed that the cup symbolising his future sacrifice might be taken away from him. Three of his disciples, Peter, James and John, sleep soundly, disobeying his request to watch and pray. Their somnolent forms prefigure Christ's lifeless corpse in the *Pietà* at the opposite end of the predella. The profile figure of Christ, with his bushy forelock and pointed beard, conforms to established Umbrian prototypes, but the brilliantly foreshortened figure of Saint John on the right, his legs crossed and his head and hands heavy with sleep, contains the seeds of a new, more naturalistic style, developing out of more conventionally posed sleeping apostles in paintings of this subject, and of the Resurrection, by Perugino and his followers, and by Giovanni Santi (see cat. 21).[4] Raphael originally conceived this composition with the chalice set upon the altar-like rock at the top right, emphasising the eucharistic significance of the scene. This was later painted out by another artist and substituted – probably at the request of the nuns – with a flying angel bearing the cup, more in accordance with Umbrian tradition.[5] This explains the weak design of the angel and why it is squeezed into the corner, a factor which may have induced nineteenth-century scholars

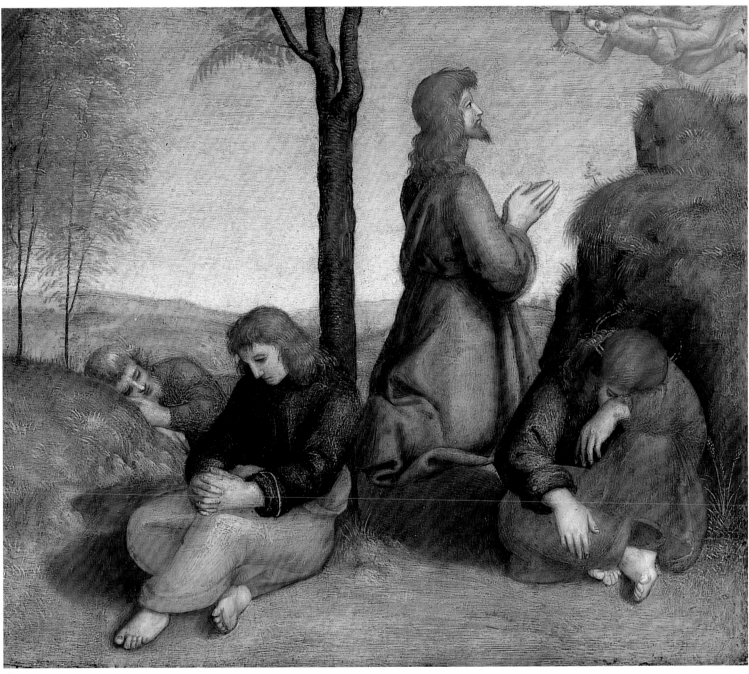

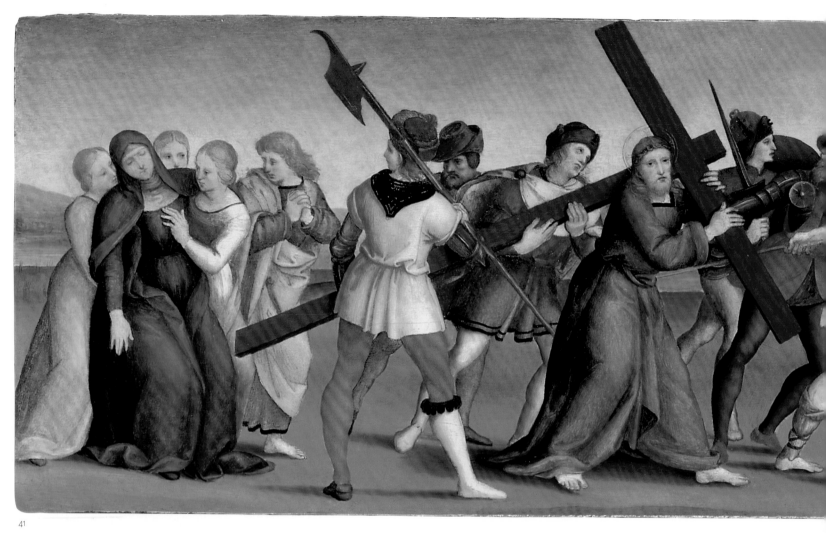

41

fig. 69 Justus of Ghent (Joos van Wassenhove)
The Communion of the Apostles, 1473–5
Oil on wood, 283.3 × 303.5 cm
Galleria Nazionale delle Marche, Urbino, 700

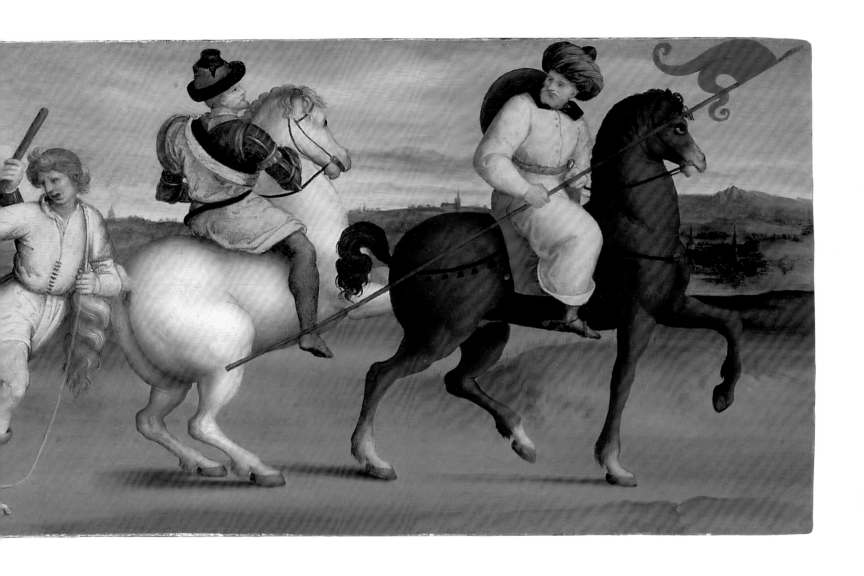

to attribute the panel to followers of Perugino such as Lo Spagna and Eusebio da San Giorgio.[6]

The *Procession to Calvary*, the centrepiece of the predella, shows Christ carrying the cross, escorted by five foot-soldiers, one of whom drags him along by a rope. Behind him, Simon of Cyrene helps bear the weight of the cross. The rearing white horse and the twisting pose of the turbaned horseman at the head of the procession suggest knowledge of Leonardo's unfinished fresco of the Battle of Anghiari (see pp. 34–5). The group of the Virgin supported by the three Maries was inspired by figures in a *Deposition* for the high altar of SS. Annunziata in Florence, begun by Filippino Lippi around 1503. As was the case with other artists of his acquaintance, Raphael appears to have had access to Filippino's designs, since his group is

closer to the underdrawing of the painting than to the finished work (which was completed by Perugino following Filippino's death in 1504).[7] The pose and to some extent the type of Christ in the *Procession* were inspired by the *Communion of the Apostles* by Justus of Ghent (fig. 69), an artist whose work greatly influenced both Giovanni Santi and Raphael (see cat. 99).

The procession divides into three distinct groups (the horsemen, the figures around Christ, and the three Maries and John), knitted together by several figures looking back over their shoulders at the groups behind. The figures are animated by a variety of poses, costumes and headgear (Vasari singled out for praise the 'beautiful movements' of the soldiers dragging Christ), and the procession in all its diversity may indicate Raphael's familiarity with

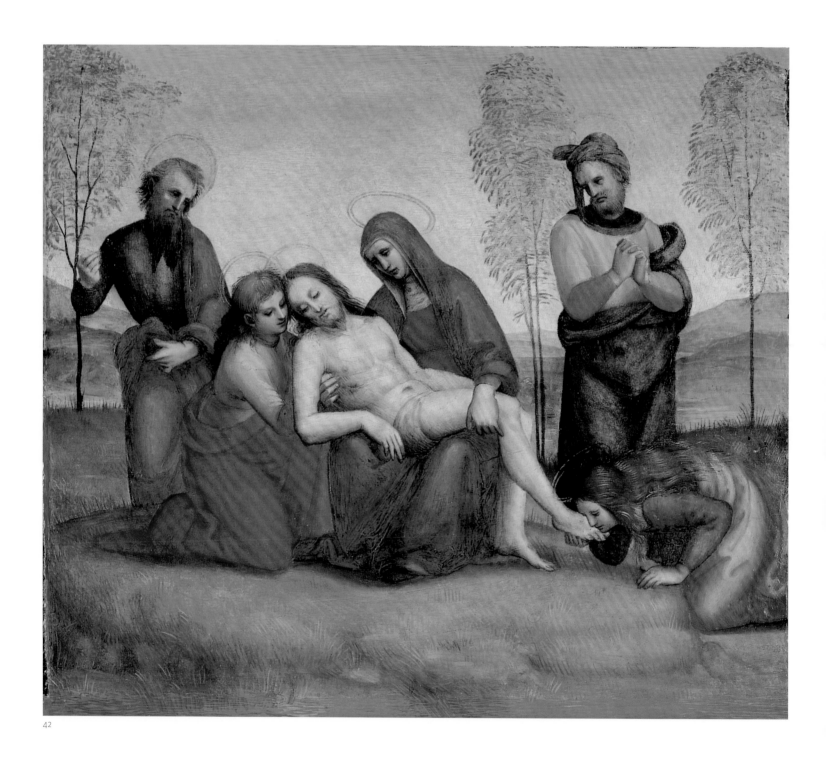

42

Schongauer's engraving of the same subject.[8] Raphael achieved greater sophistication and compositional depth in the crowd gathered about the preaching Baptist in the nearly contemporary Ansidei predella (cat. 46), also influenced by Northern prints.

In the *Pietà* at the right end of the predella, Raphael borrowed certain motifs, such as the seated Virgin, the kneeling pose of Saint John and the clasped hands of Nicodemus, from Perugino's *Pietà* in S. Giusto (fig. 70), but there is far less rhetorical gravitas and more tender intimacy in Raphael's small scene, designed specifically for the private devotions of the nuns. Perugino depicted Christ's elongated body laid out rigidly, but Raphael's Christ is small, his limbs are soft and round, and his vulnerability is conveyed by the bruised flesh around his wounds (especially that in his side) and the dark shadows under his eyes. His graceful pose is more evocative of serene sleep than death

(compare the sleeping knight in cat. 35, a painting to which both the *Agony* and the *Pietà* are stylistically very close). Neither Christ's features nor the scale of the figures are particularly consistent in the three predella scenes, perhaps implying that they were designed at intervals or simply that Raphael was not attentive to the overall design of the predella.

Although modern criticism has characterised the Sant'Antonio altarpiece as an awkward blend of styles and influences, early sources responded to it in terms of the highest praise, and it was far more influential for the subsequent development of Umbrian *sacre conversazioni* than the more highly evolved *Ansidei Madonna*.[9] Its predella, here reunited for the first time in almost two centuries, admirably demonstrates Raphael's growing talent for narrative and for drawing out a poignantly human dimension in biblical stories.
CP

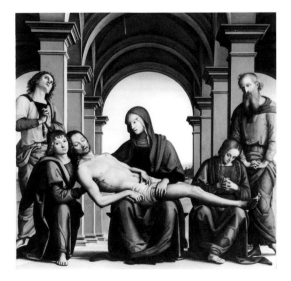

fig. 70 Pietro Perugino
Pietà, 1494–5
Oil on wood, 168 × 176 cm
Galleria degli Uffizi, Florence
inv. 1890, no. 3365

NOTES

1 Shearman 2003, p. 97. Oberhuber 1977, pp. 51–91, argues, however, for a dating around 1501–2.
2 Only one, for the *Agony*, survives in the Pierpont Morgan Library, New York (inv. I, 15); see Joannides 1983, no. 83, and Meyer zur Capellen 2001, pp. 177–8, under no. 17C. Infrared reflectography reveals pouncing beneath the very full underdrawings of the *Procession to Calvary* and the *Pietà*. For the former see Bomford (ed.) 2002, no. 8; we are grateful to Alan Chong for sending us the newly made infrared-reflectogram of the *Pietà*.
3 Vasari/BB, IV, p. 162.
4 See for example Perugino's *Agony*, now in the Uffizi (Scarpellini 1984, cat. 44); Lo Spagna in the National Gallery (NG 1032).
5 Brown 1983, p. 121, fig. 51. For Umbrian examples – all of which show an angel holding the chalice – see Nucciarelli 1998, pp. 264–79.
6 For example Crowe and Cavalcaselle 1882–5, I, p. 237; Richter 1902, p. 84.
7 Nelson 2004, p. 33–4.
8 Hollstein 1999, XLIX, pp. 32–3. We are grateful to Lorne Campbell for this suggestion.
9 Ferino Pagden 1986, pp. 98–9; Cesare Crispolti's guide to Perugia of 1597 described the Sant'Antonio altarpiece as *'di bellezza squisita'*, rating it more highly than Piero della Francesca's altarpiece in the same church (Shearman 2003, p. 1418).

SELECT BIBLIOGRAPHY

(40) Vasari/BB, IV, p. 162; Passavant 1839, II, p. 41; Zeri and Gardner 1980, II, pp. 75–8; Brown 1983, pp. 119–23; Bambach 1988, no. 224; Shearman 1996, pp. 205–6; Meyer zur Capellen 2001, no. 17C.

(41) Vasari/BB, IV, p. 162; Passavant 1839, II, p. 41; Crowe and Cavalcaselle 1882–5, I, pp. 217–21 and 236–9; Dussler 1971, p.15; Gould 1975, pp. 220–2; Oberhuber 1977; Zeri and Gardner 1980, II, pp. 72–5; Ferino Pagden 1981, pp. 231–6; Ferino Pagden 1986, pp. 98–100; Shearman 1996, p. 203; Meyer zur Capellen 2001, no. 17D; Plazzotta in Bomford (ed.) 2002, no. 8; Roy, Spring and Plazzotta 2004, pp. 18–20.

(42) Vasari/BB, IV, p. 162; Passavant 1839, II, p. 42; Dussler 1971, p. 15; Hendy 1974, pp. 193–5; Brown 1983, pp. 59–62; Ferino Pagden 1986, pp. 103–5; Meyer zur Capellen 2001, no. 17E.

ATTRIBUTED TO RAPHAEL

43,44 Saint Francis; Saint Anthony of Padua
about 1504–5

Oil on wood, 25.8 × 16.8 (*Saint Francis*) and 25.6 × 16.4 cm (*Saint Anthony*)
Dulwich Picture Gallery, London, DPG 241 and 243

Saint Francis of Assisi was the founder of the Franciscan Order and Saint Anthony of Padua was his friend and disciple. Their presence in the predella of Raphael's altarpiece for the Perugian convent of Sant'Antonio (now in the Metropolitan Museum of Art, New York, fig. 68) signalled the Franciscan affiliation of the religious house, and its dedication to Saint Anthony. Both saints are barefoot and wear simple Franciscan habits with rope belts, knotted three times as reminders of the Order's vows of poverty, chastity and obedience. Saint Francis holds a book and a crucifix. The wounds of the stigmata in his hands and feet are absent, but that in his side confirms his identity. Saint Anthony holds a book and a lily standing for purity, the attribute by which he is frequently identified. The nuns of Sant'Antonio were Franciscan tertiaries who took religious vows and lived in community, but were not completely enclosed, being able to leave the convent to perform acts of charity.

Unlike the other three scenes in the predella (cats 40–2), which were painted on a single horizontal plank, the two saints are on panels with the grain running vertically. They would almost certainly have been incorporated separately into the predella frame, perhaps in protruding elements at either end. They are not mentioned by Vasari, who described only the three eye-catching Passion scenes, nor do they feature in Claudio Inglesi's painted copy of the predella, made at the time of its sale to Queen Christina of Sweden in 1663.[1] However, the deed of sale specifies '*cinque quadretti di divotione*', implying

that the predella had been cut up to be sold more lucratively as separate items along with the two independent saints.[2] The five '*quadretti*' remained together for well over a century, passing from Queen Christina, through the Azzolino, Odescalchi and Orléans collections, before being dispersed at a sale of Italian pictures from the Orléans collection held in London in 1798.

Doubts regarding Raphael's authorship of these two panels have repeatedly been raised. The two paintings are gravely damaged, but the extensive losses are confined mainly to the background (on account of which it is impossible to verify whether double haloes consistent with the other predella scenes were ever present). The figures were unquestionably designed by Raphael – their poses and voluminous draperies recur frequently in other autograph works of around this date (see for example Saint Nicholas of Tolentino in cat. 31 and Virtue and Pleasure in cat. 35). Underdrawing revealed by infrared-reflectography suggests that the designs were transferred to panels by means of pricked cartoons, the pounced dots joined up in a liquid material in a manner highly comparable to cat. 41.[3] Conceivably the execution was left to a collaborator or assistant working to Raphael's designs (perhaps necessitated by his departure from Perugia), but it is more probable that Raphael painted the figures himself, and that their anatomical idiosyncracies (such as their crude thumbs, comparable to Christ's in cat. 41) are his own. CP

NOTES

1 Vasari/BB, IV, p. 162; Raffaello Sozi, in a manuscript list of the best paintings of Perugia of about 1591, also mentions only the three Passion scenes in the predella: '*una predella con tre misteri della Passione di figure piccole*' (see Shearman 2003, p. 1384). Inglesi's copy is in the Galleria Nazionale di Umbria, inv. 412 (see Locher 1994, p.233);
2 Files of the Department of Paintings, the Metropolitan Museum of Art, New York.
3 See Plazzotta in Bomford (ed.) 2002, no.8.

SELECT BIBLIOGRAPHY

Passavant 1839, II, p. 42; Richter 1902, pp. 83 ff.; Dussler 1971, p. 16; Murray 1980, p. 99; Meyer zur Capellen 2001, nos 17 F and G.

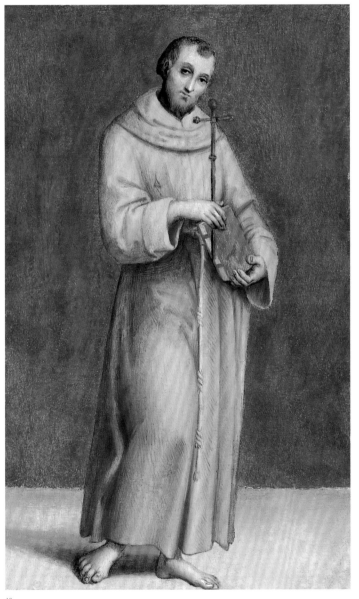

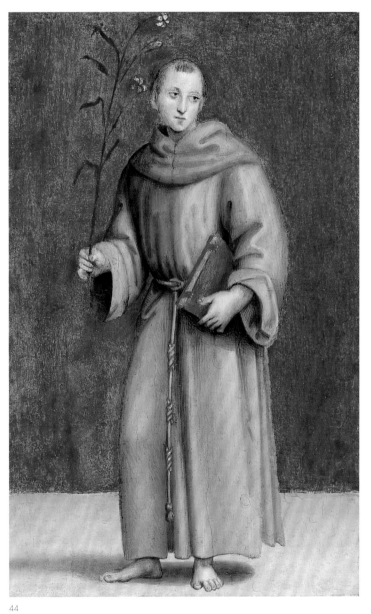

43

44

45 The Madonna and Child with Saint John the Baptist and Saint Nicholas of Bari (The Ansidei Madonna) 1505

Oil on poplar, 245 × 157 cm (painted area 216.8 × 147.6 cm)
Inscribed on the frieze above the throne: ·SALVE·MATER·CHRISTI·
and in the border of the Virgin's mantle, beneath her left arm: MDV·
The National Gallery, London, NG 1171

This altarpiece was painted for the Ansidei family chapel in the Servite Church of S. Fiorenzo in Perugia. The chapel had been erected in 1483 by Filippo di Ansideo di Simone 'de Catrano', a prosperous wool merchant, whose will of December 1490 left provision for its maintenance as well as for his burial in the church.[1] Filippo's eldest surviving son Niccolò (b. 1469 – after 1527) inherited his father's business interests and therefore probably also assumed the patronage rights of the chapel. It is he who most likely commissioned Raphael to paint the altarpiece in around 1504–5.[2] This is supported by the fact that the two saints in the altarpiece reflect his name and that of his eldest son Giovanni Battista (b. 1496).

The Ansidei altar was originally located on a pier on the south side of the nave at the point where it meets the transept. It was demolished when the church underwent extensive refurbishment in the baroque style in 1768–70. Shortly before this, in 1764, and perhaps to pay for the renovations, Raphael's altarpiece was sold by the monks of S. Fiorenzo with part of the predella (cat. 46) to the painter and dealer Gavin Hamilton, acting on behalf of Lord Robert Spencer.[3] A copy of the altarpiece (minus the predella) was commissioned from Nicola Monti to replace the original, and remains *in situ* on the reconstructed altar.

The Virgin is seated in majesty on a carved wooden throne with the Christ Child on her lap. With poignant seriousness she draws his attention to a passage in an open book, presumably containing allusions to his inevitable future sacrifice. The delicate string of coral beads suspended from the canopy above the throne, terminating in jewelled crosses, is similar to a rosary, the scarlet colour of the coral a reminder of the blood Christ will shed. Together with the Latin inscription (Hail Mother of Christ) it would have acted as a prompt to the recitation of the rosary.

The Baptist gazes up at his slender rock crystal cross, simultaneously pointing to Christ in prescience of his death by crucifixion. In contrast to Saint John's dynamic rhetorical stance, the older, more contemplative Saint Nicholas withdraws slightly behind the throne, his furrowed brow indicating his absorption in the book he is reading. At his feet are three golden balls representing the purses of gold he provided as dowries for the three daughters of an impoverished nobleman to save them from a life of prostitution.

The satisfying geometry of the composition, in which the picture space is divided vertically and horizontally into harmonious thirds (reminiscent of compositions by Piero della Francesca), was carefully calculated. Close scrutiny reveals that the picture surface was prepared with a grid nine squares high by six squares wide incised into the gesso with a stylus.[4] The whole composition is therefore based on a simple geometrical construction in the proportions of 3:2, a scheme Raphael would have worked out in squared composition drawings on paper.

One important aspect of the picture's composition was, however, improvised at a late stage, namely the pale grey architecture and vaulting behind the Virgin's throne, which endows the sacred figures with their own hallowed space. Recent technical investigation has revealed that this lofty vaulted structure was not planned by Raphael from the beginning, but was painted over the sky and landscape after painting had begun. Raphael used the pre-existing grid to position the parapet (one-third of the way up) and the mouldings (approximately two-thirds of the way up). This explains why the architecture seems so integral to the composition and why the revision has never been noted before. He may have made this significant alteration to compensate for a lack of structure in the actual architecture of the chapel or altar frame. Two separate seventeenth-century sources record that the Ansidei chapel was plain and deficient in ornament in contrast to the noble majesty of the altarpiece.[5] The idea of setting the figures in a barrel-vaulted interior had already been adopted by Raphael for his first known altarpiece (see

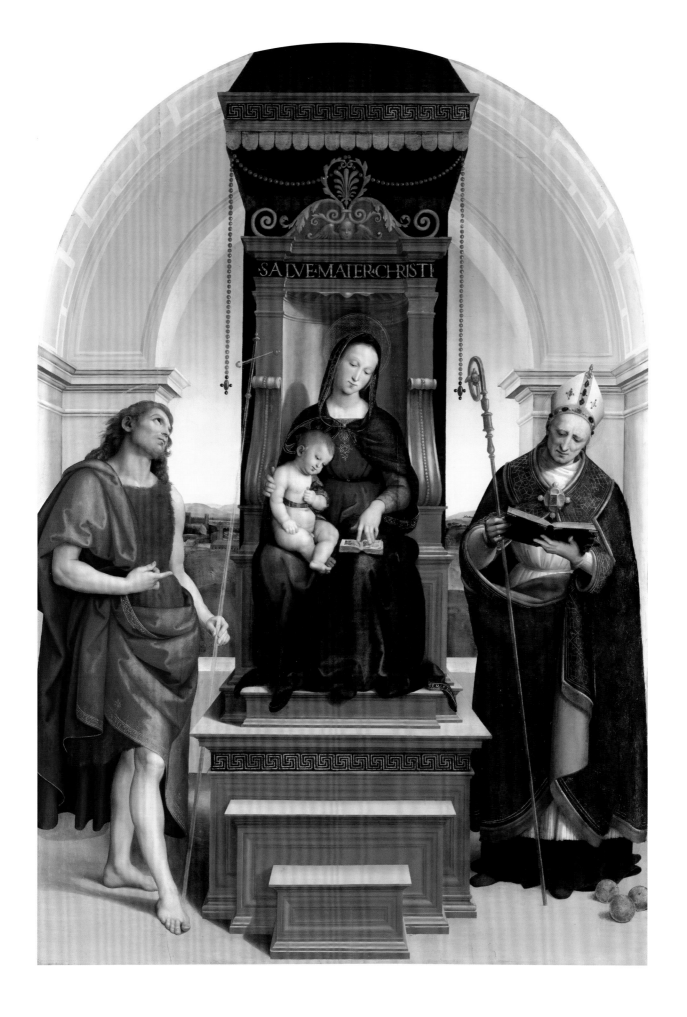

SALVE·MATER·CHRISTI

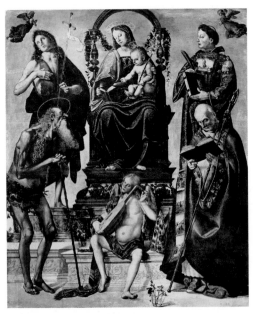

fig. 71 Luca Signorelli
**The Virgin and Child with Saints
(The Vagnucci Altarpiece)**, 1484
Oil on wood, 226 × 193 cm
Museo dell'Opera del Duomo, Perugia

cat. 17), and reflects his early exposure in Urbino to works by Piero della Francesca and his circle.

The *Ansidei Madonna* is the grandest and most resolved of Raphael's early Madonnas, which are all broadly similar in type and composition. The painting is closest in style and form to the *Colonna Altarpiece* (fig. 68), which gives some idea of how cat. 45 would have appeared before Raphael added the architectural backdrop. The broad throne and awkward circular canopy of the *Colonna Altarpiece* are transformed in the Ansidei into a taller, more slender and refined structure, and the saints are characterised in a far more lifelike, less formulaic fashion. The principal prototype for the throne, and to some extent the saints, in both works was Perugino's *Decemviri Altarpiece* (fig. 61), a composition studied and characteristically improved upon by Raphael in a slightly earlier drawing (see cat. 31). As in the *Colonna Altarpiece*, Raphael also sought inspiration in the work of Signorelli, particularly his altarpiece of 1483–4 for the chapel of Saint Onuphrius in Perugia Cathedral (fig. 71). This can be seen particularly in the way the Virgin gently supports Christ's back, and in the child's cross-legged pose, as they both read from an open book. Signorelli's ecstatic Saint John the Baptist, who also holds a rock crystal

cross, and the characterful old Saint Herculanus, who wears sumptuous bishop's regalia, and is immersed in reading a large book, certainly influenced Raphael's saints, in whom there are also fainter echoes of Santi prototypes.

There has been considerable discussion about the date of the *Ansidei Madonna*. The gilt Roman numerals M DV, which appear in the border of the Virgin's mantle beneath her left arm, are followed by two vertical strokes, which some authors have interpreted as additional numerals. The altarpiece has consequently been dated variously 1505, 1506 and 1507.[6] However, these additional strokes have the appearance of random marks inserted to extend the gilt border around the drapery fold, and certainly the style of the painting, with its eclectic assimilation of Umbrian influences, is incompatible with a date after 1505. Vasari mentioned the Ansidei commission just before the S. Severo fresco, also dated 1505 (fig. 15). The comparison with the fresco seems particularly pertinent, since the figure of Christ in that work is – but for the arms – a virtual repetition of the Ansidei Virgin's pose in reverse. A red chalk drawing closely related to the head of the Christ Child in the painting has recently come to light – the earliest example of Raphael's use of this medium.[7] C P

NOTES

1 Cooper and Plazzotta 2004.
2 Mancini 1987, pp. 57–60; Cooper and Plazzotta 2004.
3 Lord Spencer, who was then only 17, gave the main panel to his brother the fourth Duke of Marlborough. This was purchased by the National Gallery from the eighth Duke in 1885. Hamilton later tried, unsuccessfully, to buy the *Oddi Coronation* from S. Francesco al Prato in 1766 (Irwin 1962, p. 99) and the Saint Nicholas of Tolentino altarpiece from S. Agostino, Città di Castello, in 1787 (Rossi 1883, pp. 13–14).
4 The squares are 24.5 cm wide; approximately two-thirds of a Perugian *piede* (equivalent to 36.4 cm).
5 Cooper and Plazzotta 2004.
6 Shearman 2003, pp. 97–8.
7 Sotheby's, London, 8 July 2004, lot 23.

SELECT BIBLIOGRAPHY

Vasari/BB, IV, p. 323; Passavant 1839, II, no. 32; Crowe and Cavalcaselle 1882–5, I, pp. 222–8; Manzoni 1899, pp. 627–45; Gould 1975, pp. 216–18; Jones and Penny 1983, p. 16; Dalli Regoli 1983, pp. 8–19; Mancini 1987, pp. 57–60; Dunkerton *et al.* 1991, p. 204 and no. 65; Hiller 1999, pp. 67–8; Meyer zur Capellen 2001, no. 16A; Shearman 2003, pp. 97–8, 1324, 1373, 1385, 1419; Butler 2004; Cooper and Plazzotta 2004; Roy, Spring and Plazzotta 2004, pp. 20–4.

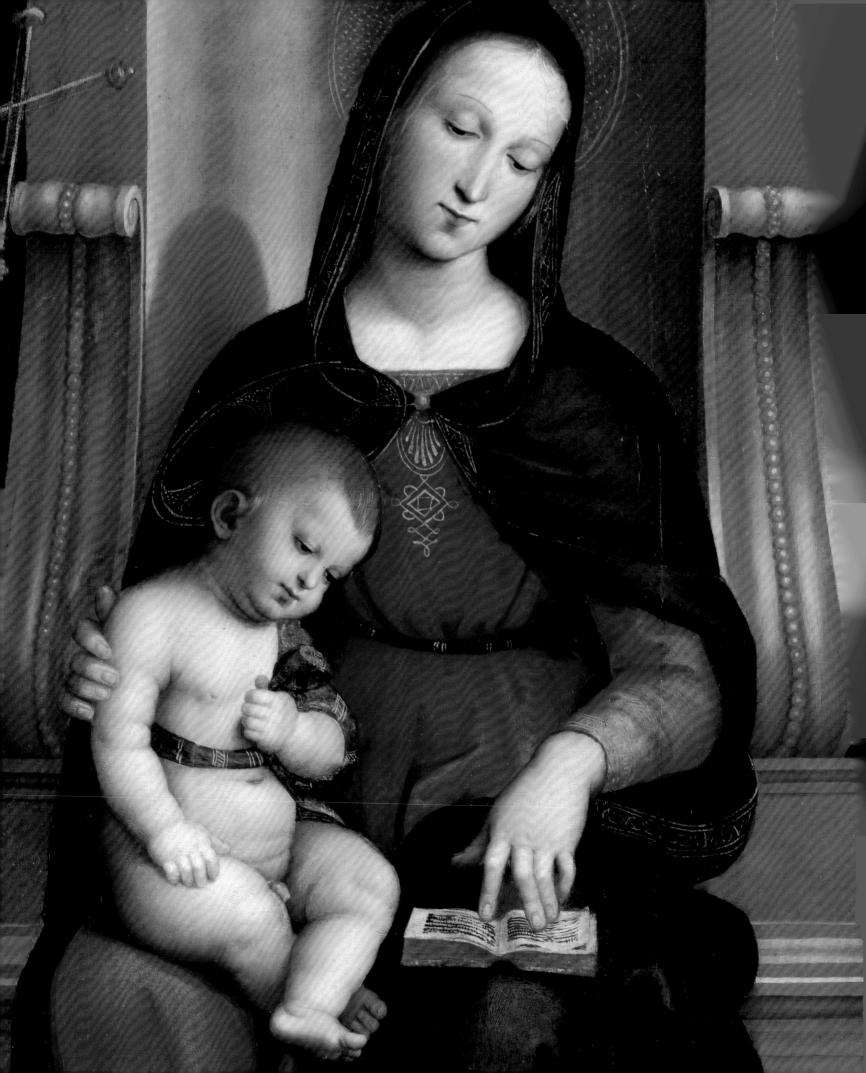

46 Saint John the Baptist Preaching

1505

Walnut oil on poplar, 29.2 × 54 cm (painted area 26.2 × 52 cm)
The National Gallery, London, NG 6480

This panel is the only surviving scene from the predella of Raphael's altarpiece for the Ansidei chapel in S. Fiorenzo, Perugia (cat. 45). The predella, not mentioned by Vasari, is first described in a manuscript list of 1597 recording outstanding works in Perugia as consisting of 'very beautiful little stories [by Raphael] and worthy of such a man'.[1] The scenes were most likely painted on a single horizontal plank (like cats 40–2). A ridge of gesso (or barb) at the top and bottom edges of the painted field of cat. 46 suggests that the predella was already framed before the gesso ground and paint layers were applied.

Confusion over the subjects of the missing scenes has arisen from two conflicting traditions, both of which mention the Preaching of the Baptist. Passavant, without specifying his source, referred to a predella with three scenes all devoted to the life of the Baptist.[2] However, such emphasis on the Baptist would have been eccentric in a chapel dedicated to Saint Nicholas. It is preferable to assume that an eighteenth-century letter from the monks of S. Fiorenzo recording a *gradino* (a step or predella) with only two scenes – the Baptist preaching and a shipwreck – is correct.[3] The subjects would thus have related vertically to the two saints in the altarpiece (the shipwreck being a posthumous miracle of Saint Nicholas).

In 1764, the monks sold cat. 46 with the main altarpiece to Gavin Hamilton, acting as agent for Lord Robert Spencer. The latter presented the main panel to his brother the fourth Duke of Marlborough, but kept the predella, which appeared in his sale at Christie's in 1801, when it was bought by Lord Lansdowne and passed to the Viscount Mersey, from whose descendants it was acquired by the Gallery to join the altarpiece in 1983.

The Baptist appears in his role as forerunner of Christ, preaching to a throng of all-male listeners (Luke 3: 1–17). His pointing gesture refers to the coming of Christ ('one mightier than I'), but it also would have related vertically to the identically dressed Baptist in the main

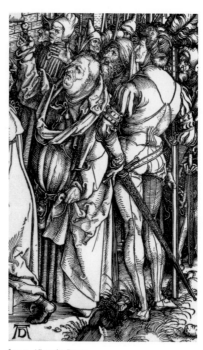

fig. 72 Albrecht Dürer
Ecce Homo (detail) from **The Large Passion**
about 1499
Woodcut, 39 × 28 cm
Albertina, Vienna, 1934/0192

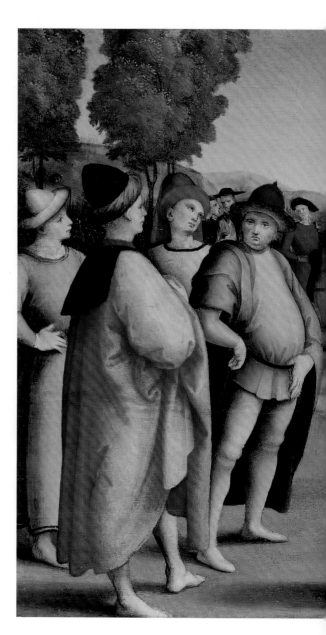

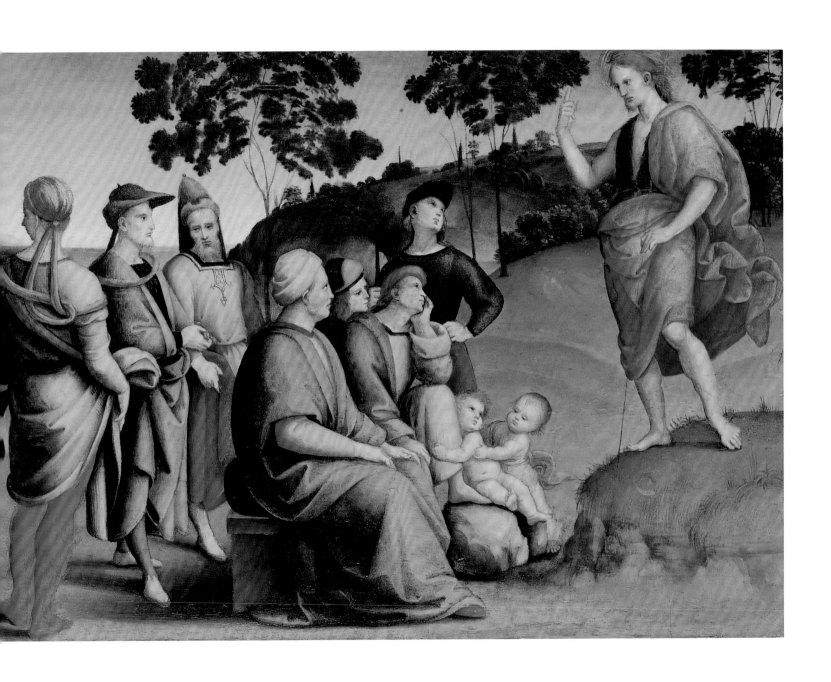

altarpiece who is pointing towards the actual Infant Christ. In contrast to the simpler frieze-like composition of the *Procession to Calvary* (cat. 36), the arrangement of the figures here is more sophisticated, with the three principal groups receding into the picture space. The different factions of the Baptist's audience are animated not just by a variety of colourful costumes and headgear, but also by their poses and perceptively differentiated characterisation. The rapt attentiveness of the man seated on a bench in the 'front row' contrasts, for example, with the evident scepticism of the fat man in the yellow tunic at the back, his hand resting indignantly on his hip and his thumb stuck into his belt to emphasise his large paunch. The back-turned pose of the elegant man in the exotic turbaned headdress who acts as a hinge between the groups is reminiscent of observer figures in prints by Dürer (such as the *Ecce Homo* from his *Large Passion* series of 1498, fig. 72[4]), and indeed the range of characterisation among the other figures suggests Raphael's familiarity with lively crowd scenes in the prints of both Dürer and Schongauer. The beautifully drawn babies anticipate Raphael's solutions for Christ and Saint John in Florentine works such as the *Terranuova* and *Bridgewater Madonnas* (fig. 23 and cat. 62), and may be intended to remind the viewer of the infant cousins, especially in the way one clings in fear to the leg of his father in response to the Baptist's predictions.

Rapid sketches for some of the figures in black chalk appear on a sheet in the Ashmolean Museum, Oxford.[5] Infrared reflectography reveals that the worked-up design was transferred to the panel by means of pouncing through a pricked cartoon. An intriguing reference in a 1771 inventory of the Palazzo Ansidei, referring to a similar sized drawing of the same subject, suggests that the cartoon may have remained in the family's possession (though its whereabouts are unknown today).[6] C P

NOTES

1 Cesare Crispolti in Shearman 2003, p. 1419: *'Nel predolino ancora della detta tavola si veggiono molto belle historiette, e degne di un tanto huomo.'*
2 Passavant 1839–58, II, pp. 44–5.
3 Cooper and Plazzotta 2004, Appendix V.
4 Hollstein 1962, VII, p. 108.
5 Joannides 1983, no. 96v.
6 We are grateful to Donal Cooper for this reference (for further details see Cooper and Plazzotta 2004).

SELECT BIBLIOGRAPHY

Passavant 1836, I, pp. 311–12; Passavant 1839–58, II, pp. 44–5; Waagen 1854, III, pp. 161–2; Crowe and Cavalcaselle 1882–5, I, pp. 241–2; Manzoni 1899, pp. 630, 636–7, 639; Dussler 1971, pp. 13–14; Braham and Wyld 1984; Plesters 1990, pp. 32–7; Meyer zur Capellen 2001, no. 16B; Cooper and Plazzotta 2004; Roy, Spring and Plazzotta 2004, pp. 25–6.

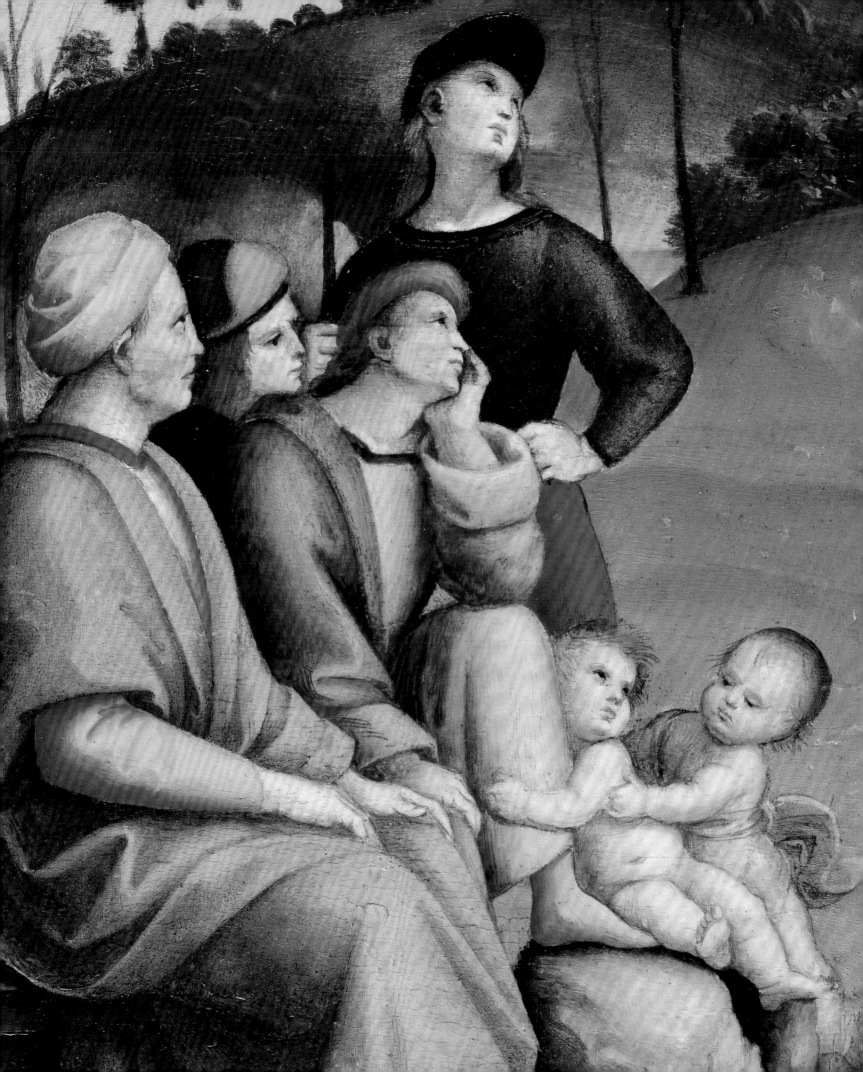

47 A group of four warriors
about 1504–5

Pen and brown ink, over rubbed black chalk and pricking holes, 27.1 × 21.6 cm
Inscribed along the lower edge: *di raffaelo mano propria* ('by Raphael's own hand')
The Ashmolean Museum, Oxford. Presented by a Body of Subscribers, 1846. 164 P II 523

The central figure is derived from Donatello's famous marble statue of Saint George of about 1414 which was made for a niche on the exterior of the church of Orsanmichele in Florence (fig. 74). The saint's pose is slightly reworked in the drawing, the figure standing more frontally and with his head turned to the right. More radically, the youthful hero is no longer poignantly isolated but placed at the centre of a composition with three other warriors, all of whom are naked except for a vaguely classical helmet worn by the one on the left. Largely ignoring the saint's armour, of which the only surviving vestige is indicated by the elliptical lines above and below the warrior's right knee, Raphael concentrated instead on the cloak wrapped around the saint. He certainly began the drawing with this figure and then filled in the others around him. The extemporary nature of his additions is indicated by the fact that he only drew in the head and part of the shoulders of the figure behind and immediately to the right of the main one.

Raphael's study is drawn over a pricked study of a man's head (fig. 73), which from the

fig. 73 **A head and other studies**, about 1504–5
Black chalk, pen and brown ink over pricked holes
(verso of cat. 47)

evidence of the black chalk on the surface of the paper must have been transferred through pouncing onto another surface (for this process see p. 142). Laboriously pricking the contours of a design with a pin was one of the means of making a same-size copy, and in this case the original matrix, now lost, can be identified as a Signorelli cartoon, thanks to Tom Henry's observation that the outlines of the Ashmolean head correspond closely to those in Signorelli's fresco of the *Resurrection of the Flesh* in Orvieto cathedral painted around 1500–1. Quite how Raphael came to possess a piece of paper first used in Signorelli's workshop (on the verso there is a slight black chalk figure study which looks as if it may be by the Tuscan master) can only be guessed at, but it does strongly indicate that the two artists met. There is no documentary evidence of such an encounter, yet in view of Raphael's evident admiration for Signorelli's work (for a drawn copy after one of his figures see cat. 20) it is entirely plausible.

This is one of several sheets by Raphael of this period with drawings in pen of nude warriors, none of which can be connected to any known commission by the artist.[1] The compact balance of the present composition has led some scholars to suggest that it may have been prepared for a decorative scheme, possibly for a palace façade, although there is nothing to suggest that Raphael was involved in any such project at this time. The purpose of the drawing remains obscure, and perhaps the most plausible explanation is that it was made as a creative exercise akin to his reworking of Michelangelo's marble *David* (cat. 58). In drawings such as this one, Raphael honed and rehearsed the skill of creating unified, yet richly varied, figural groups that came to fruition in the Stanza della Segnatura frescoes (see figs 35–9). Raphael's choice of Donatello as a source of inspiration for the central figure in this drawing bears out the justness of Vasari's description of Raphael as an artist whose gracefulness of style derived from his having combined the best elements drawn from his study of old and contemporary masters.[2] His

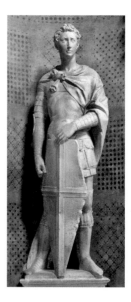

fig. 74 Donatello
Saint George, about 1416
Marble, height 209 cm
Museo Nazionale del Bargello, Florence
Sculture 361

interest in Donatello's sculpture is reflected in another reworking of its pose in a pen drawing of a nude Saint Paul, also in the Ashmolean.[3] Raphael may well have known of Donatello's figure even before his arrival in Florence because Perugino clearly admired it too, borrowing aspects of the sculpture's pose for the figure of Saint Michael in the altarpiece painted for the Certosa, Pavia, in 1496 (see cat. 10). Raphael's wider interest in Donatello is also shown by his reworking, in a much-damaged drawing now in Munich, of the sculptor's bronze relief of the *Miracle of the Miser's Heart* from the high altar of the Santo in Padua, a work he almost certainly knew on the basis of a cast or from drawn copies.[4]

HC

NOTES

1 Joannides 1983, nos 87 and 89.
2 In the preface to the Third Period, Vasari/BB, IV, p. 8: '*studiando le fatiche de'maestri vecchi e quelle de'moderni, prese da tutti il meglio.*'
3 Joannides 1983, no. 87r.
4 Joannides 1983, no. 192.

SELECT BIBLIOGRAPHY

Robinson 1870, no. 46, p. 168; Fischel 1913–41, II, no. 87; Parker 1956, no. 523; Gere and Turner 1983, no. 46; Joannides 1983, no. 88r; Knab, Mitsch and Oberhuber 1984, no. 165; Bambach 1992, pp. 9–30; Henry 1993, pp. 612–19.

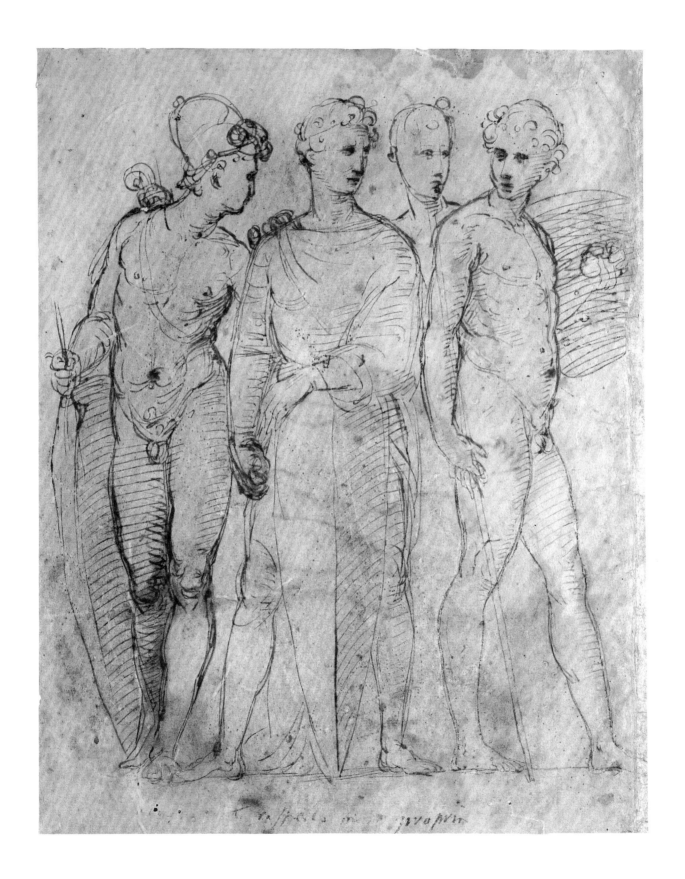

48 The Virgin and Child with a cat

about 1481

Recto: pen and brown ink, over stylus underdrawing
Verso: pen and brown ink, over stylus underdrawing with brown wash
13.2 × 9.5 cm
The British Museum, London, 1856-6-21-1

This is one of seven drawings by Leonardo showing the Virgin and the infant Christ who holds, or plays with, a cat.[1] The choice of animal is an unconventional one because, aside from the legend that a cat had given birth at the same time as Christ was born, it has no symbolic links with Christ's Passion, unlike the lamb or the goldfinch more normally associated with representations of the Virgin and Child (indeed cats were often thought to be linked with the devil).[2] Leonardo's strikingly naturalistic depiction of the interaction between the child and the animal in the drawings is similarly innovative, exemplified in the present work by the superbly observed detail of the cat's desperate attempts to escape Christ's smothering embrace. This double-sided drawing includes the most resolved version of the composition and is therefore likely to be one of the latest. Like one other in the group it shows the figures tightly enclosed within an arched space; and close compositional parallels with the *Benois Madonna* (fig. 81), probably painted in the late 1470s, are particularly evident in the study on the recto with the inclusion of a window behind the figures as in that picture. On stylistic grounds these studies can be dated a little later, to the early 1480s, the period when Leonardo was working on the *Adoration of the Magi* for the church of S. Donato a Scopeto in Florence (fig. 105). Like most of Leonardo's compositional innovations, the studies of the Virgin and Child with a cat were developed no further than the drawing stage, but were nevertheless a significant step in Leonardo's radical rethinking of the theme that led to paintings such as the *Madonna of the Yarnwinder* (a work designed but not necessarily executed by him) and the Louvre *Virgin and Child with Saint Anne* (fig. 83), in which the infant Christ's manhandling of the lamb is reminiscent of the child's treatment of the cat in some of the drawings.[3] Leonardo also continued to explore the theme on paper, perhaps most memorably in the magnificent cartoon in the National Gallery (cat. 49).

In the present drawing Leonardo began by loosely sketching the figures in an arched frame, first with a stylus then in pen and ink.[4] The composition is dominated by the strong diagonal established by the position of the protagonists' heads, and the clarity of the artist's intentions is reflected in the sureness of the outline and the characteristic left-handed shading in this portion of the drawing. The intelligibility of the upper half of the composition is in sharp contrast to the lower part, the artist's search for a satisfactory position for the Virgin's legs resulting in a maelstrom of pen lines. Leonardo then turned over the sheet of paper and, by holding it to the light, selected the favoured outlines of the design that he had just drawn on the other side. The composition is not just reversed but also subtly altered to make it more balanced, the position of the Virgin's legs and the turn of her head to the right counterbalancing the leftward diagonal established by the orientation of Christ and the struggling cat in his arms. Although the design is more resolved on this side than the other, Leonardo continued to explore different ideas, as in the case of the three positions of the Virgin's head (the central one traced through from the recto), with the artist's preferred solutions made evident by a final touch of brown wash that clarifies the outlines and obscures, at least to some extent, the various alterations.

Leonardo's restless search for innovative ways of expressing through symbolism, composition, setting, gesture and expression the emotional and theological significance of the tender bond linking the Virgin and her son was inspirational for Raphael. The older artist's influence can be felt in the extraordinary diversity of Raphael's treatment of the Virgin and Child, either with or without attendant figures such as the infant Baptist or Joseph, in paintings from 1505–6 onwards. Raphael's skill in finding different ways of combining the figures was partly developed by adopting Leonardo's 'brainstorming' technique of making rapidly drawn studies of a single motif in which a single sheet could include a multiplicity of possible variations. Pen drawings like the present one were clearly available to Raphael when he was in Florence and inspired him to create studies in the same technique, such as cats 63 and 64, which rival Leonardo's in their inventive brio and freedom of execution. HC.

NOTES

1 Aside from the present one, three others are in the British Museum (Popham 1946, nos 11, 12–13 and 15–16; Popham and Pouncey 1950, nos 98, 100–1), and the remaining ones are in a private collection, New York, the Uffizi and the Musée Bonnat, Bayonne (Popham 1950, nos 8B, 10 and 14).
2 An example of such a connection is the cat fleeing Gabriel in Lotto's *Annunciation* in the Pinacoteca Comunale, Recanati.
3 Leonardo's drawings of the subject seem to have been known by at least one of his Milanese followers, as an X-radiograph shows that the lamb held by the Christ Child in a Leonardo school painting in the Brera was originally a cat, see Bambach (ed.) 2003, p. 292.
4 For Leonardo's practice of drawing frames in his compositional drawings see M. Kemp, *Drawing the Boundaries*, in Bambach (ed.) 2003, pp. 141–54.

SELECT BIBLIOGRAPHY

Popham 1946 (and later editions), p. 38, no. 9; Popham and Pouncey 1950, no. 97; Turner 1986, no. 2; Kemp and Roberts 1989, no. 6; Kemp (ed.) 1992, no. 8; Rubin and Wright 1999, no. 38, Bambach (ed.) 2003, pp. 144–5, 293.

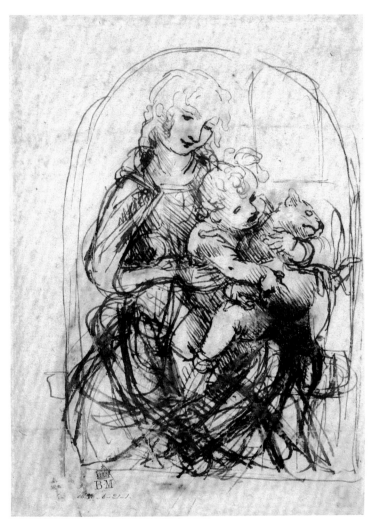

Recto

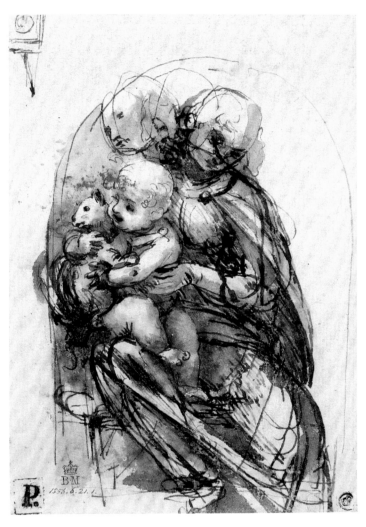

Verso

49 The Virgin and Child with Saint Anne and Saint John the Baptist

about 1499–1500

Black chalk and touches of white chalk on brownish paper
mounted on canvas, 141.5 × 106.5 cm
The National Gallery, London, presented by the National Art Collections Fund
following a public appeal, 1962, NG 6337

This remarkable drawing is the only large-scale compositional cartoon by Leonardo to have survived. It was probably made at the end of Leonardo's first stay in Milan, around 1499–1500. Raphael may not have known it first-hand since there are no direct echoes of it in his surviving oeuvre, and indeed it may never have left Milan (it is recorded there for nearly two hundred years until the early eighteenth century). However, it represents the type of monumental cartoon for which Leonardo became famous and one can infer from it the impact such works had on the young Raphael. Soon after Leonardo returned to Florence in 1500, he was commissioned to paint an altarpiece for the Servite monks of SS. Annunziata. The cartoon for this never completed work, representing the Virgin and Child with Saint Anne with a lamb, was displayed for two days in April 1501 and attracted huge crowds of admirers.[1] It was a composition that Raphael knew well, as attested by his *Madonna of the Meadow*, and *Holy Family with the Lamb* (fig. 24 and cat. 60). Although this cartoon is now lost, Leonardo's painting based on it in the Louvre (fig. 83) suggests that it was similar in size and theme to cat. 49.

It was news of two revolutionary cartoons – Leonardo's *Battle of Anghiari* and Michelangelo's *Battle of Cascina* for the Sala del Consiglio (see p. 34) – which Vasari gives as the reason Raphael hastened to Florence around 1504.[2] At this time, Leonardo was working on a number of public and private commissions in the city and Raphael, who studied and responded to all these compositions, clearly had access to the older artist's designs – preparatory sketches as well as elaborately worked cartoons. He soon adopted the practice of making cartoons in black chalk with white heightening for private commissions he received while in Florence (e.g. the cartoon for the *Belle Jardinière*,[3] and cat. 77), and came to rely on the method for larger projects following his move to Rome. The more improvisatory quality of his cartoons from this point on (see cat. 98) demonstrates the young artist's response to Leonardo's innovative, exploratory approach.

One of the most striking aspects of Leonardo's cartoon is the way the figures are piled one upon the other to create a monumental arrangement of interlocking forms. From studying such works, Raphael began to favour pyramidal arrangements of interrelated figures. Leonardo also devised complex *contrapposto* poses for the individual figures within a given group. Thus the head, torso and legs of the Virgin in the cartoon suggest how her body turns in response to her infant son twisting round in her arms to bless his tousle-headed cousin John the Baptist. The complex twisting poses of Christ in Raphael's *Terranuova* and *Bridgewater Madonnas* (fig. 23 and cat. 62) reflect such inventions. Above all, Raphael responded to Leonardo's unrivalled ability to breathe life into his compositions by infusing physical relationships with an affective – even spiritual – charge. The serene expression of the Virgin and the mischievous and playful attitudes of the children in Raphael's *Madonnas* of this period, such as the *Madonna of the Meadow* of 1505 and the *Madonna del Cardellino (Madonna of the Goldfinch)* of about 1506 (figs 24 and 26), are directly inspired by Leonardo's example. In Leonardo's cartoon, the gentle grace of the women's heads and the soft features of the children are achieved entirely by means of subtle gradations of modelling in black and white chalk. Seeking similar results, Raphael began to experiment with chalk, which could be smudged to create a smoky effect known as *sfumato*, and with delicate layers of wash (see cat. 50).

The monumental effect of Leonardo's figures is due in part to his study of sculpture, a practice he learned from his training in the workshop of the goldsmith, sculptor and painter Verrocchio and which he advocated in his treatise on painting. This was an interest that Raphael embraced with enthusiasm (see cats 47 and 68), as the simple volumetric forms and clear outlines of his figures from this point forward demonstrate. Leonardo also advocated the traditional workshop practice of making studies from draped models. His skill in this area can be gauged from the complex drapery folds of the sleeves and skirts of the

Virgin and Saint Anne. Similar concerns begin to emerge in Raphael's paintings and drawings from about 1506 (see cats 74 and 77), but it was not until he reached Rome and began designing on a grand scale that he fully absorbed Leonardo's methods in his pursuit of more powerfully monumental effects. The drapery studies for the *Disputa* (cat. 83) reveal much greater attention to subtleties of illumination, while Leonardo's range of characterisation is nowhere more profoundly acknowledged than in some of the last drawings Raphael ever made, his studies for heads in the lower half of the *Transfiguration*. CP

NOTES

1 Vasari/BB, IV, pp. 29–30.
2 Vasari/BB, IV, p. 159.
3 Joannides 1983, no. 123, now National Gallery of Art, Washington, inv. 1986.33.1.

SELECT BIBLIOGRAPHY

Lomazzo 1584, p. 171; Popham 1946, pp. 59–61; Popham and Pouncey 1950, II, pp. 66–9; Kemp 1981, pp. 20–1; Béguin 1983, pp. 77–9; Harding *et al.* 1989, pp. 4–27; Bambach 1999, pp. 43, 250, 265–6, 272; Marani 1999, pp. 256–64, Zöllner 2003, no. XX (biblio) and p. 143.

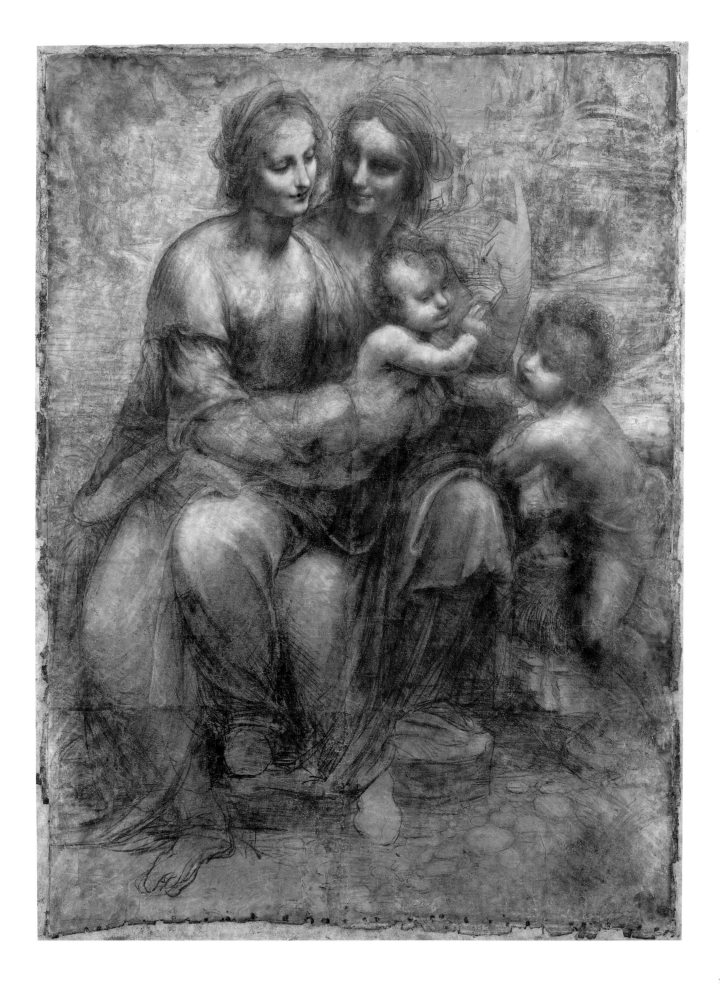

50 Studies for a Virgin and Child with the Infant Saint John

1505 or 1506

Brush and pale brown wash, heightened with touches of lead white (discoloured),
over traces of leadpoint, and light squaring also in leadpoint, the contours indented;
subsidiary sketch in red chalk, 21.9 × 18 cm
Inscribed in brown ink in the bottom right corner: ·R·v·[1]
The Ashmolean Museum, Oxford. Presented by a Body of Subscribers, 1846. 161 P II 518

The principal study on this sheet is for the *Madonna of the Meadow* (fig. 24) in the Kunsthistorisches Museum in Vienna (ambiguously dated either 1505 or 1506 in gold numerals in the Virgin's neckline). This was one of two pictures Raphael painted for his friend Taddeo Taddei (the other probably being the *Terranuova Madonna*, fig. 23), and one of several full-length Madonnas painted for Florentine patrons between 1504 and 1508. Taddei also owned a sculpted tondo of the *Virgin and Child with the Infant Saint John* by Michelangelo (see cat. 61).

Raphael made several initial sketches for the *Madonna of the Meadow* on sheets in Vienna and at Chatsworth, imaginatively exploring the interrelationship of the three figures in a variety of poses and configurations.[2] The principal study in cat. 50 was made at an advanced stage in the planning of the painting, after all the elements of the composition had been established. A simple squared grid, carried out in the same leadpoint as the underdrawing and passing beneath the wash drawing, suggests that the figures were copied from an earlier drawing to this sheet, possibly by incising around the outlines. Raphael began by lightly sketching the group in leadpoint, gradually building up the forms with layers of wash applied with the point of the brush. This is the earliest example of the use of this technique in his oeuvre, and he clearly found the fluid medium ideal for exploring the rounded maternal forms of the Virgin and the plump chubbiness of the children. In attempting to model form through light and shade, Raphael probably kept in mind the most brilliant example of preparatory chiaroscuro painting then in existence, Leonardo's unfinished *Adoration of the Magi* (fig. 105) for the church of S. Donato a Scopeto in Florence, which was abandoned at the undermodelling stage in 1482. The Virgin's serene expression, as well as the overall composition of the group and the lively interaction between the infants, are also influenced by Leonardo, whose famous cartoon of the *Virgin and Child with Saint Anne* Raphael undoubtedly knew (see cat. 49). This composition almost certainly provided direct inspiration for the Virgin's extended right leg and the way she holds the Christ Child with both hands.

The kneeling figure of the Baptist is a marvel of economical description, his form barely indicated, and the blank page embodying his pale flesh, as if caught in a shaft of brilliant sunlight. The Christ Child is more fully modelled with his facial features and some contours of his body outlined with the point of the brush (for example the ripple of creases down his left arm), blended with a more watery wash in the shadows, as over his rounded belly. The Virgin's body, which is neither draped nor nude, retains something of the mannequin-like quality of Raphael's earliest studies from life, but here he eschews simple outlines in favour of softer and more malleable forms. He built up her shoulders, breasts, belly and limbs using short, hatched strokes with the point of the brush, subsequently blended with a more dilute ink.

The sheet has been cropped to frame the wash drawing, curtailing a red chalk study in the top left corner. In this rapid sketch, Raphael explored an alternative position for the head of the Christ Child, with the Virgin's hand resting on his shoulder. The abbreviated forms bear comparison with the red chalk figure studies on the verso of cat. 64. Raphael went on to draw the whole composition again in red chalk in a drawing in the Metropolitan Museum of Art, and these two studies for the *Madonna of the Meadow* are among the earliest known examples of Raphael's use of this medium (but see also cat. 45). Cat. 50 thus combines experiments in two new, more versatile, graphic media, which Raphael would increasingly adopt when making figure studies, particularly following his move to Rome. CP

NOTES

1 R[aphael] V[rbinas] as inscribed on Viti-Antaldi collection drawings.
2 Joannides 1983, nos 110–11.

SELECT BIBLIOGRAPHY

Robinson 1870, pp. 148–50, no. 33; Fischel 1913–41, III, no. 118; Parker 1956, II, pp. 266–7, no. 518; Gere and Turner 1983, no. 55; Joannides 1983, p. 66 and no. 112; Knab, Mitsch and Oberhuber 1984, no. 123; Mitsch 1983, under no. 2; Gere 1987, no. 7; Whistler 1990, no. 11; Weston-Lewis 1994, no. 3.

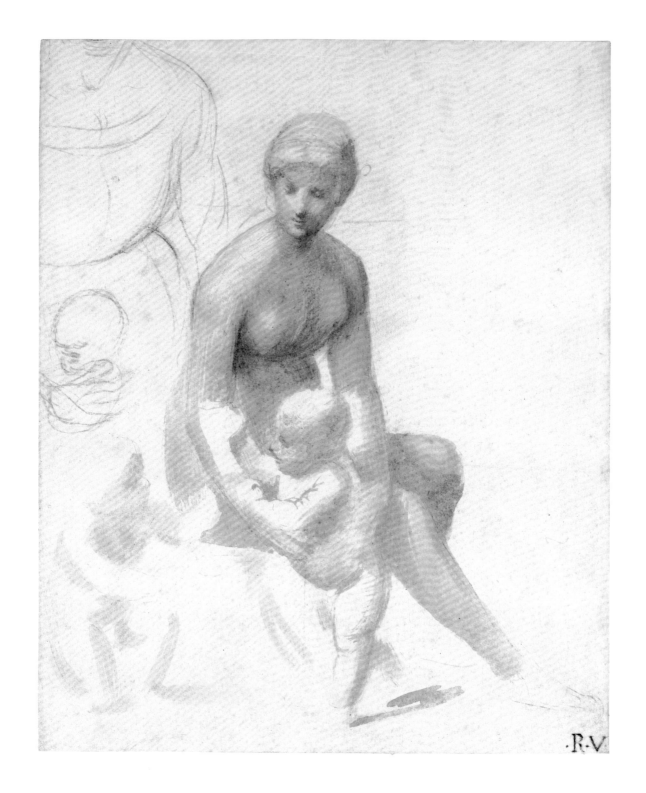

51 Portrait of a Lady with a Unicorn

about 1505–6

Oil on wood, transferred to canvas 1934–5
67.8 × 53 cm
Restored 1934–5, 1959–60
Museo e Galleria di Villa Borghese, Rome, 371

The strong underlying design and powerful three-dimensionality of this portrait of an unidentified young woman remain legible despite its extremely compromised state and the loss of much original paint. The least damaged areas are the face and bust, in which some of the original modelling still survives (see for example the shadows around the eyes, nose, chin, chain and pendant). The sitter's golden hair is much abraded and repainted but one can still gain an impression of its original effect, particularly in the way it spirals down onto her shoulders with a few tresses escaping to brush against her cheek. Raphael characteristically paid close attention to the jewelled pendant, with its knotted chain and large gems in their enamelled gold setting (anticipating those in the rings worn by Julius II in cat. 99) from which the spectacular pear-shaped pearl is so realistically suspended.

The picture is usually dated about 1505–6 by association with Raphael's portrait drawing in Paris (cat. 52) and his interest in Leonardo's *Mona Lisa* (fig. 75) at around this date. The Louvre drawing may well be preparatory for this painting, although comparison of the two works reveals a number of differences (the torso in the drawing differs in proportion, is positioned at a more acute angle to the picture plane, and the dress is somewhat different). At one time thought to be Maddalena Doni (until the latter's likeness subsequently came to be recognised in the portrait in the Galleria Palatina, fig. 29), the blue-eyed sitter in this portrait has not been convincingly identified. Nevertheless, the portrait highlights some typical characteristics of Raphael's female portraiture of this date (for example the strongly sculptural effect, the prominent larger-than life jewel), strengthening the suggestion that this picture (like that of Maddalena Doni) was probably painted in Florence. Given the connotations of the unicorn (see below), it may have been made in connection with a marriage (a pendant portrait of the sitter's husband may once have existed, as is the case with the Doni portraits, figs 28–9).

At the turn of the twentieth century the painting looked quite different. The unicorn had been covered with the attributes of Saint Catherine of Alexandria – a martyr's palm and part of a wheel[1] – and the figure's right hand and sleeves, as well as her dress, which had been extended over and around both shoulders, had been entirely repainted (the damage caused in removing these elements permanently disfigured these parts of the picture). It was in this form that the picture was first attributed to Raphael by Roberto Longhi in 1927.[2] Longhi suggested that the repainted areas were by GiovanAntonio Sogliani (1492–1544); and even after the removal of the repaints the intervention of a second hand is frequently postulated (especially in the lower third of the picture), and generally identified as Sogliani or another Florentine artist.

In place of the usual lapdog, emblematic of marital faith, the young woman holds a miniature unicorn (a conventional symbol of chastity, also found in the pendant worn by Maddalena Doni, fig. 29). Recent investigation indicates that Raphael may in fact have originally conceived the figure with a dog in her lap, and that the unicorn was painted on top. Both the under-drawing of the dog and the painting of the unicorn have been doubted as Raphael's work by the authors of a recent technical dossier on the painting, but their argument that he completed only the flesh areas and draperies in the top two-thirds of the picture, leaving the bottom third untouched, is inconsistent with the artist's usual practice at this stage in his career. The relatively unarticulated modelling of the red sleeves is in fact closely comparable with the Doni portraits, and it is not necessary to posit the intervention of another hand, though the condition problems in these areas are unquestionably severe. The underdrawing of the dog is similar to Raphael's more improvisatory underdrawing elsewhere and its sketchy nature may be explained by the fact that no animal was anticipated in the related Louvre drawing. The strikingly animated – if again gravely damaged – painting of the unicorn is reminiscent of the horse in Raphael's closely contemporary *Saint George* (cat. 34), particularly

in its flared nostrils, and it also seems related to a model by Leonardo.[3] An intervening varnish layer between the paint of the dog and that of the unicorn does suggest that an interval of time elapsed between the two campaigns, but this does not rule out the possibility that Raphael revised his own original conception, perhaps at the request of the patron.

In addition to the changes in the bottom left of the panel, Raphael also made minor adjustments to the sitter's neckline (to give her broader shoulders) and altered the opening behind her from a simple rectangle to a loggia framed by columns (anticipated in the Louvre drawing). The vertical edges of the original opening are incised onto the panel, down to the window-sill, and the landscape was brushed in up to these. This change has also been interpreted as the work of a second artist because it involved drawing these architectural elements on top of the painted landscape. However, Raphael frequently made changes to his architectural backdrops (see, for example, cats 45 and 91 and many other instances of revised backgrounds in his oeuvre) and the columns here are impressively drawn freehand.[4] T H

NOTES

1 For a similar later transformation of a portrait by Raphael into a Saint Catherine see cat. 101.
2 Longhi's attribution to Raphael was the logical sequitur to Morelli 1897, pp. 111–14, recognising the relationship with cat. 52, and Cantalmessa highlighting the fact that parts of the picture had been repainted, see Bon Valsassina 1984, pp. 20–8. An alternative interpretation of the repaints suggests that Saint Catherine's attributes were added after 1682.
3 Ashmolean Museum, Oxford, P II 15, Bambach (ed.) 2003, no. 23, pp. 307–8.
4 Damage in the parapet on the right may explain why its edges do not align with those on the left.

SELECT BIBLIOGRAPHY

Longhi 1927, pp. 168–73; Della Pergola 1959, II, pp. 114–16; Dussler 1971, p. 64; Bon Valsassina 1984, pp. 20–8; Ferino Pagden and Zancan 1989, pp. 44–5; Costamagna 2000; Meyer zur Capellen 2001, pp. 290–3, no. 44; Carratù in Paris 2001–2, no. 9.

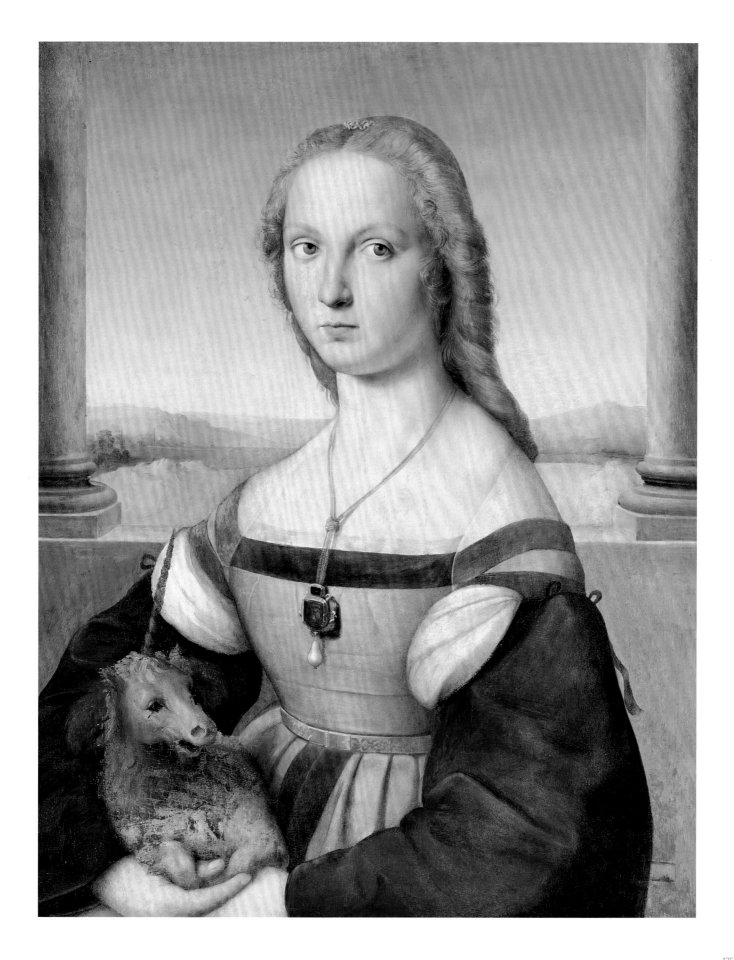

52 Portrait of a lady
about 1505–6

Pen and brown ink and wash over stylus underdrawing
and traces of black chalk, 22.3 × 15.8 cm
Département des Arts Graphiques, Musée du Louvre, Paris, inv. 3882

This imposing portrait study is the clearest
evidence of Raphael's interest in Leonardo's
portraiture, and marks a crucial stage in his own
development as a portraitist. The drawing shows
a young woman, apparently seated in an interior
(or a shaded loggia), with her arms folded and
her elbow resting on a long flat surface (a table?).
Behind her and beyond a parapet is a distant
landscape with trees and buildings (including a
church?), framed by two columns. This spatial
solution, which is entirely novel in Raphael's
portraiture, represents the artist's reaction
either to Leonardo's *Mona Lisa* (fig. 75) or
to preparatory drawings for that portrait
or another very similar. It is so indebted to
Leonardo – in the loggia setting, the leading
forearm and the considered interrelation of the
sitter's hands – to be in effect a composition

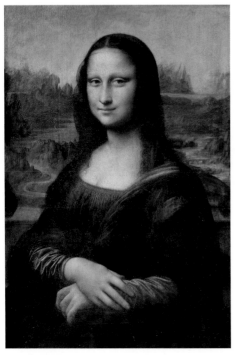

fig. 75 Leonardo da Vinci
Mona Lisa, 1503–6
Oil on wood, 77 × 53 cm
Musée du Louvre, Paris, inv. 779

drawn in the style of the older artist, and one
can even see the areas of greatest reworking
as Raphael struggling with the Mona Lisa's in-
famous smile or with the solution for her hands.
The drawing thereby adds to the evidence that
Raphael was probably in direct contact with
Leonardo (see also cats 50 and 54). This contact
probably occurred in 1505 (when both artists
were in Florence) and continued greatly to
influence Raphael until 1507 and beyond.

The drawing represents an advance from the
Portrait of a Young Woman (cat. 37) and is clearly
related to two of Raphael's painted portraits of
these years, *Maddalena Doni* (fig. 29) and the
Lady with a Unicorn (cat. 51).[1] It has occasionally
been described as preparatory for one or other
of these paintings. Although aspects of both can
be found in the drawing (the puffed sleeves and
pudgy hands, and the parapet, columns and
distant landscape), there is little sense that the
sitter here is identical with either of those in the
painted portraits. In fact it may be the case that
this drawing was not intended as a portrait of
a particular person, but represents Raphael's
investigation of the formal possibilities of
Leonardo's compositional developments (and it
may have been drawn a year or two earlier than
the painted portraits). As in other drawings of
this period the penwork also suggests Raphael's
studies from Florentine masters. He employs a
combination of parallel- and cross-hatching and
vigorous strokes that define volumes or forms –
the most striking of which are the sinuous
strokes which outline the sitter's right arm.

Despite its intense Leonardesque qualities,
a number of Raphael's mannerisms are also
evident in this study. The shorthand annota-
tion for the landscape finds parallels in earlier
drawings (for example cat. 36), and the braiding
of the woman's hair and the few tresses that
have escaped can be compared with numerous
female figures from both earlier and later in
Raphael's career.

The drawing has been cut at the sides and
it is impossible to say how closely cropped the
composition would originally have been. TH

NOTE

1 There are also parallels with the portrait of Costanza Fregoso
 attributed to Raphael by Lucco 2000, pp. 49–73, to which this
 drawing has also been related (ibid., p. 69).

SELECT BIBLIOGRAPHY

Passavant 1860, II, no. 347, p. 472; Crowe and Cavalcaselle 1882–5, I,
pp. 266–7; Fischel 1913–41, II, pp. 104–7, no. 80; Joannides 1983, pp. 62–3,
175, no. 175; Viatte 1983–4, pp. 216–18, no. 50; Knab, Mitsch and
Oberhuber 1984, no. 125; Meyer zur Capellen 1996, pp. 113–18; Viatte
2003, pp. 190–2, no. 62.

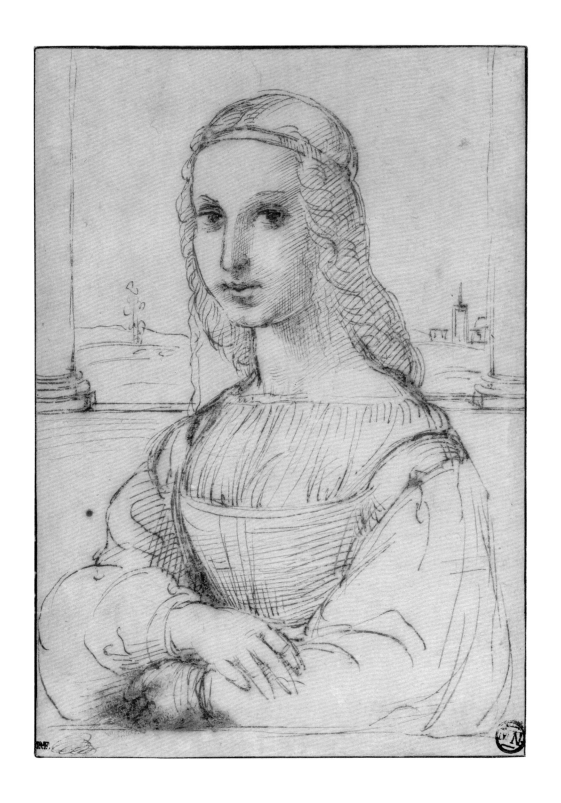

53 Leda and the Swan (AFTER LEONARDO)

about 1515

Oil on wood, 96.4 × 73.6 cm
Restored 1930, 1952
The Earl of Pembroke and the Trustees of Wilton House Trust
Wilton House, Salisbury, AB0202

In Greek mythology the god Jupiter disguised himself as a swan in order to make love to Leda, as a result of which union four children (Castor, Pollux, Helen and Clytemnestra) were born from two eggs. From the early years of the sixteenth century the subject became popular with educated patrons, not least on account of its innate eroticism.

Leonardo treated the subject in at least two painted versions (usually referred to as the 'Standing Leda' and the 'Kneeling Leda') and in numerous drawings, such as fig. 76. None of the paintings survives, but they were sufficiently famous to have been copied many times, and this picture is now held to be the best of the many copies after one of Leonardo's lost originals. Although acquired about 1730 by the Earl of Pembroke as a work by Leonardo himself, it is now usually attributed to Cesare da Sesto, a Milanese follower of Leonardo.

Several drawings by Leonardo can be related to a lost 'Standing Leda', including fig. 77. Raphael seems to have had access to Leonardo's drawings for this composition, and his copy drawing (cat. 54) was probably based on a Leonardo study differing slightly from the composition copied here by Cesare da Sesto. The principal differences between the two images are the reversal of the poses, the absence of three of the newborn babies, and the more lascivious swan in the Wilton House picture. But the difference of spirit is even more striking. Leonardo (as copied by Cesare da Sesto) makes a real play of the eroticism of the figure: Leda's right breast is squeezed against her arm while the leering swan nestles up to her, bringing his head close to her left breast. Leda's pose also makes better sense when she is made to look down at her children, and Raphael's drawing does not capture any of the ethereal mystery of her gaze which was typical of Leonardo's art.

Leonardo's composition is usually dated to the period 1507–15, but it was probably begun around 1505–6 or even earlier (on the basis of the probable date of Raphael's copy). Leonardo was in Florence from 1500 to 1506 and the

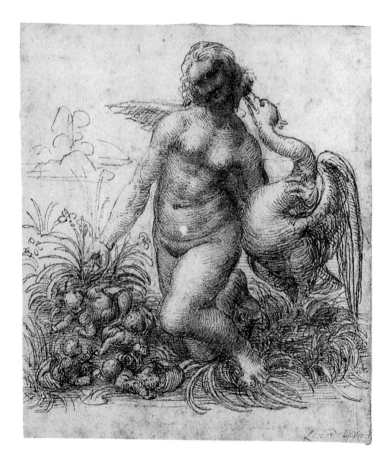

fig. 76 Leonardo da Vinci
Study for Leda, about 1503–7
Pen and brown ink, brown wash over charcoal or black chalk
16 × 13.9 cm
Devonshire Collection
Chatsworth, 717

cumulative evidence suggests that Raphael was able to study a number of his works there, both paintings and drawings, during the years 1505–7. Leonardo's lost original was described by several sixteenth-century sources, and was recorded in the French royal collections at Fontainebleau in the seventeenth century. It seems to have been lost in the early eighteenth century. Cesare da Sesto's copy has recently been dated about 1515, which would place it among the Leonardesque works that Cesare painted in Milan (Leonardo's home from 1482 to 1500 and again from 1508 until his departure for France in 1513) on his return from Rome – where, by coincidence, he had been working in proximity with Raphael, with whom he seems to have formed a close friendship. TH

SELECT BIBLIOGRAPHY

Clark 1939, p. 125; Pembroke 1968, pp. 83–4, no. 224; Carminati 1994, pp. 187–8, no. 13; Nanni 2001, pp. 140–3; Zöllner 2003, pp. 246–7.

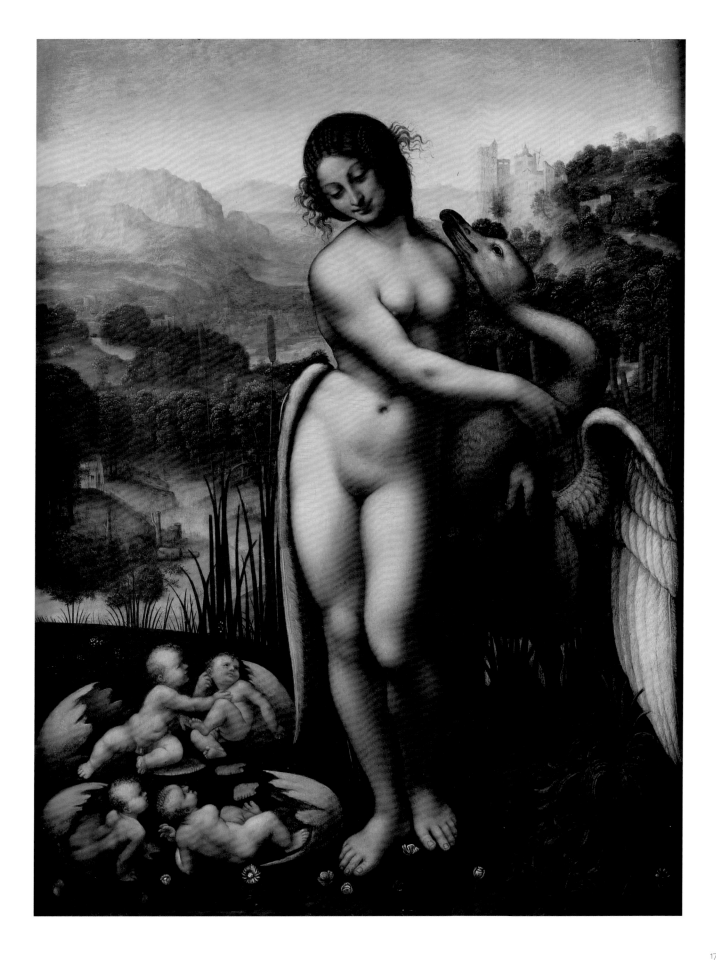

54 Leda and the swan
about 1505–7

Pen and dark brown ink, over black chalk, 31 × 19.2 cm
The Royal Collection, RL 12759

Contact with Leonardo truly revolutionised
Raphael's art. Here the young artist has copied
one of Leonardo's versions of *Leda and the Swan*
(for the subject and a painted version by Cesare
da Sesto, see cat. 53). This variant of Leonardo's
composition may have existed only as a design,
and aspects of the style of the draughtsmanship
support the idea that Raphael was copying from
a drawing by Leonardo rather than a painting.
For example, he imitated Leonardo's manner of
hatching around a drawn form in order more
fully to describe its volume. This is most obviously
the case in the pen strokes that define Leda's legs
and breasts. The simplified shorthand for the
boy emerging from an egg is also comparable
to Leonardo's pen sketches of children.

The comparison with the painting at Wilton
House (cat. 53) highlights how Raphael was
more interested in Leda's pose than in her rela-
tionship with the swan, or the eroticism of the
subject. Raphael had studied models with some
contrapposto in their pose before coming to
Florence, and had painted twisting figures of
his own, but he had never imagined the extreme
contrapposto which he was able to study in the
works of Leonardo and Michelangelo (see cat.
56). It had an instantaneous and lasting effect on
his art. The pose of Leonardo's *Leda* is found in
Raphael's *Saint Catherine* of 1507 (cat. 74), and
even underlies the *Galatea* of 1512 (fig. 41).

Echoes of Leonardo's pen drawing style are
also found in other drawings from the period
1506–12, and it was clearly an important forma-
tive influence on the young Raphael. In his
drawing of Leda and the Swan he also brought
his previous experience to bear, and the drawing
is an example of his economy of style. The swan,
the child and the *mise en scène* have been laid in
with the quickest of contour sketches. Raphael
was interested only in the *déhanchement* of the
figure: the distribution of weight, the definition

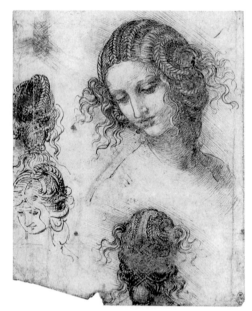

fig. 77 Leonardo da Vinci
Study for the head of Leda, 1503–7
Pen and brown ink, over black chalk, 17.7 × 14.7 cm
The Royal Collection, RL 12516

of soft rounded forms, and the play of light
across them. Aspects of the figure that were
secondary to this purpose, like the arms, were
rendered with a simple contour. The principal
outlines – which were important to Raphael
because of the way they defined the twist of the
figure and the pattern-making on the sheet –
were reinforced with further strokes of his pen.

As in his study of Michelangelo, Raphael's
study of Leonardo entailed a new understanding
of antique models, and several marble statues
of Venus, then known in Italy, may lie behind
Leonardo's invention. Raphael also paid close
attention to Leonardo's interest in Leda's hair, as
studied by the older artist in the beautiful head
in the Royal Library at Windsor (fig. 77). T H

SELECT BIBLIOGRAPHY

Fischel 1913–41, II, no. 79, p. 104; Popham and Wilde 1949, p. 309;
Joannides 1983, no. 98; Meyer zur Capellen 1996, pp. 108–13; Clayton
1999, pp. 57–9, cat. 12; Bambach (ed.) 2003, pp. 530–6, 670–1.

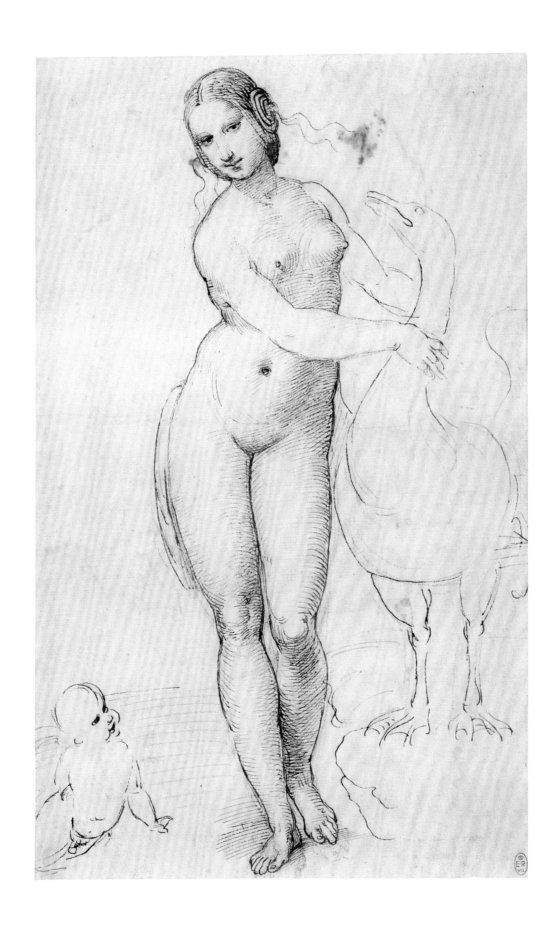

BASTIANO (ARISTOTILE) DA SANGALLO (1481–1551)

55 The Bathers (AFTER MICHELANGELO)

1542

Oil on wood, 76.5 × 129 cm
The Earl of Leicester and the Trustees of the Holkham Estate, Norfolk, 5

Sometime in the spring of 1504 Michelangelo received the commission to paint a fresco of the famous Florentine victory over the Pisans at the Battle of Cascina (1364) on the left-hand side of one of the long walls of the Sala del Consiglio in the Palazzo Vecchio, Florence (whether it was for the east or west wall is still disputed). Leonardo was already at work on his designs for the *Battle of Anghiari* which was to be painted on the right-hand side of this wall (see pp. 34–5 above, and fig. 18), and the competition between these artists resulted in two famously innovative compositions. Despite the fact that neither fresco was completed (Leonardo painted a small section of his design – the *Battle for the Standard* – while Michelangelo completed his cartoon of the *Bathers*, which was also a fragment of the whole composition, but never started to paint), both compositions had a profound impact on sixteenth-century art, especially in Florence. Vasari stated that the fame of this competition prompted Raphael's desire to spend time in the city, and lists the young artist among those who studied Michelangelo's cartoon. The evidence of this study can be seen in a pen and ink sketch by Raphael in the Vatican (fig. 78), which copies two figures from the foreground of the composition, and in the increasingly ambitious nature of his figure drawings (e.g. cats 57 and 82).

Another of the artists to study Michelangelo's cartoon was Bastiano (known as Aristotile) da Sangallo. Vasari knew him well and – at a point in 1542 when Michelangelo's original was reportedly being destroyed by the very artists who flocked to copy it – he suggested that Aristotile make a painted copy from his drawings after the cartoon. According to Vasari, Aristotile had made these drawings soon after the cartoon was completed (by the end of 1506 at the latest).[1] The grisaille painting exhibited here (which was once in the French royal collection) is universally held to be Aristotile's copy and is the only complete record of Michelangelo's cartoon. It captures the sense of dramatic confusion as the soldiers pull on

their clothes under the threat of imminent attack, and the decision to paint a monochrome means that some of the chiaroscuro modelling of the original cartoon is conveyed. Nevertheless, comparison with cat. 56 demonstrates how much more impressive the actual cartoon must have been, and suggests that Aristotile may have exaggerated both the isolation and the bulkiness of the figures under the influence of Michelangelo's later work (as Wilde observed, the *Last Judgement* had been unveiled in Rome just as Sangallo was making this grisaille).[2] Cellini described how Leonardo's and Michelangelo's cartoons were 'the school of the world',[3] and artists turned to Leonardo's depiction of the savagery of war and to Michelangelo's dynamic mastery of the male nude in action again and again as a source of inspiration for their own works, profiting in Michelangelo's case from the artist's ability to infuse sculptural qualities into his two-dimensional representations.

Raphael is known to have befriended Aristotile while in Florence (they had both worked with Perugino, so would probably have met on one of Raphael's early visits to the city), and it is entirely possible that they studied the cartoon together before Raphael left for Rome in 1508. The evidence of fig. 78, which is reasonably dated about 1507,[4] demonstrates that Raphael knew the cartoon by this date, and its influence can also be seen in the Stanza della Segnatura (figs 35–9) and the *Massacre of the Innocents* (cat. 88). Given Michelangelo's reluctance to allow his unfinished work to be seen, Raphael must either have been shown the cartoon by Michelangelo himself, or somehow saw it without permission. Wilde suggested that the latter scenario might even explain the later hostility between them, and further proposed that this might have occurred in the summer of 1508 when Michelangelo rebuked the caretaker of his workshop at the Spedale dei Tintori for allowing an unnamed Bolognese artist to copy his work.[5] TH

NOTES

1 Vasari/BB, V, pp. 393–4. See also pp. 34–5. In December 1523 Michelangelo claimed that the cartoon was finished before he went to Rome (see Barocchi and Ristori 1965–83, III, pp. 7–9).
2 Wilde 1978, p. 43.
3 Cellini 1558, I, p. 12 (1954 edn, p. 31): '*Stetteno questi dua cartoni . . . la scuola del mondo.*'
4 Morello in Bonn 1998–9, p. 529, cat. 274.
5 See Barocchi and Ristori 1965–83, I, pp. 83–4 (2.9.1508): '*Êmi istato deto che è v'è suto iscritto come e' cartone è suto disegnato. Io v'ò atenuto la fede, ma è vero chè suto disegnato . . . detegli la chiave e i' detto Tomaso ne compiacé no' so che Bolognesi.*' Wilde proposed that the Bolognese artist might have been the engraver and copyist Marcantonio Raimondi, whose print copies after the cartoon (Bartsch, XIV, 423, 463 and 487) might have been based on drawings by Raphael. See Wilde's unpublished lecture on 'Michelangelo and Raphael' (13.3.1957) in the archives of the Courtauld Institute of Art.

SELECT BIBLIOGRAPHY

Vasari/BB, V, pp. 393–4; De Tolnay 1947, I, pp. 209–19; Kemp 1992, pp. 266–8, no. 167; Rubinstein 1995, pp. 73–5; Cecchi 1996–7, pp. 112–13, no. 20; Cagliotti 2000, p. 115.

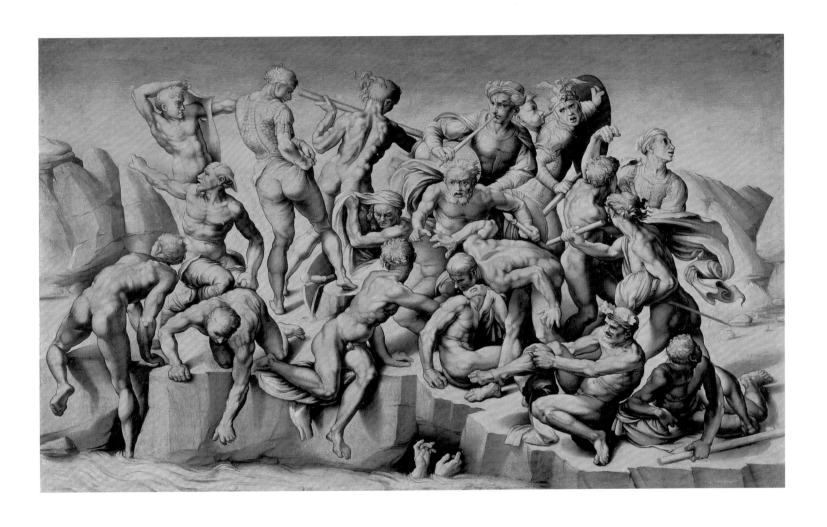

MICHELANGELO BUONARROTI (1475–1564)

56 A seated male nude twisting around

about 1504–5

Pen and brown ink, brown and grey wash, heightened with lead white (partly discoloured)
over leadpoint and stylus underdrawing, on light brown paper, 41.9 × 28.6 cm
The British Museum, London, 1887-5-2-116 (wb)

This is a study for one of the soldiers in the cartoon of the *Bathers* that Michelangelo produced in the winter of 1504–5 as he planned his fresco of the *Battle of Cascina* for the Sala del Consiglio in the Palazzo Vecchio in Florence (see pp. 34–5). The nude studied in this drawing played an important role in the composition, his twisting posture in the central foreground directing the viewer's gaze into the crowded space behind him. Michelangelo clearly had such a figure in mind from a fairly early stage because a nude in an almost identical position and pose is shown in a black chalk compositional drawing for the *Bathers* in the Uffizi, Florence.[1]

The present study is certainly taken from a live model, as is shown by the beautifully observed taut musculature, but this did not impede Michelangelo's manipulation of the form for artistic effect. His familiarity with the structure of the male body after years of life drawing is such that he successfully managed to make quite extreme distortions look entirely natural. The twist of the upper body, such a vital element in the fluid spiralling motion of the figure, is, for example, pushed to impossible limits, but it appears feasible because the rendering of the straining muscles is so compellingly realistic. Similarly the neat symmetry of the figure's projecting shoulder blades is so visually satisfying that one overlooks the fact that the right-hand one should really lie flat because of the extended right arm. When the figure in the Holkham grisaille (cat. 55) is compared with this study it is apparent that Michelangelo continued to make small adjustments to the pose in the cartoon: the upper body is thicker than that of the model in the drawing, and his right arm and shoulder are slightly lowered.

The sculptural solidity of the drawn figure is achieved through a combination of hatching and cross-hatching, the strokes of the pen giving a sense of form by their shape, direction and density. As has frequently been observed, the cross-hatching in Michelangelo's drawings is analogous to the skein of interlocking marks of the claw chisel found in unfinished areas in his marble sculptures, but the disciplines of drawings and carving are nevertheless fundamentally different – the forms built up by accretion in the former and through reduction in the latter. The sensuous, tactile quality of the modelling in Michelangelo's figure studies is much closer in spirit to his activities as a modeller rather than a carver; the manner in which the strokes of the pen chart the undulating contours of the body is a graphic equivalent of the process of shaping a figure out of clay or wax with the fingers.

By virtue of its imposing scale and the explosive energy of the figure, the present drawing gives some impression of the powerful visual effect of Michelangelo's lost cartoon, even though the figures in the *Bathers* were life-size and executed in black chalk or charcoal. Raphael is listed by Vasari among the artists who flocked to see the cartoon, and there is a quick pen sketch by him in the Vatican of the figure studied in the present drawing and also the one to his right in the cartoon (fig. 78).[2] Raphael also sought to emulate the energy of Michelangelo's composition, albeit on a much simplified scale, in his studies of battling nudes, as well as analysing individual figures in the cartoon by making drawings of nude models in dynamic Michelangelesque poses (see cats 57–8). Michelangelo's drawings were, however, much less accessible than the cartoon, as the sculptor was notoriously reluctant to allow them to be seen. Despite these difficulties it seems likely that the young Raphael did study Michelangelo's pen drawings, and their influence on him is most marked in his use of dense cross-hatching to model form in some of his *Entombment* studies, such as the one in the Ashmolean for the group of three bearers (cat. 72). HC

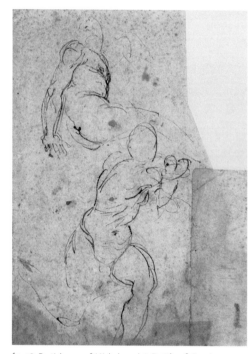

fig. 78 Partial copy of Michelangelo's **Battle of Cascina**, about 1507
Pen and brown ink, 20.3 × 11 cm
Biblioteca Apostolica Vaticana, Vatican City
inv. Lat 13391 (verso)

NOTES

1 De Tolnay 1975, no. 45r; for an analysis of this drawing see Hirst 1988, pp. 42–5.
2 Joannides 1983, no. 157v.

SELECT BIBLIOGRAPHY

Wilde 1953, no. 6; Hartt 1971, no. 41; De Tolnay 1975, no. 52; Gere and Turner 1975, no. 4; Turner 1986, no. 13; Hirst 1988, pp. 25–6, 67.

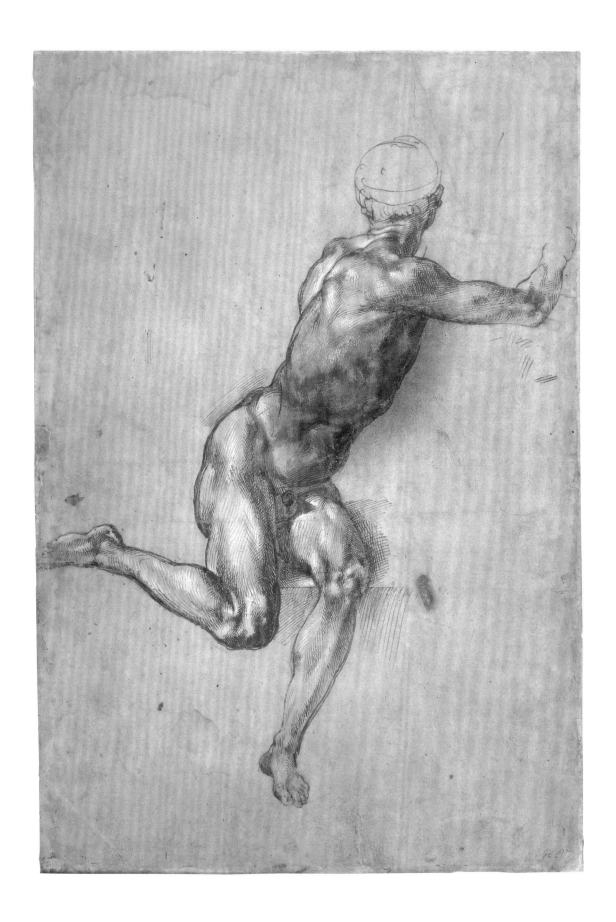

57 Five studies of nude male torsos
about 1505–6

Pen and brown ink, over some faint traces of black chalk or leadpoint
26.9 × 19.5 cm
The British Museum, London, 1895-9-15-624

The incisive revisions to the outlines of the figures and the broad simplification of detail in the internal modelling give a vivid impression of the artist drawing at speed from a model adopting a succession of quickly held poses. The order of execution is not easy to determine, but close scrutiny of the overlapping contours of the various pen studies suggests that Raphael began with the figure at the top right. He then went on to draw the same model from the rear holding a staff or spear, a pose reminiscent of the soldier in the left background of Michelangelo's *Battle of Cascina* cartoon (see cat. 55). The latter study is the only one of the five in which Raphael extends his attention beyond the study of the musculature of the upper body, cursorily including the outline of the model's left leg. The three lower studies, all of which show the model turning his head to the left, were drawn next, probably starting from the one in the centre. The fluid progression from one study to the next is underlined by the way in which the right-hand study develops out of the central one, the right contour of the latter figure ingeniously used to define the left side of the neighbouring one. The pose of the central figure is repeated in a modified form in one of the soldiers in the *Massacre of the Innocents* engraving (cat. 90) of about 1510. It is impossible to know if Raphael referred back to this study or simply remembered the pose when he was working out the composition of the print; in any case he would certainly have studied the figure anew from life since the clearly delineated back muscles and marked chiaroscuro lighting of the soldier in the preliminary studies for the engraving (cats 87–9) and the print itself are absent in this earlier drawing.

This drawing, like many from the period of Raphael's intense study of Florentine art during the period 1504–8, documents his intensive analysis of the male nude in dynamic motion, a central constituent of the new style forged by Leonardo and Michelangelo. Raphael's preferred medium for such drawings during this period was pen, probably because the sharpened tip of the quill was so uniquely responsive to every inflection and change in pressure. This quality is evident in the vibrant spontaneity of the line in the present drawing, the torsion of the model's body emphasised by the wiry energy of the contours outlining the forms. This study also illustrates the way in which the staccato rhythm of the line (a consequence of the need to recharge the pen repeatedly with ink) encouraged Raphael to concentrate on the essentials of the pose. Although the immediate stimulus for studying a male nude in contorted muscular attitudes was unquestionably Michelangelo's *Bathers* (see cat. 55), the practice of making a quick sequence of drawings after a model was already well established in Florentine workshops at least as far back as the 1470s – exemplified most notably in Filippino Lippi's numerous studies of workshop assistants in metalpoint and white heightening. HC

SELECT BIBLIOGRAPHY

Fischel 1913–41, II, no. 91; Pouncey and Gere 1962, no. 20; Gere and Turner 1983, no. 83; Joannides 1983, no. 191; Knab, Mitsch and Oberhuber 1984, no. 180.

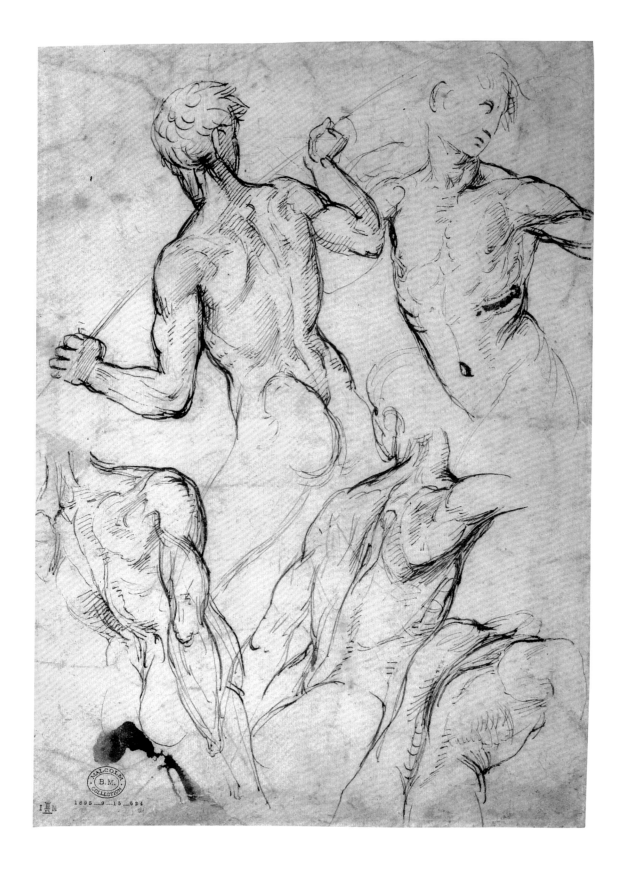

58 A back view of Michelangelo's 'David'

1507–8

Pen and brown ink, over traces of black chalk, 39.6 × 21.9 cm
The British Museum, London, Pp. 1–68

Michelangelo's colossal marble figure of the biblical hero *David* was completed by June 1503, almost a year before it was transported to its location on a pedestal beside the entrance of the Palazzo Vecchio in the Piazza della Signoria, Florence (fig. 79; the original was moved to the Accademia in 1873 and replaced by a copy in 1910).[1] The figure in this drawing diverges from the sculpture in a number of respects, most notably in the greater rotation of the upper body to the left, as well as in smaller details such as the omission of the sling hanging over the figure's left shoulder, and the reduction in scale of the disproportionately large hands and feet. Raphael may have benefited from studying the marble during the ten-day period in May 1504 when the sculpture was on ground level in the Piazza della Signoria prior to its installation, although it seems unlikely that the present drawing dates from that period because the confident and concise description of the figure's musculature is similar to that in some of the studies of around 1507 related to the Baglioni *Entombment* (cats 68–73). It is very much a creative interpretation of Michelangelo's figure, in the same vein as Raphael's roughly contemporaneous drawings inspired by Donatello and Leonardo (cats 47 and 50), and like them was almost certainly drawn from memory rather than in front of the work itself.

Raphael's fluent manipulation of the pose of Michelangelo's *David* highlights the brilliance of the young artist's creative imagination. He adds in the drawing a sense of incipient movement by exaggerating the swivelling movement of the upper body, and he also scales down Michelangelo's colossus to a figure of normal human proportion by showing the top of his right shoulder (a detail impossible to see even when the marble was at ground level). The facility with which Raphael was able to alter the sculpture's pose must have been aided by his having investigated it in life drawings (the best example of such *David*-inspired *académies* is the pen and ink drawing in the British Museum, fig. 80).[2] The varied repertoire of pen strokes and cross-hatching that Raphael employs to map out the form, the direction and shape of the lines creating a powerful sense of the body's structure and density, almost approaches the level of sophistication found in his studies in the same medium for the *Disputa* of a year or so later. HC

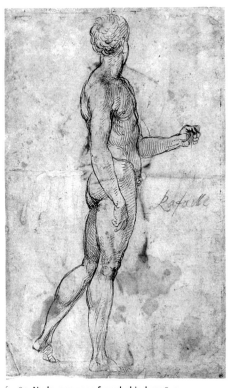

fig. 80 **Nude man seen from behind**, 1506–7
Pen and brown ink, 27.9 × 16.9 cm
The British Museum, London, Pp. 1–65

fig. 79 **David (cast after Michelangelo)**
In the position that original statue occupied outside the Palazzo Vecchio, Piazza della Signoria, Florence

NOTES

1 Hirst 2000, pp. 487–92.
2 Joannides 1983, no. 85v.

SELECT BIBLIOGRAPHY

Fischel 1913–41, IV, no. 187; Pouncey and Gere 1962, no. 15; Gere and Turner 1983, no. 39; Joannides 1983, no. 97; Knab, Mitsch and Oberhuber 1984, no. 226; Turner 1986, no. 15; Weston-Lewis 1994, no. 15.

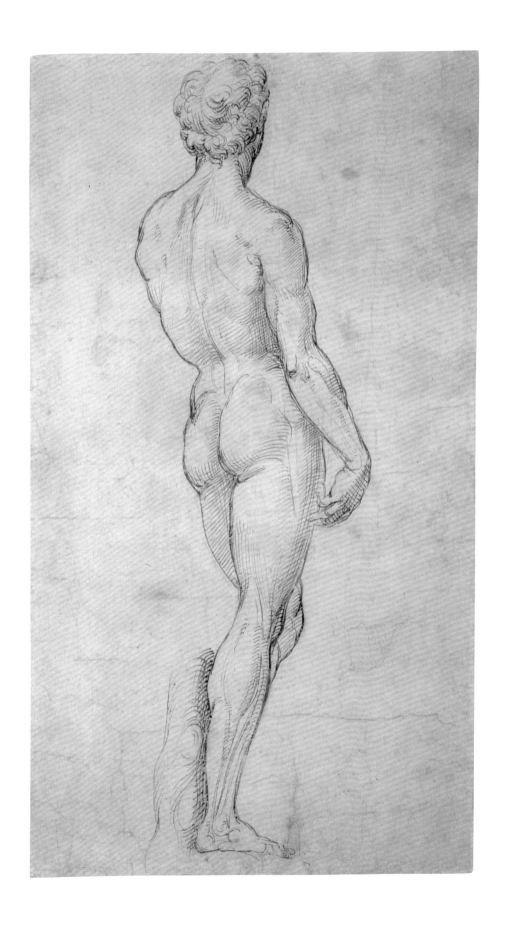

59 The Madonna of the Pinks (Madonna dei Garofani)
about 1506–7

Oil on fruitwood, 28.8 × 22.9 cm (painted area 27.9 × 22.4 cm)
The National Gallery, London, bought with the assistance of the Heritage Lottery Fund, the National Art Collections Fund,
the American Friends of the National Gallery, the George Beaumont Group and through public appeal, 2004, NG 6596

This exquisite painting depicts the youthful Virgin delighting in her infant son, perched naked on a soft white pillow on her lap. The scene takes place in her bedchamber (the green bed-curtain is gathered up in a knot at the left). The cool shade of the interior contrasts with the sunny landscape visible through the open window, with fortified ruins clinging to the crest of a rocky escarpment. A tiny chip in the grey stone window ledge is the only flaw in an otherwise perfect scene.

The child appears captivated by the delicate flowers offered by his mother, the pinks (or carnations) after which the painting is named. Known in Greek as *dianthus* ('flower of God'), the pink was a traditional symbol of divine love and healing.[1] In secular painting it symbolised

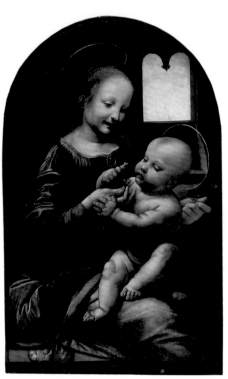

fig. 81 Leonardo da Vinci
The Benois Madonna, about 1478
Oil on canvas, transferred from wood, 49.5 × 33 cm
The State Hermitage Museum, St Petersburg, 2773

friendship and often betrothal, and this meaning would be appropriate here since the Virgin was venerated as both Mother and Bride of Christ. The latter aspect of her cult derives from traditional interpretations of the Old Testament Song of Solomon, in which the divine bridegroom (thought to represent Christ) is joyfully united with his heavenly bride (seen as the Virgin, and by extension the Church). The bed in the background, the colour of which recalls the green wedding bed in the biblical text,[2] and the pillow on which Christ sits may be further allusions to the allegorical union of the divine couple. These subtle references to the Song of Solomon were not lost on the earliest interpreters of this picture, the French engravers who reproduced it in the second half of the seventeenth century. At least one, Jean Couvay, used a verse from the biblical text, *Dilectus meus mihi et ego illi* ('My beloved is mine and I am his') as the legend beneath his engraving of about 1670, demonstrating the early currency of this interpretation.

Little larger than a Book of Hours, and comparable in refinement to a manuscript illumination, the picture may have been intended to be held in the hand for the purpose of prayer and contemplation. There is little firm evidence regarding the picture's whereabouts prior to its purchase in Paris in 1810, or soon after, by the Roman neo-classical painter and dealer Vincenzo Camuccini, but a manuscript inventory of the Camuccini collection, datable to the early 1850s, states that the painting was made for 'Maddalena degli Oddi, a nun ['Monaca'] in Perugia, from whose heirs a Frenchman acquired it in 1636, taking it to France'. Maddalena was named by Vasari as the patron of Raphael's *Coronation of the Virgin* for the Oddi chapel in S. Francesco al Prato, Perugia, of about 1503–4 (fig. 13), but her vocation as a nun is not known from any other source. Given that the inventory entry seems accurate on the matter of the picture's French provenance (the very precise date given for the picture's migration to France is borne out by several French engravings made after it in the second half of the seventeenth century), the

Oddi lead, hitherto largely discounted, deserves further consideration. Recent research has established that Maddalena inherited the family fortune from her mother in 1490, which would have made her the legal and financial head of the clan's main line in Perugia, and therefore more likely to have been in a position to commission devotional works.[3] But puzzlingly she is conspicuously absent in notarial records, a fact which could convincingly be explained by her having taken vows as many widows then did. This tender painting, with its imagery of the chaste Virgin, betrothed by the exchange of flowers with divine Love incarnate in the form of her baby son, would have been an appropriate prompt to meditation for a virtuous widow who herself had espoused Christ by taking religious vows. The painting is datable on stylistic grounds to around 1506–7, and could therefore very well have been produced for Maddalena at precisely the moment Raphael was designing and delivering the *Entombment* altarpiece (see cat. 65) for another influential Perugian woman from the rival Baglioni clan, for their chapel in San Francesco al Prato opposite that of the Oddi which housed Raphael's *Coronation*.

Though the interior is dark, the figures in the painting are brightly lit, not from the window, but artificially, from a light source at the upper left. The subtle description of light and shadow in both the flesh and the draperies reveals Raphael's familiarity with the works of Netherlandish painters. The knotted bed-curtain, the view through the window with its illusionistic chip in the sill, the square shape of the Virgin's forehead and her downcast crescent-shaped eyes also reflect Northern European prototypes (fig. 49). But the chief influence here is Leonardo, on whose *Benois Madonna* (fig. 81) Raphael's composition is closely based. The correspondence is so close as to suggest Raphael was able to study Leonardo's picture (painted about thirty years earlier) at first-hand. The cool palette, artful lighting, lively interaction of the figures, and arrangement of the draperies all reflect Leonardo's work. However, Raphael subtly reorganised the

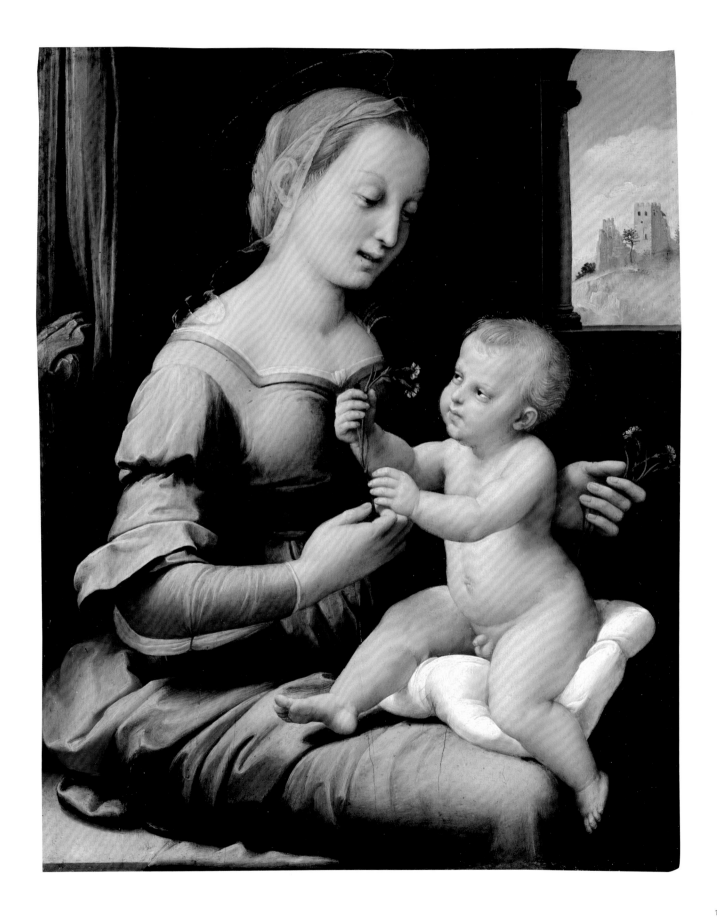

fig. 82 Infrared reflectogram
mosaic of cat. 59

dense dynamic grouping of his model, disentangling the figures and reconstructing them as clear volumetric forms in space. The joyful open-mouthed smile of Leonardo's Virgin, taken up by Raphael, was inspired by contemporary sculpture, particularly the 'sweet style' of sculptors of the preceding generation such as Desiderio da Settignano. When in Florence, Raphael took the opportunity to study these earlier sculptural sources for himself (as his father had also done), and this further informed his instinct for formal and spatial clarity, as shown here. Leonardo's painting focuses on the internal psychological dynamic between the figures, and there is no distraction other than sky through the window. Raphael on the other hand characteristically links the interior and exterior worlds (or heaven and earth) in his painting through colour.

Before taking up his brush, Raphael drew directly onto the primed gesso in metalpoint, a medium he frequently used both in drawings and underdrawings (see cat. 91). No traces of pouncing have been detected, though this does not rule out the possibility that he may have used a cartoon to transfer the outlines to the panel. Either way, he went on to elaborate the design with considerable freedom, employing broad arcs to lay in the principal forms, rapid loops for smaller forms such as the toes, and hatching to describe areas of shadow. He redefined many of the outlines several times in the manner of his drawings on paper (the exploratory nature of the underdrawing in these respects is highly comparable to that of the *Small Cowper Madonna* in the National Gallery of Art in Washington, fig. 86). Also characteristic of Raphael's style at

this moment are the smaller arcs to denote the knuckles of the hands, and the hook-ended marks to indicate drapery folds (fig. 82). Raphael followed the principal outlines of the underdrawing closely when it came to painting, but he also made several changes, in particular to the Virgin's dress, which he originally drew with a more plunging neckline and little buttons or studs in the border, and in the landscape where he suppressed a forked tree to the left of the ruins. He continued to make further revisions during the course of painting. A major change is in the bed-curtain, which was originally coloured purple, and a lesser one is in the landscape where he inserted a building over the contour of the blue hill in the distance.

The painting was celebrated in the sixteenth and seventeenth centuries, judging from the many early copies and prints made after it. It was first published as by Raphael in Francesco Longhena's monograph of 1829, but was subsequently dismissed as a copy after the greatest early authority on Raphael, Johann David Passavant (who saw the picture in Rome in 1835), published it as the best of many copies after a lost original.[4] The Camuccini themselves were demonstrably uncertain about the status of the work,[5] but it was promoted by Barberi and valued above all other paintings when the Camuccini sold their collection to the fourth Duke of Northumberland in 1854. Although installed at Alnwick as a Raphael, the painting's reputation was eroded by the negative opinions of scholars and gradually ceased to be prized as an original work. Nicholas Penny rediscovered the *Madonna of the Pinks* in 1991, and his attribution (endorsed by the vast majority of Raphael

scholars) was verified by scientific investigation of the underdrawing and the pigments, both typical of Raphael's pre-Roman productions. It was acquired by the National Gallery in 2004 following a public appeal. C P

NOTES

1 The red colour of carnations may also be associated with the Passion and the five blooms with Christ's wounds. In Italian cloves are called '*chiodi di garofani*' because of their resemblance to the nails at the Crucifixion.
2 Song of Solomon, 1:16: 'Behold, thou art fair, my beloved, yea pleasant: also our bed is green.'
3 Cooper 2004. Maddalena was probably born in the 1440s, married around 1462 and was widowed between 1474 and 1481. The tradition of her status as a patron of some influence is perpetuated in Perugian local histories. See Longhena 1829, pp. 16–17, n., and Shearman 2003, pp. 1452–3.
4 We are grateful to Martin Sonnabend, who found the reference to the painting among Passavant's notes on the Camuccini collection, in vol. 4 (1835, p. 195) of his unpublished notebooks held in the print-room of the Städel, Frankfurt. See also Passavant 1839–58, I, p. 131; II (1839), p. 79.
5 It is called '*Maniera di Raffaello*' in an inventory of the family's possessions of 1833; see Finocchi Ghersi 2002, p. 372, no. 11.

SELECT BIBLIOGRAPHY

Longhena (ed.) 1829, p. 12; Passavant 1839, I, pp. 130–1; II, no. 55; III, p. 99; Waagen 1857, IV, pp. 465–6; Crowe and Cavalcaselle 1882–5, I, pp. 343–4; Penny 1992; Weston-Lewis 1994, no. 16; Hiller 1999, pp. 247–50; Meyer zur Capellen 2001, no. 25; Roy, Spring and Plazzotta 2004, pp. 26–31.

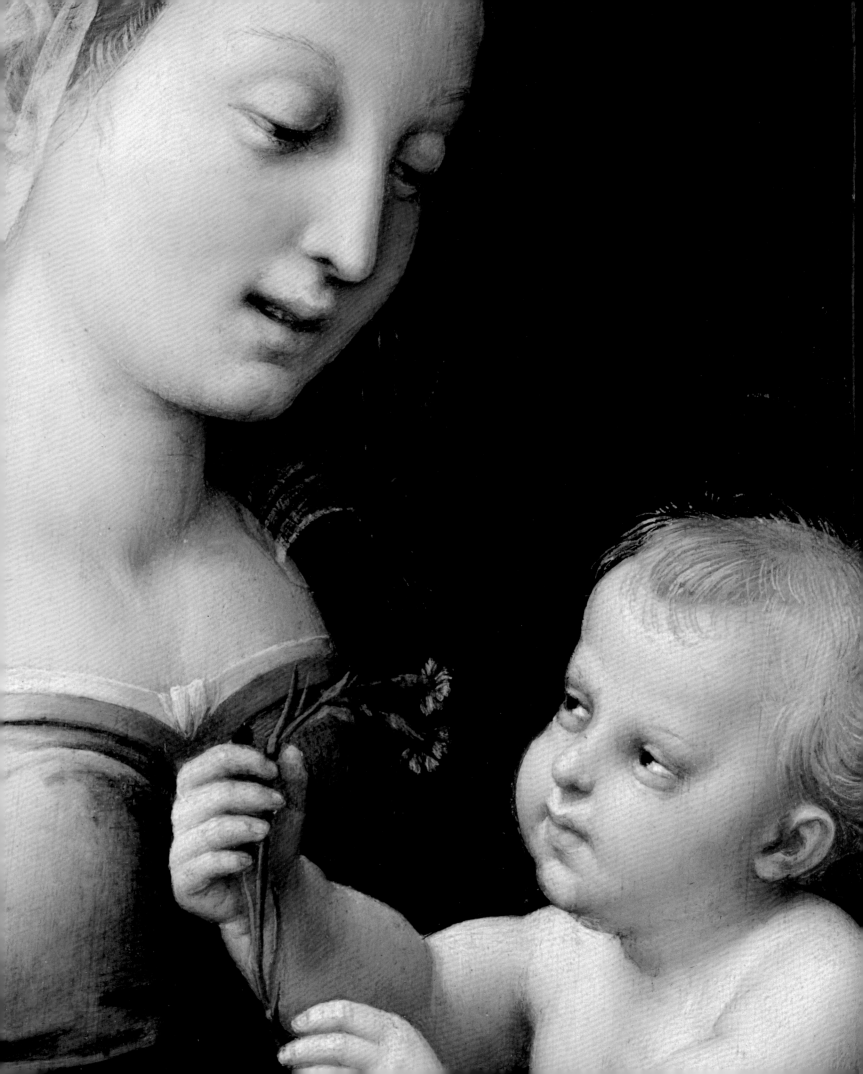

60 The Holy Family with the Lamb

1507

Oil on wood, 32 × 22 cm
Inscribed in gold on the neckline of the Virgin Mary's dress: RAPHA[EL] · URBINAS · MD VII · IV
There is a nineteenth-century inventory number at bottom left: 798
Museo Nacional del Prado, Madrid, no. 296

This picture, signed and dated 1507, shows how Raphael's compositions became more complex and dynamic as he absorbed the lessons learned from Leonardo. Leonardo had developed a particular interest in playful yet poignant combinations of the Christ Child and a lamb (a symbol of Christ's future sacrifice), and in spatial compositions that investigated different ways of grouping the Holy Family (as in cats 48–9 and fig. 83). Inspired by Leonardo, Raphael painted the child astride the lamb, and stacked the figures of Mary and Joseph above him to create a strong compositional diagonal. The overall effect is of arrested – almost vertiginous – motion, and the sense of a moment of rest on the Holy Family's flight into Egypt is enhanced by the small figures in the background which represent the journeying family as described in Luke 2:14. The landscape on the left rises up to a high peak in order to counterbalance this dominant diagonal.

The composition is known in several versions. Most scholars accept the evidence that this panel from Madrid is Raphael's original, while others

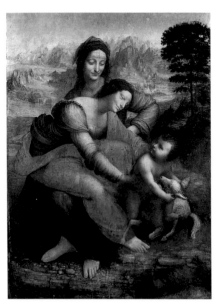

fig. 83 Leonardo da Vinci
The Virgin and Child with Saint Anne, 1510
Oil on wood, 168 × 130 cm
Musée du Louvre, Paris, inv. 776

favour a picture in a European private collection.[1] Apart from the gem-like beauty of the colours of the Madrid picture, its miniaturist technique, and the personal mannerisms of the artist that can be seen in the face of the Virgin and the rather idiosyncratic feet of the figures (aspects which can be compared to the contemporary *Madonna of the Pinks*, cat. 59), its autograph status is also supported by a study of the X-radiograph and infrared photographs. These photographs demonstrate several revisions (e.g. in the lamb and in the child's left hand, and in the late addition of the tree behind Saint Joseph).[2] Indications of pouncing also suggest that the design was transferred onto the panel from the cartoon which survives (in a ruined state) in Oxford.[3] The version in a European private collection appears to be an early (sixteenth-century) copy.

The provenance of the present picture cannot be securely traced before its appearance in the Spanish Royal Collection at the Escorial in 1837. The composition was recorded in a print of 1613, and a version was described at Urbania (near Urbino) in 1676–7. Another version was described in the Falconieri collection in Rome in 1703, but there is no evidence to confirm that either of these recorded pictures ended up in the Spanish Royal Collection. It is tempting to identify the picture with a *Rest on the Flight into Egypt* by Raphael which was bought in Rome in 1724 for Philip V of Spain from the painter Carlo Maratta, but this cannot be proved.

The various buildings in the background, which are similar to those seen in the background of other Madonnas of around 1507, bear no relation to Italian architecture of the period. They are clearly derived from (or inspired by) Northern prints, such as the engravings of Dürer which are known to have circulated in Italy, and which also influenced Perugino (e.g. cat. 8). The landscape has also been compared to paintings by Memling[4] and Lorne Campbell has noted that Raphael's lamb derives from his Pagagnotti triptych, which was widely copied in Florence in these years (fig. 84).[5]

fig. 84 Hans Memling
Saint John the Baptist
(detail), about 1480
Oil on oak, 57.5 × 17.1 cm
The National Gallery,
London, NG 747

There has been some discussion of the form of the signature on this painting – especially of the meaning of the final 'IV' that follows the date MD VII (1507). This can probably be explained as a reference to the papal indiction (dating the picture to the fourth year of Julius II's pontificate, between 6 November 1506 and 5 November 1507), and was a common form in Renaissance documents (but less common on paintings). The date has been controversial because the private collection version has a date which is usually read as 1504 (although Shearman has it as 1509),[6] and might therefore argue for the priority of that picture. It is, however, very hard to accept that this composition could have been developed as early as 1504, since its sources are to be found in works by Leonardo that Raphael assimilated only at a slightly later date. TH

NOTES

1 Notably Dussler, Meyer zur Capellen and De Vecchi.
2 See Mena Marqués (ed.) 1985, figs 9, 11–13. The late addition of the tree has sometimes been used as an argument against the authenticity of this picture, but it is a recurrent aspect of Raphael's work, e.g. in cats 29–30, 34.
3 Ashmolean Museum, Oxford, P II 520. Joannides 1983, no. 154.
4 Lee 1934.
5 See Campbell 1998, pp. 362–9, and Rohlmann 1995, pp. 438–45.
6 Shearman 2003, pp. 1462–3.

SELECT BIBLIOGRAPHY

Passavant 1860, II, p. 55; Crowe and Cavalcaselle 1882–5, I, pp. 337–9; Lee 1934, pp. 3–19; Parker 1956, II, pp. 268–9; Béguin 1983–4, pp. 114–17; Bernini Pezzini and Massari 1985, p. 188; Mena Marqués 1985, pp. 91–5, 137; Meyer zur Capellen 1989, pp. 98–111; Pedretti 1989, pp. 56–9; Ruiz Manero 1996, pp. 21–6; Hiller 1999, pp. 261–4; Bambach 1999, pp. 103–4; Shearman 2003, pp. 110, 1462–3.

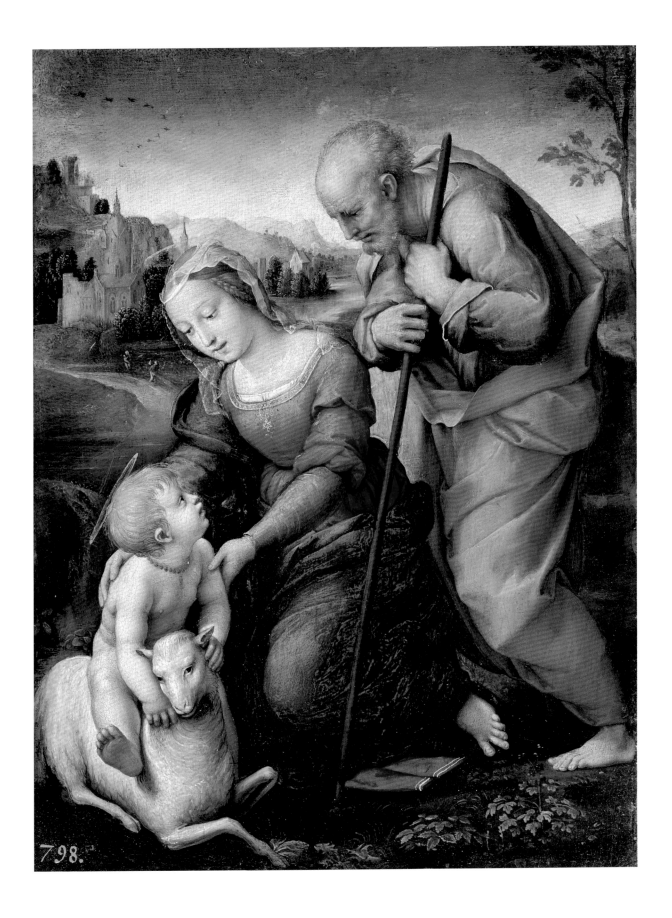

798.

MICHELANGELO BUONARROTI (1475–1564)

61 The Virgin and Child with Saint John (The Taddei Tondo)
about 1503

Marble, 109 cm diameter
(Represented in the exhibition by a modern fibre-glass resin cast, made in 1986 by John Larson.)
Royal Academy of Arts, London

Various sources record that Michelangelo carved a marble tondo of the Virgin and Child with Saint John for his Florentine contemporary Taddeo Taddei (1470–1528), and the tondo now in the Royal Academy can be traced to Taddei's descendants.[1] The relief, which is unevenly finished, has generally been placed in the years around 1503–6 when Michelangelo produced works for a number of Florentine patrons (e.g. fig. 22). Raphael took a keen interest in Michelangelo's work during this period and drew two interpretative copies of the *Taddei Tondo* (Devonshire Collection, Chatsworth House, and Louvre, Paris, fig. 85),[2] and its influence can be seen in the *Bridgewater Madonna* (cat. 62) and in drawings preparatory to a number of Madonnas that were made in these years (e.g. cats 63–4). No other work by Michelangelo was so influential upon the young Raphael, and it seems to have been the dramatic potential of such an expressively active child that made a particular impression on him.

Raphael was a close friend of the tondo's patron and Vasari describes how Taddei enthusiastically extended his hospitality to the young artist.[3] In a letter to Simone Ciarla, in April 1508, Raphael asked his uncle to make Taddei as welcome as possible when he visited Urbino (apparently to attend the state funeral of Guidobaldo da Montefeltro).[4] Vasari also described how Raphael painted two pictures for Taddei, 'in his first style' (which Vasari characterised as Peruginesque).[5] These can probably be identified as the *Terranuova Madonna* in the Staatliche Museen, Berlin, and the *Madonna of the Meadow* in the Kunsthistorisches Museum, Vienna (figs 23 and 24), and it is surely not a coincidence that one of Raphael's copies after Michelangelo's tondo is on the verso of a drawing for the *Madonna of the Meadow*.[6]

Taddeo Taddei was both a prominent citizen in republican Florence (he held numerous public offices) and a long-term supporter of the exiled Medici family. He lived in the Via de' Ginori (near San Lorenzo), where he built a new palace, designed by Baccio d'Agnolo.[7] Taddei also had connections with the court at Urbino (via his and Raphael's mutual friend, Pietro Bembo), and was closely connected to a number of Raphael's Florentine patrons, including the Nasi, patrons of the *Madonna del Cardellino* (fig. 26). The cumulative evidence suggests that he may well have been Raphael's most important contact in the city, and one can reasonably suggest that it was Raphael's work for Taddei that opened other doors in Florence.

Raphael's relationship with Michelangelo was famously strained during later years in Rome. But the evidence that in Florence Raphael knew a number of works that Michelangelo kept closely guarded in his workshop (such as cat. 56) might suggest that there was a period when the artists enjoyed better relations. TH.

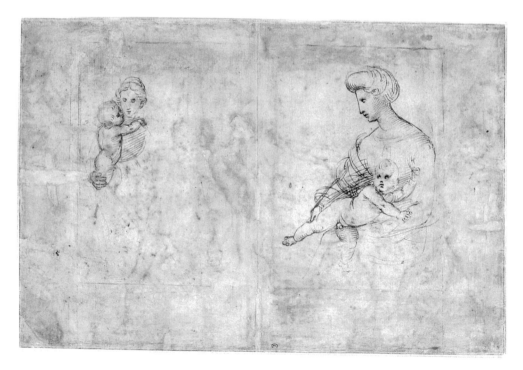

fig. 85 Copy of Michelangelo's
Taddei Tondo, about 1505
Pen and brown ink over stylus
underdrawing, 26.6 × 40.6 cm
Département des Arts Graphiques,
Musée du Louvre, Paris, inv. 3856 (verso)

NOTES

1 Vasari/BB, VI, pp. 21–2.
2 Joannides 1983, nos 111v and 93v.
3 Vasari/BB, IV, p. 160: '*fu nella città molto onorato, e particolarmente da Taddeo Taddei, il quale lo volle sempre in casa sua et alla sua tavola.*' Borghini later said that Raphael stayed with Taddei during his first visit to Florence, see Shearman 2003, p. 1323.
4 Shearman 2003, pp. 112–18.
5 Vasari/BB, IV, p. 160: '*gli fece due quadri, che tengono della maniera prima di Pietro*' [i.e. Perugino].
6 For the identification of these two pictures, see Meyer zur Capellen 2001, pp. 214–19, and Cecchi in Gregori (ed.) 1984, p. 41. The drawing is in the Devonshire Collection, Chatsworth House, Joannides 1983, no. 111r.
7 Vasari/BB, IV, p. 611.

SELECT BIBLIOGRAPHY

De Tolnay 1947, I, pp. 162–3; Lightbown 1969, pp. 22–31; Cecchi in Gregori (ed.) 1984, pp. 40–1; Olson 2000, pp. 162–5.

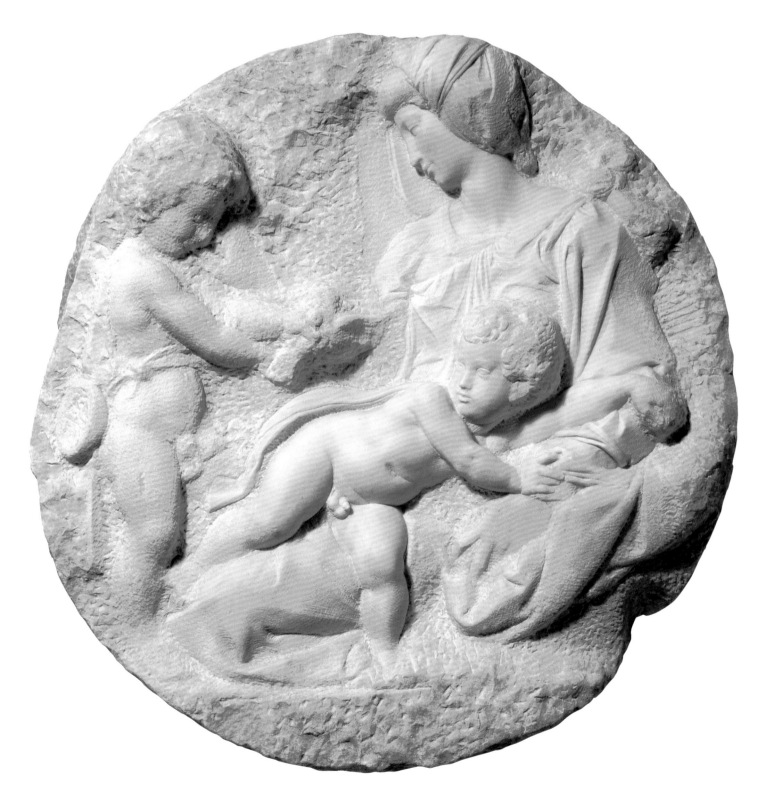

62 The Virgin and Child
(The Bridgewater Madonna) about 1507

Oil on wood, transferred to canvas in the mid-eighteenth century
and now mounted onto a synthetic support, 81 × 56 cm
Restored in 1992
Duke of Sutherland Collection, on loan to the National Gallery of Scotland, Edinburgh, NGL 065.46

This picture derives its name from the third Duke of Bridgewater (1736–1803), from whom it has passed by descent to the present Duke of Sutherland. It is usually dated about 1507 and represents the most complex treatment of the theme of the Madonna and Child that Raphael painted before he moved to Rome. Although he had previously explored the idea of the child lying across his mother's lap, Raphael had never given the child's pose so much movement, nor invested the scene with so much drama. One stimulus was the art of Leonardo (in particular the *Benois Madonna*, fig. 81, and the *Madonna of the Yarnwinder*, now known in several versions) and Raphael has mastered the lessons of the older artist much more fully than in earlier paintings such as the *Madonna of the Pinks* (cat. 59). Another stimulus was Michelangelo's *Taddei Tondo* (see cat. 61), from which the child's pose has been adapted. The complex process by which these two influences were transformed by Raphael can be studied in two preparatory drawings in London and Vienna (cats 63–4). The intricacy of the composition effectively disguises the artificiality of the solution, by which the unusually large child squirms almost unsupported on the Virgin's lap in a wholly unsustainable pose.

If this combination of visual sources and detailed preparation suggests Raphael's intense engagement with the subject during the genesis of this picture, technical examination of the picture shows that the artist continued to revise his ideas during the process of painting. Infrared photography reveals traces of an underdrawing, which seems to have been pounced from a cartoon and subsequently redrawn in black chalk. The architectural elements of the background were incised into the gesso on the original wooden support, with the aid of a straight edge and a compass. (A freehand incision indicates an alternative, raised, position for the Virgin's left thumb.) X-radiographs also establish two more radical alterations that were made as the picture was painted. The Virgin and Child were originally shown in a landscape setting.

When this was suppressed, a window with a landscape view was retained in the right background, and only later was this opening transformed into an empty niche. The light brown shape beside the niche on the extreme right was probably an internal shutter for this window, and has been retained as a door to cover the niche. It also serves to balance the wooden seat, bottom left. A landscape background appears to have been similarly rejected in the nearly contemporary *Madonna del Granduca*, and in both cases may have been the result of Raphael's desire to concentrate on the inter-action of the figures without extraneous distractions.

Significant changes were also made to the Virgin's draperies and some of these can be seen with the naked eye. Raphael originally painted the Virgin with a blue cloak wrapping around her right breast and behind the child's body. He subsequently eliminated this piece of drapery and repainted the whole of the Virgin's dress to disguise the change. It was originally red, not pink, and Raphael apparently forgot to repaint the left cuff (which still shows the original colour of the whole garment) when revising the picture. That this change was made very late in the execution of the picture is also suggested by the two parallel lines of gilding which can be made out between the child's left eye and the Virgin's left hand. Such gilding was normally left until a painting had been finished, and these lines represent the border of the original cloak, subsequently repainted.

Because this picture represents a more extreme resolution of the subject of the Madonna and Child than any other of Raphael's pre-Roman compositions, it has sometimes been dated to his early years in Rome, about 1508–12. The preparatory drawings are the most cogent arguments in favour of a dating around 1507, especially since the other compositions that are developed on these two sheets are usually dated to this period. The closest stylistic comparisons can be made with the *Saint Catherine* in the National Gallery (cat. 74). Like this saint, the Virgin has a characteristically Leonardesque twisted pose and a particularly poignant gaze. This has sometimes been related to a prefiguration of Christ's destiny, and it has also been proposed that the child's pose can be interpreted as waking from a dream in which he foresaw his future Passion. Whether or not this can be inferred, it is striking that Raphael breaks from convention to represent the child in such an active pose (just as he was also breaking free from the conventions of altarpieces in the exactly contemporary *Entombment*, fig. 34). TH

SELECT BIBLIOGRAPHY

Crozat 1729, I, p. 10; Passavant 1860, II, pp. 119–20; Crowe and Cavalcaselle 1882–5, I, pp. 345–7; De Tolnay 1947, I, p. 163; Dussler 1971, p. 23; Jones and Penny 1983, pp. 33–6; Brigstocke 1993, pp. 129–33; Weston-Lewis 1994, pp. 21–5, 56–8; Meyer zur Capellen 2001, pp. 250–3, no. 33.

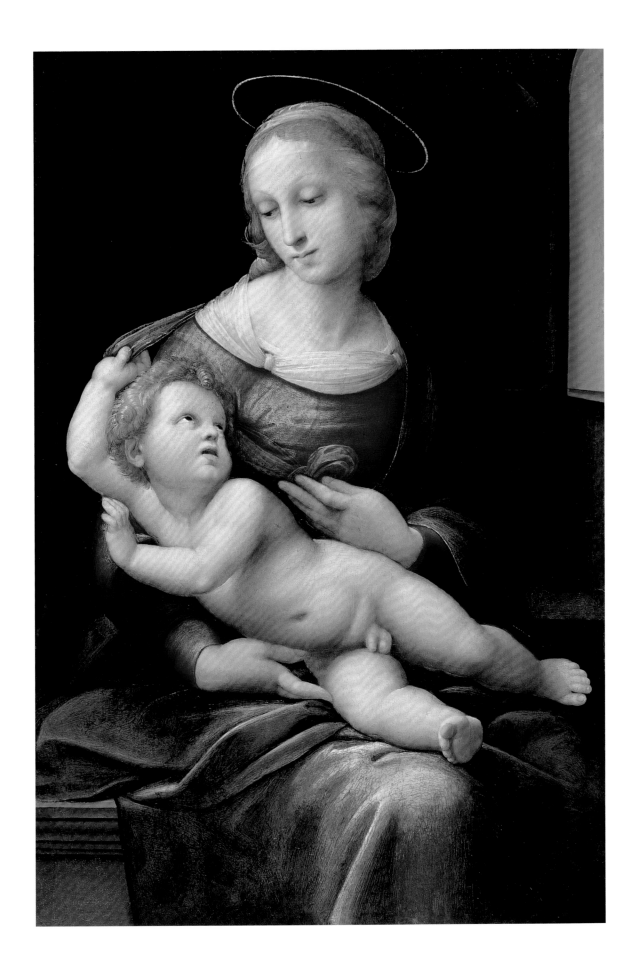

63 Studies of the Virgin and Child

about 1507

Pen and brown ink, over traces of red chalk, 25. 3 × 18.3 cm
The British Museum, London, Ff. 1.36

In this celebrated drawing Raphael rapidly sketched four variations on the theme of the Virgin and Child – each of which can be linked with varying degrees of certitude to paintings of the subject from the period 1504–9 – as well as some individual studies of the infant Christ or Baptist at the top and bottom of the sheet. This kind of free-flowing, kinetic exploration of a single theme was almost certainly modelled on Leonardo drawings, such as the British Museum study of the *Virgin and Child with a cat* (cat. 48), which include similar flurries of revisions to the outlines, the intensity of the reworking some-times causing the form to be almost obliterated by the welter of pen lines, and the use of graphic shorthand reducing body parts to simple geometric forms. Raphael's graphic shorthand is, however, noticeably more abstract than Leonardo's, his figures largely generated through a succession of intersecting segmental curves in a manner quite unlike the more descriptive, angular contours favoured by the older artist. Raphael's schematic figures in drawings like the present one also do not give the impression of having been studied from life, and in this he differs from Leonardo because the latter, even in his most hurried figural sketches, almost invariably introduces some naturalistic element in the description of gesture or expres-sion based on first-hand observation. A more practical difference between the two artists concerns their use of such study sheets. Whereas few of Leonardo's marvellously inventive graphic musings led any further, Raphael seized on this method of composition as one ideally suited to producing ideas for his serial production of paintings of the Virgin and Child over a roughly five-year period. The ingenuity and variety of Raphael's treatment of the theme owe much to his adoption of this method, a sheet such as this providing a fertile source of figural invention that could be consulted whenever he was contemplating a painting of the subject.

The study at the lower centre is the one most closely linked to a painting, the poses of the two figures being repeated with slight variation in

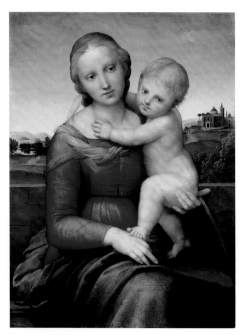

fig. 86 **The Small Cowper Madonna**, about 1505–6
Oil on wood, 59.5 × 44 cm
National Gallery of Art, Washington DC
Widener Collection, 1942.9.57

the *Bridgewater Madonna* executed around 1507 (cat. 62). Raphael derived the twisting pose of the prone Christ stretching across his mother's lap from Michelangelo's unfinished marble *Taddei Tondo* (cat. 61) dating from around 1503. Raphael's appreciation of Michelangelo's dramatic recasting of the theme is demonstrated by the survival of two slightly adapted pen copies of the Virgin and Child from around the same period (respectively in the Louvre and Chatsworth),[1] as well as a looser interpretation from the beginning of his period in Rome of the same figures in a study of identical technique now in the Uffizi.[2] In the present drawing, as in the finished painting, Raphael made a number of changes to the poses of Michelangelo's figures, reversing the orientation of Christ and in the absence of the Baptist having him look upwards at his mother who sits frontally, gazing calmly

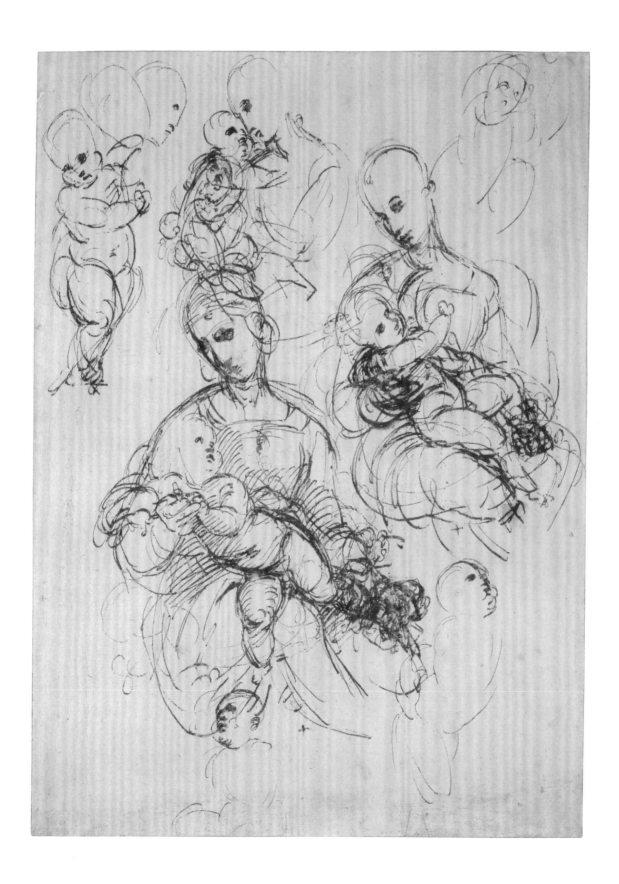

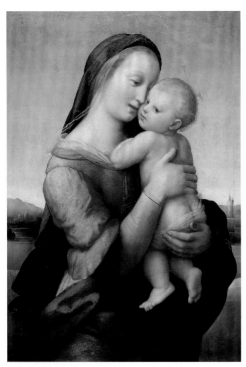

fig. 87 **The Virgin and Child**
(The Tempi Madonna), 1507–8
Oil on poplar, 75 × 51 cm
Alte Pinakothek, Bayerische Staatsgemäldesammlungen,
Munich, WA 796

downwards to her right. He clearly had in mind the idea of placing the Virgin's left hand on her child's outstretched left leg, the explosive flurry of lines in this area showing his repeated attempts to come up with a satisfactory conjunction of the two limbs. Raphael slightly reworked both poses (altering, for example, the position of the Virgin's left hand) in a larger and more considered study, now in the Albertina (cat. 64), executed in metalpoint with touches of pen and ink, which is even closer to the finished work.

Raphael's ability in his representations of the Virgin and Child to convey differing facets of the tender and poignant bond uniting mother and son by means of seemingly quite minimal alterations to their positions is well demonstrated by the study immediately to the right of the main one. The pose of the Virgin in this is almost identical to the one below it, but the baby no longer twists across her lap in a headlong movement and so her right arm no longer restrains him, but instead cradles him protectively to her body in a pose at once tender and at the same time reminiscent of the *Pietà*. The closeness of the Albertina drawing to the present one is demonstrated by the appearance on its verso (cat. 64) of slightly revised versions in red chalk of this pose, as well as the two studied in the top left of the sheet. The two drawings also share in common small pen crosses inscribed beneath the two largest Virgin and Child studies in the

present study and below the one on the lower left in the Albertina sheet. These marks appear to be in the same ink as the studies and may signify Raphael's approval of the designs and that he considered them ideas worth developing further. A somewhat similar arrangement of the two figures is found in the *Colonna Madonna* of about 1507–8 in Berlin, although in the painting Christ is more upright and his mother is seated facing to the left holding an open book in her left hand.

The study at the top left shows the Christ Child held at shoulder height by the Virgin, his pose similar but in reverse to that of his counterpart in the slightly earlier *Small Cowper Madonna* of about 1505–6 in Washington (fig. 86). The bond between mother and son is underlined further in the study immediately to the right where the heads of the two figures touch and Christ reaches out to embrace the Virgin. This long-established motif had a particular resonance in Florence through Donatello's exploration of the theme in a number of reliefs in various media, the best known of which is the marble *Pazzi Madonna* now in Berlin. The Virgin and Child appear in comparable positions, but again reversed from those in the drawing, in the *Tempi Madonna* of about 1507–8 (fig. 87), which is Raphael's most obvious homage to Donatello.
HC

NOTES

1 Joannides 1983, nos 93v (fig. 85) and 111v.
2 Joannides 1983, no. 202v.

SELECT BIBLIOGRAPHY

Fischel 1913–41, III, no. 109; Pouncey and Gere 1962, no. 19; Gere and Turner 1983, no. 84; Joannides 1983, pp. 70–1, no. 180; Knab, Mitsch and Oberhuber 1984, no. 161; Jones and Penny 1983, p. 29, pl. 33; Weston-Lewis 1994, no. 20.

64 Studies of the Virgin and Child
about 1507

Recto: pen and brown ink over metalpoint on pink prepared paper, lower left corner made up
Verso: pen and ink and red chalk, 26.2 × 19 cm
Albertina, Vienna, IV 209

Raphael made this drawing when he was preparing to paint the *Bridgewater Madonna* (cat. 62). The recto develops the earlier compositional sketch which the artist had made on another sheet, now in the British Museum (cat. 63). The pose is almost identical to the largest study on cat. 63, but Raphael has continued to make subtle changes to both figures. The Virgin's left hand has been brought up to rest on the child's waist (or perhaps to support the child by means of a ribbon wrapped around his torso – a method which Raphael also employed in the slightly earlier *Holy Family with a Palm*, on loan to the National Gallery of Scotland), while her right hand, which supports Christ's left hand (which possibly clutched flowers), has been moved fractionally further from the child's head and chest. The child's pose has not been greatly changed, except that Raphael has investigated a different solution for his right hand, which would have been raised either in blessing, or perhaps pointing to heaven (as in Leonardo's *Madonna of the Yarnwinder*). The child is more obviously supported on the Virgin's lap than in the finished painting as he straddles her right knee. Raphael had experimented with this particular idea when he first made an interpretative copy of Michelangelo's *Taddei Tondo* (see cat. 61). In a drawing now in Paris (fig. 85) Raphael copied Michelangelo's marble relief, but introduced several variations from his source as he drew. One was to show Christ's left hand raised in a similar fashion. This idea was omitted in the subsequent studies in the British Museum, before being reintroduced here. It was again omitted in the finished painting (which varies in a number of other respects as well). At the bottom right a framing line has also been drawn.

Raphael made some very deliberate choices when selecting his materials for this drawing. The paper has been prepared with a pink ground, and the figures have been sketched at speed using metalpoint – a slightly unexpected use of this medium at this point in the artist's career.[1] The colour of the ground was probably chosen to give the sheet a warm flesh-tone, and metalpoint gave the artist a subtle range of tones. These have been exploited to the full in the reworking of the Virgin's facial features where Raphael was trying to capture something of Leonardo's manner. The redoubling of the outlines of the figures and the extraordinary intersecting ovals that define the child's leg find striking parallels in the underdrawing of the *Madonna of the Pinks* (cat. 59), itself drawn in metalpoint. When Raphael felt that he had got as far as he could with metalpoint he stopped, and reinforced in pen and ink the aspect of the drawing that satisfied him, and which remained constant in all the known drawings for the *Bridgewater Madonna*: the opposing thrusts of the child's head and left arm. This is comparable to numerous drawings by Leonardo.

The verso of the sheet, like the closely contemporary drawing in the British Museum, has a series of ideas for Virgin and Child compositions. These have been drawn directly onto the paper, using pen and ink, and red chalk (which is also found on cat. 63), and were almost certainly drawn without reference to a model. The chalk studies seem to have been drawn first, starting with the study in the centre of the sheet, and develop ideas related to the *Colonna* and *Tempi Madonnas* (in Berlin and Munich) which are also studied on cat. 63. The pen sketches to the right are indirectly related to the *Madonna of the Pinks* – the Virgin and Child even seem to hold cut stems – and the *Holy Family with a Palm*, although the child seems to turn away from an open book, but they were probably ruminations on a theme rather than preparatory drawings as such. The pen sketches at the left are related to the *Orléans Madonna* at Chantilly and the *Large Cowper Madonna* at Washington. As in the case of cat. 63, this dazzling array of seven motifs on a single sheet shows the extraordinary fertility of Raphael's imagination as he developed a whole series of ideas for his Madonna and Child compositions, which he then referred back to over the years that followed. TH

NOTE

1 Although the earlier sketch of soldiers in the Ashmolean Museum (fig. 9) is similar.

SELECT BIBLIOGRAPHY

Passavant 1860, II, p. 435 no. 191; Crowe and Cavalcaselle 1882–5, I, p. 347; Fischel 1913–41, III, pp. 136–8, nos 110, 111; Mitsch 1983, pp. 46–51; Joannides 1983, no. 181; Knab, Mitsch and Oberhuber 1984, nos 162–3; Weston-Lewis 1994, pp. 64–5.

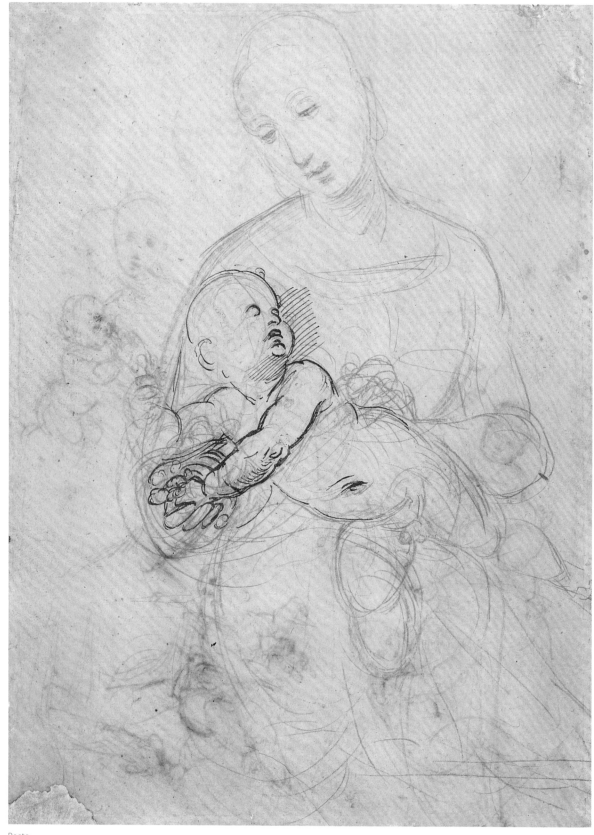

Recto

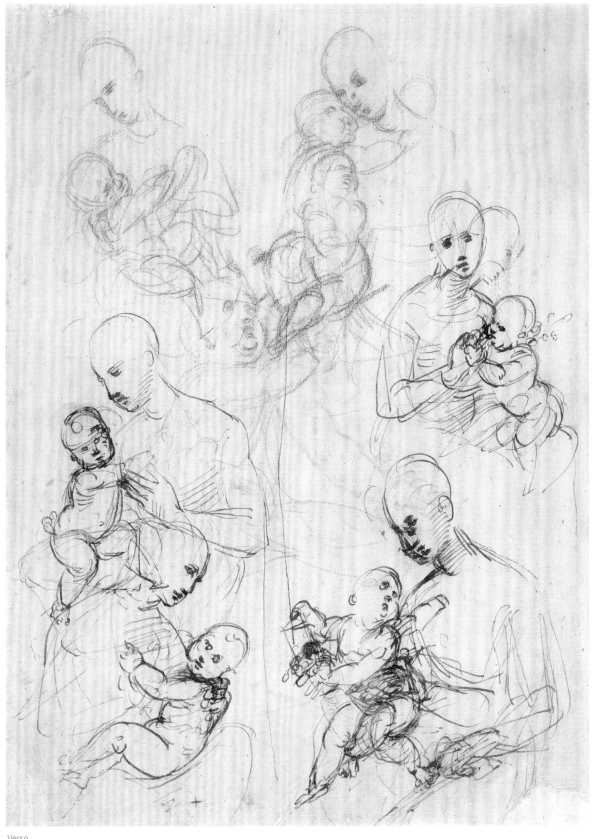

Verso

CAVALIERE D'ARPINO (1568–1640)

65 Copy after the Baglioni 'Entombment'
1608–9

Oil on canvas, 176 × 175 cm
Relined and restored in 1979.
Galleria Nazionale dell'Umbria, Perugia, 500

This picture is an extremely faithful full-scale copy of Raphael's famous *Entombment* of 1507 now in the Galleria Borghese, Rome (fig. 34). Raphael's panel, which measures 174.5 × 178.5 cm, is too fragile to be lent but this copy, which was made to replace the picture when the original was taken to Rome by Cardinal Scipione Borghese (1576–1633) in 1608, conveys a great deal of its spirit.

Raphael's altarpiece, which is signed and dated RAPHAEL VRBINAS MDVII (see fig. 97), was painted for the Baglioni chapel, dedicated to Saint Matthew, in the Franciscan church of S. Francesco al Prato in Perugia, probably at the behest of Atalanta Baglioni (Vasari's claim to this effect is confirmed by later documents). Atalanta was the matriarch of the Baglioni clan, which had great influence over the politics of Perugia (they were sometime lords of the city) and maintained their power through mercenary – and murderous – activity. The Baglioni altarpiece (fig. 88) was made up of the *Entombment*, a grisaille predella (cats 66–7), a crowning lunette and a frieze (fig. 89). Vasari claimed that the picture was designed in Florence (which is corroborated by other evidence), and it certainly represents the culmination of Raphael's activity in the city, especially his study after Michelangelo. This process of assimilation and reflection can be followed in the splendid series of drawings that he made as he planned the painting, of which cats 68–73 are a selection.

The Baglioni *Entombment* represents a huge step forward for Raphael in a number of respects. It is the first of his altarpieces which is

fig. 88 Reconstruction of the altarpiece for the Baglioni chapel in the church of S. Francesco al Prato, Perugia

God the Father (lunette), 1507
Oil on wood, 81.5 × 88.5 cm
Galleria Nazionale dell'Umbria, Perugia, 288

The Entombment (see fig. 34 and pp. 47–9)
Frieze (see fig. 89, p. 208)
Predella (see cats 66–7 and fig. 90, pp. 209–11)

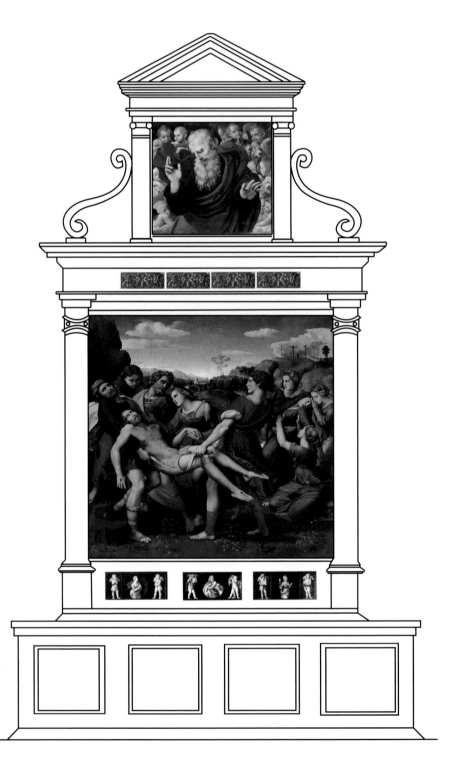

66,67 Hope; Charity

1507

Oil on poplar, 18 × 44 cm (each)
Vatican Museums, Vatican City, inv. 40330 and 40331

These two panels, and a third depicting *Faith* which is also in the Vatican Museums (fig. 90), made up the predella of the Baglioni *Entombment* of 1507 (discussed under cat. 65). When this altarpiece was removed from the church of S. Francesco al Prato, Perugia, in 1608, the predella remained in the church and was subsequently framed with Cavaliere d'Arpino's copy (cat. 65). During the Napoleonic sequestrations (1797–1815) the predella was sent to Paris and when its return was demanded it was sent to Rome. It was subsequently incorporated into the Vatican Museums.

These predella panels of the three Theological Virtues are unusual in several respects. They are non-narrative, in marked contrast to Raphael's earlier predellas (e.g. cats 40–2 and 46) which are traditional narrative episodes. It is striking that although Raphael painted several more altarpieces in the remainder of his career, he never painted another predella. This was partly a matter of fashion, with fewer patrons requesting predellas – especially in the big metropolitan centres, such as Rome – particularly when (as here) the main altar-panel represented a narrative subject. Nevertheless, the way in which Raphael rejected tradition in these panels suggests that he may have been impatient to move beyond the constraints that were imposed by including narrative scenes at the base of an altarpiece. The

division of space into fictive medallions and flanking niches is also quite unusual (although medallions do appear in earlier Umbrian predellas), as is the decision to paint the figures in grisaille against a dark green glaze (simulating marble, and perhaps deliberately classicising). In the context of having been painted for a funerary chapel (see cats 68–73), the decision to depict the three Virtues as fictive sculpture may also have been related to the representation of Faith, Hope and Charity in tomb sculpture (e.g. Innocent VIII's tomb in St Peter's, Rome, completed 1498).

The figures that flank each of the Virtues demonstrate Raphael's interest in that phase of childhood when babies become toddlers, and there seems to be a contrast between the active putti who flank *Charity* – the greatest and most worldly of the Theological Virtues is flanked by a putto with a flaming cauldron and another liberally distributing money – and the placid little angels (draped and winged in contrast to the putti) who stand on either side of *Hope* and *Faith*.

The figure of *Hope* (and indeed the figure of *Faith*) can be related to Raphael's almost contemporaneous *Saint Catherine* (cat. 74), and the many sources for that figure; while the figure of *Charity* seems to develop from Raphael's study after Michelangelo's Madonna reliefs (e.g. cat. 61, but more especially the *Pitti Tondo* in Florence, Museo Nazionale del Bargello). *Charity* is also

the only figure for whom a preparatory drawing survives[1] and seems the one best integrated into the circular format of the medallions.

Ever since Burckhardt suggested that the Baglioni *Entombment* was commissioned by Atalanta as she grieved for her son, Grifonetto, who was murdered in July 1500, the iconography of the picture has been interpreted as making reference to this tragic event in the life of the patron.[2] Although the chapel had been acquired before Grifonetto's death, and the iconography is hardly out of place within the Christian tradition, it is surely still the case that the maternal grief represented in the main panel and the nurturing of *Charity* would have had a particular resonance for Atalanta. TH

NOTES

1 Joannides 1983, no. 142r.
2 Nagel 2000, pp. 113–36.

SELECT BIBLIOGRAPHY

Dussler 1971, pp. 24–5; Ferino Pagden 1984a, pp. 24–6, no. 5; Nesselrath in Bonn 1998–9, pp. 531–2, cat. 281; Baldriga in Paris 2001–2, pp. 98–101; Cooper 2001, pp. 557–61.

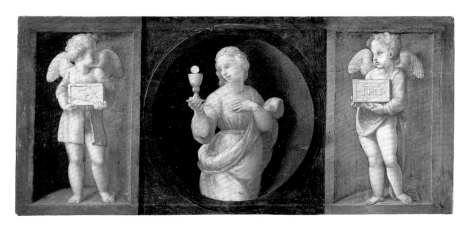

fig. 90 **Faith**, 1507
Oil on poplar, 18 × 44 cm
Vatican Museums, Vatican City
inv. 40332

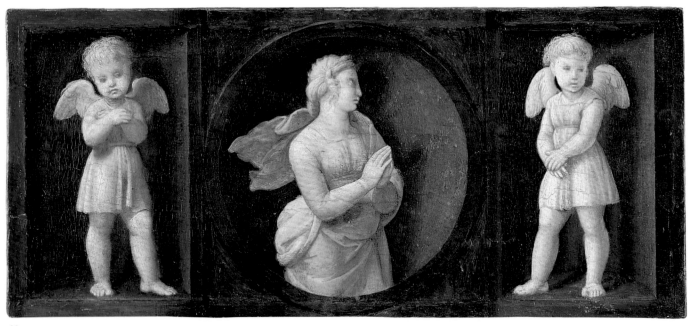

66

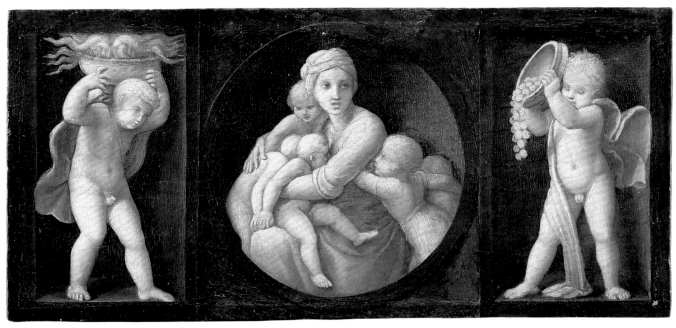

67

68–73 Studies for the Entombment
about 1507

68 The Lamentation

Pen and brown ink, over traces of black chalk and stylus,
central plumb line in stylus, scale at right, 17.8 × 20.5 cm
The Ashmolean Museum, Oxford. Presented by a Body of
Subscribers, 1846. 170 P II 529

69 A group of figures in a Lamentation

Pen and brown ink, 25 × 16.9 cm
The British Museum, London, 1895-9-15-636

70 The Entombment

Pen and brown ink, 21.3 × 32 cm
Inscribed in brown ink in the bottom right corner: R.V.[1]
The British Museum, London, 1963-12-16-1

71 The Entombment

Pen and brown ink, over black chalk, an alternative position
for the head of the bearer third from left in black chalk alone
23 × 31.9 cm
The British Museum, London, 1855-2-14-1

72 Three nude bearers

Pen and brown ink, over black chalk, the body of
Christ in red chalk only, 28.2 × 24.6 cm
The outlines of the three standing figures pricked for
transfer and with registration lines.
Inscribed in brown ink in the bottom left corner: R.V.[1]
The Ashmolean Museum, Oxford. Presented by a Body of
Subscribers, 1846. 173 P II 532

73 Anatomical study of the Virgin supported by the Holy Women

Pen and brown ink, over black chalk, body and legs of
kneeling woman in black chalk only, 30.7 × 20.2 cm
Inscribed in brown ink in the bottom left corner: R.V.[1]
The British Museum, London, 1895-9-15-617

The genesis of the Baglioni *Entombment* (fig. 34), dated 1507, can be followed with unusual completeness thanks to the survival of sixteen preparatory studies, a sequence only exceeded in number by those related to the *Disputa* (cats 78–86). The surviving *Entombment* drawings, which most likely constitute only a fraction of those made in preparation for the work, testify to the care that Raphael lavished on the altarpiece in the Baglioni chapel in the church of S. Francesco al Prato, Perugia. According to Vasari the picture was commissioned by Atalanta Baglioni from Raphael when he was in Perugia working on the *Ansidei Madonna* (cat. 45), and he states that the painter worked out the design in Florence before returning to Umbria with the cartoon to execute the altarpiece. The contract for the painting has yet to be found but there is no reason to doubt that Atalanta Baglioni was the patron, especially as there is a note in Raphael's hand on a back of a drawing in Lille[2] asking his Perugian colleague Domenico Alfani to ask 'madona Atala[n]te' to send him money.[3] The fact that such a prestigious commission was given to Raphael demonstrates the esteem in which he was held in Perugia, and the artist, doubtless with an eye for future work, responded by creating a work that reflected most fully his wide-ranging studies of art in Florence (this would also have played well with a Florentine audience who could have seen the cartoon). As it turned out it was to be his last painting for Perugia, but he may well have imagined that the city would remain a lucrative source of patronage for him as it had for Perugino. An added incentive for him to show his mettle was that the *Entombment* was destined for a chapel directly opposite one housing his Peruginesque *Coronation of the Virgin* (fig. 13) of around 1503 (painted for the Oddi family, rivals of the Baglioni), and the church also housed Perugino's *Resurrection* (fig. 57, now at the Vatican), commissioned in 1499, and his *Saint John the Baptist and Four Saints* (Galleria Nazionale dell'Umbria, Perugia).[4]

The earliest drawing in the sequence exhibited here, cat. 68, shows that Raphael's initial idea was very different from the composition he eventually painted. As was first noted by the great nineteenth-century connoisseur J.C. Robinson the composition of cat. 68 derives from Perugino's altarpiece of the *Lamentation over the Dead Christ* dated 1495, formerly in the church of S. Chiara in Florence and now in the Palazzo Pitti (fig. 33).[5] The subject matter was appropriate for an altarpiece in a funerary chapel where the patron's son Grifonetto – murdered in a family feud in 1500 – was already buried and where Atalanta too was laid to rest on her death in 1509. The pathos of Raphael's depiction of the Virgin swooning in grief shows an intensity of emotion not found in the measured contemplative treatment of the theme in Perugino's work.

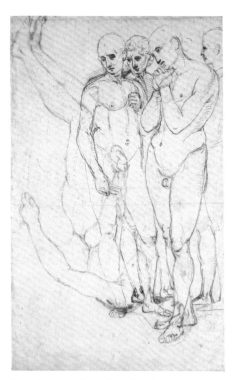

fig. 91 **Four standing male nudes**, about 1507
Pen and brown ink, over traces of black chalk
and stylus underdrawing, 32.2 × 19.8 cm
The Ashmolean Museum, Oxford, 171 P II 530

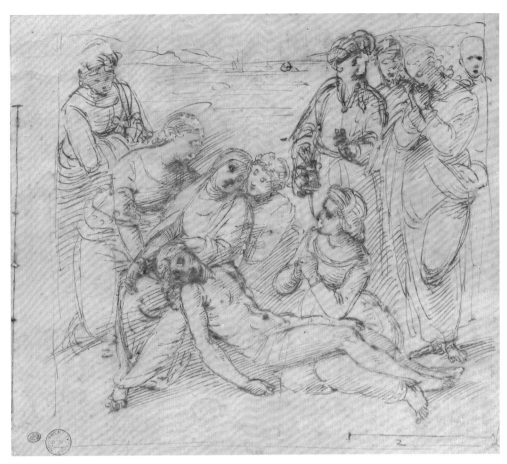

68

In the drawing Raphael made further changes to Perugino's composition, stripping it down to its bare essentials: the women lamenting the Dead Christ form a wedge-shaped block in the foreground counterpoised by a group of four figures, with Joseph of Arimathaea and Saint John in the front, on the right. The slightly muted upward diagonal of Perugino's work is made much stronger in Raphael's composition (cat. 68), the eye led successively upwards from the feet of Christ to the standing woman on the far left. Although the superbly balanced design developed in cat. 68 was ultimately rejected for the Baglioni painting, it was subsequently engraved with slight variations by Marcantonio Raimondi.[6]

The group of male mourners on the right are the subject of a separate study also in the Ashmolean (fig. 91).[7] In this the figures are shown in the nude to clarify the underlying pose before drapery was added. This was a practice recommended by Alberti in his treatise of the mid-1430s, and one that had been adopted by Florentine artists such as Leonardo. It seems that Raphael was also consciously adopting some of Alberti's compositional ideas and experimenting with his recommended models (one of which was a classical sarcophagus relief showing the transport of the corpse of Meleager) during the course of his work on the commission.[8] (The story of Meleager recounted in Ovid's *Metamorphoses* had a particular resonance because the patron's namesake, the huntress nymph Atalanta, was unwittingly one of the causes of Meleager's death at the hand of his mother.[9]) In the Ashmolean drawing the contours of the figures are pricked and the outlines of Saint John, on the right with his hands held in prayer, were transferred to an elaborately finished drawing or *modello* in the Louvre,[10] which features a close variant of the *Lamentation* composition studied in cat. 68. A quickly drawn study of the right-hand mourners in the British Museum (cat. 69) suggests that Raphael was concerned by their isolation from the main group, hence his decision to link them through one of the Holy Women who has been relieved of supporting Christ's legs. The downcast gazes of the standing male figures (the Holy Woman is presumably looking at the Virgin) demonstrate that Raphael was still thinking of having Christ's body on the ground as shown in cat. 68.

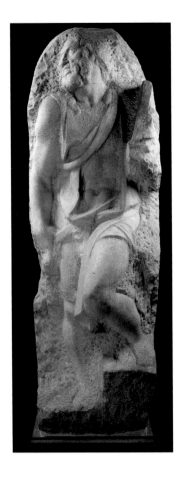

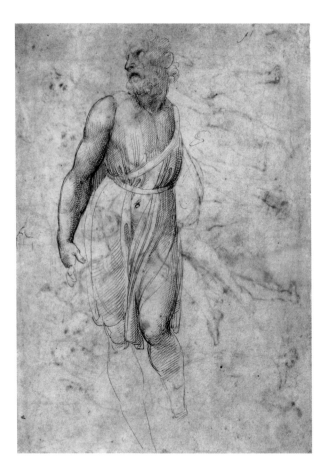

fig. 92 Michelangelo Buonarroti
Saint Matthew, 1505–6
Marble, height 271 cm
Gallerie dell'Accademia, Florence, 1077

fig. 93 **Saint Matthew (after
Michelangelo)**, about 1507
Pen and brown ink (verso of cat. 71)

Despite having gone to considerable effort in the creation of the Louvre *modello*, Raphael was clearly not content with a static *Lamentation* and he altered the narrative to the related, but intrinsically more active one of the transportation of Christ's body to the tomb (the action immediately preceding the *Entombment* as the painting is traditionally, and somewhat misleadingly, entitled in English). This may have been influenced by Michelangelo's treatment of it in his unfinished altarpiece painted in 1500–1 for S. Agostino in Rome and now in the National Gallery, London. Raphael's study of Michelangelo's Florentine works are certainly discernible in some of the *Entombment* drawings, and to a lesser extent in the painting itself, and the move to a subject that afforded Raphael an opportunity to display his skill in depicting figures in motion (a quality significantly absent in Perugino's composition) must in part have been inspired by the younger artist's admiration for the *Battle of Cascina* cartoon (see cat. 56).

The gradual shift in the narrative is documented in a study in the British Museum (cat. 70).

This shows a rather unhappy compromise between the two with the corpse in a winding sheet held aloft by two bearers, and the kneeling Virgin with two of the Holy Women at the centre. Raphael's evident struggle to find a satisfactory compromise between the two treatments is perhaps reflected in the generally stilted handling of the drawing, so different in character from the sureness of touch found in cats 68 and 71. The composition suffers from the lack of any sense of the direction in which the body is being carried, a fault in part due to the uneasy adaptation of the frontally orientated pose of Michelangelo's unfinished statue of *Saint Matthew* for the bearer on the right (fig. 92). Michelangelo's sculpture was clearly in Raphael's mind during the preparation for the Baglioni work, in part perhaps, as Cooper suggests, because the Baglioni chapel was dedicated to Saint Matthew.[11] Whatever the motivation, he made a more faithful copy of the sculpture on the verso of cat. 71 (fig. 93), and in the finished work itself there is perhaps a distant echo of the marble's pose in the emphatic twist of the head

of the figure to the left of the Magdalen kissing Christ's hand.

The deficiencies of cat. 70 are resolved in another compositional study in the British Museum (cat. 71), which comes close to the finished work. The group on the left is almost as in the painting, except for the arrangement of the legs of the left-hand bearer and the pose of the Magdalen. The right-hand group by contrast differs entirely from the painting, with the Virgin followed by two Holy Women advancing towards the left. Clearly Raphael had by now fixed on depicting an Entombment, his treatment of the theme influenced by Roman sarcophagus reliefs showing the transport of the dead body of Meleager and also by Mantegna's engraving of the subject (fig. 94).[12] His deployment of these sources was anticipated by Signorelli's treatment of the subject in the background of his *Lamentation* fresco in Orvieto (1499–1504) which, in view of the links between the two artists (see cat. 47), Raphael most probably had seen.[13] Prompted by these works Raphael took over the idea of emphasising the physical effort of the bearers in carrying the corpse on a winding sheet, their strained poses contrasting with the limpness of Christ's lifeless body. The leftward emphasis of the composition established in cat. 68 is restored, its motion in that direction given greater impetus by the movement of the bearers and the women on the right. Fitting nine figures, divided into two separate groups, into an almost square panel required considerable ingenuity, and Raphael kept in mind the space he had to play with by roughly indicating in broken vertical pen lines the composition's lateral limits as he had done in cat. 68.

The artist also explored in a drawing now in the Ashmolean (cat. 72) the idea of placing Christ in a more frontal position, as in Michelangelo's *Entombment*, with the body borne by three bearers in a manner reminiscent of the trio of satyrs supporting the corpulent Silenus in Mantegna's engraving of a Bacchanal.[14] Cat. 72 must have been drawn around the same time as cat. 71 as the pose of the left- and right-hand

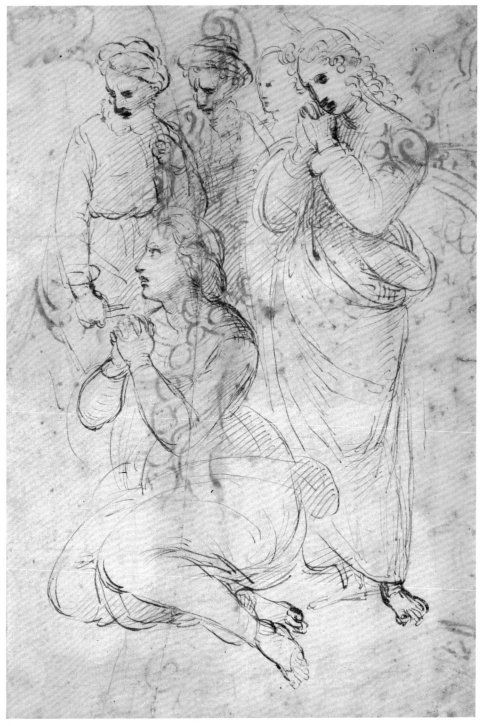

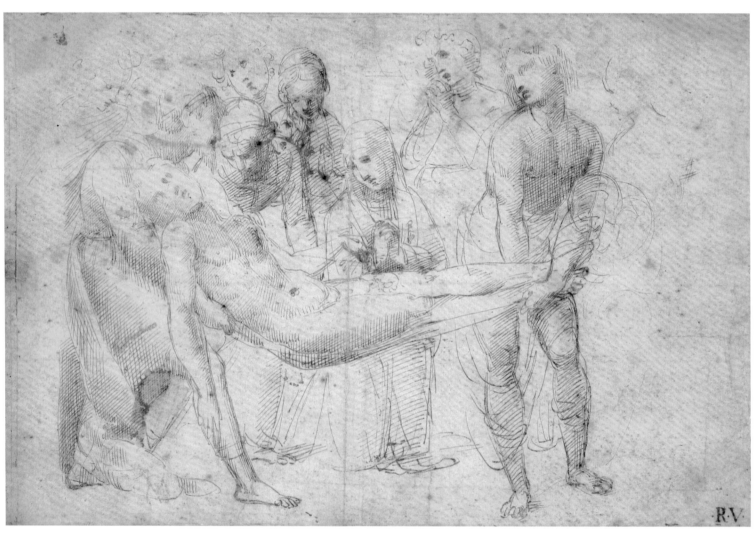

70

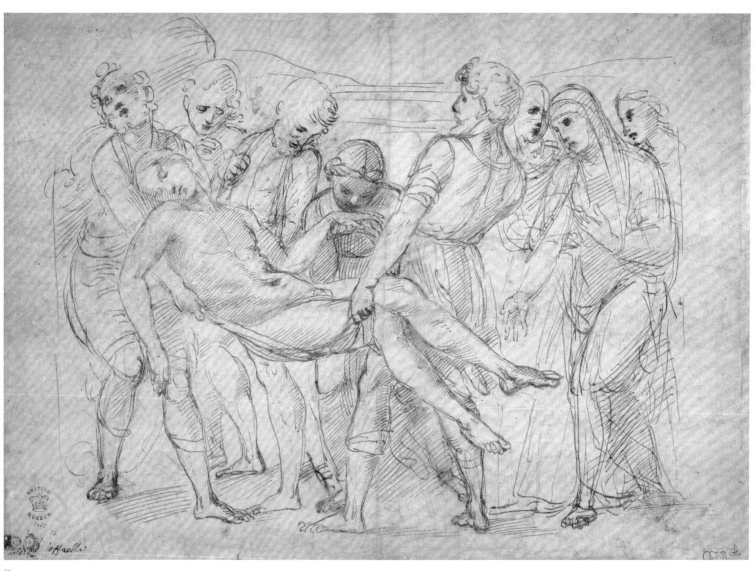

71

figures correspond exactly with those in the British Museum study. The muscular torsion of the figures in cat. 72 immediately brings to mind Michelangelo's *Battle of Cascina* (fig. 78), the debt extending to the adoption of a slightly heavy-handed version of the latter's method of cross-hatched modelling. The pricking of the outlines of the three bearers demonstrate that Raphael must have made further studies of the trio, but in the end he abandoned the idea, most likely because of the difficulty of combining them with the figure of the dead Christ (this problem is avoided in the drawing by only lightly sketching the corpse in red chalk so that it does not obscure the two leftmost figures).

The thoroughness of Raphael's preparation for the Baglioni painting is shown by his summary analysis of the anatomy of the fainting Virgin and one of the Holy Women behind her in a drawing in the British Museum (cat. 73). Again he may have been inspired to do this by Alberti's

suggestion that painters should begin with the skeleton in drawing a figure and this sketch seems to support Vasari's claim that Raphael might have studied anatomy at this period.[15] The fact that there is only one other Raphael drawing of this kind, a study of a seated skeleton in the Ashmolean,[16] datable to 1507, may suggest that his enthusiasm for such radical anatomical investigation, fired perhaps by Leonardo's example, was short-lived. The poses of the three figures (the foreground one drawn almost exclusively in black chalk and not as a skeleton) differ from the painting only in the position of the head of the standing Holy Woman and of the Virgin's left arm, and the omission of the woman standing to the Virgin's right. The three female heads with elaborately braided hair in the upper left of the sheet are studies for the heads of the Holy Women. The one top right seen in *profil perdu* is for the figure swivelling around to catch the Virgin; the head top left is most probably for

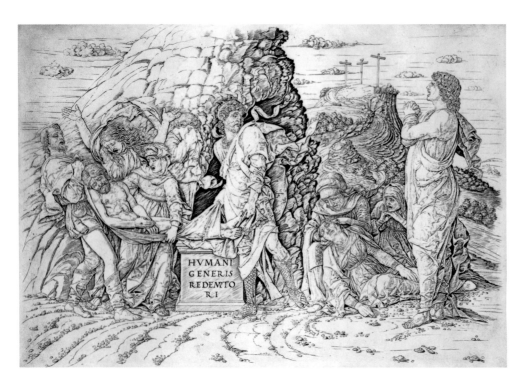

fig. 94 Andrea Mantegna
The Entombment, 1465/70
Engraving, 31.1 × 45.5 cm
National Gallery of Art, Washington DC
Rosenwald Collection, 1955.1.1

the woman standing behind the Virgin, a figure shown in the drawing as looking to the right but who in the finished work looks towards Christ. The study below is most likely for the standing woman holding the Virgin's head upright. The heads correspond fairly closely with those in an old copy in the British Museum of a lost Raphael study of the same group (fig. 96).[17] The original must have followed on closely from cat. 73 as the poses of the figures are almost identical, except the women are now clothed and the artist has added the woman to the right of the Virgin. The last surviving study, probably drawn just prior to the creation of the finished and now lost cartoon, is the highly worked squared-up pen study in the Uffizi for the left-hand group (fig. 95).[18] Executed in a delicate Michelangelesque cross-hatching technique, the Uffizi drawing underlines the enormous pains that Raphael expended on perfecting the composition because comparison with the finished work shows that he continued to make numerous minor adjustments of limbs and heads, as well as more major alterations – even at this late stage – such as the change in the position of one of the Holy Women, who appears in the study behind the Magdalen while in the painting her pose is revised and she is placed by the fainting Virgin.

The sequence of drawings documenting the evolution of the design from a static Lamentation to one centred around the transport of Christ's body to the tomb have generally been regarded as evidence of Raphael's creative approach to narrative, but this view has recently been challenged by Nagel who views the artist's change of mind as evidence of a more fundamental shift exerted on the traditional form of the altarpiece at this period.[19] Irrespective of how the change in subject matter is interpreted, the drawings demonstrate that Raphael enjoyed a certain latitude in the narrative treatment, perhaps because his patron was far away in Perugia or because he was granted such licence from the outset. In terms of what the drawings reveal of Raphael's working methods it is perhaps not surprising, in view of the preponderance of pen studies from

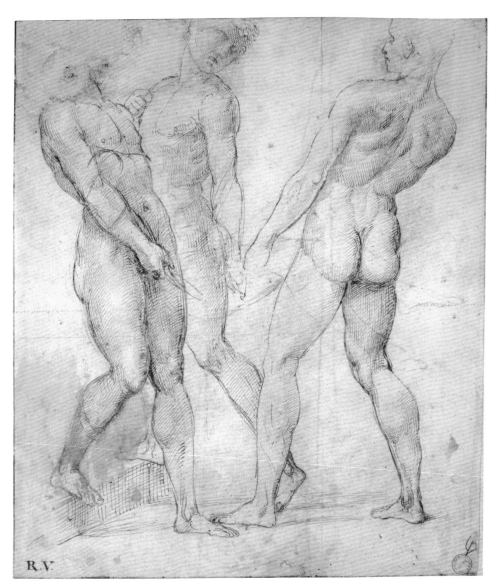

72

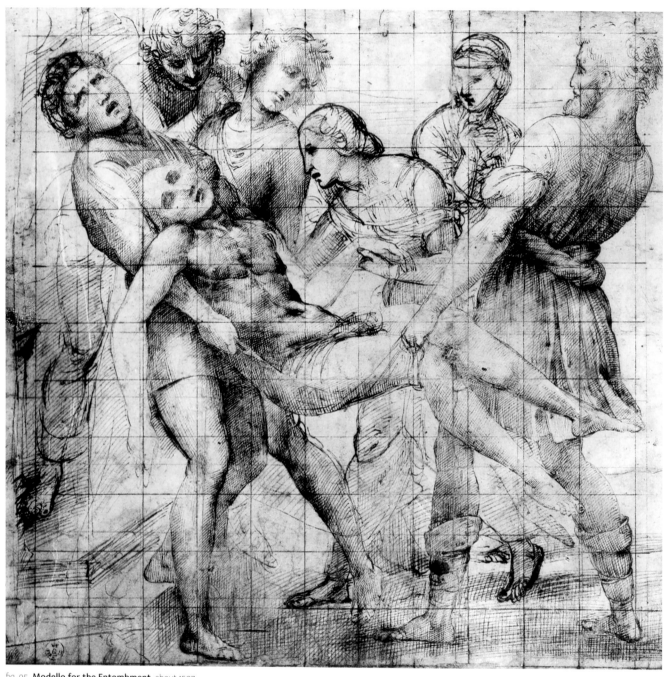

fig. 95 **Modello for the Entombment**, about 1507
Pen and brown ink, over traces of stylus underdrawing and black chalk
squared in brown ink, red chalk and stylus, 28.9 × 29.8 cm
Gabinetto dei disegni e delle stampe degli Uffizi, Florence, inv. 538E

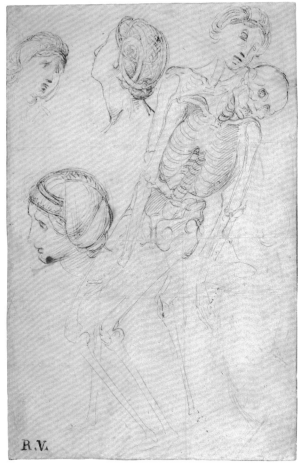

73

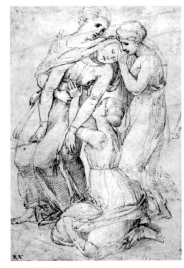

fig. 96 After Raphael
Maries in a Lamentation, 1510–20 (?)
Pen and brown ink, 28.9 × 20.1 cm
The British Museum, London
1895-9-15-616

the years 1504–8, that almost all the studies for the main panel are drawn in ink.[20] It is likely, however, that he would have followed these with more detailed figure studies in chalk (the only surviving example of which is the black chalk study of one of the bearers' heads in Chantilly[21]) and also a full-size cartoon in the same medium or in charcoal. The studies for the painting also chart how Raphael sought inspiration from a wide variety of sources – the antique, Alberti, Mantegna prints and the work of Michelangelo, Signorelli, Perugino and Leonardo – and how he explored, refined and assimilated these disparate influences to achieve a composition that is entirely his own. HC

NOTES

1 R[aphael] V[rbinas] as inscribed on Viti-Antaldi collection drawings.
2 Joannides 1983, no. 174.
3 Shearman 2003, pp. 111–12.
4 Scarpellini 1984, pp. 99 and 119–20, nos 100 and 168, figs 177–81, 272. As the painting of *Saint John the Baptist and Four Saints* is undocumented there is no certainty that it was in the church by the time that the *Entombment* was finished; Perugino's work is dated on stylistic grounds to the first decade of the sixteenth century.
5 Scarpellini 1984, p. 89, no. 63, figs 96–7, 99–100.
6 Bartsch XIV, 37.
7 P II 530, Joannides 1983, no. 124r.
8 Nagel 2000, pp. 114–15.
9 The parallels between Grifonetto's murder and the Meleager myth are explored in Nagel 2000, pp. 124–7.
10 Joannides 1983, no. 125.
11 Cooper 2001, pp. 554–61.
12 Bartsch XIII, 3. Raphael's interest in this engraving is confirmed by copies after it in the Venice *Libretto* fols. 32r and v, Ferino Pagden 1982, no. 83, figs 164–5.
13 Henry and Kanter 2002, no. 58/20, pp. 199–205.
14 Bartsch XIII, 20.
15 Vasari/BB, IV, p. 215. I am grateful to Monique Kornell for her comments on this drawing.
16 Joannides 1983, no. 122v.
17 Pouncey and Gere 1963, no. 39.
18 Joannides 1983, no. 137, pl. 13.
19 Nagel 2000, pp. 113–35.
20 The non-ink figure studies are respectively in metalpoint and black chalk, Joannides 1983, nos 126r and 158v (the verso of cat. 75).
21 Joannides 1983, no. 131v.

SELECT BIBLIOGRAPHY

(68) Robinson 1870, no. 37; Fischel 1913–41, IV, no. 164; Parker 1956, no. 529; Gere and Turner 1983, no. 72; Joannides 1983, no. 127; Jones and Penny 1983, p. 44, pl. 52; Knab, Mitsch and Oberhuber 1984, no. 187.

(69) Fischel 1913–41, IV, no. 165; Pouncey and Gere 1963, no. 10; Gere and Turner 1983, no. 73; Joannides 1983, no. 128; Knab, Mitsch and Oberhuber 1984, no. 188.

(70) Fischel 1913–41, IV, no. 170; Gere and Pouncey 1983, no. 361; Gere and Turner 1983, no. 77; Joannides 1983, no. 130r; Knab, Mitsch and Oberhuber 1984, no. 196.

(71) Fischel 1913–41, IV, no. 171; Gere and Pouncey 1983, no. 12; Gere and Turner 1983, no. 78; Joannides 1983, no. 133r; Knab, Mitsch and Oberhuber 1984, no. 199.

(72) Robinson 1870, no. 42; Fischel 1913–41, IV, no. 173; Parker 1956, no. 532; Gere and Turner 1983, no. 79; Joannides 1983, no. 134; Knab, Mitsch and Oberhuber 1984, no. 201.

(73) Fischel 1913–41, IV, no. 178; Gere and Pouncey 1983, no. 11; Gere and Turner 1983, no. 80; Joannides 1983, no. 139r; Knab, Mitsch and Oberhuber 1984, no. 204; Cazort, Kornell and Roberts 1996, no. 6.

Saint Catherine of Alexandria
about 1507

Oil on wood, 72.2 × 55.7 cm
In the bottom right corner, in white paint: 136 (Borghese inventory number)
The National Gallery, London, NG 168

Catherine of Alexandria, a fourth-century princess, was converted to Christianity by a desert hermit and in a vision underwent a mystic marriage with Christ. When she would not renounce her faith, the Emperor Maxentius devised an instrument of torture consisting of four spiked wheels to which she was bound, but a thunderbolt destroyed it before it could harm her. Catherine was then beheaded. Divorced from the narrative circumstances of her martyrdom, the saint is here depicted in a peaceful rural landscape. Reflected in the stretch of water behind her are the trees and buildings on the far shore. Without her usual attributes of a palm or sword, only the large wheel alludes to her gruesome ordeals (though this is studded rather than spiked). Instead, Raphael focused on the visionary aspect of the saint's faith, capturing her – with parted lips and hand on heart – in a moment of divine ecstasy. Raphael used gold to depict the heavenly light radiating towards her. Gustav Waagen, who saw the painting in William Beckford's house in Bath, described her attitude as 'the purest expression of holy rapture'.[1] This rapture transmitted itself to the painting's eccentric owner who exclaimed to another visitor: 'Oh gracious heaven – is she not beautiful? What a mouth! – look at the corners of that mouth! – no impure twistings – all purity; and the eyes – those eyes that seem to be looking into the very countenance of our divine Saviour with such holy devotion. There, there, now you see what Raphael is! It is one of the very sweetest heads Raphael ever painted.'[2]

It is not known who commissioned the *Saint Catherine* and its presumed date – extremely close to the Baglioni *Entombment* (see cat. 65) – could imply a Perugian or a Florentine patron. It may have been intended as an object for private devotion, perhaps for a patron devoted to the saint or even named after her (an earlier precedent for this type of image in Raphael's oeuvre is the Saint Sebastian, cat. 26). It is interesting to note that Pietro Aretino thought of presenting a picture in his possession 'in which is the image of the figure of Saint Catherine, [b]y Raphael of Urbino' to the eponymous Catherine de' Medici,

Queen of France (in the event he changed his mind and gave it to Agosto d'Adda, a Milanese banker to whom he owed favours).[3] It is impossible to tell whether the painting owned by Aretino, who records it in his possession in Venice in 1550, is identical with this *Saint Catherine*. The latter is otherwise first documented in the Borghese collection in 1650 (and was almost certainly in the possession of Scipione Borghese before 1633).[4] A previously unrecorded seal on the reverse indicates that a cardinal of the Crescenzi family may have owned the picture before it passed into Borghese's collection.[5]

Raphael's bold iconic presentation of the saint in ecstasy developed out of conventions previously adopted principally for altarpieces. Perugino was a notable pioneer of religious sentiment in devotional works, and his figures – frequently with upturned heads and raised eyes – were praised by contemporaries for their 'angelic air'. Raphael may well have been re-applying lessons learned from a work such as cat. 10, in which the saints are depicted independently, in separate compartments, on account of the original polyptych format. Perugino's juxtaposition of the figures against distant landscapes, the still-life details of flowers, and in particular Tobias's upturned head, open-mouthed expression and *contrapposto* pose, are all highly comparable to equivalent features in the *Saint Catherine* (see also cat. 54).

Perugino's influence also makes itself felt in the technique of Raphael's painting, particularly in the drawing of the drapery folds over the saint's left arm (even more apparent in the cartoon, cat. 77), the rich saturated colours, and the hatched modelling in the shadows. However, Saint Catherine's pose is far more dynamic than anything in Perugino's oeuvre, attesting in form and spirit to the double influences of Leonardo and Michelangelo. Her beautiful curving *contrapposto* is partly derived from Leonardo's standing *Leda* which Raphael had copied not long before (see cats 53–4), and the spiralling arrangement of her hair and the yellow lining of her mantle are also characteristic of Leonardo's

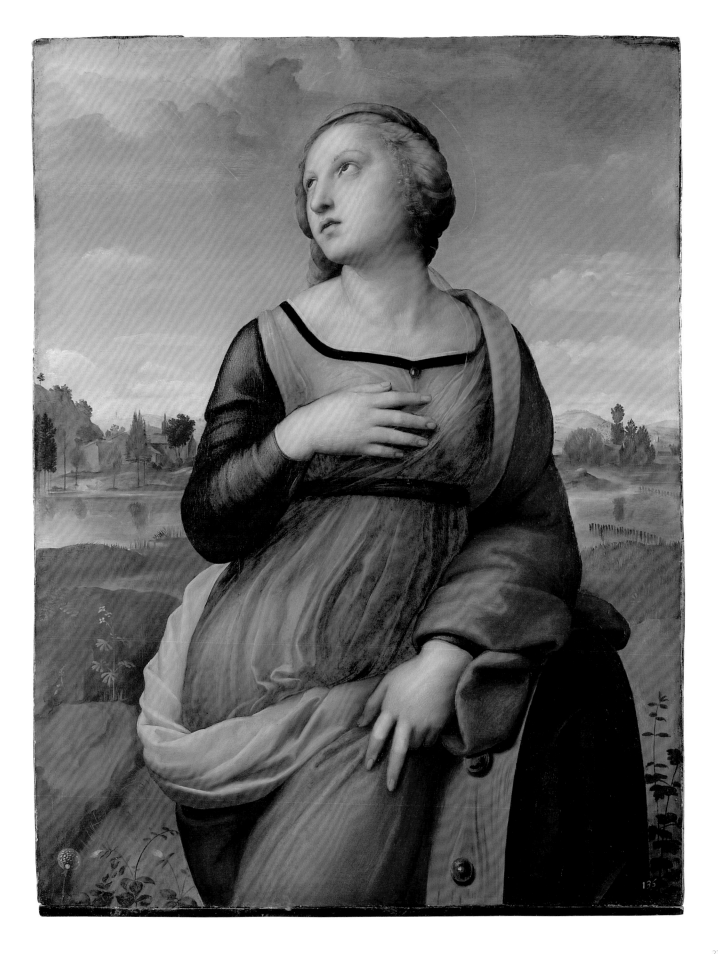

manner. The burgeoning sense of sculptural form and the foreshortening of the raised head almost certainly derive from Michelangelo's marble *Saint Matthew* (1505–6) for the interior of Florence Cathedral (see fig. 92). In Raphael's drawing after the statue, made in connection with the bearers in the Baglioni *Entombment*, and of almost exactly the same moment (see fig. 93), he characteristically clarified all the outlines and forms of Michelangelo's unfinished sculpture. Indeed, Catherine's pose is infused with all the clarity and grace of a classical statue (the figure has been likened to a *Venus pudica* and to a classical Muse).

In the bottom left corner is a dandelion (fig. 99), a bitter herb that appears in Netherlandish and German paintings of the Crucifixion, and was symbolic of Christian grief, and in particular Christ's Passion. The dandelion clock also features in Raphael's slightly earlier *Holy Family with a Palm*, and in the almost exactly contemporary Baglioni *Entombment* (fig. 97), where it is juxtaposed with Raphael's signature inscribed on a rock (it has sometimes been considered a form of signature).[6] Raphael, who was not as instinctively interested in flora as Perugino or even Giovanni Santi, may have remembered the motif from other Umbrian paintings known

to him. One such example is Bartolommeo Caporali's altarpiece representing the *Adoration of the Shepherds* for the convent church of S. Maria di Monteluce in Perugia, for which Raphael and Berto di Giovanni were commissioned to paint the *Coronation of the Virgin* for the high altar in 1505. Caporali's altarpiece (now in the Galleria Nazionale dell'Umbria) contains among other flowers a beautifully observed dandelion plant, with one whole clock, one three-quarters blown and three flowers in bud (fig. 98).[7] Raphael's long-stemmed dandelion is characteristically more graceful. CP

fig. 97 Detail of fig. 34

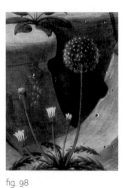

fig. 98
Bartolommeo Caporali
**The Adoration of
the Shepherds** (detail)
about 1477–80
Oil on wood, 161 × 219.5 cm
Galleria Nazionale
dell'Umbria, Perugia, 178

fig. 99 Detail of cat. 74

NOTES

1 Waagen 1838, III, p. 122.
2 Melville 1910, p. 293.
3 Shearman 2003, pp. 1006–7.
4 Barberini 1984, p. 17.
5 The only candidates are Cardinals Marcello Crescenzi (1500–1552) and Pier Paolo Crescenzi (1572–1645). I am grateful to Caroline Campbell for investigating Crescenzi cardinals.
6 Jones and Penny 1983, p. 44.
7 Galleria Nazionale dell'Umbria inv. 178–9; Santi 1989, no. 52 (as Fiorenzo di Lorenzo).

SELECT BIBLIOGRAPHY

Waagen 1838, III, pp. 122–3; Passavant 1839, II, no. 53; Crowe and Cavalcaselle 1882–5, I, pp. 340–41; Gould 1975, pp. 210–12; Jones and Penny 1983, p. 44; Plesters 1990, pp. 24–6; Dunkerton and Penny 1993, pp. 7, 9–16; Meyer zur Capellen 2001, no. 38; Roy, Spring and Plazzotta 2004, pp. 31–3.

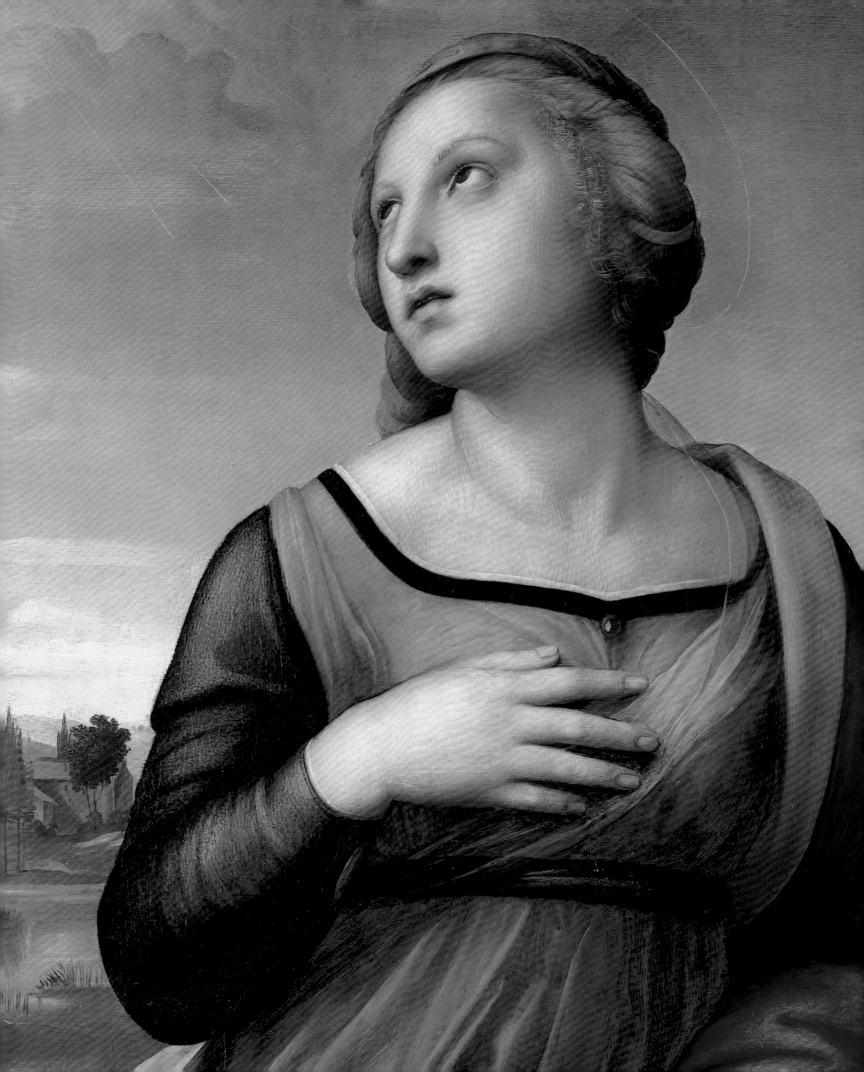

75 Study for Saint Catherine
about 1507

Pen and brown ink, 25.9 × 17 cm
A large repair top right
The Ashmolean Museum, Oxford. Presented by a Body of Subscribers, 1846. 168 P II 527

This rapid preliminary study for *Saint Catherine* (cat. 74) was made at a moment when Raphael was apparently considering the subject as a full-length composition. Although he studied the fall of the drapery over the saint's feet, he already seems to have been more interested in the upper part of her body, emphasising some of these contours with several reinforcing strokes. The problem of including such a huge wheel may have decided him against the full-length composition.

The saint is shown with her head turned in the opposite direction to the painting and resting her left arm on the wheel, only summarily indicated. The upper part of her figure is conceived as a sequence of spherical forms, rising up from the belly, through the almost circular thorax, to the head and top-knot. Her right hand may originally have been folded at the knuckles, as though she was gathering up her skirt. The two extended fingers, of which Raphael made quite a feature (transposed to the left hand) in subsequent drawings and in the finished work, appear to have been an afterthought at this stage.

On the verso (fig. 100) is a female figure seated on the ground in a pose inspired by the Virgin in Michelangelo's *Doni Tondo* (fig. 22) drawn in black chalk with the same emphasis on spherical forms as the recto study. Joannides speculates that this study and two more of female heads (also in black chalk) may be for the mourning women in the Baglioni *Entombment* (see cat. 69), which if correct would demonstrate Raphael working on the two stylistically very similar paintings more or less simultaneously. Both the figure on the recto and the two heads on the verso have somewhat comparable top-knots, eliminated in the respective paintings.
CP

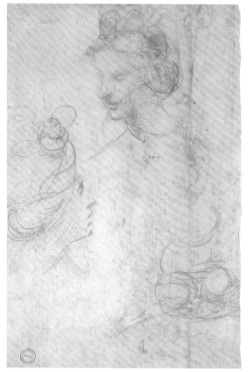

fig. 100 **Two female heads**, about 1507
Black chalk (verso of cat. 75)

SELECT BIBLIOGRAPHY

Robinson 1870, no. 53; Fischel 1913–41, II, no. 99; Parker 1956, II, no. 527; Joannides 1983, no. 158; Knab, Mitsch and Oberhuber 1984, no. 140.

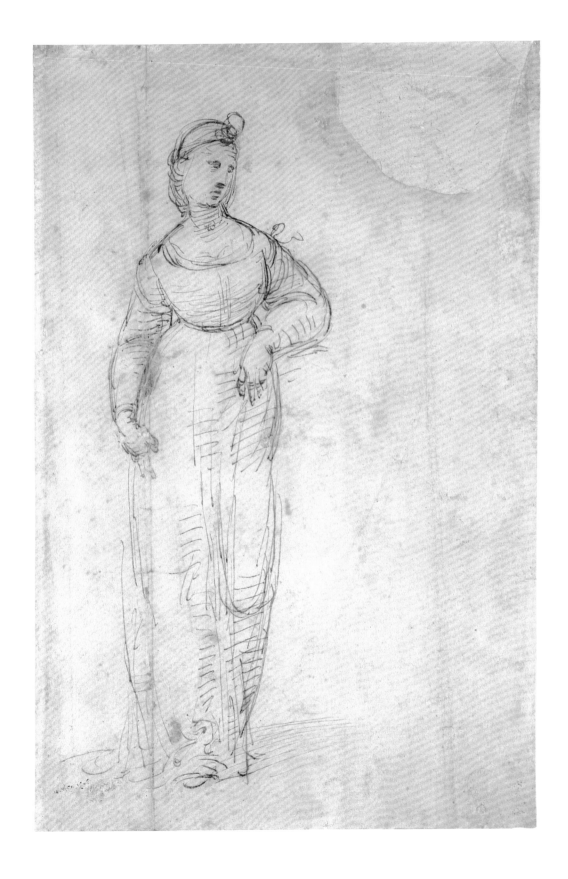

76 Four studies for Saint Catherine

about 1507

Pen and brown ink over traces of leadpoint, 27.9 × 16.9 cm
Inscribed in pen and brown ink in bottom left corner of verso: *Raf.*
The Ashmolean Museum, Oxford. Presented by a Body of Subscribers, 1846. 177 P II 536

The verso of this double-sided drawing, exhibited here, marks the moment when Raphael decided to depict Saint Catherine at three-quarter length, after having experimented with a full-length figure (cat. 75). The study on the right is from a nude (apparently male) model kneeling in a graceful *contrapposto* pose (some antique *Venus pudica* model, or one of Leonardo's studies for the kneeling Leda may have been in Raphael's mind at this moment). The sketch at the bottom of the sheet, at ninety degrees, is a three-quarter-length nude study of a similar figure in reverse, and very close to the pose of Saint Catherine in cat. 75, but with the head tilted in the opposite direction. A third study in the middle of the sheet, to the left, drawn very rapidly in the manner of Leonardo, explores the figure clothed and leaning on a more clearly delineated wheel, and – but for the position of the head and the right arm, which Raphael is here demonstrably struggling to resolve – this solution is much closer than all the previous sketches to the finished painting. He made at least three different attempts at the position of the head (to the right is a fourth very faint alternative in leadpoint for the head looking down) and two attempts at the position of the right arm. Two rapid horizontal strokes at knee height, corresponding approximately to the bottom edge of the finished picture, indicate that he was now beginning to commit to a three-quarter-length composition. In this study, the saint holds a palm symbolising her martyrdom in her left hand, a motif Raphael had previously used for the figure of Saint Catherine in the *Colonna Altarpiece* (fig. 68), but dropped as this composition developed. The final sketch in the top left corner, almost certainly made from life and again reminiscent of Leonardo, is a close-up study for the figure's neck and shoulder muscles, with particular emphasis on the play of light and shade, described by means of hatching and cross-hatching in pen and ink. The torsion of the saint's muscular neck and shoulders as she raises her head to the heavenly light is an important feature of the finished painting.

The head of Saint Catherine on the recto (fig. 101) is more highly finished than the exploratory

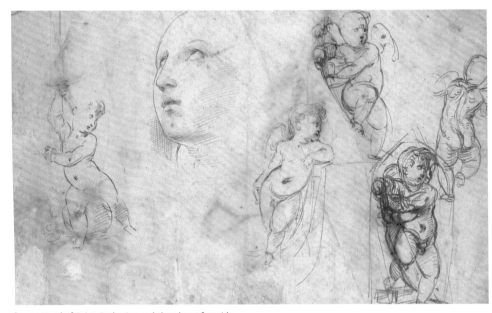

fig. 101 **Head of Saint Catherine and sketches of cupids**
Pen and brown ink over traces of black chalk (recto of cat. 76)

studies on the verso, and may represent the very last modification Raphael made to his design. It is of interest in that it records an alternative for the one aspect of the cartoon that Raphael did not repeat exactly in the finished work, namely the orientation of the head and the position of the facial features. The drawing may therefore have been made after the cartoon stage, at the moment when Raphael decided to include more of the far cheek and right eye, so that he had something to refer to when making freehand adjustments to the head in the underdrawing on the panel. (Conceivably it could have been an earlier solution that he reverted back to.)

It is not known in what connection the five studies of putti were made, but that at the bottom right appears to show a cupid bending his bow in a cusp-topped composition, with a slightly different alternative above left. These putti, with their plump bellies and cheeks, reveal Raphael's debt to Michelangelo, and a third sketch of the same putto seen from behind at the far right shows how Raphael's study of

sculpture had taught him to think in the round. The nonchalant putto in the centre of the sheet, leaning on a balustrade, resembles the Christ Child in Michelangelo's *Pitti Tondo*, but also makes an interesting parallel with the studies for Saint Catherine on the verso and cat. 75, in which she leans on her wheel in a similar *contrapposto*. This demonstrates how skilfully – at times perhaps even unconsciously – Raphael could adapt motifs and poses for different purposes. The balletic putto to the left recalls Michelangelo's *Taddei Tondo* (cat. 61) and is of a type that recurs in the *Bridgewater Madonna* (cat. 62) and later in the *Galatea* in the Farnesina (fig. 41). CP

SELECT BIBLIOGRAPHY

Robinson 1870, no. 52; Parker 1956, II, pp. 282–3, no. 536; Gere and Turner 1983, no. 82; Joannides 1983, no. 159; Knab, Mitsch and Oberhuber 1984, no. 214.

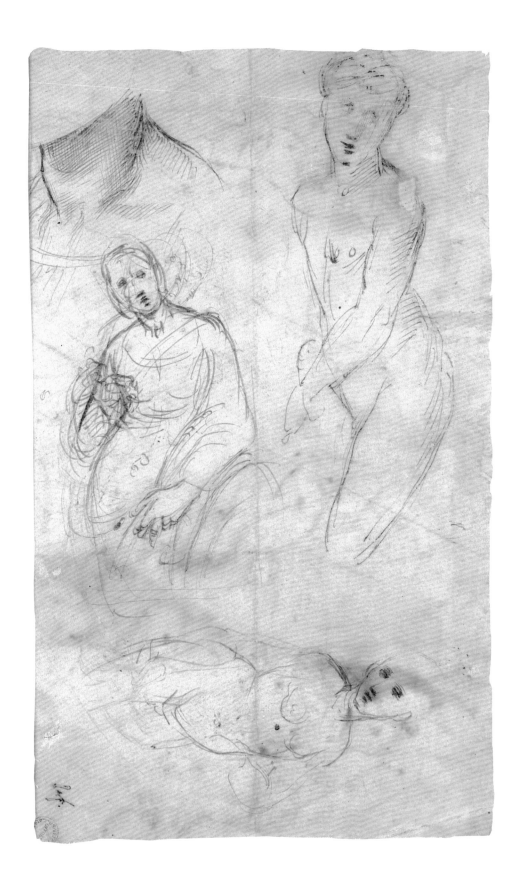

77 Cartoon for 'Saint Catherine'

about 1507

Black chalk with touches of white chalk, the outlines pricked for transfer
on four sheets of beige paper pasted together, 58.7 × 43.6 cm
Three holes in the saint's left wrist made up
Département des Arts Graphiques, Musée du Louvre, Paris, inv. 3871

This is Raphael's working cartoon for the painting (cat. 74). The direct connection between the two works has recently been demonstrated by taking a tracing from the painting and laying it over the Louvre cartoon and vice versa. The outlines of both works correspond extremely closely, except for the position of the head and the facial features. In the painting the head is less in profile and tilted further back so that more of the saint's face is visible. This passage may have been altered after further study of the angle of the head (see cat. 76). Although previously no pouncing had been detected on the panel, new infrared reflectography has revealed traces of it in some of the contours, especially over the saint's right shoulder (fig. 102), and along the outlines of both sleeves, providing further confirmation of the cartoon's role in the design process. The jerky line along these contours in the underdrawing is characteristic of the method of joining up of dots that cartoon transfer entails, though there is much freehand elaboration as well.

In contrast to Raphael's precise, linear cartoons in pen and ink for small-scale works between 1500 and 1504, the Louvre cartoon and others of this slightly later period (see cat. 98) demonstrate a rougher, more experimental type of drawing, with far greater emphasis on tonal modelling. This new approach was clearly the result of Raphael's study of techniques developed by Leonardo, who embellished his cartoons with extraordinary chiaroscuro and *sfumato* effects (see cat. 49). Raphael used a broad-ended chalk to reinforce the contours in certain areas (the wheel, some of the drapery, Catherine's neck), going over some of the outlines several times. He laid in the shadows with fairly rough hatching and cross-hatching, not always in the same direction, softening the transitions by rubbing the chalk with his fingers, and used white chalk, similarly rubbed, for some of the more prominent highlights. The cartoon would have been kept as a guide to the lighting of the figure once the contours had been transferred, and indeed hatching in the shadows of the saint's sleeves and down

the left side of her body in the underdrawing was clearly copied freehand and not traced.

Even at the cartoon stage, Raphael seems to have had doubts about whether to include the knot of drapery on the saint's right shoulder, though this faintly drawn feature was pricked for transfer and appears in the underdrawing on the panel. The drapery folds above the twist of the saint's mantle are more complex in the painting than in the cartoon, and were elaborated by Raphael in strong dark strokes of underdrawing directly onto the prepared panel. Minor pentiments in the index and middle fingers of the saint's left hand occur in both the cartoon and the underdrawing, indicating Raphael's ongoing concern to get this key passage right.

The painted composition extends about another 10 cm at the bottom. Infrared reflectography reveals no trace of pouncing in this area of the painting, but it is hard to tell whether the drawing has been cut along this lower edge or whether Raphael was presented with a slightly taller panel than he expected and simply extended the design at the painting stage. CP

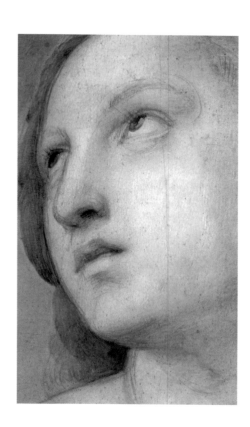

figs 102–3 Details of the face (right) and shoulder from an infrared reflectogram mosaic of cat. 74

SELECT BIBLIOGRAPHY

Forlani Tempesti 1968, p. 350; Bacou 1974, no. 4; Joannides 1983, pl. 14, and no. 160; Viatte 1983–4, no. 62; Knab, Mitsch and Oberhuber 1984, no. 217; Cordellier and Py 1992, no. 36; Dunkerton and Penny 1993, pp. 9, 11, and n. 14; Hiller 1999, pp. 254–5.

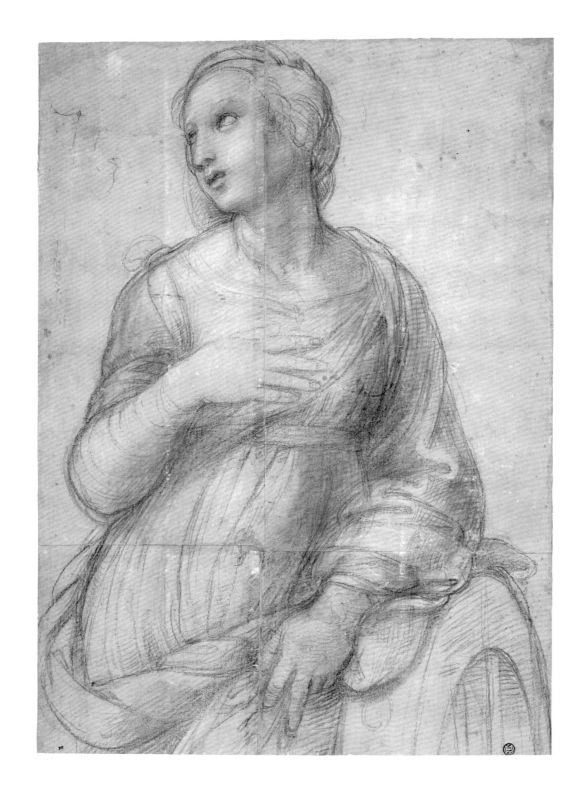

78–86 Studies for the 'Disputa'
about 1508–9

78 Compositional study for the left-hand side

Brush and brown wash, heightened with lead white over traces of underdrawing in charcoal and stylus (some drawn with a compass), partly squared in black chalk on off-white paper, 27.6 × 28.3 cm
The Royal Collection, RL 12732

79 Study for the upper half

Brush and brown wash, heightened with lead white on off-white prepared paper, 23.2 × 40 cm
Inscribed in pen lower centre: *Rafael*
The Ashmolean Museum, Oxford. Presented by a Body of Subscribers, 1846. 183 P II 542

80 Study for the lower left section

Pen and brown ink, brown wash, over stylus underdrawing heightened with lead white on the figure in the left foreground with his back turned, 24.7 × 40.1 cm
The British Museum, London, 1900-8-24-108

81 Nude man half length seen from behind

Pen and brown ink, over stylus underdrawing
14.6 × 9.5 cm
The British Museum, London, 1948-11-18-39

82 Study for the lower left section

Pen and brown ink, over traces of black chalk on right and stylus on the left, the outlines pricked, 28 × 41.6 cm
Made up upper left corner
Städelsches Kunstinstitut, Frankfurt, inv. 379

83 Study of a drapery

Brush and brown wash, heightened with lead white over black chalk or charcoal underdrawing, on off-white paper
40.5 × 26.2 cm
The Ashmolean Museum, Oxford. Presented by a Body of Subscribers, 1846. 185 P II 544

84 Study of figures in the right-hand section

Pen and brown ink, 25 × 39 cm
Inscribed, top right: *Li è [?] un pensier dolce è rimenbrase [in modo?] / di quello asalto ma più gravo el danno / del partir, ch'io restai como quei c[h]'ano / in mar perso la stella, se 'l ver odo. / Or lingua di parlar dis[c]ogli el nodo / a dir di questo inusitato ingano / ch'amor mi fece per mio gravo afanni / ma lui pur ne ringratio, lei ne lodo. / L'ora sesta era che l'ocaso un sole / aveva fatto e l'altro surse in locho / at[t]i più da far fati che parole. / Ma io restai pur vinto al mio gran focho / che mi tormenta che dove l'on sole / disiar di parlar più riman fiocho.*[1]
The British Museum, London, Ff. 1-35

85 Studies of a man leaning forward

Pen and traces of leadpoint, a small sketch below the main figure on the recto in black chalk, 36 × 23.5 cm
Inscribed, top right: *. . .llo pensier che in recercar t'afanni / [d]e dare in preda el cor per più tua pace / [no]n vedi tu gli efetti aspri e tenace / [de] cului che n'usurpa i più belli anni / . . . e fatiche e voi famosi afanni / [r]isvegliate el pensier che in otio giace / [m]ost[r]ateli quel cole alto che face / [s]alir da' bassi ai più sublimi scanni / [Di]vina alme celeste acuti ing[eg]ni / . . . un mon che scorze e forde e coi vergati e sassi / disprezando le ponpe e sietri e regno / [and to the right:] solo / nolo / stolo / dolo.*[2]
Musée Fabre, Montpellier, 825.1.275

86 Study of a seated saint

Black chalk and white chalk, 38.7 × 26.6 cm (top corners cut)
The Ashmolean Museum, Oxford. Presented by a Body of Subscribers, 1846. 189 P II 548

These nine drawings are studies for the fresco depicting the *Dispute on the Holy Sacrament*, commonly known as the *Disputa*, painted around 1508–9 in the Stanza della Segnatura in the Vatican (fig. 35). The room frescoed by Raphael is invariably known as the Stanza della Segnatura – that is, the room used by the *Signatura gratiae* (a division of the supreme tribunal of the Curia) – because this is how Vasari describes it in his *Lives*. Although this was the function of the room when Vasari was writing in the mid-sixteenth century, there is overwhelming evidence that it was originally a library.[3] This elucidates the decorative programme because the frescoes relate to the way in which books in Renaissance libraries were arranged according to their subject matter into four categories or faculties: Theology, Poetry, Philosophy and Jurisprudence. (It also explains the inordinate number of books represented in the frescoes.) Female personifications of these abstract notions are painted in roundels on the ceilings, and between these at the corner of the vault are upright scenes with subjects relevant to the tondi on either side. For example, the *Judgement of Solomon* between *Jurisprudence* and *Philosophy* illustrates both concepts as it shows a wise man making a legal judgement. This link extends to the scenes on the walls, so that under *Philosophy* is the scene showing a gathering of philosophers, the *School of Athens*, and likewise beneath *Theology* is the *Disputa*, in which theologians contemplate the mystery of the sacrament. The broad concept of the room's decoration was almost certainly devised by someone at the court of Pope Julius II, yet the dramatic changes to the composition which occur in the preparatory studies for the *Disputa* make plain that it was Raphael who was responsible for finding the brilliantly effective visual means of expressing these complex abstract notions.

Raphael's achievement in creating decorations of such unprecedented sophistication and beauty is even more impressive when one bears in mind that he had worked in fresco only once before: the *Holy Trinity flanked by Saints* painted in 1505 in S. Severo, Perugia (fig. 15). Exactly how such a relatively untried painter obtained this prestigious commission is not known, although there are a number of ways that Raphael may have come to the attention of Julius.[4] Vasari credits the Urbino-born architect Bramante as the promoter of his compatriot Raphael, and this connection is strengthened by the architect's likely collaboration in devising the architectural setting of the *School of Athens*.[5] Raphael may also have lobbied for employment in the Vatican because a passage in a letter written to his uncle in Urbino in April 1508 seems to indicate that he sought the help of Piero Soderini, *gonfaloniere* of Florence, and Francesco Maria della Rovere, the Pope's nephew and heir-presumptive of the Duchy of Urbino, to obtain work in *'una certa stanza'*.[6]

The nine drawings exhibited here are from a group of thirty studies for the *Disputa*, more than for any other in Raphael's oeuvre and indeed more than the combined total of preparatory drawings for all the other frescoes in the room. The *Disputa* has generally (but not universally) been regarded as the first to have been painted, the number of studies indicating the artist's inexperience in tackling such an esoteric subject and working on such a grand scale. That the *Disputa* was the test bed which established the pattern for the entire scheme is strongly suggested by the process of trial and error revealed in the preparatory drawings. They show how Raphael resolved such basic design issues as the relative scale of the figures, and devised the means of masking the interruption of the door frame into the pictorial field on the side walls, which subsequently established the pattern for the composition of the other three frescoes. More-over, the series of studies for the *Disputa* is more obviously related to Raphael's experience in Florence than drawings for the other walls.

The earliest surviving drawing for the *Disputa* is at Windsor (cat. 78), and it shows that the artist's initial conception was markedly different from the finished fresco. In common with two other early drawings at Oxford (cat. 79)

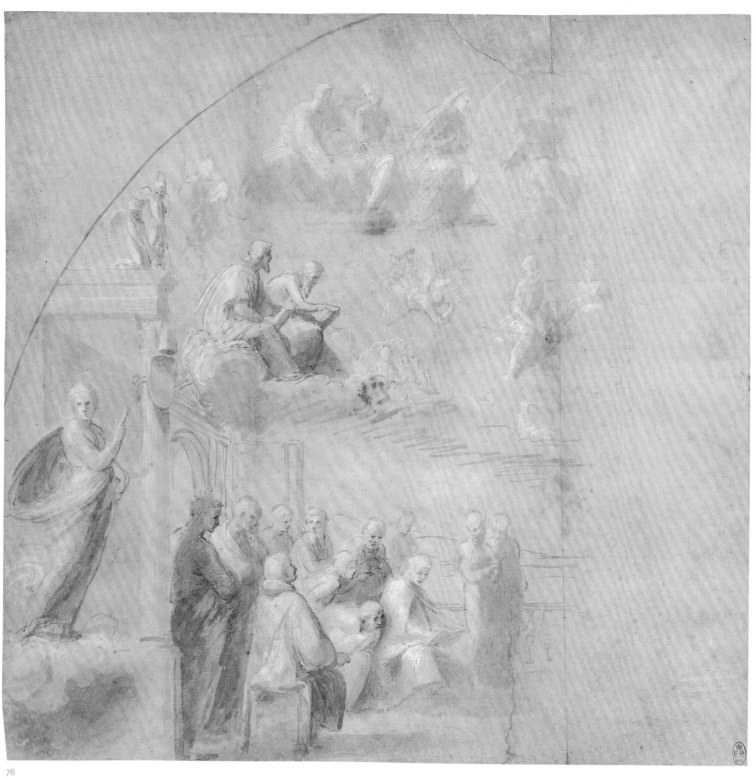

78

and in the Musée Condé, Chantilly (fig. 104),[7] the Windsor sheet is executed in brush and wash, a technique first used by Raphael in Florence (see cat. 50). He probably employed it here because establishing the basic disposition of light and shade in a composition of this size was of key importance. The scale of the fresco meant that Raphael had to devise a design that was concise and legible, and these requirements may also have influenced his decision to begin working with a brush because the broadness of its effect imposed the discipline of having to keep individual poses and figural groupings relatively simple. He initially imagined the composition cloaked in a Leonardesque chiaroscuro, the lighting effects rehearsed in the drawing by the play between the contrasting darker tones of the paper and wash with the lead-white highlights. His handling of wash in the Windsor drawing is particularly refined and delicate, the recession of the figures masterfully suggested by the paler tones of the ink used for the background figures.

The symmetry of the composition sketched out in cat. 78 is implicit in Raphael's decision to represent just the left-hand side, an economy of effort akin to that found in designs for tombs and for decorative art objects[8] and a common feature of designs for symmetrical compositions (see cat. 31). Raphael's primary focus was the arrangement of the earthly realm, as the figures in the celestial sphere are described in a summary fashion. It is just possible to make out Christ in Glory in the centre, his right hand raised in benediction, with the barely discernible figure of God the Father above him. To the left of Christ are three figures seated in a straight line of which only the Virgin is recognisable, her pose almost identical to that in the finished work. The identity of the two figures below Christ's feet cannot be made out in cat. 78, but thanks to the addition of their attributes in cat. 79, they can be recognised as Peter and Paul. On a third curved cloud hovering above the heads of the disputing theologians sit two bearded saints who, again with reference to cat. 79, can most likely be identified as a pair of

Evangelists. The gaps between the various cloudbanks are enlivened by a scattering of putti and angels, the most prominent of which, the one flying just below the Virgin, adopts a pose almost identical to that of the left-hand angel in the *Madonna del Baldacchino* (Palazzo Pitti, Florence), left unfinished by Raphael in Florence when he departed for Rome in 1508.

In comparison with the rather elaborate multi-layered groupings in the celestial sphere, the organisation of the theologians below is much simpler, the figures placed on a terrace defined by a balustrade at the back and an architectural screen at the side. The foreground and the architectural elements, consisting of columns supporting an architrave, serve to limit the space occupied by the theologians, while the high base on which the structure stands disguises the asymmetry of the wall due to the intrusion of a doorframe at the lower right corner of the fresco. The space in front of the architecture is filled by a cloud-borne male saint directing attention to Christ at the centre; a figure whose pose and function are taken over in a modified form by the epicene blond youth in the fresco. The Leonardesque physical type of this figure in the fresco is evidence of Raphael's enduring admiration for the Florentine's unfinished *Adoration of the Magi* altarpiece (fig. 105). The way in which Leonardo's tight-knit figures react individually to the Virgin and Child at the centre – and the way their poses and gestures collectively communicate a general sense of animation and excitement – was one that Raphael experimented with and adapted for the more cerebral activities of the theologians. The compact diagonal grouping of the twelve theologians framed by a brooding figure at the left in cat. 78 is loosely derived from Leonardo's composition, and Raphael's borrowings from it are even more explicit in slightly later studies for the entire group at Windsor and Chantilly (fig. 104).[9]

Raphael followed on from the Windsor drawing by making a more detailed study in the same medium, now in the Ashmolean, Oxford,

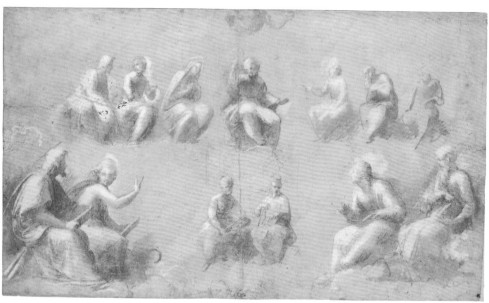

79

of the entire upper part of the fresco (cat. 79).
This resembles closely the Chantilly study for
the lower half, and it has been suggested that
they were once a single sheet. The composition
of the Oxford drawing is substantially the same
as that shown in cat. 78, the main difference
between the two being the shift in the position
of the pairs of Evangelists higher up (a stylus-
drawn semicircular curve indicates the fresco's
perimeters) and closer to the centre. The increase
in the scale of the Evangelists in relation to the
other figures dramatically increases the sense
of space separating them. Raphael continued to
play around with the relative size of the figures,
eventually reversing for the sake of legibility and
impact in the fresco the naturalistic convention
presented in cat. 78, where the heavenly figures
are smaller than the earthly ones below them.
Unfortunately, there are no drawings that chart
the further progression of the upper section to
the final arrangement of the saints seated on
a horseshoe-shaped cloud just below Christ, a
sophisticated reworking of his S. Severo fresco.
Raphael had evidently come up with the idea
by the time he drew cat. 80, as the lower limit of
the cloudbank is marked in the study by a curved
line above the altar.

The design process of the left-hand side is
marked by a similar hiatus, the drawings in
the British Museum (cat. 80) and Frankfurt
(cat. 82) showing a remarkable transformation
of Raphael's initial conception of this section of
the fresco. The introduction of an altar in cat. 80,
on which stands a chalice and wafer (in the fresco
this is replaced by a monstrance containing the
Host), provides a central focus lacking in his
early draft, while at the same time making the
subject of the fresco a great deal clearer. The
sacrament is the physical manifestation of God's
presence, and it is the mystical nature of the trans-
formation of the Host into Christ's flesh that
inspires the study and debate of the assembled
company. The elimination of the column at the
far left in cat. 78, and its replacement by a low
balustrade, opens up the space, thereby allowing
more figures to be included. Raphael avoids

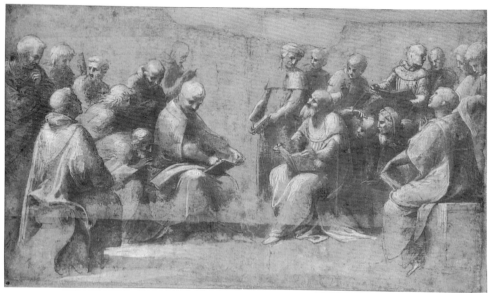

fig. 104 **Compositional study**, 1508–9
Brush and brown wash, heightened with lead white
squared in black chalk, 33.1 × 40.5 cm
Musée Condé, Chantilly, FR VII, 45

236

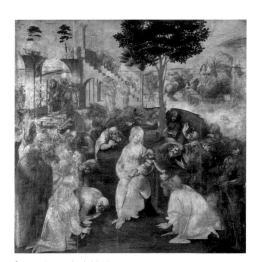

fig. 105 Leonardo da Vinci
The Adoration of the Magi, 1481–2
Oil on wood, 243 × 246 cm
Galleria degli Uffizi, Florence
inv. 1890, no. 1594

the distribution of the theologians becoming monotonous by varying their height by means of the stepped platform on which the altar stands. Cat. 80 is drawn with marvellous assurance and economy of means, the supple rhythmical pen outlines that define the figures augmented by minimal hatching or broadly applied wash. The artist made a free preliminary underdrawing in stylus (most evident in the area around the head of the rightmost kneeling man) before taking up the pen. The drawing differs from the fresco principally in the absence of the group disputing in the foreground by the balustrade, and also of the figure seen from behind standing beside Saint Gregory, seated on the foremost throne.

The next stage in the evolution of the design is represented by a study of nude figures at Frankfurt (cat. 82). It follows on closely from the composition developed in cat. 80, differing from it in the changes to the group at the far left and the pair of figures closest to the altar. The slightly disjointed quality of the Frankfurt composition, the theologians arranged into distinct groups of three or four figures, as well as the precision of its handling with few altera-tions to the outlines, suggest that it has been put together by combining pen studies from posed nude models for the various groups. The life drawings from which the study was assembled have not survived, but some impression of their appearance can be gained from a fragment cut from a larger sheet in the British Museum (cat. 81). This has the appearance of being a quick sketch from a model to study the upper half of the body of the gesturing figure in the foreground of the Frankfurt composition. Raphael must have continued to work on the pose because in the Frankfurt drawing the figure is shown in a more upright position with his left arm in a less contorted position. The artist's preoccupation with the complexities of the pose is also reflected in his small adjustments in the London drawing to the figure's outlines in a darker ink. The outlines in the Frankfurt study are finely pricked to allow the artist to transfer the design to another sheet of paper for further refinement,

and indeed comparison with the finished work shows the extent to which Raphael continued to make changes, especially in the arrangement of the figures around the balustrade in the front.

The final arrangement of the lower left corner is masterfully simple, the group orientated around the young man who encourages the trio behind him to focus their attention away from the book resting on the balustrade to the Host on the central altar. The figure stands out from his fellows because of his youthful beauty and the eye-catching hue of his blue cloak and yellow robe beneath (probably not coincidentally the familial colours of Raphael's patron, the Della Rovere). The drapery folds and the lighting of the cloak are studied in a meticulous brush drawing in the Ashmolean (cat. 83). Raphael was probably working from drapery arranged over a wooden model, and this explains why the underlying posture is difficult to decipher. The nuances of the chiaroscuro lighting in the drawing are worthy of comparison with Leonardo, but sadly such subtleties are barely discernible in the painting because of the abraded surface of the fresco. Raphael clearly changed his mind after making this drawing as the drapery in the fresco bears little relation to it. Working in such a detailed fashion in brush and ink would have been time-consuming as each application of wash would have had to dry before the next could be added, and this probably explains why, with the exception of the Lille study in the same medium related to Christ's drapery, Raphael turned to chalk and pen and ink for making similarly detailed studies.[10]

The hastily executed pen study in the British Museum (cat. 84) includes alternative ideas for the arrangement of the pair of figures standing above the fictive parapet over the actual doorway on the far right of the fresco. The first of these was probably the one in the centre with the two men shown frontally engaged in animated discourse, the border of the composition marked by a roughly indicated vertical line. The figure standing behind the parapet holds a book and turns his head towards his companion, who rests

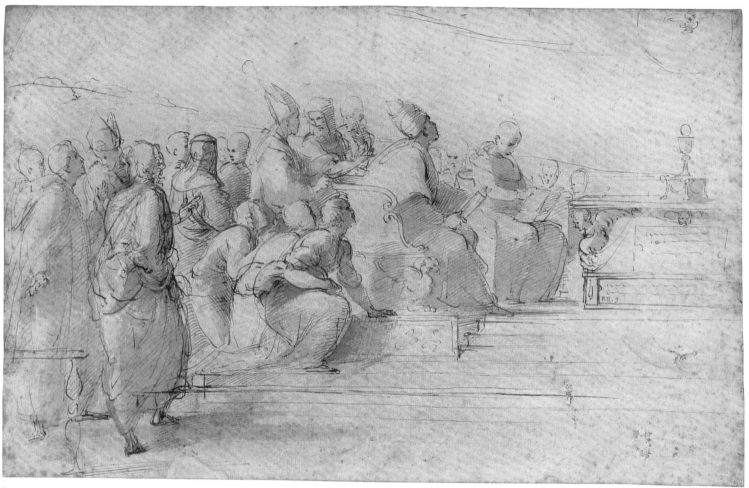

80

his left arm on the ledge and looks down to the text, his right arm extended towards the viewer with his hand boldly foreshortened. The blurring of the boundaries between painted and real space implied by the figure's outstretched arm is taken up in the fresco by the action of the right-hand figure craning forward to look to his right. Behind the two figures Raphael has cursorily indicated a standing figure looking up, his exaggerated pointed chin drawn in two positions. This figure corresponds to the magnificently robed pope in the fresco, variously identified as either Innocent III or Sixtus IV, standing on the first step of the altar platform. The detailed study of the right foot of the gesturing man in the middle of the sheet probably preceded the two variant ideas for the same figure at the lower left. His pose in these differs from the one in the main study in that he has his back to the viewer; initially he was drawn leaning on the parapet looking to the right and the artist then experimented with him

facing the other way looking up to the left. The right-hand side of the drawing has been used to draft a love sonnet, one of five surviving poems by the artist.[11] The changes that he made to the text as he searched for the right word are a literary equivalent of the alterations made to the outlines of the figures in this and other studies for the fresco.

Following on from the British Museum sheet, Raphael made the wonderfully crisp double-sided pen study, now in Montpellier, for the man leaning over the parapet (cat. 85). This too contains a draft of a love sonnet, in this case a fragmentary one, written in a Petrarchian style. The basic twisting pose of the figure in cat. 85 depends on the one with his hands on an open book in the earlier drawing, except that the book is missing and the torsion of his upper body is even more pronounced. The verso looks as if it might have been drawn from a posed model, the artist concentrating on particular

details, such as the observation of the squashed-up palm on the right side of the man's left hand, rather than the entire pose (fig. 106). He corrected his initially rather inelegant description of the figure's neck and collarbone in the main study, and then proceeded to make a smaller study of this detail below. Raphael then turned the paper over to make a drawing of the entire figure which incorporates the revisions to the profile of the neck made in the smaller study on the verso, but also introduces a number of changes such as his placement at the end of the parapet and a greater rotation of his upper body. The outline of a raised hand to the left of the figure suggests that Raphael toyed with an even more animated pose. The wonderfully supple cross-hatching used to model the form in the shadowed areas and the use of the blank paper for the highlights, a pen-style reminiscent of his nearly contemporaneous study for Marcantonio's print of the *Massacre of the Innocents* (cat. 90), may reflect

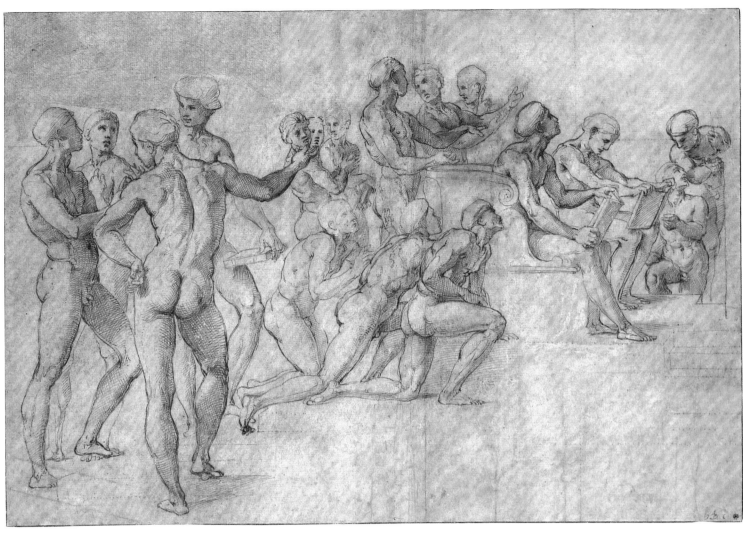

82

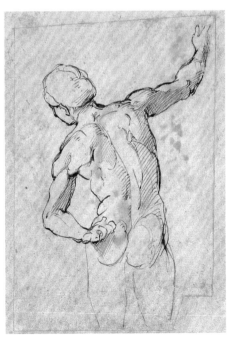

81

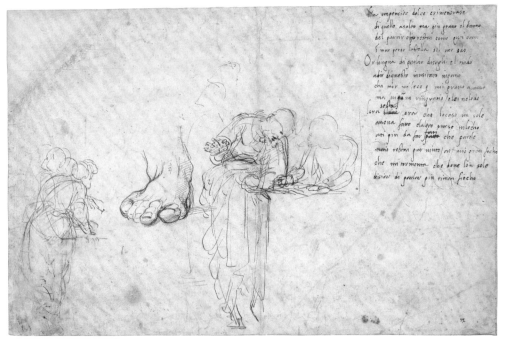

the influence of Dürer's richly toned engravings. The dramatic Michelangelesque pivoting motion of the model in the Montpellier drawing is considerably toned down in the fresco, Raphael preferring instead to emphasise the illusion that the figure is craning forward into the real space of the room.

Sadly, only a handful of preparatory drawings for individual theologians survives. More studies for individual figures are known for the upper section of the fresco, four out of five of which are executed in soft black chalk (the exception being the wash study of Christ in Lille). One of the finest of these is the Ashmolean study (cat. 86) for Saint Paul, who in the fresco appears at the far right end of the horseshoe-shaped cloud looking at Saint Peter opposite him. The saint in the finished work accords very closely in pose with the figure in this drawing, except that he rests his right hand on a sword, Paul's most familiar attribute. Raphael was evidently dissatisfied with the position of the saint's head in the main study and explored possible variations in the margins below and to the left. The latter study, showing the head in profile looking straight forward, is closest to the final pose. The figure is modelled largely through variation in the density of the black chalk shading, aided by use of white chalk and some rubbing, probably with the finger, to blend seamlessly the various tones. This painterly approach, which Raphael also employed in some of the drapery studies for the theologians in the same fresco, is anticipated

in the class of drawings most closely linked to painting, namely cartoons. Raphael seems to have been a pioneer in the creation of particularly painterly cartoons, which include the one related to the *School of Athens* (now in the Ambrosiana, Milan) and culminate in the famous tapestry cartoons now on loan to the Victoria and Albert Museum from the Royal Collection. The fact that more cartoons by the artist survive than by any of his contemporaries in Central Italy is testament to their preservation in Raphael's studio as well as to the value that was accorded to them by subsequent owners.[12] In the British Museum cartoon of the Virgin and Child (cat. 98) for the *Mackintosh Madonna* in the National Gallery, executed around the same period, there are similar passages of tonal modelling. Another possible influence for the development of this style may have been the atmospheric black and white studies of Fra Bartolommeo, who, according to Vasari, befriended Raphael in Florence (fig. 107).[13]

The Ashmolean study is another reminder of the extent to which Raphael's design of the *Disputa* was coloured by his recent experience of Florentine art. Although it would not be true to say that such influences are entirely lacking in the fresco (the cluster of farm buildings and the haystack in the left background are, for example, most likely derived from a pen landscape drawing in Cleveland by Fra Bartolommeo), Raphael's implicit debt to Florentine models – in particular Leonardo, and to a lesser extent Fra

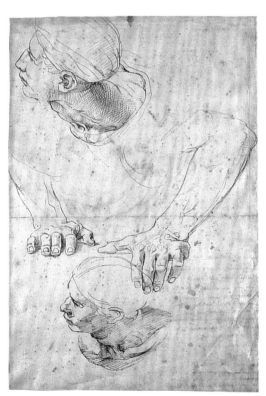

fig. 106 **Study for the Disputa: man on the right**, 1508–9
Pen and brown ink over traces of leadpoint, (verso of cat. 85)

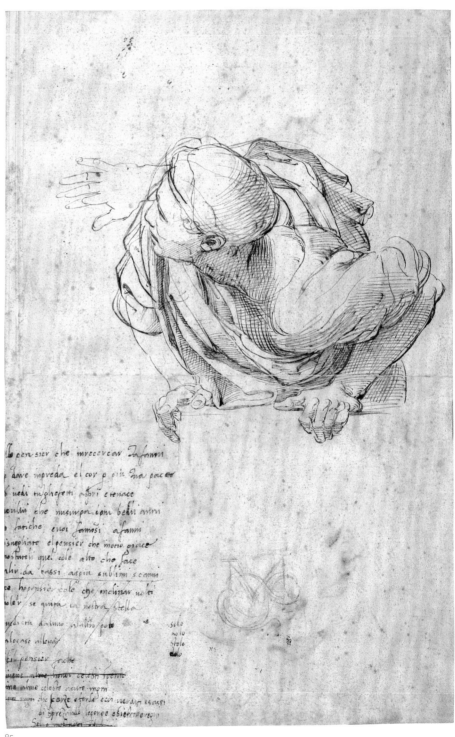

85

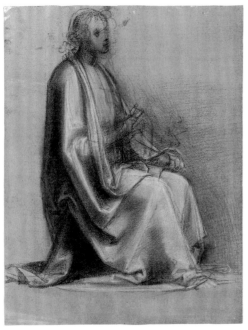

fig. 107 Fra Bartolommeo
Study of an Apostle for the Last Judgement, 1499–1500
Black chalk and white chalk on ochre prepared paper
28.1 × 21.7 cm
Museum Boijmans Van Beuningen, Rotterdam, Vol. N21

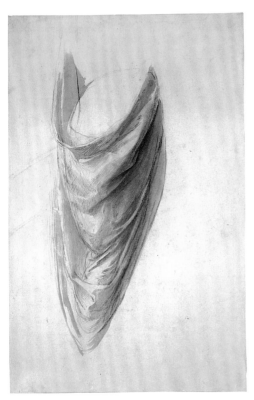

83

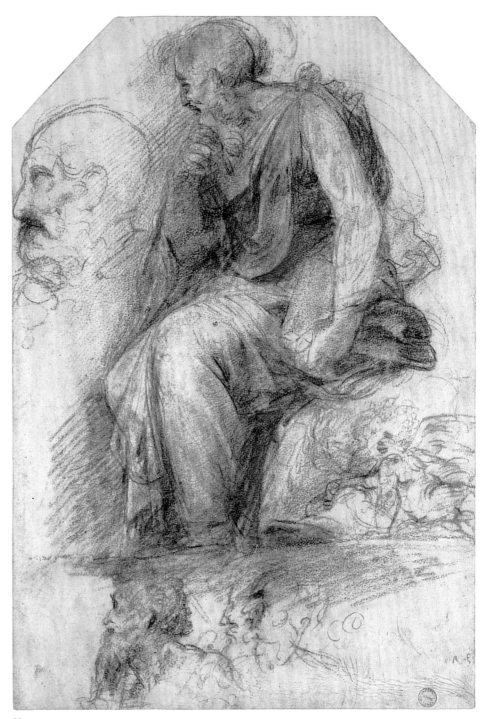

86

Bartolommeo and Albertinelli's *Last Judgement* fresco in S. Maria Nuova – would be more difficult to discern were it not for the evidence of the drawings. The explicit references to Leonardo's *Adoration of the Magi* found in the early studies are lacking in the painting, but a close analysis of Leonardo's method of grouping a crowd of figures underlies Raphael's attainment of even greater subtleties in his masterly disposition of the theologians and philosophers on the two lateral walls of the Segnatura. The sequence of drawings highlights Raphael's relentless drive to master every aspect of the composition, and shows how the formal perfection of the final work was predicated on merciless self-criticism that made him abandon ideas that he had spent considerable time in perfecting (such as the figure studied in cat. 81). In the same way that the *Disputa* fresco heralds Raphael's maturity as a painter, his drawings for the work, which include examples of every graphic technique including metalpoint, serve to underline his remarkably versatility as a draughtsman. The fresco seems to have been transferred from one large cartoon, of which the head of God the Father in the Louvre is the only remaining fragment.[14] HC

NOTES

1 'Sweet Remembrance! Hour of Bliss / When we met, but Now the more / I Mourn, as when the Sailor is / Star-less, distant far from Shore. / Now Tongue, tho' 'tis with Grief, relate / How Love deceiv'd me of my Joy; / Display the Unaccustom'd Cheat, / But Praise the Nymph, and Thank the Boy. / It was when the declining Sun / Beheld Another Sun arise; / And There where Actions should be done, / No Talking, only with the Eyes. / But I tormented by the Fire / That burnt within, was overcome: / Thus when to speak we most desire / The More we find we must be Dumb.' Translation by J. Richardson, (sen.). For the textual variations and transcription see Shearman 2003, p. 136.
2 'Deceitful thought why torture thyself in searching? / where to give the heart in prey for greater peace? / See you not the hard and tenacious effects / engraved, robbing my most beauteous years? / Hard exertions and cares for fame / away thought which rests in idleness! / Show it the elevated path which makes it / to mount from the low to the highest footstep! / Find out for me sharpwitted genii / a healing bark with whips and stones / disdaining splendour and avoiding courts.' Translation by Wanscher 1926, p. 26. For the textual variations and transcription see Shearman 2003, p. 138.
3 Shearman 1971, pp. 14–17; Jones and Penny 1983, pp. 49–57.
4 See the essay in this catalogue by Arnold Nesselrath, pp. 280–93.
5 Vasari/BB IV, p. 165.
6 Shearman 2003, pp. 112–18.
7 Joannides 1983, no. 199.
8 See for example Battista Franco's designs for maiolica dishes in the Kunstbibliothek, Berlin, Jacob 1975, nos 81–2.
9 Joannides 1983, nos 199 and 200.
10 Joannides 1983, no. 212r.
11 Shearman 2003, pp. 138–42. The five known drafts of sonnets by Raphael are all on sheets with studies for the *Disputa* (one also has a study for the *Parnassus*), indicating that the artist's rather modest literary efforts were confined to the period of the Stanza della Segnatura decorations.
12 A number of cartoons by Lombard artists like Gaudenzio Ferrari also survive from the same period.
13 Fischer 1990, no. 111, p. 393.
14 Joannides 1983, no. 226.

SELECT BIBLIOGRAPHY

(78) Fischel 1913–41, VI, no. 258; Popham and Wilde 1949, no. 794; Gere and Turner 1983, no. 85; Joannides 1983, no. 197; Knab, Mitsch and Oberhuber 1984, no. 278; Clayton 1999, no. 16.

(79) Robinson 1870, no. 60; Fischel 1913–41, VI, no. 259; Parker 1956, no. 542; Gere and Turner 1983, no. 87; Joannides 1983, no. 186r; Knab, Mitsch and Oberhuber 1984, no. 281.

(80) Fischel 1913–41, VI, no. 267; Pouncey and Gere 1963, no. 33; Gere and Turner 1983, no. 88; Joannides 1983, no. 204; Knab, Mitsch and Oberhuber 1984, no. 289.

(81) Pouncey and Gere 1963, no. 30; Gere and Turner 1983, no. 91; Joannides 1983, no. 206; Knab, Mitsch and Oberhuber 1984, no. 288.

(82) Fischel 1913–41, VI, no. 269; Malke 1980, no. 76; Joannides 1983, pp. 72–3, no. 205; Knab, Mitsch and Oberhuber 1984, no. 290; Schütt 1994–5, no. 217.

(83) Robinson 1870, no. 66; Fischel 1913–41, VI, no. 275; Parker 1956, no. 544; Gere and Turner 1983, no. 94; Joannides 1983, no. 223r; Knab, Mitsch and Oberhuber 1984, no. 297.

(84) Fischel 1913–41, VI, no. 286; Pouncey and Gere 1963, no. 32; Gere and Turner 1983, no. 90; Joannides 1983, no. 209; Knab, Mitsch and Oberhuber 1984, no. 305.

(85) Fischel 1913–41, VI, no. 287; Monbeig-Goguel 1983–4, pp. 242–5, nos 70–1; Joannides 1983, no. 225; Knab, Mitsch and Oberhuber 1984, nos 311–12.

(86) Robinson 1870, no. 63; Fischel 1913–41, VI, no. 296; Parker 1956, no. 548; Gere and Turner 1983, no. 97; Joannides 1983, pp. 76–7, no. 214; Knab, Mitsch and Oberhuber 1984, no. 321.

RAPHAEL (and RAIMONDI)

87–90 The Massacre of the Innocents
about 1510

87 Study for the Judgement of Solomon

Pen and brown ink, over black chalk and stylus
underdrawing (the study at the upper right on
an attached fragment of paper), 26.4 × 28.7 cm
Albertina, Vienna, IV.189 (verso)

88 Study for the Massacre of the Innocents

Pen and brown ink, over red chalk for two figures on
the right, the outlines pricked except for these two figures,
a central line in pen, the pavement with stylus underdrawing
23.2 × 37.7 cm
The British Museum, London, 1860-4-14-446

89 Study for the Massacre of the Innocents

Red chalk, over charcoal pouncing, stylus and black chalk
underdrawing, 24.6 × 41.3cm
The Royal Collection, RL 12737

MARCANTONIO RAIMONDI
(1470/82 – 1527/34)

90 The Massacre of the Innocents

Engraving (first state), 28.3 × 43.4 cm
Inscribed on the left: RAPHA / VRBI / INVEN
(with a monogram MAF, for MarcAntonio Fecit)
The British Museum, London, 1895-9-15-102[1]

The engraving of the *Massacre of the Innocents*
(cat. 90) of about 1510 is probably the most
celebrated product of the collaboration
between Raphael and the Bolognese printmaker
Marcantonio Raimondi. The sequence of draw-
ings connected to the print demonstrates that
the starting point of the design was a discarded
idea from the same period relating to one of the
circular compartments of the vault of the Stanza
delle Segnatura (fig. 124). A study, now in the
Albertina, Vienna (cat. 87), is for the *Judgement
of Solomon* (fig. 108) depicting the famous
example of the Old Testament ruler's legendary
wisdom (I Kings 3: 16–28). Two prostitutes who
shared the same house had given birth at the
same time, and when one of the infants died
both women claimed the surviving child. This
impasse was resolved by Solomon suggesting
that the child be cut into half. As he intended,
the real mother revealed herself when she
renounced her claim in order that her offspring

might be spared. The Vienna drawing was made
after a metalpoint study in the Ashmolean
(fig. 109) in which Raphael rapidly sketched the
fresco's composition with the figures shown in
the nude: on the right is the false mother kneeling
below the enthroned figure of Solomon, and on
the left is a soldier striding forward holding the
upended baby by one ankle with the infant's
real mother grasping the other leg.[2] The pose
of the executioner is studied again on the right
of the Ashmolean drawing, and once more in
black chalk on the recto of cat. 87 (fig. 110). In this
sequence Raphael progressively added to the
dreadful sense that the soldier is on the verge
of unleashing his deadly blow, shifting the view-
point ever more to the left and increasing the
twisting motion of the soldier's upper body. On
the verso (cat. 87) Raphael redrew the soldier,
now posed diagonally facing the two mothers,
with his right (sword-bearing) arm raised. The
figure of the seated Solomon, shown in profile

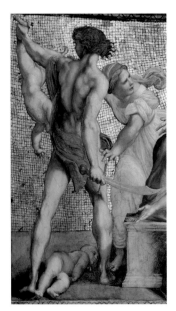

fig. 108 **The Judgement of Solomon**
(detail of fig. 124)

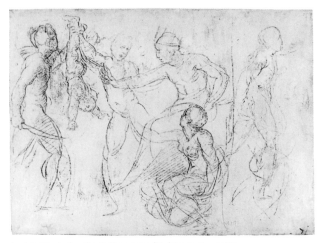

fig. 109 **Study for the Judgement of Solomon**, about 1510
Metalpoint on green prepared paper, 10 × 13.7 cm
The Ashmolean Museum, Oxford, 196 P II 555

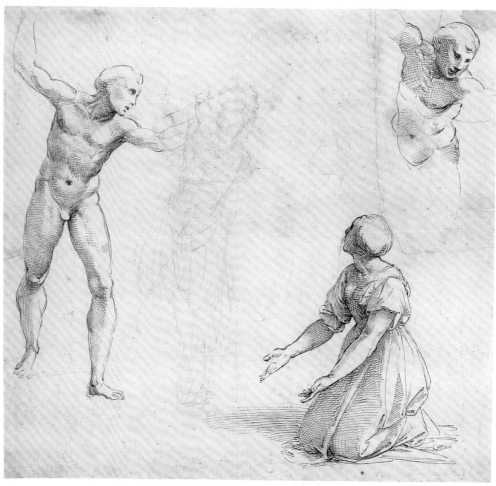

87

fig. 110 **Study for the Judgement of Solomon**, about 1510
Black chalk over stylus underdrawing (recto of cat. 87)

gesturing towards the nearmost woman, and of the true mother are drawn very lightly in black chalk only. Close scrutiny of the latter shows that Raphael originally intended this figure as the executioner – his outstretched arm is still visible on the right – before transforming the male figure into a female one, her upper body turning in alarm to the left, her arms raised with what must be meant as a baby pressed close to her shoulder. The drawing appears unfinished as Raphael's clarification in ink of the figures' poses and of their illumination from the top right seems complete only in the case of the nearmost woman, the penwork petering out in the arms of the soldier. In the top right corner is a study, perhaps torn from the same sheet and reattached at a later date, of the upper part of the executioner, his pose viewed fractionally more frontally thereby increasing the forward impetus of his body. A possible source for this pose may have been a Mantegna school engraving of

Hercules and the Hydra: the figure in the print is seen from much the same angle and with his upper body directed downwards, his right arm raised, much like the soldier in the drawing.[3]

In the painted roundel, the dynamic pose studied in cat. 87 was rejected in favour of a much more static one, with the figure seen from behind and facing to the left, perhaps because the artist judged that such extreme motion would have upset the compositional balance. Whatever the case, it is clear that Raphael did not forget such a beautiful invention, and this sword-wielding figure may well have spurred him on to choose the Massacre of the Innocents as the subject for what was probably his first collaboration with Raimondi. Vasari recounts that Raphael was inspired to become involved with printmaking because of his enthusiasm for Dürer's work.[4] The two artists exchanged gifts, one of which survives: a red chalk figure study by Raphael now in the Albertina with an inscription

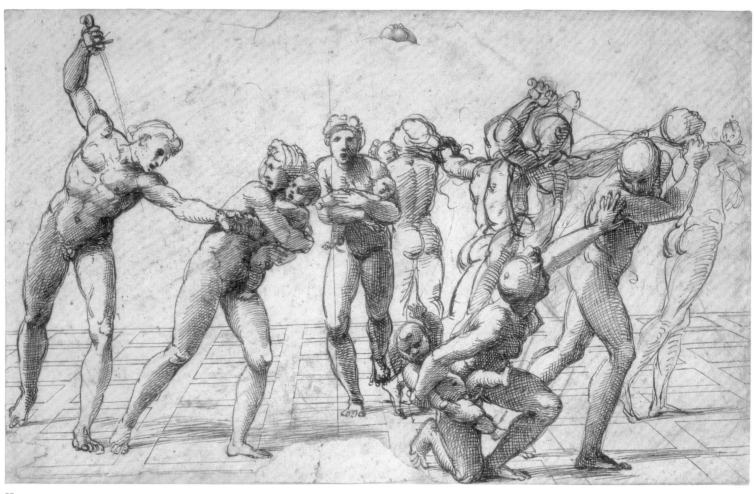

88

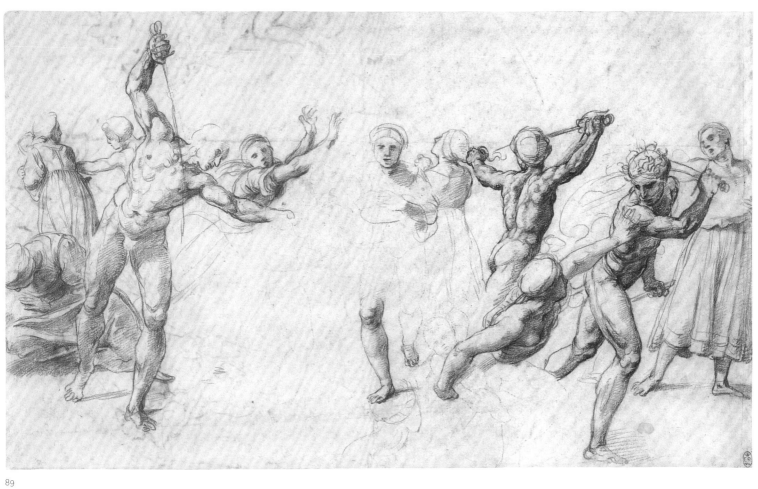

89

and date of 1515 written by Dürer.[5] The German artist's numerous engravings and woodcuts, aided by his extensive travels in Europe, had resulted in his becoming perhaps the first artist of truly international fame. Raphael may have wished to achieve a similar renown – and to supplement his income – by becoming involved in the relatively new technology of printmaking. Unlike Dürer, he could not make engravings himself, but fortunately for him his chosen collaborator, Raimondi, was the one print-maker in Rome, and perhaps in Italy, capable of approaching Dürer's technical artistry, thanks in no small part to his having been the most prolific copyist of the German's work. Raphael's genius for design, as well as an awareness of the tonal nuances now achievable in engraving, made him the ideal partner for Raimondi, whose lack of compositional skills had previously led him to seek designs from painters from his native Bologna, such as Francesco Francia and Jacopo Ripanda. According to Vasari, Raimondi had come to Raphael's attention through his engraving of *Lucretia,* which was made from one of the painter's drawings, but the two men may have met earlier before their arrival in Rome (see cat. 55).[6]

It seems that the *Massacre of the Innocents* was designed from the outset with a print in mind. In Raphael's earliest compositional study, the pen drawing in the British Museum (cat. 88), the artist is clearly aware of the dimensions of the plate, as the vertical line to the left of the central woman corresponds to the mid-point of the print. Similarly, in both this and the later compositional study from Windsor (cat. 89) the dimensions of the figures are fairly close to those in the engraving. Cat. 88 concentrates on the central group, the figures' relative positions in space being made plain, as in the print itself, by the squared pavement on which they stand. The print's Roman architectural setting is noticeably absent in this and in the Windsor study (cat. 89), and the only indication that Raphael had some idea of what he intended to do with the background is provided by the line of pin pricks

running from the left edge of the British Museum sheet to the top of the thigh of the nearest soldier. When compared to the print, this line corresponds to the lower part of the parapet of the bridge. The measured regularity of the penwork, with no corrections or underdrawing except for Raphael's reworking in red chalk of the soldier pulling the woman by the hair on the right, indicates that the drawing is a synthesis of elements developed in earlier, and now lost, drawings and is thus somewhat akin in function to the similarly neat copy drawing in Frankfurt for the *Disputa* (cat. 82). As is also true of the Frankfurt study, Raphael drew the figures in cat. 88 nude, the better to analyse their poses; in the finished print only the soldiers remain unclothed.

The biggest difference between the London drawing and the print is that the left-hand side of the composition is taken up by the striding soldier seizing a fleeing woman, the motif first developed in the *Judgement of Solomon.* The pair of figures (a soldier pulling a woman back by her hair) drawn entirely in ink on the other side of the pivotal central figure of the woman running forward correspond fairly closely to their counterparts in the engraving. Raphael explored in red chalk followed by ink the idea of changing the position of the group of the soldier pulling the woman by the hair. As these figures are the only ones whose contours have not been carefully pricked for transfer, Raphael evidently abandoned this idea, probably because it skewed the balance of the composition too much to one side. With characteristic thrift he recycled the rejected poses for the figures of a sea-centaur pulling back another by the hair in a pen study for a metalwork dish on the verso of cat. 89 (fig. 112). The head of a baby studied at the top of the sheet, the contours of which have also not been pricked, corresponds to that of the dead infant in the central foreground of the engraving. One can only conjecture whether this is a revision to the first-drawn pose because the section of the paper where the baby's head would have been has been torn away from the sheet. As Pon has rightly observed, the receding grid of paving

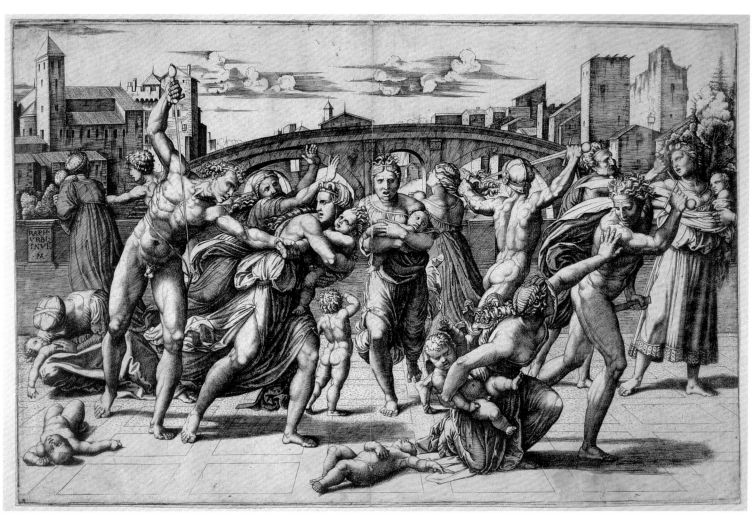

90

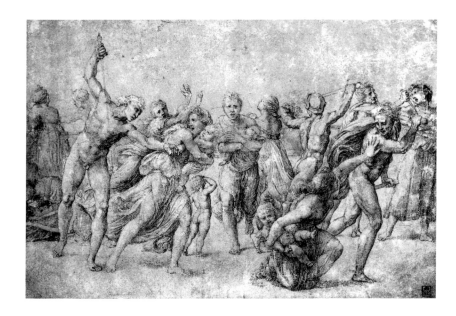

fig. 111 After Raphael (?)
Study for the Massacre of the Innocents, about 1510–11
Pen and two shades of brown ink on light grey prepared paper
26.2 × 40 cm
Museum of Fine Arts, Budapest, 2195

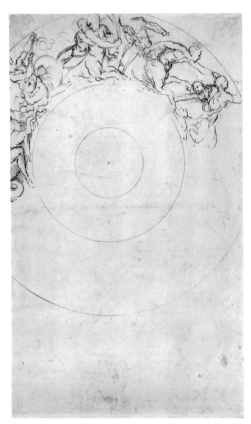

fig. 112 **Design for a salver**, about 1510–11
Pen and brown ink, (verso of cat. 89)

stones drawn in ink over stylus indications was added by Raphael after the figure composition had been drawn, as is shown by the fact that the horizontal lines do not overlap any of the figures' contours.

The black chalk pounced underdrawing in the Windsor compositional drawing (cat. 89), most evident in areas where it has not been gone over with red chalk, such as the figure of the baby held by the half-kneeling woman in the right foreground, has often been thought to depend on the pricked outlines in cat. 88. Pon has recently demonstrated with the help of computer scans that this is not the case, as the

outlines of the figures in the two drawings do not actually coincide, and there must have been at least one intervening drawing between them. The composition of the central section of cat. 89 follows very closely that developed in the earlier drawing, the artist adding first in stylus and then in chalk the group of figures behind the lunging soldier on the left and the woman on the right. These peripheral figures appear almost unchanged in the print; the absence of the figure of the soldier attacking the woman on the right in cat. 89 is probably explained by Raphael's realisation that he had not left sufficient space for him. He resolved this in the final design by allowing a little more space between the two sword-wielding soldiers and by moving the woman fractionally backwards. The change to red chalk in cat. 89 from the pen used in cat. 88 is significant, as it allowed the artist to explore with far greater precision the lighting and the straining bodies of the figures. The degree to which the figures have been finished in cat. 89 is extremely selective and it seems, at least for the central group, that Raphael was particularly exercised by the modelling of flesh illuminated by the fall of light from the top left (the opposite direction of the lighting in cat. 87), leaving the draperies for another study. Interestingly, there is a void on the left where in the print (and in cat. 88) the figure of the woman clutching her baby to her bosom appears, perhaps suggesting that Raphael had already satisfactorily resolved the figure and felt no need to repeat it. Coincidentally, the only surviving figure study, now in the Albertina (fig. 113), for the *Massacre* is principally for the same woman, although it cannot be the definitive one as the pose differs from the final one shown in the print.[7]

Raphael must have made further drawings after cat. 89 before handing over a final design for Raimondi to engrave. A highly finished pen drawing in Budapest in which all the figures are found as in the engraving, except the two dead infants in the foreground, is either an abraded original by Raphael or perhaps more likely a good early copy (fig. 111).[8] It cannot in any case

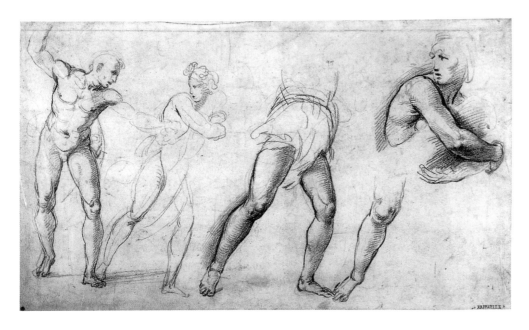

fig. 113 **Study for the Massacre of the Innocents**, about 1510
Red chalk, 23.5 × 41 cm
Albertina, Vienna, IV 188

be the final design as it does not include the architectural background incorporating the Ponte Quattro Capi.

Raimondi's print of the *Massacre of the Innocents* exists in two versions, both of which are now generally thought to have been engraved by him, the most marked difference between the two being the presence or absence in the right background of a fir tree. The first, the one with a fir tree, was most likely produced by Raimondi under contract from Raphael and his agent, Il Baviera, and as they owned the engraved copper plate from which impressions were taken the printmaker could profit from the popularity of the print only by creating a second plate, perhaps clandestinely. In artistic terms the collaboration

between painter and printmaker was a triumphant success. Raphael transforms the biblical episode into a stylised tableau of entirely bloodless violence, every element in the design carefully choreographed to create an intricately layered, yet harmoniously balanced, composition ideally suited to examination at close quarters by the buyer of the print. Raimondi for his part proved himself equal to the challenge of translating the nuanced description of lighting and of textures in drawings such as cat. 89 to the copper plate. The extraordinary quality of the print made it a prize piece for collectors from an early date (it is mentioned in the sixteenth-century collections of Antofrancesco Doni and Parmigianino's friend and patron, Francesco Baiardo).[9] HC

NOTES

1 Bartsch, XIV, 18.
2 Joannides 1983, no. 251r.
3 Bartsch, XIII, 12; for this and other Mantegna connections in the print see Pogány-Balás 1972, pp. 25–40.
4 Vasari/BB, IV, p. 190: '*Avendo dunque veduto Raffaello lo andare nelle stampe d'Alberto Duro, volonteroso ancor egli di mostrare quel che in tale arte poteva.*'
5 Joannides 1983, no. 371; Nesselrath 1993, pp. 376–89.
6 Bartsch, XIV, 192; for Vasari's account of the two artists meeting in his life of Raimondi see Vasari/BB, V, p. 9.
7 Joannides 1983, no. 253v.
8 Joannides 1983, no. 289; Zentai 1991, pp. 31–41, suggests it might be by Raimondi.
9 Early references to the print are given in Shearman 2003, pp. 964, 1095–6.

SELECT BIBLIOGRAPHY

(87) Fischel 1913–41, V, no. 231; Stix and Fröhlich-Bum 1932, no. 64; Joannides 1983, no. 252v; Mitsch 1983, pp. 62–6, no. 18; Knab, Mitsch and Oberhuber 1984, no. 338; Pon 2004, p. 127.

(88) Fischel 1913–41, V, no. 233; Pouncey and Gere 1963, no. 21; Gere and Turner 1983, no. 122; Joannides 1983, no. 287; Jones and Penny 1983, p. 84, pl. 96; Knab, Mitsch and Oberhuber 1984, no. 340; Bambach 1999, pp. 310–12; Pon 2004, pp. 122–36; Pon 2004a, p. 6, fig. 4.

(89) Fischel 1913–41, V, no. 234; Popham and Wilde 1949, no. 793; Gere and Turner 1983, no. 123; Joannides 1983, no. 288; Knab, Mitsch and Oberhuber 1984, no. 341; Clayton 1999, pp. 80–5, no. 20; Pon 2004, pp. 122–36.

The Madonna and Child with the Infant Baptist
(The Garvagh Madonna)
about 1509–10

Oil on wood, 38.9 × 32.9 cm
The National Gallery, London, NG 744

The *Garvagh Madonna* (also known as the *Aldobrandini Madonna* after another former owner) is one of several small and mid-size Madonnas painted by Raphael in the years immediately following his arrival in Rome. These devotional paintings, which are close in colour and figure type to the Stanze frescoes, must have been produced in spare moments around the longer-term project for the Pope, probably for discriminating members of his court. Several rapid exploratory sketches relating to the *Garvagh* and other Madonnas of this period on pink prepared paper once formed part of a 'pink sketch-book' that Raphael used around 1509–11 (cats 92 and 96–7 and figs 114–16).[1] This also included studies for the ceiling frescoes in the Stanza della Segnatura and the pose of the Christ Child in the *Garvagh Madonna* recalls that of one of the putti in the ceiling roundel depicting *Poetry* (see fig. 124).

Although the *Garvagh Madonna* evolved out of Raphael's Umbrian and Florentine Madonnas, this and other examples from his early Roman years are distinguished by a greater informality of dress and pose, increased complexity of composition and a cooler, less saturated palette. Here, the Virgin sits sideways on a simple bench or plinth, with one leg tucked beneath her. She wears a blue, green and gold striped headdress, gracefully bound up in a turban-like arrangement (similar orientalising headdresses also feature in the *Alba, della Tenda* and *della Sedia Madonnas* – cat. 93 and figs 135 and 44 – and probably reflect a contemporary Roman fashion). The Christ Child is depicted with extraordinary naturalness, propping himself up with his left arm on the Virgin's belly, his drawn-up knee and chubby foot splayed with all the flexibility of a real baby at this age. With a mischievous glance, he takes the sinuous carnation, symbolic of his future Passion, from the infant Baptist. Reminiscent of an allegorical figure of Charity (and indeed echoing in composition that subject in the Baglioni *Entombment* predella, cat. 67), the pensive Virgin seems prescient of the children's future destinies, protectively drawing her mantle around Christ's nakedness with one hand, while with the other gathering the sensuously rendered camel-hair pelt around the Baptist.

As a foil to the curving rhythms running through the figure group, Raphael introduced a dark architectural backdrop with two arched openings, suggestive of a loggia, giving onto a distant landscape reminiscent of the Roman *campagna*. Visible through the left-hand arch are a church, with a bell tower and a hemispherical apse, and hills shrouded in blue haze beyond. Through the right-hand arch is a larger building, perhaps also a church, buttressed and ringed by perimeter walls. In the underdrawing, the landscape and buildings extend beneath the central pier, suggesting that Raphael originally conceived the composition with the group located in front of a simple parapet. He subsequently drew in the vertical mouldings which so satisfyingly frame the graceful oval of the Virgin's head and the S-shaped bend of her neck, and then added the segments of the arches with a compass, closing off the composition artificially with two strips painted at either edge.[2] The idea of showing the Virgin in an interior between two arched windows occurs in early works by Leonardo and his followers, and it is possible that Raphael had some such model in mind.

The vivid rose-coloured lake of the Virgin's dress contrasts with the two subtly differentiated blue tones of her billowing shirt and crumpled mantle, and these colours, together with those of her headdress, resonate harmoniously through the more faded hues of the misty landscape. The distinctive palette of this brief period, which also characterises the newly cleaned *Alba Madonna*, caused several distinguished authors to doubt the autography of the painting, but all reservations were dismissed following the cleaning of the work in 1971, and the attribution to Raphael was further corroborated by the publication of a highly characteristic underdrawing in 1993.

Among Raphael's small-scale Madonnas, the *Garvagh Madonna* represents the height of formal purity, and the metalpoint underdrawing shows that the idealising tendency extends to

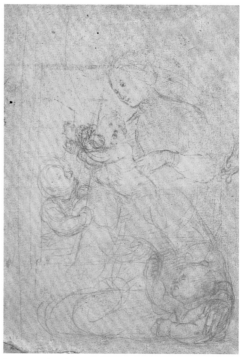

fig. 114 **Studies for the Garvagh Madonna**
(detail), about 1509–10
Metalpoint on pink prepared paper, 11.7 × 14.4 cm
Musée des Beaux-Arts, Lille, inv. PL 437

individual features, which are prepared with a schematic shorthand of arcs and circles. The perfect proportions of the Virgin's head epitomise a formal ideal that fascinated later classicising painters, including Sassoferrato, and above all Ingres. CP

NOTES

1 For further details of the so-called 'pink sketch-book', see cats 92 and 96.

2 For other examples of Raphael modifying the backgrounds of his compositions as they developed see cats 45 and 62.

SELECT BIBLIOGRAPHY

Passavant 1839, II, no. 90; Crowe and Cavalcaselle 1882–5, II, pp. 129–31; Gould 1975, pp. 215–16; Dunkerton and Penny 1993, pp. 6–20; Hiller 1999, pp. 250–4; Plazzotta in Bomford (ed.) 2002, no. 9; Roy, Spring and Plazzotta 2004.

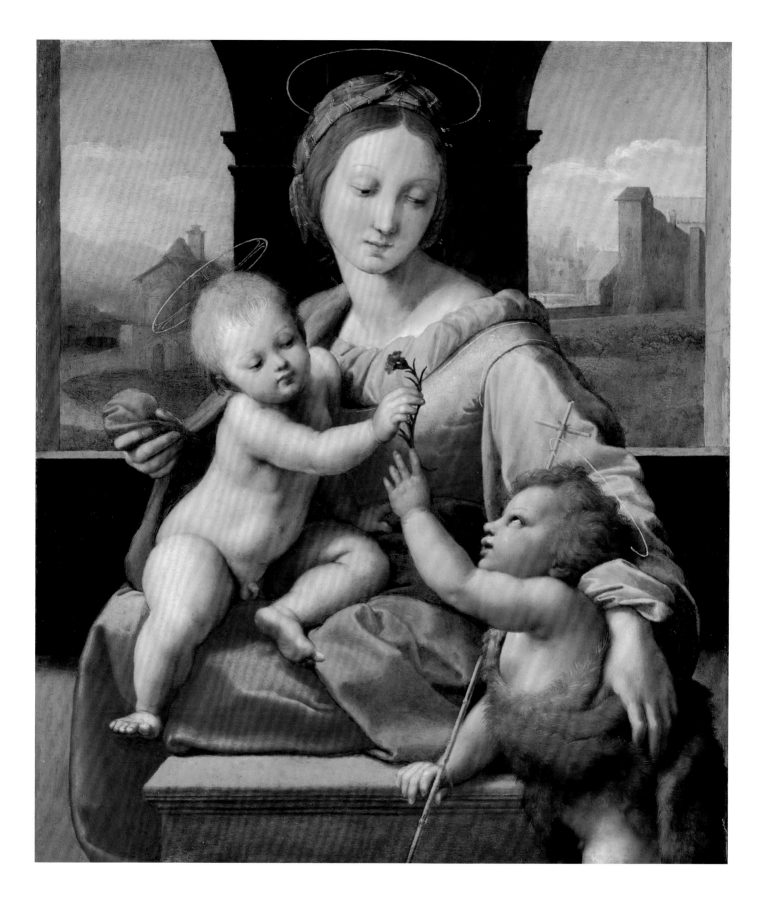

92 Studies for the Virgin and Child

about 1509–10

Metalpoint on pink prepared paper, 12 × 16.2 cm (cut at top and at the left)
Inscribed in ink, on the right: 23
Musée des Beaux-Arts, Lille, inv. PL 454 (recto) and 455 (verso)

In this rapid, investigative sketch, Raphael developed ideas for a Madonna and Child composition in which the Virgin would be shown apparently sitting behind a plinth, with her thighs parallel to the picture plane, and her feet tucked behind her. The Christ Child sits on the Virgin's lap, looking up from an open book towards his mother. Raphael studied this group five times, paying particular attention to the child's pose. There is also an unrelated study, drawn with the right-hand edge of the sheet at the top, of the head and wings of an angel (?), which is loosely related to figures in the *Disputa* and *Poetry* (both in the Stanza della Segnatura, figs 35 and 124). Rotating the sheet, with the left-hand edge at the top, there are a series of architectural designs, studying part of an elevation (on the left a pilaster applied to a pier on a plinth; on the right a profile view of an entablature on a larger scale). These studies have been related to the planning of the background of the *Disputa*

(fig. 35; although they could also relate to the *School of Athens*, fig. 37), or – more tentatively – to Raphael's ideas for the church of Sant'Eligio degli Orefici in Rome.[1]

The motif of the Virgin and Child seems to represent the first phase in the evolution of the *Garvagh Madonna* (cat. 91). Although the figure of Saint John the Baptist has not yet been introduced, and despite the fact that the finished picture is in the opposite sense (i.e. reversed) and the book is replaced by a carnation, there are strong connections between the pose of the child and his mother in the painting and this drawing. Similarities have also been noted between the schematic facial features and arcs of this drawing, and the underdrawing that has been discovered on cat. 91.[2]

The number added in ink on the right-hand side of cat. 92 is in the same hand as the numbers on cats 95–6, and establishes that the drawing was part of the same group as these two sheets at some point in its history. Fischel argued that these three drawings, and eight others, were part of a 'pink sketch-book' that Raphael used around 1508–11, and in which the artist studied a number of Madonna and Child compositions (such as fig. 115). The connections of this sheet, and others in the pink sketch-book, with the *Garvagh Madonna* and with the Stanza della Segnatura support this date.

A drawing on the verso (fig. 116) develops the composition of the Virgin and Child from the recto. The Virgin's pose is essentially the same as on the recto, but the child has been rotated through ninety degrees, and instead of concentrating on his mother and a book he plays with her veil. The format of the composition has been established with a series of ruled framing lines and – like the studies on the recto – this sketch is again part of the genesis of the *Garvagh Madonna*. When Raphael came to paint that picture, however, he reversed the Virgin's pose and moved the child to the other side of his mother's lap, placing a carnation in the centre of the composition and introducing the figure of the Baptist. TH

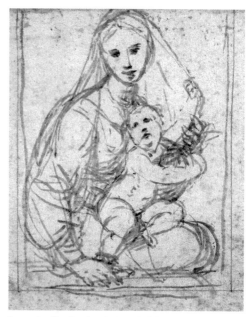

fig. 116 **Studies for the Virgin and Child** (detail),
Pen and brown ink (verso of cat. 92)

fig. 115 **Study for the Garvagh Madonna**, about 1509–11
Metalpoint on pink prepared paper, 16.2 × 11.3 cm
Musée des Beaux-Arts, Lille, inv. PL 436

NOTES

1 See Joannides 1983, no. 269, and the further references discussed in Monbeig Goguel 1983–4, pp. 272–5. For this church see Frommel (ed.) 1984, pp. 143–56.
2 Plazzotta in Bomford (ed.) 2002, pp. 134–5.

SELECT BIBLIOGRAPHY

Fischel 1913–41, VIII, p. 363, nos 346–7; Fischel 1939, pp. 181–7; Joannides 1983, p. 200, no. 269; Monbeig Goguel 1983–4, pp. 272–5, cat. 92–3; Knab, Mitsch and Oberhuber 1984, p. 619, nos 411–12; Brejon de Lavergnée 1997, pp. 188–9, cat. 539; Plazzotta in Bomford (ed.) 2002, pp. 134–5.

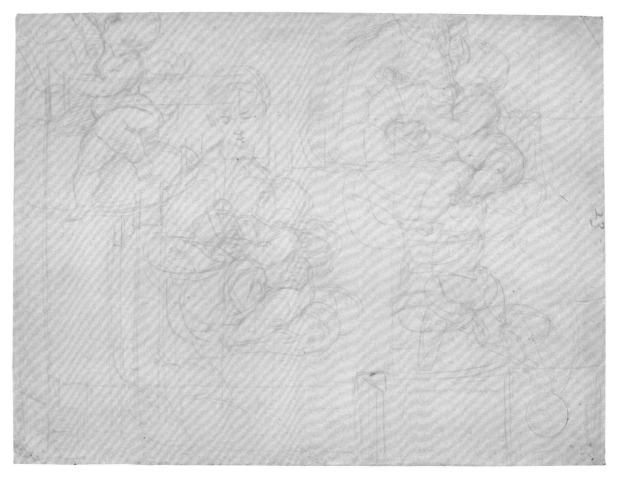

ACTUAL SIZE

93 The Virgin and Child with Saint John (The Alba Madonna)

about 1509–11

Oil on wood, transferred to canvas in 1837, 95.3 cm diameter
Cleaned and restored in 2003–4
National Gallery of Art, Washington DC, Andrew W. Mellon Collection, 1937.1.24

The *Alba Madonna* is the culminating master-piece of Raphael's exploration of the tondo form, demonstrating a confidence within a circular format that is lacking in earlier works (e.g. cat. 32 and fig. 23). The dominant diagonals of the Virgin's pose are carefully positioned within curves that complement the format of the picture.[1] She is close to the picture plane – although not as close as in cat. 94 – and sits on the ground, recalling the iconography of the Madonna of Humility. Christ's future Passion is alluded to by the three figures' concentration on the Baptist's cross. Jesus indicates acceptance of his fate by taking the cross from the young Saint John, whose solemn expression implies that he understands the significance of this gesture. The Virgin leans forward to comfort and protect the two boys, and her finger might be thought to mark the page in the holy text which tells of Christ's Passion, just as the veil gathered in her lap might allude to the shroud in which Christ would be wrapped at his death. The icono-graphic subtleties of the picture are enhanced by the symbolic meaning of some of the flowers in the foreground (for example, the anemones that the Baptist has gathered in his arms were frequently associated with the Resurrection).

The composition was studied on several leaves of the 'pink sketch-book' (see cats 92 and 96–7) as well as on the double-sided drawing in Lille (cat. 94), and the development of the composition is discussed in connection with these drawings. Alternative designs for the picture were known to the Lombard painter Cesare da Sesto (1477–1523), who recorded them in drawings of his own, attesting to the close friendship of the two artists during Raphael's early years in Rome.[2]

The most startling revelation of the recent restoration has been the recovery of the delicate pastel palette, and the hazy depth of the land-scape. The beautiful colour balance is very subtly constructed, with the pale blues and the pinks of the Virgin's drapery being picked up in the landscape. The quality of the light, and the way it is seen to fall (for example through the

high building with its arched openings on the right), are extraordinary and develop the increasingly refined approach to depicting atmosphere first encountered in Raphael's work around 1507 (e.g. cat. 74). Technical examination also revealed that the composition had been transferred to the panel using a combination of pouncing from a cartoon (for parts of the figure group) and freehand drawing, especially in the landscape.[3] Several changes were made during the picture's execution. These included the elimination of a large structure on the skyline to the left of the Virgin Mary (this building,[4] which can be seen in the infrared reflectogram and was apparently red in colour, was subsequently covered with clouds, fig. 117). The underdrawing also shows how the Saint John was fleshed out on the panel (compare his right arm in the painting, fig. 117 and cat. 95). The Baptist's right hand also overlapped Christ's leg, Christ's left foot was not originally covered by the Virgin's drapery, and the Virgin's right cuff originally covered more of her wrist. Each of these changes to the figures seems to have been motivated by a desire to emphasise their individual volume while at the same time maintaining the composi-tional harmony of their interaction.[5]

These compositional interests are subtly different from those of Raphael's earlier work, and seem to have been stimulated by his arrival in Rome. A similar search for felicitous harmony and idealised beauty is seen in the Stanza della Segnatura, as for example in the *Parnassus* (fig. 38) – where there are close parallels between the Virgin and the figure of Sappho. In some respects the Virgin is even more classicising: her sandal clearly has an antique inspiration, while at the same time Raphael demonstrates a shoe-maker's mastery of its blue leather construction, and the picture demonstrates early signs of Raphael's increasingly serious archaeological and antiquarian interests, which were to come to the fore under Pope Leo X.[6] Of course, Raphael did not forget the lessons that he had learnt in Florence, and the picture can be related to Michelangelo's *Taddei Tondo* (cat. 61) and his

256

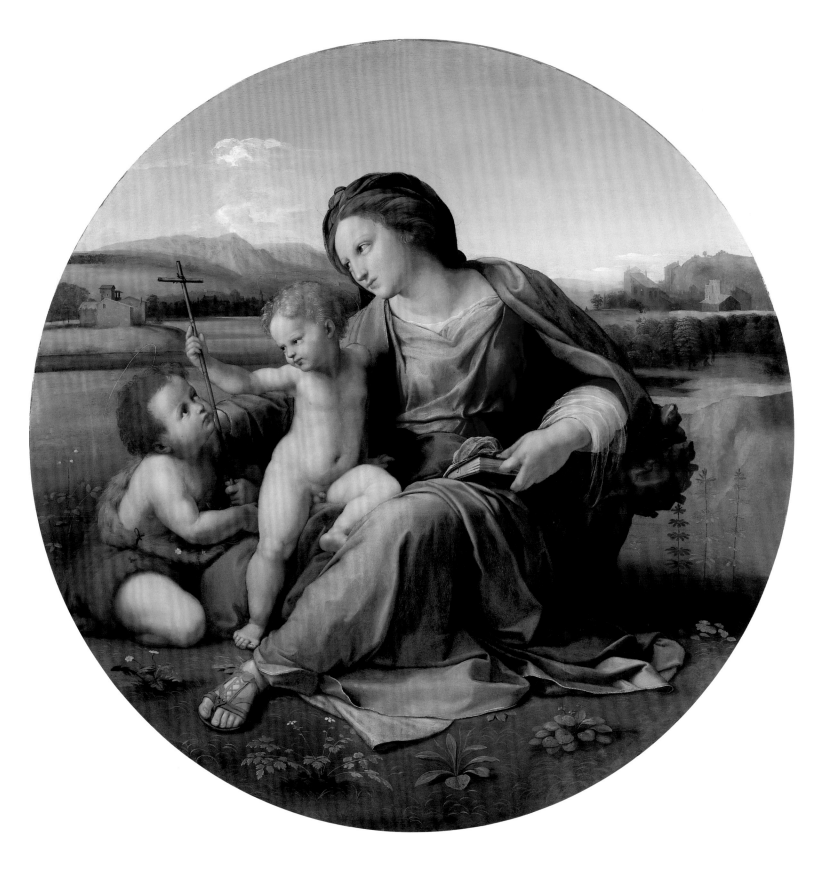

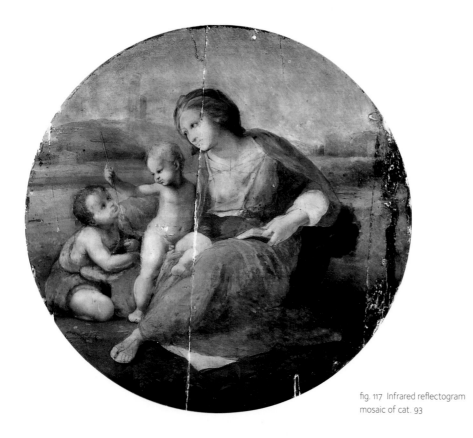

fig. 117 Infrared reflectogram
mosaic of cat. 93

Doni Tondo (fig. 22); and the origin of the figure group can be found in Leonardo's *Virgin and Child with Saint Anne* (cat. 49) as well as in the *Madonna of the Yarnwinder*. But a comparison with any of Raphael's earlier tondi – including those on the vault of the Stanza della Segnatura – shows how much more sophisticated this picture is than anything else that Raphael ever attempted in this format. These aspects of the picture all point to a date of about 1509–11, although earlier dates have also been proposed. The closest stylistic parallels are with the *Garvagh Madonna* (cat. 91), the only picture to have a similar palette and atmosphere, and in which one again finds a blue and green turban, threaded with gold, and a similarly sensuous rendering of fur in the Baptist's camel-skin wrap.

This picture was first recorded in 1610, over an altar in the Olivetan church of S. Maria del Monte Albino at Nocera de' Pagani, south-east of Naples. It was sold to the Spanish Viceroy Gaspar de Haro, Marquis of Carpio, in 1686 and passed by marriage and descent to the Duques de Alba in Spain, from whom it acquired its present name. The picture was subsequently in London and the Hermitage, St Petersburg (from

1836), before it was acquired by Andrew Mellon in 1931 and given to the National Gallery of Art in Washington.

Andrea Zezza recently demonstrated that the principal benefactor of the Olivetans at Nocera de' Pagani was a literate and well-connected military commander, Giovan Battista Castaldo (1493–1563), and that it was almost certainly he who gave the picture to the church of S. Maria del Monte which was built between 1541 and 1557.[7] Zezza also noted that a source from 1685 states that the picture was transported to Nocera after the Sack of Rome in 1527, and pointed to one eighteenth-century author (Placido Troyli) who claimed that Castaldo (who was on the victorious Imperial side during the Sack) removed it from the sacristy of St Peter's to which it had been presented by Julius II. Although this claim is not verified by any earlier evidence, it accords with Crowe and Cavalcaselle's proposal that the picture had been commissioned by Julius, even if the grounds they cite, that the stump against which the Virgin leans is an oak (and alludes to the Della Rovere, *rovere* meaning oak in Italian), may be wishful thinking. TH

NOTES

1 See Oberhuber 1999, p. 110.

2 See Carminati 1994, pp. 235 (D8, The British Museum, 1862-10-11-196) and pp. 311–12 (D97, Royal Library, Windsor, RL 12563). For Cesare da Sesto's activity in the Vatican from 1508, and his association with Raphael in these years, see Henry 2000, pp. 29–35.

3 Raphael had increasingly relied on this combination of under drawing techniques (e.g. in the *Madonna del Cardellino*, fig. 26), which also explains why his larger cartoons usually only include the principal figures and not the backgrounds. This also explains why the backgrounds of his pictures – e.g. cat. 62 – frequently underwent major revisions.

4 It is difficult to work out what this structure was meant to be on the basis of the infrared reflectograph (fig. 117). The proportions are similar to the tall building on the right of the *Garvagh Madonna*, cat. 91, but would appear ludicrously oversized on this distant hillside. The only alternative would seem to be some remnant of a huge classical brick building, like those known at the Villa Adriana and elsewhere in Rome, or perhaps two tall columns of unequal height. It is worth noting that cat. 94 recto appears to show trees (?) occupying this area of the picture, and again out of scale with the implied distance of the hillside.

5 There is, however, no evidence that the Christ Child ever reached up to the Virgin's neck (as reported in Christensen 1986, pp. 52–4, and repeated as fact thereafter).

6 Nesselrath 1986.

7 Zezza 1999, pp. 29–41, correcting the often-repeated claim that the picture was commissioned by Paolo Giovio (1483–1552), who was Bishop of Nocera from 1527.

SELECT BIBLIOGRAPHY

Crowe and Cavalcaselle 1882–5, II, pp. 124–9; Friedmann 1949, pp. 213–20; Dussler 1971, pp. 35–6; Wasserman 1978, pp. 35–61; Brown 1983, pp. 92–4, 168–78, 198–200; Christensen 1986, pp. 52–4; Ruiz Manero 1996, pp. 47–51; Zezza 1999, pp. 29–41; Olson 2000, pp. 214–16.

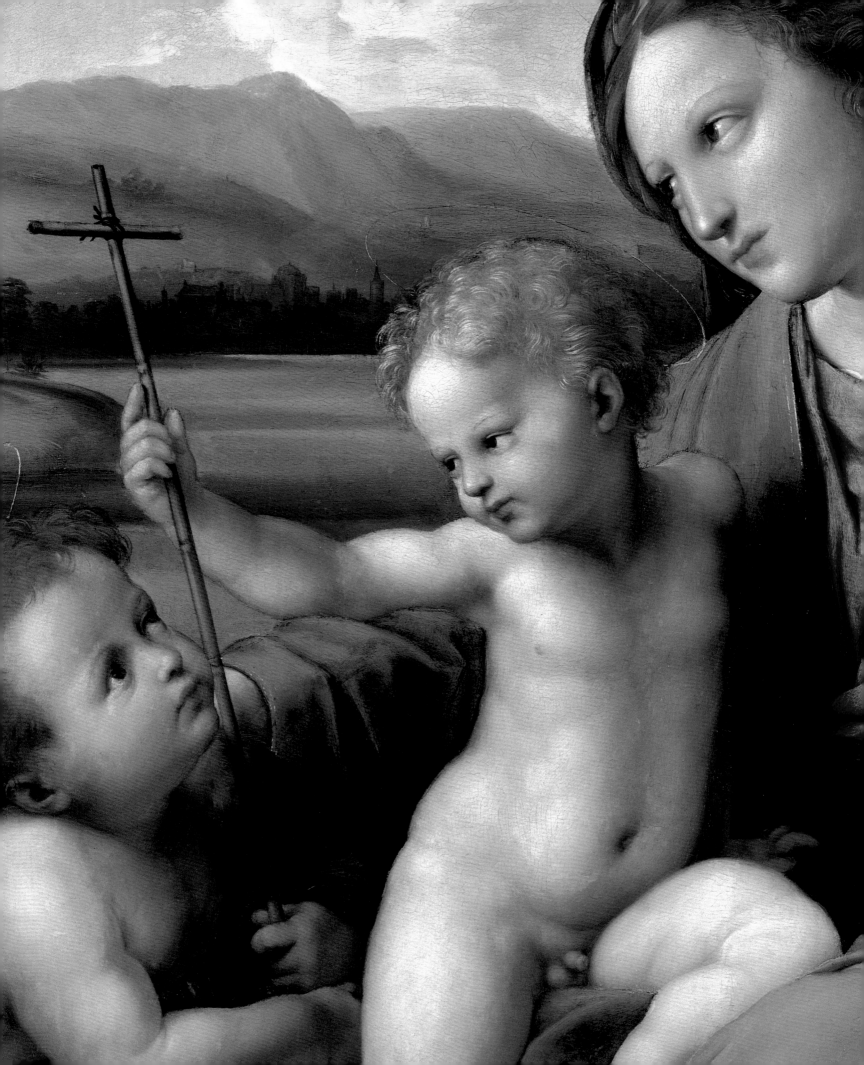

94 Studies for the Alba Madonna and other sketches

about 1509–11

Recto: red chalk, pen and ink and black chalk, with touches of white heightening
Verso: red chalk, 42.2 × 27.3 cm
Musée des Beaux-Arts, Lille, inv. PL 456 (recto) and 457 (verso)

This spectacular double-sided drawing is principally concerned with the genesis of the *Alba Madonna*, now in Washington (cat. 93).[1] Working in red chalk, with a notably orange-red tone, Raphael studied the whole composition on the recto, before making a detailed study for the Virgin (based on a male *garzone*) on the verso. In both the controlled fluidity of the drawing – a series of curving arcs that are best compared with his contemporary studies in metalpoint (e.g. cat. 92) – is extraordinary, and the range of techniques that Raphael employed at this point in his career is dazzling.

The studies of the Virgin and Child and the young Saint John the Baptist on the recto are very close to the finished painting, but the composition was subtly different at this stage in its evolution. The figures were always destined for a circular composition – the tondo frame is inscribed freehand around the figures – but they are much nearer to the frame in this drawing. The landscape also pressed in upon the figures (it seems to have been drawn before the figure of Saint John), and the sense of movement is more vertiginous than in the picture as painted. This was partly because of the drawn solution for Saint John, who moves forward to kneel on one leg, his face in profile. This figure's revised position was separately studied in a metalpoint drawing in Rotterdam (cat. 95).

However, the most interesting revisions were made in the figures of Christ and his mother. Originally the Virgin held up an open book (presumably a holy text) in her right hand. It was in the line of sight between the two central figures and the cross held by Saint John (represented as a diagonal line above John's head). In the painting the book was closed, and moved to the Virgin's left hand (as shown here on the verso); the cross was also given more prominence and was held by the outstretched hand of Christ (as well as by Saint John). The first steps towards this change are also evident in this drawing. Initially, Christ reached down with his right arm to stroke the head of a lamb which was held in the outstretched arms of Saint John (this

solution was even reinforced over the red chalk with pen and ink, but seems to have been subsequently scratched off). When he rejected the idea of including the lamb (a symbol of Christ's sacrifice and frequent companion of the Baptist), Raphael redrew the child's right hand in the position that it occupies in the painting (although there is no suggestion that it grasps a cross, and it is more likely to have been raised in blessing). Raphael then changed from chalk to pen. He quickly sketched an idea for the Christ Child sitting astride the Virgin's right leg at the bottom of the sheet. This sketch not only relates to the problem that Raphael was trying to solve, but also refers back to Michelangelo's *Taddei Tondo* (cat. 61) and to Raphael's development of this idea in the *Bridgewater Madonna* (cat. 62). For the final transformation of this Florentine motif, Raphael selected yet another medium: black chalk. He drew in a new position for the right arm, first on the small study at bottom right, and then, in ink, on the main study (where it is the only element to be drawn in ink alone). In the process the iconography of the picture was significantly transformed.

On the verso of the sheet, Raphael posed one of his workshop assistants or *garzoni* in the position that he had decided on for the Virgin. One only needs to look at the knees or the thighs to know that the artist was drawing from a male model, and comparisons can be drawn with Michelangelo's contemporary figures on the Sistine Chapel ceiling (for example, Adam in the *Creation of Adam*, which Raphael might have seen before his picture was completed). In this detailed study the way in which the Virgin is supported is more evident than in the recto (in the finished painting she leans against a tree stump), but Christ's position is only vestigially indicated above the Virgin's right arm, which is also more loosely sketched than the rest of her figure (partly because it would be largely hidden by the figure of Christ, and partly because the solution shown here, in which the palm of the Virgin's hand would have been uppermost, was not one that Raphael would pursue in the

finished picture). The Virgin's left hand is a first attempt at transferring the book from her right hand (as seen on the recto) to her left, and shows the Virgin marking her place with a finger.

The recto of the sheet also has a number of studies unrelated to the *Alba Madonna*. At top right are two architectural studies, also executed in red chalk. One of these is a square ground-plan; the other an elevation of a two-storey arcaded building. These have been related to a villa, to a mausoleum and to the building under construction in the background of the *Disputa*, or more generically to the loggia of Agostino Chigi's villa (the so-called Farnesina).[2] Beside these are two pen and ink studies of the Virgin and Child (these studies have been drawn over

the red chalk and were therefore late additions to the sheet). Both show a rectangular composition in which the Virgin sits behind a plinth with her right leg parallel to the picture plane. She was originally shown in profile with more of a gap between her face and the child's. Her right hand reached down to touch his feet. The figures were then redrawn to show the pair with their faces pressed close together, in a way that recalls the *Madonna della Tenda* in Munich (fig. 135), and the Virgin's right hand was brought up to support the child's torso. In the more finished of the two studies a third figure (who seems to be bearded and may therefore be Saint Joseph, although in the *Madonna della Tenda* he is the young Saint John) is also included. TH

NOTES

1 The origin of the *Alba Madonna* can probably be traced to a pen and ink drawing in the Uffizi, Florence (Joannides 1983, no. 202v).
2 Brejon de Lavergnée 1997, p. 192.

SELECT BIBLIOGRAPHY

Crowe and Cavalcaselle 1882–5, II, pp. 127–8; Fischel 1913–41, VIII, pp. 378–9, nos 364–5; Joannides 1983, p. 202, no. 278; Jones and Penny 1983, p. 88; Brown 1983, pp. 174–5; Monbeig Goguel 1983–4, pp. 288–91, cats 103–4; Frommel (ed.) 1984, pp. 116, 119, cat. 2.1.7; Brejon de Lavergnée 1997, pp. 191–2, cat. 545.

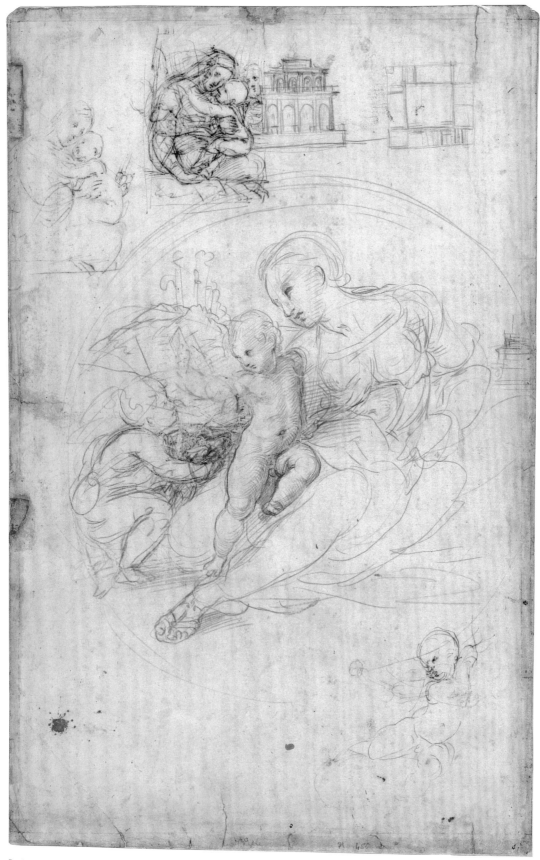

Recto

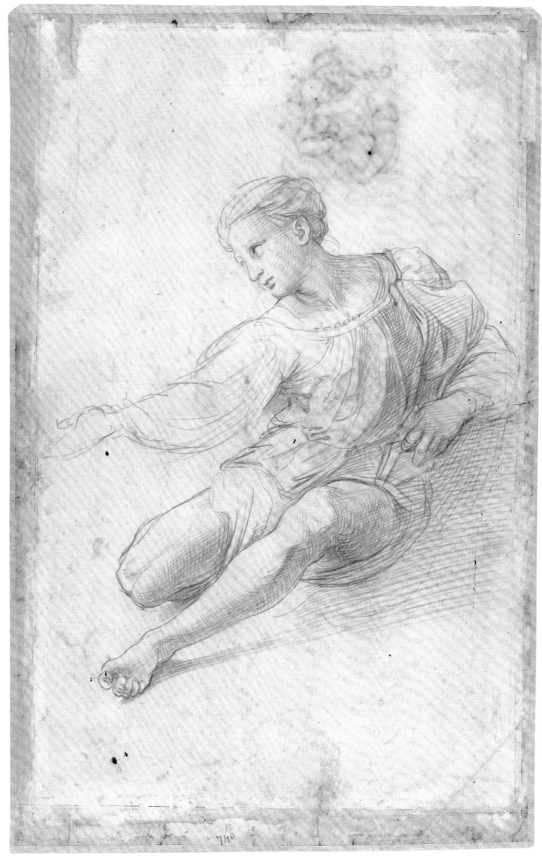

Verso

95 Study for the Alba Madonna
about 1509–11

Metalpoint on off-white prepared paper, 11.5 × 10.5 cm
Inscribed in ink, top centre: 19; and top right: 75
Museum Boijmans Van Beuningen, Rotterdam, I-110

This tiny drawing is an isolated study for the figure of the young Saint John the Baptist in the *Alba Madonna* (cat. 93). The child has gathered flowers in the folds of his camel-skin draperies, a development from the original idea seen in the double-sided preparatory drawing in Lille (cat. 94), where John originally held a lamb in his outstretched arms. At this earlier point in the design process, the Baptist was also envisaged in profile, and slightly more elevated than in this drawing and the painting – in both of which he is shown almost sitting back on his haunches. The drawing nevertheless differs from the finished painting in a number of respects, most obviously in the positioning of the child's right hand, and of his head (which is turned up and towards the cross in the painting).

The drawing may have been part of a sketch-book that Raphael used during his early years in Rome, having perhaps started to use it just prior to his departure for the city. The sketchbook was partially reconstructed by Oskar Fischel who called it Raphael's 'pink sketch-book'. And while the specific connection of this sheet with the sketchbook has been doubted (the drawing is smaller than the other sheets and its ground is off-white rather than pink), Fischel was probably correct to group it with these early Roman studies. Not only does the study relate to a picture that Raphael painted in these years, but the numbering on some of the sheets proves that they were kept together at an earlier stage of their history. The inscriptions on this sheet can be compared with those on cats 92 and 96, to demonstrate that the sheets were numbered on recto and verso and were together at two different times (to account for the numbers at the centre '19' and '22', and those in the top right corner '75' and '81').

Among other compositions which are studied in the pink sketch-book are the ceiling of the Stanza della Segnatura and the *Garvagh Madonna* (cat. 91). Other drawings develop ideas encountered in the *Bridgewater* and *Mackintosh Madonnas* (cats 62 and 98).

The present drawing shows how metalpoint can be used to capture subtle tonal observation, especially when studying areas of flesh. This was a common technique but – as seen in cat. 92 – Raphael also used metalpoint for much freer compositional studies. TH

SELECT BIBLIOGRAPHY

Fischel 1913–41, VIII, p. 367, no. 355; Fischel 1939, pp. 181–7; Haverkamp-Begemann 1957, pp. 36–7, no. 39; Joannides 1983, p. 203, no. 279; Brown 1983, pp. 175–6; Knab, Mitsch and Oberhuber 1984, p. 617, no. 387.

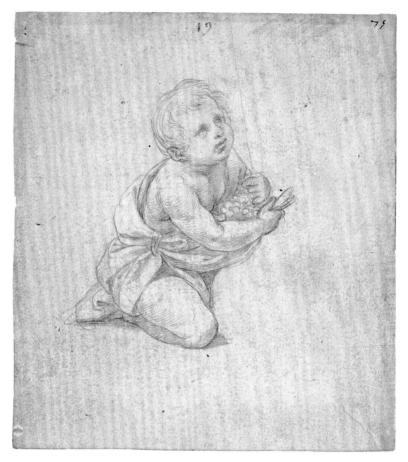

ACTUAL SIZE

96 Studies for an infant Christ
about 1509–11

Metalpoint on pink prepared paper, 16.8 × 11.9 cm
Inscribed in pen and ink: 22 and 81
The British Museum, London, Pp. 1-72

For much of the fifteenth century, metalpoint had ranked second only to pen in frequency of usage by Italian artists, but by the beginning of the following century it had been almost entirely supplanted by chalk and Raphael was among the last of his contemporaries to employ it regularly. He had been trained in its use from an early age because it was a technique still favoured by Umbrian artists at the end of the fifteenth century: Perugino like Leonardo, his fellow student in Verrocchio's shop, being a particularly skilled practitioner. Raphael continued to make metalpoint drawings until well into his Roman career, the last surviving ones dating from around 1516.

This and cats 92, 95 and 97 are from a group of eleven small-scale metalpoint studies, predominantly on pink paper from Raphael's early Roman period, about 1509–11, that Fischel suggested came from a single sketchbook (the so-called 'pink sketch-book'). Whether or not the drawings were actually ever bound together is debatable since there are no traces of binding holes nor markedly more wear on the right side of the sheets indicative of page turning. However, this question is of little consequence because Fischel was certainly right in bringing together such a stylistically homogenous group of studies. In addition, similar ink numbers probably dating from the sixteenth century found on this and several others in the series including the Lille and Rotterdam drawings (cats 92 and 95) demonstrate that some of them remained together.[1] The present example is one of the most free-flowing from the group: in the confined space of the page the artist sketched eleven ideas (not counting the single leg drawn at the lower right) for a reclining infant Christ. This kind of quick-fire exploration of a single

motif is reminiscent of his earlier sheet of pen studies of the Virgin and Child (cat. 63), and indeed the two drawings also share in common the inspiration of Michelangelo's sculpted *Taddei Tondo* (see cat. 61) for the pose of the infant Christ twisting around to look over his shoulder. Michelangelo's sculpture had also been the starting point for the child in Raphael's *Bridgewater Madonna* (cat. 62), painted a year or so before he made the present drawing, and the pose of the figure drawn just below the centre echoes most closely the infant Christ in that painting. Despite the similarities, this drawing cannot be directly related to the painting, as has sometimes been suggested, because Raphael clearly had in mind a composition with the Christ Child reclining on a flat surface with his head supported by a pillow as is found in his so-called *Madonna di Loreto*, painted around 1511, in the Musée Condé at Chantilly (fig. 129). Raphael's parallel investigation of the Christ Child in a twisting pose and in a less active reclining pose with his arms aloft, like that employed in the Chantilly painting, is demonstrated by a drawing from the same 'pink sketch-book' group at Lille which includes studies of both motifs.[2] The Lille drawing was probably made soon after the present one because it includes a more developed study of the pose found in the upper right of this sheet. Raphael's sustained fascination with the combined forward motion and backward turn of the head of Michelangelo's sculpted Christ Child is shown not only in drawings such as this one and cats 63 and 64 but also in his use of the pose for the putto in the lower right of his *Galatea* fresco (fig. 41) of about 1512 in the Roman villa (now known as the Villa Farnesina) of the Sienese banker Agostino Chigi. HC

NOTES

1 A faint number '20' (?) probably by the same hand is found on another Lille 'pink sketch-book' drawing (Joannides 1983, no. 272). A larger metalpoint on pink prepared paper in the British Museum for the *Parnassus* (*idem*, no. 243) has a very similar inscription, '19', the same number as found on the Rotterdam sheet (cat. 95).
2 Joannides 1983, no. 272.

SELECT BIBLIOGRAPHY

Fischel 1913–41, VIII, no. 350; Pouncey and Gere 1962, no. 23; Gere and Turner 1983, no. 116; Joannides 1983, no. 271; Knab, Mitsch and Oberhuber 1984, no. 415, p. 620; Weston-Lewis 1994, no. 22.

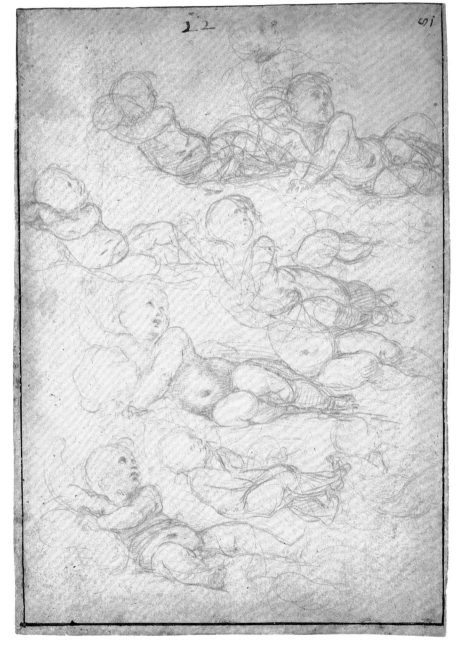

ACTUAL SIZE

97 Study of the heads of the Virgin and Child

about 1509–11

Metalpoint on pink prepared paper, 14.3 × 11 cm
The British Museum, London, 1866-7-14-79

This luminous metalpoint study from the so-called 'pink sketch-book' (see cat. 96) cannot be related specifically to any of Raphael's early Roman Madonna and Child paintings. The refined beauty and downward-cast gaze of the Virgin in the drawing is perhaps most reminiscent of the figure in the National Gallery *Garvagh Madonna* (cat. 91); while his tender portrayal of the joyful child may have been a source of inspiration for his depictions of the infant Christ in the *Large Cowper Madonna* in Washington and in the much damaged *Mackintosh Madonna* in the National Gallery (fig. 118). The turn of Christ's head away from his mother is also related to an early study for

the *Garvagh Madonna* in another 'pink sketch-book' drawing at Lille (fig. 114).[1] Raphael's virtuoso handling of metalpoint is exemplified by the subtle modelling of the Virgin's head which is achieved almost entirely through parallel hatching with only minimal internal modelling. The crystalline precision of the detail in the description of the Virgin's youthful features contrasts with the sketchier treatment of her hair and of the Christ Child.

This is one of two Raphael drawings recorded in the collection of the Roman neo-classical painter Vincenzo Camuccini (1771–1844), who also owned the *Madonna of the Pinks* (cat. 59).
HC

NOTE

1 Joannides 1983, no. 274.

SELECT BIBLIOGRAPHY

Fischel 1913–41, VIII, no. 349; Pouncey and Gere 1962, no. 24; Gere and Turner 1983, no. 117; Joannides 1983, no. 275; Knab, Mitsch and Oberhuber 1984, p. 619, no. 414.

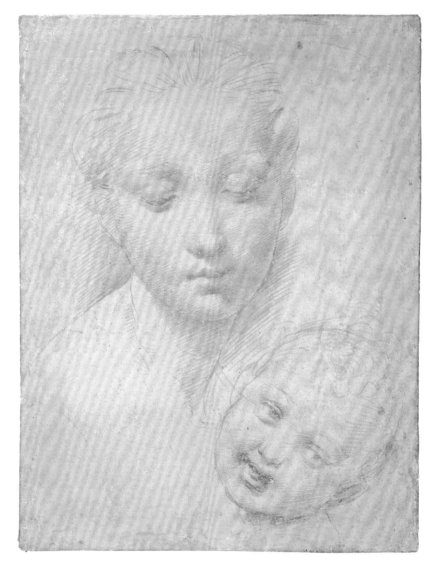

ACTUAL SIZE

98 Cartoon for the 'Mackintosh Madonna'
about 1509–11

Black chalk and/or charcoal, touches of white chalk, the outlines pricked and partly indented
on two joined sheets (a strip added on the left side), 71 × 53.5 cm
The British Museum, London, 1894-7-21-1

This is a cartoon for a painting in the National Gallery of the Virgin and Child (fig. 118), a work generally known as the *Mackintosh Madonna* after its donor Miss Eva Mackintosh. Sadly the picture is in such a ruinous and repainted condition, in part due to it having been transferred from panel to canvas in the eighteenth century, that it has not been included in the present exhibition. Although the cartoon is in a better state than the painting, it too has suffered: the chalk or charcoal (or perhaps a combination of the two) and the paper are much abraded. As a result, in the more shadowed areas the tonal gradations and the underlying modelling of form have been blurred to a virtually impenetrable blackness. This is especially apparent in the passages around Christ's left leg and in the Virgin's drapery at the lower right corner. These damaged areas can be interpreted by comparison with the ruined original, and conversely some idea of the original quality of the painting can be gained through study of the cartoon. For example, the drawing indicates that the artist

intended the figures to be bathed in a soft Leonardesque twilight, the lighting emphasising the fleshy rounded contours of their faces. The subtlety of Raphael's characterisation of mother and child is similarly more readily appreciable in the drawing: the artist adds a new note of poignancy to his depiction of the Virgin and Child by contrasting the joyous display of filial affection on the part of the Christ Child (his smiling expression reminiscent of the infant in the metalpoint study of the same period, cat. 97) with the withdrawn pensiveness of his mother. The slight turn of the Virgin's head away from her child and her lowered eyes eloquently convey a sense of the burden she has to endure, her thoughts clouded, even in moments of such intimacy, by the knowledge of her son's fate. Such telling details give the composition a psychological depth not found in the Quattrocento sculptural models on which it is based. It is particularly close in the arrangement of the figures to a glazed terracotta relief by Luca della Robbia.[1] Thanks to the cartoon we are afforded some idea of how the *Mackintosh Madonna* looked originally and can see why it was one of Raphael's compositions that appealed most powerfully to later artists.[2]

The cartoon is remarkably free in execution – the artist's search for his preferred solution is visible in passages such as the flurry of lines around the Virgin's left shoulder and arm. In this, as well as in the markedly tonal nature of the modelling of form, it is closer to the Louvre cartoon fragment for the head of God the Father in the *Disputa* of around 1508–9 than to slightly earlier cartoons such as that for *Saint Catherine* (cat. 77) executed around 1507.[3] The *Mackintosh Madonna* is generally dated to the period of Raphael's work in the Stanza della Segnatura (1509–11), and a sense of his confidence and creative vitality, born from his mastery of this enormously ambitious project, can perhaps be felt in the assured and fluid draughtsmanship of the cartoon. Clearly even at this last preparatory stage Raphael was willing to explore refinements to the poses established in earlier,

and now lost, studies. The outlines of the figures have been carefully pricked and also show signs of having been incised with a stylus, although the method of transfer Raphael employed for the National Gallery painting cannot be determined. The incised or indented contours may have come about because a copy was made after the design (the verso of the sheet would be rubbed with black chalk so that it acted like carbon paper), and indeed the popularity of the composition is proved by a smaller-scale reprise of the two figures in a painting of 1518 of the *Virgin with Saints Gregory and Nicholas* in the Galleria Nazionale dell'Umbria, Perugia, by Domenico Alfani. The latter was a Perugian artist who had collaborated with Raphael (see cat. 32) and is known to have been sent a compositional drawing by Raphael to help in the painting of an altarpiece.[4]

A curious feature of the present cartoon is that Raphael has not drawn in chalk the billowing fold of drapery around the Virgin's left elbow, a detail found in the finished work, although careful scrutiny of the area reveals that there are pricked lines describing its form. Raphael may have studied this area in a separate drawing on the same scale and then had the alteration transferred to the cartoon, or he may simply have made a sketch of the drapery and instructed the assistant wielding the pin to follow that. HC

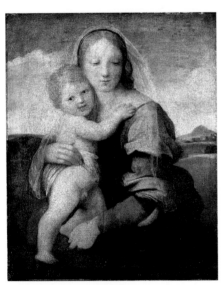

fig. 118 **The Madonna and Child (The Mackintosh Madonna)**, about 1509–11
Oil (almost entirely repainted) on canvas, 78.8 × 64.2 cm
The National Gallery, London, NG 2069

NOTES

1 This comparison was made by Weston-Lewis 1994 who illustrates one of the two versions of the relief – the *Bliss Madonna* in the Metropolitan Museum of Art, New York (fig. 49 on p. 72). The other, known as the *Shaw Madonna*, is in the Museum of Fine Arts, Boston.
2 It was copied in the seventeenth century by Sassoferrato and in the nineteenth century by Ingres, see Gould 1975, p. 219.
3 For the *God the Father* cartoon see Joannides 1983, no. 226.
4 Alfani's painting is illustrated by Bambach 1999, fig. 98. Raphael's compositional drawing for Alfani's *Holy Family with Saints* is in Lille (Joannides 1983, no. 174r).

SELECT BIBLIOGRAPHY

Fischel 1913–41, VIII, no. 362; Pouncey and Gere 1962, no. 26; Gere and Turner 1983, no. 119; Joannides 1983, no. 277; Knab, Mitsch and Oberhuber 1984, no. 323; Weston-Lewis 1994, no. 28; Bambach 1999, p. 105, fig. 97.

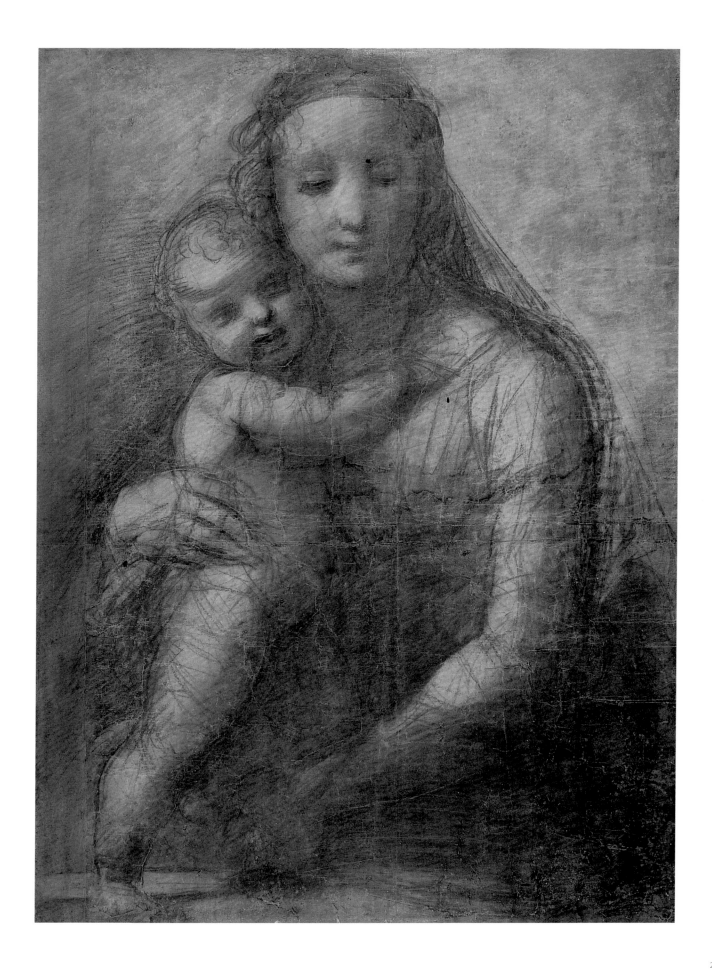

99 Portrait of Pope Julius II

mid-1511

Oil on poplar, 108.7 × 81 cm
Inscribed in the bottom left corner, in white paint: 118 (Borghese inventory number)
The National Gallery, London, NG 27

On 12 September 1513 the Venetian ambassador to Rome reported to the Venetian Senate that a portrait of the recently deceased Pope Julius II della Rovere (1443–1513) – a very natural likeness, which he had commissioned and donated to the church – was on display on the altar of S. Maria del Popolo over the eight-day feast of the Birth of the Virgin, and all Rome was hastening to view it, 'so that it seemed like a jubilee'.[1] The church had been rebuilt by Julius's uncle Pope Sixtus IV della Rovere, and Julius had continued the family patronage there. The high altar of S. Maria del Popolo contained a miraculous icon of the Virgin and Child so he may have donated his portrait to the church as a votive offering, just as he gave another portrait of himself to the church of S. Marcello 'because of a vow made to an image of Our Lady', in December 1511.[2] The date of his donation is not known.[3] However, this extraordinarily lifelike effigy had probably not been on public view before, or it would not have elicited such widespread interest on this occasion. Although no mention was made of the author of the painting, a later commentator, describing the famous monuments of Rome in 1544, recorded two pictures by Raphael that were displayed on pilasters in the church on solemn feasts, one of which was 'Pope Julius with the beard seated in a velvet chair, in which the head, the draperies and the whole alike are marvellous'.[4] The other painting was a Holy Family, identifiable from subsequent descriptions as the *Madonna di Loreto*, now in the Musée Condé, Chantilly (fig. 129).[5] A few years later, Vasari characterised the portrait (still shown, with the *Madonna*, only on feast days) as 'so lifelike and true that it struck fear into those who saw it, as if it were the living man'.[6] The two paintings remained in the church until they were purloined in 1591 by Cardinal Sfondrati, from whose collection they passed into the Borghese collection. The portrait probably left Borghese possession between 1794 and 1797, and is next documented in the collection of J.J. Angerstein by 1823. Bought with Angerstein's collection in 1824, it was the first Raphael to enter the National Gallery.

In the earliest National Gallery catalogues, the portrait was classified – as it had always been in the past – as an autograph work by Raphael, but it soon came to be regarded as an early copy of a version in the Uffizi, Florence (though some authors were not persuaded that any of the extant versions could be identified as the original).[7] This situation persisted until 1969 when X-ray investigation of the National Gallery picture revealed numerous pentiments, including a radical revision of the background (see fig. 122). This, in conjunction with the discovery of the Borghese inventory number in the bottom left corner, convinced almost all critics that the National Gallery portrait was after all the original one by Raphael.[8]

The portrait is usually dated to the one-and-a-half-year period during which Pope Julius is known to have worn a beard. This he grew as a token of mortification between October and December 1510 while he was recovering from a serious illness brought on by the loss of Bologna to French troops. The pope vowed to remain unshaven until the French had been chased out of Italy, and removed his beard only when events seemed to take a turn for the better in March 1512. The earliest date Raphael could have taken a bearded likeness was 27 June 1511, when Julius returned to Rome from his Emilian campaign. It is probable that the portrait was painted very shortly after this date, because of its close compositional relationship with the frescoed portrait of Julius as Pope Gregory IX approving the Decretals in the Stanza della Segnatura (fig. 119) which was completed by August 1511 when Isabella d'Este's ambassador described it as 'His Holiness from the life with the beard'.[9] Many scholars have assumed that the easel portrait was painted after the *Decretals* fresco because of Julius's older and more haggard appearance (Vasari suggested Raphael painted it when work had begun on the Stanza di Eliodoro).[10] However, it has recently been established that the heads in the easel portrait and the fresco match each other exactly line for line, and that therefore one depends on the other.[11] It seems

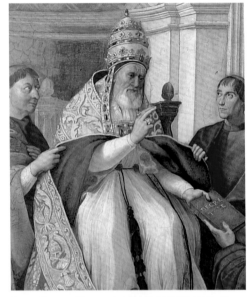

fig. 119 **Gregory IX approving the Decretals** (detail), 1511
Fresco, width at base 220 cm
Stanza della Segnatura, Vatican Museums, Vatican City

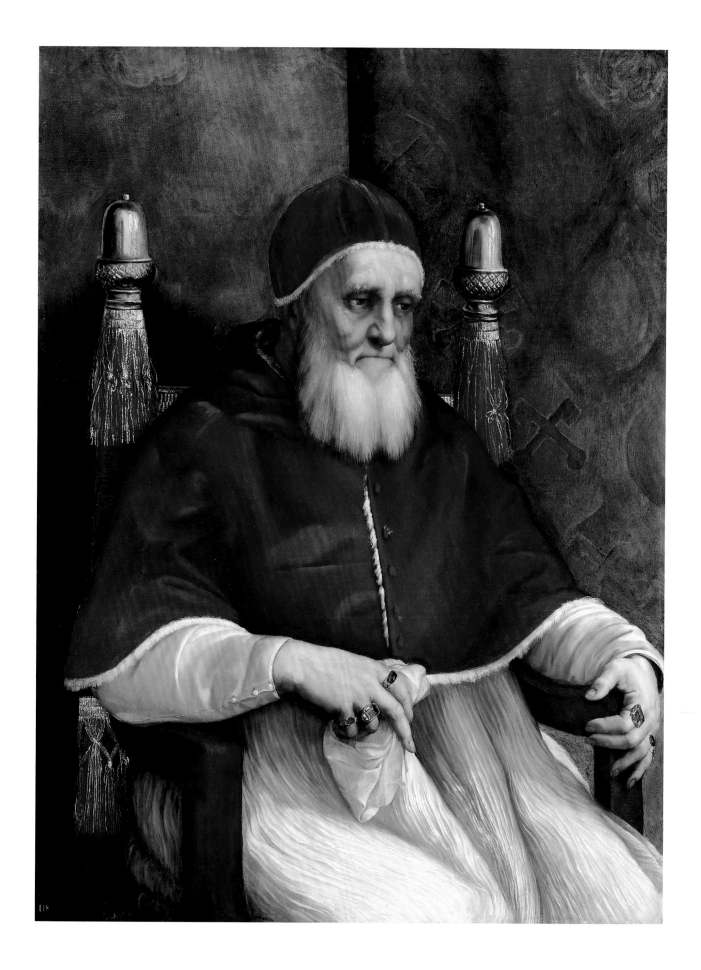

fig. 120 **The Expulsion of Heliodorus** (detail), 1511–12
Fresco, width at base 750 cm
Stanza di Eliodoro, Vatican Museums, Vatican City

fig. 121 Detail of fig. 128

more probable that Raphael made the easel portrait first, studying his model from life. The pope's careworn expression may be explained by his continuing precarious state of health. In August 1511, he was struck by a second near fatal illness during which he received the last rites.[12] It is less likely that such a powerful likeness, which shows signs of having been swiftly and spontaneously executed, could have been achieved from a traced design. The easel painting would thus have provided the model for the rather more formal head in the *Decretals*, reproduced using a tracing or cartoon (see cat. 100).[13] The precedence of the easel portrait could explain the pope's rather odd position in the *Decretals*, facing into the corner of the room. The frescoed likeness appears to have been tidied up for posterity (the vestigial moustache and unkempt beard, which led contemporaries to compare the pope to 'a bear' and 'a hermit', were tamed, and the pope is attired in splendid ceremonial robes rather than the more informal *mozzetta* and *camauro* of the easel portrait). Julius's image underwent further invigoration in the two later profile portraits in the Stanza di Eliodoro (figs 120–1), where he is characterised as an even more powerfully monumental figure, in defiance of the illnesses and decline we know preceded his death in 1513.

Before Raphael covered it with the plain green colour visible today, the background behind the pope originally consisted of a pattern of

teardrop-shaped fields containing heraldic symbols arranged in diagonal rows, representing alternately the papal tiara, crossed keys and another symbol which recent investigation has proved was on a blue field (fig. 122). This most likely bore the Della Rovere coat of arms, which consisted of a yellow oak tree on a pale blue field. The three symbols, a combination of papal and family arms, frequently appeared juxtaposed in Julian projects. Their combination in the cope of Pope Julius in the guise of Gregory IX handing over the Decretals (fig. 119) may constitute a discreet echo of the original background of cat. 99. One can only speculate why Raphael suppressed these emblems in favour of a more uniform green colour (followed in all subsequent copies). The design would certainly have looked very busy, with the yellow, white and blue design distracting from the extraordinary portrayal of the aged pope, deep in thought, and the dazzling *tour de force* of the two flanking golden acorns on the chair, alluding to the Della Rovere family name (*rovere* is Italian for oak). The emblems were in any case only roughly painted before Raphael switched to the less distracting green backdrop, the bisecting vertical above the pope's head perhaps denoting the corner of a room or canopied pavilion. It is worth noting that Justus of Ghent's portrait of Julius's uncle, Pope Sixtus IV, which Raphael would have known from Federigo da Montefeltro's *studiolo* in the Ducal Palace at Urbino, and which may have

inspired the composition of cat. 99,[14] also shows the pope with a green damask curtain behind him. The reflections in the two gleaming acorns of Julius's chair reveal that he was seated opposite a doorway in a narrow room lit by a mullioned window. Since similar windows had recently been installed to light Julius's apartment on the third floor of the Vatican palace, it is possible that one of these rooms provided the setting for the portrait, perhaps the richly appointed *antecamera* where the pope received visitors.[15]

Raphael's portrait was enormously influential and became the model for ecclesiastical portraiture over the following two centuries. Sebastiano, Titian (who made the copy of the Julius portrait today in the Palazzo Pitti), El Greco, Velázquez, Domenichino, Reni and Guercino are among the many artists who adopted this formula. The three-quarter-length format brings the viewer in very close, and this sense of intimacy, further enhanced by Raphael's penetrating psychological analysis of the warlike pope, feared for his *terribilità*, must partly explain what drew the crowds to S. Maria del Popolo.

Raphael portrays the pope as both meditative and powerful: his contemplative old face (with hooded eyes, sagging cheeks and wispy white beard and brows) contrasts with his large muscular hands with their long talon-like fingernails, one forcefully gripping the arm of his chair, the other

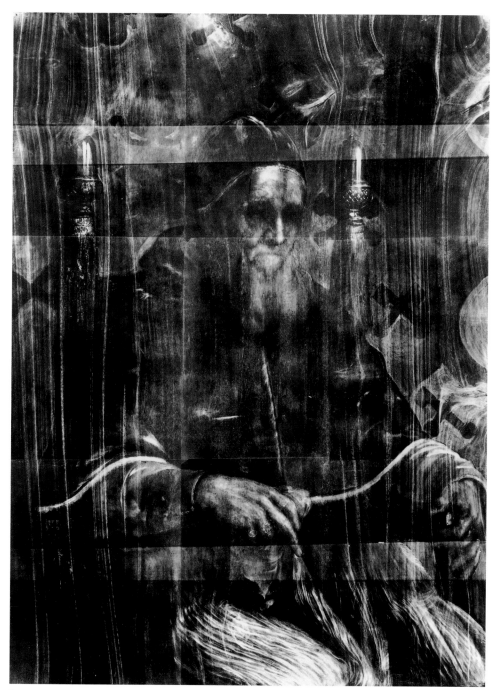

fig. 122 X-radiograph of cat. 99

aristocratically holding a white handkerchief, and both adorned with three rings set with enormous gems (in which the pope took a keen interest). Some of the more painterly qualities in the painting, both in the flesh and the textiles, suggest that Raphael was absorbing lessons from North Italian artists such as Sebastiano del Piombo and Lorenzo Lotto alongside whom he worked on different projects in Rome. With great virtuosity, he manipulated the thick lead-tin yellow paint to create the illusion of texture and sheen in the golden acorns, braid and randomly knotted tassels. Using a rapid feathering technique, he transformed sweeping bands of white paint into the fur trim of the pope's cap and hooded cape, and with deft strokes conjured up tufts of fur poking through the button-holes. CP

NOTES

1 Sanuto 1887, XVII, col. 60, fol. 36v; Shearman 2003, pp. 171–2.
2 Sanuto 1887, XIII, col. 350, fol. 192.
3 Kempers 2004 suggests it was donated in 1511 on Julius's recovery from a near-fatal illness.
4 Anonimo Magliabechiano, in Shearman 2003, p. 945.
5 The *Madonna di Loreto* is not mentioned in 1513 and could have entered the church any time before it is first recorded there in 1544. It was certainly not conceived as a pendant to the portrait of Julius since it differs in size and date (being a slightly earlier work of around 1509–10).
6 Vasari/BB, IV, p. 174.
7 Crowe and Cavalscelle 1882–5, II, pp. 102–9.
8 One exception is Beck 1996.
9 Shearman 2003, p. 148.
10 Vasari/BB, IV, p. 174.
11 We are grateful to Arnold Nesselrath for pointing this out.
12 Kempers 2004.
13 Julius was in a hurry to complete the last wall of the Segnatura as attested by his delegation of the scene of *Tribonian presenting the Pandects to Justinian* to Lorenzo Lotto; see Nesselrath 2000, pp. 4–12.
14 Campbell 1990, pp. 60–1.
15 Shearman 1971, pp. 6–7; Henry 2001, pp. 18–9.

SELECT BIBLIOGRAPHY

Vasari/BB, IV, p. 174; Gould 1970; Gould 1970a; Gould 1975, pp. 208–10; Zucker 1977; Partridge and Starn 1980; Martinelli 1987, pp. 521–4, pp. 521–24; Jones and Penny 1983, pp. 88, 157–9; Plesters 1990, pp. 28–31; Beck 1996; Kempers in Bonn 1998–9, pp. pp. 15–29; Hiller 1999, pp. 266–70; Henry 2001, pp. 18–19; Shearman 2003, pp. 171–2, 846–7, 945, 1068, 1111, 1325, 1369, 1398, 1400–1, 1415, 1440–2; Kempers 2004; Roy, Spring and Plazzotta 2004; Dunkerton and Roy 2004.

100 Head of Pope Julius II

after mid-1511

Red chalk on oiled paper, 36 × 25.3 cm
Inscribed on the mount in pen and brown ink:
*Rafaello da Urbino. / Ritratto di Giulio 2*do* – *1
Devonshire Collection, Chatsworth, 50

This drawing corresponds exactly in scale, detail and lighting with the National Gallery *Portrait of Pope Julius II* (cat. 99), as was confirmed by placing a tracing of the painting over the drawing. Physical and stylistic evidence suggests that the drawing was itself traced from the painting. The sheet of paper is exceptionally thin and was evidently brushed with oil, according to traditional practice,[2] in order to render it transparent (the oily strokes can be seen running horizontally across the sheet). The outlines were then lightly and somewhat hesitantly traced through (as in those around the cap), and subsequently reinforced in places with a firmer touch (as in the contours of the far cheek, the nose and the mouth). Tonal and textural qualities in the painting were necessarily rendered by line, hence the hatched shading standing for the shadows of the face and neck, and the linear spikiness of the beard. The heavy parallel hatching denoting the shadow in the area of the ear, for example, would only be logical in a copy after a painting, and not a drawing for it. The mechanical process of tracing also helps to explain the drawing's flat appearance (especially in the crudely drawn cap), and its lack of unity and overall coherence. Although some scholars have considered it an autograph study by Raphael from the life,[3] his characteristic springiness of touch and sensitivity to outline, modelling and form are notably absent. The lack of coherent structure in the eyes and lips greatly dilutes the awe-inspiring psychological intensity of the painted portrait.

The *Portrait of Pope Julius II* (cat. 99) was the prototype of a host of replicas, which must have been made using scale cartoons or tracings. A faithful full-length cartoon attributable to Raphael's workshop (with all the tonal values of the painting systematically recorded in black chalk and white heightening, and pricked for transfer) survives in the Corsini collection in Florence.[4] The Chatsworth tracing is probably also a product of Raphael's workshop, made either with the intention of incising or pricking the outlines for transfer to another surface (though red chalk would be an unusual medium for this procedure), or simply as a record of the painting for the workshop's reference. The facial features of Pope Julius in *Gregory IX approving the Decretals* in the Stanza della Segnatura correspond exactly with those in the National Gallery portrait, demonstrating the reproductive function that detailed templates of the Pope's head such as the Chatsworth tracing might have served. C P

NOTES

1 The hand is that of Jonathan Richardson (sen.), the drawing's former owner.
2 Cennini 1960, p. 14.
3 Fischel 1948, p. 93; Joannides 1983, pp. 78–9; Martinelli 1987, pp. 523–9.
4 Assirelli 1983, no. 77.

SELECT BIBLIOGRAPHY

Fischel 1913–41, VI, no. 257; Fischel 1948, p. 93; Gere and Turner 1983, no. 140; Joannides 1983, pp. 78–9, no. 291; Knab, Mitsch and Oberhuber 1984, no. 382; Martinelli 1987, pp. 523–4; Jaffé 1994, no. 330; Kempers in Bonn 1998–9, p. 434, no. 3.

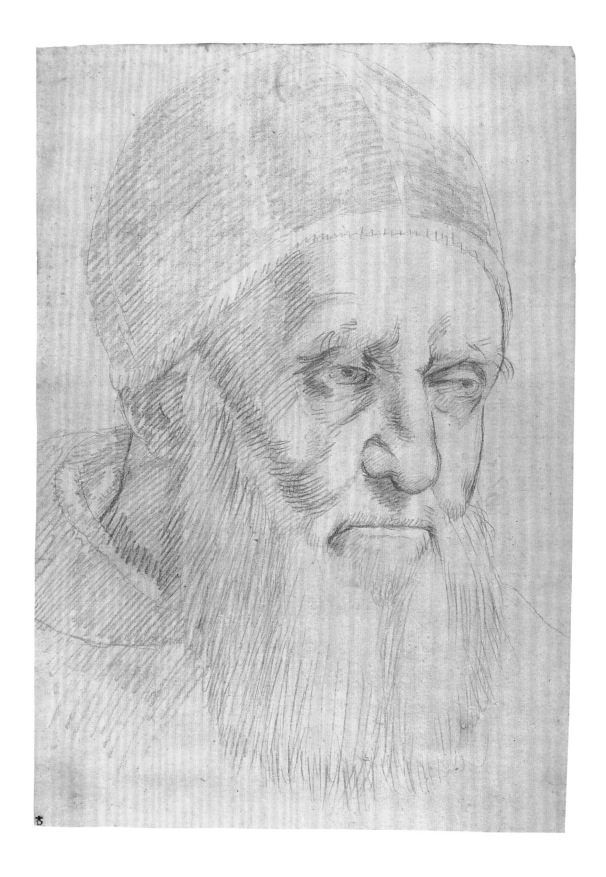

101 Portrait of a Lady ('La Donna Velata')

1512–13

Oil on canvas, 82 × 60.5 cm
Galleria Palatina, Palazzo Pitti, Florence, 1912, no. 245

This sensuous portrait of a young woman, known as the *Donna Velata* (Veiled Lady), stands at the threshold of a new chapter in Raphael's art. The tactile rendering of both flesh and fabric marks his response to a more painterly approach to portraiture pioneered by Venetian artists, and particularly by Sebastiano del Piombo who had arrived in Rome in 1511. Like Raphael's earlier female portraits, such as the *Lady with a Unicorn* and *Maddalena Doni* (cat. 51 and fig. 29), the composition of *La Velata* depends on Leonardo's *Mona Lisa* (fig. 75). But the clear outlines and simplified volumetric forms that characterise these earlier works are here replaced by softer transitions in the flesh painting and very free and energetic brushwork in the costume. By exploiting such effects, Raphael was able to introduce an enhanced sense of immediacy and intimacy into his portraiture. Vasari, who saw (and indeed copied) the painting when it was in the Florentine house of his friend Matteo Botti, was particularly struck by its lifelike quality, describing it as 'a most beautiful portrait, which seemed really alive'.[1]

The sitter's identity has been the subject of romantic speculation ever since Vasari first suggested that she was the mistress loved by Raphael until his death.[2] Subsequent tradition associated this mistress, to whom there are several tantalising references in Vasari's biography, with the legendary Fornarina ('Baker's daughter'), thus named because she was the daughter of a Sienese baker called Francesco Luti. The Fornarina is also frequently linked with the portrait of a half-naked woman wearing an armband inscribed with Raphael's name in a portrait in the Galleria Nazionale, Rome. Whoever that portrait is by (its attribution oscillates most often between Raphael and Giulio Romano), the woman's features are quite distinct from those of the sitter in cat. 101, and her provocative attire, suggestive gesture and proprietorial armband give her a much better claim to be a woman intimately involved with Raphael. *La Velata*, on the other hand, appears from her sumptuous costume to be a wealthy noblewoman, and the voluminous cream-coloured veil that enfolds her was a type of garment worn by Roman matrons. The sitter's elevated status is further underlined by the tripartite jewel in her hair, her elegant cornelian necklace and a substantial gold bracelet set with precious gems. Raphael went to special lengths to convey the elaborate slashed sleeve of her dress, delighting in depicting its abundant folds of cream silk damask, and in tracing the complex undulations of its gold trim. His scrutiny also penetrates inside the sleeve, alighting on the gleaming gold lining and snatches of the cambric undershirt, the soft crumpled folds of which emerge in ripples of white paint through the apertures, at the cuff, and, with greater transparency, over the sitter's bosom above the low *décolletage* of her bodice.

It is not surprising that Vasari and later commentators projected the myth of Raphael's lover onto this demure yet seductive portrait, for this idealising vision of womanhood owes much to conventions of courtly love poetry (a genre which Venetian painters were seeking to rival in their paintings). Raphael's interest in poetic composition following his arrival in Rome is attested by several Petrarchan sonnets of his own invention drafted on sketches for the frescoes in the Stanza della Segnatura (see cats 36–9). In one of these, he uses conventional imagery to evoke his beloved's face, describing how he became 'ensnared' by the beautiful lights of her eyes, her snow-white skin, and rose-coloured blush.[3] *La Velata* seems the very embodiment of such qualities, captivating the viewer with her direct, penetrating gaze, the smile hovering about her sensitive mouth, and the alluring softness of her flesh, the merest hint of abandon implicit in the escaped lock of hair undulating across her temple. In the poem, Raphael also praises his beloved's lovely discourse ('*bel parlar*'), and the portrait too is made to 'speak' through the gesture of the hand held on the heart. Thus while the sitter may have been a real person (and certain features such as her brows, nose and ears seem quite particularised), she is poetically refashioned according to the painter's personal ideal (what Raphael called 'a certain Idea that comes into my mind'[4]). Enamoured of his own creation, Raphael used the lady's features as the prototype for the Virgin in several religious paintings of around this time (she recurs as a celestial vision in the *Sistine Madonna* and as the tender mother in the *Madonna della Sedia*; figs 132 and 44). Raphael's sensual feminine ideal in turn inspired portraits of unnamed beauties by Venetian painters, including Titian. CP

NOTES

1 '*un ritratto bellissimo, che pareva viva viva*' (Vasari/BB, IV, p. 190). Although almost certainly painted in Rome, nothing is known of the portrait before Vasari's mention of it in 1550. For a comprehensive description of its subsequent history and critical fortune, see Gregori (ed.) 1984, no. 15.
2 '*una sua donna, la quale Raffaello amò sino alla morte*' (Vasari/BB, IV, p. 190).
3 Shearman 2003, p. 131.
4 See the letter purporting to be from Raphael to Castiglione, which suggests that this tendency towards idealisation was his conscious choice (ibid., p. 735): '*per dipingere una bella, mi bisogneria veder più belle . . . scelt[e] del meglio. Ma essendo carestia di belle donne . . . io mi servo di certa Iddea che mi viene nella mente.*' Although Shearman is probably correct in dating the letter posthumously (about 1522) and attributing it to Castiglione himself, it nevertheless conveys an authentic flavour of Raphael's thought.

SELECT BIBLIOGRAPHY

Vasari/ BB, IV, p. 190; Passavant 1839–58, I, pp. 224–8; II, pp. 336–8; Dussler 1971, p. 32–3 (biblio); Oberhuber 1982, pp. 156–7; Gregori (ed.) 1984, no. 15, and pp. 267–8; Paolucci in Paris 2001–2, no. 6; Shearman 2003, pp. 1080, 1153, 1327, 1380, 1383.

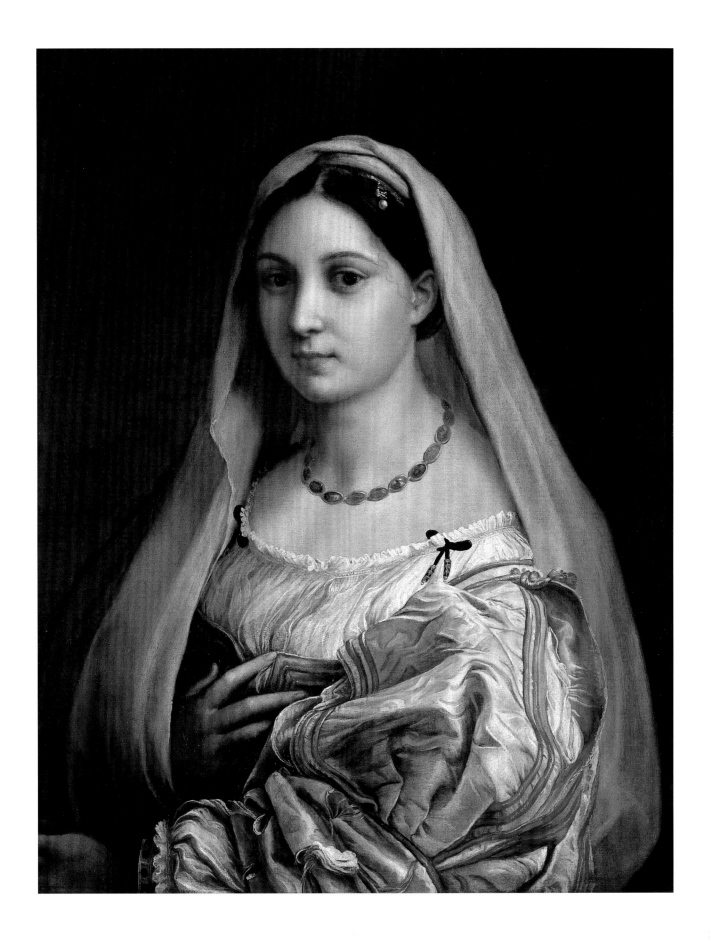

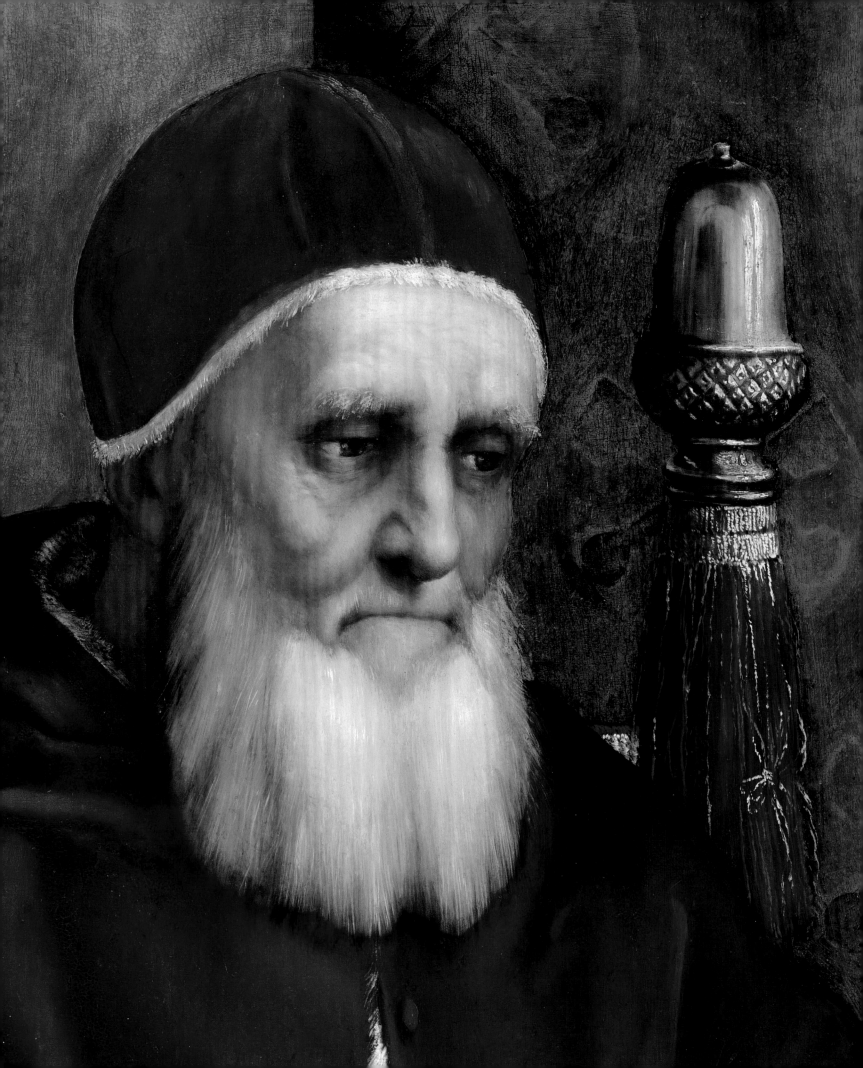

Raphael and Pope Julius II

ARNOLD NESSELRATH

Julius II was elected pope in the shortest conclave in history on 31 October 1503[1] and died in 1513. Had he succeeded his uncle Sixtus IV in 1484 in the first of his three attempts to achieve the supreme office of the Western Church, he would have been one of the three longest reigning popes up to the present date. Even as it was, his decade-long pontificate was momentous. Nowhere can the impact of Julius's personality be experienced more forcefully than in Raphael's portrait in the National Gallery (fig. 123 and cat. 99). Here the extraordinary interaction between patron and artist is ultimately manifest. It is no surprise therefore that the portrait became the most influential of all papal likenesses.

Julius II's politics and his means of realising them led very soon to an image of the Pope which is perhaps most effectively conveyed in Vasari's famous anecdote about the bronze statue of Julius that Michelangelo was commissioned to erect in Bologna in the winter of 1506–7. According to this, when asked by Michelangelo whether he wanted a book put into the figure's left hand, the Pope replied: 'Give me a sword; I am not a man of letters.'[2] From such narratives, however apocryphal, sprang the image of Julius II as the warrior pope.[3] It was less his notorious presence on the battlefield that earned him this title, however, than his conviction, unprecedented in its strength, that the pope could fulfil his spiritual mission only if he also wielded temporal power. Jakob Burckhardt appreciated this policy, debatable though it may be, and delivered a much more subtle judgement on Julius II than most later historians, calling him the 'saviour of the papacy'[4] who had used his office to the benefit of the Church rather than his own person or family.[5] This view seems in fact to reflect the reactions of Pope Julius's contemporaries. When one considers, for example, that he intended to seek a two-thirds majority of the college of cardinals for all major decisions, including the nomination of new cardinals,[6] he hardly comes over as an autocrat or a second Julius Caesar. The question of whether Julius II was the warrior pope or the saviour of the papacy has an essential bearing on our understanding of the works Raphael created for him, as well as his patronage as a whole.[7]

Perhaps basing their arguments on suggestions made at the time that Julius Caesar was his model – a comparison the Pope may have found flattering but nonetheless generally rejected[8] – art historians over the last century have built up Julius's Caesarean image,[9] neglecting the pragmatic side of his strong and choleric personality.[10] In this context Michelangelo's own account of his first plan for the tomb of Julius II, which the artist's first biographers Vasari and Condivi state was commissioned in 1505 as a free-standing monument,[11] has given rise to the most fantastic visions of the project, of its relationship with the building history of the new basilica of St Peter's, and of Julius's self-imagery in general.[12] The understanding of Raphael's Stanze has also often suffered from this tendency. It should be remembered, however, that the evidence for the first tomb project of 1505 is very limited,[13] and that Michelangelo's surviving preparatory drawing contradicts his biographers' account, since it shows a wall tomb with classical orders and is derived from a Quattrocento tradition.[14] It is, furthermore, indicative of Julius's vision that his tomb proved not to be his first priority and that he gave precedence to the reorganisation of the Sistine Chapel,[15] the chapel of the Apostolic residence at the Vatican Palace, and to the new frescoes on its vault.

It is necessary to distinguish Julius's own intentions from the ambitions of artists like Bramante and Michelangelo, though he had personally recognised both men's capacities early on. When still a cardinal he had got to know Bramante in Milan, and it was he who sent the painter-architect to Rome and commissioned from him the fresco over the Porta Santa at the Lateran Basilica, thus becoming his first Roman patron.[16] When Julius was elected pope, he called on Bramante's services as architect to design the new scheme for the Vatican palace and to rebuild St Peter's basilica; at the same time he put him in overall charge of all architectural and artistic enterprises in Rome, including his urban planning schemes.[17] As for Michelangelo, it seems to have been his growing fame and his *Pietà* in the Chapel of the King of France next to St Peter's that captured Julius's attention.[18]

This was the environment at the papal court when Raphael arrived in Rome in 1508. At first Julius had tried to entrust the decoration of his new state rooms, known today as the Stanze,[19] to Perugino.[20] When the old master declined and chose to work only in the last and most important room, the Pope summoned Luca

fig. 123 Detail of cat. 99

281

Signorelli.[21] Both artists had already successfully worked for Sixtus IV in the Sistine Chapel from 1481 to 1482,[22] and were among the most famous painters in Central Italy at the time. There are slightly varying reports regarding the circumstances surrounding Raphael's arrival in Rome. According to the artist's first biographer Paolo Giovio, his 'authority' was not yet 'confirmed'[23] when he arrived in the papal city, dominated by so many strong personalities. He had, however, received a number of important commissions in Florence, in Perugia, and for Siena. Vasari reports that Raphael had been called from Florence by Bramante whom Vasari calls his relative,[24] and thus received his recommendation at the papal court from its most powerful artistic and architectural figure. Furthermore, the ageing Perugino, himself engaged in the Stanze, albeit with a reduced presence at his own request, was Raphael's former teacher. Only a few years earlier, in the Piccolomini Library in Siena, Raphael had helped Pintoricchio, the great entrepreneur who then became the preferred painter of the Della Rovere family and was about to begin to decorate the crossing vault of S. Maria del Popolo in 1509.[25] Raphael must have known Signorelli quite well – on one occasion he drew on a piece of the older artist's scrap paper[26] – and even Michelangelo was an old acquaintance from earlier days in Florence when they had met in the circle of Baccio d'Agnolo.[27] All these major players on the Roman scene were Raphael's friends and could have been his advocates when Julius II was looking for someone to decorate the middle room of his Stanze. In fact, writing from Florence on 21 April 1508 to his uncle Simone Ciarla in Urbino, Raphael requested letters of recommendation to Piero Soderini to work in 'una certa stanza' which 'sua S.' was allocating.[28] If 'sua S.' really means 'sua Santità',[29] Raphael's move to Rome was not as sudden as it seemed.[30]

At the papal court the situation was very different from that in Florence. Raphael had no workshop when he arrived, but soon found himself working alongside Sodoma and the Fleming Johannes Ruysch. Furthermore, new intellectual challenges were presented to him by the patron or his theological advisers, as can be seen from the evolution of the ideas in the preparatory drawings for the *Disputa*. According to Vasari, Bramante promoted Raphael and convinced Julius to let him demonstrate his skills by painting a wall in the room destined at the time as Julius's library,[31] and now known as the Stanza della Segnatura. In contrast to the rooms on either side, the physical structure of the cross-vault in this room was modified and its edges smoothed, probably by Bramante,[32] indicating its special status. Interpreting the internal chronology of the room's paintings and their iconography is still one of the greatest challenges faced by art historians. Major disturbances during the design and execution can be detected both in the drawings and on the painted surface, making construction of the evolution of the room particularly difficult. Related documents are scarce. Raphael's first biographers already constructed their own versions of the story, so their degree of reliability is difficult to establish. Reconsidering the sources,

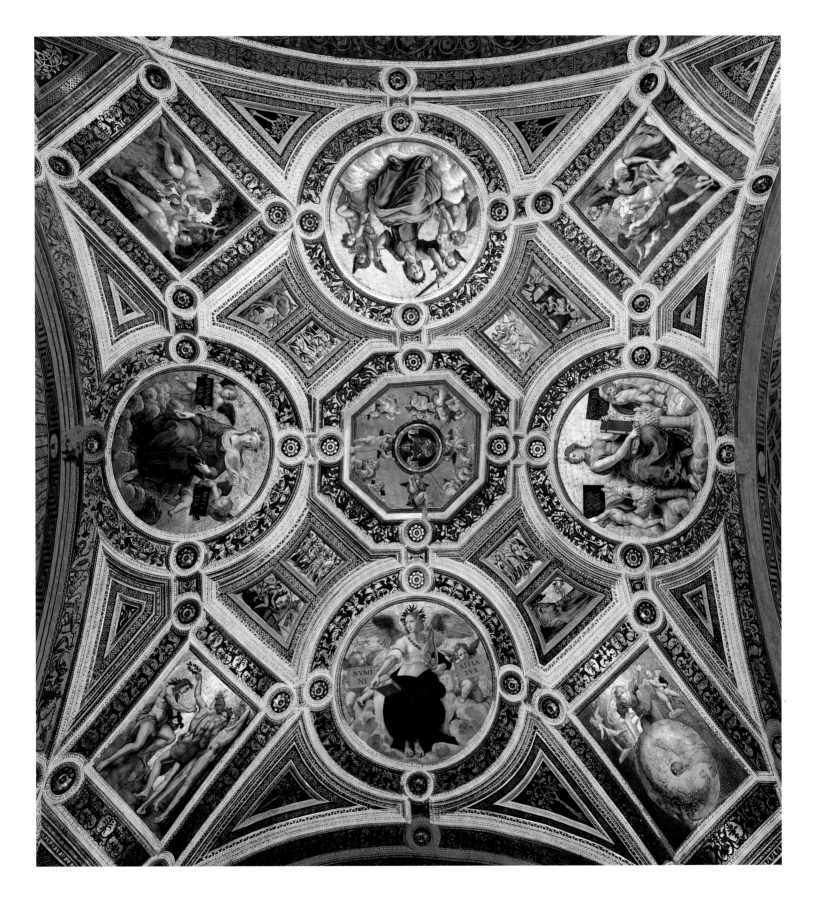

comparing them with the technical data available, and scrutinising the whole stylistically may bring us closer to the dialogue Raphael and his patron Julius exchanged over the frescoes.

The Pope took a personal interest in the decoration of his apartment, where Raphael worked, in Giovio's words, 'to Julius's prescription'.[33] Painting in the Stanza della Segnatura started, as was normal, from the vault (fig. 124) and proceeded logically downwards from the central marble keystone with Nicholas V's coat of arms.[34] The putti around the centre and the fictive structure of the vault and its *grotteschi* can be attributed on stylistic grounds to Sodoma, who must therefore have begun the painting.[35] Sodoma was hired for a well-defined piece of work, since he just had to paint an amount worth 50 ducats, the same amount as Johannes Ruysch,[36] who must be the second hand identifiable in the vault's ornaments and monochromes. That it was Sodoma who transformed the initially circular oculus in the centre into the octagon that forms the basis for the present scheme[37] fits Vasari's attribution to him of the overall design.[38] There is no evidence that Raphael was the inventor of the scheme, and he may indeed have been hired initially to paint the walls alone. However, since the finishing touches by Sodoma or Ruysch overlap the border of the tondo containing the allegorical figure of *Theology*, which was prepared in drawings and executed by Raphael, all three artists must have worked at least for some time together on the ceiling.[39] Inconsistencies in Raphael's *giornate* (the sections of plaster equivalent to a day's work) and in the paint layers also bear witness to a disturbed sequence in this area.[40] Work here may in fact have been interrupted, since in a later sketch on a preparatory sheet with a drawing for Adam in the *Disputa* (fig. 125) Raphael articulated the areas of the vault he had to fill, which probably had not yet been executed when he was working on this wall.[41]

The framing arch around the *Disputa* was executed together with the vault, and the plaster of vault and arch was applied simultaneously. It was thus intended to continue the work by painting this wall first. According to Vasari, however, Raphael's first mural for Julius II was the *School of Athens* (fig. 37), preceding even the ceiling.[42] Raphael's struggle with the iconography of the all-important *Disputa* can be traced in the preparatory drawings, which may also document delay in getting started with this fresco. This may have suited Bramante. For if we are right to assume that he advised Raphael on the invention of the architectural setting in the *School of Athens*,[43] this fresco could then have provided an opportunity for the great architect to demonstrate to the Pope, through the brush of his protégé Raphael, the imposing and sober monumentality he envisaged for the new St Peter's. The hall in Raphael's *School of Athens*, with its classical orders and coffered vault, is indeed an unprecedented structure both in built and painted architecture up to that date, and it remained the most complete idea Julius II could ever have had of how his new basilica, finished long after his death, would eventually look.

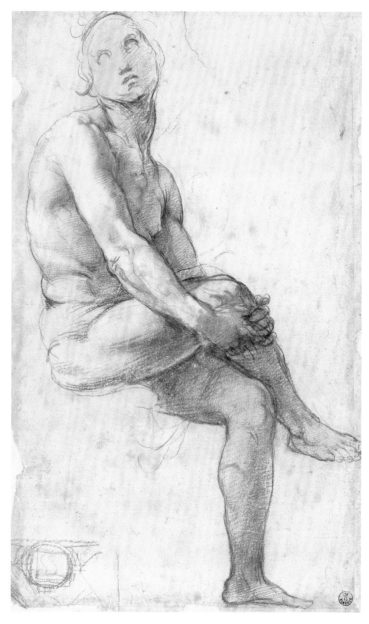

fig. 125 **Study for Adam**, about 1508–9
Black and white chalk, 35.7 × 21 cm
Gabinetto dei disegni e delle stampe degli Uffizi, Florence, inv. 541 E

Several additional arguments make Vasari's version of the chronology of the facing walls worth considering. There are two changes in technique visible in the *School of Athens*, and in both cases it is the second procedure which is consistently found in the rest of the room. The upper half of the fresco is painted on poorly prepared plaster which has formed a pattern of numerous small cracks not found in the lower half.[44] It seems that Raphael had initial problems with the Roman *pozzolana*, a kind of local cement, and modified the recipe for his plaster, which is consistent elsewhere in the room. Even more significant is the fact that, whereas in much of the *School of Athens* Raphael reinforced the pouncing from the pricked cartoon by incising the outlines directly with a stylus into the plaster, in the last *giornate* of the group surrounding Ptolemy in the bottom right-hand corner he substituted drawing with a brush for stylus incision. Brush drawing is found on all other walls in the room and also, it should be added, in the areas Raphael painted on the ceiling.

Furthermore, on the sheet studying a late addition to the *Disputa*, there appear the first sketches for *Parnassus* (fig. 38), the third fresco executed in the room,[45] suggesting a close chronological sequence between the two. After the *School of Athens* was completed, a new area of plaster was inserted for the figure of the 'Thinker' in the foreground (fig. 126).[46] The insertion of this contemporary portrait may have been requested to conform with all the other frescoes in the room which contain portraits.

Raphael was paid 100 ducats in his first instalment, twice as much as Sodoma and Ruysch. He received the money on 13 January 1509,[47] which suggests that by then he had finished a significant part of the decoration in the Segnatura. He had also been given responsibility for painting the entire apartment, since Julius sent away all the other artists working in the Stanze,[48] although this decision undoubtedly meant prolonging the campaign.

A stylistic comparison of the *School of Athens* and the *Disputa* is not decisive for resolving their relative chronology since, while the compositions are quite different – the former being set in architecture, the latter in a landscape – the distribution of the figures in pictorial space is extremely complex in both, and the colour schemes, involving 'shot' colours (*cangianti*), are very similar and also resemble those of Raphael's figures on the vault. A different approach on Raphael's part, with a more monumental figure style, intense portraits and a virtuosity in juxtaposing colours or tones in the distribution of light and shade, occurs with the *Parnassus*. The technical data of the sequence of the *giornate* establish that this fresco was the third one to be painted.[49] More important than hypothesising the precedence of the *School of Athens* over the *Disputa* or vice versa, is to notice the formal and iconographical bonds between the two murals, painted in the course of about twelve months.

It was the famous theorist Giovan Pietro Bellori who in 1695 reversed Vasari's dates for the two murals, thereby influencing

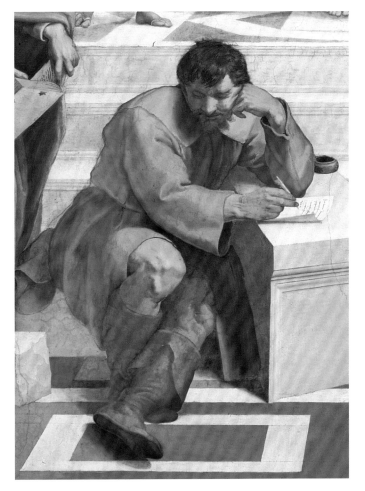

fig. 126 Detail of fig. 37

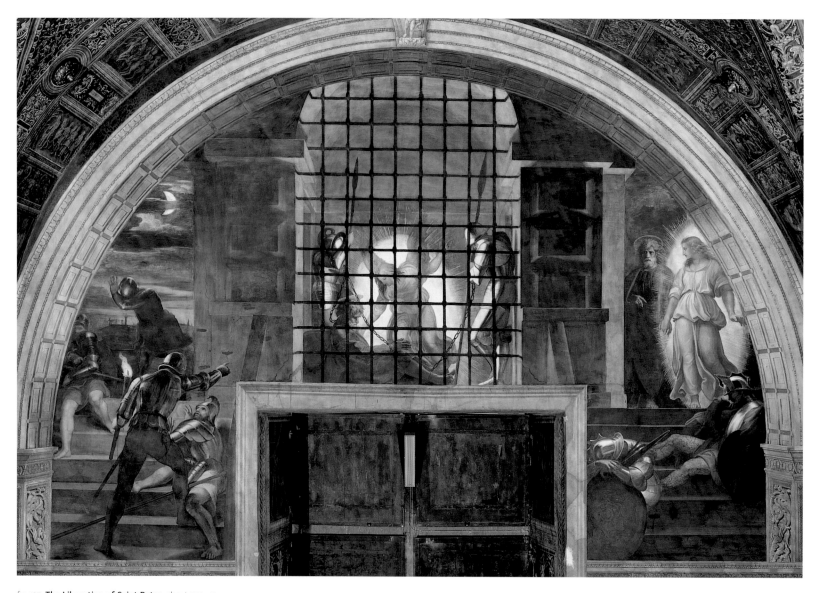

fig. 127 **The Liberation of Saint Peter**, about 1512–13
Fresco, width at base 660 cm
Stanza di Eliodoro, Vatican Museums, Vatican City

286

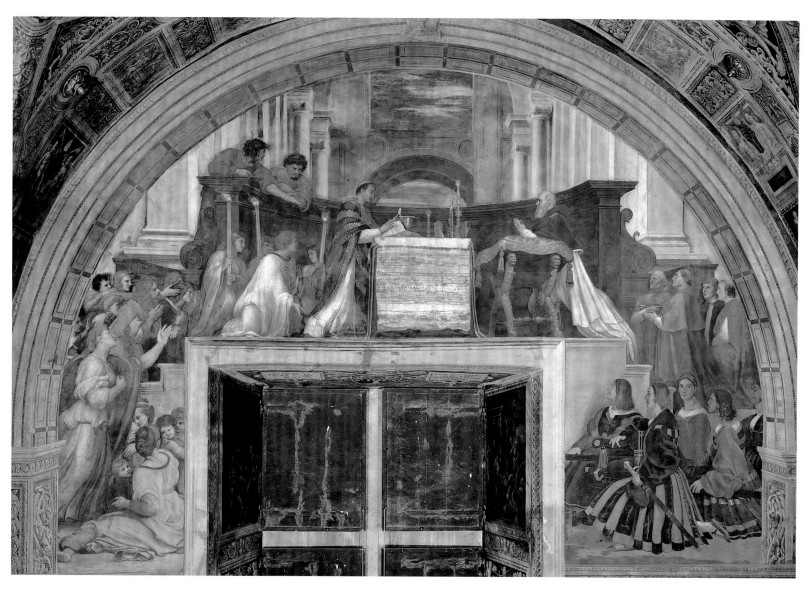

fig. 128 **The Miracle of the Mass of Bolsena**, about 1512–13
Fresco, width at base 660 cm
Stanza di Eliodoro, Vatican Museums, Vatican City

art-historical discussion right up to the present day.[50] Tied to his classicising ideas, Bellori gave a stylistic interpretation to the iconographic concept of the *Disputa*, stressing its medieval reminiscences. He did not take into consideration that in this fresco, more than in any other of Raphael's compositions, the artist's invention was under the constant scrutiny of the papal theologians. To represent the Christian faith Raphael did indeed recall the scheme of medieval apse decorations, but consciously. It allowed him to shape the entire Stanza, capitalising on the power of a Roman tradition over a thousand years old. Theological configurations such as the Deesis – the risen Christ between his two primary intercessors at the Last Judgement, the Virgin Mary and Saint John the Baptist – were immediately familiar and understandable from the Roman basilicas. The Western Christian Church is shown assembled in heaven and on earth around the Trinity and the Holy Sacrament. Bellori was wrong to assume that Raphael painted on a gold ground: instead he used extraordinary pictorial means to imitate the effects of gold with yellow pigments, and to create clouds of angels in the semicircular space in front.

The figures in the *Disputa* which Raphael or his theological adviser wanted to be recognisable are identified through attributes or even inscriptions inside their haloes. Likewise, the main philosophers in the *School of Athens* are similarly distinguished. The dominating role of theology, its constant evolution through the discussions of the great teachers of the Church, and its interaction principally with philosophy, are the main themes of the room. *Parnassus*, painted after December 1509, shows the benefit of a flourishing papacy and celebrates the beginning of a new Golden Age.[51] After the military disaster of 1511 when Julius lost Bologna and grew his famous beard, Raphael was asked to eliminate the previously planned scene of the *Opening of the Seventh Seal*,[52] and substitute instead the *Tribonian presenting the Pandects to the Emperor Justinian* and the *Gregory IX approving the Decretals* underneath the *Three Virtues*. Thus the Jurisprudence wall was transformed into a more explicit representation of papal authority (fig. 39).

This approach was maintained in the Stanza di Eliodoro, an audience chamber, painted by Raphael between 1511 and 1514. Here Julius wanted his immediate political concerns expressed – the liberation of Italian territories from French occupation was an urgent necessity in order to save the papacy. Raphael invented a highly sophisticated iconography in which historical instances of God's intervention on behalf of his people, from the Old Testament to the Middle Ages, are conflated with the time of the bearded Pope Julius II, personifying the calamity of the actual Church.[53] In the *Expulsion of Heliodorus,* an episode from the Old Testament, Julius is on hand when angels save the treasure from the temple in Jerusalem, thus securing the temporal power of the high priest; the *Liberation of Saint Peter* (fig. 127), a reference to Julius's titular church as cardinal (S. Pietro in Vincoli), alludes to the overcoming of

the schism initiated by French cardinals; the *Repulse of Attila* recalls the most dramatic threat posed to the Church by invaders of Italy; and in the *Miracle of the Mass of Bolsena* (fig. 128) Julius, venerating the relic of the *corporale*, participates in the medieval miracle during which the bleeding wafer confirmed a Bohemian priest's faith in transubstantiation and simultaneously calls upon God's help in his own political turmoil. The wall paintings in the Stanza di Eliodoro are perhaps Raphael's most beautiful frescoes, with their extraordinary lighting effects in which the painter succeeds in capturing the essence of divine light in the face of the natural light coming through the window.

Under the pressure of the growing demand for his art, Raphael had already established an efficient workshop as work progressed for the Stanza della Segnatura. Lorenzo Lotto had executed *Tribonian presenting the Pandects* according to the master's designs,[54] and Baldassare Peruzzi assisted with a monochrome in the window embrasures.[55] Both were fully trained artists. Integrating these personalities and benefiting from their inspiration, while also training up young painters such as Giulio Romano, Giovanfrancesco Penni and Perino del Vaga, became one of the secrets of Raphael's success and established his reputation as a pleasant and attractive person as well as an efficient organiser.[56]

During his employment by Julius II in the Stanze, Raphael also accepted commissions from the Pope's banker, Agostino Chigi,[57] and a number of panel paintings were produced in his studio. Whether Julius himself commissioned the *Madonna di Loreto* (fig. 129) now in Chantilly, and for what purpose it was initially intended, remain open questions.[58] But the fact that this painting was exhibited together with Raphael's portrait of Julius in the church of S. Maria del Popolo, for which the Della Rovere had a particular devotion, is striking confirmation of Julius's admiration of the painter. The two pictures were paired on just this one occasion, since the *Madonna* had been painted about two years earlier than the papal likeness, as becomes clear from the preparatory drawings,[59] as well as from the similarity of the figure of the Virgin with that of *Justice* (fig. 130) in the vault of the Stanza della Segnatura.[60]

The integration of fully trained collaborators continued in Raphael's workshop for the production of easel paintings, such as his first great Roman altarpiece, the *Madonna di Foligno* (fig. 131).[61] The panel was commissioned by Julius's friend and private chamberlain Sigismondi de'Conti. It was finally installed, probably in 1512, on the high altar of S. Maria in Aracoeli, where it was juxtaposed with the much-praised medieval apse decoration by Pietro Cavallini,[62] a confrontation with the very tradition on which Raphael had drawn for the *Disputa*. The landscape in the background of the altarpiece was executed by the Ferrarese painter Dosso Dossi in the latter's own personal style.[63]

Perhaps Raphael's most famous altarpiece, the entirely autograph *Sistine Madonna* (fig. 132), was also commissioned by Julius II. It was

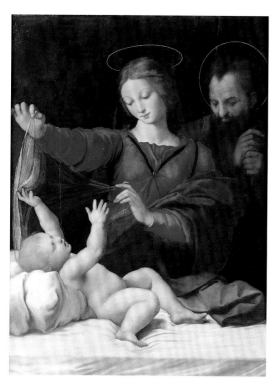

fig. 129 **The Madonna di Loreto**, 1509–10
Oil on wood, 120 × 90 cm
Musée Condé, Chantilly, N040

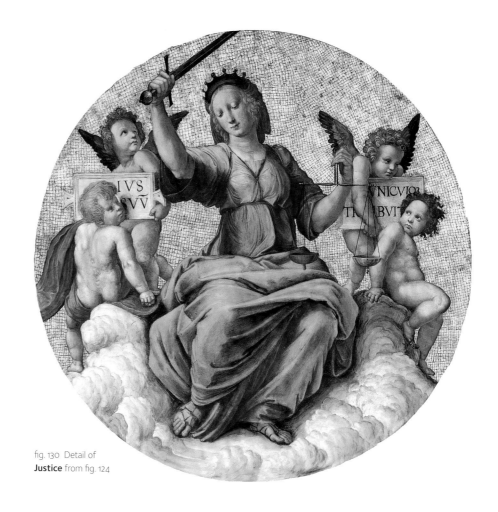

fig. 130 Detail of
Justice from fig. 124

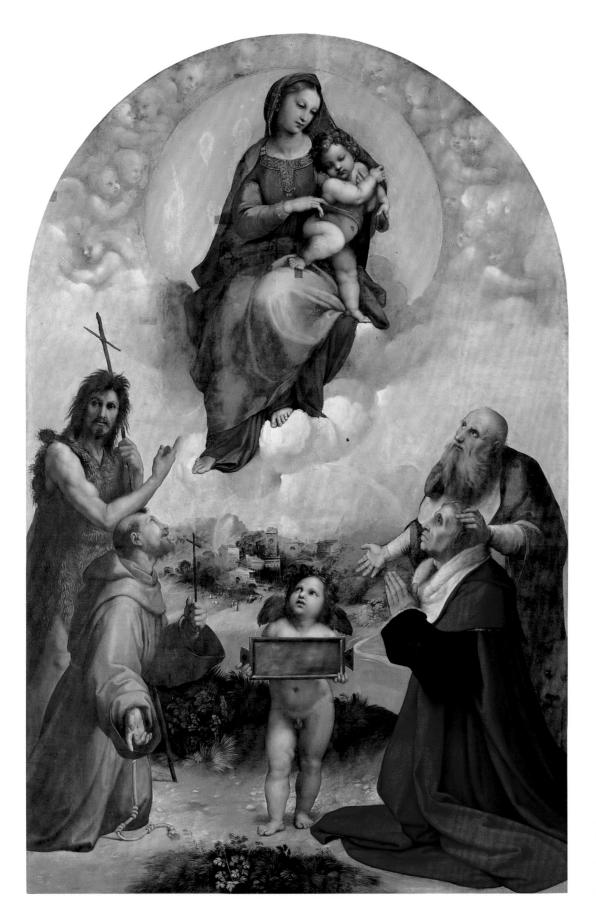

fig. 131 **The Madonna di Foligno**, about 1512
Oil on canvas (transferred from wood), 301 × 198 cm
Vatican Museums, Vatican City
inv. 40329

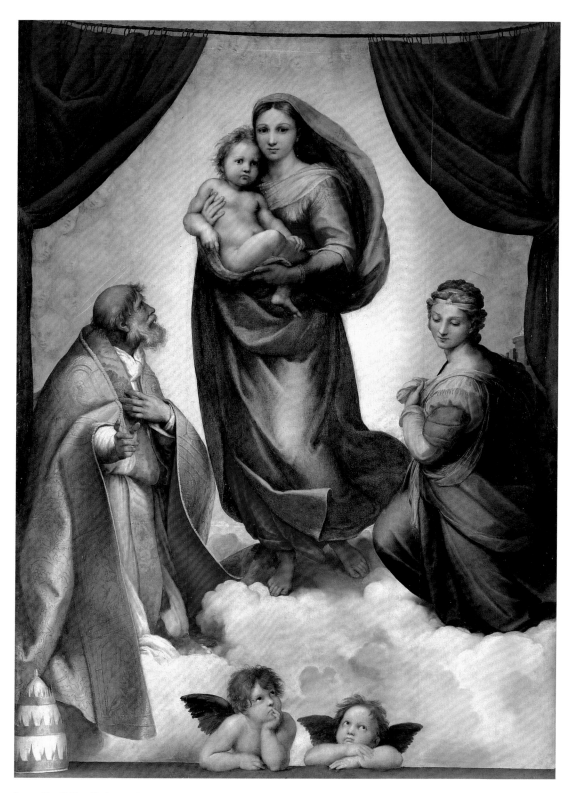

fig. 132 **The Sistine Madonna**, about 1512–14
Oil on canvas, 265 × 196 cm
Gemäldegalerie Alte Meister, Staatliche Kunstsammlungen, Dresden, 93

never intended that the painting should remain in Rome, as it was always destined for the church of S. Sisto in Piacenza.[64] Probably commissioned in mid-1512 at the peak of the work in the Stanza di Eliodoro and finished after Julius's death on 21 February 1513, it sums up Raphael's artistic achievements under his first papal patron – the monumentality of his forms, the originality of his inventions, the intriguing use of space and the creation of visions through the use of colour and light.

The Stanza di Eliodoro was finished under Julius II's successor, the Medici pope Leo X. The changes Leo demanded in the last fresco in the room, the *Repulse of Attila*, shows on the one hand the continuation of Julian politics and patronage, and on the other the new challenges that Raphael and the other artists at the papal court now had to face.[65]

When Bramante died only a year after Leo's election in April 1514, the Pope called upon Raphael to succeed his friend and mentor as chief architect not only for the new St Peter's, but for the whole Vatican. Palaces, churches, and, perhaps most important of all, the Villa Madama were to follow.[66] For Raphael it meant even greater collaboration with other artists and architects. Antonio da Sangallo the Younger became his assistant for his architectural projects.[67] Lorenzo Lotto executed the new ceiling of the Stanza di Eliodoro after Raphael's autograph cartoons,[68] but left Rome after it became clear that Raphael would retain, in addition to his other offices, the direction over the papal painting projects.[69] Lotto's position was filled by Giovanni da Udine, another experienced artist with a Venetian background, who had trained in Giorgione's workshop.[70] An enterprise almost comparable to the Julian Stanze was Raphael's

commission from Leo to design the cartoons for the tapestries in the Sistine Chapel.[71] Raphael's contacts in Rome with humanists, poets, learned men and colleagues such as Fra Giocondo[72] also earned him papal responsibilities beyond his activities as painter and architect. Thus he distinguished himself in his study of the antique, for which he had particular support from Giovanni da Udine[73] and arrived at a scholarly archaeological method.[74] Raphael never ceased to create great works himself. When he died on 6 April 1520 his second most important altarpiece, the *Transfiguration*, was almost finished.[75]

It is not surprising that Vasari hails Raphael as '*un ottimo universale*'.[76] As soon as he arrived on the Roman scene under Julius, he revealed a more pragmatic approach than the restless searching of Leonardo. Michelangelo's great creations were born out of an anguish which caused him still in 1542, over twenty years after Raphael's death, to persecute his former Florentine friend with weird accusations.[77] In his time Raphael was the obvious heir of Bramante. The latter, however, remained for many centuries an enigmatic figure behind his innumerable buildings and initiatives: only through the research of the last few decades has he begun to emerge as a key figure at the papal court. It has been equally difficult to distinguish between Julius's actual personality and the image of him created by his entourage: his judgement, his far-reaching decisions and his continued independence from his courtiers made him an outstanding pope. The environment he dominated inspired and stimulated Raphael in the creation of works which became icons of Western culture.

1 Shaw 1996, pp. 121–2.

2 Vasari 1906, vol. VII, p. 171. The statue was destroyed by the Bolognese in December 1508.

3 See Shaw 1996; also Kempers 1998.

4 Burckhardt 1928, p. 119.

5 This is perhaps exemplified visually in the transfer of the Apollo Belvedere from his private collection at SS. Apostoli to the Vatican whence it was never removed by his heirs (Nesselrath 1998, pp. 14–16).

6 Von Pastor 1924, pp. 681–8.

7 John Shearman (1986, p. 75) has pointed out in a similar context that 'a great artist . . . may share the creative role with his patron'.

8 Vasari 1906, vol. IV, pp. 79–80 (Bramante); Frommel 1976, pp. 89–90 (Egidio da Viterbo); Weiss 1965, p. 180 (Caradosso). See Shaw 1996, pp. 196, 204.

9 Panofsky 1937; Hartt 1950; Schröter 1980, pp. 229–34; De Chapeaurouge 1993, pp. 21–51; Winner 2000.

10 Shaw 1996, pp. 189–207, gives sophisticated historical reasons for rejecting the interpretation of Julius as a second Caesar, tracing the development of the theory in the art-historical literature.

11 Vasari 1906, vol. VII, pp. 162–167; Condivi 1874, pp. 35–7.

12 Metternich 1975, pp. 19–27; Frommel 1976, pp. 89–90; Bredekamp 2000, pp. 25–9.

13 John Shearman (1995, pp. 220–2) made a realistic assessment of the existing evidence's potential for a serious interpretation.

14 New York, Metropolitan Museum of Art, Rogers Fund, 1962, inv. no. 62.93.1. Hirst 1988, pp. 82, 91–2 and 94, figs 173–4; Hirst 1988a, pp. 26–9, cat. 9.

15 Nesselrath 2004a, pp. 36–7.

16 Nesselrath 2001.

17 Bruschi 1990, pp. 127–255; Denker Nesselrath 1993; Alfieri and Nesselrath 1993; Frommel 1989; Frommel 1998; Pagliara 1998, pp. 219–22; Frommel 2002, pp. 76–98. Pier Nicola Pagliara and Suzanne Brown Butters are preparing a monograph on one of Bramante's most important projects for Julius II, the Palazzo dei Tribunali.

18 Vasari 1906, vol. VII, p. 162; Condivi 1874, pp. 25–6.

19 Shearman 1971; Shearman 1993.

20 Vasari 1906, vol. VI, p. 385.

21 Nesselrath 1992, pp. 31–3; Nesselrath 1993, pp. 205; Nesselrath 1998a; Henry and Kanter 2002, pp. 70, 216. The complexities of the dating of the first commissions in the Stanze (between 1504 and 1508) and the chronology of events cannot be fully traced here.

22 Nesselrath 2003, pp. 48–60; Nesselrath 2004a, pp. 16–33.

23 Giovio 1999, pp. 260–1; Golzio 1936, p. 192; Shearman 2003, pp. 807, 808.

24 Vasari 1906, vol. IV, pp. 164, 328–9.

25 Schulz 1962.

26 Henry 1993.

27 Vasari 1906, vol. V, p. 350; Nesselrath 1990, p. 142.

28 Golzio 1936, p. 19; Shearman 2003, p. 113.

29 Recently suggested again by John Shearman (2003, pp. 116–17).

30 Chiarini 1991, p. 13.

31 I follow here John Shearman (1971, pp. 13–17) in his analysis of the function of this room. The reference to what appears to be a different room as a 'biblioteca nova segreta' by Albertini (1510, fol. Z ii r), frequently quoted by scholars who reject Shearman's position (e.g. Pope-Hennessy 1970, p. 138; Gombrich 1972, p. 86; Agosti and Farinella 1990, pp. 587–90, or Bartalini 2001, p. 550), is not relevant in this context since the Pope's so-called private library has to be part of his State Rooms as has been the practice up to the present day; in other words, there must have been two distinct rooms. for the biblioteca privata and the biblioteca segreta.

32 Shearman 1965, p. 161; Shearman 1993, pp. 22–3; Bartalini 2001, p. 551.

33 'ad praescriptum Julii'; Giovio 1999, pp. 260–1; Golzio 1936, p. 192; Shearman 2003, pp. 807, 809.

34 This can be verified through the sequence of the giornate.

35 Shearman 1993, pp. 21–2; Bartalini 2001, pp. 548–51.

36 Golzio 1936, p. 21; Shearman 1965, p. 160; Jones and Penny 1983, p. 56; Shearman 1993, pp. 21–2; Bartalini 2001, pp. 549–50; Shearman 2003, p. 125.

37 Redig de Campos 1965, pp. 20–1; Bartalini 2001, p. 548.

38 Vasari 1906, vol. IV, pp. 332–3, and vol. VI, pp. 385–6.

39 Following normal practice, Sodoma executed his work on the ceiling in two phases: first in fresco and then a secco, including the gilding, corrections and the final heightening with lead white. The latter is found only on the cornice around Theology, but not around the other three Virtues. See also Bartalini 2001, p. 552 (with further arguments for the contemporary presence on the scaffolding). I should like at this point to thank the restorer Paolo Violini with whom I have discussed the entire chronology of the Stanza della Segnatura and who has provided me with the technical data.

40 After finishing the Theology Raphael cut out all the flesh areas of the female figure and inserted new plaster, replacing her hands and head, including her veil, and overpainting the cloud below her feet. The Theology tondo is the only one of the four allegorical tondi with more than four giornate.

41 Florence, Uffizi, inv. 541 E r. Ferino Pagden 1984; Knab, Mitsch and Oberhuber 1983, pp. 584–5, cat. 318.

42 Vasari 1906, vol. IV, pp. 330–3.

43 Vasari 1906, vol. IV, p. 159; Oberhuber 1983, pp. 67–77; Burns 1984, p. 382; Frommel 1984a, p. 18; Frommel 1984b, pp. 246, 255. In the literature it is sometimes argued that Bramante was actually responsible for designing the architectural background of the School of Athens. However, since it is an integral part of the entire composition, as is also clear from the fact that a full cartoon once existed for the entire fresco (the lower half of this cartoon – lacking the upper half with architecture – survives in the Ambrosiana), it is inconceivable that two artists could have invented the two halves of the picture separately; see Nesselrath 1996, pp. 21–2.

44 Nesselrath 1996, p. 14, figs 47 and 60.

45 Oxford, Ashmolean Museum, inv. PII 545 r and v (Joannides 1983, p. 187, nos 218 and 219). The group inspired by Leonardo's famous Adoration of the Magi in the Uffizi was not, as has been claimed, moved from the Disputa to the School of Athens (to the group around Pythagoras), making the chronological sequence of the frescos explicit (Oberhuber 1983, p. 38). On the contrary Raphael created a new variation of the group in the Disputa by splitting and transforming it further – witness the man with the beard in the blue drapery standing in front of the throne of Pope Gregory the Great. This final figure was not invented together with the rest of the group, but developed in the sheet in Oxford and only subsequently inserted into the composition. The separation of the figure on another sheet confirms the later date of the drawing.

46 I do not, however, believe that the figure can be identified as a portrait of Michelangelo, as is often suggested, since the likeness is insufficient. See also Nesselrath 1996, pp. 20–1, figs 85–90, 97–8.

47 Golzio 1936, p. 370; Shearman 2003, pp. 122–3.

48 Vasari 1906, vol. IV, p. 332.

49 Nesselrath 2004a, p. 146.

50 Bellori 1695, pp. 22–4.

51 Nesselrath 2004b.

52 Paris, Louvre, inv. 3866. Shearman 1965, p. 164, fig. 5.

53 Nesselrath 1993.

54 Nesselrath 2000.

55 Nesselrath 1998b, p. 245; Nesselrath 2000, p. 12.

56 Vasari 1506, vol. IV, pp. 384–5 and 643–5, vol. V, pp. 523–5

57 Hirst 1961; Shearman 1961; Jones and Penny 1983, pp. 92–111.

58 Chantilly, Musée Condé, inv. 40. Béguin 1979; Jones and Penny 1983, p. 88, fig. 98.

59 Knab, Mitsch and Oberhuber 1983, pp. 595–6, cats 415–18.

60 This relationship, although frequently observed (e.g. Jones and Penny 1983, p. 88), has never been considered in terms of its consequences for the chronology of the vault in the Stanza della Segnatura.

61 Città del Vaticano, Musei Vaticani, Pinacoteca, inv. 40329. Jones and Penny 1983, pp. 88–92, figs 99 and 101; Schröter 1987 (with previous literature).

62 Vasari 1906, vol. I, p. 539; Schröter 1987, p. 50.

63 Rothe and Carr 1998, pp. 61–2, fig. 39. Recent research on Dosso Dossi makes this old attribution plausible once again. The hypothesis found support when John Shearman and I were able to observe the painting under a particular light. Andrea Rothe has conducted a lengthy technical analysis in connection with his work on Dosso Dossi and has discussed the problem with me on several occasions.

64 Putscher 1955; De Chapeaurouge 1993.

65 Nesselrath 1993, pp. 232–42; Kemper 1998, pp. 45–6.

66 Frommel (ed.) 1984.

67 See Frommel 1986, although Raphael's inspiration and Sangallo's schematic approach need to be distinguished further.

68 This attribution was presented during the colloquium at the National Gallery in London on 9 November 2002. See also Nesselrath 2000, p. 11, n. 31. On Raphael's preparatory drawings see Ferino Pagden 1990, on Raphael's autograph cartoon in Naples for the figure of Moses in front of the Burning Bush see Muzii 1993.

69 Denker Nesselrath 1993a; Mancinelli and Nesselrath 1993.

70 Nesselrath 1989.

71 Today in the Victoria and Albert Museum. Shearman 1972; Fermor 1996.

72 Golzio 1936, p. 32; Nesselrath 1986, p. 361.

73 Nesselrath 1989, pp. 254–62; Oberhuber 1995; Denker Nesselrath 1993a, pp. 66–72.

74 Nesselrath 1986.

75 Mancinelli 1979.

76 Vasari 1906, vol. IV, p. 376.

77 Barocchi and Ristori 1965–83, III, p. 155.

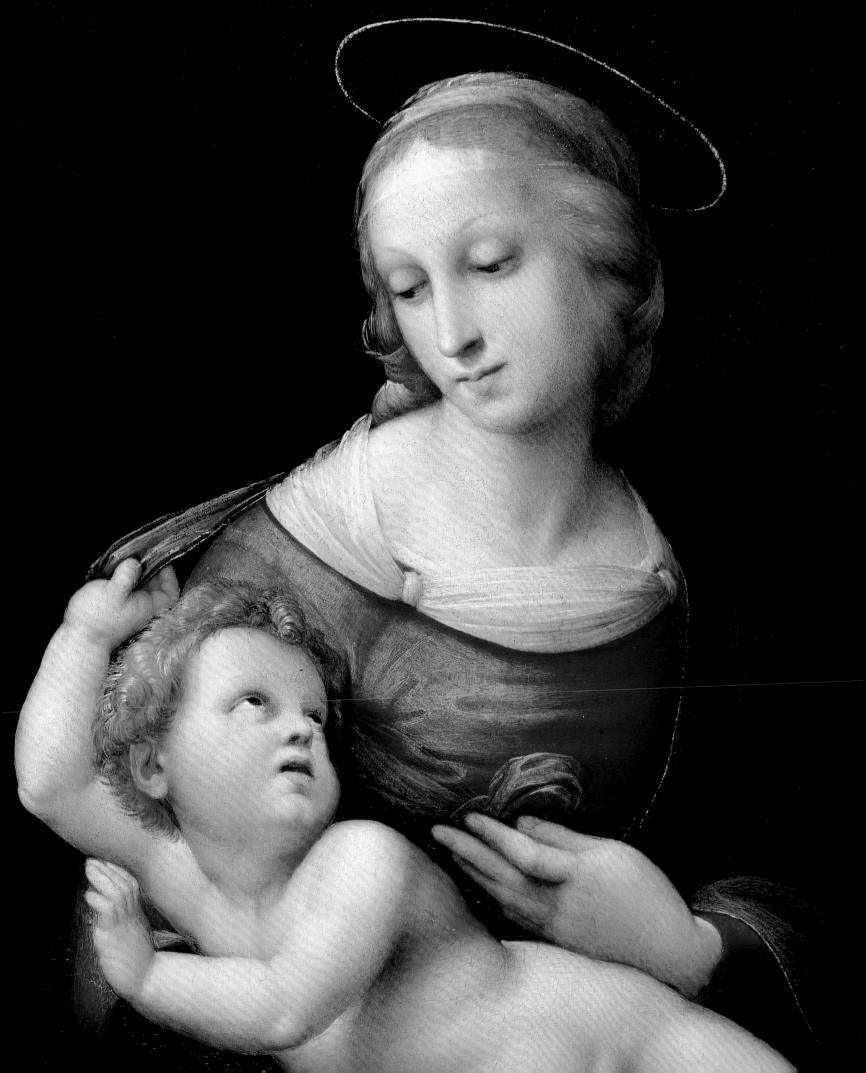

Raphael and the Early Victorians

NICHOLAS PENNY

In July 1835 Lady Cowper, petitioned by the Duke of Sutherland, instructed her housekeeper to permit Doctor Waagen, Director of the Royal Gallery in Berlin, to view the paintings at Panshanger, her country house in Hertfordshire. The distinguished German scholar was able to relish for many hours a fine collection of Old Masters hung on crimson silk in the drawing room and adjacent apartments – the tranquillity of his visit 'interrupted only by the humming of innumerable bees round the flowers which grew in the greatest luxuriance beneath the windows'. The chief objects of his attention were the two paintings by Raphael of the Virgin and Child (now in the National Gallery of Art in Washington and named after the Cowper family, fig. 86).[1]

Access to the Marquis of Stafford's Old Masters in Cleveland House in the West End of London was easier. The house was open for a dozen or so afternoons in the year to persons known to the Marquis and, after his death in 1833, to his second son, Lord Francis Egerton (later Earl of Ellesmere),[2] or to those recommended by a person of nobility or other distinction – provided that they came by carriage if the weather were 'wet or dirty'.[3] 'To possess one Raphael', according to Anna Jameson, 'is to have one's home converted into a shrine'[4] – an announcement that must have alarmed several private owners in London. But in this case the family was prepared. There were four Raphaels in their collection (of which two are accepted as such today, the *Bridgewater Madonna* (cat. 62 and fig. 133) and the *Holy Family with a Palm*, both on loan to the National Gallery of Scotland), and three of them were clustered in the centre of one wall in the great Italian Gallery above an imposing neo-classical table.[5] Limited public admission remained possible when the collection was displayed in Bridgewater House,[6] the great palace designed by Charles Barry that replaced Cleveland House in the mid-nineteenth century, but the Raphaels were kept in private rooms, and by the end of the century silver-framed photographs, porcelain bowls and cut flowers – the precious and personal furnishings of the countess's boudoir[7] – came between the privileged visitor and the paintings.

Raphael's Madonnas had been painted for living rooms of a kind, not for picture galleries, and continental visitors such as Waagen were impressed to find them preserved in such domestic settings in Britain.[8] But at the same time they believed that these paintings possessed a power to inspire and comfort, to reinforce ideals and purify sentiments, which made their confinement in opulent homes seem wrong. The idea that high art could appeal directly to the uneducated poor was not a new one, but it was taken to extremes in early Victorian Britain, as exemplified by a story published in 1853 in *Household Words*, the mass-circulation periodical directed by Charles Dickens.[9] Mrs Brown here explains to her genteel interrogator how she was married to a common soldier posted in India. Having lost many children, she determined to carry her surviving baby back to her native Britain and with the baby, she took 'a little picture, ma'am – done by a Catholic foreigner, ma'am – of the Virgin and the little saviour, ma'am. She had him on her arm, and her form was softly curled round him.' This 'picture' was a print, the gift of an officer's wife for whom Mrs Brown had done some washing – 'she had heard it had been painted on the bottom of a cask'. So we know that it was a print of the *Madonna della Sedia* (see figs 134 and 44). 'And when my body was very weary, and my heart was sick . . . I took out that picture and looked at it, till I could have thought the mother spoke to me.'

'Access' and even 'outreach' were perhaps of more genuine concern in the early nineteenth century than in recent times when these terms were made popular. The jibes of the French that the British had made the great Orléans collection – which had been open to all artists and art lovers in Paris throughout most of the eighteenth century – a matter of commercial speculation to be divided into the property of private individuals[10] had probably helped prompt Lord Stafford (who together with his uncle, the Duke of Bridgewater, had been the principal purchaser of the Italian portion of this collection) to concede occasional and limited public access to Cleveland House after 1806.[11] The recollections of the munificent conduct of princely collectors on the continent also prompted the creation in 1805 of the British Institution with its loan exhibitions of Old Masters, made at first for the benefit of artists but after 1813 for a larger public, exhibitions at which, for example, the Cowper Raphaels were shown.[12] These developments form a sort of

fig. 133 Detail of cat. 62

fig. 134 Raphael Morghen
The Madonna della Sedia (after Raphael), about 1793
Etching and engraving, 39.5 × 32.1 cm
The British Museum, London, 1843-5-13-1011

overture to the foundation of the National Gallery in 1824.[13] Such gallant attempts to prove that Britain was not merely a 'nation of shopkeepers' were perhaps motivated as much by pride as by philanthropy. Noble liberality has of course often involved the former vice, confused with, softened by, or disguised as the latter virtue. In the National Gallery, as distinct from London's private collections or the exhibitions mounted by the British Institution and the Royal Academy, the public that was welcomed included women with babies, that is women who did not employ nurses, women as distinct from ladies – in fact Mrs Brown and child. When the new building opened in Trafalgar Square in 1838 it became highly attractive as a resort, or at least as a refuge, for the poor.[14] Polite society found this rather disturbing and the more optimistic and liberal-minded commentators hoped that if the interiors were made less mean and shabby, if they were decorated and furnished as a 'palace dedicated to the arts', as was the case with the infinitely more splendid, commodious and convenient new gallery in Munich (designed by von Klenze), rather than as 'an ill-regulated workhouse', then the floor would cease to be

littered with 'sandwich papers and orange peel', and the public would behave in a more decorous way.[15]

The committee of management (not yet constituted as trustees) and the Keeper, William Seguier, who were responsible for the care and increase of the collection during its early years[16] were well aware that the founding collection of John Julius Angerstein included only one Raphael, the portrait of Pope Julius II (cat. 99), which within a couple of decades would be doubted as an original.[17] This was a poor show when the holdings of the Louvre were considered: poor too when compared with the new national gallery that opened in the Prado, Madrid, in 1819. Magnificent copies of the Prado's Raphaels had been shown at the British Institution in 1822.[18] Some notable Raphaels had also found their way from Spain to London. One of these, the *Madonna della Tenda* (fig. 135), had indeed been extracted from the Spanish royal collection. In 1819, its owner, the banker Sir Thomas Baring, sold it for £5,000 to another royal collection, that of Bavaria.[19] Recollections of this transaction should have alerted the National Gallery's committee (which was formed into a Trust in 1828), but they soon let another Raphael from Spain pass into the collection of a foreign prince.

Raphael's *Alba Madonna* (cat. 92), which was said to have cost the 'merchant and banker' W.G. Coesveldt £4,000, was one of a collection of ninety pictures kept in Coesveldt's townhouse in Carlton Gardens, London. The whole collection was offered for sale to the National Gallery for £40,000 in 1836.[20] The offer was not accepted, but to judge from an annotated copy of the illustrated catalogue, published to help promote the sale, the committee did consider purchasing a group of Coesveldt's paintings.[21] By then Franz Xavier Labinsky, the artist, connoisseur and agent of the Tsar Nicholas I, seems already to have reserved a group which included the Raphael. The Trustees were not organised to act as decisively and swiftly as Labinsky. In addition, they seem to have questioned the attribution of the *Alba Madonna*. Perhaps British connoisseurs expected a richer palette and darker, softer shadows. A clear idea of Raphael's stylistic variety and development was only just being formed, notably by Johann David Passavant and Gustav Waagen. Although the former's great catalogue of the artist's work was not known to the National Gallery's committee, they could easily have discovered how highly he esteemed this particular example.[22]

Passavant's research on Raphael grew out of the keen interest in Raphael's early work developed by German artists and amateurs in Rome before 1820. This interest was shared by the Crown Prince Ludwig of Bavaria who had purchased the *Madonna della Tenda*. In 1827, by which year Ludwig was king, William Buchanan, London's most successful art dealer, offered him, through George Dillis, director of the new Pinakothek in Munich, the long furniture painting adorned with episodes of the creation which is now attributed to Albertinelli (fig. 136) but which he believed to be by Raphael. He had offered it to the National Gallery's committee in

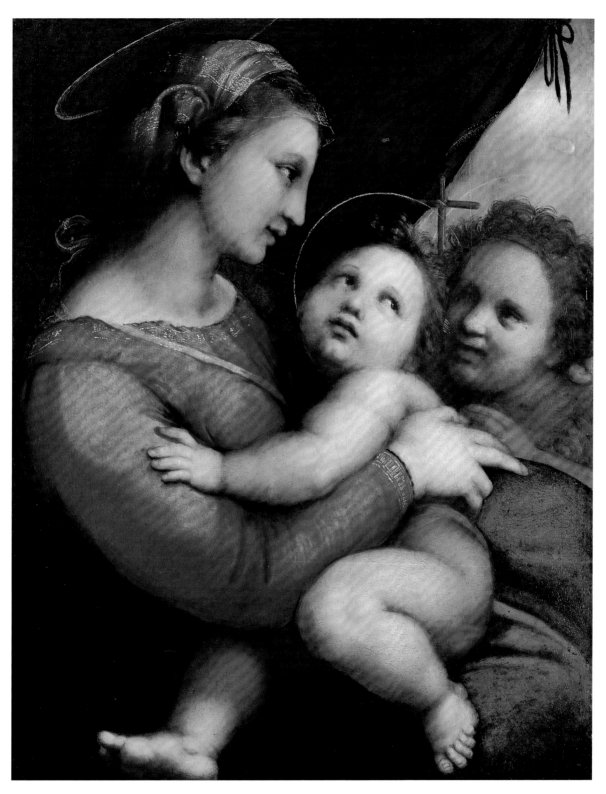

fig. 135 **The Madonna della Tenda**, 1514
Oil on wood, 65.8 × 51.2 cm
Alte Pinakothek, Bayerische Staatsgemäldesammlungen, Munich

vain – 'unfortunately, and I am sorry to be obliged to say it, these gentlemen in general possess but very little knowledge of Italian masters, and their taste has been all corrupted by the fashion of the present day in this country.'[23] In fact, the major purchases that the committee made were of great Italian paintings by Correggio and Titian, but Buchanan was surely right that this picture, in which he ingeniously but over-optimistically detected Raphael's debt to both Perugino and Fra Bartolomeo, was 'too simple and primitive' to appeal to the committee, who were keen to acquire only unquestioned masterpieces.[24]

When the National Gallery did finally buy a Raphael, in 1839, it was, significantly, at the instigation of a German scholar and perhaps with the implied threat of possible sale to Berlin. Raphael's *Saint Catherine* (cat. 74) had been purchased by William Beckford, probably soon after he had been stung by Hazlitt's derisive account of the precious trifles assembled in Fonthill Abbey, only one or two of which, Hazlitt alleged, were by a really great master.[25] The Raphael hung in Beckford's dining room in Lansdowne Crescent, Bath, surrounded by nine smaller pieces, selected for historical connection or poetic affinity, which were divided by windows commanding views of both the city of Bath and the Avon Valley.[26] Waagen thought it 'perhaps the most beautiful room in the world', but by the time he published this opinion in 1838,[27] Beckford may have tired of it. In that year the collection was visited by Waagen's friend, the scholar, theologian and diplomat Baron Christian Carl Josias Bunsen, who had a special interest in Raphael. Beckford would certainly have known of Bunsen's influence at the Prussian

court and he had let Bunsen know that he might be prepared to sell the Raphael. Bunsen told his brother-in-law Sir Benjamin Hall, who wrote to his friend Thomas Spring-Rice, who had recently become a trustee of the Gallery on account of his position as Chancellor of the Exchequer.[28] After some bargaining, Beckford obtained 7,000 guineas for the Raphael together with a Garofalo and Mazzolino from the same room; the transaction was kept quiet because of Beckford's aversion to publicity. The price, which was very high, was never formally discussed by the Trustees.[29]

In the 1840s a few British painters, critics and theorists began to absorb ideas that had been expressed by the German Nazarenes, by the movement known as 'purismo' in Italy, and by the French medievalist Alexis Francis Rio. Some of them now dared to denounce Raphael for 'secularising' art and Titian for 'sensualising' it,[30] hence the adoption at the end of the decade of the term Pre-Raphaelite by a group of young British artists. But Raphael's pre-Roman painting and even his earlier Roman work was in fact often admired and imitated by the artists involved in these interconnected movements, and the exact point at which Raphael ceased to be a truly Christian painter was much debated. The hard edges and chaste colours with which William Dyce gave an archaic accent – to him a guarantee of sincere piety – to his painting of the Virgin and Child in 1845 (fig. 137) may have been encouraged by the availability of the *Saint Catherine* in Trafalgar Square, but his composition deliberately avoids Raphael's sophisticated *contrapposto*, and he disregards what Raphael owed to Leonardo and the antique – preferring the pose of the *Madonna del Granduca*, turned ninety degrees.[31]

fig. 136 Mariotto Albertinelli
The Creation, Temptation and Fall, 1513
Oil on wood, 37.5 × 165.5 cm
Courtauld Gallery, Somerset House, London

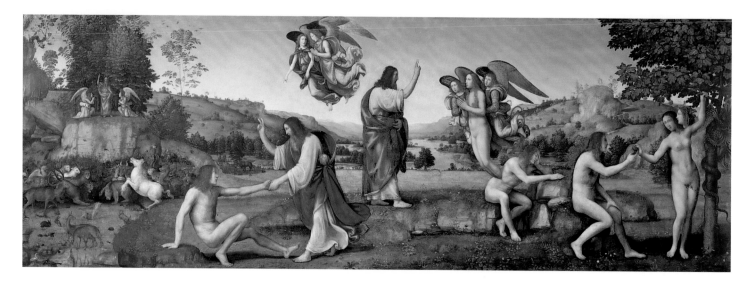

In 1840, the year after the acquisition of the *Saint Catherine*, the *Quarterly Review* carried an anonymous review of Passavant's monograph on Raphael which welcomed the book while making some shrewd observations on its limitations.[32] The author of his review was known to be the painter Charles Lock Eastlake, and the article demonstrated that he was as erudite as Bunsen (to whom he refers with the greatest respect[33]), and possessed as much knowledge of painters as his friend Waagen. In 1843, on the death of William Seguier, Eastlake was made Keeper of the National Gallery and endeavoured to persuade the Trustees to pursue a more historical approach, and to take more initiatives in the way of acquisitions, but his powers were limited. He was able to instruct the dealer William Woodburn to represent the Gallery in Rome at the time of the sale of the huge collection of Napoleon's uncle, Cardinal Fesch, in 1845, but only an official agent enjoying the special confidence of the Trustees would have extracted from the reserved portion of the Fesch collection Raphael's great early altarpiece of the Crucifixion (cat. 27), one of the pictures in which Eastlake was most interested.[34] This painting was in fact acquired in 1847 by the immensely rich young nobleman Lord Ward (later, first Earl of Dudley), then living in Rome. It is perhaps significant that he had inherited Raphael's *Three Graces* from his father in 1835.[35] The exhibition of Lord Ward's collection, free of all charge, for a little over a year, commencing on 1 May 1851, in the Egyptian Hall, Piccadilly, attracted much notice at a time when London was thronging with visitors to the Great Exhibition, and it was pointed out that the National Gallery had nothing to match the *Crucifixion* or the *Last Judgement* by Fra Angelico (now in Berlin).[36] What it did have, however, was the pendant to the *Three Graces*, the little picture known as the *Vision of a Knight* (cat. 35).

This little painting was offered to the Gallery by the Rev. Thomas Egerton for 1,000 guineas. Rumohr, Passavant and Waagen considered that it was by Raphael, and so did Eastlake, but this was not enough. Indeed, given that much of the hostility to the Gallery was generated by collectors and dealers who had been wounded by the new German scholarship, it was important to obtain support from other authorities.[37] The painting was acquired in 1847 and exhibited together with the artist's cartoon (transferred, in recent years, to the British Museum, but reunited for this exhibition, cat. 36).[38] Eastlake's care over this matter is all the more understandable when we follow the increasingly unbalanced polemics of his enemy Morris Moore (see p. 80). Ironically, Moore not long afterwards purchased a painting which in many ways resembles Raphael's *Vision of a Knight*, Perugino's exquisite *Apollo and Daphnis* (cat. 7), and ardently championed it as a work by Raphael.[39]

The attribution of the *Vision of a Knight* owed something to the drawing, and it had not yet been settled that the National Gallery was not a suitable repository for Old Master drawings. In the 1830s and early 1840s the drawings by Raphael and Michelangelo from

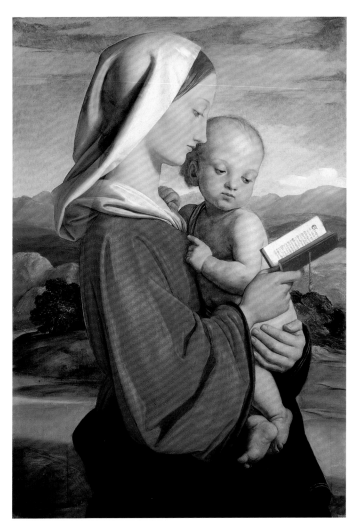

fig. 137 William Dyce
The Madonna and Child, about 1845
Oil on canvas, 80 × 63.6 cm
The Royal Collection, RCIN 403 745

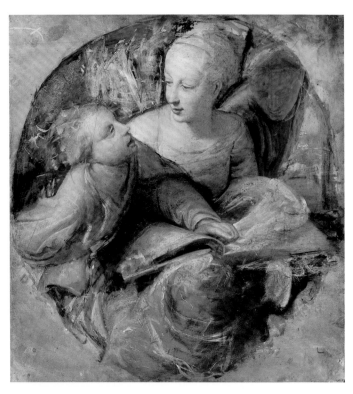

fig. 138 Alfred Stevens
King Alfred and his Mother, about 1848
Oil on wood, 37.6 × 33.6 (painted area diameter 34.3 cm)
Tate, London, NO 1923

Sir Thomas Lawrence's collection were repeatedly offered to the Trustees by the dealer Samuel Woodburn (brother of the William mentioned above) and, after the sale of these to the University Galleries in Oxford, Woodburn continued to make other proposals involving drawings.[40] Unfortunately, Woodburn's optimistic interpretation of polite interest, his allegations of bad faith or neglect, his complicated terms, and his confusion of his own generous intentions with commercial interest exasperated the Trustees,[41] and Eastlake himself, although he had in 1840 declared himself in favour of having drawings by Raphael in the National Gallery on rotating display, in frames, as Old Master drawings were in the Louvre.[42] The Trustees even rejected Woodburn's offer to present what he claimed was the cartoon for the *Saint Catherine*.[43]

The Prince Consort, who was on friendly terms with Eastlake at this period, would have been keen to see Raphael's paintings and drawings displayed together. He had already begun to reorganise the drawings and prints in the Royal Library, an enterprise which would evolve after 1853 into the formation of the Raphael collection by his librarian Carl Ruland, one of the first photographic archives established for art-historical purposes.[44] The Prince Consort was well aware of how careful he had to be not to be seen to influence public affairs but he was made President of the Fine Arts Commission, which strove to promote a new interest and competence in mural painting, and he commissioned from Eastlake and other leading British painters illustrations to Milton's *Comus* for a new garden pavilion in the grounds of Buckingham Palace where the Raphaelesque grotesque ornament was supplied by Ludwig Grüner.[45] He would have agreed with Eastlake that the style of mural painting in Barry's Gothic-Revival Houses of Parliament need not be Gothic in character: Raphael's tapestry cartoons for the Sistine Chapel (then in the Royal Collection and since 1865 on loan to the Victoria and Albert Museum, London) had been created at a period when the Gothic was still the dominant style in Britain.[46] Albert would probably also have favoured the transfer of the cartoons to the National Gallery – had there been room for them there.[47]

The garden pavilion was decorated in 1844, the year in which the most talented of all British students of Italian Renaissance art, Alfred Stevens, settled in London and started working for interior decorators. He had been trained as a painter and sculptor and his unfinished painting of King Alfred taught to read by his mother of about 1848 (fig. 138) looks like a design for a relief.[48] It embraces those aspects of Raphael's style most worrying to William Dyce. Figures are united with a sensuous flowing line; compact, twisting salients of heads, shoulders and knees combine and contrast. In Rome, Stevens must have looked especially hard at the ceiling of the Stanza della Segnatura, as well as at the Sistine ceiling, but he was influenced by two aspects of Raphael's work which were the subject of keen interest in London in the 1840s – his drawings and his activity as a decorator and designer. Stevens is the first

great modern draughtsman to model his drawing style directly on Raphael's.

Eastlake resigned as Keeper in 1847, but he became one of the Gallery's trustees in 1851, ex officio, when he was elected President of the Royal Academy. Then in 1855 he was appointed as the Gallery's first director. The most expensive of the numerous acquisitions he made over the following decade was the *Madonna and Child* (cat. 91) by Raphael that he bought from Lord Garvagh (after whom it is now named) and his mother in 1865 for the colossal sum of £9,000, after tricky negotiations with the owners, who invoked – and perhaps invented – an interested foreign buyer (not a German prince this time, but a North American war contractor).[49] The painting's lucid composition and light and airy palette would have appealed to Eastlake, who, as a painter, had been a master of white with pale blue and rose pink – clean colours combined with clear lines in a summery setting, as exemplified by his double portrait, *The Sisters*, inspired partly by the graciously intertwined muses of Raphael's *Parnassus*.[50] His painting of *Virtue ascending to the Higher Sphere* painted for the garden pavilion in 1844 and filled with putti, some holding tablets like those on the vault of the Stanza della Segnatura, also seems to have recalled this moment in Raphael's development.[51] And so does the pedimental sculpture of the Fitzwilliam Museum, for which Eastlake made the designs.[52] He lacked, alas, the energy of Stevens.

Eastlake's most explicit reference to Raphael in his paintings was the imaginary portrait that he exhibited in 1851, the year he was elected President of the Royal Academy.[53] It depicts Ippolita Torelli (fig. 139), the young wife of Raphael's friend Baldassare Castiglione, as she is described (or rather, is supposed to describe herself) in a Latin sonnet by Castiglione, looking lovingly and longingly at Raphael's portrait of her husband.[54] It is a type of pendant never perhaps previously attempted, and a testimony to Eastlake's art-historical erudition. It also reveals the poetic sentiment which so seldom colours his printed prose. Admiring critics were reminded of Titian – the Titian, presumably, of the *Sacred and the Profane Love* – but it also recalls the ample sleeves and plump-featured beauty of Raphael's *Donna Velata* (cat. 101), and it includes beautiful, nearly segmental lines which sweep around the neck and turbaned hair – lines which recall the compositions of the *Alba Madonna* (cat. 93) or the *Madonna of the Meadow* (fig. 24).

Eastlake's Raphaelesque paintings, like some of the late works of Paul Delaroche by which he may have been inspired,[55] accord well with the copies after Raphael assembled at Osborne House – a shrine to the artist and to 'family values'. The rhapsodic praise lavished by critics on his *Sistine Madonna* (fig. 131) and on his *Madonna della Sedia* (fig. 44) made them represent a spiritual ideal too elevated to be imitated. The paralysis of the artist in Henry James's short story, *The Madonna of the Future* (1879), is partly explained by this. There was, however, also the problem of over

fig. 139 Charles Eastlake
Ippolita Torelli, 1851
Oil on canvas
89.5 × 72.5 cm
Tate, London
(formerly 1398,
destroyed by flood
in 1928)

familiarity. In the same story an American 'high priestess of the arts' bears upon her bosom a 'huge miniature copy of the *Madonna della Seggiola [Sedia]*'.

The style of Raphael's tapestry cartoons – the open mouths, profile poses, pointing fingers, heavy feet – had conditioned British enthusiasm for Poussin during the eighteenth century. The style of the *Transfiguration* – with its dark shadows, outflung arms and violent expressions – had established a type of baroque rhetoric which was still alive in the works of Benjamin West not long before the National Gallery was formed. Neither style was adequately defended after 1850 against successive waves of purist, realist and formalist disapprobation or doubt.[56] A loud echo of the *School of Athens* (fig. 37) is unmistakable even in the darkened ruin of Watts's mural of great lawgivers.[57] Stevens hoped to recreate on the dome of St Paul's the ideas that Raphael had never quite adequately realised in the Chigi Chapel in S. Maria del Popolo. But heroic narrative gradually ceased to be the most respectable mode for an ambitious painter.[58]

The great altarpieces by Raphael had not arrived in Trafalgar Square when Eastlake died. The loan of the *Colonna Altarpiece* (fig. 68), the purchase of the *Ansidei Madonna* (cat. 45) and the bequest of the *Mond Crucifixion* (as Cardinal Fesch's painting, acquired by Lord Ward, came to be known) lay in the future.[59] But there would be little question of these paintings exercising a powerful influence on the practice of British art, whereas in the first fifty years of the National Gallery's life there had been good reason to hope that Raphael would affect the work of Britain's painters and touch the hearts of her common people.

1 Waagen 1838, pp. 1–13 (for Panshanger) and p. 3 (for bees in particular). The Raphaels – and the other Italian paintings – had been acquired by Earl Cowper in Florence in the 1770s. For their reputation in the late nineteenth century, and their acquisition by Widener and Andrew Mellon in the twenties, see Brown 1983, pp. 80–7 and 91–2.

2 Lord Francis (1800–1857) changed his name from Leveson-Gower to Egerton. He inherited a separate fortune from the Duke of Bridgewater, whose family name was Egerton, in 1829 and in 1833 he inherited Cleveland House and the Bridgewater portion of the Orléans paintings, while those acquired by his father, the Marquis of Stafford (who was created Duke of Sutherland in 1833, the year of his death), passed to Lord Francis's elder brother who is the Duke of Sutherland mentioned in the opening lines of this essay.

3 Britton 1808, preface. See Westmacott 1824, p. 170, for slight changes in the arrangements for ticketed access.

4 Jameson 1844, p. 83.

5 For the way the paintings were arranged, see Britton 1808, op. cit. note 3; Westmacott 1824, op. cit. note 3; and Jameson 1844, op. cit. note 4. It is implied by Timothy Clifford in the preliminary essay by Weston-Lewis 1994 that the three paintings by Raphael grouped in the centre of the gallery were the trio now on loan to the National Gallery of Scotland, but in fact the Bridgewater Madonna was not in this group and does not agree in figure scale. The painting that hung together with the Holy Family with a Palm and the Madonna del Passeggio was a copy of the Virgin of the Diadem in the French royal collection (now Louvre) which had formerly belonged to Sir Joshua Reynolds.

6 For access to Bridgewater House see Pearce 1986, p. 182.

7 For the boudoir in 1890 see ibid., fig. 138, p. 183. Pearce also points out that, a couple of decades earlier, the Raphaels were in a sitting room – this may have been the same room which later changed name and function. The paintings stayed in London until 1946 so it is curious how they have become, after hardly more than a half century, part of Scotland's heritage.

8 'I cannot refrain from praising the refined taste of the English for thus adorning the rooms they daily occupy.' Waagen 1838, pp. 3–4. This is a frequent theme for the author, found first in Waagen 1838 and later in Waagen 1854.

9 The story of Mrs Brown (which is set in the 1830s) is incorporated in Elizabeth Gaskell's Cranford as Chapter XI. It was first published in Household Words on 15 January 1853. More engravings of this painting by Raphael were published than of any other paintings by him – or perhaps any other artist – in the late eighteenth century and the first half of the nineteenth and many of them were of superlative quality – see Bernini Pezzini, S. Massari, and S.P. Valenti Rodinò 1985, pp. 196–9.

10 The engravings of the Galerie du Palais-Royal by Jacques Couché which began to be issued in 1786 were finally published as three volumes in 1806, by when the pictures were dispersed into three dozen British collections – almost all of their new owners would have bought his volume and read in the Notice Historique (I, p. 4) by Croze-Magnon the acid observation that 'les amateurs anglais, conservant le caractère national, spéculèrent sur la curiosité publique'.

11 May 1806 is the date when the galleries were first opened to ticket holders. The number of months when access was possible was reduced to three in 1808 – Britton 1808, p. vii. He specifically refers to French allegations – presumably that of Croze-Magnon, cited in note 10, among them – and goes on to mention in defence of the precautions taken by Lord Stafford the behaviour of the 'vulgar' lower orders and (more interestingly) the 'insolence' of the 'lounging persons' in modern London.

12 For the British institution see Haskell 2003, pp. 46–81. Paintings exhibited are listed in Graves 1914 (for Raphael see III, pp. 994–5), one of the Cowper Madonnas was shown in 1816, another [or the same?] in 1841; both were included in the Manchester Art Treasures Exhibition of 1856.

13 The best history of the National Gallery remains Holmes and Collins Baker 1924, pp. 1–12, which gives a succinct account of his early years.

14 Ibid., pp. 11–12, give an explanation for the Gallery's popular appeal which is a welcome antidote to the sentimental claims made in recent years in support of the Gallery's 'mission'. The rise of popular art forms and alternative shelters in central London both ensure that the National Gallery will in fact never again achieve the 'access' which it originally enjoyed – in 1842 it was indeed noted that 'great numbers of the lower class attend and in fact I suspect more often than any other class' (Edward Everett, diary entry for 9 August 1842, Massachusetts Historical Society archive).

15 The quotations concerning the Workhouse, the palace and the orange peel are taken from Henry Layard's anonymous article on the Gallery in the Quarterly Review, 1859, pp. 339–80.

16 For the Committee of Management see Holmes and Collins Baker 1924, op. cit. note 13.

17 Gould 1975, p. 210, note 2, mentions that the attribution to Raphael was 'soon abandoned'. The painting did in fact excite considerable tributes of admiration even in the 1830s.

18 The Madonna of the Fish, La Perla, The Spasimo and The Salutation (i.e. Visitation), all 'copied from the King of Spain's collection' in 1817 for the Duke of Wellington, were exhibited at the British Institution in 1822 as nos 161–4. Graves 1914, p. 994.

19 The sale was managed by Buchanan who approached the Crown Prince with a price of 5,000 guineas. Baring accepted £5,000. The painting had been exported from Spain by George Wallis in 1809 and arrived in London in 1813 (it was previously in Germany). Buchanan noted that the Prince had seen the picture on a visit to London. According to Buchanan, Baring had 'several pictures of the most esteemed Italian masters, which are of too high value for a private collection'. Transcriptions of letters by Buchanan and Baring which are in the Royal archives in Munich were shown to me by the late Sir Ellis Waterhouse about twenty years ago. I have since found copies of them in the National Gallery Library (NC 505 (p) BUCHANAN).

20 The only authority for this (but it is reliable) is Anna Jameson's prefatory essay to the 1837 edition of the catalogue of Coesveldt's collection (p. VII). It should be recalled that the Angerstein collection had been purchased for £60,000. The price Coesveldt himself was said to have paid for the Alba Madonna is given by Eastlake (or his editor) in his anonymous review of Passavant published in the Quarterly Review in June 1840 (reprinted in Eastlake 1848 – see p. 236 note).

21 Little is known about Coesveldt, but his background may have resembled Angerstein's. The catalogue of 1836 consists of etchings by F. Joubert dated 1835. After the sale at Christie's on 2 and 3 June 1837 the catalogue was reissued with Mrs Jameson's text (as cited in note 20). The pictures which did not meet their reserves were offered at Christie's on 12 June 1840. Among notable paintings in the collection The Virgin and Child with Saints by Titian (NG 635) should be mentioned.

22 Eastlake 1848, pp. 236–7, refers to the Alba Madonna as 'a specimen, by the way, with regard to which, notwithstanding Passavant's just admiration, some difference of opinion existed'. Passavant had seen the painting in 1831 and his view of it was published in his account of his English travels published in German (Kunstreise) in 1833 (p. 151) and in English in Passavant 1836, I, p. 316.

23 Buchanan's letter is dated 9 July 1827 and is included in the transcripts cited in note 19. He wanted 1,500 guineas for his painting which, he noted, James Irvine had purchased in Italy in 1804. He described it as painted on limewood and five and half foot long – that corresponds fairly well with the painting's present length (165.5 cm) which shows that it had already been cut down by that date (see Borgo 1976, no. 28, pp. 348–57, for the history of this painting and the other pieces originally attached to it). The new fashion in Britain was, according to Buchanan, for Flemish and Dutch pictures and it is true that spectacular sums had been paid for these not long before – Rubens's Chapeau de Paille, after a public exhibition attended by 20,000 people, was sold to Sir Robert Peel for 3,500 guineas (an example which pained Buchanan since the Nieuwenhuys firm and that of J.T. Smith handled the business). In a subsequent letter of 30 August Buchanan made it clear that he especially resented Charles Long, Lord Farnborough, King George IV's chief adviser, whom he believed also to be the most influential person on the Gallery's committee – 'Lord Farnborough who has the most to say, looks at nothing but gay and gaudy colours.'

24 Ibid., he also mentions, as Irvine's idea, the resemblance of Adam in the temptation scene to Raphael himself!

25 Hazlitt's review of the paintings at Fonthill was published in the London Magazine in November 1822 (see Howe (ed.) 1930–4, XVIII, pp. 173–80). As pointed out in Jones 1978, pp. 278–96, the impact of his review may have prompted the cancellation of the sale announced by Christie's and Hazlitt's influence was certainly acknowledged by Phillips who commissioned further – less hostile criticism – from Hazlitt before he took over the sale. Beckford acquired the Raphael from Lord Northwick before 1824.

26 Waagen 1838, III, pp. 121–5 (122–3 for the room). The pictures included a Perugino, a Garofalo (NG 170), two Mazzolinos (NG 169 and 641), a Girolamo da Carpi, a Filippino Lippi (NG 1124), a Patenier, a Civetta and an Elsheimer.

27 The date of the letter is 4 September 1835.

28 Letters concerning this transaction are in the dossier for NG 168 (cat 74). Those from Sir Benjamin Hall (1802–1867) reporting his brother-in law Bunsen's information to 'Rice' (Thomas Spring-Rice 1790–1866, created Baron Monteagle in 1839), are dated 5 and 29 December 1838 and 22 February 1839. As Hall noted, Beckford was 'an extraordinary animal to deal with' and his fear of publicity made a private transaction essential. Beckford was said to have changed his mind – but too late to cancel the deal.

29 Holmes and Collins Baker 1924, p. 10. According to Boyd Alexander 1962, p. 288, note 26, Beckford had purchased the Saint Catherine for 2,000 guineas and now obtained 6,000 guineas for it. It isn't in fact clear exactly what percentage of the 7,000 guineas was designated for the Raphael. A note of 6 February 1839 in the National Gallery valued it at 4,000 guineas.

30 'I know that there are critics who look upon Raphael as having secularised and Titian as having sensualised art: I know it has become a fashion to prefer an old Florentine or Umbrian Madonna to Raphael's Galatea; and an old German hard-visaged, wooden-limbed saint to Titian's Venus', Jameson 1846, p. 5. Her own position, like Eastlake's, was that the archaic should be admired rather than imitated: 'as it has been with the classical languages, so it is with the arts of the middle ages; they live and are immortal, – but for all present purposes they are dead' (ibid. pp. 28–30). An interesting recent account of the evolution of the preference for early Raphael is given in Gombrich 2002, ch. 3. It is worth observing that there is one early and surprising example of Raphael's early work influencing a British painter. Thomas Stothard's once-famous Canterbury Pilgrims (Tate Gallery) was certainly influenced by Raphael's Procession to Calvary and it cannot be a coincidence that both paintings were acquired for the collection of Philip Miles at Leigh Court near Bristol (about which I hope to publish in the near future).

31 Carter 1964, cat. no. 23.

32 Eastlake 1848, op. cit. note 20.

33 Ibid., pp. 251–2 – 'one of the most accomplished persons who ever taught the lessons of minute diligence.'

34 Woodburn was authorised to pay up to £2,000 for the Crucifixion but the Fesch heirs deliberately bid it up at the sale. See Woodburn's report of 15 May 1845 in NG5/60/1845. Eastlake had at first valued the altarpiece at £1,500 – see Sir Robert Peel's papers in the British Library, Add MSS 40540, fol. 83 and MSS 40537, fol. 278.

35 Waagen 1854, II, pp. 229–36, and Waagen 1857, pp. 102–3.

36 Athenaeum, no. 1236, 5 July 1851, pp. 722–3. The article makes a pointed reference to the National Gallery which 'appoints no agent abroad'.

37 Robertson 1978, pp. 93–4. Moore's attacks always made Eastlake out as a pawn of German pedants.

38 The painting had previously belonged to Lady Sykes who had obtained it from Lawrence. She

had also owned the drawing and it is very likely that this also came from Lawrence.

39 For Morris Moore and his Raphael see Haskell 1987, pp. 154–74. There is no room here to discuss the Raphaels which Eastlake declined to buy, but it is worth mentioning that he did believe the portrait of Cardinal Pucci currently on loan to the National Gallery to be by Raphael (it is now acknowledged to be by Parmigianino) and was in favour of the Trustees buying it if the condition was thought to be sufficiently good – Peel Papers, British Library, Add MSS 40586, fol. 246, letter to Peel of 9 March 1846.

40 I hope to publish in the near future a full account of Woodburn's dealing with the National Gallery during the 1840s. A summary is provided in Avery-Quash 2003, pp. XXVII–XXVIII. He emerges as perhaps mentally unbalanced and certainly less heroic than he is supposed to have been – and perhaps was – during the 1830s. His dealings with government over the Lawrence drawings have been most fully described in Sutton 1970, pp. VII–XXXIII.

41 Ibid.

42 Eastlake 1848, pp. 230–1. For his involvement in the business during the 1830s see Robertson 1978, p. 52, and White, Whistler and Harrison 1992, pp. XI, XIII, XVI and XVIII.

43 Woodburn mentions the offer of the drawing in a letter of 19 March 1839 to the Chancellor

of the Exchequer (NG 5/37/1839) and again in a letter to Rogers (ibid.) – 'Mr. Samuel Woodburn hopes that no difference between the directors and him will cause any hesitation in accepting it.' However, the Trustees did not accept the offer, doubtless because they were declining Woodburn's offer of drawings for £12,000 (Minutes of the Board, I, pp. 140–1, 20 April 1839). It is not clear what drawing of Saint Catherine Woodburn was offering: the actual cartoon was already in the Louvre.

44 Ruland 1876, pp. IX–XIII, traces the origins and growth of the project.

45 Robertson 1978, p. 74 and pp. 269–70, note 148.

46 Eastlake's views were published in the appendices he supplied for the Reports by the Commissioners of the Fine Arts between 1841 and 1846 (subsequently reprinted in Eastlake 1848) where his praise of the compositional clarity and 'masterly clearness in telling a story' in Raphael's cartoons is found on pp. 47–8 and his point that the Tudor style of Gothic was coeval with the highest development of art in Italy is found on p. 126.

47 For the moves to transfer the cartoons to Trafalgar Square see Shearman 1972, pp. 156–8. As Shearman notes, it was hoped that the National Gallery would move to South Kensington where there would have been more space. When this was abandoned in 1856 the South Kensington Museum had attracted

Royal attention as an alternative. The eventual 'solution' was probably due to Redgrave's influence but was not at all in line with Prince Albert's intentions (he wished to see all Raphael's works reunited in British collections).

48 Romney Towndrow 1950, p. 67, no. 72. The date of around 1848 is Towndrow's. There does seem to be some relationship with the tondi Stevens painted for Deysbrook House, Liverpool, in 1847. But Stevens designed tondi before that date and the historical subject seems likely to have been suggested by those commended by the Fine Art Commission as suited to the decoration of the Houses of Parliament.

49 Robertson 1978, pp. 229–31. It was a remarkable achievement to secure the Raphael at £9,000 (Lord Garvargh had wanted 9,000 guineas) since in 1863 Gladstone had refused to allow it to be bought for £8,000.

50 Ibid., p. 268, no. 140, and see also nos 141, 145 and 154 for repetitions.

51 Ibid., p. 74, and pp. 269–70, no. 148.

52 The design was made at the request of George Basevi in 1837, ibid., p. 49.

53 Ibid., p. 271, no. 158.

54 The Royal Academy catalogue carried the note (under no. 135) 'see Castiglione's poemata'; Eastlake had discussed the poem in his 1840 article, for which see Eastlake 1848, pp. 247–9.

55 Bann 1997, pp. 233–45, and Ziff 1977, pp. 207–15. The paintings in question are those of the

1840s such as A Mother's Joy and the Childhood of Pico della Mirandola which are now in the Musée Pescatore, Luxembourg, the Wallace Collection, London, and the Musée des Beaux-Arts, Nantes. The exquisite paintings of the holy family by Charles Müller in a bedroom at Mount Stewart, Isle of Bute, are fine examples of Delaroche's influence, reflecting his fascination with Raphael's tondo compositions.

56 The most notable attack on the cartoons was made by John Ruskin – see especially Cook and Wedderburn 1903–12, V, p. 81.

57 For Watts's mural see Watts 1912, I, pp. 135–6 and 150–2.

58 Stevens's scheme for St Paul's is preserved on the wood and plaster half model of 1862–5 in the Cathedral's Trophy Room. Both this and the trial mosaic of about 1864 in the Victoria and Albert Museum are illustrated in Beattie 1975, figs 57–9, together with some of the preparatory drawings, ibid., figs 60–1.

59 For the acquisition of the Ansidei and Mond altarpieces see pp. 9–10. The loan of the Colonna Altarpiece is less well known. According to Wornum's manuscript diary (National Gallery archive) it arrived from Paris on 19 July 1871 and was placed in a temporary frame on 16 October. It was removed on 13 March in the following year. It was sometimes referred to at that date as the 'Ripalda Raphael'.

CHRONOLOGY

Minna Moore Ede

1482 Guidobaldo da Montelfeltro succeeds his father, Federigo, as Duke of Urbino.

1483 28–29 March or 6–7 April Raphael (born Raffaello Santi), son of Giovanni Santi (about 1440/5–1494) and Magia di Battista Ciarla, is born in Urbino, in The Marches, north-east Italy. Raphael's birth date is calculated from his death on Good Friday 1520, since he was allegedly born on the same feast day. As Easter does not fall on the same date every year there is some uncertainty as to the exact date of his birth.

1482–7 Santi writes his rhymed chronicle 'La vita e le gesta di Federico di Montefeltro duca d'Urbino', a homage to the deceased duke. It is presented to Duke Guidobaldo around 1492 and contains valuable insights into artistic and court life.

1488 Duke Guidobaldo marries Elisabetta Gonzaga. As court painter, Santi produces designs for the wedding celebration.

1491 In October Santi pays for a Mass to be said in the church of S. Francesco, Urbino, following the death of his wife. Raphael is eight years old.

1492 In August Rodrigo Borgia is crowned Pope Alexander VI, following the death of Pope Innocent VIII on 25 July.

1494 Santi dies on 1 August. Raphael is entrusted to his uncle Bartolomeo, a priest also living in Urbino.

1498 Savonarola, the Dominican friar who preached apocalyptic sermons on the immorality of the Church and contemporary society, is burnt at the stake in Florence on 23 May.

1500 Raphael and Evangelista di Pian di Meleto (d.1549), who had been Santi's closest assistant, sign a contract on 10 December with the wool merchant Andrea Baronci, for an altarpiece of the *Coronation of Saint Nicholas of Tolentino* for his chapel in the church of S. Agostino, Città di Castello. The painting, Raphael's first documented work, is largely destroyed by an earthquake in 1789 (for the four surviving fragments see cats 15–16, and figs 2 and 54).

1501 On 13 September Raphael and Evangelista acknowledge receipt of 33 ducats on delivery of the *Coronation of Saint Nicholas of Tolentino*.

1502 Cesare Borgia, the illegitimate son of Pope Alexander VI, appointed by his father as commander of the papal armies and sent to subdue the cities of Central Italy, annexes Urbino and removes valuable books, statues and tapestries.

Piero Soderini (c.1452–1522) is appointed *Gonfaloniere a Vita*, head of the Florentine Government for life.

In June Pintoricchio (1454–1513) is commissioned to decorate the library of Siena cathedral with frescoes depicting scenes from the life of Aeneas Silvius Piccolomini (Pope Pius II). Between 1502 and 1503, Raphael provides drawings for the frescoes (see pp. 23–6). Raphael may have been in Siena in the latter part of 1502.

1503 Raphael's *Mond Crucifixion* (cat. 27) for the Gavari chapel in S. Domenico, Città di Castello, is thought to have been completed by or during 1503, as this date is carved on the frame above the altar in which the work was placed.

Raphael is documented as present in Perugia on 19 January, and again in March. It is possible that he was based in Perugia for much of the period between 1502 and 1505.

The occupation of Perugia by the troops of Cesare Borgia ends on the death of Pope Alexander VI on August 18. Borgia is captured and exiled to Spain.

In October Leonardo da Vinci (1452–1519) is commissioned by Soderini to paint the *Battle of Anghiari* in the Sala del Consiglio in the Palazzo Vecchio, Florence.

On 31 October Giuliano della Rovere is elected Pope Julius II.

1504 Duke Guidobaldo adopts his nephew Francesco Maria della Rovere (d.1538) – also nephew of Pope Julius II – as his heir.

Raphael's *Betrothal of the Virgin* in S. Francesco, Città di Castello, is signed and dated 1504 on the temple in the background (see fig. 12).

On 12 January Raphael is recorded as living in Perugia.

In May the statue of *David* by Michelangelo Buonarroti (1475–1564) is installed beside the entrance to the Palazzo Vecchio.

During the summer, Michelangelo is commissioned to paint the *Battle of Cascina* in the Sala del Consiglio in the Palazzo Vecchio (see cat. 55).

Giovanna Feltria, the widow of Giovanni della Rovere and sister of Guidobaldo da Montefeltro, writes a letter (dated 1 October) recommending Raphael to Soderini (the authenticity of this document has been disputed, see p. 34).

1505 Raphael's *Colonna Altarpiece* (fig. 68) for the nuns of Sant'Antonio da Padua in Perugia is thought to have been completed by this date. Although no inscription is visible today, the German art historian Gustav Waagen (1794–1868) recorded the date 1505 inscribed on the picture when he saw it in Naples in 1859.

The *Ansidei Madonna*, painted for the Ansidei family chapel in the Servite church of S. Fiorenzo in Perugia, is dated 1505 (?) in the hem of the Virgin's robes (see cat. 45).

On 12 December Raphael and the Perugian artist Berto di Giovanni sign a contract to paint an altarpiece of the *Coronation of the Virgin* for the Franciscan convent of S. Maria di Monteluce, outside the walls of Perugia. Work never begins and a new contract is negotiated in 1516, stipulating that the altarpiece is to be painted by Raphael, and the predella and frame by Berto. The altarpiece is eventually painted by Raphael's pupils, Giulio Romano and Gianfrancesco Penni, and finally delivered in 1525.

1505/6 The *Madonna of the Meadow* is dated in the Virgin's neckline (fig. 24). Whether the numerals inscribed read as 1505 or 1506 is still debated.

1506 On 18 April Julius II commissions the architect and painter Donato Bramante (1444–1514) to oversee the rebuilding of St Peter's in Rome.

Julius II visits Perugia on 13 September, accompanied by twenty cardinals, Duke Guidobaldo da Montefeltro, Giovanni Gonzaga and others.

1507 Raphael signs and dates the *Holy Family with a Lamb* in the neckline of the Virgin's dress (cat. 60). In the same year, Raphael dates the *Entombment* for the Baglioni chapel in the church of S. Francesco al Prato, Perugia (fig. 34, see also cats 65–73).

Baldassare Castiglione is present at the court of Urbino. His chronicle of court life, *Il Cortegiano (The Book of the Courtier)* published in 1528, alludes to Raphael's exemplary manners as well as his talent.

On 11 October Raphael is present in the Palazzo Ducale, Urbino, regarding his purchase of a house in the city.

1508 Raphael signs and dates *La Belle Jardinière* (fig. 27) in the hem of the Madonna's mantle. In the same year, he signs and dates the *Large Cowper Madonna* (today in the National Gallery of Art, Washington DC) in the neckline of the Madonna's dress.

In April Francesco Maria della Rovere succeeds Guidobaldo as Duke of Urbino.

On 21 April Raphael writes from Florence to his uncle Simone Ciarla in Urbino. This letter is the only secure record of Raphael's presence in Florence. Raphael expresses his interest in an as yet unallocated commission to decorate 'a certain room' (sometimes thought to be another work for the Sala del Consiglio in the Palazzo Vecchio, but more likely an allusion to the commission from Julius II to paint a suite of rooms in the Vatican Palace) and asks his uncle to obtain for him another letter of recommendation to Soderini, this time from the pope's nephew, Francesco Maria della Rovere.

In May Michelangelo begins work on the ceiling decoration of the Sistine Chapel in the Vatican.

1509 On 13 January Raphael acknowledges a payment of 100 ducats for work begun in a room in the papal apartments. This is the first time Raphael is documented in Rome, although he must have arrived in the second half of 1508.

1510–11 The Holy League alliance is formed by Julius II, consolidating the powers of Venice, the Swiss cantons, Ferdinand II of Aragón, Henry VIII of England and the Holy Roman Emperor Maximilian I, with the purpose of expelling Louis XII of France from Italy.

1511 On 23 May Julius II loses the city of Bologna to French troops. He vows to remain unshaven until the French have been forced out of Italy.

A letter dated 12 July to Isabella d'Este in Mantua, from her ambassador in Rome, describes Raphael painting in two rooms in the Vatican Palace for Julius II, the Stanza della Segnatura (completed within the year), and the Stanza di Eliodoro (painted 1511–14).

In August the first half of Michelangelo's Sistine ceiling is unveiled. In the same month the Venetian painter, Sebastiano del Piombo (c.1485–1547), accompanies the Sienese banker Agostino Chigi from Venice to Rome.

On 4 October Julius II appoints Raphael to the office of *Scriptor Brevium*, a papal sinecure arranged so that 'he may be maintained more fitly through the office'.

1512 The Fifth Lateran Council is convened to address the need for church reform.

In August the Medici family are restored to power in Florence, under the leadership of Duke Lorenzo.

In October Michelangelo completes the ceiling of the Sistine Chapel.

1513 Niccolò Machiavelli writes *Il Principe (The Prince)*.

Pope Julius II dies on 20/21 February. In March, Giovanni de' Medici is elected as Pope Leo X.

On 12 September the Venetian ambassador to Rome reports to the Venetian Senate that a portrait of the recently deceased Julius II on display on the high altar of S. Maria del Popolo is causing a public sensation. Although Raphael's name is not mentioned, subsequent records prove that the portrait was cat. 99.

1514 Bramante dies on 12 March.

In a letter dated 1 July, Raphael writes to his uncle Simone Ciarla in Urbino, reporting that he has begun work in another room in the Vatican Palace, probably the Stanza dell'Incendio. He also reacts to a suggestion that he should marry, commenting that he grows rich without a wife.

Sometime before 1 August Raphael is paid 100 ducats by the *Fabbrica* of St Peter's for the completion of the pope's new rooms. This is the only recorded payment, though for a task of this size other larger payments would have been made.

On 1 August Raphael is officially appointed architect of St Peter's, although he probably assumed the role immediately after Bramante's death.

1515 The first recorded payment for designs for tapestries for the Sistine Chapel is made to Raphael on 15 June. Seven cartoons depicting scenes from the *Acts of the Apostles* survive in the Victoria and Albert Museum, London, and the resulting tapestries are in the Vatican Museums.

On 27 August Pope Leo X appoints Raphael as overseer of all the archaeological excavations in and around Rome. Raphael has prior rights to all the stone and marble excavated so that it can be used for the rebuilding of St Peter's.

On 8 November Raphael acquires a house in the Via Sistina in the Borgo, the artists' quarter, near the Vatican.

1516 In a letter dated 22 November, Leonardo Sellaio (an agent of the banker Pierfrancesco Borgherini) writes to Michelangelo, informing him that Raphael has engaged the Florentine architect Antonio da Sangallo as his partner at St Peter's.

Raphael receives the final payment for the Sistine Chapel tapestry cartoons on 20 December.

1517 During 1517 Agostino Veneziano dates an engraving after Raphael's composition for an altarpiece of Christ carrying the Cross, known as *Lo Spasimo,* for the Olivetan monks of S. Maria dello Spasimo in Palermo (today in the Museo del Prado, Madrid).

On 19 January Sellaio reports to Michelangelo that Cardinal Giulio de' Medici has commissioned two paintings for a chapel in Narbonne cathedral in France. Raphael is to paint the *Transfiguration* (today in the Vatican Museums) and Sebastiano is to portray the *Raising of Lazarus* (National Gallery, London, NG 1). Sellaio also suggests that – to avoid competition – Raphael is doing his best to prevent Sebastiano from taking up the commission.

1517 Raphael is first approached by Alfonso
(cont.) d'Este, Duke of Ferrara, in March. Of the
resulting correspondence, the most important
letter (dated 11 September) discusses the
Duke's hope that Raphael will contribute a
work to the *camerino* in his palace in Ferrara.
Although seemingly interested in this project,
Raphael does not paint anything for Duke
Alfonso, probably because of his many other
commitments.

On 31 October Martin Luther fastens his
'Ninety-Five Theses upon Indulgences' to
the church door at Wittenberg, Germany, in
protest against the enormous sums of money
that Pope Leo X was levying for the rebuilding
of St Peter's in return for indulgences.
It marks the start of the Reformation.

1518 During 1518 Raphael signs and dates his
Saint Michael and also the *Holy Family with
Saints Elizabeth and John the Baptist and
Angels* (both today in the Louvre, Paris).
Intended as gifts for the King and Queen of
France from Duke Lorenzo de' Medici and
Leo X these works were principally executed
by Raphael's workshop following his designs.

In March Raphael receives a payment of
32 ducats for the decoration of the private
loggia of Pope Leo X. This modest sum would
only have been part-payment. By this time
Raphael is running a large and successful
workshop, and is greatly assisted in the
decoration of the loggia (which was certainly
complete by June of 1519) by Giulio Romano,
Gianfrancesco Penni, Giovanni da Udine,
Polidoro da Caravaggio and Perino del Vaga.

On 2 July Sebastiano writes to Michelangelo
explaining that he has progressed slowly with
the *Raising of Lazarus* so that Raphael will
not see it before he is finished.

A document dated 5 August shows that work
is underway on the construction of the Villa
Madama for Cardinal Giulio de' Medici on
the hillside of Monte Mario, north of the
Vatican. A letter written by Raphael, dated
March 1519, in which he describes his plan
for the villa, survives.

On 1 September Duke Lorenzo de' Medici
is sent a letter informing him that Raphael's
*Portrait of Pope Leo X with Cardinals Giulio
de' Medici and Giulio de' Rossi* (the pope's
nephews) is to be sent to him the next
day. The portrait of the pope is today in
the Uffizi, Florence.

1519 On 1 January Sellaio again writes to
Michelangelo claiming that Sebastiano's
Raising of Lazarus is almost finished, and
that he is far ahead of Raphael. Sellaio also
describes Sebastiano's criticism of the
Psyche loggia, decorated by Raphael and
his workshop, at Agostino Chigi's villa
(today known as the Villa Farnesina). Like
the fourth stanza in the Vatican Palace (the
Sala di Costantino) only the designs for the
frescoes are by Raphael and the execution
is entirely by his workshop.

On 1 April Raphael is paid 1500 ducats for
his previous five years' employment as
Director of Works at St Peter's.

On 2 May Leonardo dies in Amboise, France.

Agostino Chigi's will, dated 28 August, states
that work on his burial chapel in S. Maria
del Popolo (primarily built between 1513 and
1516, but still unfinished on Chigi's death in
1520) is to be finished according to Raphael's
plans. The chapel is the most complete
example of Raphael's architectural projects.
The mosaics, sculpture, and two tombs in
the chapel were also originally executed
according to designs by Raphael.

On 26 December Paris de Grassis, the pope's
master of ceremonies, records the unveiling
of the tapestries, based on Raphael's
cartoons, in the Sistine Chapel.

1520 Before April the Ferrarese poet, Antonio
Tebaldeo, composes a funeral ode following
the death of Raphael's fiancée, Maria Bibbiena.
Maria's marriage to Raphael seems to have
been under negotiation when she died. Her
precise relationship to Cardinal Bibbiena,
private secretary to Pope Leo X, cannot be
firmly established. However, the cardinal's
Vatican apartment was decorated by Raphael
and his workshop, and he is said to have
inherited Raphael's house upon his death.

On or around 5 April Raphael makes a will.
It is estimated that on his death he left
about 16,000 ducats, of which 1,500 were an
endowment for the decoration of a chapel in
the Pantheon in Rome, in which he wished
to be buried with Maria Bibbiena.

On 6 April Marcantonio Michiel, the
Venetian writer and collector, records that
Raphael is seriously ill.

On 7 April Michiel records the death of
Raphael on his thirty-seventh birthday.
The precise cause of his death is not known,
although he languished with a fever for ten
days. Vasari suggested that he had died from
amatory excess. Raphael's funeral Mass is
celebrated at the Vatican, his *Transfiguration*
placed at the head of the bier. Despite
the intense rivalry between Raphael and
Sebastiano, the two paintings commissioned
for Narbonne are exhibited together only
days after Raphael's death.

BIBLIOGRAPHY

AGOSTI AND FARINELLA 1990
G. Agosti and V. Farinella, 'Interni senesi "all'antica"'
in ed. P. Torriti, *Domenico Beccafumi e il suo tempo*,
exh. cat., Siena (S. Agostino) 1990, pp. 578–99.

ALBERTINI 1510
F. Albertini, *Opusculum de mirabilibus nouae et veteris
urbis Romae*, Rome, 1510.

ALEXANDER 1962
B. Alexander, *England's Wealthiest Son*, London 1962.

ALEXANDER 1994–5
ed. J.J.G. Alexander, *The Painted Page. Italian Renaissance
Book Illumination 1450–1550*, exh. cat., London (Royal
Academy) 1994–5.

ALFIERI AND NESSELRATH 1993
M. Alfieri and A. Nesselrath, 'Model of the Vatican
Palaces during the Pontificates of Julius II and Leo X'
in *High Renaissance in the Vatican: The Age of Julius II
and Leo X*, Tokyo 1993, vol. I, pp. 66–72, and vol. II,
pp. 39–42, cat. 24.

ALIPPI 1891
A. Alippi, 'Di Maestro Evangelista da Piandimeleto
pittore', *Nuova Rivista Misena*, IV (1891), pp. 51–3.

AMY 2000
M. Amy, 'The dating of Michelangelo's *St Matthew*',
The Burlington Magazine, CXLII (2000), pp. 493–6.

ASSIRELLI 1983
M. Assirelli in ed. M.G. Ciardi Dupré Dal Poggetto
and P. Dal Poggetto, *Urbino e le Marche prima e dopo
Raffaello*, exh. cat., Urbino (Palazzo Ducale) 1983.

AVERY-QUASH 2003
S. Avery-Quash, 'The Growth of Interest in Early Italian
Painting in Britain' in D. Gordon, *National Gallery
Catalogues. The Fifteenth Century Italian Paintings*, vol. I,
London 2003, pp. XXVII–XLIV.

BALDINI 2004
N. Baldini in Perugia 2004.

BAMBACH 1988
C. Bambach Cappel, *The Tradition of Pouncing Drawings
in the Italian Renaissance Workshop: Innovation and
Derivation*, doctoral thesis, Yale University 1988.

BAMBACH 1992
C. Bambach Cappel, 'A Substitute Cartoon for
Raphael's *Disputa*', *Master Drawings*, 30.1 (1992),
pp. 9–30.

BAMBACH 1999
C. Bambach, *Drawing and Painting in the Italian
Renaissance Workshop. Theory and Practice, 1300–1600*,
Cambridge 1999.

BAMBACH (ED.) 2003
ed. C. Bambach, *Leonardo da Vinci, Master Draftsman*,
exh. cat., New York (Metropolitan Museum of Art) 2003.

BANN 1997
S. Bann, *Paul Delaroche: History Painted*, Princeton 1997.

BARBERINI 1984
G. Barberini in *Raffaello nelle Raccolte Borghese*,
exh. cat., Rome (Galleria Borghese) 1984.

BAROCCHI AND RISTORI 1965–83
P. Barocchi and R. Ristori, *Il Carteggio di Michelangelo*,
Florence 1965–83 (5 vols).

BARTALINI 1996
R. Bartalini, *Le Occasioni del Sodoma*, Rome 1996.

BARTALINI 2001
R. Bartalini, 'Sodoma, the Chigi and the Vatican Stanze',
The Burlington Magazine, CXLIII (2001), pp. 544–53.

BARTSCH
A. Bartsch, *Le peintre graveur*, Vienna 1803–21 (21 vols).

BAXANDALL 1972
M. Baxandall, *Painting and Experience in Fifteenth
Century Italy*, Oxford 1972.

BEATTIE 1975
S. Beattie, *Alfred Stevens*, London 1975.

BECHERUCCI 1968
L. Becherucci in ed. M. Salmi, *Raffaello: L'opera, le fonti,
la fortuna*, Novara 1968.

BECK 1996
J. Beck, 'The *Portrait of Julius II* in London's National
Gallery. The Goose that turned into a Gander', *Artibus
et Historiae*, XXXIII (1996), pp. 69–95.

BÉGUIN 1979
S. Béguin, *La Madone de Lorette*, Paris 1979.

BÉGUIN 1982
S. Béguin, 'Un nouveau Raphaël: un ange du retable
de Saint Nicolas de Tolentino', *La Revue du Louvre*,
XXXI.2 (1982), pp. 99–115.

BÉGUIN 1983–4
S. Béguin in *Raphael dans les collections françaises*,
exh. cat., Paris (Grand Palais) 1983–4.

BÉGUIN 1986
S. Béguin, 'The St Nicholas of Tolentino Altarpiece'
in *Raphael before Rome, Studies in the History of Art*, 17
(1986), pp. 15–28.

BÉGUIN 1987
S. Béguin, 'Nouvelles recherches sur le "Saint Michel"
et le "Saint Georges" du Musée du Louvre' in eds
M. Sambucco Hamoud and M.L. Strocchi, *Studi su
Raffaello*, Urbino 1987, pp. 455–64.

BELLORI 1695
G.P. Bellori, *Descrizione delle quattro immagini dipinte
da Raffaello d'Urbino nella Camera della Segnatura nel
Palazzo Vaticano* (Rome 1695) in *Descrizione delle immagini
dipinte da Raffaello d'Urbino nel Vaticano e di quelle della
Farnesina, hrsg. v. Melchior Missirini*, Rome 1821.

BELTRAMI 1919
L. Beltrami, *Documenti e Memorie riguardanti la Vita e
le Opere di Leonardo da Vinci*, Milan 1919.

BENAZZI (forthcoming)
G. Benazzi, 'Raffaello ridotto alla sua concreta umanità.
Un inedito gonfalone giovanile a Gubbio', *Bollettino
d'Arte*, forthcoming.

BERENSON 1896
B. Berenson, 'Les peintures italiennes de New York et de
Boston', *Gazette des Beaux-Arts*, XV (1896), pp. 195–214.

BERENSON 1897
B. Berenson, *The Central Italian Painters of the
Renaissance*, London and New York 1897.

BERNINI PEZZINI AND MASSARI 1985
G. Bernini Pezzini, S. Massari and S.P. Valenti Rodinò,
*Raphael Invenit: Stampe da Raffaello nelle Collezioni
dell'Istituto Nazionale per la Grafica*, exh. cat., Rome
(Istituto Nazionale per la Grafica) 1985.

BIRKE AND KERTESZ 1992–7
V. Birke and J. Kertesz, *Die italienischen Zeichnungen
der Albertina: Generalverzeichnis*, Vienna 1992–7
(4 vols).

BOMBE 1915
W. Bombe in eds U. Thieme and F. Becker, *Allgemeines
Lexikon der bildenden Künstler*, vol. XI, Leipzig 1915,
pp. 96–7.

BOMFORD (ED.) 2002–3
ed. D. Bomford, *Underdrawings in Renaissance Paintings*,
exh. cat., London (National Gallery) 2002–3.

BOMFORD AND TURNER 1986
D. Bomford and N. Turner, 'Perugino's Underdrawing
in the *Virgin and Child adored by an Angel* from the
Certosa di Pavia Altarpiece' in Fabjan (ed.) 1986,
pp. 42–8.

BOMFORD, BROUGH AND ROY 1980
D. Bomford, J. Brough and A. Roy, 'Three Panels
from Perugino's Certosa di Pavia Altarpiece', *National
Gallery Technical Bulletin*, 4 (1980), pp. 3–31.

BON VALSASSINA 1984
C. Bon Valsassina in Rome 1984.

BONN 1998–9
*Hochrenaissance im Vatikan – Kunst und Kultur im Rom
der Päpste 1503–1534*, exh. cat., Bonn (Kunst- und
Ausstellungshalle der Bundesrepublik Deutschland)
1998–9.

BORCHERT 2002
ed. T.-H. Borchert, *The Age of Van Eyck 1430–1530*,
exh. cat., Bruges (Groeningemuseum) 2002.

BORGO 1976
L. Borgo, *The Works of Mariotto Albertinelli*, D.Phil.
thesis, Harvard University 1968, published Ann Arbor
1976.

BORGO 1987
L. Borgo, 'Fra Bartolommeo e Raffaello: l'incontro
romano del 1513' in eds M. Sambucco Hamoud and
M.L. Strocchi, *Studi su Raffaello*, Urbino 1987,
pp. 499–507.

BRAHAM AND WYLD 1984
A. Braham and M. Wyld, 'Raphael's *Saint John the
Baptist Preaching*', *National Gallery Technical Bulletin*,
8 (1984), pp. 15–23.

BREDEKAMP 2000
H. Bredekamp, *Sankt Peter in Rom und das Prinzip der
produktiven Zerstörung*, Berlin 2000.

BREJON DE LAVERGNÉE 1997
B. Brejon de Lavergnée, *Catalogue des Dessins Italiens.
Collections du Palais des Beaux-Arts de Lille*, Paris 1997.

BRIGSTOCKE 1993
H. Brigstocke, *Italian and Spanish Paintings in the National Gallery of Scotland*, Edinburgh 1993 (2nd edn).

BRITTON 1808
J. Britton, *Catalogue Raisonné of the Pictures belonging to the most honourable the Marquis of Stafford, in the Gallery of Cleveland House*, London 1808.

BROWN 1983
D.A. Brown, *Raphael and America*, exh. cat., Washington, DC (National Gallery of Art) 1983.

BROWN 1992
D.A. Brown, 'Raphael, Leonardo and Perugino. Fame and Fortune in Florence' in ed. S. Hager, *Leonardo, Michelangelo and Raphael in Renaissance Florence from 1500–1508*, Washington, DC 1992, pp. 29–53.

BROWN 2001–2
ed. D.A. Brown, *Leonardo's Ginevra de' Benci and Renaissance Portraits of Women*, exh. cat., Washington, DC (National Gallery of Art) 2001–2.

BROWN 2003–4
D.A. Brown in eds A. Chong, D. Pegazzano, D. Zikos, *Raphael, Cellini and a Renaissance Banker: The Patronage of Bindo Altoviti*, exh. cat., Boston (Isabella Stewart Gardner Museum) 2003–4, pp. 93–114, 380–2.

BRUSCHI 1990
A. Bruschi, *Bramante*, Rome and Bari 1990.

BUCHANAN 1824
W. Buchanan, *Memoirs of Painting: with a chronological history of the importation of pictures by the great masters into England since the French Revolution*, London 1824.

BURCKHARDT 1928
J. Burckhardt, *Die Kultur der Renaissance in Italien*, Berlin 1928.

BURNS 1984
H. Burns, 'Raffaello e "quell'antiqua architettura"' in ed. C.L. Frommel, *Raffaello architetto*, Milan 1984, pp. 381–404.

BUTLER 2002
K. Butler, *Full of Grace: Raphael's Madonnas and the Rhetoric of Devotion*, doctoral thesis, Johns Hopkins University, Baltimore 2002.

BUTLER 2004
K. Butler, 'Rethinking Early Raphael', *Atti del Convegno internazionale su Raffaello – pluralità e unità, Bibliotheca Hertziana, 2–4.5.2002*, Rome 2004 (forthcoming – text available at: http://colosseum.biblhertz.it/event/Raffael/texte/butler/butler.htm).

CAGLIOTI 2000
F. Caglioti, *Donatello e i Medici*, Florence 2000.

CALZINI 1912
E. Calzini, 'Dei ritratti dipinti da Giovanni Santi', *Rassegna Bibliografica dell'art italiana*, XV (1912), pp. 11–17.

CAMESASCA 1987
ed. E. Camesasca *Da Raffaello a Goya ... da Van Gogh a Picasso; 50 dipinti dal Museu de Arte di San Paolo del Brasile*, exh. cat., Trento (Palazzo delle Albere) 1987.

CAMESASCA 1993
E. Camesasca, *Raffaello. Gli scritti*, Milan 1993.

CAMPBELL 1990
L. Campbell, *Renaissance Portraits*, New Haven and London 1990.

CAMPBELL 1998
L. Campbell, *National Gallery Catalogues. The Fifteenth Century Netherlandish Schools*, London 1998.

CANUTI 1931
F. Canuti, *Il Perugino*, Siena 1931 (2 vols).

CAPORALI 1536
G.B. Caporali, *Architettura ... con il suo comento et figure Vetruvio in volgar lingua raportato per M. Gianbatista Caporali*, Perugia 1536.

CARLI 1960
E. Carli, *Il Pintoricchio*, Milan 1960.

CARMINATI 1994
M. Carminati, *Cesare da Sesto 1477–1523*, Milan and Rome 1994.

CARTER 1964
C. Carter, *Centenary exhibition of the Work of William Dyce R.N., 1806–1864*, Aberdeen (Art Gallery) and London (Agnew and Sons) 1964.

CARVALHO DE MAGALHÃES 1993
R. Carvalho de Magalhães, 'Ragioni di un'attribuzione: la *Resurrezione* di Raffaello al Museo d'arte di San Paolo' in ed. R. Varese, *Studi per Pietro Zampetti*, Ancona 1993, pp. 626–30.

CASTIGLIONE 2002
B. Castiglione, *The Book of the Courtier* (trans. C. Singleton and ed. D. Javitch), New York and London 2002.

CAZORT, KORNELL AND ROBERTS 1996
M. Cazort, M. Kornell and K.B. Roberts, *The Ingenious Machine of Nature, Four Centuries of Art and Anatomy*, exh. cat., Ottawa (National Gallery of Canada) 1996.

CECCHI 1987
A. Cecchi, 'Agnolo e Maddalena Doni committenti di Raffaello' in eds M. Sambucco Hamoud and M.L. Strocchi, *Studi su Raffaello*, Urbino 1987, pp. 429–39.

CECCHI 1996–7
A. Cecchi in *L'Officina della Maniera*, exh. cat., Florence (Uffizi) 1996.

CELLINI 1558
B. Cellini, *La Vita ...*, Florence 1558 (ed. E. Camesasca, Milan 1954).

CENNINI 1960
Cennino d'Andrea Cennini, *The Craftsman's Handbook* (trans. D.V. Thompson), New York 1960.

CERTINI 1726–8
A. Certini, *Origine delle chiese e monasteri di Città di Castello*, Città di Castello 1726–8, Archivio Vescovile, ms. I.

CHIARINI, CIATTI AND PADOVANI (EDS) 1991
eds M. Chiarini, M. Ciatti and S. Padovani, *Raffaello a Pitti. 'La Madonna del baldacchino': storia e restauro*, exh. cat., Florence (Palazzo Pitti) 1991.

CHIARINI AND PADOVANI (EDS) 2003
eds M. Chiarini and S. Padovani, *La Galleria Palatina e gli Appartamenti Reali di Palazzo Pitti. Catalogo dei Dipinti*, Florence 2003 (2 vols).

CHRISTENSEN 1986
C. Christensen, 'Examination and Treatment of Paintings by Raphael at the National Gallery of Art', *Raphael before Rome, Studies in the History of Art*, 17 (1986), pp. 47–54.

CIARDI DUPRÉ DAL POGGETTO 1987
M.G. Ciardi Dupré Dal Poggetto, 'Osservazioni sulla formazione di Raffaello' in eds M. Sambucco Hamoud and M.L. Strocchi, *Studi su Raffaello*, Urbino 1987, pp. 33–54.

CIARDI DUPRÉ DAL POGGETTO 2004
M.G. Ciardi Dupré Dal Poggetto in Perugia 2004.

CIARTOSO 1911
M. Ciartoso, 'Nuove attribuzioni ad un discepolo di Giovanni Santi', *L'Arte*, XIV n. 4 (1911), pp. 258–62.

CLARK 1939
K. Clark, *Leonardo da Vinci: an account of his development as an artist*, New York and Cambridge 1939.

CLAYTON 1999
M. Clayton, *Raphael and his Circle*, exh. cat., London (The Queen's Gallery, Buckingham Palace) 1999.

CLAYTON 2002–3
M. Clayton, *Leonardo da Vinci: The Divine and the Grotesque*, exh. cat., Edinburgh (The Queen's Gallery, Holyroodhouse) and London (The Queen's Gallery, Buckingham Palace) 2002–3.

CLOUGH 1987
C. Clough, 'Il San Giorgio di Washington: fonti e fortuna' in eds M. Sambucco Hamoud and M.L. Strocchi, *Studi su Raffaello*, Urbino 1987, pp. 275–90.

CONDIVI 1553
A. Condivi, *Vita di Michelagnolo Buonarotti*, Rome 1553.

CONDIVI 1874
A. Condivi, *Das Leben des Michelangelo Buonarroti*, trans. R. Valdek, ed. R. Eitelberger von Edelberg, Vienna 1874.

CONTI 1627
A. Conti, *Fiori vaghi delle vite de' Santi e Beati della Chiesa e reliquie della Città di Castello*, Città di Castello 1627.

COOK AND WEDDERBURN 1903–12
eds E.T. Cook and A. Wedderburn, *The Works of John Ruskin*, London 1903–12.

COONIN 1999
A.V. Coonin, 'New documents concerning Perugino's workshop in Florence', *The Burlington Magazine*, CXLI (1999), pp. 100–5.

COOPER 2001
D. Cooper, 'Raphael's altar-pieces in S. Francesco al Prato, Perugia: patronage, setting and function', *The Burlington Magazine*, CXLIII (2001), pp. 554–61.

COOPER 2004
D. Cooper, 'New documents for Raphael and his patrons in Perugia', *The Burlington Magazine*, CXLVI (2004).

COOPER AND PLAZZOTTA 2004
D. Cooper and C. Plazzotta, 'Raphael's Ansidei Altar-piece in the National Gallery', *The Burlington Magazine*, CXLVI (2004).

COSTAGMAGNA 2000
A. Costamagna, *Raffaello. Dama con liocorno*, CD-ROM, 2000.

CRISPOLTI 1648
C. Crispolti, *Perugia Augusta*, Perugia 1648.

CROWE AND CAVALCASELLE 1864–6
J.A. Crowe and G.B. Cavalcaselle, *A History of Painting in Italy*, London 1864–6 (3 vols).

CROWE AND CAVALCASELLE 1882–5
J.A. Crowe and G.B. Cavalcaselle, *Raphael: His Life and Works*, London 1882–5 (2 vols).

CROZAT 1729
J.A. Crozat, *Recueil d'estampes ...*, Paris 1729.

CUGNONI 1878
G. Cugnoni, *Agostino Chigi il Magnifico*, Rome 1878 (extract of *Archivio della Società Romana di Storia Patria*).

CUZIN 1983
J. Cuzin, *Raphaël*, Fribourg 1983.

DALLI REGOLI 1983
G. Dalli Regoli, 'Raffaello "angelica farfalla": note sulla struttura e sulle fonti della pala Ansidei', *Paragone*, 399 (1983), pp. 8–19.

DALLI REGOLI 1999
G. Dalli Regoli, 'Parsimonia, prudenza, equidistanza: modalità operative nella pittura di Giovanni Santi' in Varese (ed.) 1999, pp. 46–52.

DAVIES 1961
M. Davies, *The Earlier Italian Schools*, National Gallery, London 1961 (2nd edn).

DE CARO 1960
G. De Caro, 'Alidosi, Francesco', *Dizionario biografico degli Italiani*, 2, Rome 1960, pp. 373–6.

DE CHAPEAUROUGE 1993
D. de Chapeaurouge, *Raffael: Sixtinische Madonna*, Frankfurt 1993.

DE COSNAC 1885
G.-J. de Cosnac, *Les richesses du Palais Mazarin*, Paris 1885.

DE TOLNAY 1947
C. De Tolnay, *Michelangelo*, Princeton 1947.

DE TOLNAY 1975
C. De Tolnay, *Corpus dei Disegni di Michelangelo*, I, Novara 1975.

DE VECCHI 1986
P. De Vecchi, 'The *Coronation of the Virgin* in the Vatican Pinacoteca and Raphael's activity between 1502 and 1504' in *Raphael before Rome, Studies in the History of Art*, 17 (1986), pp. 73–84.

DE VECCHI (ED.) 1994
ed. P. De Vecchi, *The Sistine Chapel: A Glorious Restoration*, New York 1994.

DE VECCHI 1995
P. De Vecchi, *Raffaello: la mimesi, l'armonia, e l'invenzione*, Florence 1995.

DE VECCHI 1996
P. De Vecchi, *Lo Sposalizio della Vergine di Raffaello Sanzio*, Milan 1996.

DE VECCHI 2003
P. De Vecchi, *Raffaello*, Milan 2003.

DE VECCHI 2004
P. De Vecchi, 'Perugino, Raffaello e la "imitatio"' in ed. L. Teza, *Pietro Vannucci detto il Perugino*, Perugia 2004, pp. 183–98.

DE ZAHN 1867
A. De Zahn, 'Notizie artistiche tratte dall'Archivio Segreto Vaticano', *Archivio Storico Italiano*, VI (1867), I, pp. 166–94.

DEL BRAVO 1983
C. Del Bravo, 'Etica o poesia, e mecenatismo: Cosimo il Vecchio, Lorenzo, e alcuni dipinti' in eds P. Barocchi and G. Ragionieri, *Gli Uffizi, quattro secoli di una galleria, atti del convegno*, Florence 1983, pp. 201–16.

DELLA PERGOLA 1959
P. Della Pergola, *Galleria Borghese: I Dipinti*, Rome 1959.

DENKER NESSELRATH 1993
C. Denker Nesselrath, 'I cortili' in ed. C. Pietrangeli, *Il Palazzo Apostolico Vaticano*, Florence 1993, pp. 216–35.

DENKER NESSELRATH 1993a
C. Denker Nesselrath, 'La Loggia di Raffaello' in *Raffaello nell'appartamento di Giulio II e Leone X*, Milan 1993, pp. 39–79.

DOLCE 1557
L. Dolce, *Dialogo della Pittura . . . intitolata L'Aretino*, Venice 1557.

DUBOS 1971
R. Dubos, *Giovanni Santi*, Bordeaux 1971.

DÜLBERG 1990
A. Dülberg, *Privatporträts: Geschichte und Ikonologie einer Gattung im 15. und 16. Jahrhundert*, Berlin 1990.

DUNKERTON 1999
J. Dunkerton, 'Osservazioni sulla tecnica della Madonna londinese di Giovanni Santi', in Varese (ed.) 1999, pp. 57–60.

DUNKERTON AND PENNY 1993
J. Dunkerton and N. Penny, 'The Infra-red Examination of Raphael's *Garvagh Madonna*', *National Gallery Technical Bulletin*, 14 (1993), pp. 7–21.

DUNKERTON AND ROY 2004
J. Dunkerton and A. Roy, 'The Altered Background of Raphael's *Portrait of Pope Julius II* in the National Gallery, London', *The Burlington Magazine*, CXLVI (2004).

DUNKERTON AND SPRING 1998
J. Dunkerton and M. Spring, 'The Development of Painting on Coloured Surfaces in Sixteenth-Century Italy' in *Painting Techniques, History, Materials and Studio Practice*, Dublin 1998, pp. 120–30.

DUNKERTON ET AL. 1991
J. Dunkerton, S. Foister, D. Gordon and N. Penny, *Giotto to Dürer. Early Renaissance Painting in The National Gallery*, New Haven and London 1991.

DUSSLER 1971
L. Dussler, *Raphael – A Critical Catalogue of His Pictures, Wall-Paintings and Tapestries*, London and New York 1971 (trans. from L. Dussler, *Raffael Kritisches Verzeichnis der Gemälde, Wandbilder und Bildteppiche*, Munich 1966).

EARP 1902
F.R. Earp, *A Descriptive Catalogue of the Pictures in the Fitzwilliam Museum*, Cambridge 1902.

EASTLAKE 1848
C. Eastlake, *Contributions to the Literature of the Fine Arts*, London 1848.

EKSERDJIAN 1984
D. Ekserdjian, Book Review of J. Cuzin, 'Raphaël, vie et oeuvre' and K. Oberhuber, 'Raffaello', *Burlington Magazine*, CXXVI (1984), p. 440.

ETTLINGER 1983
H.S. Ettlinger, 'The question of St George's garter', *The Burlington Magazine*, CXXV (1983), pp. 25–7.

FABJAN (ED.) 1986
ed. B. Fabjan, *Perugino, Lippi e la Bottega di San Marco alla Certosa di Pavia, 1495–1511*, exh. cat., Milan (Pinacoteca di Brera) 1986.

FERINO PAGDEN 1979
S. Ferino Pagden, 'Timoteo Vitis Zeichnungen zum verlorenen Martinszyklus in der Kapelle des Erzbishofs Arrivabene im Dom von Urbino', *Mitteilungen des Kunsthistorischen Institutes in Florenz*, XXIII (1979), pp. 127–44.

FERINO PAGDEN 1979a
S. Ferino Pagden, 'A Master and his Pupils: Pietro Perugino and his Umbrian Workshop', *Oxford Art Journal*, 1979, pp. 9–15.

FERINO PAGDEN 1981
S. Ferino Pagden, 'Raphael's Activity in Perugia as reflected in a drawing in the Ashmolean Museum,

Oxford', *Mitteilungen des Kunsthistorischen Institutes in Florenz*, XXV (1981), pp. 231–52.

FERINO PAGDEN 1982
S. Ferino Pagden, *Disegni Umbri del Rinascimento da Perugino a Raffaello*, exh. cat., Florence (Uffizi) 1982.

FERINO PAGDEN 1983
S. Ferino Pagden, 'Pintoricchio, Perugino or the Young Raphael? A Problem of Connoisseurship', *The Burlington Magazine*, CXXV (1983), pp. 87–8.

FERINO PAGDEN 1984
S. Ferino Pagden, *Gallerie dell'Accademia di Venezia. Disegni umbri*, Milan 1984.

FERINO PAGDEN 1984a
S. Ferino Pagden in *Raffaello in Vaticano*, exh. cat., Vatican City 1984–5.

FERINO PAGDEN 1984b
S. Ferino Pagden, 'Raffaello, Nudo maschile seduto con le mani incrociate sul ginocchio destro e schizzo di decorazione architettonica' in *Raffaello a Firenze – Dipinti e disegni delle collezione fiorentine*, Milan, 1984, pp. 337–38, fig. 99, cat. 31.

FERINO PAGDEN 1986
S. Ferino Pagden, 'The Early Raphael and his Umbrian Contemporaries' in *Raphael before Rome, Studies in the History of Art*, 17 (1986), pp. 93–107.

FERINO PAGDEN 1986a
S. Ferino Pagden, 'Iconographic demands and artistic achievements: the genesis of three works by Raphael' in eds C.L. Frommel and M. Winner, *Raffaello a Roma: il convegno del 1983*, Rome 1986, pp. 13–27.

FERINO PAGDEN 1986b
S. Ferino Pagden, 'I disegni di Perugino' in ed. B. Fabjan 1986, pp. 42–8.

FERINO PAGDEN 1987
S. Ferino Pagden, 'Invenzioni Raffaellesche adombrate nel libretto di Venezia: la "Strage degli Innocenti" e la "Lapidazione di Santo Stefano" a Genova' in eds M. Sambucco Hamoud and M.L. Strocchi, *Studi su Raffaello*, Urbino 1987, pp. 63–72.

FERINO PAGDEN 1989
S. Ferino Pagden, 'Giulio Romano pittore e disegnatore a Roma' in *Giulio Romano*, exh. cat., Mantua (Palazzo Ducale) 1989.

FERINO PAGDEN 1990
S. Ferino Pagden, 'Raphael's Heliodorus vault and Michelangelo's Sistine ceiling: an old controversy and a new drawing', *The Burlington Magazine*, CXXXII (1990), pp. 195–204.

FERINO PAGDEN AND ZANCAN 1989
S. Ferino Pagden and M.A. Zancan, *Raffaello. Catalogo completo*, Florence 1989.

FERRIANI 1983
D. Ferriani in eds M. G. Ciardi Duprè Dal Poggetto and P. Dal Poggetto, *Urbino e le Marche prima e dopo Raffaello*, exh. cat., Urbino (Palazzo Ducale) 1983.

FINOCCHI GHERSI 2002
L. Finocchi Ghersi, '"Il moccolo che va avanti, fa lume per due". Pio IX, il marchese Campana e la vendita della collezione Camuccini', *Rivista dell'Istituto Nazionale d'Archeologia e Storia dell'Arte*, 57, XXV (2002), pp. 355–79.

FIORE AND TAFURI 1993
eds F.P. Fiore and M. Tafuri, *Francesco di Giorgio architetto*, exh. cat., Siena (Palazzo Pubblico) 1993.

FISCHEL 1898
O. Fischel, *Raphaels Zeichnungen. Versuch einer Kritik. . .*, Strasbourg 1898.

FISCHEL 1912
O. Fischel, 'Raffaels erstes Altarbild, die Krönung des Hl. Nikolaus von Tolentino', *Jahrbuch der Königlich Preuszischen Kunstsammlungen*, XXXIII (1912), pp. 105–21.

FISCHEL 1913–41
O. Fischel, *Raphaels Zeichnungen*, Berlin 1913–41 (vols I–VIII).

FISCHEL 1917
O. Fischel, *Die Zeichnungen der Umbrer*, Berlin 1917.

FISCHEL 1937
O. Fischel, 'Raphael's Auxiliary Cartoons', *The Burlington Magazine*, LXXI (1937), pp. 167–8.

FISCHEL 1939
O. Fischel, 'Raphael's Pink Sketch-book', *The Burlington Magazine*, LXXIV (1939), pp. 181–7.

FISCHEL 1939a
O. Fischel, 'Fresh light on two well-known Italian drawings: (2) A motive of Bellinesque derivation in Raphael', *Old Master Drawings*, XIII (1939), pp. 50–1.

FISCHEL 1948
O. Fischel, *Raphael*, London 1948.

FISCHER 1990
C. Fischer, *Fra Bartolommeo. Master Draughtsman of the High Renaissance*, exh. cat., Rotterdam (Museum Boijmans Van Beuningen) 1990.

FONTANA 1981
W. Fontana in eds P. Dal Poggetto and P. Zampetti, *Lorenzo Lotto nelle Marche. Il suo tempo, il suo influsso*, exh. cat., Ancona (Chiesa del Gesù) 1981.

FORLANI TEMPESTI 1968
A. Forlani Tempesti in ed. M. Salmi, *Raffaello: L'Opera, Le Fonti, La Fortuna*, Novara 1968.

FORLANI TEMPESTI 1985
A. Forlani Tempesti, 'Raffaello e il Tondo Doni' in *Studi in onore di Luigi Grassi*, Florence 1985, pp. 144–9.

FORLANI TEMPESTI 2000
A. Forlani Tempesti, 'Anteprima per Raffaello: un foglio molto giovanile' in eds A. Gnann and H. Widauer, *Festschrift für Konrad Oberhuber*, Milan 2000, pp. 34–41.

FORLANI TEMPESTI 2001
A. Forlani Tempesti in eds A. Forlani Tempesti and G. Calegari, *Da Raffaello a Rossini, la collezione Antaldi: i disegni ritrovati*, exh. cat., Pesaro (Palazzo Antaldi) 2001.

FRANKLIN 1994
D. Franklin, *Rosso in Italy*, New Haven and London 1994.

FRANKLIN 2001
D. Franklin, *Painting in Renaissance Florence, 1500–1550*, New Haven and London 2001.

FRIEDMANN 1949
H. Friedmann, 'The Plant Symbolism of Raphael's Alba Madonna in the National Gallery of Art, Washington', *Gazette des Beaux–Arts*, XXXVI (1949), pp. 213–20.

FROMMEL 1976
C.L. Frommel, 'Die Peterskirche unter Papst Julius II. im Licht neuer Dokumente', *Römisches Jahrbuch für Kunstgeschichte*, XVI (1976), pp. 57–136.

FROMMEL (ED.) 1984
ed. C.L. Frommel, *Raffaello architetto*, Milan 1984.

FROMMEL 1984a
C.L. Frommel, 'Raffaello e la sua carriera architettonica' in ed. C.L. Frommel, *Raffaello architetto*, Milan 1984, pp. 13–46.

FROMMEL 1984b
C.L. Frommel, 'San Pietro. Storia della sua costruzione' in ed. C.L. Frommel, *Raffaello architetto*, Milan 1984, pp. 241–55.

FROMMEL 1986
C.L. Frommel, 'Raffael und Antonio da Sangallo der Jüngere' in eds C.L. Frommel and M. Winner, *Raffaello a Roma: il convegno del 1983*, Rome 1986, pp. 261–304.

FROMMEL 1989
C.L. Frommel, 'Bramante e il disegno 104 A degli Uffizi' in eds P. Carpeggiani and L. Patetta, *Il disegno di architettura*, Milan 1989, pp. 161–8.

FROMMEL 1998
C.L. Frommel, 'I tre progetti bramanteschi per il Cortile del Belvedere' in eds M. Winner, B. Andreae and C. Pietrangeli, *Il Cortile delle Statue: der Statuenhof des Belvedere im Vatikan: Akten des internationalen Kongresses zu Ehren von R. Krautheimer*, Mainz 1998, pp. 17–66.

FROMMEL 2002
C.L. Frommel, 'La città come opera d'arte: Bramante e Raffaello (1500–1520)' in ed. A. Bruschi, *Storia dell'architettura italiana. Il primo Cinquecento*, Milan 2002, pp. 76–131.

GARAS 1983
K. Garas, 'Sammlungsgeschichtliche Beiträge zu Raffael: Raffael-Werke in Budapest', *Bulletin du Musée Hongrois des Beaux-Arts*, 60–1 (1983), pp. 41–81, 183–201.

GERE 1987
J.A. Gere, *Drawings by Raphael and his circle from British and North American Collections*, exh. cat., New York (Pierpont Morgan Library) 1987.

GERE AND TURNER 1983
J.A. Gere and N. Turner, *Drawings by Raphael from the Royal Library, the Ashmolean, the British Museum, Chatsworth and other English Collections*, exh. cat., London (British Museum) 1983.

GHISETTI GIAVARINA 1990
A. Ghisetti Giavarina, *Aristotile da Sangallo: architettura, scenografia e pittura tra Roma e Firenze nella prima metà del cinquecento*, Rome 1990.

GIBBON 1764 (1961 edn)
E. Gibbon, *Journey from Geneva to Rome. His Journal from 20 April to 2 October 1764*, ed. G.A. Bonnard, London 1961.

GILBERT 1965
C. Gilbert, 'A Miracle by Raphael', *North Carolina Museum of Art Bulletin*, VI (1965), pp. 3–35.

GILBERT 1980
F. Gilbert, *The Pope, his banker, and Venice*, Cambridge, MA 1980.

GILBERT 1986
C. Gilbert, 'Signorelli and the Young Raphael' in *Raphael before Rome, Studies in the History of Art*, 17 (1986), pp. 109–24.

GIOVIO 1999
P. Giovio, *Scritti d'arte – Lessico ed ecfrasi*, ed. S. Maffei, Pisa 1999.

GNOLI 1923
U. Gnoli, *Pittori e miniatori nell'Umbria*, Spoleto 1923.

GOLZIO 1936
V. Golzio, *Raffaello nei documenti, nelle testimonianze dei contemporanei e nella letteratura del suo secolo*, Vatican City 1936.

GOLZIO 1971
V. Golzio, 'Raphael and Siena' in Pedretti 1989, pp. 66–8.

GOMBRICH 1972
E.H. Gombrich, 'Raphael's Stanza della Segnatura and the Nature of its Symbolism' in *Symbolic Images: Studies in the Art of the Renaissance*, London 1972, pp. 85–101.

GOMBRICH 2002
E.H. Gombrich, *The Preference for the Primitive*, London 2002.

GOODISON AND ROBERTSON 1967
J.W. Goodison and G.H. Robertson, *Catalogue of Paintings in the Fitzwilliam Museum, Cambridge, Italian School*, Cambridge 1967.

GOULD 1970
C. Gould, 'The Raphael *Portrait of Pope Julius II* Problems of Versions and Variants; and a Goose that turned into a Swan', *Apollo*, XCII (1970), pp. 187–9.

GOULD 1970a
C. Gould, *Raphael's Portrait of Pope Julius II. The Re-emergence of the Original*, London 1970.

GOULD 1975
C. Gould, *National Gallery Catalogues. The Sixteenth-Century Italian Schools*, London 1975.

GRAVES 1914
A. Graves, *A Century of Loan Exhibitions*, London 1914.

GREGORI (ED.) 1984
ed. M. Gregori, *Raffaello a Firenze*, exh. cat., Florence (Palazzo Pitti) 1984.

GREGORI 1987
M. Gregori, 'Considerazioni su una mostra' in eds M. Sambucco Hamoud and M.L. Strocchi, *Studi su Raffaello*, Urbino 1987, pp. 649–55.

GRIMM 1882
H. Grimm, 'Zu Raffael, III: Die Rossebändiger auf Monte Cavallo', *Jahrbuch der königlich preussischen Kunstsammlungen*, III (1882), pp. 267–74.

GRONAU 1902
G. Gronau, *Aus Raphaels Florentiner Tagen*, Berlin 1902.

GRONAU 1908
G. Gronau, 'Zwei Predellanbilder von Raphael', *Monatshefte für Kunstwissenschaft*, I (1908), pp. 1071–9.

HARDING ET AL 1989
E. Harding *et al.*, 'The Restoration of the Leonardo Cartoon', *National Gallery Technical Bulletin*, 13 (1989), pp. 4–27.

HARTT 1950
F. Hartt, 'Lignum Vitae in Medio Paradisi, the Stanza d'Eliodoro and the Sistine Ceiling', *Art Bulletin*, XXXII (1950), pp. 115–45.

HARTT 1951
F. Hartt, 'Pagnini, Vigerio, and the Sistine Ceiling', *Art Bulletin*, XXXIII (1951), pp. 262–73.

HARTT 1971
F. Hartt, *The Drawings of Michelangelo*, London 1971.

HASKELL 1987
F. Haskell, 'A Martyr of Attributionism: Morris Moore and the Louvre *Apollo and Marsyas*' in *Past and Present in Art and Taste*, New Haven and London 1987, pp. 155–74.

HASKELL 2003
F. Haskell, *The Ephemeral Museum*, London and New Haven 2003.

HAVERKAMP-BEGEMANN 1957
E. Haverkamp-Begemann, *Vijf eeuwen tekekunst*, exh. cat., Rotterdam (Museum Boijmans Van Beuningen) 1957.

HENDY 1974
P. Hendy, *European and American paintings in the Isabella Stewart Gardner Museum*, Boston 1974.

HENRY 1993
T. Henry, 'Raphael, Signorelli and a Mysterious Pricked Drawing at Oxford', *The Burlington Magazine*, CXXXV (1993), pp. 612–19.

HENRY 1996
T. Henry, 'Berto di Giovanni at Montone', *The Burlington Magazine*, CXXXVIII (1996), pp. 325–8.

HENRY 1997
T. Henry, 'Cartoons Restored to View', *Renaissance Studies*, 11.4 (1997), pp. 441–5.

HENRY 1998
T. Henry, *Signorelli in British Collections*, exh. cat. London (National Gallery), 1998–9.

HENRY 1999
T. Henry, 'Nuovi documenti su Giovanni Santi', in Varese (ed.) 1999, pp. 223–6.

HENRY 2000
T. Henry, 'Cesare da Sesto and Baldino Baldini in the Vatican apartments of Julius II', *The Burlington Magazine*, CXLII (2000), pp. 29–35.

HENRY 2001
T. Henry, 'Reflections on Il Marcillat's work in the Vatican Palace', *Apollo*, CLII, no. 467 (2001), pp. 18–27.

HENRY 2002
T. Henry, 'Raphael's altar-piece patrons in Città di Castello', *The Burlington Magazine*, CXLIV (2002), pp. 268–78.

HENRY 2002a
T. Henry, '*Luca de ingegno et spirito pelegrino*' in eds D. Gasparotto and S. Magnani, *Matteo di Giovanni e la pala d'altare nel senese e nell'aretino 1450–1500. Atti del Convegno Internazionale di Studi (Sansepolcro, 9–10 Ottobre 1998)*, Sansepolcro 2002, pp. 175–83.

HENRY 2004
T. Henry, 'New perspectives on Raphael before Rome', *Atti del Convegno internazionale su Raffaello – pluralità e unità, Bibliotheca Hertziana, 2–4.5.2002*, Rome 2004 (forthcoming – text available at http://colosseum. biblhertz.it/event/Raffael/texte/Henry/henry.htm).

HENRY 2004a
T. Henry, 'La formazione di Pietro Perugino' in Perugia 2004, pp. 73–9.

HENRY 2004b
T. Henry, 'Raphael's *Siege of Perugia*', *The Burlington Magazine*, CXLVI (2004).

HENRY 2005
T. Henry, '*magister Lucas de Cortona, famosissimus pictor in tota Italia … fecisse etiam multas pulcherrimas picturas in diversis civitatibus et presertim Senis*' in *Siena nel Rinascimento: l'ultimo secolo della repubblica, Convegno Internazionale di Studi, 28–30 September 2003*, Siena 2005 (forthcoming).

HENRY AND KANTER 2002
T. Henry and L. Kanter, *Luca Signorelli*, London 2002.

HILLER VON GAERTRINGEN 1999
R. Hiller von Gaertringen, *Raffaels Lernerfahrungen in der Werkstatt Peruginos. Kartonverwendung und Motivübernahme im Wandel*, Munich and Berlin 1999.

HIND 1938
A.M. Hind, *Early Italian Engraving*, London 1938.

HIRST 1961
M. Hirst, 'The Chigi Chapel in S. Maria della Pace', *Journal of the Warburg and Courtauld Institutes*, XXIV (1961), pp. 161–85.

HIRST 1981
M. Hirst, *Sebastiano del Piombo*, Oxford 1981.

HIRST 1988
M. Hirst, *Michelangelo and his Drawings*, New Haven and London 1988.

HIRST 1988a
M. Hirst, *Michelangelo Draftsman*, Milan 1988.

HIRST 2000
M. Hirst, 'Michelangelo in Florence: "David" in 1503 and "Hercules" in 1506', *The Burlington Magazine*, CXLII (2000), pp. 487–92.

HIRST AND DUNKERTON 1994–5
M. Hirst and J. Dunkerton, *Making and Meaning: The Young Michelangelo*, exh. cat., London (National Gallery) 1994–5.

HOLLSTEIN 1954
F.W.H. Hollstein, *German engravings, etchings and woodcuts c.1400–1700*, Amsterdam 1954.

HOLMES AND COLLINS BAKER 1924
C. Holmes and C.H. Collins Baker, *The Making of the National Gallery: 1824–1924*, London 1924.

HOOGEWERFF 1945–6
G.I. Hoogewerff, 'Documenti, in parte inediti, che riguardano Raffaello ed altri artisti contemporanei', *Rendiconti della Pontificia accademia romana di archeologia*, XXI (1945–6), pp. 253–68.

HORSTER 1980
M. Horster, *Andrea del Castagno: complete edition with a critical catalogue*, Oxford 1980.

HOWE (ED.) 1930–4
ed. P.P. Howe, *The Complete Works of William Hazlitt*, London 1930–4 (21 vols).

IRWIN 1962
D. Irwin, 'Gavin Hamilton: Archaeologist, Painter and Dealer', *Art Bulletin*, XLIV (1962), pp. 87–102.

JACOB 1975
S. Jacob, *Italienische Zeichnungen der Kunstbibliotek Berlin*, Berlin 1975.

JAFFÉ 1994
M. Jaffé, *The Devonshire Collection of Italian Drawings*, London 1994 (4 vols).

JAMESON 1844
A. Jameson, *Companion to the most celebrated picture galleries in London*, London 1844.

JAMESON 1846
A. Jameson, *Memoirs and Essays*, London 1846.

JOANNIDES 1983
P. Joannides, *The Drawings of Raphael with a Complete Catalogue*, Los Angeles and Oxford 1983.

JOANNIDES 1987
P. Joannides, 'Raffaello and Giovanni Santi' in eds M. Sambucco Hamoud and M.L. Strocchi, *Studi su Raffaello*, Urbino 1987, pp. 55–62.

JONES 1978
S. Jones, 'The Fonthill Abbey Pictures: two additions to the Hazlitt canon', *Journal of the Warburg and Courtauld Institutes*, XLI (1978), pp. 278–96.

JONES AND PENNY 1983
R. Jones and N. Penny, *Raphael*, New Haven and London 1983.

JUNGIC 2001
J. Jungic, 'Raphael's Saint Michael and the Demon and Savonarola's "Flagellum Dei"', *Gazette des Beaux-Arts*, CXXXVIII (2001), pp. 61–72.

KANTER 2004
L. Kanter, 'Luca Signorelli and Girolamo Genga in Princeton', *Princeton Art Journal*, 2004.

KEMP 1981
M. Kemp, *The Marvellous Works of Nature and Man*, London, Melbourne and Toronto 1981

KEMP 1992
M. Kemp in ed. J.A. Levenson, *Circa 1492. Art in the Age of Exploration*, exh. cat. Washington, DC (National Gallery of Art) 1992.

KEMP (ED.) 1992
ed. M. Kemp, *The Mystery of the Madonna of the Yarnwinder*, exh. cat., Edinburgh (National Gallery of Scotland) 1992.

KEMP 2003
M. Kemp, 'Drawing the Boundaries', in Bambach (ed.) 2003, pp. 141–54.

KEMP AND ROBERTS 1989
M. Kemp and J. Roberts, *Leonardo da Vinci*, exh. cat., London (Hayward Gallery) 1989.

KEMPER 1998–9
M.-E. Kemper, 'Leo X. – Giovanni de'Medici (1513–1521)' in Bonn 1998–9, pp. 30–47.

KEMPERS 1998–9
B. Kempers, 'Julius inter laudem et viuperationem. Ein Papst unter gegensätzlichen Gesichtspunkten betrachtet' in Bonn 1998–9, pp. 15–29.

KEMPERS 2004
B. Kempers, 'The Pope's two bodies. Julius II, Raphael and Saint Luke's Virgin of Santa Maria del Popolo' in *The Miraculous Image in the Late Middle Ages and Renaissance*, eds E. Thuno and G. Wolf, Munich 2004, pp. 189–213.

KNAB, MITSCH AND OBERHUBER 1984
E. Knab, E. Mitsch and K. Oberhuber, *Raffaello, I Disegni*, Florence 1984 (first published as *Raphael: Die Zeichnungen*, Munich 1983).

KREMS 1996
E.-B. Krems, *Raffaels 'Marienkrönung' im Vatikan*, Frankfurt 1996.

KUSTODIEVA 1994
T. K. Kustodieva, *The Hermitage Collection of Western European Painting: Italian Painting, 13th–16th Centuries*, Moscow and Florence 1994.

LANCELLOTTI 1676
O. Lancellotti, *Scorta sacra*, mss. B.4-B.5, Bibl. Augusta, Perugia, before 1676.

LANZI 1795–6
L. Lanzi, *Storia pittorica della Italia*, Bassano 1795–6 (4 vols).

LAZZARI 1693
F.I. Lazzari, *Serie di Vescovi e breve storia di Città di Castello*, Foligno 1693.

LEE 1934
Lee of Fareham, 'A new version of Raphael's Holy Family with the Lamb', *The Burlington Magazine*, LXIV (1934), pp. 3–19.

LEONE DE CASTRIS 1999
P. Leone De Castris, *Museo e Gallerie Nazionali di Capodimonte. Dipinti dal XIII al XVI secolo*, Naples 1999.

LIGHTBOWN 1969
R.W. Lightbown, 'Michelangelo's Great Tondo: Its Origins and Setting', *Apollo*, LXXXIX (1969), pp. 22–31.

LOCHER 1994
H. Locher, *Raffael und das Altarbild der Renaissance: Die 'Pala Baglioni' als Kunstwerk im sakralen Kontext*, Berlin 1994.

LOHUIZEN-MULDER 1977
M. van Lohuizen-Mulder, *Raphael's Images of Justice, Humanity, Friendship. A Mirror of Princes for Scipione Borghese*, Wassanaar 1977.

LOMAZZO 1584
G.P. Lomazzo, *Trattato de la pittura*, Milan 1584.

LONDON 1930
Italian Art 1200–1900, exh. cat., London (Royal Academy) 1930.

LONGHENA (ED) 1829
ed. F. Longhena, *Istoria della vita e delle opere di Raffaello Sanzio da Urbino del Signor Quatremère de Quincy*, Milan 1829.

LONGHI 1927
R. Longhi, 'Precisioni nelle Gallerie italiane', *Vita Artistica*, II, nos 8–9 (1927), pp. 168–73.

LONGHI 1955
R. Longhi, 'Percorso di Raffaello Giovane', *Paragone*, XX (1955), pp. 9–20.

LUCCO 2000
M. Lucco, 'A New Portrait by Raphael and its Historical Context', *Artibus et Historiae*, XXI.41 (2000), pp. 49–73.

LUCHS 1983
A. Luchs, 'A Note on Raphael's Perugian Patrons', *The Burlington Magazine*, CXXV (1983), pp. 29–31.

LYNCH 1962
J.B. Lynch, 'The History of Raphael's Saint George in the Louvre', *Gazette des Beaux-Arts*, LIX (1962), pp. 203–12.

MAGHERINI AND GIOVAGNOLI 1927
G. Magherini and E. Giovagnoli, *La Prima Giovinezza di Raffaello*, Città di Castello 1927.

MAGHERINI GRAZIANI 1897
G. Magherini Graziani, *L'Arte a Città di Castello*, Città di Castello 1897.

MAGHERINI GRAZIANI 1908
G. Magherini Graziani, 'Documenti inediti relativi al "San Niccolò da Tolentino" e allo "Sposalizio" di Raffaello', *Bollettino della Regia Deputazione di Storia Patria per l'Umbria*, XIV (1908), pp. 83–95.

MALKE 1980
L.S. Malke, *Italienische Zeichnungen des 15 und 16 Jahrhunderts: aus eigenen Beständen*, Frankfurt 1980.

MANCINELLI 1986
F. Mancinelli, 'The *Coronation of the Virgin* by Raphael' in *Raphael before Rome, Studies in the History of Art*, 17 (1986), pp. 127–38.

MANCINELLI AND NESSELRATH 1993
F. Mancinelli and A. Nesselrath, 'La Stanza dell'Incendio' in *Raffaello nell'appartamento di Giulio II e Leone X*, Milan 1993, pp. 293–337.

MANCINI 1832
G. Mancini, *Istruzione storico-pittorica per visitare le Chiese e i Palazzi di Città di Castello*, Perugia 1832.

MANCINI 1983
F.F. Mancini, 'Raffaello e Francesco Tifernate: un documento e alcune precisazioni', *Antichità Viva*, 22.5–6 (1983), pp. 27–34.

MANCINI 1987
F.F. Mancini, *Raffaello in Umbria*, Perugia 1987.

MANCINI (ED.) 1989
ed. F.F. Mancini, *Pinacoteca Comunale di Città di Castello: Dipinti*, Perugia 1989.

MANZONI 1899
L. Manzoni, 'La Madonna degli Ansidei', *Bollettino della Regia Deputazione di Storia Patria per l'Umbria*, V.III (1899), pp. 627–45.

MARABOTTINI 1983–4
A. Marabottini, *Raffaello giovane e Città di Castello*, exh. cat., Città di Castello (Pinacoteca Comunale) 1983–4.

MARABOTTINI 1989
A. Marabottini, 'La Pinacoteca di Città di Castello ed Elia Volpi. Storia di una raccolta e di un mecenate' in Mancini (ed.) 1989.

MARANI 1999
P.C. Marani, *Leonardo. Una camera di pittore*, Milan 1999, pp. 256–64.

MARIOTTI 1788
A. Mariotti, *Lettere pittoriche Perugine*, Perugia 1788.

MARQUES (ED.) 1998
ed. L. Marques, *Catalogue of the Museu de Arte de São Paulo Assis Chateaubriand*, São Paulo 1998.

MARTELLI 1984
F. Martelli, *Giovanni Santi e la sua scuola*, Rimini 1984.

MARTINEAU (ED.) 1992
ed. J. Martineau, *Andrea Mantegna*, exh. cat., London (Royal Academy) and New York (Metropolitan Museum of Art) 1992.

MARTINELLI 1987
V. Martinelli, 'I ritratti papali di Raffaello' in ed. M. Sambucco Hamoud and M.L. Strocchi, *Studi su Raffaello*, Urbino 1987, pp. 517–31.

MELVILLE 1910
L. Melville, *The Life and Letters of William Beckford*, London 1910.

MENA MARQUÉS 1985
M. Mena Marqués, *Rafael en España*, exh. cat., Madrid (Prado) 1985.

MERCATI 1994
E. Mercati, *Andrea Baronci e gli altri commitenti tifernati di Raffaello. Con documenti inediti*, Città di Castello 1994.

METTERNICH 1975
F.G.W. Metternich, *Bramante und Sankt Peter*, Munich 1975.

MEYER ZUR CAPELLEN 1989
J. Meyer zur Capellen, 'Raffaels "Hl. Familie mit dem Lamm"', *Pantheon*, 47 (1989), pp. 98–111.

MEYER ZUR CAPELLEN 1996
J. Meyer zur Capellen, *Raphael in Florence*, London 1996.

MEYER ZUR CAPELLEN 2001
J. Meyer zur Capellen, *Raphael. The Paintings. Volume I. The beginning in Umbria and Florence ca. 1500–1508*, Landshut 2001.

MICHEL 1999
P. Michel, *Mazarin, prince des collectionneurs*, Paris 1999.

MICHELINI TOCCI (ED.) 1985
G. Santi, *La Vita e Le Gesta di Federico di Montefeltro Duca d'Urbino*, ed. L. Michelini Tocci, Vatican City 1985.

MILANESI 1856
G. Milanesi, *Documenti per la storia dell'arte senese*, Siena 1856.

MITSCH 1983
E. Mitsch, *Raphael in der Albertina aus anlass des 500. Geburtstages des Künstlers*, exh. cat., Vienna (Albertina) 1983.

MONBEIG GOGUEL 1983–4
C. Monbeig Goguel in *Raphael dans les collections françaises*, exh. cat., Paris (Grand Palais) 1983–4.

MORELLI 1683
G.F. Morelli, *Brevi Notizie Delle Pitture e Sculture che adornano l'augusta citta di Perugia*, Perugia 1683.

MORELLI 1882
I. Lermolieff (Morelli), 'Raphaels Jugendentwicklung: Worte der Versständigung gerichtet an Herrn Professor Springer in Leipzig', *Repertorium für Kunstwissenschaft*, V (1882), pp. 147–78.

MOTTOLA MOLFINO 1985
A. Mottola Molfino, 'La croce Visconti Venosta e Raffaello giovane' in *La Madonna per San Sisto di Raffaello e la cultura piacentina della prima metà del Cinquecento. Atti del Convegno (10.12.1983)*, Piacenza 1985, pp. 11–20.

MULAZZANI 1986
G. Mulazzani, 'Raphael and Venice: Giovanni Bellini, Dürer, and Bosch' in *Raphael before Rome, Studies in the History of Art*, 17 (1986), pp. 149–53.

MURRAY 1980
P. Murray, *Dulwich Picture Gallery: a catalogue*, London 1980.

MUZII 1993
R. Muzii, *Raffaello, Michelangelo e bottega – I cartoni farnesiani restaurati*, Naples 1993.

NAGEL 2000
A. Nagel, *Michelangelo and the Reform of Art*, Cambridge 2000.

NANNI 2001
R. Nanni in eds G. Dalli Regoli, R. Nanni and A. Natali, *Leonardo e il mito di Leda*, exh. cat., Vinci (Museo Leonardiano, Palazzina Uzielli) 2001.

NATALE 1987
M. Natale in *Museo Poldi Pezzoli. Tessuti-Sculture Metalli Islamici*, Milan 1987, pp. 310–11.

NELSON 2004
J.K. Nelson, 'La pala per l'altar maggiore della Santissima Annunziata. La funzione, la commissione, i dipinti e la cornice' in ed. F. Falletti, *La Deposizione di Filippino Lippi e Perugino: restauri, indagini, collaborazioni*, Florence 2004, pp. 22–43.

NESSELRATH 1986
A. Nesselrath, 'Raphael's Archaeological Method' in *Raffaello a Roma: il convegno del 1983*, eds C.L. Frommel and M. Winner, Rome 1986, pp. 357–71.

NESSELRATH 1989
A. Nesselrath, 'Giovanni da Udine disegnatore', *Monumenti Musei e Gallerie Pontificie*, IX (1989), pp. 237–91.

NESSELRATH 1990
A. Nesselrath, 'Raffaello: Due Putti della parte sinistra del trono della Sibilla Cumana' in *Michelangelo e la Sistina – La tecnica, il restauro, il mito*, eds F. Mancinelli, A.M. De Strobel, G. Morello and A. Nesselrath, Rome 1990, pp. 141–3, cat. 23.

NESSELRATH 1992
A. Nesselrath, 'Art-historical Findings during the Restoration of the Stanza dell'Incendio', *Master Drawings*, XXX (1992), pp. 31–60.

NESSELRATH 1993
A. Nesselrath, 'La Stanza d'Eliodoro' in *Raffaello nell'appartamento di Giulio II e Leone X*, Milan 1993, pp. 202–45.

NESSELRATH 1996
A. Nesselrath, *Raphael's School of Athens*, Vatican City 1996.

NESSELRATH 1998
A. Nesselrath, 'Il Cortile delle Statue: luogo e storia', *Il Cortile delle Statue: der Statuenhof des Belvedere im Vatikan: Akten des internationalen Kongresses zu Ehren*

von Richard Krautheimer, Rom 21.–23. Oktober 1992, eds M. Winner, B. Andreae and C. Pietrangeli, Mainz 1998, pp. 1–16.

NESSELRATH 1998a
A. Nesselrath, 'Werkstatt des Luca Signorelli, Grotesken-ornament (1504–1508/9)' in Bonn 1998–9, pp. 534–5.

NESSELRATH 1998b
A. Nesselrath, 'Päpstliche Malerei der Hochrenaissance und des frühen Manierismus von 1506 bis 1534' in Bonn 1998–9, pp. 240–58.

NESSELRATH 2000
A. Nesselrath, 'Lorenzo Lotto in the Stanza della Segnatura', The Burlington Magazine, CXLII (2000), pp. 4–12.

NESSELRATH 2001
C. and A. Nesselrath, 'Die Wappen der Erzpriester an der Lateranbasilika oder Wie Bramante nach Rom kam' in Italia et Germania – Liber Amicorum Arnold Esch, eds H. Keller, W. Paravicini and W. Schieder, Tübingen 2001, pp. 291–317.

NESSELRATH 2003
A. Nesselrath, 'The Painters of Lorenzo the Magnificent in the Chapel of Pope Sixtus IV in Rome' in J. M. Cardinal Mejia, A. Nesselrath, P.N. Pagliara and M. De Luca, The Fifteenth Century Frescoes in the Sistine Chapel (Recent Restorations, vol. IV), Vatican City 2003, pp. 39–75.

NESSELRATH 2004
A. Nesselrath, 'La pala della "Resurrezione": l'opera e l'artista' in Il Perugino del Papa, Milan 2004, pp. 20–5.

NESSELRATH 2004a
A. Nesselrath, Il Vaticano – La Cappella Sistina: Il Quattrocento, Parma 2004.

NESSELRATH 2004b
A. Nesselrath, '"Muse make the man thy theme, for shrewdness famed . . .": Apollo accompanies Homer in the proclamation of Julius II in Raphael's Parnassus' in Nella luce di Apollo, Cinisello Balsamo and Milan 2004, pp. 146–9.

NUCCIARELLI AND SEVERINI 1999
F.I. Nucciarelli and G. Severini, San Pietroburgo, Ermitage. Raffaello, Madonna del libro o Madonna Conestabile, Perugia 1999.

OBERHUBER 1977
K. Oberhuber, 'The Colonna altarpiece in the Metropolitan Museum and Problems of the early style of Raphael', Metropolitan Museum Journal, 12 (1977), pp. 51–91.

OBERHUBER 1982
K. Oberhuber, Raffaello, Milan 1982.

OBERHUBER 1983
K. Oberhuber, Polarität und Synthese in Raphaels Schule von Athen, Stuttgart 1983.

OBERHUBER 1986
K. Oberhuber, 'Raphael and Pintoricchio' in Raphael before Rome, Studies in the History of Art, 17 (1986), pp. 155–72.

OBERHUBER 1995
K. Oberhuber, 'A marble Horse on the Quirinal' in The touch of the Artist: Master Drawings from the Woodner Collection, ed. M. Morgan Grasselli, Washington, DC 1995, pp. 156–8, no. 33.

OLSON 2000
R.M. Olson, The Florentine Tondo, Oxford 2000.

ORSINI 1784
B. Orsini, Guida al Forestiere per la città di Perugia, Perugia 1784.

PADOVANI 2004
S. Padovani, Il lato nascosto dei 'Ritratti di Agnolo e Maddalena Doni' di Raffaello: il restauro delle due storie del Diluvio, del 'Maestro di Serumido', leaflet accompanying display, Florence (Palazzo Pitti) 2004.

PAGLIARA 1998
P.N. Pagliara, 'Der Vatikanische Palast' in Bonn 1998–9, pp. 207–26.

PANOFSKY 1930
E. Panofsky, Hercules am Scheidewege und andere antike Bildstoffe in der neueren Kunst, Berlin 1930.

PANOFSKY 1937
E. Panofsky, 'The first two projects of Michelangelo's Tomb of Julius II', Art Bulletin, XIX (1937), pp. 561–79.

PARIS 1974
ed. R. Bacou, Cartons d'artistes du XV au XIXe siècle, exh. cat., Paris (Louvre) 1974

PARIS 2001–2
Raphael Grace and Beauty, exh. cat., Paris (Musée du Luxembourg) 2001–2.

PARKER 1956
K.T. Parker, Catalogue of the Collection of Drawings in the Ashmolean Museum, vol. II. The Italian Schools, Oxford 1956.

PARTRIDGE AND STARN 1980
L. Partridge and R. Starn, A Renaissance Likeness: Art and Culture in Raphael's Julius II, Berkeley and London 1980.

PASSAVANT 1833
J.D. Passavant, Kunstreise durch England und Belgien, Frankfurt 1833.

PASSAVANT 1836
J.D. Passavant, The Tour of a German Artist in England, London 1836 (2 vols).

PASSAVANT 1839–58
J.D. Passavant, Rafael von Urbino und sein vater Giovanni Santi, Leipzig 1839–58 (3 vols).

PASSAVANT 1860
J.D. Passavant, Raphael d'Urbin et son père Giovanni Santi, Paris 1860 (first published as Rafael von Urbino und sein vater Giovanni Santi; abridged English edn, London 1862).

PASSAVANT 1983
G. Passavant, 'Reflexe nordischer Graphik bei Raffael, Leonardo, Giulio Romano und Michelangelo', Mitteilungen des Kunsthistorischen Institutes in Florenz, XXVIII (1983), pp. 193–222.

PASTOR 1924
L. von Pastor, Geschichte der Päpste seit dem Ausgang des Mittelalters, vol. III.2, Freiburg im Breisgau 1924.

PASTOR 1949–53
L. von Pastor, The History of the Popes, London 1949–53 (40 vols).

PEARCE 1986
D. Pearce, London Mansions, London 1986.

PEDRETTI 1989
C. Pedretti, Raphael. His Life and Work in the Splendors of the Italian Renaissance, Florence 1989.

PEMBROKE 1968
S. Pembroke, Paintings and Drawings at Wilton House, London 1968.

PENNY 1992
N. Penny, 'Raphael's "Madonna dei garofani" rediscovered', The Burlington Magazine, CXXXIV (1992), pp. 67–81.

PERUGIA 2004
eds V. Garibaldi and F.F. Mancini, Perugino. Il Divin Pittore, exh. cat., Perugia (Galleria Nazionale) 2004.

PILLION 1908
L. Pillion, 'La Légende de Saint Jérôme d'après quelques peintures italiennes du XVe siècle au Musée du Louvre', Gazette des Beaux-Arts, 501 (1908), pp. 303–18.

PLESTERS 1990
J. Plesters, 'Technical Aspects of Some Paintings by Raphael in the National Gallery, London' in eds J. Shearman and M. Hall, The Princeton Raphael Symposium: Science in the Service of Art History, Princeton 1990, pp. 15–37.

POGÁNY-BALÁS 1972
E. Pogány-Balás, 'L'influence des gravures de Mantegna sur la composition de Raphael et de Raimondi "Massacre des Innocents"', Bulletin du Musée Hongrois des Beaux-Arts, 39 (1972), pp. 25–40.

PON 2004
L. Pon, Raphael, Dürer and Marcantonio Raimondi: Copying and the Italian Renaissance Print, New Haven and London 2004.

PON 2004a
L. Pon, 'Parmigianino and Raphael, a note on the foreground baby from the "Massacre of the Innocents"', Apollo, CLIX (2004), pp. 6–7.

POPE-HENNESSY 1970
J. Pope-Hennessy, Raphael, London 1970.

POPHAM 1931
A. Popham, Italian drawings exhibited at the Royal Academy, Burlington House, London, 1930, London 1931.

POPHAM 1946
A. Popham, The drawings of Leonardo da Vinci, London 1946.

POPHAM AND POUNCEY 1950
A.E. Popham and P. Pouncey, Italian Drawings in the Department of Prints and Drawings in the British Museum: The Fourteenth and Fifteenth Centuries, London 1950.

POPHAM AND WILDE 1949
A.E. Popham and J. Wilde, The Italian Drawings of the XV and XVI Centuries in the Collection of His Majesty the King at Windsor Castle, London 1949.

POUNCEY AND GERE 1962
P. Pouncey and J. Gere, Italian Drawings in the Department of Prints and Drawings in the British Museum: Raphael and his Circle, London 1962.

PUNGILEONI 1822
L. Pungileoni, Elogio Storico di Giovanni Santi, Urbino 1822.

PUNGILEONI 1829
L. Pungileoni, Elogio Storico di Raffaello Santi da Urbino, Urbino 1829.

PUNGILEONI 1835
L. Pungileoni, Elogio Storico di Timoteo Viti da Urbino, Urbino 1835.

QUATREMÈRE DE QUINCY 1824
A.-C. Quatremère de Quincy, Histoire de la vie et des ouvrages de Raphaël, Paris 1824.

QUEDNAU 1983
R. Quednau, 'Raphael und "alcune stampe di maniera tedesca"', Zeitschrift für Kunstgeschichte, 46 (1983), pp. 129–75.

REDIG DE CAMPOS 1965
D. Redig De Campos, Raffaello nelle Stanze, Milan 1965.

RICCI 1902
C. Ricci, Pintoricchio, London 1902.

RICHTER 1902
J.P. Richter, 'The Old Masters at Burlington House', *Art Journal*, 3 (March 1902), p. 84.

RIITANO 2003
P. Riitano, 'Anticipazioni sulla pulitura della *Madonna del Cardellino* di Raffaello' in *Restauri e Ricerche: Dipinti su tela e tavola, Atti della Giornata di Studio (17 December 2002)*, Florence 2003, pp. 71–5.

ROBERTS 1959
H. Roberts, 'St. Augustine in "St. Jerome's Study": Carpaccio's Painting and its Legendary Source', *Art Bulletin*, XLI (1959), pp. 283–97.

ROBERTSON 1978
D. Robertson, *Sir Charles Eastlake and the Victorian Art World*, Princeton 1978.

ROBERTSON 1986
C.D. Robertson, 'Bramante, Michelangelo and the Sistine Ceiling', *Journal of the Warburg and Courtauld Institutes*, 49 (1986), pp. 91–105.

ROBINSON 1870
J.C. Robinson, *A Critical Account of the Drawings by Michel Angelo and Raffaello in the University Galleries, Oxford*, Oxford 1870.

ROHLMANN 1995
M. Rohlmann, 'Memling's "Pagonotti Triptych"', *The Burlington Magazine*, CXXXVII (1995), pp. 438–45.

ROME 1984
Raffaello nelle Raccolte Borghese, exh. cat., Rome (Galleria Borghese) 1984.

ROME 1992
Raphael. Autour des dessins du Louvre, exh. cat., Rome (Villa Médicis) 1992.

ROMNEY TOWNDROW 1950
K. Romney Towndrow, *The Works of Alfred Stevens, Sculptor, Painter, Designer, in the Tate Gallery*, London 1950.

ROSENBERG 1986
C.M. Rosenberg, 'Raphael and the Florentine *Istoria*' in *Raphael before Rome, Studies in the History of Art*, 17 (1986), pp. 175–87.

ROSSI 1872
A. Rossi, 'Documenti per completare la storia di alcune opera di Raffaello già esistenti nell'Umbria, I. Sul trafugamento da Perugia a Roma della tavola rappresentante Cristo portato al sepolcro', *Giornale dell'Erudizione Artistica*, I (1872), pp. 225–35.

ROSSI 1877
A. Rossi, 'Documenti per Raffaello in Umbria 3. I Passaggi di proprieta, le stime e la vendita della Madonnina del Libro', *Giornale dell'Erudizione Artistica*, VI (1877), pp. 321–36.

ROSSI 1883
A. Rossi, 'Documenti risguardanti le vicende delle tre tavole di Raffaele che erano in Città di Castello', *Giornale dell'Erudizione Artistica* (NS) I.1 (1883), pp. 8–16.

ROSSI 1979
F. Rossi, *Accademia Carrara, Bergamo*, Bergamo 1979.

ROTHE AND CARR 1998
A. Rothe and D. Carr, 'Poetry with Paint' in ed. A. Bayer, *Dosso Dossi – Court Painter in Renaissance Ferrara*, New York 1998, pp. 55–64.

RÖTTGEN 2002
H. Röttgen, *Il Cavalier Giuseppe Cesari D'Arpino. Un grande pittore nello splendore della fama e nell'inconstanza della fortuna*, Rome 2002.

ROWLAND (ED.) 2001
ed. I. Rowland, *The correspondence of Agostino Chigi (1466–1520) in cod. Chigi R.V.c*, Vatican City 2001.

ROWLAND 1986
I.D. Rowland, 'Render unto Caesar the Things which are Caesar's: Humanism and the Arts in the Patronage of Agostino Chigi', *Renaissance Quarterly*, XXXIX (1986), pp. 673–730.

ROY, SPRING AND PLAZZOTTA 2004
A. Roy, M. Spring and C. Plazzotta, 'Raphael's Early Work in the National Gallery: Paintings before Rome', *National Gallery Technical Bulletin*, 25 (2004), pp. 4–35.

RUBIN 1990
P. Rubin, 'Il contributo di Rafaello allo sviluppo della pala d'altare rinascimentale', *Arte Cristiana*, 737–8 (1990), pp. 169–82.

RUBIN 1995
P. Rubin, *Giorgio Vasari, Art and History*, London and New Haven 1995.

RUBIN AND WRIGHT 1999
P. Rubin and A. Wright, *Renaissance Florence: the Art of the 1470s*, exh. cat., London (National Gallery) 1999.

RUBINSTEIN 1995
N. Rubinstein, *The Palazzo Vecchio 1298–1532*, Oxford 1995.

RUIZ MANERO
J.M. Ruiz Manero, *Pintura Italiana del siglo XVI en España. II Rafael y su escuela*, Madrid 1996.

RULAND 1876
C. Ruland, *The Works of Raphael Santi da Urbino…in the Royal Library at Windsor Castle…*, privately printed 1876.

RUSSELL 1986
F. Russell, 'Perugino and the Early Experience of Raphael' in *Raphael before Rome, Studies in the History of Art*, 17 (1986), pp. 189–201

SANTI 1979
F. Santi, 'Il restauro dell'affresco di Raffaello e del Perugino in S. Severo di Perugia', *Bollettino d'Arte*, LXIV.1 (1979), pp. 57–64.

SANTI 1985
F. Santi, *Dipinti, sculture e oggetti dei secoli XV–XVI, Galleria Nazionale dell'Umbria, Perugia*, Rome 1985.

SANUTO 1879–1903
M. Sanuto, *I Diarii*, ed. R. Fulin *et al.*, Venice 1879–1903 (58 vols).

SCARPELLINI 1984
P. Scarpellini, *Perugino*, Milan 1984.

SCARPELLINI AND SILVESTRELLI 2004
P. Scarpellini and M.R. Silvestrelli, *Pintoricchio*, Milan 2004.

SCATASSA 1901
E. Scatassa, 'Due opere sconosciute di Evangelista di Pian di Meleto', *Rassegna bibliografica dell'arte italiana*, IV (1901), p. 197.

SCHÖNE 1950
W. Schöne, 'Raphaëls Krönung des Heiligen Nicolaus von Tolentino', *Eine Gabe der Freunde für Carl Georg Heise zum 28.VI.1950*, Berlin 1950.

SCHÖNE 1958
W. Schöne, *Raphael*, Berlin and Darmstadt 1958.

SCHRÖTER 1980
E. Schröter, 'Der Vatikan als Hügel Apollons und der Musen. Kunst und Panegynik von Nikolaus V. bis Julius II', *Römische Quartalsschrift für christliche Altertumskunde und Kirchengeschichte*, LXXV (1980), pp. 208–40.

SCHRÖTER 1987
E. Schröter, 'Raffaels Madonna di Foligno – Ein Pestbild?', *Zeitschrift für Kunstgeschichte*, L (1987), pp. 46–87.

SCHULZ 1962
J. Schulz, 'Pinturicchio and the revival of Antiquity', *Journal of the Warburg and Courtauld Institutes*, XVI (1962), pp. 35–55.

SCHÜTT 1994–5
J. Schütt in eds H. Baureisen and M. Stuffmann, *'Von Kunst und Kennerschaft'. Die Graphische Sammlung im Städelschen Kunstinstitut unter Johann David Passavant 1840 bis 1861*, exh. cat., Frankfurt (Städelsches Kunstintistut und Graphische Sammlung) 1994–5.

SEABRA CARVALHO 1999
J. Seabra Carvalho in ed. J.L. Porfirio, *Museu Nacional de Arte Antiga, Lissabon*, exh. cat., Bonn (Kunst- und Ausstellungshalle der Bundesrepublik Deutschland) 1999.

SHAW 1996
C. Shaw, *Julius II – The Warrior Pope*, Oxford 1996.

SHEARMAN 1961
J. Shearman, 'The Chigi Chapel in S. Maria del Popolo', *Journal of the Warburg and Courtauld Institutes*, XXIV (1961), pp. 129–60.

SHEARMAN 1965
J. Shearman, 'Raphael's Unexecuted Projects for the Stanze', *Walter Friedländer zum 90. Geburtstag*, Berlin 1965, pp. 158–80.

SHEARMAN 1971
J. Shearman, 'The Vatican Stanze: Functions and Decorations', *Proceedings of the British Academy*, LVII (1971).

SHEARMAN 1972
J. Shearman, *Raphael's Cartoons in the Collection of Her Majesty the Queen and the Tapestries for the Sistine Chapel*, London 1972.

SHEARMAN 1977
J. Shearman, 'Raphael, Rome and the Codex Escurialensis', *Master Drawings*, XV (1977), pp. 107–46.

SHEARMAN 1986
J. Shearman, 'The Expulsion of Heliodorus' in eds C.L. Frommel and M. Winner, *Raffaello a Roma: il convegno del 1983*, Rome 1986, pp. 75–87.

SHEARMAN 1986a
J. Shearman, 'The Born Architect?' in *Raphael before Rome, Studies in the History of Art*, 17 (1986), pp. 203–10.

SHEARMAN 1993
J. Shearman, 'Gli Appartamenti di Giulio II e Leone X' in *Raffaello nell'appartamento di Giulio II e Leone X*, Milan 1993, pp. 14–37.

SHEARMAN 1995
J. Shearman, 'Il mecenatismo di Giulio II e Leone X' in eds A. Esch and C.L. Frommel, *Arte, committenza ed economia a Roma e nelle corti del rinascimento 1420–1530*, Turin 1995, pp. 213–42.

SHEARMAN 1996
J. Shearman, 'On Raphael's Chronology 1503–1508' in *Ars naturam adiuvans. Festschrift für Matthias Winner*, Mainz 1996, pp. 201–7.

SHEARMAN 2003
J. Shearman, *Raphael in Early Modern Sources – 1483–1602*, New Haven and London 2003.

SHEARMAN AND HALL 1990
eds J. Shearman and M. Hall, *The Princeton Raphael Symposium: Science in the Service of Art History*, Princeton 1990.

SHOEMAKER 1981
I.H. Shoemaker, *The Engravings of Marcantonio Raimondi*, exh. cat., Lawrence, KS (The Spencer Museum of Art, The University of Kansas) 1981.

SONNENBURG 1983
H. von Sonnenburg, *Raphael in der alten Pinakothek*, exh. cat., Munich (Alte Pinakothek) 1983.

STEFANIAK 2000
R. Stefaniak, 'Raphael's Madonna di Foligno: Civitas sancta, Hierusalem nova', *Konsthistorik Tidskrift*, LXIX (2000), pp. 65–98.

STIX AND FRÖHLICH-BUM 1932
A. Stix and L. Fröhlich-Bum, *Beschreibender Katalog der Handzeichnungen in der Staatlichen Graphischen Sammlung Albertina (bd. III). Die Zeichnungen der toskanischen, umbrischen, und römuischen Schulen*, Vienna 1932.

SUIDA 1955
W.E. Suida, 'Raphael's Painting of "The Resurrection of Christ"', *The Art Quarterly*, XVIII (1955), pp. 3–10.

SUTTON 1970
D. Sutton, 'Oxford and the Lawrence Collection of Drawings' in *Italian drawings from the Ashmolean Museum, Oxford*, exh cat., London (Wildenstein) 1970, pp. VII–XXXIII.

TEMPESTINI 1999
A. Tempestini, 'L'iconografia del Cristo morto nelle regioni adriatiche occidentali' in Varese (ed.) 1999, pp. 171–6.

THOENES 1986
C. Thoenes, 'Galatea: tentativi di avvicinamento' in eds C.L. Frommel and M. Winner, *Raffaello a Roma: il convegno del 1983*, Rome 1986, pp. 59–72.

TODINI 1990
F. Todini, 'Una crocifissione del giovane Raffaello a Perugia', *Studi di Storia dell'Arte*, I (1990), pp. 113–44.

TURNER 1983
N. Turner, 'Umbrian Drawings at the Uffizi', *The Burlington Magazine*, CXXV (1983), pp. 118–20.

TURNER 1986
N. Turner, *Florentine Drawings of the Sixteenth Century*, exh. cat., London (British Museum) 1986.

TURNER 2000
N. Turner, *European Master Drawings from Portuguese Collections*, exh. cat., Cambridge (Fitzwilliam) 2000.

VAN CLEAVE 1995
C. Van Cleave, *Luca Signorelli as a Draughtsman*, doctoral thesis, Oxford University 1995.

VAN MARLE 1933
R. Van Marle, 'Giovanni Santi, Bartolommeo di maestro Gentile ed Evangelista di Pian di Meleto', *Bollettino d'Arte*, Ser. III, II (1933), pp. 493–503.

VARESE 1994
R. Varese, *Giovanni Santi*, Fiesole 1994.

VARESE (ED.) 1999
ed. R. Varese, *Giovanni Santi, Atti del convegno, Urbino, Convento di Santa Chiara, 17–19 March 1995*, Milan 1999.

VARESE 2004
R. Varese, 'Giovanni Santi e Pietro Perugino' in ed. L. Teza, *Pietro Vannucci detto il Perugino*, Perugia 2004, pp. 199–228.

VASARI 1878–85
G. Vasari, *Le Vite de più Eccellenti Architetti, Pittori e Scultore* (1568 edn), ed. G. Milanesi, Florence 1878–85.

VASARI 1906
G. Vasari, *Le Opere*, ed. G. Milanesi, Florence 1906.

VASARI/BB
G. Vasari, *Le Vite . . .*, Florence [1550 and 1568], eds R. Bettarini and P. Barocchi in *Le Vite . . . nelle redazioni del 1550 e 1568*, Florence 1966–87.

VENTURI 1913
A. Venturi, *Storia dell'arte Italiana*, VII.2, Milan 1913.

VENTURINI 2004
L. Venturini in Perugia 2004.

VERMIGLIOLI 1837
G.B. Vermiglioli, *Bernardino Pinturicchio*, Perugia 1837.

VIATTE 1983–4
F. Viatte in *Raphael dans les collections françaises*, exh. cat., Paris (Grand Palais) 1983–4.

VIATTE 2003
F. Viatte in eds F. Viatte and V. Forcione, *Léonard de Vinci. Dessins et manuscrits*, exh. cat., Paris (Louvre) 2003.

VISCHER 1897
R. Vischer, *Luca Signorelli und die italienische Renaissance*, Leipzig 1879.

VOLPE 1956
C. Volpe, 'Due questioni raffaellesche', *Paragone*, VII.75 (1956), pp. 3–18.

WAAGEN 1838
G. Waagen, *Works of Art and Artists in England*, London 1838 (3 vols).

WAAGEN 1854
G. Waagen, *Treasures of Art*, London 1854.

WAAGEN 1857
G. Waagen, *Galleries and Cabinets of Art*, London 1857.

WAGNER 1969
U. Wagner, *Raffael im Bildnis*, Bern 1969.

WANSCHER 1926
V. Wanscher, *Raffaello Santi da Urbino. His Life and Works*, London 1926.

WASSERMAN 1978
J. Wasserman, 'The Genesis of Raphael's *Alba Madonna*' in *Raphael before Rome. Studies in the History of Art*, 8 (1978), pp. 35–61.

WATTS 1912
M. S. Watts, *George Frederic Watts: The Annals of an Artist's Life*, London and New York 1912 (3 vols).

WEISS 1965
R. Weiss, 'The Medals of Pope Julius II (1503–1513)', *Journal of the Warburg and Courtauld Institutes*, XXVIII (1965), pp. 163–82.

WESTMACOTT 1824
C.M. Westmacott, *British Galleries of Painting and Sculpture*, London 1824.

WESTON-LEWIS 1994
ed. A. Weston-Lewis, *Raphael. The Pursuit of Perfection*, exh. cat., Edinburgh (National Gallery) 1994.

WHISTLER 1990
C. Whistler, *Drawings by Michelangelo and Raphael*, Oxford 1990.

WHITE, WHISTLER AND HARRISON 1992
C. White, C. Whistler and C. Harrison, *Old master drawings from the Ashmolean Museum*, exh. cat., Oxford (Ashmolean Museum) 1992.

WILDE 1953
J. Wilde, *Italian Drawings in the Department of Prints and Drawings in the British Museum. Michelangelo and his Studio*, London 1953.

WILDE 1978
J. Wilde, *Michelangelo*, Oxford 1978.

WIND 1967
E. Wind, *Pagan Mysteries in the Renaissance*, London 1967 (2nd edn).

WINNER 1993
M. Winner, 'Progetti ed esecuzione nella Stanza della Segnatura' in *Raffaello nell'appartamento di Giulio II e Leone X*, Milan 1993, pp. 246–91.

WINNER 2000
M. Winner, 'Lorbeerbäume auf Raffaels Parnass' in ed. M. Seidel, *L'Europa e l'arte italiana*, Venice 2000, pp. 186–209.

WITTKOWER 1963
R. Wittkower, 'The Young Raphael', *Allen Memorial Art Museum Bulletin*, XX (1963), pp. 150–68.

WOODS-MARSDEN 1998
J. Woods-Marsden, *Renaissance Self Portraiture*, New Haven and London 1998.

ZENTAI 1979
R. Zentai, 'Contribution à la période ombrienne de Raphaël', *Bulletin du Musée Hongrois des Beaux-Arts*, 53 (1979), pp. 69–79.

ZENTAI 1991
L. Zentai, 'Le "Massacre des Innocents". Remarques sur les compositions de Raphael et de Raimondi', *Bulletin du Musée Hongrois des Beaux-Arts*, 75 (1991), pp. 27–42

ZERI AND GARDNER 1980
F. Zeri and E. Gardner, *Italian Paintings. A Catalogue of the Collection of the Metropolitan Museum of Art: Sienese and Central Italian Schools*, New York 1980.

ZEZZA 1999
A. Zezza, 'Giovan Battista Castaldo e la chiesa di Santa Maria del Monte Albino: un tondo di Raffaello, un dipinto di Marco Pino e un busto di Leone Leoni a Nocera de' Pagani', *Prospettiva*, 93–4 (1999), pp. 29–41.

ZIFF 1977
N. Ziff, *Paul Delaroche*, New York and London 1977.

ZÖLLNER 2003
F. Zöllner, *Leonardo da Vinci, 1452–1519: the complete paintings and drawings*, Cologne, London and Los Angeles 2003.

ZUCKER 1977
M.J. Zucker, 'Raphael and the Beard of Julius II', *Art Bulletin*, LIX (1977), pp. 524–33.

LIST OF LENDERS

BERGAMO
Pinacoteca dell'Accademia Carrara, cat. 26

BERLIN
Staatliche Museen zu Berlin-Preußischer
Kulturbesitz (Gemäldegalerie, cat. 25)
(Kupferstichkabinett, cat. 13)

BOSTON, MA
Isabella Stewart Gardner Museum, cat. 42

CAMBRIDGE
The Fitzwilliam Museum, cat. 6

CHATSWORTH
Devonshire Collection, the Duke of Devonshire
and the Chatsworth Settlement Trustees,
Chatsworth, cat. 100

CITTÀ DI CASTELLO
Pinacoteca Comunale, cats 18–19

EDINBURGH
Duke of Sutherland Collection, on loan to
The National Gallery of Scotland, cat. 62

FLORENCE
Galleria degli Uffizi, cats 2, 8
Galleria Palatina, Palazzo Pitti, cat. 101

FRANKFURT
Städelsches Kunstinstitut, cats 31, 82

LILLE
Musée des Beaux-Arts, cats 17, 92, 94

LISBON
Museu Nacional de Arte Antiga
(National Museum of Ancient Art), cat. 29

LONDON
The British Library, cat. 9
The British Museum, cats 36–8, 48, 56–8, 63,
69, 70–1, 73, 80–1, 84, 88, 90, 96–8
Dulwich Picture Gallery, cats 43–4
The National Gallery, cats 4, 10, 27, 35, 41, 45–6,
49, 59, 74, 91, 99
Royal Academy of Arts, cat. 61

MADRID
Museo Nacional del Prado, cat. 60

MILAN
Museo Poldi Pezzoli, cat. 14

MONTPELLIER
Musée Fabre, cat. 85

NAPLES
Museo Nazionale di Capodimonte, cats 15–16

NEW YORK
The Metropolitan Museum of Art, cat. 40

NORFOLK
The Earl of Leicester and the Trustees of the
Holkham Estate, cat. 55

OXFORD
The Ashmolean Museum, cats 1, 12, 20, 23–4, 28,
47, 50, 68, 72, 75–6, 79, 83, 86

PARIS
Musée du Louvre, cats 7, 33–4, 52, 77

PERUGIA
Galleria Nazionale dell'Umbria, cat. 65

PESARO
Ente Olivieri, Biblioteca Oliveriana, cat. 22

RALEIGH, NC
North Carolina Museum of Art, cat. 30

ROME
Museo e Galleria di Villa Borghese, cat. 51

ROTTERDAM
Museum Boijmans Van Beuningen, cat. 95

SALISBURY
The Earl of Pembroke and the Trustees of
Wilton House Trust, Wilton House, cat. 53

SÃO PAULO
Museu de Arte de São Paulo Assis
Chateaubriand, cat. 21

ST PETERSBURG
The State Hermitage Museum, cat. 32

URBINO
Galleria Nazionale delle Marche, cat. 5

VATICAN CITY
Vatican Museums, cats 66–7

VIENNA
Albertina, cats 39, 64, 87

WASHINGTON, DC
National Gallery of Art, cat. 93

WINDSOR
The Royal Collection, cats 3, 11, 54, 78, 89

PHOTOGRAPHIC CREDITS

INDEX

Numbers in *italics* refer to pages with illustrations.